The Discovery of the Art of the Insane

The Discovery of the Art
of the Insane

JOHN M. MacGREGOR

Princeton University Press / Princeton, New Jersey

Published by Princeton University Press, 41 William Street,
Princeton, New Jersey 08540
In the United Kingdom: Princeton University Press,
Guildford, Surrey

This book has been composed in Linotron Century Schoolbook

Clothbound editions of Princeton University Press books are
printed on acid-free paper, and binding materials are chosen for
strength and durability. Paperbacks, although satisfactory for
personal collections, are not usually suitable for library
rebinding

Printed in the United States of America by Princeton
University Press, Princeton, New Jersey

Library of Congress Cataloging-in-Publication Data
MacGregor, John M. (John Monroe)
The discovery of the art of the insane / John M. MacGregor.
 p. cm.
Based on author's thesis (Ph. D.)—Princeton University, 1978.
Bibliography: p.
Includes index.
ISBN 0-691-04071-0 (alk. paper)
1. Art and mental illness—History. I. Title.
RC455.4.A77M33 1989
616.89—dc19 88-37986

To the memory of my father

CHARLES EDWARD McGREGOR

1898–1963

Contents

Illustrations

FIGURES

Preface

The sequence of events that lead to the decision to undertake a long and complex interdisciplinary investigation is not readily discernible in the final product of such a study. In most cases the historical background of even the most unusual subject of research and the individuals who contribute to its selection and evolution are of little importance once the task has been concluded. In the case of the book with which the reader is now confronted, however, these individuals and events have themselves become part of the historical process of discovery, the investigation of which forms the subject of all that follows. In reconstructing the history of the discovery of the art of the insane (and in evaluating its impact on the art and artists of the nineteenth and twentieth centuries), they and I have inevitably contributed to that process of discovery which it has been my task to describe. While the chapters that follow describe the role of the pioneering contributors, most of whom belong to time past, this preface is the appropriate place to mention the names of contemporary physicians, scholars, art historians, teachers, and friends who, during the years when the book was taking shape, contributed their energy, memories, knowledge, and support to a historical endeavor whose value and function they often recognized more clearly than the author. In the years since my work began, many of these colleagues and friends have died, so that my words of acknowledgment and thanks can serve only to commemorate rich experiences shared, and fragments of memory preserved from loss.

In that this project originated within the context of a doctoral dissertation, I would like to acknowledge my debt to certain members of the department under whose auspices it was carried out. The decision to undertake what was, at that time, an all but unacceptable subject of research, resulted from the encouragement of Professor Wen C. Fong who, in the face of my own deep-rooted skepticism, convinced me that the interdisciplinary study of relations between art and psychiatry was a matter of profound importance to the history of art, the investigation of which rightfully occupied a place within the Department of Art and Archaeology of Princeton University.

I am also deeply grateful to the then chairman, Professor David R. Coffin, who kindly agreed to my request that an external supervisor and reader be appointed from outside of the university and the discipline of art history, a scholar whose area of expertise would be psychiatry and psychoanalysis. Given the nature of the topic, Dr. Coffin also understood and supported my decision to undertake a year of research and study at the School of Psychiatry of the Menninger Foundation in Topeka, Kansas, and at the C. G. Jung Institute in Zurich.

I also wish to thank Chairman Professor John Rupert Martin, who played an active role in facilitating the writing of the dissertation in its later stages, and who lent his encouragement at a period during which the project seemed likely to collapse as a result of the extreme complexity of bringing such an elaborate interdisciplinary study to a final conclusion. It is a remarkable accomplishment when art historians coming from fields as diverse as Asian art, Renaissance architecture, and Baroque painting concern themselves with an investigation so remote from their usual concerns, taking a firm stand in support of a graduate student's right to unorthodox and difficult interdisciplinary study and research.

Although responsibility for the form and content of this work must rest solely on my shoulders, credit for sustaining the process of research and writing over the period of fifteen years that it required must go to the late Paul Pruyser, Ph.D., Henry March Pfeiffer Professor and Director of the School of Psychiatry of the Menninger Foundation, who served with absolute commitment in the difficult role of psychiatric advisor to what proved to be an unusually long project. Dr. Pruyser's personal involvement with the psychological investigation of art and its history, combined with his professional training in the fields of clinical psychology, psychiatry, and psychoanalysis, uniquely qualified him for this uncommon and yet profoundly interesting responsibility. A true friend, his wisdom and kindly support sustained me in frustrating and difficult times.

It stands as a tribute to those at the Menninger Foundation that they were willing to accept a psychiatric layman as a visiting researcher, providing him

not only with an office and secretarial services, but with access, as well, to the full range of courses offered by their education department. The interest of both the staff and students of this famous institution in the subject with which I was involved afforded valuable insight and stimulation. I wish to express my sincere appreciation to Dr. and Mrs. Gardener Murphy who provided me with a splendid home during my studies in Topeka.

The long period of study of which this volume represents the final product was made financially possible through the generosity of two institutions, to the directors of which I gratefully acknowledge my indebtedness. The year of research in Topeka and Zurich, as well as a further year of study at Princeton, and yet another in London and Europe, was made possible through the financial support of the Canada Council through their program of grants in the humanities and social sciences. The remainder of my research was subsidized, perhaps unwittingly, by the Ontario College of Art, Toronto, which in 1971 took the unconventional step of creating a lectureship in Art and Psychiatry which it was my privilege to hold for a period of fifteen years. Two fifteen-month sabbaticals provided an opportunity for additional research and writing, which enabled a dissertation to be transformed into an updated and publishable manuscript. I am indebted to my many students whose interest in the psychiatric exploration of art spurred me to see more deeply into the problems than I might otherwise have done.

My year of study in London was made particularly valuable through the kind offices of a number of people among whom I would like first to mention the late Anna Freud. Whatever understanding I may possess of psychoanalysis, its history and theory, is due to the intervention on my behalf of this splendid offshoot of Sigmund Freud, who made it possible for me to enjoy a full year of research and study at the Hampstead Clinic, London.

I am grateful, too, to Dr. Raymond Levy through whose good offices I was made a Visiting Fellow of Bethlem Royal Hospital, Kent, and the Maudsley Hospital, London, an honorary appointment that opened the archives of Bethlem Hospital to me, with invaluable results. The archivist of that venerable institution, Miss Patricia Allderidge, contributed more to the content of the dissertation than any other single individual. Her devotion to the task of reconstructing the history of Bethlem Hospital made possible a detailed study of the evolution of the art of the insane within this most famous of all psychiatric establishments. It is to Miss Allderidge that I owe my introduction to the work of Richard Dadd, and to the almost completely unknown drawings of Jonathan Martin.

Other British contributors to this study include Miss Sophie Dann, Librarian of the Hampstead Clinic; Miss Doris M. Wills; Mr. Roger Cardinal, the great authority on Outsider Art; Mr. John Hewett; John Ingamells, Director of the York City Art Gallery; Miss Dorothy Stroud, Director of the Sir John Soane's Museum; and Mr. Alastair Lunn of the British Reference Library, London.

Among the artists who contributed to this study, a single name must stand out above all others, that of Jean Dubuffet. Through my encounter with Dubuffet, both in person and in his writings on Art Brut, I was led to a fundamental revision of my thinking in regard to the art of the insane and to a no less fundamental recasting of the form and content of the book in its final stages. Dubuffet's efforts on behalf of these images that he loved so deeply have, almost single-handedly, forced the acceptance of this uniquely human form of pictorial expression within the realm of art. I am grateful, too, to M. Michel Thévoz, the Director of the Collection de l'Art Brut, Lausanne, and to his assistant Mlle. Geneviève Roulin, for placing both the archives and the collections of this museum at my disposal.

I am similarly indebted to Dr. Inge Jàdi, Curator of the Prinzhorn Collection, Heidelberg; to Professor Dr. Sergio Tovo, Curator of the Lombroso Collection, Turin; to Mrs. Elka Spoerri, Curator of the Adolf Wölfli-Stiftung at the Kunstmuseum, Bern; to Professor Dr. Hans Walther-Büel, Director of the Morgenthaler Collection at the Psychiatrische Universitätsklinik, Bolligen; and to Arnulf Rainer, artist and creator of the Arnulf Rainer Collection of Psychiatric Art in Vienna. It is with particular pleasure that I mention here the scholarly cooperation and friendship offered without limit by Dr. Leo Navratil of Klosterneuburg, Austria.

On this side of the ocean I would like to mention the assistance I have received from Miss Elizabeth Roth, Keeper of Prints of the New York Public Library; Miss Pearl Moeller, of the Department of Special Collections of the Museum of Modern Art; Ms. Adele Lerner, Archivist of the New York Hospitals; Miss Frederica Oldach, Head Librarian of the Marquand Library, Princeton University; Dr. James L. Foy of Washington, D.C.; Dr. Irene Jakab of Pittsburgh; Professor Aaron Sheon of Pittsburgh; Mr. and Mrs. Selwyn Dewdney of London, Ontario; Dr. Graeme J. Taylor of Toronto, Ontario; Mr. George Grant of the Metropolitan Toronto Public Library; the staff of the Ontario College of Art,

Toronto, especially Ms. Diana Myers; and Mr. and Mrs. Andrew P. MacNair of New York, whose hospitality made my research visits to that city unusually bearable.

Among my most pleasant memories of New York are those associated with my visits to Dr. Marianne Kris, whose fond descriptions of the life and personality of her late husband, Dr. Ernst Kris, succeeded in restoring him to life for me.

One of the most treacherous and difficult journeys a book must make, if it is ever to reach the reader for whom it is intended, is from the author's desk to that of its eventual publisher. For this rocky voyage, a well-known and powerful scholarly vessel is invaluable, a supportive role played, in the case of this book, by art historian and humanist, Professor Sir Ernst Gombrich. Professor Gombrich's involvement with the project came about as a result of a fortuitous meeting in Kyoto between himself and my friend and colleague Robert Singer. Having read the enormous manuscript, Professor Gombrich generously offered his friendship and encouragement, as well as his active assistance in locating a publisher, to an unknown author who had abandoned all hope of seeing his book in print. Among my happiest memories during those dark years were conversations over tea and cake with Professor and Mrs. Gombrich in their garden in London.

The book's reception at Princeton University Press was one of the final tasks of Fine Arts Editor Christine K. Ivusic, whose tragically early death deprived the author of a good friend and an enthusiastic supporter. My sincere thanks also go to my typist, Mrs. Janet Kaethler, to my endlessly patient editors, Robert E. Brown and Brian R. MacDonald, and to the book's designer, Susan Bishop. I would also like to thank Kerry K. Ko for his help with the index.

One of the historical responsibilities that I have often neglected to observe in the thick of research is to keep track of my many scholarly debts. As a result, many collaborators and contributors to my work, despite my wish to remember all, must go unmentioned here. Their generosity, not less important for being forgotten, has also shaped both me and my book.

Finally, I want to express my deepest appreciation and thanks to two faithful friends, William Muysson and Fu Ch'ing-ming, whose ability to remain calm at the center of an almost continual storm, enabled this labor of love to find its way safely to harbor.

San Francisco, June 1988

The Discovery of the Art of the Insane

These are primitive beginnings in art, such as one usually finds in ethnographic collections, or at home in the nursery. Do not laugh, reader! Children also have artistic ability and there is virtue in their having it! . . . Parallel phenomena are provided by the works of the mentally diseased; neither childish behavior nor madness are insulting words here, as they commonly are. All this is to be taken seriously, more seriously than all the public galleries when it comes to reforming today's art.

 —*Paul Klee*

We will not cease until justice has corrected the blind and intolerant prejudice under which works of art produced in asylums have suffered for so long, and so long as we have not freed them from the aura of worthlessness which has been created around them.

 —*André Breton*

The madman is a reformer, an inventor of new systems, intoxicated with invention. . . . This is exactly what is required of the artist, and explains why the creation of art is so worthless when it does not originate in a state of alienation, when it fails to offer a new conception of the world, and new principles for living.

 —*Jean Dubuffet*

Introduction

At the end of the nineteenth century and the beginning of the twentieth, as a result of forces that had been building for at least a hundred years, the idea of what art was underwent sudden and enormous change and expansion. It is no exaggeration to speak of a cultural and artistic revolution that expressed, in part, a profoundly altered conception of how pictorial images functioned in human life. As an important aspect of this cultural "shift," the art of primitive peoples, of the oriental races, of naive and folk painters, and to a lesser extent, of children and the insane suddenly emerged as artistically viable statements worthy of serious consideration, aesthetic contemplation, and systematic collection as art. This study undertakes to investigate and document one small aspect of this expansion in the concept of art, the "discovery" of the art of the insane.

The discovery of so-called primitive art, particularly that of Africa and the islands of the Pacific, has been extensively studied. The fact that the reevaluation of these objects was largely the achievement of a small group of artist-innovators is well known. The massive influence of primitive art on the new visual languages of the twentieth century has been explored in depth.[1] Scholarly studies of the contributions of Gauguin, Vlaminck, Derain, Matisse, Picasso, Braque, and Modigliani to the discovery and utilization of primitive form, subject matter, technique, and aesthetic concept have established the process whereby these "curios" were transformed into an integral part of the artistic heritage of the Western world.[2] This process of reevaluation, while differing in motivation and function, can be seen as continuing similar discoveries of styles remote either in time or place that formed an essential aspect of the Romantic period, the incorporation into art of Gothic architecture and sculpture, of Chinese and Japanese artifacts, and of much art of the pre-Greek world.[3] The historical development of Romantic and post-Romantic art would be incomprehensible without an understanding of the role played by these images once thought to be alien or barbaric.

Still more surprising and difficult to account for is the inclusion within twentieth-century art of the paintings of a few untrained amateurs, naive painters whose elaborate pictures had, until the later years of the nineteenth century, been perceived as at best amusing and, more commonly, beneath contempt. Here too the contribution of artists and writers was fundamental in effecting a change in perception and attitude that led to these images' being transformed from pictorial jokes into the artistic equals of work by more traditionally recognized painters. Beginning with the acceptance of paintings by the French customs official Henri Rousseau (1840–1910), the critical achievement of the writers Alfred Jarry (1873–1907), Guillaume Apollinaire (1880–1918), and Rémy de Gourmont (1858–1915), and of the painter Pablo Picasso (1881–1973), the history of the artistic conquest of naive painting has received careful investigation and documentation.[4]

The systematic historical reconstruction of these processes of aesthetic mutation, these unexpected patterns of changing perception and influence, is necessitated by the fact that these newly discovered images may prove to have been as important for the art of this century as the sequence of Classical revivals was for art of the Middle Ages.[5] For these curiously crude objects and images contained within themselves an astonishing intensity and a latent power to work changes on the milieu into which they had been imported. Inherent in these acts of reappraisal is evidence of a changing conception of the nature and function of the creative process, and of its products, which was to have a pronounced effect on the form and content of visual images born in this new context. Apparently, one does not discover what one has no need of. For artists at the turn of the century, the new images seem to have satisfied a deeply felt need for contact with, and cultivation of, a radically different aesthetic. As Georges Braque explained, "African masks opened a new vista before me. They allowed me to make contact with instinctive things, with pure manifestations which opposed false traditions, traditions which horrified me."[6] This passionate rejection of tradition and the attendant search for primitive or "instinctive" forms and images are rooted in the profoundly changed under-

standing of man and his world induced in the European personality by that complex psychological phenomenon, Romanticism.

Art historical accounts of the enlarged aesthetic response so typical of this century tend to indulge in overgenerous enthusiasm. For example, Dora Vallier, in a somewhat exaggerated appraisal of Henri Rousseau's influence, makes the following statement:

Rousseau symbolizes a turning point in history, and thanks to his gifts, all our notions of primitive art today derive from his prodigious example. There were primitive painters before him, just as there have been primitive painters since, but it was his example alone—occurring as it did in an especially crucial time and place—that restored this other tradition to our consciousness. He added something unique to the cultural ferment of the nineteenth century. Thanks to him, the doors of art were flung open once and for all. The art of children and madmen no longer falls outside our aesthetic concepts, and no primitive painter ever again need feel awkward at his lack of formal training.[7]

Bernard Dorival grapples with the problem of the process of the acceptance of naive painting in a similar passage:

The problem presented to us here is not to explain the existence of naive painting, but rather to take into account its success at the eve and immediately after the war of 1914, or more exactly its advancement to the level of art, of a major art, an adult art, of an art equal in dignity, in quality, even in financial value. . . . The continued popularity of this art was therefore not the effect of something new which had suddenly become fashionable, but rather the expression of a permanent public need. And the question one may well ask is: How does one account for the audience that this art attracted? Several answers, all very different, may be given. For example, the probing of the irrational in creative art which simultaneously urges all our contemporaries to examine paintings by children and insane people.[8]

The successful entry of primitive sculpture and naive painting into the august realms of art cannot be questioned. However, it has become common for art critics and art historians to refer in their accounts of the process to the simultaneous acceptance of the art of children and of the insane as well. The passages just quoted are fairly typical examples of this tendency. It would appear that, an "open-door policy" having been established, anything might gain admission on terms of equality to the charmed, but curiously undefined, circle of art. Lumping together the various primitive arts, as well as naive and folk art, with the painting of young children and insane adults tends to obscure the fact that neither the art of children nor the art of the insane has ever been fully accepted as art. Also, by grouping these, superficially similar forms of expression, one implies that the significance and beauty of each different type of image were recognized through an identical process, or at least through a common underlying motivation.[9]

In the early twentieth century several European artists had become aware of the art of the mentally ill and were influenced by it. Exhibitions of psychopathological art were held for the first time and a number of publications appeared that made the contents of private collections of outstanding examples of this unique art publicly available. Occasionally, images produced in psychiatric hospitals began to gain recognition as powerful visual statements capable of holding their own in the world of art. Discussion of the life work of so-called schizophrenic masters led to an awareness that there were unrecognized artists of extraordinary quality whose astonishing productions stood above the mass of uninspired paintings and drawings produced both inside and outside of hospitals.[10]

The discovery of the art of the insane was not confined to psychiatric circles, nor was appreciation of it limited to a small group of devotees. Despite the very restricted quantity of such work that was easily available, art produced within the context of insanity excited intense public interest. The cliché of the mad artist, so prevalent even in our own day, inspired tremendous curiosity about these images.

Although the influence of the painting and drawing of the mentally ill becomes visually and ideologically obvious during the first quarter of the twentieth century, the origins of this new sensibility appear very strongly as a fundamental aspect of Romanticism. Within this all-pervasive movement the concept of insanity and the attitude toward insane people underwent a profound and permanent change, the implications of which are still being felt. The madman was transformed from a mindless, unfeeling animal into a heroic embodiment of the Romantic ideal, his art a pure expression of the Romantic imagination unchained.

Because the art of the insane, like the art of children, or primitive peoples, has always existed, it is worth considering in what sense it is meaningful or correct to speak of its "discovery." What necessity is there to discover that which is already in existence? The art of the madhouse, to a greater extent than primitive art or naive painting, suffered from invisibility. Rich in form, it was seen as chaotic. Loaded with meaning, it was understood as meaningless. The product of terrifying intensity of feeling and human need, it was dismissed as trivial and insignificant. To the ex-

tent that it can be said to have existed at all, the art of the insane was seen only as refuse to be ignored, or obliterated, or prevented. Its discovery can therefore only be said to occur at the moment when these images in all their reality entered human consciousness. Although this process may have occurred in many places and in many minds, the first evidence for its occurrence is found in art.

From the beginning these images, although dismissed as incomprehensible or mad, were identified as art, the art of the insane.[11] They awaken curiously ambivalent responses in most people. The art of the insane, just as insanity itself, is both attractive and repellent, a fact that may account for its uncertain position on the border of art, an embarrassing skeleton in the artistic closet. For despite the undeniable visual authority and emotional power, not even the finest examples of the painting and sculpture of the insane have found a permanent place in the museums of the Western world.[12] There is no market for the work of these people, there are no historical monographs on the art of celebrated madmen, and no courses on the psychopathology of art are to be found in art history departments.[13] The conquest of the art of the insane was incomplete, its success nowhere near that of primitive or naive art. Our task is nevertheless to define and to document its discovery, the extent of its visibility and influence, the degree of acceptance and rejection it encountered, and the reasons for its ambivalent reception in the twentieth century.

The failure of this art to gain full recognition within the realm of art resulted partly from the reluctance of critics and students of art to grapple with visual material that they considered the province of another discipline, the emerging field of medical psychiatry. Although the discovery of the artistic activity of the insane was accomplished by artists, the systematic collection, classification, and study of these images was begun by alienists, physicians who specialized in treating the mentally ill. The development of psychiatry as a specialty, an achievement of eighteenth- and nineteenth-century medicine, tended to encourage the belief that the understanding of such manifestations of mental illness as the patients' artistic activity was best left to experts. The emergence of hospitals specifically created to care for and treat the insane rapidly led to the disappearance of these people, and their strange ideas and behavior, from the community. As a result, insanity became an imaginative conception rather than a commonly encountered reality. During the very period when the insane were becoming an object of intense interest, fostered by Romanticism, their public

visibility was becoming more and more limited.[14] For the most part, the art of the insane was now to be found only within the walls of institutions.[15] Among the problems that we shall have to confront in detail is the question of the means of access to this unique type of artistic expression. How available was the art of the insane? Who knew about its existence? What possibility of contact existed between the general public and the madman, between the artist and his mad brother?

An instructive parallel is provided in the case of primitive art. These objects, originating in Africa or Oceania, had somehow to find their way into the hands of sensitive and receptive European artists before their reevaluation and influence could make itself felt. The creation of artist-shamans, so remote geographically as to be invisible, these objects too were seen as belonging to other fields of study, anthropology and ethnology. For at least a century, study of primitive sculpture was confined to experts in these emergent disciplines.[16] In contrast, contact between the artistic community and the insane was far more extensive and occurred much earlier. Interest in the art of the insane by creative artists precedes their involvement with primitive art by a hundred years. However, the possibility of exposure to primitive art was enhanced by the development of museums of ethnology, whereas collections of psychopathological art, while they existed, were not generally open to the public. Examples of African and Oceanic art were being imported and sold in shops dealing in antiquities and curios. The art of the insane was rarely available for purchase or collection by private individuals. Nevertheless, the end of the nineteenth century witnessed the formation of several major collections of patient art, which provided the basis for present-day research collections. For a long time public access was chiefly through visits to the hospitals. Artists and writers inspired by Romantic notions of insanity saw the asylum as a source of inspiration, and their visits are recorded in journals and publications of the period.

Toward the end of the nineteenth century, physicians began to publish detailed descriptions and classifications of their patients' artistic productions, and to furnish their studies with increasing numbers of illustrations. That knowledge of these publications was not limited to medical circles can and will be demonstrated. The role of the physician as interpreter of this new type of image was very influential, determining to some extent the way in which it was received at first by the lay public. Nevertheless, as was the case with primitive art, the creative artist saw these images in his own unique way, displaying admirable indepen-

dence of, and skepticism toward, the psychiatric experts. Although some physicians appear to have been sensitive to the aesthetic aspects of their patients' productions, the acceptance of a small minority of these images as works of art, to the extent that it occurred, was not, and could not be, the accomplishment of medical professionals.

The developing relationship between members of the new medical specialty and the artistic community has, with the notable exception of the encounter between Théodore Géricault and Etienne Georget, been little studied.[17] Whereas the pervasive influence of Romantic philosophy and thought on the development of psychiatry has been carefully investigated by students of the history of psychiatry, study of the extent and nature of the contacts between artists and alienists has been totally neglected. The new involvement with the visual expressions of the insane, manifested by both physicians and artists, can be understood as a result not only of the Romantic involvement with insanity and its fascination with the concept of the mad genius but, more obviously, as the outcome of the increasing contact and collaboration between physicians and artists common in the nineteenth century.

At this point I should perhaps emphasize that my investigation is not concerned with several controversial problems that have plagued students of the psychopathology of expression and rendered their research and findings distasteful and suspect to students of art. In this investigation, discussion of the art of the insane is confined to drawings, paintings, and sculpture executed by individuals who were clearly diagnosed as mentally ill, and is not at all concerned with the elucidation of the life and work of celebrated artists who may have exhibited symptoms of mental illness. Specifically therapeutic encounters between physicians and artists are not discussed. The only exception to this limitation is necessitated by instances of highly trained artists who experienced a period of severe mental disturbance during which they continued to paint or draw, and whose work during their illness may have affected the public's perception of the nature and function of the art of the insane in general. An example is provided by the work of the English painter Richard Dadd.

Furthermore, I do not deal with psychological interpretation of works of art, except in terms of historical reconstruction of the varied approaches to the problem of interpretation as it was understood by early students of the art of the insane. The phrase "art of the insane" is used, after much deliberation, as a matter of convenience and historical authenticity. Whether the graphic or sculptural productions of the insane are at present considered to be "art" is irrelevant to the subject of this investigation. That they were at times so perceived is, on the other hand, a historical fact of considerable importance to this study. The meaning of the phrase "art of the insane" evolved over a long period. In its early usage it implied all drawings, paintings, and sculpture made by madmen. Toward the end of the nineteenth century, and most clearly in the early years of the twentieth century, the phrase began to be used in referring to those rare works perceived as being of unusually high artistic quality or meaning. While in a narrow sense my goal is an investigation of the changing meaning and implication of this phrase, in the wider sense it embraces the extent and quality of the encounter between artist, physician, and patient, as it was manifested in the serious preoccupation with the image-making activity of the insane over two centuries.

The contribution of mentally ill individuals to this new field of study and aesthetic response, while obvious, deserves to be emphasized. The rare images whose power had come to attract and fascinate visually sensitive people were created by very real men and women, who gave birth spontaneously to concrete images in response to a creative drive expressing fearful inner need and intense feeling. These images are the externalized expression of their mental conflicts, insight, confusion, and pain; and, as with most art, they represent an accidental but nonetheless profound gift to humanity. Less obvious, and less well known, is the contribution these people made to the understanding of their own art; their writings and explanations have led others into deeper awareness of these images as rich sources of information and experience about the human mind and its symbols.

The psychiatric hospital, prison, asylum, or caring environment within which this art was created was an undeniably real factor promoting and at times opposing the creation of the images made by its inhabitants. The history of the growth and development of these institutions forms a part of the story of the art of the insane, as the milieu within which these artists lived profoundly influenced their psychological state and the way in which they saw themselves and their images. For this reason the history of patient art within one institution, Bethlem Royal Hospital, London, the once-notorious "Bedlam," has been allowed to assume a role in my investigation that might suggest an unusually active group of artist-patients dwelt within its walls. This is not the case. Any hospital might have provided an equally interesting series of cases and artistic doc-

uments. Bethlem plays so prominent a part only because its archives contain a remarkably complete picture of its history throughout the period with which I am concerned. Conditions at Bethlem were no more and no less horrific than in other hospitals, and at times it pioneered new forms of care and treatment of patients, which were reflected in the work of the men and women who benefited from them. This hospital can therefore be seen as an example of the changing climate of creation within which the artists, by necessity, lived their lives and gave expression to their unique inner and outer reality.

The interdisciplinary focus of this historical investigation into the origins of interest in psychopathological art follows the erosion of barriers between the creative artist and the world of science and technology that characterized the nineteenth and twentieth centuries. The influence of the Enlightenment, so crucial to the development of modern psychiatry, found expression in art as well. Artists, having freed themselves from the limiting environment of the guild system, the workshop, and the academy, were increasingly involved in exploring and interpreting the whole range of human knowledge. There is a deepening of psychological penetration and insight evident in nineteenth- and twentieth-century art that seems to reflect the artist's increasing knowledge of himself and of the human mind in general. The relentless confrontation with the world of the unconscious and the courageous involvement with the private symbols thrown up from that inner darkness were of as much concern to artists as to physicians; if anything, for much of the period the creative artist was well ahead of the psychiatrist in his intuitive understanding of the visual symbols and imagery of the insane.

The history of the discovery of the art of the insane cannot be confined to a reconstruction of events in art. The full story describes a sequence of interrelated events occurring more or less simultaneously in two areas, areas that were not ignorant of each other but were, in fact, involved in a relationship deriving from a common involvement with ideas, emotions, and symbols. Members of both fields found themselves faced with fundamental questions and attitudes about the human mind and the significance of its productions, images, and creative mechanisms.

Within psychiatry the discovery of the art of the insane was a slow and frustrating process. Here too the mere existence of scraps of paper bearing drawings, or of marks on hospital walls that possessed some vague form, was not sufficient in itself to provoke real discovery. The process whereby seemingly random and meaningless scribbles came to be seen as worthy of sustained and careful investigation is by no means simple or obvious. Here too there were creative thinkers, pioneers whose courageous ability to withstand their own fears led to the possibility of deeper understanding and respect. Unlike other subjects of scientific investigation, the productions and behavior of the mentally ill can awaken in the observer an intense resistance that interferes with the task of observation. It requires unusual determination to confront the often chaotic, seemingly meaningless, and at times bizarre and frightening manifestations of mental disturbance, even when they are confined to paper. The decision to undertake research into material traditionally dismissed as senseless or "crazy" is not made easily, nor does it occur without preparation. The struggle of physicians to impose order on a mass of seemingly chaotic images parallels in many ways the strenuous endeavor of historians of contemporary art in the twentieth century to come to grips with nonobjective art in its varied manifestations. Both dealt with material with which their traditional methodologies were poorly equipped to cope, material that was largely rejected as valueless, which they heroically sought to conceptualize. One need only recall that the art of this century has been repeatedly, and erroneously, associated with the art of the insane and dismissed as worthless on that basis.

The primary documents for a historical investigation into the psychiatric side of the discovery of the art of the insane are, of course, the early publications of nineteenth-century alienists. Buried in antiquated and difficult-to-obtain psychiatric journals, these first studies of the art of the mentally ill are scientifically outmoded today. Once-illustrious names such as Lombroso, Tardieu, Meunier, Noyes, and Simon are, if not utterly forgotten, dismissed as of merely historical interest, their findings destroyed or replaced along with much of the psychiatric theory of their time. Nevertheless, as the originators of all later scientific study of patient art, these individuals and their work represent a vitally important aspect of the process of discovery of the art of the insane. An accurate evaluation of their relative historical significance as pioneers in an emergent field is a necessary task attempted here for the first time.[18] An effort has been made to present the methods and findings of these men with as little distortion as possible, and a clear line of distinction is maintained between the historical facts and my interpretation of them. The archaic, often confusing, psychiatric terminology that they used has been retained, and words such as *lunatic, madman, asylum,* or *insane* are employed in those sections of the discussion where

they contribute to the correct portrayal of historical attitudes and material, despite the fact that they have, for good reason, fallen into disuse in contemporary psychiatry.

The decision to unearth and examine these outmoded and at times naively awkward scientific reports is not, therefore, the result of mere antiquarian zeal. Only through the detailed study of these records can one reconstruct the confrontation between the psychiatrist and the art of the insane. The questions are these: How does an entirely new object of investigation enter the domain of science? How does one account for the fact that modes of behavior that had been occurring unnoticed for centuries suddenly require examination and explanation? The emergence of the visual productions of the insane as a subject of scientific investigation is no less mysterious than the presence and influence of those images within the domain of art. Given the desire to explore this strange new territory, what approaches were taken, what attitudes revealed? What methodological procedures were employed in this new task, and from what sources did they come? Whatever their prejudices and limitations, the early students of the art of the insane seem to have been visually sensitive men, knowledgeable, at least as cultivated amateurs, in the appreciation of art. On the whole, the earliest scientific approaches to these images were not motivated by any strong conviction that they were art, or that they were beautiful in any sense. Nevertheless the methods of analysis employed were, for the most part, borrowed from the study of visual material in art, both in the classification of subject matter, and in the careful descriptive exploration of formal elements and style, as well as in later efforts at interpretation and understanding. Later psychiatric approaches to patient art reveal unmistakably the physician's growing respect for and appreciation of these images as aesthetically pleasing, even moving—an observation that is made at first with some uncertainty and reluctance. The contribution of artists and individuals trained in art history and aesthetics was the essential element that forced the discussion of this aspect of patient art out of the field of psychiatry and into the somewhat less well-defined territory of art. Within this context, certain mentally ill individuals of unusual artistic ability began to be singled out as "masters."

In the first quarter of the twentieth century the area of overlap between the two fields tended to produce a number of new areas of study existing in a sort of no-man's-land between art and the various psychological disciplines. It has taken the remainder of the century for these fields of research and specialization to establish themselves as viable approaches to the study of art, and for individuals adequately trained in the necessary disciplines to emerge. The contribution of scholars of international reputation has led to rather grudging recognition being accorded to the new fields of inquiry: Prinzhorn and Morgenthaler in the psychopathology of art, Pfister and Kris in the psychoanalytic investigation of art, and Arnheim and Gombrich in the psychology of art. The dependence of all psychological and psychiatric approaches to the study of art, including the investigation of the art of the insane, on fairly sophisticated art historical knowledge is reflected in the extensive art historical training of all of these interdisciplinary innovators. The emergence of such highly educated specialists represents the most recent outcome of the historic encounter between art and psychiatry.

On the psychiatric side, the investigation of the function of art in the patient's life and illness has led to the development of the clinical field of art therapy, and of diagnostic techniques that utilize drawings—but these are outside the limits of my subject.[19]

These fields of interdisciplinary endeavor suffer from the lack of a historical foundation. Inevitably the emergence of new areas of inquiry is a rather disorganized and unselfconscious process. The investigation of the historical events that necessitated their existence is a late, but essential, undertaking. This study of the discovery of the art of the insane is a first attempt to provide the historical foundation for studies in the psychology and psychiatry of art.[20]

The task then is to reconstruct events occurring over some two hundred years in Europe and America, and in two disciplines usually considered distinct and unrelated. It is helpful to conceive of our topic as a triangle, the corners of which are occupied by three unique types of people: first, the insane; second, psychiatrist-physicians concerned with their treatment; and third, established artists.

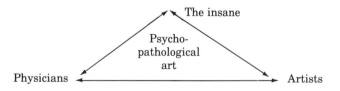

The lines that form the sides of this figure represent contacts and influences occurring between members of the three groups, whereas, the central space represents

the common focus of their attention, the images created by the insane.

Although the pattern of changing and developing interaction between these three groups is the essential subject of this investigation, interest in the visual expressions of the experience of madness is inevitable, as we explore their reality and search for their meaning along with the artists and physicians who first encountered them. We are thereby led into the study of the art of the insane along an evolutionary path, reexperiencing the processes of discovery, the excitement, the dead-ends, the fertile avenues, the frustration, and the growing aesthetic pleasure.

An important aspect of this study is the need to consider not only the ambivalence resulting from the sometimes alien and uncanny emotions awakened by the images themselves but also the hostility that the conjunction of psychiatry and art can often awaken in some individuals. It is a regrettable and yet significant fact that psychiatric approaches to the art of the insane were employed surprisingly early as a means of attacking nonpathological art. Physicians and laymen both saw in these tools weapons to be used in aggressive and totally nonscientific attacks on whatever new art form happened to meet with their displeasure, or that appeared to conflict with their notions of art. While Delacroix's paintings were assailed as comparable with the artistic endeavors of a child, the Impressionists were already being diagnosed as insane, their work dismissed as the tragic product of megalomania and dementia.[21]

Obviously, the violent changes in art shortly after the turn of the century inspired, and still inspire, equally violent reactions in the uninitiated. It is a true and yet very misleading observation that much art of this century has presented images that, whether deliberately or not, share certain characteristics with the form and content of some examples of the art of the insane. The extent and the implications of the similarities and parallels are anything but obvious or easy to explain. Nevertheless, for much of this century artists have been forced to undergo the humiliation of having psychiatric bloodhounds poking about in their private lives, and of being diagnosed and rediagnosed, on the basis of their work, as suffering from one or another form of mental disorder.[22] Even today contemporary art is occasionally dismissed as the product of a neurotic or even psychotic mind and, consequently, as without value or meaning. It is significant that at the very moment that forces were at work fighting for the acceptance of the art of the insane within the canon of

art, other forces were at work attempting to exclude much of modern art from that canon on the basis of an implied identity with the art of the insane. Nor was this departure from scientific objectivity and goals a game indulged in only by psychiatrists. Facts derived from psychiatric research into the nature of psychopathological art were available to critics and historians of art who utilized and distorted them for their own tendentious purposes, some historians going so far as to diagnose not only the art of the twentieth century but the age itself as the product of psychopathological processes indicative of cultural imbalance and disintegration.[23]

Although the use of psychiatric terminology and methods to engage in polemics within the field of art was, and is, unscientific and unproductive, it had unexpected effects upon certain artists and their work. As we have seen, artists at the beginning of the century were seeking primitive and violent visual means. They sought purity of expression in their work, a vision of reality free of tradition and convention. In the context of this quest of unusual intensity and violence, comparison with the uncontrolled products of the mind of a madman, while intended as hostile criticism, was accepted as proof of a successful journey into the truly unknown. Among artists an element of conscious identification with, and emulation of, the insane can occasionally be detected—an idealistic and somewhat Romantic, antitraditional position, which motivates the creative individual to cultivate the appearance of insanity in his life-style, and its artistic characteristics in his art.

It is paradoxical that the first extensive investigation of the discovery and study of the art of the insane, in psychiatry and in art, should appear at a time when this unique form of human expression is fading into history. The production of art by severely mentally ill people will soon cease almost entirely.[24] Artistic activity among the mentally ill was dependent upon long years of hospitalization and of unsuccessful methods of treatment. The other possibility, that of the patient whose illness went untreated and who continued to live and work outside of the hospital, is once more becoming common as the mentally ill are again abandoned to the streets of large cities. The occasional artistic activity of these individuals usually goes undiscovered and is lost. Much of the art discussed in this book was typically the product of prolonged psychotic illness coupled with the psychological results of long institutionalization in the absence of any form of therapy.

The introduction of new forms of chemical intervention, supplemented by the development of new kinds of therapeutic environment, has led to a dramatic reduction of the duration and severity of the experience of mental illness. Mental hospitals themselves are rapidly becoming a thing of the past. The wealthier patients today tend to be admitted to the psychiatric wing of their local general hospital, are treated for a period of weeks or months, and are then returned to the community. Although art therapy often forms part of the hospital program, the spontaneous creation of images that is essential to a truly psychotic art is becoming a very rare occurrence. The drawings and paintings that form the focus of events described in this study were without exception created in response to a spontaneous impulse arising from within the individual personality. The tremendous fascination that they exerted on artists and physicians in the nineteenth and twentieth centuries derived from this purity of impulse and content. It seems likely that the human needs concealed within this taste for the undisguised and unadorned products of the inner world will long outlive the images that for a brief time satisfied these needs, the art of the insane.

Because of the complexity of this investigation, embracing as it does interrelated events occurring in several areas of human activity, it seems essential to point out the plan on which the study is based. The approach is historical and chronological. It follows the art of the insane from the first sign of its discovery to its period of greatest acceptance and influence. To some extent the events described conform to a sequence of geographical areas, so that one chapter focuses on Italian contributions to the study of patient art, and another on artistic influences that were felt in France, England, or Germany. While individual chapters are sometimes devoted to events occurring in the fields of psychiatry or art, respectively, the emphasis is on the emerging relationship between them, and on the ways in which they influenced each other. The story of the discovery of the art of the insane, for all its complexity, is one story with many characters.

ONE

The Confrontation:
The Artist and the Madman

Madness, Thou Chaos of ye Brain,
What art? That Pleasure givst, and Pain?
Tyranny of Fancy's Reign!
Mechanic Fancy that can build
Vast Labarynths, and Mazes wild.
—John Hoadly

In 1735 the English artist William Hogarth (1697–1764) published a set of engravings entitled *The Rake's Progress*.[1] The prints depict eight stages in the downfall of a youth of weak moral principles named Tom Rakewell.[2] Beginning with Tom's entry, through inheritance, into the world of the fashionably rich, the engravings narrate the sad, though edifying, story of his rapid descent into the underworld of eighteenth-century London. Tempted on every side, Tom succumbs to the lure of fashion, gambling, drink, and ladies of ill repute. He and his audience are taken on a "Cook's Tour" of the world of taverns, gambling dens, brothels, moneylenders, and petty criminals.

In depicting the details of Rakewell's education in vice, Hogarth had an excuse for confronting his audience with aspects of life that some must have known well from personal immersion, while others, carefully protected from the realities, must have found exotic and titillating. Hogarth functioned as both a social critic and a satirist, while pandering to the viewer's desire to participate, if only vicariously, in the pleasures of evil. This latter characteristic of his viewers had a good deal to do with Hogarth's enormous popularity. However, even in the eighteenth century, morality demanded at least some measure of redeeming social content in the form of a fitting retribution for this orgy of licentious living. The final plate in the series depicts the hero, reduced to madness, being confined in the hospital for the pauper insane, the Bethlem Mental Asylum (Fig. 1.1).

This hospital, familiar to Londoners as "Bedlam," was a much-frequented place of amusement on rainy Sundays (Fig. 1.2).[3] For an admission price of a penny visitors could entertain themselves in watching the antics of the insane.[4] Ending one's days in Bedlam was a terrifying possibility, and a suitable conclusion for this tale of moral disintegration.[5]

Hogarth's depiction, a convincing vision of the fate of a man deprived of reason and of the horror of life in eighteenth-century Bedlam, where the poor were exhibited as animals, is by no means a simple drawing of a typical ward in Bethlem Mental Hospital. While he undoubtedly knew the hospital well, and may even have studied it carefully to execute the painting on which this plate is based, the collection of mental patients assembled in this one room is a creation of his intellect and the result of a long tradition of depicting the insane.

Insanity as a subject in art is worthy of investigation in that it provides considerable insight into changing attitudes toward mental illness over the centuries. I examine such depictions only as they relate to a discussion of the patient as artist.

Mental states that would be diagnosed as pathological today may be seen in Classical art in representations of states of ecstasy or possession typical of Dionysiac ritual (Fig. 1.3). In Christian iconography, the driving out of devils from men insane through demonic possession demanded fairly detailed portrayals of mental illness, usually involving states of violent excitement (Fig. 1.4).[6] In these depictions the devils that were thought to have caused the disease are frequently shown emerging from the patient's mouth. States of mass hysteria and psychosis were well known in the Middle Ages. An example is provided by the phenomenon known as St. Vitus' dance, a neurological disorder referred to today as Sydenham's chorea. Even in the eighteenth century madness was popularly associated with dance (Fig. 1.5). In some instances mass psychoses were characterized as a form of "lunacy" engendered by the appearance of the full moon. Love could provoke madness, and the portrayal of the lover made mad by love or by its frustration is not unknown in art. Among the strangest images of the mind gone astray is the ship of fools, a common subject in the late Middle Ages, best known from the picture of that title by Hi-

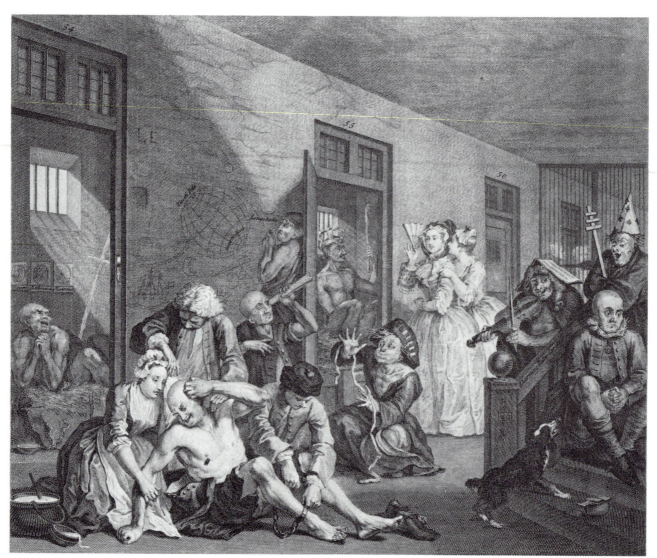

1.1. William Hogarth, *The Rake's Progress*, plate 8, "In Bedlam," 1735, engraving (first state), Princeton University Art Museum, Princeton, New Jersey.

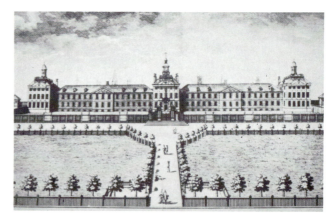

1.2. Anonymous, Robert Hooke Bethlem Hospital, 1764–1766, engraving, The Bethlem Royal Hospital, London.

1.3. Kleophrades Painter, detail from an Attic red-figure vase showing an ecstatic maenad, ca. 510 B.C., from Vulci, now in the Staatliche Antiken Sammlungen, Munich.

1.4. Anonymous, Saint Francis healing a woman possessed by the devil, detail from an altar painting in the Treasury of San Francesco, mid-thirteenth century, Sacro Convento di S. Francesco, Assisi.

eronymus Bosch.[7] In Bosch's picture, as in Hogarth's, a connection is made between licentious living, overindulgence, and madness.[8]

Having devised representational schema for depicting generalized states of insanity, artists refined their observations to include specific types of madness. Faced with depicting the torment of melancholia, a term that embraced an enormous variety of emotional experience ranging from mild sadness to deep psychotic depression, the artist inexperienced in the representation of this psychological state could rely on established formulas to assist him. Pictorial sourcebooks such as Cesaré Ripa's *Iconologia* provided standardized visual symbols and external attributes representative of *malincolia* (Fig. 1.6). Depictions of "Dame Melancholy" were not necessarily intended to suggest insanity, in that the term was expressive not only of a diagnostic category, but of a whole complex of ideas and experience not evident in the word itself or in Ripa's visual equivalent. As Erwin Panofsky has indicated, the depiction of melancholy "emerges from a pictorial tradition, in this case dating back thousands of years. This is the motif of the cheek resting in one hand."[9] A far more elaborate portrayal of the subject is to be seen in Dürer's famous engraving *Melancholy I*, the implications of which extend far beyond the limited realm of psychopathology. Figures are also occasionally depicted in the strange frozen postures associated with catatonia. It took a long while for artists concerned with realistic portrayal of the mentally ill to free themselves from these conventional schemata.

Hogarth's engraving, and the painting on which it is based, can be understood as belonging to a lengthy art historical tradition. Provided with sufficient visual clues and traditional attributes, the viewers for which it was designed could be expected to recognize the disturbed mental condition of these inhabitants of Bedlam, and to proceed to identify each of the stereotyped

varieties of madness depicted. As in every Hogarth print, the most minute details can be read; behind every object and every minor character there lies a story.

It would appear that Hogarth was familiar with the major psychiatric syndromes used in eighteenth-century diagnosis, and he has accordingly assembled a complete spectrum of mental illness. Sixteen people appear in the engraving, of whom eight are male in-

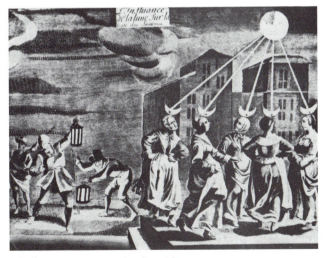

1.5. Anonymous, moonstruck maidens, eighteenth century, engraving.

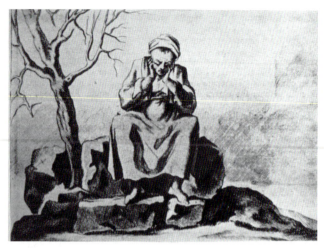

1.6 *Malincolia*, from Cesaré Ripa, *Iconologia* (Padua, 1611).

mates of the hospital ward. All eight patients suffer from easily identifiable disorders, a situation not paralleled in actual hospital settings, where diagnosis is not often possible on the basis of the patient's appearance. Tom Rakewell is seen in the foreground being stripped and chained by two of the keepers. He is accompanied by his faithful girlfriend Sarah. The two women in the middle ground, a lady and her maid, are to be understood as visitors to the hospital who, having paid their admission fee, are free to wander about among the less dangerous patients. There are two further ladies visible beyond the bars at the end of the room. They may be visitors, or possibly female attendants in the women's ward. As Hogarth makes clear, male and female patients were separated.

In cell 54 the patient is seen at prayer, a homemade crucifix beside him. It has been suggested that the poses of Tom, and of this patient who suffers from religious melancholy, are derived from a set of statues that once adorned the main entrance to the Bethlem Mental Hospital. They were the work of Caius Gabriel Cibber (1630–1700) and were intended to depict melancholy and raving madness (Figs. 1.7 and 1.8).[10] On the rear wall of the cell are three religious pictures in oval frames, inscribed (C)lemen(t), St. Athanatius, and St. Lawrence. Although Hogarth may have intended these images to be understood as creations of the patient, more probably they represent cheap religious engravings that the patient has acquired in some way.

1.7. Caius Gabriel Cibber, *Melancholy*, ca. 1676, portland stone, The Bethlem Royal Hospital, London.

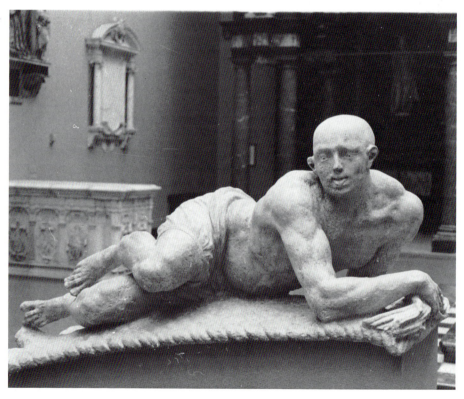

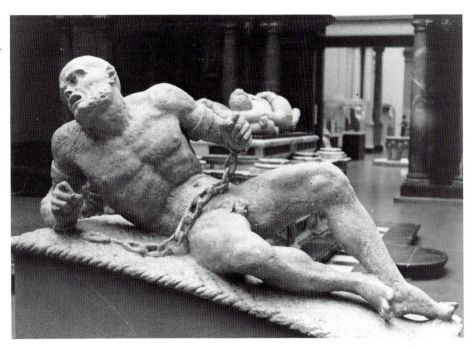

1.8. Caius Gabriel Cibber, *Raving Madness*, ca. 1676, portland stone, The Bethlem Royal Hospital, London.

The fact that they are on paper would suggest an outside source.

Cell 55 contains a patient intended to depict megalomania, delusions of grandeur. He is seen crowned, holding a homemade scepter. In order to add a comic touch, Hogarth depicts him in the act of urinating, to the delight and consternation of the lady visitors. Cell 50 is closed, and may possibly suggest the presence of more violent or dangerous patients.

A second type of megalomania, in this case delusions of religious grandeur, is represented by the patient seated at the top of the stairs. Equipped with a paper miter and a cross, he is portrayed singing. Whether he is intended to be accompanied by the violin-playing patient is not clear. However, the fact that the musician's music book is worn on his head suggests a certain lack of harmony between the two.

The inclusion of this amusing detail provides an example of Hogarth's debt to an old tradition in the depiction of the insane. The portrayal of insanity by placing a book on the head has an extensive history. One of the better-known examples of it occurs in Bosch's picture *The Cure of Folly*. As part of an amusing depiction of early neurosurgery, a nun is seen leaning on a table and watching the operation. The book on her head, probably intended as a Bible, informs the viewer that she too is mad. The association of music with the insane is common and may be intended by Hogarth to represent the extravagance of a state of manic excite-ment. The artist has refrained from using another traditional means of depicting insanity, the presence of wildly dancing figures, perhaps because the suggestion of violent movement would have distracted from his central group.

Kneeling beside this group is an individual (sometimes identified as a tailor) in a state of childish excitement intended to represent either imbecility or dementia. He is senile, or feebleminded in some sense, as he gestures and plays with a scrap of paper or tape while making funny noises with his mouth.

It is important to compare Hogarth's choice of psychiatric disorders with the accepted nosological systems in use by diagnosticians of the period. Among the foremost English students of mental disorder was the famous theologian Robert Burton (1577–1640). In 1621 he published *The Anatomy of Melancholy*, in which he developed a comprehensive system of classification that included melancholy as a subdivision of diseases of the brain, and which also included phrenitis (frenzy); madness (mania), including ecstatic and visionary states; St. Vitus' dance; and demoniacal possession (Fig. 1.9).[11] Melancholy itself was carefully divided into a number of distinct types, which may well have influenced Hogarth's composition: love melancholy; religious melancholy; and melancholy arising from study, a disorder that Burton knew from personal experience.

The patient sitting on the lower stairs is depicted in

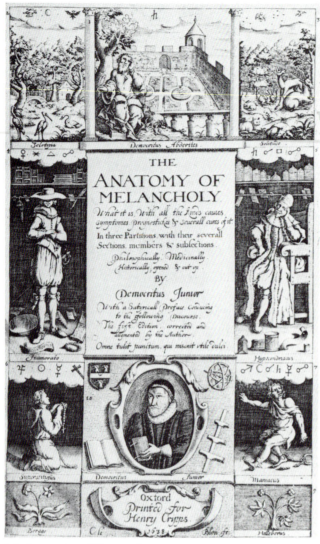

1.9. Anonymous, title page from
Robert Burton, *The Anatomy of Mel-
ancholy* (Oxford, 1638), engraving by
C. Le Bon.

a state of totally noncommunicative melancholy,
depression so deep as to suggest a catatonic with-
drawal. Hogarth introduces the barking dog to dem-
onstrate to what extent this patient has lost contact
with the world. Other details enable us to identify his
illness as an example of Burton's Melancholy of Love.
He wears a picture of a woman on a band of straw
around his neck. Carved on the stair rail beside him is
the name "charming Betty Careless," presumably in-
scribed by her hapless lover in a more active state,
since the lady in question was a well-known prostitute
of the day, and not an inmate of Bedlam.

Behind the central group are two individuals in-
volved with scientific pursuits and illustrating Bur-
ton's melancholy arising from study, the so-called Mis-
ery of Scholars. The concentration and seriousness of
expression of the astronomer who gazes at the heavens
through a telescope of rolled-up paper suggests the ex-
tremes to which one may be driven by scholarly pur-
suits.

The range of illnesses present in Hogarth's Bedlam
does not include all of the diagnostic categories in use
at the time, nor does it conform to any one contempo-
rary psychiatric system. But the patients, as general-
ized representatives readily recognizable to lay visitors
to the hospital, can serve to indicate the extent of psy-
chiatric knowledge possessed by the educated public of
Hogarth's day. If I have discussed at such great length
the patients' individual disorders and Hogarth's means
of making these disorders visible, it is because I am
concerned throughout this study with the changing at-
titudes to the insane which, in time, prompted a dra-
matic change in the awareness of their reality and of
their artistic productions. These changing attitudes
are clearly reflected in the development of new and
more complex methods of portraying the insane that
appeared in the nineteenth century.

The unique importance of this engraving in the con-
text of the subject under investigation lies in a scarcely
noticeable detail—the drawing on the wall of the hos-
pital between doors 54 and 55, and the patient who is
still executing it. Although drawing on walls and other
surfaces available to patients was not uncommon, Ho-
garth seems to have been the first artist ever to depict
the insane artist in the act of creating.

It is not impossible that on one of his visits to the
hospital Hogarth may have seen patients' drawings on
the walls or even observed the act of drawing. How-
ever, a still earlier depiction of the interior of Bethlem
Hospital may have suggested the idea of the insane
artist and his work. In 1710, twenty-five years earlier,
a decision was made to bring out an illustrated edition
of *A Tale of a Tub* by Jonathan Swift (1677–1745). One
of the illustrations, included in the famous "Digression
on Madness," was an interior of a male ward in Bedlam
with visitors looking in on the inmates through barred
windows (Fig. 1.10).[12] There are six male patients con-
fined in a large hall, and Swift describes each of them
in turn.

A naked and shackled patient, lying on a bed of
straw in the foreground, is sufficiently close in pose to
Tom Rakewell as to suggest that Hogarth made use of
the earlier engraving in arriving at his depiction of the
hospital. Directly above the head of this figure is an-

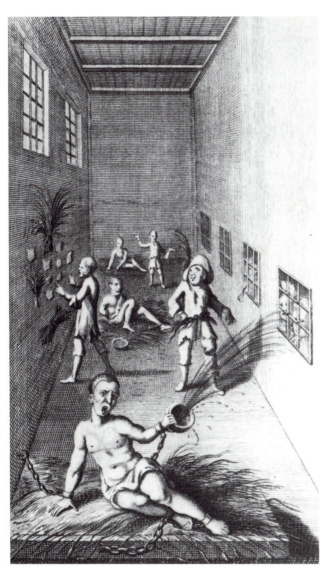

1.10. Anonymous, male ward in Bedlam, engraving by Bernard Lens and John Sturt, from Jonathan Swift, *A Tale of a Tub*, fifth edition (London, 1710), The Bethlem Royal Hospital, London.

the invisible thoughts or visions of this obsessed individual. The subject of the drawing is unclear. It includes three bundles or sheaves of grasses and eight small white shieldlike forms impossible to identify. Nothing in the text seems to throw light on the image, whose connection with the iconography of madness is obscure. The figure himself is most likely the third of those described by Swift, the one who is "gravely taking the dimensions of his kennel." Certainly he is not intended to be depicted as drawing, unlike the similar figure in Hogarth.

Nevertheless, this creation of a forgotten artist represents the first, somewhat casual, reference to the image-making activity of the insane, and a significant source leading to the far more important representation of a psychotic artist at work in the final plate of *The Rake's Progress*. The study of art of the mentally ill can therefore be said to begin with these depictions of Bethlem Hospital interiors. References to the artistic activities of the mentally ill in scientific and psychiatric literature were to occur only very much later. It is certainly significant that artists were the first to note the artistic activities of patients, recording either the existence of the drawings themselves or, in Hogarth's case, depicting the insane artist actually at work on the wall.

The drawing itself is of only minor importance in the context of the scene, a single detail among many, yet as with all such seemingly insignificant details in the oeuvre of Hogarth, it tells a story. Like many drawings made by patients, this image is a diagram rather than a naturalistic representation. Its creator, partly concealed behind the open door of room 55, is completely preoccupied with his drawing and the geometrical calculations that it entails. Study of the drawing reveals that Hogarth added to it in each stage of the engraving's development, which suggests that he took a considerable interest in the work of this less fortunate fellow artist.

The first state of the engraving, usually considered an unfinished proof, shows the diagram in its simplest form (Fig. 1.11). The globe of the earth appears joined by a chain to the door of the room at left—an attempt to get it to hold still? It is identified as the earth by the lines of longitude and latitude marking its surface. Above the chain is a large cannon from which a shot has just been fired, the ball arcing around the earth, its trajectory clearly indicated. The patient's gaze is fixed on this cannonball, and he responds to its movement with the obscure geometric forms that he is drawing. Still more of these geometric shapes are found just below the planet.

other inmate profoundly involved with a group of images that appear before him on the side wall of the room. He is seen in pure profile, as is the Hogarth artist. He does not appear to be drawing on the wall, but rather is gesturing at the images before him, completely absorbed in these externalized representations of his inner world.

Swift makes no reference to any drawings on the wall. The unknown illustrator seems to have added them spontaneously, possibly as a means of depicting

1.11. William Hogarth, *The Rake's Progress*,
detail from plate 8, "In Bedlam," 1735, engraving
(unfinished proof), Princeton University
Art Museum, Princeton, New Jersey.

The finished version of the plate adds several further details. To the left of the jailer's head a three-masted ship floats on the waves below the cannon, perhaps suggesting that the cannon is to be fired aboard the ship. A crescent moon appears in the sky, its features clearly visible, while the sun rises from behind the jailer's head. The identity of the planet is further clarified by the addition of the words "North Pole, Antarctic Circle" and, in the area of the patient's calculations, the word "Longitude." Above the diagram appear the initials L. E.

The subject of the drawing is so specific that the student of Hogarth's work is inevitably led to suspect that it is intended to refer to an equally specific idea or event. Although Hogarth may have copied an actual drawing done by a patient confined at Bedlam, Hogarth's usual procedures would make the former possibility more likely. In fact, the significance of the diagram has been identified.[13] It refers to a strange scheme suggested by William Whiston (1667–1752) for ascertaining the longitude of the earth.[14] Obviously, the plan was considered mad and was sufficiently well known to be identifiable by Hogarth's audience in 1735. In that the patient is engaged in scientific pursuits, he may be understood as a second representative of the melancholy of the scholar. However, in that he appears here as an insane draftsman, he represents, as well, the first recorded confrontation between an artist and the artistic faculty gone astray. Drawing, as an activity indulged in by the insane, would have considerable interest for an individual whose chief activity in life was the making of drawings. The depiction of an insane artist or his work would inevitably have emotional implications for Hogarth or any other artist, if only to the extent of awakening feelings of "there but for the grace of God go I." For later artists, developing

within the aura of Romanticism, the emotional impact was to be still greater. It is significant that Hogarth associated his mad artist with science and literature rather than art.[15]

In 1763 Hogarth reworked the engraving, changing the patient's drawing rather extensively. An enormous half-penny piece was added, overlapping the globe and obscuring the diagram. The coin bears the date 1763, and is adorned with the figure of Britannia gone mad. She appears somewhat disheveled, her hair in wild disorder, yet another traditional attribute of madness. Through this device Hogarth is able to comment on the mental state of the world outside of Bedlam's walls, at the same time revising a visual joke that may in the intervening twenty-eight years have become somewhat obscure.

Before leaving Hogarth's depiction of Bedlam we should not neglect to notice a second drawing by a patient, this one inscribed on the newel post of the staircase. It is a simple drawing of a house, or possibly a church, as it appears to have a cross at the peak. Within the building are inscribed the initials S. H. (the S is reversed). The meaning of this set of initials is not known.

HOGARTH'S engraving of the interior of a mental hospital was influential in inspiring a series of pictures portraying the mentally ill in hospital settings. It is not too great an exaggeration to see in a film such as *Titicut Follies* (1967) by Frederick Wiseman a modern descendant of Hogarth's realism and social criticism within the context of the mental hospital. However, for a considerable time artists stayed rather closer to Hogarth's conception of the problem and even to his composition.[16]

Hogarth was deeply angered, in fact, by pirate versions of his engravings, which were in circulation at the same time as his editions. Figure 1.12 probably represents an example of this type of borrowing. However, in this version two insane draftsmen are depicted, one executing a still more elaborate drawing of Whiston's scheme (Fig. 1.13), the other drawing, between the doors of the first and second rooms, an enormous head with horns. The origin of this head, which is not in Hogarth's engraving, poses an interesting problem. At first it might appear that the copyist was allowing himself a moment of freedom in executing a subject that, because it was supposed to be the idea of a madman, did not matter.

1.12. Anonymous, interior of a madhouse, eighteenth century, engraving, The Bethlem Royal Hospital, London.

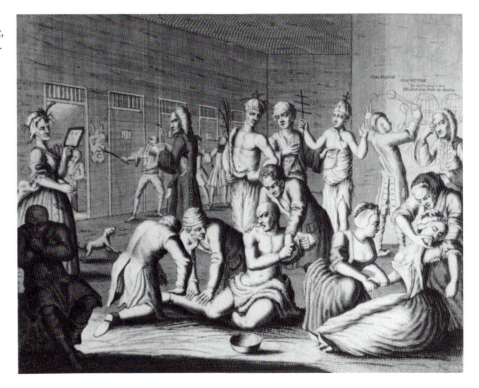

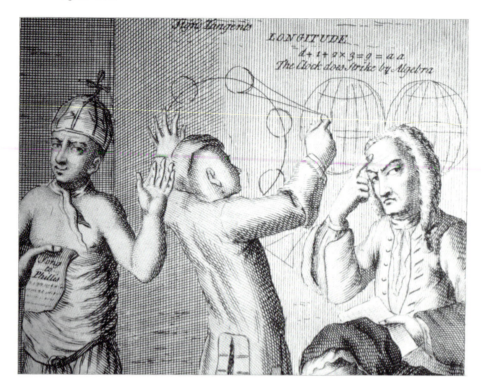

Flere Tangente

LONGITUDE
d + i + q × q = q = a a
The Clock does Strike by Algebra

1.13. Detail of Fig. 1.12.

The alienist Daniel Hack Tuke (1827–1895) included an interior of Bedlam in his book *Chapters in the History of the Insane in the British Isles* (London, 1882) (Fig. 1.14). The illustrator, whose name is not included, has borrowed most of his composition from Hogarth, including the Rake himself, who is seen here as a violent patient being shackled by a group of keepers. In the background a number of patients are depicted, including the artist at work on the wall. The engraver of this version has also changed the patient's drawing, substituting an enormous drawing of a man's head with staring eyes and disheveled hair, possibly intended as a self-portrait of the artist as the devil. The fact that this engraving was used in a serious historical study of British asylums suggests that Hogarth's depiction of a ward in the Bethlem Hospital was understood to be essentially accurate. The drawing on the wall could then have been altered to bring it closer to the type of drawings that patients might be expected to make.

The source of this drawing was revealed by study of Hogarth's original oil paintings for *The Rake's Progress*, upon which the engravings were based. Although the paintings have darkened considerably, examination of the surface of the picture yielded evidence that there were two drawings on the wall, one depicting Whiston's diagram, the other the large head of a man or devil.[17] It would therefore seem clear that the engraver of the pirate version of the print worked from Hogarth's painting, or at least was familiar with it. Far from being freed by the possibility of madness, he was obsessionally accurate.

Hogarth's depiction of image making in the madhouse became a standard subject included in all representations of asylum interiors from then on. Its hold on the imagination may be explained by the fact that it had particular meaning for artists. Faced with the necessity of illustrating a scene in an asylum, the artist included himself in it through this device. Hogarth's retribution for being its inventor was not slow to follow. A contemporary cartoon, the work of Paul Sandby, inspired by the publication of Hogarth's book *The Analysis of Beauty* in 1753, shows the artist himself confined to Bedlam (Fig. 1.15). His artistic ambition is seen to be more extensive than that of his scientifically minded predecessor, and he is shown adorning the hospital walls with an elaborate series of religious pictures all leading up to his apotheosis as the supreme creator on the rear wall. Significantly, his chain conforms exactly to the curve of beauty that had become

an obsession with Hogarth. The cartoon is of value in confirming, if only humorously, that the artist involved in the depiction of madness tends to identify with the artist-inmate, a fact that gave to this confrontation between artist and madman a curiously personal meaning.

ONE HUNDRED years after the publication of *The Rake's Progress*, another engraving was made that again took up the theme of the mental hospital and its inhabitants. Entitled *Das Narrenhaus*, it was the work of the German historical painter Wilhelm von Kaulbach (1805–1874). Although Kaulbach's reputation has now grown rather dim, in his own day he achieved enormous success and influence as a painter of large historical murals. His work is chiefly associated with

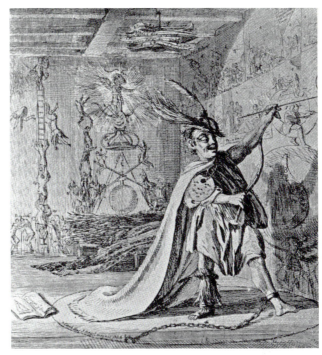

1.15. Paul Sandby, *The Author Run Mad* [Hogarth], etching, British Museum, London.

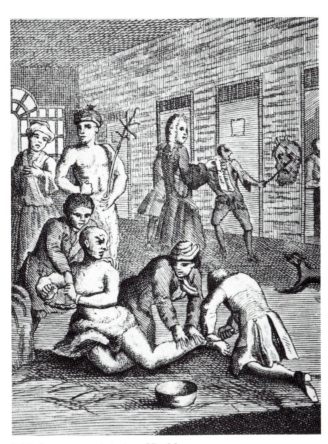

1.14. Anonymous, interior of Bethlem Hospital, engraving from Daniel Hack Tuke, *Chapters in the History of the Insane in the British Isles* (London, 1882).

Munich, where from 1849 on he was director of the Academy. However, the Narrenhaus belongs to the early years of his career when he was a student of Peter Cornelius (1783–1867) in Düsseldorf. The publication of the drawing in the form of an engraving executed by Caspar Heinrich Merz (1806–1875) caused a sensation in European artistic and medical circles (Fig. 1.16).[18] Speaking of the drawing's reception, Kaulbach's daughter stated, "This was the first picture with which my father began to make a name for himself. It was not only praised by laymen, but was also extolled by physicians as being exemplary for the study of psychiatry. It appeared as a scientifically accurate work that used particular types associated with the different appearances of illness, physiognomies which the artist had depicted through personal observation."[19] So great was the curiosity aroused by the strange scene that a pamphlet was published by Guido Görres that purported to explain the picture detail by detail.[20]

Kaulbach is said to have been inspired to execute the work as a result of seeing Hogarth's engraving of Bedlam. The most obvious instance of this influence is the fact that Kaulbach included a drawing by a patient on the rear wall of the hospital (Fig. 1.17). The style of the

1.16. Wilhelm von Kaulbach, *Das Narrenhaus*, 1835, engraving by Casper Heinrich Merz, The Philadelphia Museum of Art.

drawing is derived from the drawings of children, reflecting the commonly held opinion of the period that the art of the insane and that of children were closely connected. However, despite the naiveté of its style, the drawing betrays an aspect of the hospital that is not apparent in the scene itself. It shows a rather corpulent man wielding a whip with the obvious intention of beating a helpless patient. The little man can be identified, by the key in his pocket, as keeper of the asylum. The drawing is, therefore, an accurate if childish portrayal of the fat fellow standing immediately behind it. He too is identified as the keeper by the set of keys in his hands and the whip partially protruding from his pocket.

Once again, it seems unlikely that this drawing is an accurate reflection of an actual piece of patient art. It is put there to tell a story, as in Hogarth, and to represent the artist's idea of what patient art would look like, as in the Tuke illustration. A closer approximation to the reality of patient drawings, quite possibly based on observation, can be seen in the scarcely visible geometric diagram that is drawn in the earth beside the foot of the man at the lower left. An obvious representative of scholarly melancholia, its creator would seem to have been preoccupied with the solution of a complicated geometrical problem, which, in the absence of more suitable materials, he has worked out on the ground.

Comparison with Hogarth's version of the subject does not reveal an excessive dependence on Kaulbach's part, although the emphasis on identifiable psychiatric "types" is common to both. The motivation underlying Kaulbach's picture differs markedly from that which inspired Hogarth, stemming from a far more personal source. During his student days in Düsseldorf, Kaulbach seems to have undergone a period of serious mental illness. He stated at the time that the drawing of this picture was in some sense therapeutic or cathartic for him, and was undertaken with the goal of helping him to recover from his depression. He referred to it as "a means of salvation from mental illness." The scene takes place in the mental hospital outside Düsseldorf, but no evidence that he was confined there exists.[21] Nevertheless, according to Görres, the figure in the foreground with his head buried in his arms is Kaulbach himself, in a state of deep depression. The letter in his hand confirms this identification to some extent in that it is addressed to the engraver of the picture.

Despite its rather contrived composition and the use of obvious quotations from Renaissance art, the picture represents an intense experience of the reality of the world of the mentally ill at this time as seen from in-

side.[22] A fundamental and significant difference exists between this work and that of Hogarth, in that the artist is now part of that reality. We have moved in a hundred years from the objective and satirical narrative of Hogarth in the eighteenth century to the subjective involvement with personal experience so characteristic of artists immersed in the atmosphere of Romanticism. It cannot be forgotten that Hogarth's depiction of Bedlam and its inmates was only incidental to the ongoing story of Tom Rakewell. He was not inspired by any obvious desire to provoke reform in the treatment of the mentally ill. There is no reason to

1.17. Detail of Fig. 1.16.

think that he saw these people differently from other visitors to the hospital. It would never have occurred to Hogarth to paint this scene independently of the story he was telling, and certainly the idea of representing himself amidst these madmen would have been out of the question, even if he had suffered from mental illness at some time in his life. In short, Kaulbach's painting is a document of a fundamentally different kind. In the interval that separates the two compositions, dramatic changes had occurred in the world of ideas and in the subject matter of art.

Hogarth's discovery of the insane artist was in some sense an accident. The mad artist and his drawing are, after all, only one detail among many, part of the vast store of anecdotal visual detail in which Hogarth and his audience delighted. We have considered the question of whether the depiction of this detail of life in Bedlam can truly be regarded as a discovery. The art of the insane has probably always existed, and it is in the nature of artistic activity that it is noticeable. In what sense then is Hogarth a discoverer? The answer would seem to lie in the strange ability of art to capture from the chaotic world around us fragments of

reality and, by subduing them with pencil or brush, to make them visible. By being recorded as a simple fact, a visual statement as yet unadorned with theories or speculation, the reality of this expressive gesture emerges from the obscurity of seemingly random and meaningless insanity. It enters consciousness as a phenomenon of behavior that can be contemplated and questioned. The puzzle on the wall that Hogarth has provided, that astronomical scheme that contemporary viewers could with some thought have recognized, was to lead in time toward further picture puzzles, which were to yield their secrets far less easily.

Significantly Hogarth's contribution is an observation concerning the artistic behavior of a madman, and not the product of that behavior. The fact that madmen sometimes displayed an inclination to make images was of interest well before the actual graphic product was thought worthy of examination. Hogarth and his imitators felt it necessary to invent drawings for their mad artists. The art of the insane, in that it was still dismissed as worthless and of no interest to anyone, could not serve their purpose.

TWO

The Physician and the Art
of the Patient

The spontaneous production of images, drawings or paintings, by individuals whose unique experience of reality and whose behavior would be characterized as insane, either in the context of their own society and time or in terms of contemporary diagnostic practice, is not a new phenomenon. The question might be raised as to whether historical evidence indicates that mentally ill individuals have always been inclined to make pictures. Of course, only a few patients in a mental hospital draw or paint spontaneously, but is the making of pictures by these people a new thing, confined to the nineteenth and twentieth centuries—a response, possibly, to the democratization of art and the changed position of the artist in society? Would it occur to a madman in ancient Greece, or in the Middle Ages, to begin drawing in response to his altered perception of reality? Are there surviving historical examples of the art of the mentally ill from the more remote past?

As will become apparent in the course of this discussion, it is not possible, or desirable, to identify specific images as products of insanity in the absence of other evidence derived from the behavior and mental processes of the artist. Nevertheless, a few historical cases demonstrate that at least some insane individuals were using graphic means to express their ideas and feelings well before the modern era.

Spontaneous production of graphic images is not, and never has been, confined to the mentally ill. The pictorial graffiti of the ancient world contain numerous examples of drawings made by children and untrained adults in response to various impulses.[1] The making of sexual graffiti, for example, has a long history. Such spontaneous activity, not to be confused with the graphic activity of the mentally ill, shows that the tendency for untrained people to produce simple drawings and diagrams in response to inner impulses is not confined to our own day. Careful study of such pictorial graffiti scrawled on ancient monuments might reveal examples clearly identifiable as the work of individuals suffering from severe emotional disturbance.

Further examples of the art of the insane are provided by cases in which a professional artist, while continuing to paint, became insane. Such occurrences inevitably attracted the attention and comment of the artist's contemporaries, and examples of the work of these artists were more likely to survive, while the less sophisticated markings of the insane layman were destroyed. The case of German sculptor Franz Xaver Messerschmidt (1736–1783) provides a striking example of the metamorphosis in style resulting from a severe psychotic illness.[2]

In "A Seventeenth Century Demonological Neurosis," Sigmund Freud describes the case of a minor German artist, Christoph Haizmann, who became mentally ill, believing himself to be possessed by the devil, and suffered from severe convulsions, hallucinations, and delusions.[3] A set of eight paintings executed by the artist survive, unfortunately only in the form of small copies. They provide worthwhile material for a study of mental illness in the context of the religious conceptions of the period. Contemporary accounts of his illness, as well as a diary written by the artist, supply convincing evidence that the artist was indeed insane. (Plate 14)

Ernst Kris has published a detailed account of a fourteenth-century Italian cleric, Opicinus de Canistris, who produced a number of huge drawings that are still extant (Fig. 2.1) and have been convincingly identified by Kris as the work of an individual suffering from a psychotic illness. The diagnosis of schizophrenia is based on the style and content of the drawings and on a life history written by Opicinus himself, in which he described his illness in detail.[4]

Undoubtedly, further cases could be brought forward. However, examples of this type of pictorial material will remain rare. In the past, drawing materials were not generally available and patients were not encouraged to engage in activities that seemed useless and wasteful. There was, moreover, no reason whatever for preserving such drawings until interest in this type of material began to develop in the second half of the nineteenth century. The one exception to this rule is provided by drawings or paintings that involved re-

25

ligious delusions, as in the cases described by both Freud and Kris. These were often thought to be the result of divine inspiration and were therefore worth preserving.

Although the existence of this form of activity on the part of the insane could be demonstrated throughout history, it is first mentioned in the literature on insanity only at the beginning of the nineteenth century. Despite a vast amount of written speculation about the nature and causes of insanity, as well as detailed description of the behavior and symptoms of the insane, from the classical period onward, the graphic activity of the mentally ill went unnoticed, or at least undescribed. Presumably, it was felt to be of no importance, and unworthy of even passing comment. Then, at the beginning of the nineteenth century, and chiefly as a

result of the pioneering contribution of Philippe Pinel, the first references to the drawings of mental patients began to appear. Changes in the world of art and literature were to prepare the way for the development of new attitudes and ideas in the scientific thinking of physicians and theorists.

THE UNFORGETTABLE image of the psychiatric revolutionary Philippe Pinel (1745–1826) releasing the tormented madmen of Paris from their chains has tended somewhat to obscure the less dramatic reality of his life and work as physician in chief to the Bicêtre and Salpêtrière Hospitals for the Mentally Ill (Fig. 2.2). Burdened with honorary titles such as the weighty "Father of Modern Psychiatry," Pinel, like many celebrated heroes of the past, is much admired and often mentioned, but little read. Written over one hundred seventy years ago, his *Medical-Philosophic Treatise on Mental Disturbance or Mania* remains a convincing and profoundly moving argument for the humane treatment of individuals experiencing mental illness, a declaration of human rights for the insane.[5] Although he has been long superseded as a theoretician, Pinel's achievement as the radical reformer of mental hospitals would be worthy of emulation in our own day. Influenced by the social idealism that ushered in the French Revolution, and by the scientific progress and optimism of the Age of Enlightenment, he was a man of action, a practical reformer more than a theorist.[6] His *Medical-Philosophic Treatise* played a central part in changing the prevalent attitude toward the mentally ill as incurable and unable to benefit from proper care. Preaching the gospel of "moral treatment of the insane," he sought to describe a hospital environment in which the patient might be encouraged to recover. As he pointed out, as long as a patient is chained in an atmosphere of chaos and confusion, it is difficult to decide whether his insanity is the result of illness or of his chains. His experience as chief physician at Bicêtre, the famous hospital for men, from 1793, and at the Salpêtrière, the women's hospital, from 1795, provided him with ample evidence that practical changes in hospital management and environment could be expected to produce worthwhile changes in many of the inhabitants. That he himself had grown and developed as a result of his continuing relationship with the mentally ill is apparent from the humane and objective outlook that pervades his writings.

He was imbued with a belief in the necessity for careful observation and accurate description, so it is not surprising that the earliest scientific account of the graphic activity of the mentally ill occurs in Pinel's

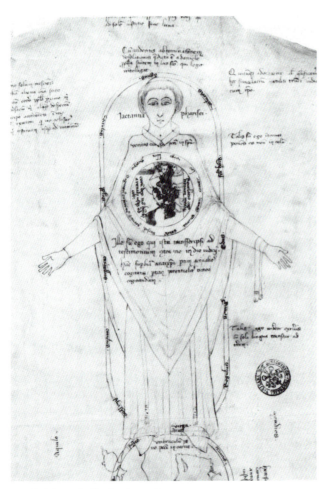

2.1. Opicinus de Canistris, confessional self-portrait, 1335–1336, Vatican Library, Rome.

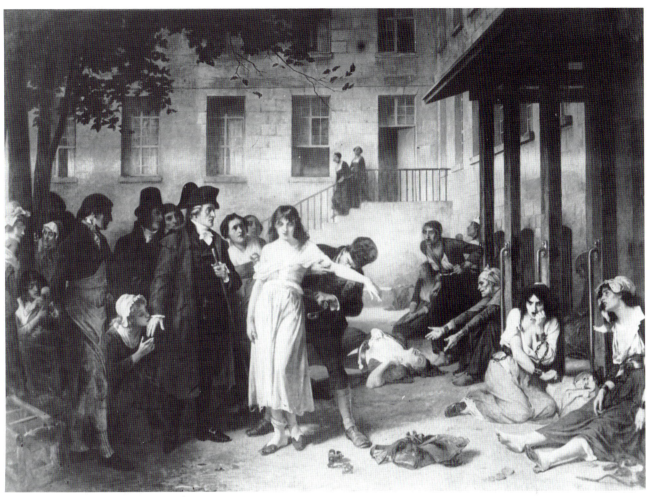

2.2. Tony Robert-Fleury, *Pinel Unchaining
the Insane at the Hospital of Salpêtrière*,
1878, oil on canvas, Salpêtrière, Paris.

Treatise. Included in the wide range of conscientiously described case material are two reports of individuals whose behavior involved drawing or painting.

In the first of these accounts, drawing was only a by-product of the patient's intense involvement with the design of a perpetual motion machine, a not unusual preoccupation of patients at this time.[7] One wonders if this concern with perpetual motion reflected a struggle against the idea of the inevitability of death. The patient, once a celebrated watchmaker in Paris, worked constantly at drawings and plans relating to the machine, which he wished to construct. "The idea of perpetual motion frequently recurred to him in the midst of his mad wandering, and he penciled constantly on walls and doors drawings of the necessary mechanism to make it work."[8] Believing that his patient would benefit from a real involvement with the task of making the impossible machine, Pinel arranged for the necessary equipment and materials to be set up in his hospital room. A series of elaborate mechanisms were, in fact, produced. (I have included as Fig. 2.3 an elaborate machine that, although not the work of this patient, is of the same period.) The successful outcome of the case is suggested by the title Pinel chose for the chapter, "A Happy Expedient Used in the Cure of a Maniac."

Pinel's interest in the graphic activity of patients was confined to cases in which painting and drawing had played a part in the patient's life and employment prior to the onset of his illness. There are no references to spontaneous picture making by untrained individuals under the impact of illness, or as a response to the

crushing monotony of the hospital regime. Although more bizarre drawings were undoubtedly to be encountered in his wide practice, he apparently saw no reason to comment on them. Both of the individuals whose cases he described used drawing as a normal aspect of their professional activity. He made it clear that he understood this behavior as belonging to a surviving healthy portion of the patient's personality, a view of the situation that would find ready acceptance in the context of present-day dynamic psychiatry. This conviction, which was later to be forgotten, prompted him to take special pains to assist and encourage patients' activity in the hope that they might "speedily recover themselves upon an object presenting itself calculated to attract and fix their attention in the midst of their chimerical wanderings."[9]

At the commencement of convalescence, and at the first indication of recovery, it frequently happens, that the taste of the individual for his former pursuit of the fine arts, science or literature begins to reassert itself. The first ray of returning talent ought to be seized upon with great avidity by the hospital attendants, in order to foster and hasten the development of his moral faculties.[10]

Pinel's practical recommendations in this passage represent a clear understanding of the therapeutic value of drawing and painting in the hospital setting, at least in cases where this activity played a part in the patient's prior existence. He constantly emphasized the acute sensitivity of the mentally ill and the necessity of treating them with consideration and respect, at a time when very different attitudes prevailed.

The second of his cases describes the tragic outcome of a failure to "support the patient's returning involvement with the Fine Arts."[11] The patient, "a sculptor, student of the celebrated Lemoine," after a period of violent agitation, displayed a renewed interest in drawing and painting. The description of the situation that developed between the patient and the people who were in charge of him (this was not one of Pinel's cases) demonstrates the new way in which the art of the professional artist-patient was beginning to be understood at this period, and provides a glimpse of what might be called the creative milieu, or environment, of a fairly advanced mental hospital. It is essential to remember that this young man was a highly trained artist. The hospital authorities gave as the cause of his illness his failure to be accepted as a member of the French Academy. For this reason his renewed interest in drawing was understood as something that should be encouraged. The drawings themselves were seen as having artistic merit, and we may suppose, in the absence of the pictures themselves, that they would have been relatively conventional academic studies, sufficiently accomplished to arouse the enthusiasm of the governors of the hospital. We are told that he executed portraits of the governor and his wife, and it seems from Pinel's account that they may have had less interest in the patient's emotional well-being than in his artistic productions. As Pinel pointed out, the situation was mishandled and the patient's interest in art was destroyed.

2.3. Machine constructed by a paranoic, nineteenth century, from Roback and Kiernan, *Pictorial History of Psychology and Psychiatry*, p. 53.

The talent that he had recovered, the desire to lend support to this reemerging activity, and, in this way, to rescue a competent artist for society, induced the board of Bicêtre to commission a picture, leaving the choice of subject to him, in order to give him freedom in selecting a composition. The convalescent, as yet imperfectly restored, felt this task to be beyond his ability, and asked that a subject be chosen for him, and that a correct and proper sketch be given him for a model. His request was evaded, and the only opportunity of restoring him to reason was thus allowed to escape. He became exceedingly indignant, considering this omission as an

2.4. Alexis-Vincent-Charles Berbiguier, *The Scourge of Demons*, frontispiece from *Les farfadets*, vol. 1 (Paris, 1821), engraving by Langlumé, signed by Quinart.

2.5. (far right) Alexis-Vincent-Charles Berbiguier, *Pinel as a Devil*, plate 6, from *Les farfadets*, vol. 2 (Paris, 1821) engraving by Langlumé, signed by Quinart.

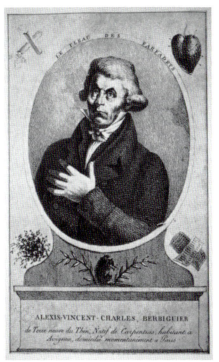

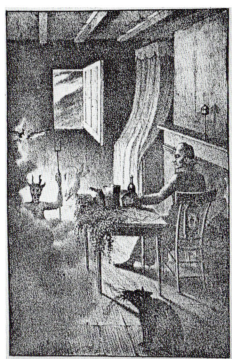

unequivocal mark of contempt, destroyed his brushes, palette and sketches, and loudly declared that he was through forever with the cultivation of the fine arts.[12]

In contrast to the careless handling of this case, Pinel's insight into the needs and limitations of this individual is particularly apparent in his recognition of the patient's reason for requesting a suitable composition that he could use as the basis for his painting.

The only surviving drawings by a patient associated with Pinel are found in a curious publication of 1821. *Les farfadets: or not all devils come from the other world* was the lifework of a madman who signed himself Alexis-Vincent-Charles Berbiguier de Terre Neuve du Thym (Fig. 2.4).[13] This extraordinary psychiatric document is a very detailed account of the experiences of a man who believed himself to be persecuted by demons. Berbiguier was apparently never hospitalized. He did, however, see Pinel for a single consultation. Then, as his illness developed, Pinel began to play a central role in his delusional system as one of the most dangerous devils or "farfadets." The book is illustrated with eight lithographs, each of which is explained by the author. In the sixth picture, Pinel is depicted as a horned devil coming up out of the floor (Fig. 2.5). The plates are signed by an artist Quinart and by an engraver Langlumé. Whether the lithographs are adap-

tations of original drawings by Berbiguier himself is not made clear, but this would seem to be the case.[14] If the drawing of Pinel is by Berbiguier, it would be of unique importance as the first portrait of a psychiatrist by a psychotic patient. The demonic portrait was not intended as a compliment. Berbiguier's intention throughout his long book was to malign the reputation of the prestigious psychiatrist in a violent and libelous fashion. What Pinel thought of this literary and pictorial depiction of himself is not known.

IN AMERICA, the first reference to the drawings of the insane occurs in the writings of Benjamin Rush (1745–1813), often described as the initiator of systematic studies in psychiatry on this continent (Fig. 2.6). In his influential textbook *Medical Inquiries and Observations Upon the Diseases of the Mind*, published in 1812, he commented that individuals suffering from mental illness may occasionally display talents they had not exhibited prior to falling ill.[15]

From a part of the brain being preternaturally elevated, but not diseased, the mind sometimes discovers not only unusual strength and acuteness, but certain talents it never exhibited before. The records of the wit and cunning of madmen are numerous in every country. Talents for eloquence, poetry, music and painting, and uncommon ingenuity in several of

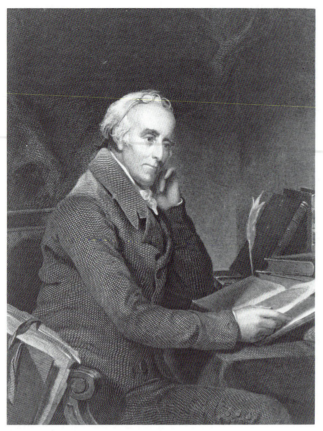

2.6. Thomas Sully, *Benjamin Rush*,
engraving by R. W. Dodson, The
Historical Society of Pennsylvania,
Philadelphia.

the mechanical arts, are often evolved in this state of madness. . . . Two instances of a talent for drawing, evolved by madness, have occurred within my knowledge. The disease which thus evolves these new and wonderful talents and operations of the mind may be compared to an earthquake, which, by convulsing the upper strata of our globe, throws upon its surface precious and splendid fossils, the existence of which was unknown to the proprietors of the soil in which they were buried.[16]

Works by at least one of Rush's patients survive among his papers preserved in Philadelphia.[17] The patient, who signs his work, Richard Nisbett, Mariner, is identified on the reverse of one painting as "a maniac in the Pennsylvania Hospital." He is the author of several poems, including a lengthy work entitled "Notional," as well as complex and wildly imaginative watercolor maps and paintings.

The maps, an example of which was recently discovered in the archives of the Historical Society of Pennsylvania, are pictorial compositions of a mixed geographical and mythological nature (Plate 1).[18] They seem to function as illustrative guides to a very rich inner world centering on ideas of either religious or classical mythological content. The painting on the upper part of this map, for example, includes depictions of "the Divine Pluto," including, his "first Step in motion." Pluto is depicted twice, along with figures representing the three Destinies, Hecate, and Themis, all suggestive of an aquaintance with classical mythology, despite the fact that the tiny full-length figures are all dressed in the costumes of the late eighteenth century. The map below is covered with writing, rich in schizophrenic word play, with the various land masses chaotically dispersed, but carefully labeled and painted. It embodies the richness of an elaborately developed delusional system, encompassing both space and time, a private universe with its own symbolic geography. These maps, so like the imaginative inventions of a Swift or Tolkien, could not help but capture the interest of a mind such as Rush's, awakening his curiosity as to the nature of the mental processes prompting their creation.

The scenery of Nisbett's very personal world is reflected in paintings such as the one in the archives of the Library Company of Philadelphia entitled *An Antarctic Scenery* (Fig. 2.7).[19] Nisbett here illustrates a miraculous nautical event said to have occurred off the coast of Antarctica, in which a host of swimming angels "decoy a large fleet of Murtherous Pirates into the Golef of the Zophim Antarctics." The artist's involvement with the sea is to some extent confirmed by his detailed depictions of ships, including the large convoy of bare-masted pirate vessels (at upper right), and the small fully rigged ship (at left). His visualization of Antarctic scenery as a series of huge arcs, lapped by a gentle sea in which small icebergs appear to float, demonstrates that at least some of his travels were confined to the realm of imagination. The presence of numerous angels, or seraphim, as well as a variety of crosses, suggests his participation in nautical battles of a mythological and epic, rather than historical, character.

Nisbett's writings, including the short poem "Origin of Quick-silver & Quick-sand," are phrased in a language that is both impressive in terms of its references to "the Atomic System," "fresh resources of Spasmodic pain," or "Adamant Serene," and at the same time unintelligible. Unfortunately Rush does not refer to this case in any of his published work, and so the extent to which his dramatic description of the art of the insane was shaped by his encounters with the work and mind of Richard Nisbett is unknown.

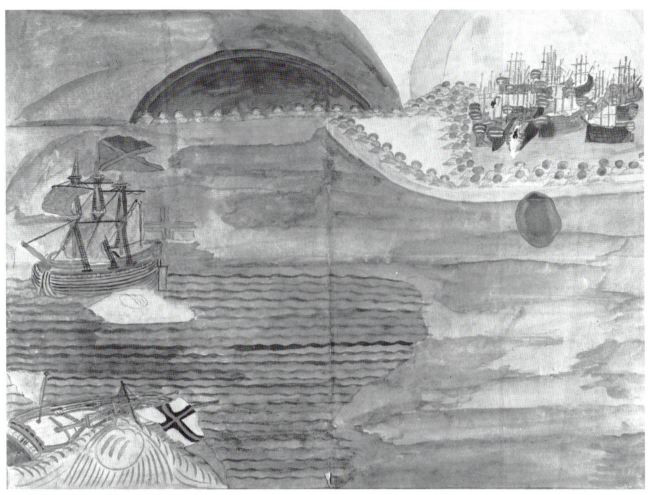

2.7. Richard Nisbett, Mariner, *An Antarctic Scenery*, 1816, watercolor, The Library Company of Philadelphia.

It is significant that, unlike Pinel, Rush was struck by the sudden development of image-making activity in individuals who had no prior involvement with art. The spontaneous emergence of an interest in painting or drawing accompanying, or as a result of, mental disturbance was to be the central concern of all the nineteenth-century investigations into the pictorial activity of the mentally ill. Rush was, of course, aware that in the case of professional artists, or amateur painters, their intense involvement with art could find expression in their behavior during illness. He had encountered painters who while ill drew pictures on the walls of their hospital rooms. Unfortunately, he saw no reason to describe the nature of their work.

Perhaps it is Rush's imagery, particularly the use of the earthquake as an analogy of the mental process,

that is most able to intrigue us today. There can be no doubt that he is describing the appearance of material from a deeper, and unconscious, level of the mind. But it is striking that he should refer to these images and ideas as "precious and splendid fossils." He seems to imply two things here: the antiquity of some of the material, and its unusual quality. Toward the end of the eighteenth century, students of the mind were becoming aware of the possible existence of unconscious mental contents. They were struck by the fact that this unconscious material could occasionally be different in kind, and superior in quality, to the individual's normal, or conscious, mental products. The work of Franz Anton Mesmer (1734–1815) and of Amand-Marie-Jacques de Chastenet, Marquis de Puységur (1751–1825) led to an entirely new and more complex concep-

tion of the mind.[20] Hypnosis, or "Mesmerism," had opened up the possibility of exploring the unconscious, and in the later part of the eighteenth century the first descriptions of "split" or "double" personality began to appear.[21] In his poetic use of the earthquake imagery, Rush indicates his familiarity with the newly developing conception of the unconscious, as well as his enthusiasm for the unique artistic products that appeared to derive from mental illness. His awareness of this phenomenon did not, however, lead him to investigate the artistic activities of his patients more deeply, and his published descriptions of drawings consist only of references to the fact that they exist.

NEITHER Pinel nor Rush was sufficiently impressed by the artistic productions of any of his patients to consider reproducing examples of their work. The *act* of drawing or painting caught their attention, as it had caught that of artists, and it did not occur to them that their readers might have been curious about the nature of these images. A British colleague of theirs, John Haslam (1764–1844), made up for their failure by including in a book what may be the first example of patient art ever reproduced.

John Haslam occupied the position of apothecary to Bethlem Hospital (Fig. 2.8). Inevitably his reputation, like that of any physician connected with Bethlem, has suffered by being associated with an institution that managed to preserve its notoriety well into the nineteenth century. Over fifty years had passed since Hogarth revealed the madness of Bedlam for all the world to see. Had things improved?

Bethlem in the first decade of the nineteenth century still occupied the building in Moorfields. Beautifully designed from the exterior, a virtual palace for madmen, it was now in a dangerous state of disrepair, with subsiding foundations, plagued by damp, and unfit to serve its patients' needs. By 1800 a decision had been reached to replace it with a new building on a more suitable site. While the practice of exhibiting the insane for the amusement of the London public had apparently ended by 1770, the squalor and degradation in which at least some of the poorer and more helpless patients were forced to live continued unchanged. Bethlem had become a closed and secret preserve where inhumanity could flourish unseen, selectively, and without the excuse of ignorance or custom.

To some extent Bethlem in the early years of the nineteenth century, despite its position in the center of one of the most socially and intellectually advanced capitals of Europe, represented a deliberate "holdout" against all that had been learned about mental illness

and its treatment. If the example of Pinel had not been sufficiently felt in England, the same could not be said of the pioneering work of William Tuke (1732–1822). The dramatic change in attitude toward, and treatment of, the mentally ill introduced by Tuke at his famous Retreat at York, founded in the 1790s, provided clear evidence of the benefits to be derived from humane care of the insane. The influence of Tuke's methods of caring for the mentally ill had spread throughout England, and his ideas were known on the Continent.[22] That Bethlem's doors remained closed to reform would seem to have been a result of either a deliberate policy of neglect or of sheer blind stupidity and arrogance. In 1815 a government commission finally succeeded in exposing what had become a tragic situation of incompetence and inhuman neglect. London awoke to a scandal that shamed the whole medical profession and wrecked the career of the famous physician and mad doctor, visiting physician to Bethlem, Dr. Thomas Monro (1759–1833) (Fig. 2.9). This then was the environment in which John Haslam worked and carried out his research, and for which he must inevitably bear a part of the responsibility.

That Haslam was in fact carrying out any research at all is quite astonishing under the circumstances. But, in fact, charged with the responsibility of conducting autopsies, he had made himself something of an authority on the pathology of the brain. "His autopsy descriptions are so vivid that it is possible to identify one of his post-mortem findings as probably the first record of syphilis of the brain."[23] His preoccupation with observation and description of dead patients is somewhat less interesting to us than his equally vivid account of a living patient who had been admitted to the hospital in 1797, James Tilly Matthews.

In 1809 Haslam wrote an elaborate report on the delusional system of this man, entitled *Illustrations of Madness* (Fig. 2.10), devoting the entire book to the patient's account of his persecutions and bodily experiences, of the criminals who were tormenting him, and of the mechanical devices they used to do this. The case is an early account of the influencing machine in paranoia. The book was widely read and is often referred to in the European literature.[24] To the modern psychiatrist Haslam's detailed description of the case, his objectivity and precision, appear worthy of admiration. We must be careful, however, in projecting our own motivations and interests backward into history. Haslam's goal in writing his book appears to have been merely to prove Matthews mad. An attempt had been made by the patient's family to have him pronounced sane and to remove him from the hospital. A legal in-

2.8. G. Dawe, *Portrait of John Haslam, Apothecary of Bethlem Hospital,* engraving by H. Dawe, 1812, The Bethlem Royal Hospital, London.

2.9. (below) Henry Monro, *Portrait of Dr. Thomas Monro,* ca. 1810, pastel, The Royal College of Physicians, London.

2.10. (far right) Title page from John Haslam, *Illustrations of Madness* (London, 1810).

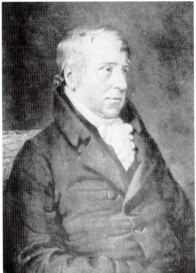

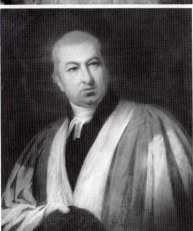

ILLUSTRATIONS
OF
MADNESS:
EXHIBITING A SINGULAR CASE OF INSANITY,
AND A NO LESS
REMARKABLE DIFFERENCE
IN
MEDICAL OPINION:
DEVELOPING
THE NATURE OF ASSAILMENT,
AND THE MANNER OF
WORKING EVENTS;
WITH A
DESCRIPTION OF THE TORTURES EXPERIENCED
BY
BOMB-BURSTING, LOBSTER-CRACKING,
AND
LENGTHENING THE BRAIN.

EMBELLISHED WITH A CURIOUS PLATE.

BY JOHN HASLAM.

" Oh! Sir, there are, in this town, Mountebanks for the mind, as well
as the body."—*Foote's Devil upon Two Sticks; Scene the last.*

London:

PRINTED BY G. HAYDEN, BRYDGES-STREET, COVENT-GARDEN;
And Sold by
RIVINGTONS, ST. PAUL'S CHURCH-YARD; ROBINSONS, PATERNOSTER-ROW;
CALLOW, CROWN-COURT, PRINCES-STREET, SOHO;
MURRAY, FLEET-STREET; AND GREENLAND, FINSBURY-SQUARE.

1810.

quiry had been held at which various medical authorities gave evidence. The book sought to embarrass those physicians who had testified publicly to Matthews's sanity, ridiculing them by presenting the mad ideas of the patient for all the world to see. It is not insignificant that the patient's actual name was used and no attempt was made to conceal his identity or to protect his family. The magnificent detail, the precise observation and description of the influencing machine, and the terrifying mental and bodily experiences connected with it are not Haslam's achievement, but that of the patient. Most of the book is composed of direct quotations from notebooks prepared by Matthews.[25] The decision to reproduce the drawing was motivated by the belief that it would make the pa-

tient's insanity visible and concrete. The explanation of the drawing's meaning is entirely the patient's own. Careful reading of *Illustrations of Madness* leaves one with the impression that Haslam was a man of little insight much impressed with himself, and that the truly magnificent figure in the story was James Tilly Matthews, architect.

There can be no doubt that Matthews was mad and, quite possibly, dangerous. His insanity appears to have been contained, limited to specific topics and beliefs, leaving the remainder of his mind free to carry on with the business of living, a task that he accepted with unusual liveliness and ambition despite his enforced residence in Bedlam. Matthews believed himself to be emperor of the whole world, the reigning sover-

eigns being usurpers and imposters. He felt that his residence in Bethlem was the result of an international conspiracy, the action of an organized gang that had obtained power over him by planting a magnet in his brain. From the hospital he issued orders putting people to death and having them arrested and imprisoned.

There are 13 or 14 in the gang attacking me, and, they say, Five or Six others who took part in murdering my only son. Several others Concerned in murdering my brother William and distant parties who murdered my mother and only sister during my infancy and youth.[26]

As for the workers themselves, especially those gangs who have been Concerned in their attacks upon myself and my Family; It is with me a Great Object to have them delivered up to me alive and in their perfect senses, . . . and their machinery, Air-looms, Magnets, etc., whole that all my subjects may have the sight of them, and know such weapons of murder wherever they may be.[27]

Matthews experienced fearful attacks on his mind and body carried out through the use of a curious machine that he identified as an air-loom, an appropriate invention in terms of the suffering inflicted on the English people by the mechanized chaos of the Industrial Revolution. The complex structure and function of the air-loom are explained at length, and the text is illustrated by his own drawing and floor plan, showing the influencing machine and its gang of operators (Fig. 2.11). The engraved drawing as it appears in the book is the result of a collaboration between the patient and an English engraver, John Hawksworth (active ca. 1820), who specialized in engraving plates for books. He translated Matthews's drawing into a line engraving so that it might be printed.

The engraving bears the legend, "DIAGRAM, or Plan of the Cellar, or Place where the Assassins Rendezvous and Work, Shewing their own, and their Apparatus's Relative Positions, as it has at all times appeared to Me by the Sympathetic Perception." It is clearly labeled as drawn by J. T. Matthews. Each section of the mechanism is identified and its use explained. The drawing includes tiny figures, portraits of Matthews and his tormentors. The figure represented at X is the patient himself, upon whom the magnetic influences of the machine, as well as the malevolent "brain-sayings" of its operators, can be seen to focus. Many drawings made by patients are concerned with making visible what is invisible to others, particularly the telepathic transmissions that they experience as the source of thoughts and ideas coming to them from outside.[28]

The style of the engraving might incline one to the opinion that the drawing was only partly the work of Matthews, refined and corrected by the engraver. Such an opinion would negate the significance of this first drawing by a patient to be reproduced, implying that the personal element in the picture has been lost, while admitting that the construction of the machine and the location of its various operators are undoubtedly the patient's own invention. However, it can be proved that the style of the drawing is Matthews's own, and that Hawksworth did no more than translate the drawing as accurately as possible into the different medium. In that it was Haslam's intention to use the patient's own writings and drawings to prove him mad, it is unlikely that he would have permitted the engraver to improve upon the original.

In discussing the operation of the air-loom, Matthews demonstrates an interest in electricity, magnetism, and at least some familiarity with Mesmer's "magnetic fluid."[29] It appears that he spent some part of his life in France, and this may account for the nature of his machine, which appears to utilize electricity and magnetic fluids much as did Mesmer's "baquet." The drawing was intended as a scientific diagram; in fact, he insisted that a similar mechanism was to be seen "in Chambers' Dictionary, edited by Dr. Rees in 1783, under the article loom, and that its figure is to be seen in one of the plates relating to pneumatics."[30] Study of Chambers's *Cyclopedia* has failed to reveal any description of Matthews's influencing machine. Nevertheless, comparison of his drawing with the scientific apparatus reproduced in the plate volume of the *Cyclopedia* under "pneumatics" does suggest that Matthews was familiar with these illustrations and that his own private machine was influenced in its details by those he saw in the book. His style of scientific illustration was not without precedent. Nevertheless, his machine is an invention of his own, not a copy. Many of the drawings made by the mentally ill consist of diagrams or plans, and it is necessary to consider these in any discussion of patient art.

Two years after the publication of Haslam's *Illustrations of Madness*, James Tilly Matthews, inspired perhaps by the success of the apothecary's venture into publishing, decided to undertake a similar venture on his own. From Bethlem he issued a handbill announcing the publication of a series of architectural plans with the title, *Useful Architecture*.

TO THE PUBLIC

Many Strangers, as well as my own Friends, having expressed their Wishes that I would cause a series of my Designs for public and private Buildings to be engraved, I had

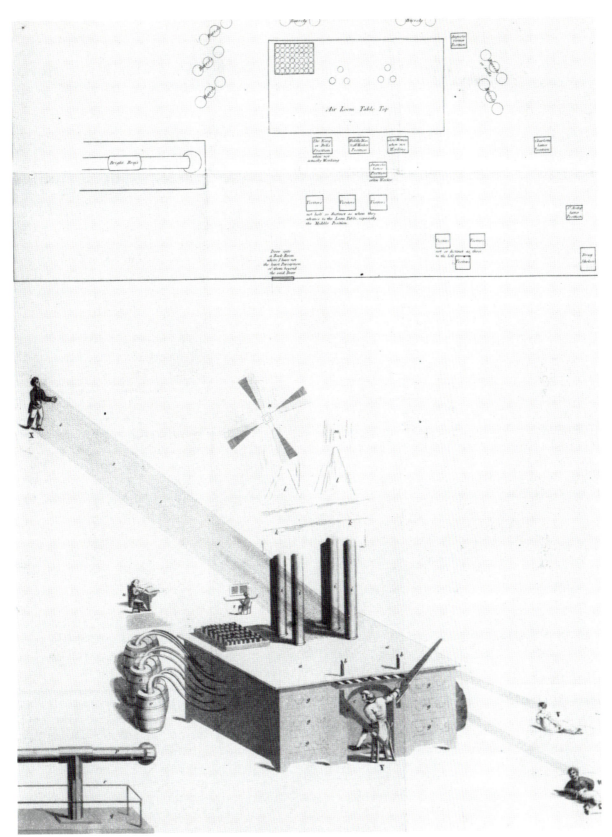

2.11. James Tilly Matthews, *DIAGRAM, or Plan of the Cellar, or Place, where the Assassins Rendezvous and Work*, from John Haslam, *Illustrations of Madness* (London, 1810).

determined to gratify them, when an eminent Artist kindly offered to instruct me in the Species of Engraving necessary. I accepted his friendship; and being now an Etcher of several weeks progress, I shall offer such Designs wholly etched by myself, in numbers under the title Useful Architecture. The first few, as Engravings, I hope will be viewed with the Indulgence generally shewn to a Novice.—I trust I may promise great improvement as I proceed.

The price of each number shall be six Shillings, Coloured and Sewed. Any Lady or Gentleman, desirous of having each Number as it comes out, whether as a Work for Use, or as a Curiosity, by sending their Commands to me, at Bethlem, where I am confined, may rely on having them carefully selected, prepared, and sent to them, the Money to be paid on delivery. Oct. 31, 1812.[31]

The first number of *Useful Architecture* contained the plans for a small cottage (Plate 2), and an economical villa (Plate 3). It had a short text and four hand-colored plates, "Designed, Drawn, and Etching Engraved by J. T. Matthews." Nothing about the text or the plans suggests anything unusual about the author's mental condition. Pink floor plans are a bit rare, but hardly grounds for a diagnosis of schizophrenia. What interests us about the publication is simply its existence. It is astonishing that in the Bethlem of 1812 a patient could conceive and carry out such a complex project. Matthews's family may have helped, carrying the plates to the printer, and then back to Matthews to be colored and bound, as part of their effort to prove to the authorities that he was sane. But the hospital authorities may also have encouraged Matthews in his creative activity.

Bethlem's visiting physician, Dr. Thomas Monro, had interests that extended beyond his psychiatric concerns. He is known in the history of art as the foremost patron of the English school of watercolor painting, the friend of John R. Cozens (1752–1842), of Thomas Girtin (1775–1802), John Cotman (1782–1842), and J.M.W. Turner (1775–1851). His home in London functioned as a sort of work club in which young artists were welcome to study and even to make copies under his supervision.[32] He himself had studied painting under the artist John Laporte (1761–1839), and had gone sketching with Thomas Gainsborough (1727–1788). An example of Dr. Monro's kindness to an insane artist is provided by his devoted care of John Cozens, who had become insane in 1793, and whom he looked after until Cozens's death in a hospital he administered in Smithfield. It is not impossible that Dr. Monro facilitated Matthews's architectural work and removed obstacles in the way of his publishing his designs.

An entry in the Bethlem Sub-committee Book for 1805–1814 throws some light on this subject: "This committee this day ordered that Ja. Tilly Matthews should have a room appropriated for him for his greater comfort and that he should fit up the same for himself at a moderate expense under the direction of the steward. December 1809."[33] That he had learned engraving while in the hospital is also surprising. He does not reveal who his eminent artist friend was, but one may speculate that it was the engraver Hawksworth. In any case, although a beginner, he was now able to produce engraved versions of his own drawings. Comparison of the style of drawing in the house elevations with that in the influencing-machine drawing confirms the belief that the engraving of the air-loom was an accurate reproduction of Matthews's personal style of architectural rendering. Far from being an untutored madman scrawling plans on scraps of paper, he is revealed as a trained professional capable of highly finished perspectives and ground plans. Even the layout—floor plan above, perspective below—is characteristic of the period.

Matthews's publication awakened the interest of a renowned architect, an early instance of the sane artist attending to the creations of his insane brother. In 1826 Sir John Soane wrote to John Haslam to ask if he might obtain a copy of *Useful Architecture*. Haslam replied with a friendly letter and enclosed the copy now preserved in Sir John Soane's Museum.[34]

A further piece of information indicates not only Matthews's ambition, but also the potential of the artist-patient in Bethlem. In 1810 a competition was held for the design of the new hospital in St. George's Fields. James Tilly Matthews entered the competition, formally submitting very extensive plans, now lost, for the new building! The plans had to be submitted anonymously, so for the first time Matthews's reputation was protected under a pseudonym. He was Number 5, and chose the name "Deuce take it." No comment survives concerning the judge's attitude to this particular set of plans, and the work of another architect, James Lewis, was selected as the winner. But Matthews's description of the contents of his submission indicates that it was probably similar to the plans in his *Useful Architecture*, and in no way absurd or bizarre.[35] The tragedy of the insane architect is that residence in a madhouse provided little opportunity for the realization of architectural projects. Despite Matthews's unusual tenacity, no building of his appears to have been executed while he was in Bethlem. It is nevertheless fitting that he should have been the first patient-artist

to have his pictures reproduced both in the scientific literature and, thanks to his own efforts, in the architectural literature of the early nineteenth century.[36]

DESPITE the incredible achievements of Berbiguier and Haslam in making their work known to a wider public, the first scientific accounts of the drawing and painting of the mentally ill at the beginning of the nineteenth century consist of the mere mention that some patients produce drawings. The focus of attention was not on the drawings themselves, on their possible value or meaning, but on the patient's actions. This concern with the observation and recording of behavior was an aspect of the strenuous effort to make sense out of the chaotic variety of symptoms and behavioral manifestations of severe mental disturbance. Preoccupied with classification, physicians at this moment regarded the patient's occasional interest in drawing as one form of bizarre activity among many. That their visual productions might be worthy of study in themselves was not recognized. As a result, there are no descriptions of actual works. For the most part, they seem to mention only those patients whom they saw as talented. Certainly Pinel concerned himself with drawings only in those cases where they represented a revival of the patient's prior professional activity. Nevertheless, the enormous influence of Pinel was the single most important factor motivating the first explorations of the pictorial production of patients at the beginning of the century. His awareness that, in at least some cases, the opportunity to draw or paint might contribute to the patient's recovery had no immediate effect. The emphasis on diagnosis and classification precluded awareness of the therapeutic value of the patient's image-making activity. In terms of present psychiatric, and particularly psychoanalytic, preoccupations, John Haslam's detailed case presentation might inspire respect, were it not for the fact that Haslam's sole intention was to use the patient's productions to prove him to be crazy. We owe whatever understanding we have of this first drawing to James Matthews himself. The patient's contribution to the understanding of the art of the insane was to be, throughout the early part of the century, the major source of explanation and insight.

Georget and Géricault:
The Portraits of the Insane

The failure of images made by the insane to be perceived as existent and meaningful was dependent on two seemingly opposed factors.[1] The first was the tendency to conceive of insanity as a mental state overriding the individuality of the patient. A madman ceased to be a person, his individuality was consumed, and he became a member of a fraternity of lunatics whose random and meaningless behavior was not thought to express personality. The stereotyped modes of representing the insane reflected this loss of identity. The artist might for one reason or another depict madness, but no individual experience of insanity ever inspired a portrait prior to the nineteenth century. Similarly, the embodiments of individual experience that spontaneous images represent remained invisible, or were dismissed as meaningless.

A seemingly opposite situation is seen in the awareness of eighteenth- and nineteenth-century physicians and alienists that insanity was a hydra with an almost infinite number of heads. The emphasis on description and classification that was so prevalent seems to suggest an overwhelming, almost paralyzing, awareness of the uniqueness of each patient. This was not the case, however. The chaos and confusion experienced by the early psychiatrists resulted from the limitless variety of symptoms they encountered, and in that vast multiplicity of symptoms the patient as an individual again disappeared. The fact that some patients drew was observed and recorded; the individual drawings, however, remained, at least temporarily, unclassifiable and therefore invisible.

The process of discovering the art of the insane parallels and comes directly from a much more significant process whereby the insane have been transformed bit by bit into separate men and women, each with a unique, and at times painfully distinct and separate, life experience. Part of our task is to try to reconstruct the stages in this gradual, and still far from complete, process of change.

This chapter describes the first stages of this new perception of the insane as individuals as it occurred in the curious borderland between science and art. In attempting to describe the origin and the development of new attitudes and ideas about the insane and their work, and to account for the movement of these new concerns from one field to another, it is not often possible to do more than indicate that new modes of responding were "in the air" at the time, without outlining precisely the course of events, or the individuals involved.[2] The influence of artists or writers on the preoccupations of scientists usually cannot be adequately documented, remaining for the most part in the realm of nebulous possibility. However, one exception to this situation of uncertainty exists in the contact between art and psychiatry in the nineteenth century; the little-known collaboration between one of the foremost painters of the period, Théodore Géricault (1791–1824), and the distinguished alienist Etienne Georget (1795–1828). The lives of these two gifted men, near contemporaries, paralleled each other to the extent that, after initially brilliant careers, both died tragically early at the age of thirty-three, long before their revolutionary contributions to their respective fields had been fully realized. The story of their collaboration and the series of portraits of patients that originated as a result of it demonstrate strikingly the extent to which innovations in French psychiatry contributed to the development of French art in the early nineteenth century.

Etienne Georget represented a third generation of the pioneers of the French school of psychiatry. As the most promising pupil of Jean Etienne Dominique Esquirol (1772–1840), he could be described as the intellectual grandson of Philippe Pinel. Despite the brevity of his professional career, he achieved prominence as a major contributor to French psychiatry, publishing the book that added most to his fame, *De la folie*, in 1820 when he was twenty-five.[3]

As with most psychiatric investigations of the period, Georget's research was concerned primarily with further refinement of the various systems of nosological classification and with increasingly accurate description and differentiation of types of mental illness, in an effort to impose some degree of order upon the

chaos of symptoms and patterns of behavior that seemed so confusingly resistant to precise diagnosis and treatment. This obsession with classification inevitably appears to the modern psychiatrist to have been an incredibly time-consuming and misguided expenditure of energy that contributed little to the well-being of the patient. This is particularly evident today in that current efforts in psychiatry tend in the direction of freeing psychiatric thought from an excessive reliance on diagnostic categories and labels.[4] Nevertheless, it is not difficult to understand the psychological necessity motivating physicians at the beginning of the nineteenth century to attempt to discover some method of grouping with which they could begin to organize the frightening variety of bizarre human behavior. Their systems provided a defense enabling them to confront forms of human experience that would otherwise have provoked more anxiety than they could withstand and still continue with their task of trying to understand and help. Franz Alexander, in summarizing Georget's contribution, states, "Georget's descriptions of mental disturbances were so exact that he described precisely a serious form of psychosis which later was called Hebephrenia."[5] Alexander was also struck by Georget's apparent awareness that some mental disturbances may arise from a refusal to allow certain unacceptable ideas to become conscious. The early death of a psychiatrist of this caliber represented a serious loss to French psychiatry.

Georget has sometimes been portrayed as a quack because of his ideas about the importance of physiognomy in the diagnosis of mental illness. It is perfectly true that in his careful descriptions of patients at the Salpêtrière hospital, Georget indicated any abnormal or unusual physical or physiognomical symptoms. But such scrupulous observation continues to be necessary even today. In a modern psychiatric textbook, the student is advised to make notes of his "initial impression of the patient, gait, posture, clothing, voice, manner of speech, facial expression and muscular tension."[6] A few quotations from Georget's observations will suffice to indicate the importance of physiognomy to the nineteenth-century physician faced with the task of differential diagnosis. Describing the onset of a condition known as "ataxie," he mentions "a sudden and profound alteration of facial expression, extreme and convulsive mobility, or a paralytic freezing of the muscles of the eyes and face."[7] Discussing the observable symptoms of catalepsy, he indicated the following facial characteristics: "the eyes are fixed and directed straight ahead or upward. The face itself is generally little changed, though often it is flushed and animated,

or in some cases pale and discolored."[8] How important such observations could be in this period is indicated in this brief description of the means of distinguishing between catalepsy and deathlike trance states: "There is no other indication beyond the convulsive state of the eyes and the general impression of the physiognomy that can furnish a method of distinguishing one from the other."[9] As to the suggestion that Georget was overly concerned with physiognomical diagnosis, he speaks for himself:

In the majority of cases involving insanity, the nutritive function remains in good condition, and in terms of external appearance the patient appears to be in good health. This is particularly true after the first days following the onset of the illness, and prior to the final stages of illness which lead inevitably to the grave. In conclusion, those who have had considerable experience in observing the insane will not contradict me when I put forward the opinion that in the large majority of cases, these patients look no different from individuals who are in perfect health.[10]

In making this courageous statement, Georget would seem to have put himself in opposition not only to much of current psychiatric opinion, but to the entire pictorial tradition for depicting the insane, which depended on clear physiognomic and bodily signs of illness. His observation would also seem to have precluded any need for illustrations of patient's appearance in psychiatric publications. Yet it is about this time, or slightly later, that he commissioned Géricault to execute the portraits of the insane. How are we to understand this apparent contradiction?

Interest in the appearance of specific patients, and in the use of pictures of them to illustrate their case histories, undergoes a clear evolution from Pinel, through Esquirol, to Georget. The pictures can be used as evidence for the very rapid development occurring in French psychiatry in the first quarter of the nineteenth century.[11]

Philippe Pinel, in his *Traité* of 1801, included only two images of patients: the one a maniac, the other an idiot. His concern was chiefly in the more permanent features of the face influenced by the underlying bone structure, and he used proportional ratios to demonstrate differences between the insane and an ideal norm represented by the Apollo Belvedere. His idiot was no abstract representative of the type, but a drawing of a specific individual, a farmer's son resident in the Bicêtre Hospital. The simple front view and profile drawings are accompanied by an equally simple case description. However, as case histories became more specific and autobiographical, more elaborate pictorial

3.1. Mania, from J.E.D. Esquirol, *Des maladies mentales considérées sous les rapports médical, hygiénique et médico-légal* (Paris, 1838).

3.2. Demonomania, drawn by Georges-François-Marie Gabriel from engraving in J.E.D. Esquirol, *Des maladies mentales considérées sous les rapports médical, hygiénique et médico-légal* (Paris, 1838).

images would be needed to accompany the more detailed verbal descriptions.

With Pinel's student and coworker, J.E.D. Esquirol, the involvement with pictorial illustration of individual patients took an enormous step forward. During his long career, he employed a series of artists to illustrate cases that he was studying at the Salpêtrière, later using some of their drawings as the basis for engravings used in the psychiatric publications he produced. In one of these artists, Georges-François-Marie Gabriel (1775–ca. 1836), he was particularly fortunate.

A minor portrait painter specializing in miniatures, Gabriel was responsible for a series of portrait drawings that, as engravings, were used to illustrate Esquirol's psychiatric entries in the *Dictionnaire des sciences médicales*, which appeared between 1812 and 1822. These depictions of specific individuals, identified only by the psychiatric illnesses from which they suffered, are the immediate ancesters of the Géricault portraits.

Over the years Esquirol amassed a considerable collection of these portraits of patients; in 1838 he mentioned having had over two hundred such studies prepared.[12] Because Georget lived in Esquirol's home during the final years of his life, he would certainly have seen the collection and been familiar with its purpose and with the artists involved. Esquirol's choice of artist would have been dictated by the nature of the

project, the recording of the appearance of specific individuals under the impact of various psychiatric illnesses, and by the specific requirements of early nineteenth-century book production, which necessitated the translation of line drawings into engravings.

Although the chronology of Gabriel's Salpêtrière portraits is unknown, it seems that he was initially burdened with all of the standard pictorial conventions used in depicting the insane, so that his first attempts at scientific illustration were completely lacking in both objectivity and individuality (Fig. 3.1). With more extensive experience in the hospital, he was able to free himself from some of this art historical baggage, and to begin to see the patients as real individuals (Fig. 3.2). In his depiction of a patient, diagnosed as a demonomaniac, it is possible to sense something of the reality of the old woman, seemingly so tiny, and yet so fierce, propelled by her internal preoccupations into violent activity. Gabriel's drawings, a number of which survive in their original state, established a new standard of objective psychiatric illustration.[13] Nevertheless, his work at the Salpêtrière is separated from the roughly contemporary activity of Géricault by a huge gulf that is essentially reflective of the unbridgeable gap between pedestrian talent and genius.

AROUND 1822, Georget's interest in physiognomy and its relation to diagnosis seems to have led him to approach the well-known, somewhat controversial, young artist Théodore Géricault with what at first seems to have been a not unusual request. Probably in emulation of the work of his teacher and friend Esquirol, he commissioned a series of portrait studies of patients resident in the Salpêtrière and Bicêtre hospitals. No information about the nature of the commission survives, but it is certain that ten life-size oil paintings were produced. The first detailed account of the pictures occurs in a catalogue raisonné of Géricault's work prepared by his biographer, Charles Clément, in 1868.[14]

Surpassing anything that Dr. Georget might have envisioned when he ordered the pictures, the Portraits of the Insane, only five of which can be identified today, are among the most significant masterpieces of French painting in the first quarter of the nineteenth century (Plate 4). Completely transcending the limited aims of psychiatric illustration, they stand as major monuments in the history of Western art, enlarging the meaning and function of portraiture in general by investing it with depths of psychological insight and intensity rarely ever attained or attempted.[15] Our task is to try to understand something of the historical con-

text, the motivation, and the significance of this extraordinary accomplishment, which occurred somewhere on the borderline between psychiatry and art.

Despite the brevity of Géricault's life, his artistic development underwent rapid changes that carried him far outside the accepted artistic conventions of his day. The Portraits of the Insane represent the last in a series of changes of style that characterized Géricault's brief career. Such sudden shifts in personal style demand explanation, unless one is content to accept the decision made by Klaus Berger with regard to the Portraits of the Insane: "This transformation into penetrating psychological portraits can be no better explained than by saying that it is Géricault's secret; no other artist of that epoch has achieved anything similar."[16]

It is not easy to characterize the unique contribution of Géricault's work to the history and development of French art during a century in which France produced so many of the great names in the history of art. Four fairly distinct trends developed and intermingled in the course of the century: Neoclassicism, Romanticism, Realism, and, at the close of the century, Impressionism. In terms of this extreme oversimplification, Géricault is usually seen as a major force in the development of French Realism. The term *realism* is confusing in that it might seem to refer to a concern with naturalistic illusionism. This is, in fact, one aspect of Realist painting. Perhaps the meaning of the term is more easily understood in the context of literature, where it implies an objective and unflinching documenting of reality, as opposed to an attitude of idealism or fantasy. In the novels of Stendhal (1783–1842), Balzac (1799–1850), or Zola (1840–1902), it can imply, as well, an involvement with the ugly or at least banal side of life. The realist chooses to portray what others prefer to forget. It is not difficult to see parallels between the scientific objectives of early nineteenth-century psychiatry and the objective, detailed, and unflinching examination of reality in Realist art and literature. Both involved a new respect for the phenomenological reality of the individual.

It was Géricault's achievement to have contributed to the origins of this movement, which was to culminate later in the century in the intense social consciousness of the paintings of Gustave Courbet (1819–1877), Jean François Millet (1814–1875), and Honoré Daumier (1808–1879). In the context of these full-blooded realists, Géricault's vision can be seen as a sort of Romantic realism, in that he had a strong predilection for the dramatic moment, the heroic gesture, and the macabre. His most famous work, the enormous *Raft of the Medusa*, effectively illustrates the mingling of these art historical currents. Scenes of shipwreck, storm-tossed seas, dark and menacing skies, and tormented victims abandoned to the elements were among the staples of Romantic imagery. Yet in Géricault's hands the subject came rather closer to home than good taste permitted. His subject was lifted from the newspaper and illustrated an actual event of the day, which had resulted in a political scandal. If his choice of subject was in doubtful taste, the blunt realism of the style he employed was considered shocking in the extreme. In his depiction of the dead and dying, based on contemporary medical accounts, he attained heights of verisimilitude that verged on the morbid.[17] Scenes of shipwreck were expected to be theatrical, dramatic, and slightly inspiring. Géricault's version came closer than ever before to the blunt reality of a city morgue. The scandal that resulted from the exhibition of the painting in the Salon of 1819 did much to enhance the fame of the young painter.

Unfortunately, no document exists concerning the commissioning of the later Portraits of the Insane, or of the nature of the commission, and it is not likely that a written record ever existed. The nature of the relationship between the painter and the psychiatrist Georget is not known, although it is usually characterized, with little evidence, as a friendship. Denise Aimé-Azam has suggested that Géricault may have been seeing Dr. Georget professionally with regard to personal difficulties, a possibility that is not too far-fetched in terms of the serious emotional problems with which Géricault was troubled in those years. He had attempted suicide on several occasions while on a visit to London the year before.[18]

Géricault, despite his considerable reputation, was not noted as a portraitist. Why then would Georget have selected him to carry out the exacting task of portraying the features of his patients? If we ignore for the moment the possibility of a friendship, or a therapeutic relationship having been established between them, the fact remains that Georget had probably heard of Géricault's reputation in another context. During the years 1818 to 1819 Géricault became widely known in medical circles as a result of the highly unusual procedures he adopted in preparing for the *Raft of the Medusa*. Scrutiny of this period of Géricault's life reveals many aspects of his behavior that can be termed, without exaggeration, pathological. His studio was filled with anatomical fragments and corpses in varying stages of decomposition, which were used in the creation of a series of depictions of severed heads, bizarre still-life compositions of severed arms and legs, and

portraits of the dead and dying, far surpassing the demands of the *Raft*. During this period he is known to have frequented the Beaujon Hospital, which was located close to his studio, in order to study the effects of imminent death on the features of terminal patients. He also did one anatomical depiction of a patient who had died in the Bicêtre mental hospital.[19]

The necessity of obtaining complete cadavers and parts of bodies for use in his studio, his activity in the hospitals where he painted and drew patients, dead and alive—all this would have involved an extensive acquaintance with members of the medical profession. His reputation as a painter of such unconventional and frequently gruesome subjects would have spread rapidly among the devotees of medical science and illustration. To the physicians and their assistants, Géricault would have seemed unique, in terms not of art but of science: an artist interested in their world, capable of accurate scientific studies of singularly unaesthetic subject matter. It is, therefore, not surprising that Dr. Georget saw Géricault as the perfect choice for the type of painting he required. The uniqueness of Géricault's talent lay in his ability to comply in so extraordinary a manner with the desires of the brilliant alienist, for it must be admitted that the creation of the new style of representation utilized in these justly famous portraits was entirely Géricault's own achievement.

The ten portraits of mentally disturbed patients commissioned by Dr. Georget can, to a limited extent, be seen in terms of the psychiatric preoccupations of Esquirol and his students. Essential to their efforts at exact description and classification was accurate, detailed, and scrupulously objective observation. Both Esquirol and Georget were interested in forms of mental disturbance involving obsessional ideas of a delusional type, the so-called monomanias. Georget's system of classification included monomania as one of five basic subdivisions of mental illness.[20] It is therefore no accident that the five surviving portraits all portray individuals suffering from varieties of monomania: patients whose obsessions included delusions of military grandeur, the kidnapping of children, uncontrolled gambling and theft, and pathological jealousy.

Why the portraits were executed has never been properly explained. The more plausible suggestions see them either as preparatory studies for engravings for a new edition of *De la folie* or as substitutes for actual patients in the lecture room where cases were under discussion.

Georget had intended to produce a revised edition of his book, but his illness and death prevented this. It is not impossible that he wished to include illustrations of patients whose cases he may have planned to add to the enlarged edition of his text; however, it is not possible to relate the surviving Portraits of the Insane with any of the case material described in *De la folie*.

Although Georget's initial motivation may simply have been a desire to emulate his teacher, by acquiring and using depictions of patients, he eventually found himself going far beyond this original concept. In commissioning oil paintings from an artist of unique importance, he moved in a new and somewhat unexplainable direction. What was the function of these elaborate images?

The Géricault portraits were probably never intended to be published. Géricault was fully conversant with the processes involved in print making and engraving. He would be perfectly aware of the waste of time involved in executing highly finished portraits in oil if the end of the process was to be black-and-white line engravings.[21] As well, since Esquirol would have been very familiar with the ten paintings, how are we to account for the fact that the pictures had no influence whatever on the new engravings that he commissioned for the 1838 edition of *Des maladies mentales*? Were they not felt to be diagnostically explicit or medically valuable?

The suggestion that the portraits were to be substituted for live patients is far more plausible than it may seem to us today. It was not unusual for patients to be exhibited to students in the lecture hall while their case was under discussion. In situations where it was difficult or inconvenient to bring living specimens from the hospital ward to the lecture room, depictions of them were commonly used. Although we may think that such "stand-in" portraits would have limited usefulness in that they were inanimate, the use of drawings, and later photographs, was once an accepted part of psychiatric education.

Photography had been introduced in 1839, but it was not until the 1850s that the first efforts to use the new art to study the physiognomy of the insane occurred. For example, from 1852 to 1856 the French scientist Guillaume Benjamin Amant Duchenne de Boulogne (1806–1875) had a series of photographs prepared, illustrating the facial movements of a mental patient (Fig. 3.3). Some of the collodion photographs were the work of Adrien Tournachon, the younger brother of the famous Félix Nadar (Caspar Félix Tournachon [1820–1910]). These early photographs provide another example of a productive and influential collaboration between medical psychology and an artist of the nineteenth century.[22]

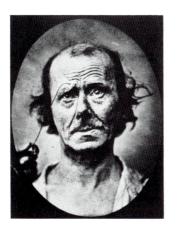

3.3. A patient, photograph by Adrien Tournachon, from Duchenne de Boulogne, *Mécanisme de la physionomie humaine* (Paris, 1862).

In an article published posthumously in 1880, the prominent English psychiatrist Forbes Winslow (1810–1874) described a collection of portrait drawings of the insane that formed part of a three-volume book in his possession entitled *Melancholy Records of Art in Madness*, containing drawings of patients executed over a period of twenty years.

The first volume is confined to portraits in pencil of fifty-five inmates of the asylum, which are described as having been in many cases striking likenesses, and which, at all events, convey the impression of characteristic displays of power or weakness, sentiment or sensuality. We are not, however, left to conjecture the prevailing mental constitution of the individual depicted, as the species of alienation, diagnosed by the attendant physician, has been appended to each.[23]

Although Winslow was writing more than fifty years after Géricault's death, he indicates that such drawings were still in use as teaching material:

Among these melancholy records of art in madness, as the volumes have been entitled, are a number of bold, graphic, magnified delineations in chalk of small plates in Esquirol, Morison etc., thrown off from night to night in order to become the illustrations of lectures on alienation the following day. The chief interest hinges upon the fact that the painter was himself a maniac, knew the nature of the subjects with which he was dealing, the purpose for which they were coveted, and caught the very attitude, feature, and expression which was desired.[24]

The most likely conclusion is that the Portraits of the Insane were intended by Dr. Georget as illustrations for his lectures on psychiatric case material. His requirements would accordingly have been for large finished portraits. The extent to which Georget's commission played a part in determining the final form of the portraits has not been sufficiently understood. The pictures must be seen as a collaboration between a

brilliant clinician whose training in observation and description would have inclined him to be very specific about what he desired, and the single artist of the first half of the century capable of executing portraits in accord with Georget's scientific objectives. The decision to portray these individuals using the conventional half-length portrait format, in full face, without either background or accessories indicative of their disturbed condition, should not be attributed to Géricault. The artist was undoubtedly fully aware of the scientific purpose that the portraits were to serve, and Dr. Georget's instructions were most probably very precise. As a result, the pictures represent an interesting example of the effect of the precise methodology of the influential French school of psychiatry on the development of French painting of the same period. Georget's commission, and the medicopsychological milieu out of which it emerged, provided Géricault with an extremely unusual opportunity. His genius lay in his ability to respond to this unique set of conditions by creating what is essentially a new style of portraiture, which might be termed the realist portrait. We must remember that these pictures are not merely portraits, commissioned reflections of bourgeois personality, but objective and unsentimental studies of individuals diagnosed as insane, individuals existing outside of the society, outside of the realm of acceptable subject matter for the artist.

Previous renderings of the insane depended upon theatrical expression, bizarre gestures and behavior, or a hospital setting for their effect. Géricault, probably because of his medical experience, and possibly because of his own emotional conflict, was capable of confronting these people with an unprejudiced eye.[25] That it was a true confrontation cannot be doubted. "The mentally ill have always been with us; to be feared, marvelled at, laughed at, pitied, or tortured, but all too seldom cured. Their existence shakes us to the core of our being, for they make us painfully aware that sanity is a fragile thing."[26] The essence of the art of portraiture at its highest lies in the act of confrontation between two human beings. That the encounter was an intensely meaningful event for Géricault is indicated by the extent that he succeeded in responding to these people as individuals, rather than types, seeking to reach below the surface in his depiction of their reality. The result was a very noticeable deepening of Géricault's power as a portraitist. Klaus Berger describes the surprising change in Géricault's approach to the portrait. "In comparison with David, Prud'hon, Ingres, Goya, and Lawrence, Géricault showed a certain lack of craving for conquest in the field of physiognomy. His

earlier portraits almost always have members of his circle for subjects. . . . Psychological probing is less important than a decorative picturesqueness of the still life type. . . . The faces take up only a small area of the canvas, and the characterization comes from the surroundings of accessories, from the outside in.[27]

The Portraits of the Insane therefore represent an astonishing accomplishment for an artist previously so little concerned with serious portraiture. Assiduously avoiding all previous means of depicting insanity, Géricault could not utilize details of costume, pose, or setting as a means of identifying his sitters. While the military commander's uniform is bizarre enough to lead the viewer to question this patient's mental condition, the other surviving portraits provide no immediately obvious clues as to the disturbed mental state of the sitters. Despite the efforts of art historians to discover physiological symptoms in the portraits that could be linked with nineteenth-century psychiatric theory, there are no readily discernible physical manifestations of illness. It is justifiable to wonder whether, had the titles been lost, anyone would have been aware of the unusual nature of Géricault's assignment.[28] We are reminded of Georget's insistence that, for the most part, the mentally ill look no more unusual or bizarre than the average person. If Géricault sought for evidence of mental pathology, he did so with a subtlety worthy of his psychiatrist-patron, and with a scrupulous avoidance of obvious gestures, strained and necessarily frozen expressions, or other identifying characteristics.

Nevertheless, the psychological intensity of each of these unique individuals remains sufficiently strong to hold the spectator in a near hypnotic trance. As with the presence of the insane themselves, something of this contained intensity can, on occasion, inspire fear. This is most markedly so in the case of the old woman identified as involving a monomania of jealousy (Plate 4). The dark and glistening eyes, so alive and precisely focused within the smoldering red of the lids, betray something of the mental activity taking place beneath the curiously mobile yellow mask of her face. The alert pose, the unexplained play of light on the forehead, the tightly drawn lips barely covering the pronounced curve of the teeth, all contribute to making of this old woman a menacing image of a mind bent on destruction. Close examination of the brushwork, particularly around the right eye, indicates some of the more subtle formal means used by the artist in suggesting the extreme internal tension and the lack of control inherent in her mental state. Though she says nothing, everything about her image awakens stark fear in the beholder. How much more strongly she must have affected Géricault himself, as he struggled to comprehend and transcribe the power of this mind run wild, trapped within the body and gaze of this disheveled and obsessed madwoman.[29] Provided with nothing but the obscure diagnoses once attached as labels to these lives, we value the opportunity to confront, across time, the solitary reality of these men and women, to share in the intensity of their troubled and troubling existence.

Jonathan Martin of Bedlam

The discovery of the art of the insane began with a paradox: the insane artist was perceived as an object of interest and curiosity long before his art. Seemingly mad and distorted manifestations of human creativity were noticed and described in the absence of any real concern with the pictures or objects to which they gave birth. Behavior, however crazy, might be worthy of study, but the image resulting from that behavior remained apart and invisible.

With more conventional art forms the reverse is true. It is the significant or symbolic object that, because of its beauty, or power, or uniqueness, awakens interest in the artist, his mind, and his motivation. The insane artist, however, in the eighteenth and early nineteenth centuries, was seen as creatively impotent, possessed of a perverse desire to create, but deprived of the essential mental powers that would make creation possible. Art and rationality were allied in the Age of Reason. Images of madness were looked for in the madman himself and not in the mindless scribbles that his hand might trace. As a result, our story was forced to begin with the discovery of the insane artist; with written accounts of the image-making activity of the insane, and visual depictions of the mad artist at work. The drawings or sculptures that these people made were not seen as significant or valuable and were destroyed. More correctly, they were "not seen." Examples of psychopathological art from the first half of the nineteenth century and earlier are therefore extremely rare.

This chapter is devoted to a descriptive examination of the work of one individual, Jonathan Martin (1782–1838), an inhabitant of the ward for the criminally insane at Bethlem Hospital.[1] Martin's case is unique in that, because of his enormous notoriety, his activities as an insane draftsman attracted considerable public attention and curiosity. In the eyes of the newspaper-reading public, the fact that he drew was less interesting than the question of what was in the drawings. Could the drawings reveal the state of his mind? Martin's lasting fame ensured that some of his work was preserved as a keepsake or oddity. As a result, we possess considerable descriptive and biographical information, both contemporary public accounts of his work

and a sufficient number of large and intriguing drawings.

It would be possible, though unwise, to account for the emergence of interest in the artistic activity of the mentally ill without referring to their art. Changes in the intellectual and aesthetic climate of the eighteenth and nineteenth centuries, developments within the emerging field of psychiatry, and dramatic shifts in the perceived function of art and artist may explain the relatively sudden awareness of the mad artist and, slightly later, of his art. However, the nature of this art, the unusual form and content of these strange "new" images, played an important part in calling attention to itself, and profoundly influenced the character and direction of the various attempts to understand, interpret, and appreciate it.

References to "the art of the insane" seem to imply both general familiarity with that art, and an unchanging continuity in this form of visual expression, both of which are illusory. The art of the mentally ill is not removed from time. Inevitably the preoccupations of the madman are reflections, perhaps disguised, at times intensified, of the preoccupations of his age and his environment. Even the completely untrained artist, for example, must have his pictorial sources and must depend on the visual conventions of his own period. But we must go beyond the generalized and often misleading phrase "art of the insane" to establish the nature of these images at various points in time, and to observe the effect of the historical period in which they were produced on their form and content. Part of our problem is to begin describing the evolution of this form of visual image, and to demonstrate that it has a history that to a considerable extent parallels, is influenced by, and eventually influences that of the "fine arts." The drawings of Jonathan Martin provide the first of a series of examples of psychopathological art that will permit us to study the changing nature of these images, and of contemporary responses to them, at various points during the nineteenth and early twentieth centuries.

During the period with which we are concerned, most of the drawings and paintings of the insane were produced in hospitals and asylums. These institutions

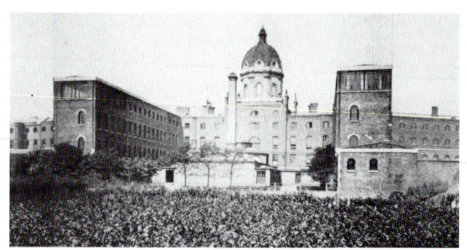

4.1. Bethlem Hospital, Saint George's Fields, Southwark, London, 1815, rear view with the wing for the criminal insane (destroyed), architect, James Lewis, The Bethlem Royal Hospital, London.

were also evolving. The distance that separates Hogarth's Bedlam from a ward in the psychiatric wing of a modern hospital is immense. Many of the characteristics of the drawings or sculpture of the mentally ill can be accounted for on the basis of the difficult conditions within which they were produced, a fact not accounted for by early students of this art. For example, it is not a result of mere chance that all of the eighteenth-century depictions of insane artists at work that we have examined showed them drawing on walls. James Tilly Matthews and Jonathan Martin, on the other hand, both worked on paper, a fact that made the survival of their work possible.[2] The occasional decision to provide lunatics with paper and pencil, however it occurred, indicated a significant change in attitude toward them.

It is, therefore, essential that we examine the environment within which the insane artist had to work, and to discover, whenever possible, the conditions both physical and social that influenced his life and his activity as a draftsman or sculptor. Having chosen Bethlem Hospital as our sample institution, we can make use of Jonathan Martin's stay there (1829–1838) to observe the changes that had occurred in the care of the mentally ill, as well as in the attitude toward them, which may have influenced both the quality and quantity of the images produced by patients.

Jonathan Martin was not confined in the hospital familiar to Hogarth or Matthews. That more notorious madhouse at Moorfields had been pulled down in 1815, and a new and architecturally less splendid edifice, the work of James Lewis, was erected in Saint George's Fields, Southwark, between 1812 and 1815 (Fig. 4.1).[3] The building included a new and separate wing for the detention and long-term care of criminal lunatics, and it was in this ward that Martin was to spend the final nine years of his life. Bethlem Hospital was never merely a dumping ground for madmen. Patients were admitted only for a year and, if they did not recover, were returned to their families. They tended to be acute cases, for whom there was considerable possibility of recovery. The shortness of their stay in Bethlem usually precluded much artistic activity, in that drawing or carving tended to be forms of behavior that developed significantly in the more chronically ill patients. For this reason Bethlem was never an ideal institution in which to collect patient art, a fact that does not, however, prevent its playing an important part in the history of such studies.

In 1723 a ward for incurable patients had been established, which, with the addition of the criminal lunatic department in 1816, provided a more stable and long-term population whose stay at Bethlem would extend over many years, thus providing a situation that accidentally encouraged the production of art in the hospital.

Hospital conditions had been radically improved as a result of an inquiry into the treatment of patients in the old hospital in 1815, which had revealed a situation of inhuman neglect and gross negligence. Vicious maltreatment of patients and the exhibition of lunatics were no longer features of everyday life in Bethlem.[4] A surprising aspect of life in the new hospital was the fact that some of the patients, including those in the criminal lunatic wing, were able not only to make small articles, but also to sell them to visitors as a means of earning pocket money. Nevertheless, by 1829 conditions were again deteriorating, medical supervi-

sion was poor, chains and other forms of restraint were still in use (though not used indiscriminately), and proper case notes were not being kept. Responsibility for this state of affairs must to some extent be laid at the feet of the visiting physician, Dr. Edward Thomas Monro (1790–1856), a far from illustrious member of a family who had specialized in the care of the insane for four generations.[5] Dr. Monro's interest in patients may have been surpassed by his involvement with art and so his name comes up occasionally in the history of patient art at Bethlem. However, although Martin mentions him, it is doubtful that he played any part in the development of his artistic activities.

Another of Bethlem's celebrated inmates at this time was James Hatfield (ca. 1841), imprisoned for an attempt to assassinate King George III. He is known to have made baskets, and to have written and illustrated poems, which he offered for sale.[6] The Bethlem archives possess a copy of a poem entitled "Epitaph of my poor Jack, Squirrel," ornamented with an illustrated version of the subject done in watercolor (Plate 8). While not an outstanding example of psychotic art, the fact that it bears the date July 23, 1826, demonstrates that even this early, patients could obtain paints and brushes, and involve themselves in artistic activities. That such pictures were being sold suggests some degree of interest in, or at least of curiosity about, the art of the insane.

A portrait of Martin can profitably be studied in the context of the Géricault portraits of the insane (Fig. 4.2). The work was painted by an obscure English painter, Robert Woodley Brown, in 1829 while Martin was confined in the prison at York. While not commissioned by a physician for use in a clinical setting, it was executed with the same objectivity and the same avoidance of theatricality or sensationalism that we encountered in the Géricault portraits. Indeed it forces us to weigh what we have said about the uniqueness of Géricault's accomplishment, at least insofar as his use of a straightforward realistic style is concerned.

The painting is an accomplished performance that presents the sitter in a dignified, rather thoughtful frame of mind, which must have contrasted markedly with the wild excitement and sensationalism that surrounded his trial and the newspaper reports about him. What prompted the artist to portray him in such a restrained and elegant manner?

As in the Géricault portraits, oddities of the sitter's clothing betray that the picture is something other than a conventional portrait. Martin's unusual dress formed part of the eccentric image that he cultivated and that the inhabitants of York and the surrounding

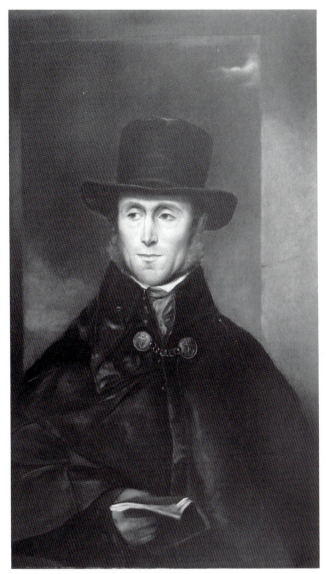

4.2. Robert Woodley Brown, *Portrait of Jonathan Martin*, 1829, oil on canvas, York City Art Gallery.

area had come to know. The artist has transformed his old sealskin cape and broad-brimmed hat into a costume worthy of a Venetian nobleman, a change that accorded better with Martin's conception of his own importance than with the reality of his rank in society. Appropriately, Martin holds a copy of his autobiography.

Comparison with the Géricault portraits reveals far less involvement with what might be called the psychological task of portraiture. Brown operated within the conventions of English portraiture, while Géricault broke free of tradition in search of a new intensity of

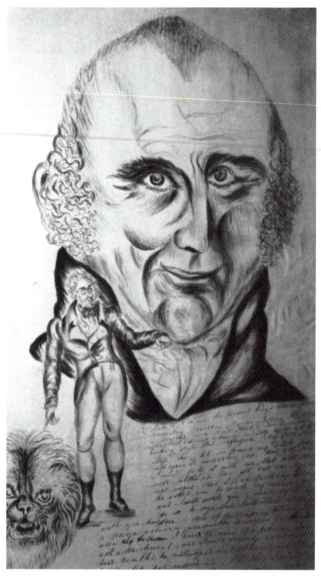

4.3. Jonathan Martin, *Self-Portrait with the Battle of the Lambton Worm,* detail, 1829, private collection, London.

experience and of documentary realism. As a result, Brown's picture, while undoubtedly an excellent likeness, fails to allow us to make contact with the man. Martin's face remains inscrutable.

Unlike the patients depicted in the Géricault portraits about whom no biographical material survives, Jonathan Martin is one of the most fully documented madmen of the nineteenth century. He emerges with incredible clarity in his autobiographical writings, and in the numerous accounts of him. We know him intimately—his ideas, his passions, his dreams. Nothing of

this extraordinary man is to be found in the portrait. Here we are forced to recognize the greatness of Géricault, who could search the face and uncover the subtle hints of what lay beneath the surface.[7] Brown's painting is a depiction of insanity in name only. What madness we see in it is our own invention.[8]

Martin's appearance at his trial did not conform to popular expectation. Newspaper accounts convey the disappointment experienced by those who anticipated a raving lunatic. It is therefore of some interest that the medical and psychiatric experts who appeared on behalf of the defense based their diagnosis, in part, on aspects of his appearance, which they associated with insanity. All of the physicians agreed that his eyes were glassy, and dilated, and red, and that, "when he was excited, they betrayed a great deal of monomaniacal expression, or appearance, which would strike any person accustomed to these diseased patients, so that they cannot mistake the nature of their complaint."[9]

Our good fortune in possessing a portrait of Martin is much enhanced by the fact that we also possess a self-portrait executed only a few months later after his arrival in Bethlem. The existence of such a pair of portraits is very rare. The motives that inspired Martin to undertake a self-portrait can be assumed to have differed markedly from those that would lead an artist to paint the portrait of a madman, though it is possible that the unusual sensation, for Martin, of being the object of so much attention may have awakened a desire to continue with the pleasurable experience. Having been moved to Bethlem, and abandoned by portrait painters, he may have tried to substitute his own activity as portraitist for theirs (Fig. 4.3).

In a sense, all of the art of the insane is self-portraiture. It is a highly private art in which the self looms large. The epic of Martin's life formed the essential subject of his art. But in this drawing we see Martin through his own eyes. The inscription below the portrait, written by him, reads, "This is Jonathan Martin's likeness taken by himself by the aid of a looking glass that magnified. May, 1829, London," The figure shown in full length is the "Duke of Orleans, the present King's son in France."[10]

If the conventional portrait painter failed to capture Jonathan Martin's spirit, Martin rectified this omission, producing a highly convincing image of his own fierce reality. The likeness is maintained: the conventional dress, the high domed head, the long thin nose, the tangled sideburns. But the intensity of the image has been increased dramatically. Conforming with contemporary psychiatric opinion, he narrows in on

the eyes, darkening them within the head, and setting them afloat so that each may go its own way. The strangely emphasized planes of the face, so reminiscent of Cézanne, seem to set the face in motion, echoing the rhythm of the mouth with its haunting smile. This is indeed Jonathan Martin, as we know him: inspired prophet, valiant fighter against the forces of evil, madman.

MARTIN's incarceration in Bethlem was the result of a trial for arson. He had been found not guilty of setting fire to York Minster by reason of insanity.[11] His insanity was quite obvious, but it is not easy in terms of modern medical opinion to determine the exact nature of his illness. That he had become a danger to the community as a result of religious delusions that prompted him to violent behavior was undeniable. He saw himself in the role of an Old Testament prophet charged by God with chastising the clergy of the Church of England. "You won't notice me, but I can assure you I am next to God himself, for he has revealed the Gospel to me. I am a prophet and have a commission from God."[12]

There is evidence in the drawings, and the inscriptions that invariably accompany them, of occasional periods of excitement during which verbal and pictorial coherence tended to break down. These excited periods seem to have alternated with depression, suggesting a tentative diagnosis of manic-depressive psychosis. Martin had a long history of mental illness, having been confined for life some eleven years previously in the asylum at Gateshead as a result of a threat to shoot the Bishop of Oxford.

The chief source of information about Martin is a pamphlet he wrote and distributed, entitled *The Life of Jonathan Martin of Darlington, Tanner, Written by Himself. Containing an Account of the Extraordinary Interpositions of Divine Providence on his behalf during a period of six years' service in the Navy, including his wonderful escapes in the Action of Copenhagen, and in many affairs on the Coasts of Spain and Portugal, in Egypt, &c. Also, an Account of the Embarcation of the British Army after the Battle of Corunna. Likewise an Account of his subsequent Conversion and christian Experience, with the Persecutions he suffered for Conscience' sake, being locked up in an asylum and ironed, describing his miraculous Escape through the roof of the house, having first ground off his Fetters with a Sandy Stone. His Singular Dream of the Destruction of London, and a Host of Armed Men overrunning England &c. &c.* The pamphlet appeared in three editions, and Martin sold it himself as a means of earning extra money.[13] His life, even prior to the fire, consisted of a remarkable series of adventures and experiences in which he consistently saw the hand of God. The autobiography provides extraordinary insight into Martin's view of his own inner reality, reflecting his mental state at various periods of his life. His delusional system appears to have been contained for the most part within the sphere of religion, but it interfered increasingly with his ability to function normally in his day-to-day activity. In the context of his intimate relationship with God, who continually communicated with him in dreams, Jonathan did not see himself as insane, though he admitted, "The devil suggested to me that people would think me mad."[14] He therefore experienced his periods in asylum as unjust, the result of persecution by his enemies and the devil. "Let my readers picture to themselves, what a rational man must feel, to find himself shut up for life in a madhouse, amongst madmen, and subject to the same treatment as if he himself was insane, and to add to the melancholy picture, have irons riveted to his legs, and his windows double barred; and to make assurance double sure, the walls of his prison raised so high, that any attempt to get over them (admitting other obstacles to be removed), would be certain destruction."[15]

Another valuable source of information is provided by the transcripts of his trial. The decision to undertake a defense on the grounds of insanity necessitated a series of medical witnesses competent, in terms of the medicolegal conceptions of the period, to testify as to his psychological state. The opinions of the physicians who had known Martin, or who had interviewed him for the trial, provide a valuable glimpse into the kind of psychiatric thinking current in England in the 1820s. The general opinion was that he represented a typical example of "monomania."[16]

Martin's fame as the incendiary of York Minster was enormous. As he himself commented, "I have made as much noise as Buonaparte ever did."[17] It is difficult to imagine the excitement that surrounded him, or the intensity of the impulse that prompted people to see him, or to obtain his autograph.

The curiosity to be introduced to the man who has immortalized his name by the burning of York Minster, is scarcely inferior to that which prevailed as to Buonaparte when at St. Helena. Noblemen and titled ladies, a crowd of persons of rank and distinction, throng to Martin's levées; they are all very graciously received, have the honour to shake the incendiary's hand, and depart highly gratified. Martin, on his part, is no less flattered, and declares that he never in his life shook hands with so many people of quality, as he has done since he burnt the Minster.[18]

Even at the time of the trial, Martin was very much involved with drawing, and examples of his art were much sought after and discussed, as well as bought and sold. The enormous interest in Martin as a near legendary figure accounts for the fact that his work was collected and preserved. Had he not been so famous, we would know nothing of his activity as an artist.

In studying the art of the insane, a careful distinction was always made between the drawings of untrained patients and the more sophisticated productions of skilled artists who had received professional training prior to their hospitalization. Bethlem provides examples of both types, which elicited very different reactions (see chapter 8). Jonathan Martin was completely untrained and, because his family was very poor, largely uneducated. But despite the family's poverty, all four Martin brothers enjoyed drawing and continued to use their ability as draftsmen in adulthood. Jonathan was fond of drawing as a boy, well before any obvious signs of mental disturbance made themselves felt. His illness may be said to have changed the function of drawing in his life, but not to have created the urge. In his autobiography he describes an event that occurred while he was in the navy. Confined to a naval storage yard at Portsmouth, he determined to escape with a peculiar errand in mind. "Having a great desire for a box of colours for painting, I resolved to attempt getting out to buy one; but did not know how to elude the vigilance of the sentry."[19] Caught as he attempted to return to his ship, Martin admitted his error and explained the irresistible impulse to which he had yielded. "I . . . told him that all my family had a taste for drawing, and that I could not resist the temptation of procuring the means of amusing myself in that way to which I was particularly attached."[20] Later in his life Martin retained his unusual ability to acquire drawing materials in spite of all opposition.

As his religious preoccupations grew more intense, and he began to find himself in conflict with the clergy, Martin found less time for drawing. He describes a visit to the family of his pastor: "I felt a desire to speak with the Clergyman, but could not tell how to get introduced into his company. His lady having heard tell of my being a drawer, sent for me in order to see some of my drawings, of which both he and she approved, and she said that she would dispose of them for me, among the quality, if I would but let the Bible alone, and leave the Methodists. I told her that I took great delight in reading the Scriptures; and had left off drawing."[21]

The conflict with the representatives of the Church of England reached a climax in 1818 with Martin's threat to shoot the Bishop of Oxford. He was taken into custody and, after a brief inquiry by the Justices at Stockton, was "sentenced to be confined in a madhouse for life."[22]

The decision concerning Martin's mental state was based in part on a group of drawings he had done. "Martin did not deny the allegations made against him, but with respect to the affair of the pistol, justified the fact, to the best of my recollection, producing some strange drawings, with a kind of commentary upon them, the particulars of which I cannot state at this distance of time. The magistrates were of the opinion that he was a lunatic, dangerous to be permitted to be at large, and committed him to an asylum."[23] This may well be the first instance of psychopathological art playing a part in the deliberations of a court of law, a medicolegal application that later attracted considerable attention.

Confined in a private asylum at Gateshead, Martin resumed his artistic activities, producing elaborate and rather bizarre religious drawings that derived in part from his dreams. After escaping from the madhouse, in 1821, he employed his skills as a draftsman in producing the illustrations that adorned the account of his life and adventures, which he published in 1826.

It was only in 1829, as a result of his incendiary activities, that his drawings suddenly became the subject of concern. Much sought after, they were discussed in the press as a possible source of insight into the mind of the madman. Readers of the *York Herald* of April 11, 1829, were kept informed of his every move. "Jonathan is now very peacefully amusing himself in his prison, by drawing and painting figures which his own disordered imagination alone can portray, and madman like, in laughing at the mischief he has effected, and in exalting over the universal regret and interest thereby excited."[24] A week later the *Yorkshire Gazette* described the subject of his artistic endeavors: "This person is amusing himself with drawing the combat of Samson and the Lion; he himself is still the great lion of the city jail; and is visited by numerous persons, who seem as happy if they procure his autograph, as if it were that of a prince."[25]

A report written by the jailer in charge of Martin at the York City Jail survives, and is of value in providing insight into his mental state at that time.

He is quiet and inoffensive in his general behavior, subject to slight fits of excitement and depression, but requiring no personal restraint. He converses with propriety on most subjects with the exception of religion, especially with reference to the conduct of the ministers of the Established Church—When

these are introduced he quickly evinces his disordered imagination, and that he is labouring under delusion. He is perfectly well in bodily health, and has been drawing figures for his amusement for a few days past as he is in the prison alone, and for which he seems to evince very considerable natural talent. April 13, 1829.[26]

Martin was admitted to Bethlem Hospital on April 28, 1829. He remained there until his death in 1838. Although he was one of Bethlem's more celebrated inhabitants, little is known of the details of his existence. As few records were kept concerning the patients at this period, we must rely on occasional descriptions written by visitors to the hospital. We know that he had a room to himself, and that what few comforts the family were permitted to provide would have been made available. He was visited regularly by his son Richard, and by his brothers and sister, several of whom lived in London.

The early years of his hospitalization were made difficult and unpleasant by the fact that he was kept in irons. He had established his reputation as a gifted escape artist at Gateshead, and it was felt that he was capable of making his way out of the hospital unless serious measures were taken to hinder him.[27] That such cruel measures were really necessary is difficult to believe, and it appears that in later years irons were only resorted to on the rare occasions when he was taken out into the hospital yard.

The effect of these primitive systems of physical restraint can be seen in the drawings, both in the form of descriptions and depictions of irons and chains and, more important, in the fact that when he worked on large sheets of paper, he was forced to limit himself to one area of the paper at a time, producing an incoherent composition. This restriction of movement may also account for odd changes in the orientation of objects depicted at various points on the sheet of paper. The common use of physical restraint in these years must be taken into account in studying the formal aspects of the art of patients prior to the middle of the nineteenth century, and even later in more backward areas. Martin repeatedly describes the difficulty of working under these trying conditions. In a letter to Lord Durham found on the back of one of his drawings he signs himself as follows: "From your humble servant Jonathan Martin bound a prisoner of the law with a pound of iron on each hand (attached) to seven pounds more around my loins from morning to night, and from night to morning, locked both hands and feet upon my back upon a bed of straw.... I have drawn this with my hands bound to my loins upon my seat with one knee upon the ground."[28] That he continued

to draw under such conditions demonstrates the tremendous force of the expressive impulse motivating him. The whole of his life force and of his identity went into the making of these strange and powerful images.

Martin's artistic activities soon met with considerable opposition from the hospital staff. "When he was first admitted into the hospital he was allowed the use of paper and pencil, but the governors, finding that whenever this indulgence was extended to him he invariably occupied his time in drawing sketches of York Minster, and that his doing so threw him into a state of very considerable excitement, they prohibited his being supplied with those articles in future, of which prohibition he frequently and bitterly complained."[29]

The decision to interfere with Martin's strong desire to draw may account for the rarity of his drawings today.[30] Drawings from the Bethlem years (and Martin clearly indicated on them his residence as Bethlem Hospital) are all dated to the first two years of his stay. Only one depicts York Minster (Fig. 4.4).[31]

Perhaps he was permitted to draw on rare occasions when he was sufficiently calm. That he continued ardently to desire to draw is suggested by the fact that two days prior to his final illness he asked for and was given permission to draw. An account of this last drawing appears in a letter written by his son after his death.

He had got permission to draw a little, which he had not been allowed to do for a long time. I left him paper, etc., and he began with eagerness, and must have worked very hard at it; for he would not get the paper until Tuesday morning, and on Wednesday it was that he felt himself ill, and gave his drawing and everything up to the keeper, and said he was assured

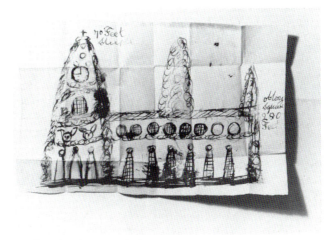

4.4. Jonathan Martin, *York Minster*, Library of York Minster, York.

that he would not require them anymore, and he would only read his Bible. In a short time he had half covered a large sheet of drawing paper with a serpent, lions, archers shooting, and other things which I do not remember as I have not the drawing yet.[32]

This letter explains the source of the large sheets of paper on which several of the drawings were made. Beyond that, it seems to imply that Jonathan's drawings were regarded, by at least one family member, with respect and interest, and that this last drawing was intended to be returned to the family (though not all of the family members felt the same way).

The single most important description of Martin in Bethlem was published in the *Monthly Magazine* in 1833.[33] Under the title, "Bits of Biography," it paired two religious visionaries, Martin and Blake. An inevitable result of this was that Blake was often incorrectly described as having been an inmate of Bethlem. That there were similarities in the attitudes to life and religion of the two men is both obvious and meaningful. The description of Martin's environment and personality, while disappointingly insensitive and uninformative, provides our only real contact with his world at that time.

But now for Martin:—He had an apartment on the first floor. I followed the keeper up the stone staircase, and a little way along the granite gallery. He took out his bunch of keys, ran over them, and soon found the right one. We were opposite a repulsive, austere-looking door. He opened it, I strode in, and the next moment found myself locked up with a madman. . . . The aspect of the room told the inhabitant at a glance that he was imprisoned for life, that the four naked walls constituted his future world. On my left there was a plain comfortable bed; on the right stood a table and one chair. Everything was painfully clean and orderly; the furniture was evidently under the inspection of a committee; there was not the slightest appearance of that sort of temporary litter which evinces that a man is in his own house: the inanimate articles were in quiet subjection, in perfect keeping.[34]

Inherent in the account of Martin that follows, and in the expectant attitude that his visitor had brought with him to the hospital, is the Romantic ideal of the madman and his role. In this respect Jonathan was a disappointment, failing as he did to conform to his visitor's expectations of the sublime.

But where was the lion of this solitary den? . . . He stood up, and never in my life have I beheld a human being so perfectly harmless. Passion never seemed to have ploughed his forehead with its adamantine keel: the surface was smooth and unruffled as that of a villager's babe. I dived into the depths of his eye, but brought up neither monster nor pearl: it was barren—it was commonplace,—there was nothing in it. It grinned, not sardonically, but because it seemed to have nothing better to do. The mouth was feeble, almost inane. I sought earnestly for some lurking expression, but could find none: not even the ghost of an idea flitted over his features. Still he looked like anything but a Bedlamite: there was no fearful aberration of intellect visible. Had I met him on the highway, I should have concluded from his lineaments that he was one of the most gentle of God's creatures: apparently he would not injure a worm. . . . Smiling simplicity was the prevailing character of his countenance. It required an effort to make me feel I was talking to the Incendiary of York Minster. I expected to have found him sublime; but he was quite insignificant.[35]

This description provides an ideal demonstration of the way in which the insane were expected to conform with the expectations and needs of their environment. Romanticism created a dream world of its own identified with the insane. It invented its own version of madness and its own expectations in regard to their art. Whereas the drawings of the insane were once dismissed as childish scribbles, in the context of the Romantic taste for the sublime and the terrible, the art of the insane took on a new aspect. Alongside of the actual pictorial productions of the mentally ill were the imaginary creations of imaginary madmen invented in response to deeply felt ideals and needs that had been making themselves felt in other quarters for some time. Seen in terms of this highly charged poetic vision, even the wildest of Martin's productions was disappointing. For the first time we encounter the immensely significant contrast between the art of the insane and its imaginary, but extremely influential, shadow.

Prior to the arrival of his visitor, Martin had been at work on a drawing. It is described as "a bishop with seven heads, under the influence of absolute fatalism, undaunted by its bituminous breath, rushing into the open jaws of a colossal crocodile! The artist disappointed me: he was crude, ignorant, impotent. His sketch was a mere exaggerated matter of fact, madly conceived and contemptibly executed. It made me pity him."[36] It is curious that even so wild a drawing could not satisfy this demanding critic. Obviously expectations in regard to the art of madmen were on the increase. Only for a moment does something of the real Jonathan Martin appear. We are told that "he wanted nothing but lots of Indian Ink and Brookman's black-lead pencils."[37] How difficult it must have been to confront such a mountain of expectations with a desire so simple and so concrete.

Jonathan Martin continues to exist in his drawings and in his writings. Deprived of education and opportunity, this simple man found means to express his intense experience of his inner life and his very personal, undeniably pathological, view of the world. It is not easy to understand why this almost illiterate man, long before the deed that ensured his fame, felt so strong a need to communicate his private conception of the world.

Beyond the private world of this one man, the drawings can provide us with an impression of the visual phenomenon that is called the art of the insane and, in particular, of what might be called its historical ground, those elements that betray the era and milieu out of which its form and content are inevitably shaped. Martin's art, like that of James Matthews, belongs to that crucial period when these images were just beginning to impinge on the consciousness of a small unorganized group of receptive individuals. The drawings form part of a far larger body of images and ideas that would, as the century went on, contribute to a changed and changing conception of the meaning and importance of personal expression in human life and in art. It is not without significance that Martin's drawings were produced in the same period that witnessed the intensely private, often obscure, and sometimes no less bizarre productions of Blake (1757–1827); Fuseli (1741–1825); and Palmer (1805–1881), whose Shoreham period coincided with Martin's Bethlem years.

In pausing at this point to examine the work of this one individual, we must unavoidably anticipate discoveries that were only to be made later in the century. In 1829 all that could be said of Martin's curious involvement with drawing was that he made pictures and that they were somehow strange or "crazy." Beyond this there was now a vague suspicion that the drawings revealed the insane delusions with which his mind was filled. The moment we begin to examine the form and content of the drawings, even if only descriptively, we are going beyond the attitude to them characteristic of the first half of the nineteenth century. Nevertheless, it seems necessary to obtain a first impression of these images, and some conception of the ideas and milieu that brought them into being. What was Martin's art about?

At the trial it was pointed out repeatedly that he believed in dreams, that he was guided by dreams, and, in fact, that the decision to set fire to York Minster was the result of a dream.[38] Martin might be said to anticipate Freud in that much of his autobiography is taken up with detailed accounts of his dreams and his interpretations of them.[39] He informs us that many of the drawings are nothing more than illustrations of remarkably vivid and detailed dream images. In his dreams and in his art, Martin lived a life of epic grandeur and enormous influence. Again and again one senses his unconscious determination to use his art and his imagination as a means of overcoming, or at least denying, his condition of utter helplessness at the hands of his enemies. His enforced lack of contact with the world in which he felt he should live and move led to his using art as a means of placing himself once again in the realm of action and influence. Through his drawings Martin escaped, if symbolically, the confines of his cell and fought the powers of evil. The self-portraits, both allegorical and representational, are used to establish his ideal self-image as a man to be reckoned with, a man "more sinned against than sinning."

The content of all of the drawings was derived from the well-circumscribed area of his mind referred to as his monomania. Once this body of ideas is understood, nothing in the drawings seems out of place. The majority of his subjects concern the conflict between the forces of good and evil, and with his own central role in that conflict. Figures from legend, history, and the Bible symbolically present his own history and significance. He saw himself reflected in all the great martyrs of history and depicted them as prefiguring his struggle and his temporary defeat at the hands of his enemies. His favorite book was Foxe's study of the English martyrs.

Martin's eventful but insignificant life is enlarged in the same magnifying glass in which he studied his face. An illustration from his autobiography depicts *Jonathan Martin's Miraculous Escape from the Asylum at Gateshead, near Newcastle* (Fig. 4.5). He also celebrated this historic moment in a poem, which as it conveys his personal understanding of the event, deserves to be quoted in full:

Again the devil thought to shut me in,
But with a sandy stone, I cut my iron chain.
With locks, and bolts, and bars of every kind,
Fain would the devil had me all my life confin'd
But by the help of God, by faith and prayer,
The devil loosed his hold, and I did break his snare.
Through the lofty garret I thrust and tore my way,
Through dust, and laths, and tiles, into the open day.
But yet more dangers still, beset me round,
Till by God's help, I landed on the ground,
Then with a thankful heart, I praised the God I found,
And cried, "sleep on ye sleepers, sleep both safe and sound,

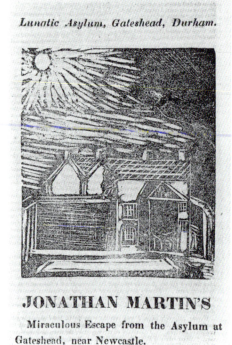

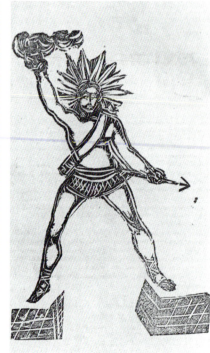

4.5. (far left) Jonathan Martin, *Jonathan Martin's Miraculous Escape from the Asylum at Gateshead near Newcastle,* wood engraving from *The Life of Jonathan Martin of Darlington, Tanner,* third edition (Lincoln, 1828).

4.6. Jonathan Martin, *The Son of Buoneparte Capturing England,* copper engraving, frontispiece from *The Life of Jonathan Martin of Darlington, Tanner,* second edition (Barnard Castle 1826).

Till I escape from your enchanted ground."
These three long years, now almost gone and past,
My God has saved me from your hands at last;
Therefore to him, will I give all the praise,
And thank and bless his Holy Name always.[40]

Unlike many asylum inmates at this period, Martin did not believe himself to be Napoleon. He was, however, obsessed with the son of Napoleon, who he believed was destined to conquer England.[41] It is obvious that, at times, the distinction between this son of Bonaparte and himself became blurred. Martin was then himself the destructive agent, the avenging son of God: "The reason I set fire to the Cathedral was on account of two particular dreams. In the first dream, I dreamt that a man stood by me, with a bow, and a sheath of arrows. He shot an arrow, and the arrow stuck in the Minster door. I then wished to shoot, and the man presented me with the bow, and I took an arrow from the sheath, and shot; and it struck on a stone, and I lost it."[42]

The theme of the man with the arrow had appeared in Jonathan's art three years earlier. A nude male figure with a halo, carrying a flaming vessel and armed with the arrow and sheath, appeared as the frontispiece to his autobiography (Fig. 4.6).[43] The scene is identified as *The Son of Buoneparte Capturing En-*

gland, the image having been adapted from contemporary depictions of the Colossus of Rhodes, a procedure that was typical of Martin's working method. The inscription further identifies the male figure as an allegorical representation of England, a point of confusion that underlines Martin's uncertainty as to whether he was to be the savior of his country, or the avenging messenger of an angry God. As a frontispiece to his *Life* it would seem probable that the figure is, on some level, symbolic of Martin himself.

The final outbreak of Martin's destructiveness at York was predicted in drawings he made many years earlier, long before he had any conscious idea of setting fire to the Minster. It would seem that he was living out a personal myth, which he embodied first in his art, and only later carried into action. At the trial a drawing was produced that had been made while he was an inmate of the Gateshead Asylum. Although it no longer exists, it was considered sufficiently important at the time to be described in detail in the *Yorkshire Gazette*:

After the trial, and while the Jury were out of court, there was handed to the Judge a curious picture, drawn and coloured by Jonathan Martin, while in the Asylum at Gateshead, exhibiting extraordinary marks of uninstructed talent, mixed with frenzy and wildness. It describes a Christian's

progress through various steps of his religious experience: his heart pierced by the sword of the spirit; then set on fire by divine love: in another part of the picture, he is exhibited in armour, combating with the fiends of darkness, but principally with lions, tygers, vultures, and other beasts and birds of prey; who are depicted with great spirit. Explanations, in Martin's handwriting, are interspersed. Near the bottom of the picture, there is an alter, on which is placed a heart, and from the heart, a fire is ascending. On the alter itself, Martin has written the following apposite verse, from a hymn of Charles Wesley's:

"See how great a flame aspires,
Kindled by a spark of grace,
Jesu's love the nations fires,
Sets the kingdoms on a blaze;

To bring fire on earth he came,
Kindled in the heart it is;
O that all might catch the flame,
All partake the glorious bliss,"

Mrs. Orton, the keeper of the Gateshead Asylum, sold the picture in York, and we saw it on Thursday at Mr. Barklay's.[44]

Martin's subject matter appears to have remained consistent throughout his life, conforming to his megalomanic vision of his role in the divine plan, and the elemental nature of his conflict with the devil and his forces—forces that the modern psychologist would understand as representing a split-off part of Martin's own personality.

In the later years of the nineteenth century when systematic study of the art of the insane begins, one particular aspect of this art would attract more and more attention, what might be termed the problem of its characteristic pictorial form. Beginning with extremely vague and unsuccessful attempts to list the essential features of "insane art," the problem was defined and redefined until it had shifted to a concern with personal style in the individual artist. Preoccupation with the effect of psychosis on form led, however, to a complete neglect of what can legitimately be called the art historical factor within the psychopathology of art, the contribution of the style of the period within which the insane artist, like any other, must live and work. Wölfflin's law, "not everything is possible at all times," holds true even within the walls of the asylum.[45] The search for artistic sources is as necessary to the study of psychopathological art as it is to the fine arts. Concern with the contribution of the experience of insanity to the creation of new, often unique, pictorial languages must be accompanied by a thorough inquiry into the pictorial sources available to, and utilized by, the patient. It must be possible to clarify why drawings produced by patients in the early

nineteenth century differ from those made later in the century, or in our own time. Up to this point, study of this material has been conducted in a "time vacuum," as though all such images were the product of the present. That they had a history that contributed to their form has not been apparent, and early examples of this type of art have not been readily available.

One of the most chaotic and disturbed of Martin's drawings is a picture that I have entitled *The Gates of Hell* (Fig. 4.7). In it are found many of the themes with which he was obsessed: the devil, the sinful priest, and the figure of Death depicted as a disorganized skeleton. (The one-legged lion, an image that occurs in all of his drawings, will be discussed later.) As in many Martin drawings, the inscriptions clarify much that is obscure. The subject matter reflects the period in which the drawing was made. One would not expect a patient in the twentieth century to draw this particular range of subjects even if he suffered from religious delusions similar to Martin's. However, study of this drawing in the absence of detailed knowledge of its pictorial and literary sources could lead one into considerable error.

The style of the drawing, its composition, and the structure of its forms are of importance in clarifying some of the specifically personal elements that enter the drawing as a result of Martin's mental state at the time it was made. Comparison with his other known drawings shows that he was in a far more excited psychological condition than was usually the case when he was drawing. The written inscriptions reflect this increased excitement and loss of control—spelling breaks down and the flow of ideas verges on incoherence. Similarly, his ability to depict form deteriorates, the structure of objects becomes loose, contours wander or break, and the spatial composition is confused. The brush strokes, usually firm, are weak and uncertain. The drawing confirms the truth of the observation made by the Bethlem authorities that when he was allowed to draw, he tended to become overexcited and even incoherent. This drawing, more than any other, reveals the extreme of Martin's personal style under the impact of his illness, but it was influenced by other important and more objective considerations as well.

The so-called psychopathological element can to a certain extent appear to free the artist from a total dependence on the pictorial conventions of his age, with the result that some of these pictures convey an impression of timelessness, or even of surprising modernity. Modern painters were later to remark on the degree to which the art of the insane anticipated twentieth-century innovations and concerns. To some extent this is true of certain aspects of Martin's work.

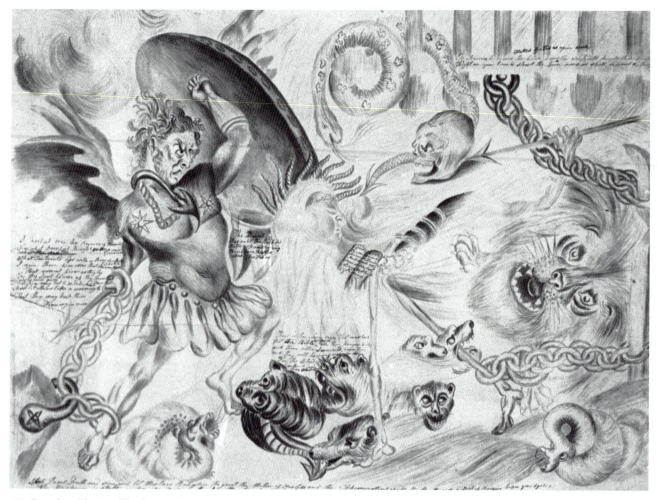

4.7. Jonathan Martin, *The Gates of
Hell*, May 6, 1830, private collection,
London.

The self-portrait, with its hint of Cézanne's drawing style, is an example. The drawings can be said to look forward and back, and yet to be firmly grounded in the style of their own day.

In other pictures the influence of the period is objectively present in that specific pictorial sources can be identified. Martin himself occasionally identifies elements borrowed from pictures available to him. In one of his drawings, the figure of the queen, the wife of William IV, is provided with an inscription: "Taken from a copper plate by Jonathan Martin."

Popular prints and illustrations, particularly of Biblical subjects, appear to have provided an occasional stimulus for his work. One of the most interesting examples of the process whereby he adapted previously existing images to his own needs occurs in two related drawings executed in York just prior to the move to Bethlem. They are, in fact, the drawings mistakenly identified in the *Yorkshire Gazette* as the *Combat of Samson and the Lion*. The mistake is understandable, as that was undoubtedly the original source of Martin's composition. The subject commonly appears in nineteenth-century family Bibles, and Martin likely had access to a Bible that included the scene among its engraved illustrations. Under the influence of his unique conception of history, the subject of the drawing became *Jonathan Martin's Combat with the Black Lion of Hell and All His Combined Power* (Fig. 4.8). The accompanying inscription refers to Samson as a Biblical prototype for Martin's struggle and imprisonment. "Oh Daniel, Thy God whom thou serves will deliver thee out of their hands though they roar upon

thee as a lion yet like Samson thou shalt tear them in pieces."[46]

Although it is not known from which picture Jonathan's drawing is derived, it probably followed upon a nineteenth- or late eighteenth-century prototype. The anatomical accuracy of the lion's back legs suggests an external pictorial source. Samson's curious pose, with his left leg over the lion's back is rare, but not unknown. The gesture of pulling the lion's mouth open, and the extremely distended tongue, is traditional, as is the choice of a profile view for both combatants. A faint hint of Neoclassicism in Samson's head and hair may help both with dating and identifying more precisely the image that served as a model. Samson's combat with the lion is usually represented in a landscape setting, although architectural details were commonly included in the distance. The town in Martin's version may, however, owe its existence to a source other than the picture from which the figures derive.

Martin's own contributions to the drawing are most likely to be found in certain distortions, particularly in the two principal figures. Samson is a strange, pea-headed giant dominated by enormous, and mindless, energy. His assault on the lion is so violent as to force the animal backwards; the two figures appear to merge, and the face of the beast expresses total disorientation and shock as he is wrenched apart.

The second version of the drawing, dated April 27, 1829, one day later, is in part a tracing copy (Fig. 4.9).[47] As the report published in the *Yorkshire Gazette* describing a drawing of "Samson and the Lion" is dated April 18, it would seem probable that Martin was preoccupied with the subject to the extent of producing a whole series of drawings, of which only two survive. The great demand for his drawings at this stage in his career may have influenced him to repeat himself.[48]

In this second surviving version, the personal element has increased, so that the historical factors become less obvious. Although the main forms were exactly transferred by tracing, the second drawing is extremely different in feeling. Varied textures have begun to possess the surface at the expense of form, the lion's mane is transformed into pure spiral rhythm, and the whole drawing is simplified. These spiral rhythms will reappear in other drawings by Martin and may relate rather closely to his specific psychotic condition. The drawing becomes more childlike and free as it moves further away from the original prototype. Martin has invented a new background, more suitable to his subject in that it includes a depiction of the prison in which he was confined. An increase in ex-

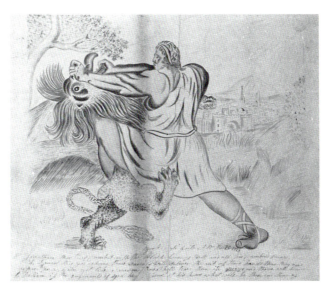

4.8. Jonathan Martin, *Jonathan Martin's Combat with the Black Lion of Hell and All His Combined Power*, April 26, 1829, York Minster Library, York.

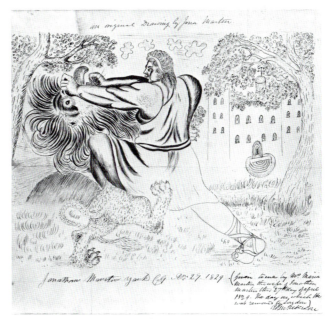

4.9. Jonathan Martin, *Jonathan Martin's Combat with the Black Lion of Hell and All His Combined Power*, April 27, 1829, York City Art Gallery.

citement and confidence is apparent, as reflected in a partial breakdown of form, particularly in the modeling, which was quite extensive and carefully handled in the first version. Well correlated with his exuberant mental state are the four clouds that he places in the sky with utter spontaneity and sureness.

The lion as a symbol dominated all of Martin's work. He offers various explanations for its appearance, and for the curious fact that it was usually distinguished by having only one leg (when depicted frontally). In one passage he identifies the lion with England: "The lion is an emblem too. That England stands but on one foot, And that has lost one toe; Therefore long it cannot stand."[49] Elsewhere he explained the missing leg as the result of not having had time to complete a drawing. Such variety of explanation, suggesting, as it did, that the patient himself did not have any coherent knowledge of what his symbols might mean, was in time to become a source of much confusion for physicians and others who attempted to come to grips with the question of the meaning of the art of the insane. As mentioned earlier, it is probable that in some sense Jonathan Martin used the one-legged lion as a symbol of himself, or part of himself. In this connection, it is of interest that his eldest brother William, known as "The Philosophical Conqueror of All Nations," and "The Anti-Newtonian," also used the lion as a symbol of himself (Fig. 4.10).[50] His version of the lion was not noticeably less strange than Jonathan's. In a copy of William's autobiography in the British Reference Library, he has written in his own hand, "The lion with the ball under his foot signifies myself as no man can prove me wrong and I am not afraid of Lord Brougham doing it, nor none on earth."[51]

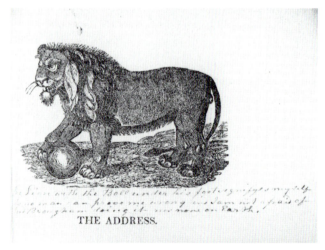

4.10. William Martin, *Lion, Symbol of Himself*, engraving from William Martin, *A Short Outline of the Philosopher's Life* (Newcastle, 1833). The autograph inscription occurs only on the copy of the book in the British Reference Library, London.

We know nothing of Jonathan Martin's attitude to his own artistic activities and his pictures. There is no indication that he believed himself to be an unrecognized master, or even an artist, although he was obviously proud of the fact that the Duke of Orleans had visited him and purchased a drawing for a sovereign, a story that he described both in a drawing and in words (Fig. 4.3).[52] Beyond that we can only say that he used drawing as a means of embodying his ideas in a form more concrete than writing.

Although most of his subjects were original, and imbued by him with private, often obscure, personal meanings, he borrowed from the art of his day whenever he could, adapting pictures by other artists to suit his own needs. His personal style, and the degree of pathological influence, can be accurately established only through comparison of his version of the subject with the original source. It is frequently in adaptation and distortion that his originality is to be found.

STILL TO BE discussed is a crucial part of the puzzle, one that I have kept back to ensure that the perception of Martin's work might not be influenced prematurely by facts that would complicate any understanding of his image-making activity. For this factor inevitably contributed both to Martin's development as an artist, and to the formation of his pictorial style.

The youngest of Jonathan Martin's brothers, John Martin (1789–1854), was one of the most famous and popular English painters of the first half of the nineteenth century. His fame prior to and at the time of Jonathan's hospitalization was enormous. Although almost forgotten until recent years, his pictures excited a degree of popular enthusiasm and devotion in the 1820s and 1830s equaled in the twentieth century only by the impact generated by Hollywood extravaganzas. His Biblical illustrations, both in family Bibles and as framed prints, found their way into every home and into the public imagination. His influence on the later development of English Romantic painting has only recently been recognized.[53]

Jonathan, although he only saw his brother on rare occasions, was extremely proud of him. In the introduction to his autobiography he characterized the differing roles in life of the brothers: "God has raised of us four brothers: my eldest brother he has made a natural philosopher, my youngest an Historical Painter, his drawings and engraving has [*sic*] made Kings and Emperors to wonder. I, the unworthyest, God has given me the gift of prophesy."[54]

Unlike Jonathan and William, John Martin never exhibited any sign of mental instability. After his

death he came to be known as "Mad Martin" only as a result of confusion with his brother. Although mildly eccentric, he functioned well throughout his life, achieving professional and financial success, as well as international recognition, while raising a large family. His pictures, undeniably unusual in terms of twentieth-century aesthetic preoccupations, contain nothing that would suggest psychological disturbance.

The lives of John and Jonathan, nevertheless, reveal remarkable similarities, and equally striking contrasts. Superficially they were rather dissimilar: John an elegant, educated, and accomplished artist and man of the world; his brother a working man, barely literate, a religious fanatic and self-styled prophet. The more deeply one probes into their lives, the more apparent it becomes that the underlying themes and preoccupations that motivated them can be understood as similar, if not identical. While it is not possible, or necessary, to enter into the life and work of John Martin here, some insight into the common themes that prompted their respective artistic expressions is needed, in order to grasp the way in which John's art entered into his brother's.

Although John considered himself as a historical painter, his fame rested on a series of spectacular architectural reconstructions of vanished civilizations. He was a master of dramatic and unconventional space construction used in the service of epic depictions of the natural or man-made upheavals that had, on occasion, brought the history of ancient cultures to a sudden and violent conclusion. His conception of history centered on the theme of cataclysm, and the recognition that once proud civilizations could crumble or be crushed. His imagination ranged over the history of the world, from Babylon to Pompeii, from Nineveh to Sodom. He reconstructed the total annihilation of man at the time of the flood, and envisioned the future and final destruction of the planet in the Last Days. While aided by what little archaeological evidence was then available, his chief source of evidence and inspiration was the Bible. In no sense a religious fanatic, he expressed his religious preoccupations by becoming one of the leading illustrators of the Bible, and a large part of his artistic talent was devoted to recreating the climactic moments of religious history. In the light of our more exact archaeological knowledge, his "reconstructions" are seen as wildly imaginative, even fantastic, expressions of a fundamentally Romantic and deeply personal vision. He sought in history the themes that gave suitable scope to his unique taste for monolithic and impossible architectural composition, designed so as to emphasize staggering effects of spatial recession,

what he termed "the perspective of feeling." Considerable knowledge of geology enabled him to create overwhelming images of natural cataclysm: volcanic eruption, massive flooding and earthquake, mountains exploding into the air, and seas displaced and flowing across the world—a vision of nature out of control.[55] His ability to make use of geology in the service of fantasy carried him beneath the earth to a hellish underground of dark caverns, opening one out of the other to infinity.[56]

It is not difficult to establish parallels between the preoccupations of the two brothers, but what must be considered are the strikingly different ways in which they sought to realize their concerns. To some extent it is correct to observe that John gave expression to his megalomanic ideas in his art, projecting his destructive visions back into history, whereas Jonathan carried the same fantasy world into action, confusing fantasy and reality, and allowing his destructive and aggressive drives to dominate his behavior. Where John was content to portray the destruction of Babylon in a painting, Jonathan was driven to set fire to York Minster.

Both brothers were unmistakably motivated by intense ambition and were determined to make their mark on the world. Announcing his intention to paint a monumental picture of Belshazzar's Feast, John stated, "the picture shall make more noise than any picture ever did before," a phrase that was echoed ten years later by Jonathan's famous statement, "I have made as much noise as Buonaparte ever did."[57]

An anecdote that emerged from the fire at York illustrates quite precisely the similarity of imagination shared by the two brothers. "It is said, that one of the ladies who were introduced into the nave of the Minster, during the conflagration, while admiring the sublime and terrific spectacle which it presented, was forcibly reminded of some of John Martin's paintings. She exclaimed, 'What a subject for Martin!', little conceiving that she was indebted to the hand of the painter's brother, for the view which excited her admiration."[58]

John's relatively sedate and elegant life-style was constantly troubled by the scandalous behavior of his brothers. Inevitably his contemporaries tended to draw parallels between them and, on occasion, to look askance at John. One critic, who undoubtedly knew of Jonathan's residence in Bethlem, was inspired to remark on seeing one of John's pictures, "the artist really deserves as much pity as the poorest maniac in Bedlam."[59] Others, more discerning, were led to contrast the respective contributions of the two brothers, describing John as "possessing the genius that to mad-

4.11. John Martin, *Satan, Sin, and Death*, from his illustrations to Milton, *Paradise Lost* (London, Septimus Prowett, 1827), British Museum, London.

ness nearly is alli'd."[60] It was therefore inevitable that in terms of the poetic equation of madness and genius inherent in Romanticism, John and his brother should have merged in the epithet "Mad Martin."

Unlike the art of John Martin, Jonathan's work has never been considered worthy of study. He too embodied his imaginative life in pictures, and particularly after his imprisonment attempted under compulsion to confine his epic ambition to image-making activity. It is not without psychological significance that following the fire and Jonathan's imprisonment, John largely abandoned painting to work on a series of wildly ambitious, though not impractical, schemes concerned with architecture and town planning. Both brothers dreamed of changing the face of London, John by rebuilding much of it, Jonathan by burning it to the ground.

Not surprisingly, Jonathan occasionally drew on his brother's art for inspiration and source material for his pictures, on rare occasions adopting whole compositions for his own purposes. In those cases where a common theme inspired them both, we are provided with a unique opportunity of seeing how Jonathan's personal style and ideas functioned in modifying compositions that originated with his brother. In the study of psychopathological art, it is extremely rare for an exact pictorial prototype to be available for comparison. In some cases John's influence manifests itself in minor details that Jonathan had remembered and repeated rather freely. An example is provided by the townscape in the background of the first version of *Jonathan Martin's Combat with the Black Lion of Hell*. The view of a distant city may derive from a somewhat similar scene in John's first successful picture, *Joshua Commanding the Sun to Stand Still* (1818).

In 1825 John executed a series of mezzotint engravings illustrating Milton's *Paradise Lost*.[61] One of the scenes depicted "The Conflict Between Satan and Death," book 11, line 727 (Fig. 4.11). Though not one of John's better works, suffering from his general inability to draw the human figure, it was of interest to Jonathan, who was always more devoted to large figure compositions. Jonathan's drawing, *The Gates of Hell*, may to some extent derive from his brother's picture, at least insofar as it suggested the subject to him. His pictorial source, however, was not his brother's version of the scene, but a depiction of the same subject by Hogarth.[62] Hogarth's painting, of uncertain date, and the engraved version by Charles Townsley, which appeared in 1767, both differ from John Martin's version in their greater fidelity to Milton's text. It is probable, nevertheless, that John knew and was influenced by Hogarth's conception of the scene.

In Hogarth's illustration, the nude figure of Sin has

a serpent's barbed tail in place of the lower half of her body. Beneath her a pack of dogs bark and snarl and bite at both Sin and her son Death. These details conform exactly with Milton's description of the scene (lines 650–56), and are retained by Jonathan.

The one seemed woman to the waist, and fair;
But ended foul in many a scale fold
Voluminous and vast: A serpent armed
With mortal sting: About her middle round
A cry of Hell-hounds never ceasing barked
With wide Cerberean mouths full loud, and rung
A hideous peal. . . .

Jonathan Martin, faithful to Hogarth, changes only those details that interfere with his new conception of the problem. In accordance with his obsession with the iniquity of the priests and bishops of the established Church, he has replaced the nude figure representing Sin with that of the kneeling bishop, whose miter the devil has just kicked off. The chief sin with which Jonathan charges the bishop is blasphemy. This substitution belongs very precisely to Jonathan's private fantasy world, deriving neither from Hogarth's version of the subject, that of his brother, nor from Milton's poem. He wished to depict the priests as sons of the devil, and guardians of the gates of Hell.

In John's picture the figure of Death is obscure; he merges with the inky darkness to the point of invisibility. Jonathan's figure of Death, derived from that of Hogarth, is, however, so widely scattered over the page that he is not readily perceived. It is possible to understand this chaotic skeleton as another instance of the effect of Jonathan's state of manic excitement, part of the disintegration of form that can be observed throughout the picture. But reference to Milton's description of the figure of Death (lines 666–69) suggests that Jonathan, always scrupulously honest, may have had a more objective motive for this jumble of bones.

　. . . The other shape,
If shape it might be called that shape had none
Distinguishable in member, joint, or limb.

Jonathan's version of the Hogarth picture differs from it in that there is a terrifying violence inherent in his depiction of the scene, and a mood of wild excitement bordering on frenzy. Hogarth's illustration, slightly too concrete, leaves little to the imagination. Jonathan has seized upon the glaring eyes of both Death and the devil, forcing the effect in the direction of irrationality. The chains, which appear in the Hogarth version as a detail of the gates of Hell, are multiplied in Jonathan's picture and used to restrain all of the participants in

4.12. Detail of Fig. 4.7.

the drama, a detail of his own invention reflective of his situation while working on the picture. The fire-vomiting snakes and the enraged lion are also intruders not found in Milton. The lion, his personal symbol, seen here in chains, can be read as the clearest indication of his own state of mind: his intense belief that he, Jonathan Martin, was personally involved in this conflict, and his desire, thwarted by the chain that holds him, to throw himself into the battle (Fig. 4.12):

Stop deval death and sine. . . .
Hell's gate is open. . . .
To arms to arms the lion roars, the sarpent points
their deathly. . . .
Fight on your time is short the lion roars,
We shall be bound a . . . years.[63]

It was mentioned earlier that Jonathan was often inspired to draw by portentous visions that came to him in dreams. The firing of the Minster, inspired by a dream, was only the beginning. During the years of his imprisonment he began to envision far grander projects, and to dream of destruction on a scale worthy of his brother's imagination. Jonathan's dreams were not of times past, but of the future:

The union Jack capsiz'd upside down
A sign that England shall be over thrown
As it is hoisted to the right and left
England shall be like a Ship at Sea in great distress.
As sure as lofty monument stands
London shall be all in Flames.[64]

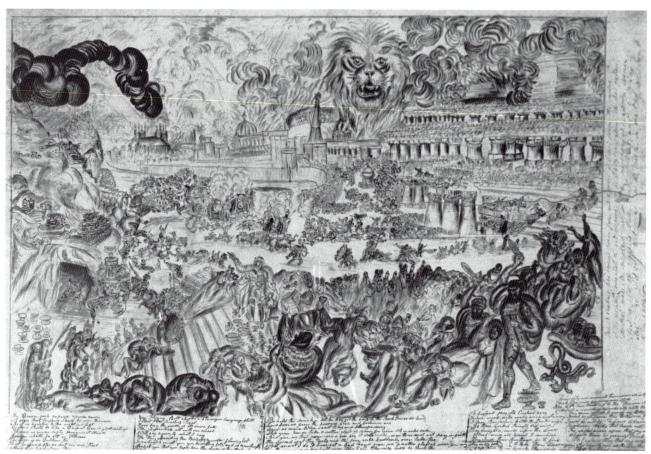

4.13. Jonathan Martin, *London's Overthrow*, 1830, pen and ink and wash on paper, private collection, London.

These prophetic utterances were inscribed on an ambitious drawing that Jonathan executed in 1830, entitled *London's Overthrow* (Fig. 4.13). He drew it in response to a dream that he then recorded in both words and a picture.

In my dream I saw the awful scene;
the inhabitants in great distress; an horrid
sight to see them tearing each others flesh; when
to the City I was brought by the spirit of
my God, a voice to me distinctly said, in one
day, the city shall be burnt unto the ground.[65]

The theme of the overthrow of a great city and civilization was central to John Martin's imaginative vision. He too was a poet of destruction. Yet even in his art he had been content to confine his dreams of destruction to history. Nevertheless, his paintings were understood by his contemporaries as containing within them a warning. It was acknowledged that his vision of history embodied a moral lesson and example of relevance to the present and to England. It was left to the viewer to project into the future the terrible destructive potential of nature or man gone astray. John never carried out this imaginative leap himself, and never undertook to depict his own great city, London, torn by fire or flood, in the midst of cataclysm or in ruins.[66]

Brother Jonathan, the prophet of destruction, had no such reservations. In the large drawing *London Overthrown* he adapted his brother's terrifying visions to his own purposes. Faced with a pictorial task well beyond his own limited ability, he turned to his brother for assistance. "If I had sought the whole creation round, A better subject than my brother's downfall of Nineveh I could not have found; to help me to paint sad London's overthrow."[67]

John Martin's *The Fall of Nineveh*, exhibited in 1828, was undoubtedly his most elaborate attempt at portraying urban upheaval (Fig. 4.14). As he himself

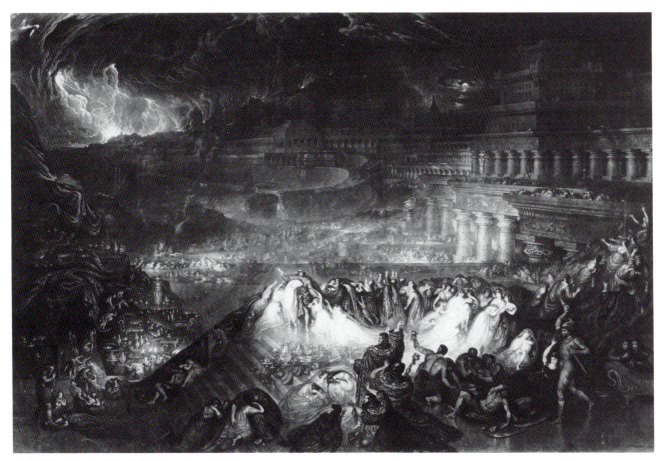

4.14. John Martin, *The Fall of
Nineveh*, messotint engraving, 1829,
British Museum, London.

described it, "Seen through the mist of ages, the great
becomes gigantic, the wonderful swells into the sub-
lime."[68] It is doubtful whether Jonathan could have
seen the painting prior to his arrest and imprisonment.
However, in July 1830 John published a large mezzo-
tint version of the subject. Jonathan's version of the
composition is modeled so closely on John's picture as
to make it quite certain that he had been given a copy
of the print in Bethlem.[69] Comparison of Jonathan's
picture with its prototype leads deep into his mental
processes, showing the way in which he transformed
visual material in accord with his own very personal
fantasies, and the effect of his illness on the construc-
tion of space and form. His drawing is an incredibly
inventive reworking of the original painting, filled
with his own ideas, enthusiasm, and excitement. He
entered into the violence of the moment, and partici-
pated with relish in his vindication.

The overall structure of Jonathan's drawing is de-
rived very closely from John's composition. The archi-
tecture of Nineveh becomes that of London; the endless
rows of columns are repeated quite exactly. Jonathan
tends to multiply details—for example, he added a
story to the building on the extreme right. The Tigris,
about to overflow its banks, is converted unchanged
into the Thames. However, along the river bank in the
distance he has added new details: Saint Paul's Cathe-
dral, Westminster Abbey, an unidentified pyramid,
and, easily recognizable, Wren's Monument to an
event very much in accord with Jonathan's taste, the
Great Fire of London (Fig. 4.15). Adapted from one of
John's characteristic lighthouses, Jonathan uses the
monument as a flagpole from which two inverted
Union Jacks are flying. Nineveh has unmistakably
been transformed into the London of 1830.

Nineveh fell, not to the forces of nature, but to en-
emy troops. This bit of history agreed well with Jona-
than's prophetic vision. High on a cliff to the left is the

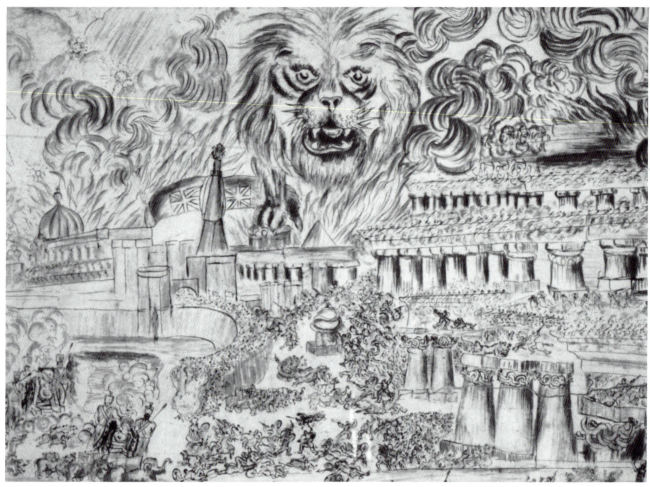

4.15. Detail of Fig. 14.13.

figure of Napoleon, or more probably his son. Seated on a descendant of the faithful Marengo, and wearing his father's tricorn, this curious embodiment of Jonathan's own desires looks down upon the scene of carnage and destruction.

In the middle ground the battle rages: numerous French officers on rearing horses, gigantic cannons, tiny elephants, men fighting with bow and arrow, shields and spears—a marvelous mélange of the forces of Nineveh and Bonaparte let loose on the south bank. Sudden changes of scale occur all over the surface, thousands of extra figures are added, and empty spaces are filled at random with piles of golden goblets and vessels, stolen from the horde of Sardanapalus. The sky is filled with exploding bombs, lightning, and dark roiling clouds, not insignificantly reminiscent of the night skies of van Gogh.[70] Above the burning city a

monstrous lion emerges from the flames, its one leg resting on the buildings beneath.

The figures in the foreground were retained from John's picture (Fig. 4.16). Slight changes were made: the figure at right with a dagger raised in his fist was doubled, becoming two figures, both with knives. Sardanapalus was recostumed as the king of England; his courtiers were brilliantly transformed into a rollicking crew of drunken priests and bishops, playing cards, guzzling wine, and falling down in a stupor, while one of their number reads from a prayer book held with its cover toward him. Jonathan supplied accompanying dialogue:

Behold the drunken sot he has got the back of the book
 towards him
Lord save us from the sword fire and famine and
send us more wine roast Beef and plum pudding.

Yon flaming bolt speaks a stranger language still,
That those priests of Baal have been the cause of its
 downfall,
The dissenters all with one accord
Will say amen to what I say,
The King up-braiding the Bishops, yonder flaming bolt
Is a witness against you, you drunking [*sic*] sots and is a
 witness
Against you that you have been the cause of this calamity
That has come on my people and me,
The Lord reward you according to your doings.[71]

The gigantic lion whose terrifying face appears in the sky has a curious origin that throws light on Jonathan's creative mechanisms. In John's version of the picture, a half-veiled moon appears among the clouds, its light pale beside the fires that light the sky at the left. With but little activity of the imagination, clouds and moon together form the vague semblance of a cat's face, including even the whiskers. It is this Rorschach reference that Jonathan has transformed, in accord with his own internal picture of the world, into the image of himself triumphant.

The drawing of London's destruction is a unique document in the psychopathology of art, in that it provides an opportunity of witnessing the metamorphosis of a major Romantic painting at the hands of a psychotic patient. It is paradoxical that its appeal today might conceivably be greater than John's picture of the Fall of Nineveh. In 1830 it remained, of course, completely unknown, buried with Jonathan in his cell at Bethlem. However, one person certainly would have seen it, a person upon whom its distortions and extravagance, as well as its undeniable power, must have had a terrible impact—John Martin. John and his nephew Richard often visited Jonathan, and would inevitably have been shown his drawings, particularly one so large and important as this.

No evidence survives that provides information about John's attitude toward his brother's work. Only a single reference to it is known. In a letter written to the Governors of Bethlem at the time of his brother's death, John, having made arrangements for the funeral, concludes: "I have only to express the grateful sense I have of the treatment pursued towards my poor Brother, and to add that if there are any drawings or other little articles belonging to him which his keeper may be desirous to retain I doubt not that my Nephew will hand them over to him in accordance with my wish."[72] This reference to Jonathan's drawings, written on the day of his death, cannot be quite so insignificant as it at first appears. He dismisses them as equivalent to "other little articles," and attempts to get rid of them by palming them off on Jonathan's keeper, though why he would want them is not explained. The nephew, Jonathan's son, had, as we have seen, other ideas. In his letter of May 31, a few days later, he

4.16. Detail of Fig. 14.13.

clearly implied that he expected Jonathan's last drawing to be returned to him. It is possible that the difference of opinion hinted at in these two letters may indicate some reluctance on John's part to be confronted with his brother's activity as an artist in Bethlem.[73]

In our discussion of Hogarth's experience as a visitor at Bedlam, we considered the meaning of that first confrontation between a sane and a mad artist, the impact on Hogarth of seeing the creative drive transformed into earnest and pitiful scratching upon the wall, of his own role in life mimicked with utter seriousness by a lunatic turned artist. In the case of John and Jonathan Martin, that confrontation would have been intensified to an almost unbearable pitch: the madman was his brother; his drawings, reflections of John's own work seen in a monstrously distorted mirror. The destructive impulses that underlay it become painfully transparent. For John this experience was no subject for a humorous print, nor was it a sublime encounter to be grasped at in the half light of Romantic sentiment. Far from inspiring him, his brother's tragic fate may well have contributed to the complex of motives that led him to abandon painting for many years.[74] Certainly there is no evidence whatever to suggest that John's art was influenced by that of his brother. What influence there was all flowed in the opposite direction. Jonathan's variations on his brother's pictures, and his sometimes amusing efforts to improve upon them, can only have appeared to John as a painful reminder of the madness that had overthrown his brother's reason and destroyed his life. In 1838, the art of Jonathan Martin ceased.

Insanity in the Context
of Romanticism

The asylum as a subject worthy of independent depiction in art is a creation of the Romantic mind. As images intimately linked with the Romantic conception of reality, paintings of asylum interiors can be useful in providing pictorial evidence for understanding the unique and varied conception of mental illness engendered and sustained by Romantic writers, painters, and theoreticians. Paintings and writings of the period reveal that insanity was a subject that deeply preoccupied the Romantic artist, who, for the most part, saw mental illness in new, surprisingly sympathetic, terms and greeted its manifestations, in imagination if not in reality, with lively curiosity and respect approaching awe. How are we to understand this enhanced estimation of mental illness and the general acceptance of paintings of the asylum and its inmates as meaningful new images? Why this preoccupation with the dark side of the mind?

It is significant that attempts to define Romanticism tend to characterize this curiously elusive phenomenon in psychological terms, as a psychological reality with enormous power and influence in the outside world. "Romanticism refers not to a specific style but to an attitude of mind that may reveal itself in any number of ways."[1] Brion refers to Romanticism as "certain habits of thinking and feeling," and as "a condition of human consciousness."[2] Rosenblum asks, "What are we to call those strange new emotions we feel welling up in so much late eighteenth century art, if not Romanticism?"[3] It is essential here to attempt to define specifically the nature of this new psychological reality, this altered mode of perceiving and feeling, at least insofar as it resulted in a dramatic shift in attitude toward the mentally ill and their art. Examination of a small number of Romantic paintings and drawings of asylums should provide some insight into the motives impelling their creation, and their possible significance both to the artist and to the public.

One of the initiators of the Romantic movement in England was Henry Fuseli (1741–1825). In about 1779 he executed a wash drawing entitled *The Escapee* (Fig. 5.1), an early example of the Asylum Picture that depicted "a real moment of terror in a madhouse."[4] The drawing, reworked as a line engraving, was then used as an illustration in the 1781 edition of Johann Caspar Lavater's (1741–1801) *Essays in Physiognomy*.[5] Because the drawing functions within the context of an essentially scientific undertaking, it provides an extremely early instance of a collaboration between an artist and a scientist engaged in a psychological investigation. Fuseli and Lavater had known each other for many years, and so it was natural that the two Swiss compatriots should collaborate, and that Fuseli should have provided some of the illustrations of physiognomy that Lavater needed for his text. What is perhaps surprising is the choice of this illustration, a scene of dramatic violence in a mental hospital, which has little to do with physiognomical studies and much to do with the early but intense stirrings of the Romantic spirit. However, physicians and scientists were by no means unaffected by the new sensibility.

The engraved version of *The Escapee* includes a statement by the artist indicating that the work was "drawn from memory from a real scene in the Hospital of S. Spirito in Rome." Thus, Fuseli had visited the insane in S. Spirito. The event that he witnessed and recorded involved a group of priests bringing the sacraments to the mentally ill patients in the hospital. One of the patients, terrified in the extreme by this event, has run amok, and with all the violence and strength at his command is attempting to avoid the confrontation with the host. An allusion is intended to the expulsion of demons and to the violent reaction of the evil spirits when exposed to the sacraments or to the cross. The scene might be intended as an exorcism, but, if we are to believe the artist, it occurred rather too suddenly to suggest planning. Except for the static and somewhat ominous presence of the clergy, the composition conveys an impression of violence and frenzied movement, and of intense emotional excitement experienced by both the patient and his captors. The hysterical reaction of the women in the background contributes to this atmosphere of crisis. One can well imagine that, caught up in this explosive event, Fuseli

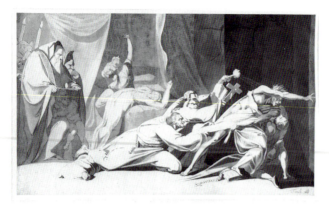

5.1. Henry Fuseli, *The Escapee*, ca. 1779, pen and wash drawing, British Museum, London.

most unappeasable hunger for emotional experience, for new intensities of feeling at whatever cost. It is as if reality could only be experienced in situations of violence, or ecstasy, or madness. Insanity is understood, perhaps naively, as a form of heightened existence, as a state of pure emotion free of the restraints imposed by the mind, the polar opposite to the mind governed by intellect and reason.

Characteristic of Romantic "enthusiasts" is a tendency to doubt the validity of facts, or a conception of reality derived from the exercise of pure reason. Reason itself was seen in its extreme form as madness. Feeling and emotion were now seen as modes of perception and experience superior to intellect.

All Pictures that's Painted with Sense and with Thought
Are Painted by Madmen as sure as a Groat;
For the Greater the Fool in the Pencil more blest,
And when they are drunk they always paint best.
..
When Men will draw outlines begin you to jaw them;
Madmen see outlines and therefor they draw them.[8]

There was a growing awareness of a chaotic and disordered inner world, which was the source of valuable insights and images, and yet which was undeniably dangerous and threatening. The artist and the poet venture forth into this new territory at first with trepidation, later with near self-destructive lust. Fuseli re-

was indeed terrified. However, this was only the first of a series of depictions of the insane that occur throughout his work. Fuseli was deeply attracted by unusual psychological conditions and by violent scenes expressive of inner states of extreme emotional intensity.

Lavater seemed to understand this when he described the artist in his text as involved with "fury and force, an energy uniformly supported and ever active,—that is what distinguishes most of the figures and compositions of this masculine genius. Specters, demons, and madmen; fantoms, exterminating angels, murders and acts of violence—such are his favorite objects. . . . a taste for terrible scenes, and the energy which they require."[6]

Such interests were not confined to Fuseli. They represent an aspect of the emerging forms of feeling and awareness that came to be known as Romanticism, which deliberately sought out violence and terror. Edmund Burke (1729–1797), in his famous book *A Philosophical Inquiry into the Origin of our Ideas of the Sublime and the Beautiful*, describes in curiously positive terms emotions that most of us seek to avoid

The ideas of pain, sickness, and death, fill the mind with strong emotions of horror. . . . Indeed terror is in all cases whatsoever, either more openly or latently, the ruling principle of the sublime. . . . Whatever is fitted in any sort to excite the ideas of pain, and danger, that is to say, whatever is in any sort terrible, or is conversant about terrible objects, or operates in a manner analogous to terror, is a source of the sublime, that is, it is productive of the strongest emotion which the mind is capable of feeling.[7]

The Romantic artist worshiped at the altar of emotion. Throughout the period one encounters a deep, al-

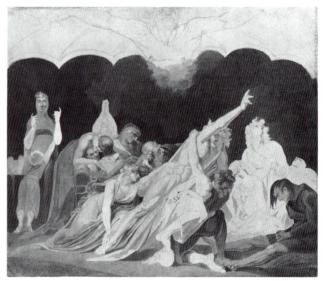

5.2. Henry Fuseli, *The Vision of the Lazar House*, 1791–1793, pencil and sepia wash drawing, Kunsthaus, Zurich.

vealed what was to become a typical obsession with dreams and nightmares, sleep and sleepwalking, the supernatural and the pathological. In pursuit of the irrational the artist was led deeper and deeper into the dark places of the mind. From scenes of physical violence he proceeded into the investigation of the mind and its conflicts. As a result, Romanticism was to contribute fundamentally to the development of psychology and psychiatry.

A second madhouse picture by Fuseli is entitled *The Vision of the Lazar House* (Fig. 5.2). Intended as an illustration to Milton's *Paradise Lost*, it is best understood as a variant of the S. Spirito drawing. It clearly depicts the interior of an asylum filled, as were the Hogarth and Kaulbach pictures, with a number of representatives of the various types of mental disorder. The lady at left, her hands and arms frozen into strange gestures, is easily diagnosed as suffering from some sort of catatonia. The barking dog in the Hogarth is here replaced by a child who clamors for attention. To her left a religious maniac is seen, his hands clasped in prayer. Erotic obsessions were of considerable interest to Fuseli and this form of obsession is portrayed in a number of women involved in one way or another with the males in the picture. Interestingly, in a letter written some years later in 1804 he remarked that according to one of his medical friends the largest number of inmates of Bedlam were women in love.[9] The figure at the center is another version of *The Escapee*. At far right is a clear depiction of a severely depressed patient. Only the figure of Death who spreads his wings above the scene provides a clue to the literary source of this drawing. It was intended to illustrate the following verses from *Paradise Lost*:

Immediately a place
Before his eyes appear'd, sad, noisome, dark,
A Lazar house it seem'd, wherein were laid
Numbers of all diseas'd, all maladies
Of ghastly spasm, or racking torture, qualms
Of heartsick Agony, all feverous kinds,
Convulsions, Epilepsies, fierce Catarrhs,
Intestine stone and Ulcer, Colic pangs,
Daemoniac Frenzy, moping Melancholy
And Moon-struck madness. . . .
..
And over them triumphant Death his Dart
Shook, but delay'd to strike, though oft invoked
With vows, as their chief good and final hope.[10]

Representations of this scene in the art of the period, including Blake's famous version, take up the theme of sickness and death. Fuseli is alone, but very much in character, in interpreting the scene as a madhouse,

5.3. Henry Fuseli, *Mad Kate*, 1806–1807, oil on canvas, Freies Deutsches Hochstift, Frankfurt.

and in utilizing Milton's reference to "Daemoniac Frenzy, Moping Melancholy / And Moon-struck madness" as a pretext for an exploration of psychopathology.

The significance of most scenes we are examining is that, while they undoubtedly express a new Romantic sensitivity, they also depict contemporary hospitals and madmen encountered by the artist. They did not belong exclusively to the realm of the imagination. Records of profoundly felt experience, they reveal that the quest of terror and the sublime made the madhouse an ideal place for the cultivation of Romantic emotions.

I want to refer to one more portrayal of madness associated with a literary source because it suggests another aspect of the Romantic conception of insanity—Fuseli's *Mad Kate* (Fig. 5.3). It is an illustration of William Cowper's (1731–1800) poem *The Task*, in which a girl made mad by love wanders by the sea awaiting the return of her drowned lover.[11] Fuseli's portrayal of the insane girl—her hair torn by the wind, her eyes staring, her fingers reaching out into empty space—is an excellent example of one standard method of depicting insanity. In accord with the poem, Mad Kate is set in a landscape. She is part of nature, returned to it as a result of madness.[12]

The Romantic adulation of nature enters into its conception of insanity. Lunatics were seen as in some sense natural, as primitive men or savages uninhibited by the restraints imposed by reason, society, or conventional morality. Madness served as an excuse for the liberation of instinct. Within Romanticism animals emerge as powerful symbols of unrestrained emotion; battling lions become images of pure instinctual energy and violence; the horse appears in endless

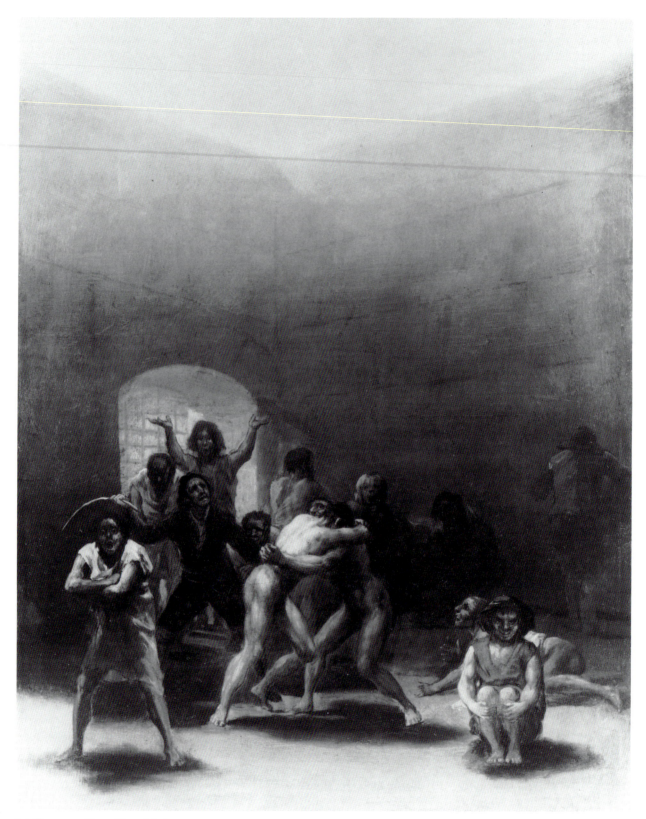

5.4. Francesco Goya, *Corral de locos*,
ca. 1794, oil, Meadows Museum, Dallas.

contexts and variations expressive of a host of different intense psychological realities, including unbounded masculine sexuality and lust. The image of the madhouse can also be understood as an equivalent of these animal symbols, a vision of natural man unleashed and of the force of pure emotional intensity. "The instincts erupt to the surface, the cruelest lusts clamour for satisfaction, the darkest passions proclaim their dominion—all this must be borne in mind when we think of the great madmen whom the Romantic imagination produced."[13]

AMONG the most significant depictions of the milieu of the insane associated with Romanticism are a number of pictures by Francisco Goya (1746–1828). Goya, the greatest artist of the Romantic era, reveals a close and continuing involvement with the madhouse theme. Two major paintings and an important series of black chalk drawings testify to a preoccupation with madness as an existential reality of unusual significance to the artist. It is legitimate, if difficult, to inquire into the possible implications of this subject for the artist and his public. What levels of meaning are contained within these representations of dungeons inhabited by madmen? Answers to this question, even within the context of Goya criticism, are very numerous and highly imaginative. The problem is only partially resolved by Goya himself, who referred to one of the paintings in a series of letters written in 1794 to his influential friend and patron Don Bernardo de Iriarte.[14] The painting, entitled *Corral de locos*, was among a group of small cabinet pictures sent by Goya to the Academy of San Fernando in Madrid (Fig. 5.4). The letter begins as follows: "Most excellent Sir, in order to occupy my imagination mortified by the contemplation of my sufferings, and in order to compensate in part for the considerable expense which they have caused me, I devoted myself to painting a set of cabinet pictures in which I have managed to make observations for which there is normally no opportunity in commissioned works which give no scope for fantasy and invention."[15]

From these remarks, dated January 4, 1794, we are made aware of a number of vitally important facts about this group of paintings. Goya himself links them with a serious illness from which he was just recovering. He states clearly that they were not executed as the result of a commission, and he expresses the view that the pictures were unusual in providing an opportunity for artistic exploration of subject matter not usual in the art of his day, a type of observation that he associates with fantasy and invention. There is no specific reference to the theme of the madhouse. However, in a second letter he referred specifically to the painting known as *The Yard with Lunatics*, saying that it was as yet unfinished. He then added the valuable comment that it depicted a scene he had witnessed in Saragossa. "It represents a yard with lunatics and two of them fighting completely naked while their warder beats them, and others in sacks. It is a scene which I saw in Saragossa."[16]

It is customary, and undeniably significant, to relate this painting of madmen to Goya's recent illness, which was nearly fatal and which left him totally deaf. Surviving contemporary descriptions of his condition, while not sufficiently detailed to permit an accurate diagnosis of his illness, do make it clear that the illness was very violent and that it temporarily disturbed his sense of balance; the right side of his body was paralyzed so that he was unable to walk and developed temporary partial blindness. On the basis of this information it is at least possible to state that the illness involved a period of acute neurological disturbance.[17]

Students of Goya have tried to postulate a connection between Goya's depiction of the inmates of the asylum and his own experience of illness possibly accompanied by the agonizing fear of permanent and inevitable mental derangement.[18] Quite possibly his illness did play a part in the appearance of this new image in his art; indeed, he suggests that this was so himself. Nevertheless, it would seem to be a small achievement, and irrelevant to our investigation, to establish a generic link between Romantic depictions of mental hospitals and the supposed mental disorders of their creators. After all, many artists went mad without painting asylum scenes. Although the personal involvement with mental illness provides a comprehensible motive for the artistic exploration of the theme of the madhouse, such an explanation fails to explain why the image of the madhouse was acceptable to a wider public. In fact, we accept these pictures as of more than personal significance—the sociohistoric milieu appears almost to have demanded the creation of these strange new images.[19]

Within the context of Romanticism and its involvement with madness, this distressing subject had become artistically viable all over Europe. It is perhaps paradoxical that while Romanticism was in some respects a public phenomenon, its essential nature tended to focus on experience of a highly private character, on inner experience and on the introspective perception of feeling, intuition, and emotion. Extreme individuality is an essential component of the Romantic artist and his work. Heine, writing in 1833, referred to "the cult of the individual that the world no longer

holds in check."[20] The madman was seen as the ultimate expression of the tendency to withdraw into a private world obedient only to its own laws, the visionary who alone could see realities invisible to others.

In a series of drawings executed late in his career, probably between 1824 and 1828, Goya returned to the theme of the madman and his world (Fig. 5.5). Almost certainly based on observation in a hospital, possibly in Bordeaux, these thirteen drawings depict specific individuals whose illnesses are identified by inscriptions written by Goya on the drawings themselves, information about the patients supplied most probably by the asylum keeper or physician. Examples include *Raging Lunatic, African Lunatic, Mad through Scruples,* and *Mad through Erring.*[21] The drawings are highly individualized portrayals of real people rather than types, and represent a first move in the perception of the insane as people, individuals caught in a circumscribed private reality from which they cannot escape. The madman is seen as lost within his own uniqueness, totally alone, a bizarre embodiment of the Romantic agony.

In Goya's depiction of the madhouse (Fig. 5.6), this isolation is evident; there is no communication, each patient is totally possessed by his own delusions and visions. This conception of the madman as isolated, alone with his visions, is an extreme version of the Romantic view of the artist as outsider, rejecting and rejected by his society. In this view the artist was conceived of as a kind of monster, and a curious affinity between artist and madman began to trouble the Romantic imagination as the artist came to be seen, and to see himself, as the inspired victim of his own subjective vision, ostracized and penalized by society as a result of his excessive and dangerous preoccupation with the world of fantasy and imagination. Romanticism had brought about a serious change in the personality of artists and in the approach of the public to the profession.[22]

Goya, more than other men, explored to the fullest this irrational inner world in search of monsters. "The Black Paintings" stand as terrifying evidence of the depths to which his uncompromising investigation of the mind led him. Yet in his paintings of the insane it is doubtful that he intended to portray these tormented figures in a state of sublime insight or as heroic voyagers into the uncharted regions of the inner world. His lunatics are tragic figures at war with one another and themselves. On the basis of his own experience he could differentiate empirically the world of the insane from that of the creative artist. "Deserted by reason the imagination breeds impossible monsters; united

with it, it is the mother of the arts and of all their wonders."[23] Within Romanticism madness was also defined as a disease of the imagination, the source of valuable insights and images, and yet dangerous and threatening. The world of the madhouse served as a warning for those who ventured too far in the search for intensity of experience and freedom from conventional morality and reason. It would be a distortion to conceal the fact that many Romantic writers held strongly negative views of madness. In the image of the madhouse they saw an allegory of the world gone mad, a microcosm expressive of the human condition. In such a conception a far from positive view of madness makes itself felt. "In the nineteenth century, madness, crime, sensual orgies, . . . were felt to be manifestations of a hell that was everywhere immanent and so a worthy subject for the painter."[24]

IMPLICIT in all of the depictions of asylums painted by Romantic artists is yet another attitude to madness, an attitude that perhaps represented the fundamental motive for the Romantic preoccupation with the insane. This is the pervasive belief that genius and madness are somehow related and that the true artist's personality is closer to that of the madman than to that of the normal individual. According to Arthur Schopenhauer (1788–1860), for example, "Genius is nearer to madness than the average intelligence."[25]

This idea, which is usually referred to as the genius–insanity theory, originated with Plato, was refurbished to some extent in the Renaissance, rose to a dominant and extremely influential position in the Romantic era, and has not yet been laid to rest. It is intimately

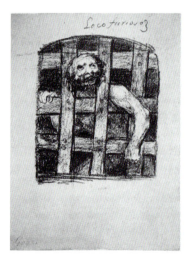

5.5. Francesco Goya, *Loco furioso,* 1824–1828, black chalk drawing from Album G.3, private collection, Paris.

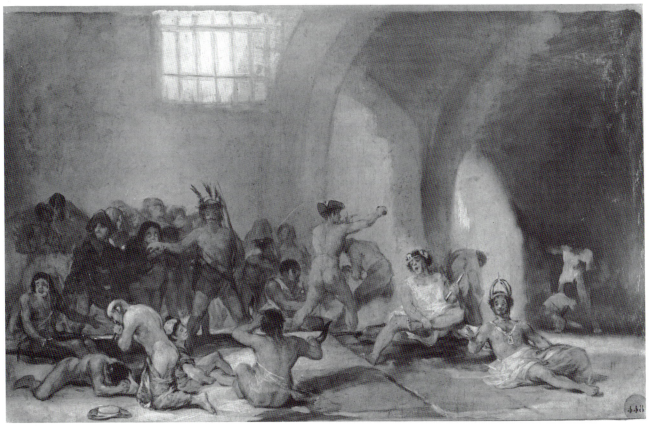

5.6. Francesco Goya, *The Madhouse*,
ca. 1812–1819, oil on panel, Royal
Academy of San Fernando, Madrid.

associated with periods in which the artist's personality becomes a significant reality in itself, independent of the work of art, a phenomenon most clearly seen in Romanticism. The curious and annoying persistence of this idea, appearing and disappearing in the history of Western culture over a period of twenty-five hundred years in various forms and disguises, is no testimony to its correctness. (Even in our own day the average person carries this notion that geniuses, none of whom he has ever met, exist right on the edge of madness and that the boundary between the two categories is somehow very narrow and unstable.)

Whether this hypothesis is correct is of no importance to this study. That the idea existed and was strongly influential during the Romantic era is of fundamental concern to us. Its existence is a psychological fact, a belief the existence of which, as Rudolf Wittkower has indicated, is deeply significant and worthy of investigation.[26] It is, indeed, a symbol, containing within itself the power to affect permanently and change the public's attitude both to the artist and to the madman.

Plato's suggestion that creative power and madness are related is the product of his highly ambivalent attitude to art and artists, and of his effort to describe exactly what is occurring during the act of creation. In Plato it represents only a part of a far more consequential theory of inspiration or possession, the view that the artist's insight into the nature of reality or truth is bestowed upon him by the gods or the muses:

The gift which you possess is not an art but an inspiration, there is a divinity moving you.

God takes away the minds of the poets and uses them as his ministers.

The poets are only the interpreters of the gods by whom they are severally possessed.[27]

Disturbed because the insight of the artist-poet did not seem to be arrived at through the functioning of reason and intellect, and unwilling to reject their products as of no worth, Plato was driven to attribute the insights

of men of genius to an intervention on the part of a god. However, he went further, describing the creative process itself in terms of the religious-psychological state of possession that he associated with madness. In the *Laws* he states: "Everyone knows that when a poet is composing he is not in his senses."[28] In the *Ion* he expresses a similar belief: "There is no invention in him until he has been inspired, and is out of his senses, and the mind is no longer in him."[29]

It has been argued that Plato is not actually equating the creative genius with a lunatic. He understands clearly that the artist moves in and out of this peculiar mental state and is not trapped in it as is the madman. Nevertheless, it would seem that while he is in it there is little distinction between the artist and his mad brother, other than the extreme difference in the worth of their respective productions. Conscious of the similarities and differences in the psychological reality that he was investigating, Plato was led to postulate the existence of four varieties of what he termed "madness of divine origin," pointing out that the ancients considered such forms of madness superior to a sane mind. One of the types he discusses is that of the poet:

The third kind is the madness of those who are possessed by the muses, which taking hold of a delicate and virgin soul, and there inspiring a frenzy, awakens lyrical and all other numbers. . . . but he who having no touch of the muses' madness in his soul, comes to the door and thinks he will get into the temple by the help of art, he, I say, and his poetry are not admitted, the sane man disappears and is nowhere when he enters into rivalry with the madman.[30]

Aristotle too was intrigued by what might be called the psychological nature of genius. His view of the problem is rather less ambivalent than that of Plato. He endeavored to define a personality type characteristic of the artist and in doing so came close to the Romantic conception of the artist's mentality as an unstable balance between genius and insanity. He included the philosopher and the artist within one personality grouping, which he termed the atrabilious or melancholic temperament. The melancholic's body contains black bile, which tends to produce excitability, moodiness, and fitful sleep. In the *Problemata* he states that in madness black bile is naturally present. He who has black bile in proper proportions in his body is a genius, in extreme proportions is mad. To Aristotle there is a clear distinction between genius and insanity. While genius is in no sense to be confused with madness, the border between the two is narrow and easily crossed. In the *Problemata* he refers to the case of Maracus the Syracusan, who was actually a better poet when he was out of his mind.[31]

The relationship between genius and insanity was discussed by Seneca, whose words "nullum magnum ingenium sine mixtura dementiae fuit," have generally, as Rudolf Wittkower has pointed out, been distorted by being quoted out of context.[32]

While the concept of divine inspiration guiding the hand and mind of the artist continued to be important in the Middle Ages, the secondary idea of the artist as mad while creating disappeared. The elevated position of the artist in the Renaissance was accompanied by a revival of the Platonic conception of creative madness, most significantly in the writings of Marcilio Ficino (1433–1499), leader of the Platonic Academy in Florence. It finds its most elegant expression in England in the famous lines from Shakespeare's *A Midsummer Night's Dream*:

Lovers and madmen have such seething brains,
Such shaping fantasies, that apprehend
More than cool reason ever comprehends.
The lunatic, the lover, and the poet
Are of imagination all compact.
One sees more devils than vast Hell can hold,
That is the madman. The lover, all as frantic,
Sees Helen's beauty in a brow of Egypt.
The poet's eye, in a fine frenzy rolling,
Doth glance from heaven to earth, from earth to heaven;
And as imagination bodies forth
The forms of things unknown, the poet's pen
Turns them to shapes, and gives to airy nothing
A local habitation and a name.[33]

Seneca's view of the problem is magnificently distorted in John Dryden's (1631–1700) succinct statement:

Great Wits are sure to Madness near alli'd
And thin Partitions do their Bounds divide.[34]

These lines more than any other single source seem to have captured the popular imagination, at least in English-speaking countries.

Rejecting reason and intellect as their modus operandi, Romantic artists sought justification for their introspective searchings, and emphasis on emotion and the irrational, in the Platonic theory of divine madness. However, in the context of Romanticism, it is the element of creative insanity that is emphasized, rather than the phenomenon of external inspiration. Far less intellectually rigorous than Plato, the Romantic theorists tend to neglect the subtle distinction between pathological and creative forms of madness, accepting all forms of insanity with uncritical enthusiasm and reverence, and cultivating to varying degrees the concept of the creative personality as a bizarre, disturbed, or eccentric being. The doctrine of insanity and genius, for such it now was, took a variety of forms. Found in

almost every Romantic writer, it is nowhere stated with any degree of programmatic clarity.

In May 1826 Charles Lamb (1775–1834) published an essay, "Sanity of True Genius."[35] In it he sought with measured prose and calm logic to dismiss the erroneous idea that there could be any connection between genius and insanity. He begins, "So far from the position holding true, that great wit (or genius, in our modern way of speaking), has a necessary alliance with insanity, the greatest wits, on the contrary, will ever be found to be the sanest writers."[36] Although it would appear that Lamb was issuing a challenge to John Dryden, attacking his famous couplet of some 145 years earlier, Lamb's quarrel lay not so much with Dryden as with the notion of insanity and genius. Here, as in many of the *Essays of Elia*, Lamb was attacking what he termed "popular fallacies." Thus already in 1826 the link between insanity and genius had become common currency, what Lionel Trilling has defined as "one of the characteristic notions of our culture."[37] That the concept, in the form propounded by Dryden, had captured the popular imagination cannot be doubted. The entire panoply of Romantic conceptions of creativity and genius were readily available, but when we search for the source of this specific concept among the early Romantic writers, it is difficult to discover who exactly was responsible for the immense influence and popularity of the idea. There is no Edmund Burke to whom we can turn for an elaborate presentation on the madness of men of creative genius. What was the line of transmission from Dryden to Lamb?

The search for the Romantic ideal of the mad genius, and for the early exponents of this theory, leads to Denis Diderot (1713–1784), the great encyclopedist and thinker of the Enlightenment. In the area of art and creativity, and in his conception of the nature of the creative genius, Diderot can rightfully be understood as one of the fundamental contributors to the origin of the Romantic attitude. In the early *Pensées philosophiques* (1746), he had already assumed an obviously Romantic stance. "Nevertheless, it is only the passions, the great passions, which can lift the soul to the perception of great things. Without them, nothing sublime . . . the fine arts would regress to infancy."[38] In his life-style too, Diderot established new norms of acceptable eccentric behavior for the artist. "The type of the mad genius may be said to have begun with Diderot. . . . He was the first of the literary Bohemians of Paris, picturesque and loquacious, versatile and inexhaustible, his manners unconventional and his appearance unkempt."[39] Whatever his life-style, it

is clear that the conception of the insane genius enters Diderot's theory of creativity only in a very diluted form, and then only in the earlier period of his life.

As Herbert Dieckmann has indicated,

The transition from the conception of genius as mere talent to the conception of the genius as an individual was accomplished through a specific act of thought. . . . Diderot accomplished this act of thought and thereby became conscious of the problem of "the genius" as a type of person. He makes the inner constitution of the individual we call the genius the subject of his research, he describes the workings of his mind.[40]

In his exploration of the nature of genius, a subject he returned to throughout his career, Diderot characterizes the problem in terms of emotion and feeling, and particularly that violent form of emotional experience referred to in the eighteenth century as "Enthusiasm." "The idea in question is that the genius seized by enthusiasm is in a pathological state of obsession, that enthusiasm is a kind of sublime fit, and genius a pathological phenomenon."[41]

This [artist] is a sublime imitator of nature. You see how much he knows how to do, with a modeling tool, a pencil, or a brush. You admire his astonishing work. But, no sooner has he laid down the tools of his trade, than he is insane. This poet, who appears to be inspired by wisdom, and whose writings are filled with maxims which deserve to be engraved in golden letters, in the space of an instant, no longer knows what he is saying or doing; he is insane. This orator, who takes possession of our souls and spirits, disposing of them as he wishes, having stepped down from his rostrum, he is no longer master of himself; he is insane. What a difference, I cried, between genius and common sense, between a tranquil man and a man of passion![42]

It is important to notice that, like Plato, Diderot restricts the period of mental disturbance, attributing it to the moment of creation and shortly thereafter, rather than characterizing it as a mental state associated with the genius as a distinct pathological type. However, in other passages he extends his diagnosis. "The genius is reduced by Diderot to an abnormality in man and called a monster. It seems to him that genius is caused by a one-sidedness, whether this one-sidedness consists in the predominance of one sense, or of one organ."[43]

I conjecture that these men of sombre and melancholy temperament only owed that extraordinary and almost divine penetration which they possessed at intervals, and which led them to ideas sometimes so mad and sometimes so sublime, to a periodic derangement of the organism. They then believed themselves inspired, and were insane. Their attacks were preceded by a kind of brutish apathy, which they re-

garded as the natural condition of fallen man. Lifted out of this lethargy by the tumult within them, they imagined that it was Divinity, which came down to visit and exercise them. . . . Oh, how near are genius and madness.[44]

Diderot was strongly influenced in his conception of the creative process by English philosophers, in particular Edmund Burke and Lord Shaftesbury (1621–1683), whose essay on enthusiasm provides one of the earliest sources for an understanding of the creative drive in terms of mental instability. However, the English tradition was not an essential factor in motivating Diderot toward his ambivalent conception of the functioning of genius, in that French philosophy also contained occasional references to this problem. Pascal (1623-1662) had stated, "l'extreme esprit est voisin de l'extreme folie."[45] Nor is Diderot's ambivalent conception of the problem, his alternation between what can be termed the Romantic versus the Classical understanding of genius, unique. The conception of genius as bordering on, and sometimes as partaking of, insanity appears always to have been both attractive and repellent to anyone who concerned himself with it.

Charles Lamb provides an excellent illustration of this ambivalence, for despite his strong public stance in opposition to the "popular fallacy," the voice of measured reason had a more private side, at least in the early years, a point of view that he shared only with his friends. Writing to Coleridge (1772–1834) on May 27, 1796, Lamb describes an event in his life that appears to have had a profound effect on him. "The six weeks that finished last year and began this your very humble servant spent very agreeably in a madhouse at Hoxton. I am got somewhat rational now, and don't bite anyone. But mad I was, and many a vagary my imagination played with me, enough to make a volume if all told."[46] Lamb was twenty-one at the time; his essay was written some thirty years later. In the years in between he was forced to cope with the terrible problems not of his own mental disturbance, but that of his sister who, while insane, had murdered her mother. Every year or so she became sufficiently mad to necessitate a return to the asylum. These seemingly insignificant details are of importance to us in that they suggest the source of Lamb's violent antipathy in later years to the notion of the insane genius. The Romantic view of madness was seldom based on any real experience of the insane. It was a fantasy, a dream of madness as a treasure trove of the imagination free of reason and constraint. The actual experience of mental illness, particularly that of his sister, led Lamb slowly out of this Romantic dream. But at twenty-one he was as strongly imbued with the Romantic view of the

problem as anyone, despite his own recent experience with what appears to have been a severe but brief period of mental illness. His letter continues: "The sonnet I send you has small merit as poetry but you will be curious to read it when I tell you it was written in my prisonhouse in one of my lucid intervals."[47] Lamb was well aware of Coleridge's interest in the problem of creativity in the context of madness, and willingly shares with him his own experience of that strange world. In a second letter dated June 10, 1796, he returned to the subject.

In your absence, the tide of melancholy rushed in again, and did its worst mischief by overwhelming my reason. I have recovered. . . . At some future time I will amuse you with an account as full as my memory will permit of the strange turn my frenzy took. I look back upon it at times with a gloomy kind of envy. For while it lasted I had many hours of pure happiness. Dream not, Coleridge, of having tasted all the grandeur and wildness of Fancy, till you have gone mad.[48]

In this last line the Romantic attraction to pathological mental states finds its most succinct expression. Madness held within it the promise of new and unexplored realms of the imagination, and the Romantic artist constantly seems to have felt that another world lay just inches away, that he was separated from it by the thinnest of membranes, and that some sudden turn of the mind could lead him, all unresisting, into this unexplored, and vastly more real, reality.

Coleridge, for his part, despite his reputation as a poet who composed in his sleep or under the influence of opium-induced states of Romantic reverie, was an astute and incredibly penetrating psychologist, whose brilliant observations anticipate many of the findings of psychoanalysis. Perhaps as a result of his own desperate struggle with narcotic addiction, he was driven to a clear-headed understanding of the profound distinction between genius and insanity. In a discussion of poetic sensibility published in the *Biographia Literaria* (1817), Coleridge takes Dryden to task in a footnote:

This is one instance among many of deception by the telling the half of a fact and omitting the other half, when it is from their mutual counteraction and neutralization that the whole truth arises, as a tertium aliquid different from either. Thus in Dryden's famous line, "Great wit" (which here means genius) "to madness sure is near allied." Now as far as the profound sensibility, which is doubtless one of the components of genius, were alone considered, single and unbalanced, it might be fairly described as exposing the individual to a greater chance of mental derangement; but then a more than usual rapidity of association, a more than usual power of passing from thought to thought and image to image, is a

component equally essential; and in the due modification of each by the other the genius itself consists.[49]

In making his famous distinction between fancy and imagination, Coleridge again distinguished between creativity as a form of mental activity involving reason, and insanity.

Repeated meditations led me to suspect that fancy and imagination were two distinct and widely different faculties, instead of being in the common belief, either two names with one meaning, or, at furthest, the lowest and highest degree of the same power. You can conceive the difference in kind between the fancy and the imagination in this way—that if the check of the senses and the reason were withdrawn, the first would become delirium, and the last mania.[50]

By the middle of the nineteenth century the various manifestations of Romanticism were disappearing or, perhaps, going underground. The Romantic preoccupation with the insane genius continued to exist, taking on new forms and disguises as it adapted itself to changing conditions. In the early years of the century genius and insanity were seen as precariously near-neighbors; by the middle of the century they were beginning to be conceived of as occupying the same house. Genius was soon to be diagnosed in medical circles as a type of mental disorder. But even among poets the two concepts were being merged. Lamartine writes of "the mental illness which is called genius."[51]

THE RESULT of this curious equation of creative genius and mental pathology, combined with the far more general and extensive Romantic attitudes toward insanity, was to focus attention on the asylum and its inmates as a possible source of inspired creation. Could the madman give birth to art? At the beginning of the century the answer to this question would still have been a resounding "no." But artists were beginning to note that under the impact of mental disturbance individuals who had never displayed any involvement with art developed an unexplained inclination to make images, to draw. Artists inspired with Romantic ideals began to frequent the asylum and to record their observations of the insane artist at work. While the first depictions in art of the drawings of the insane (Hogarth, Kaulbach) are mere fabrications, inventions purporting to represent what the art of the insane should look like, interest was developing among artists as to what the drawings and paintings of madmen actually did look like. Was there such a thing as insane art?

In a diary entry for the year 1838, the French Romantic sculptor Pierre-Jean David d'Angers (1788–1856) recorded his impressions of a visit to the Asylum of the Salpêtrière in Paris:

In the courtyards of the Salpêtrière where the insane are confined, I saw a great number of these poor people, crouching there like Egyptian sculptures. In the Orient, the insane are privileged, in that they are accepted as being inspired by God. No doubt it is this posture, so common among the insane, which art has assimilated and used in depicting gods in sculptural form. Physiologically, this pose of the insane, is explained by the activity of the flexor muscles which are dominating the extensor muscles; just as in sleep. It can be readily understood that, all of their strength being directed toward the brain, their limbs are left in a complete state of inertia. In the Orient, religious fanatics in a state of ecstasy remain always in the same position. Their limbs ossify, or to put it differently, they turn themselves into sculpture. There is no longer any struggle between matter and spirit. Their spirit is completely predominant and maintains a continual relationship with God.[52]

His reaction is that of a sculptor—objective, seeking material he can use, studying the musculature and pose. The Romantic element finds expression only in the association he makes with the religious fanatics of the East and in his conception of the struggle between matter and spirit, which finds its resolution in the bodies of individuals immobile as stone.

Writing of this visit, David's memory awakened: "At Saint-Rémy, in Provence, in a hospital for the insane, I saw a poor young artist driven mad by love. With much mystery, he showed me the profile of his mistress which he had sculpted himself, but in a manner so lacking in form that the features could be seen by no one but himself. By this mystery his jealousy was avoided. He didn't want anyone to be able to admire the love of his life."[53]

The context from which these passages are taken is expressive of a Romanticism so intense that they might have been written by Victor Hugo (1802–1885). There can be no doubt that David was moved by his memory of the young sculptor made mad by love. His next words carry him into pure poetry: "If silence is so noble, so sculptural, and if I could express myself in this way, it's because the silent being seems to be in harmony with an invisible spirit, while that being who speaks conveys instead everything by which it is disturbed."[54]

It is not without significance that David's memory of an insane artist and his work should have referred to a piece of sculpture created by a madman, a small head in profile not unlike those on the medals he specialized in making. For the artist this confrontation with the creative process of the insane involved some element of identification, and of empathy. He was not led by Romantic enthusiasm to an overestimation of the work itself. The piece he was shown was so lacking in shape

that the features of the face were invisible, except to the artist. There is, nevertheless, unusual understanding in David's insight that the sculptor wished to conceal as much as to reveal, that he sought to retain some part of the mystery for himself. This incident in the life of David d'Angers reflects a literary masterpiece, written six years earlier, that the sculptor may well have known—the short novel *Le chef-d'oeuvre inconnu* by Honoré de Balzac (1799–1850).

IN *Le chef-d'oeuvre inconnu*, written at the beginning of his career, Balzac presented his conceptions of art and beauty, of the creative process and the nature of genius, creating what Pierre Laubriet has called his "catéchisme esthétique."[55] As the work of a young writer developing in the full intensity of the Romantic movement, the story embodies to a remarkable degree all of the typical Romantic theories of the nature of the creative personality. In the figure of Frenhofer, the mad genius, Balzac gave literary expression to the theory of genius and insanity by taking this embodiment of divine genius across the "thin partition" into madness.

The story was first published in 1831 in the then new periodical *L'artiste*.[56] As Balzac was only just emerging as a writer of importance, it is logical to assume that the story of "the unknown work of art" was thought to provide some degree of insight into the workings of the creative imagination worth presenting in a review devoted to "contemporary art"—this despite the fact that the tale is set in Paris of the seventeenth century. That Balzac felt this work to be of major significance in establishing his view of the nature and function of the artist is indicated by the work's subsequent inclusion in the *Etudes philosophiques*, part two of his life work *La comédie humaine*.

Only one of the novel's many themes is central to our investigation—the mental disintegration of the genius Frenhofer and the work that serves as the evidence of his disturbed mental state, a painting of a beautiful courtesan called *La belle noiseuse*. Frenhofer is portrayed by Balzac as an artist of unquestionable genius. "Everything about this old man went beyond the limits of human nature."[57] "This old man with his pale eyes, at once attentive and stupid, became for him more than a man, appearing to him as a fantastic genius, inhabiting an unknown realm."[58] The description of Frenhofer at work suggests early in the story that the creative act carries him inevitably to the edge of sanity. Gripped by creative frenzy, he takes on the appearance of a madman:

He worked with such passionate fervor, that beads of sweat gathered upon his bare forehead. His hand moved so quickly, in little impatient jerks that . . . it seemed that there was within the body of this strange character a demon, who acted through his hands, forcing them in fantastic ways against the man's will. The supernatural brilliance of his eyes, and the convulsive movements which seemed the effect of internal struggle, lent a semblance of truth to this idea.[59]

This description, a vivid portrayal of the Romantic artist in the act of creation, may well betray the influence of Diderot. It is well known that Balzac's thinking, particularly in the realm of art, was strongly influenced by the Salon reviews published by the philosopher.[60] In his "Essay on Painting," Diderot describes the artist at work:

Imagine yourself in an artist's studio, watching the artist at work. If you see him arranging with great care his tones and his half tones around the edge of his palette, and if in a quarter of an hour he has not completely obscured that order, you can boldly announce that this artist is cold, and that he will never do anything of value. The stamp of genius is lacking. He who has a living feeling for color, has his eyes glued to the canvas; his mouth is half open, he is breathless, and his palette is the picture of chaos. It is into this chaos that he dips his brush, and from it he draws the work into creation. But why doesn't the character, even the mood, of the man influence the coloring of his work? If his normal mood is sad, somber and black, if it is always night within his melancholy brain, and in his gloomy studio, if he banishes the day from his room, if he searches for solitude and shadows, would you not have reason to expect his painting to reveal a scene, vigorous perhaps, but dark, dull, and somber? Just as a mute and taciturn man, who once in his life raises his voice. The explosion accomplished, he returns to his natural state, silence.[61]

Well before the story's denouement Balzac raises the question of Frenhofer's sanity, describing him as "as much a madman as a painter."

Frenhofer, was he sane or mad? Did he find himself dominated by an artist's fantasy, or did the ideas which he exposed derive from the inexpressible fanaticism produced in us by the lengthy childbirth of a masterpiece? Could one ever hope to come to grips with such a bizarre passion?[62]

It is a paradox of deep significance for our study that the meaning of *Le chef-d'oeuvre inconnu* has undergone a radical change in the years since the story was written. The twentieth-century reader is no longer likely to encounter the novel's final scene as Balzac intended. The story of Frenhofer's masterpiece has a tendency today to seem prophetic, vindicating the artist

and raising questions in the contemporary reader as to the justice of considering him insane. In this new context Frenhofer emerges as the misunderstood genius, the first abstract painter, a considerable accomplishment either in 1621, or in 1831 when the story was composed.

Balzac's audience in 1831 would have been in no doubt as to the mental condition of the artist at the end of the story. The mysterious painting is revealed as the work of a madman. Driven by his ambition to rival nature and God, tormented by a vision of unattainable perfection, Frenhofer succumbs to complete insanity. The painting, on which he has labored for ten years, has undergone what Balzac describes as "an unbelievable, slow and progressive process of destruction."[63] The artist is portrayed as a man possessed by illusions, no longer in touch with reality, a tragic and pitiful figure. "His hair was disordered, his face aglow with a supernatural ecstasy. His eyes sparkled and he panted like a young man drunk with love."[64] For a brief moment he emerges from his madness and understands: "I am an imbecile, a madman, with no ability. . . . I have produced nothing then."[65]

Balzac's description of the painting created by the mad artist is probably pure invention, not based on any specific experience of the art of the insane. Nevertheless, in creating this word image he reflects the growing Romantic interest in the problem of what effect insanity would have on the work of an accomplished artist. Having built the tension in regard to the unknown masterpiece to an almost unbearable point, the picture is revealed:

> "Do you see anything?" Poussin asked Porbus.
> "No. And you?"
> "Nothing—the old 'lansquenet' is playing with us," said Poussin returning to the supposed picture. "I see nothing there but confused masses of color bounded by a multitude of fantastical lines which form a dead wall of paint." Moving closer to it, they noticed in one corner of the canvas part of a bare foot which emerged from the chaos of colors, tones, and vague nuances which contributed to the formless mist.[66]

We have been led down a Romantic garden path, only to be rudely confronted by the Realist Balzac at its end. The painting of his insane genius is a meaningless muddle, incomprehensible to anyone but the artist. The beautiful woman of his dreams is as featureless as the sculpted profile shown to David d'Angers in the asylum at St. Rémy. The unknown masterpiece is seen to exist only within the confines of the Romantic imagination. To Balzac the implied

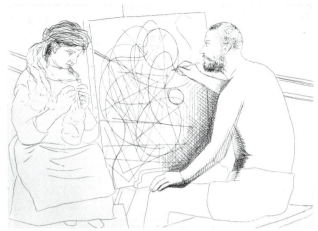

5.7. Pablo Picasso, *Painter with a Model Knitting*, 1927, from a series of etchings made to illustrate Balzac, *Le chef d'oeuvre inconnu* (Paris, 1931), collection, The Museum of Modern Art, New York.

meaning of the story had to do with "art killing the work; that is, the work and its execution is killed by too great an abundance of the creative principle."[67]

It is extraordinary, therefore, to encounter a recent critic characterizing the novel "either as a satire on abstract art, written a century early, or as an intellectual defense of it."[68] Nor is he unique in seeking to understand the story in this light. In 1931, Picasso illustrated *Le chef-d'oeuvre inconnu* with a series of etchings that make it quite clear that he saw Frenhofer as a predecessor whose search for perfection had led him logically, if prematurely, into abstract painting (Fig. 5.7).[69] Revolutionary changes in the world of art have played a part in this reappraisal of Frenhofer's painting. But, as we shall see, equally revolutionary changes in attitude toward the art of the insane over the period of one hundred years between Balzac and Picasso had created a new context in which the art of a madman could be encountered and understood in a radically different and positive way.

The ground for this dramatic change was prepared in the last half of the eighteenth century and the first half of the nineteenth, in part within the context of Romanticism. However, the preoccupation with the concept of the insane genius does not disappear with the decline of Romantic sensibility. The second half of the nineteenth century witnessed an intensification of interest in what would come to be known as the psychopathology of art; the birth of the pseudoscience of pathography; and the first studies, exhibitions, and

collections of the art of the insane. The notion that one might discover actual works of art in the asylum, and that insanity could, in certain types of individuals prepared by heredity, unleash creative genius where it had not previously existed, is essentially a product of the last half of the nineteenth century when more and more extreme versions of Romantic ideas and illusions concerning insanity came to be formulated.

In literature, the writings of the boy-genius Arthur Rimbaud (1854–1891) reflected and encouraged this new viewpoint. Attempting to discover his own relationship to the task of the poet, and the methods to be adopted in accomplishing that task, Rimbaud was led to propose the idea of the disordering of the senses as a means of attaining visionary insight into the nature of reality. In a series of letters written in May 1871 he clarified his intentions:

Now I am going in for debauch. Why? I want to be a poet, and I am working to make myself a visionary: you won't possibly understand, and I don't know how to explain it to you. To arrive at the unknown through the disordering of all the senses, that's the point. The sufferings will be tremendous, but one must be strong.[70]

The poet makes himself a visionary through a long, a prodigious, and rational disordering of all the senses. Every form of love, of suffering, of madness; he searches himself, he consumes all the poisons in him, keeping only their quintessences. Ineffable torture in which he will need all his faith and superhuman strength, the great criminal, the great sick man, the accursed,—and the supreme Savant! For he arrives at the unknown! Richer to begin with than any other! He arrives at the unknown: and even if, half crazed, in the end, he loses sight of his visions, he has seen them![71]

Rimbaud allied himself consciously with the Romantic writers. "The first Romantics were visionaries without quite realizing it: the cultivation of their souls began accidentally."[72] For Rimbaud insanity had become something to be deliberately sought out and cultivated. No longer the gift of the gods, it had become an artistic credo and a systematic program. There is, needless to say, no question of Rimbaud's ever having been insane. To quote Polonius, "Though this be madness, yet there is method in't."[73] His vision of the madman, the great criminal, represents the final development of a trend already evident in Romanticism for the artist to see himself as existing outside of society, a monster and an outcast crying in the wilderness. Rimbaud comes at the end of a long line of French writers possessed by an extreme ideal of the Romantic introvert creating out of, and at the expense of, his own inner substance and sanity: de Sade (1740–1814), Baude-laire (1821–1867), Lautréamont (1846–1870), and Gérard de Nerval (1808–1855).

The life and work of Gérard de Nerval (Fig. 5.8) is of particular importance in illustrating the changing attitude toward the artistic productions of the insane. Although the uniqueness of his contribution was fully recognized only in the twentieth century, when the Surrealists came to see him as a spiritual predecessor, in his own day he was extremely well known in Parisian literary circles. Nerval's desperate psychological condition was no secret. Maxime du Camp (1822–1894), in *Souvenirs littéraires*, discussed the subject at some length.

Gérard's real name was Labrunie; he had adopted the pseudonym de Nerval, which he made famous. He was insane; his intermittent insanity left him, in moments of calm, possessed of a gentle originality and a very disconnected existence. When during an acute attack, he became dangerous to others and to himself, he was taken to Passy, to the former residence of the Duke of Penthièvre, which is now an asylum, directed by Dr. Blanche. . . . His attacks, which could sometimes result in a coma, and at other times lead to a state of overexcitement bordering on frenzy, never lasted more than six months. He came out of them slowly like a man only half awake, who is still under the influence of a dream. . . . Gérard de Nerval was never of sound mind.[74]

The illness from which Nerval suffered, almost certainly an extreme form of manic-depressive psychosis, included auditory and visual hallucinations, periods of delirium, and fits of violence. Du Camp refers to Nerval as suffering from the erotic form of insanity, "erotomanie," a diagnosis deriving from the fact that the

5.8. Gérard de Nerval, 1855, photograph by Felix Tournachon (Félix Nadar).

main content of his psychotic delusional system revolved around a vaudeville singer of the day named Jenny Colon. Nerval took his own life in 1855.

His book *Aurélia: Le rêve de la vie*, in publication at the time of his death,[75] had been written during various periods while he was hospitalized, and is a fairly direct portrayal of his visions and ideas while insane. Théophile Gautier (1811–1872) referred to it as "insanity describing itself."[76] Du Camp's understanding of the work is similar. "It is a sort of last testament left to the contemplation of alienists. It's insanity caught in the act, described by a madman in a moment of lucidity."[77] Nerval was well aware of the nature of these visionary writings. "If I did not have a useful goal in mind, I would stop here and I would not endeavor to describe all that I have experienced in a series of visions, mad perhaps, or, more crudely, sick."[78]

That these writings were published, not as case material or examples of the effect of mental illness on a writer, but as visionary literature is an extraordinary fact. It was recognized that while insane Gérard de Nerval had something significant to say. A critical comment written at the time by Alexandre Dumas père (1824–1895) is of value in accounting for this new attitude toward the ideas and work of a madman.

From time to time, when some piece of work had begun to strongly preoccupy his imagination, this resident madness would momentarily overpower his reason which is never more than mistress of his mind. Madness would then dominate. . . . Our poor Gérard was seen by men of science as sick and in need of treatment, while for us, he was simply more of a storyteller, more of a dreamer, more spiritual, more happy or sad than ever. . . . On another day, he believed himself to be insane, and he described, like a gossip, how it had happened, with such liveliness and joy, and with such amusing reversals and vicissitudes, that each of us felt a desire to become mad too, in order to follow this guide who wandered in the land of hallucination and chimeras.[79]

This description of Gérard contains the typical Romantic attitudes toward the insane genius—the old Romantic theory that madness is caused by an excess of imagination in the absence of reason, and the attraction of this mental state for the artist who finds himself envying the madman, wishing to possess his dreams and visions. Uniquely, Dumas distinguishes between the perception of the physician and the artist: "For the men of science you are ill, but for us. . . ." The Romantic writer or artist saw the dreams of a madman in a new way. Aware of the disparity between his view and that of the scientist or physician, he still insists on the validity of his insight into the phenomena of madness,

and he identifies not with the rational view of the physician, but with the reality of his patient. Nerval's belief in the value of his insights and his visions was shared by his fellow writers. At this point the world of the madman and that of the artist fuse. The product of the asylum is accepted as a work of art. *Aurélia* remains the most prominent and highly respected example in the nineteenth century of this new genre of literature.

The acceptance of the writing of the insane antedated by many years the reception of the painting and sculpture of the mentally ill within the boundaries rather vaguely circumscribed by the word art. Poetry and prose reveal the influence of the writing of the insane well before the visual arts show any sign of submitting to such an irrational source of stimulation.

Gérard de Nerval's contribution to art was not confined to writing. While hospitalized in the asylums of the Drs. Blanche[80] he began to draw and paint.

Wanting to record in more permanent form my favorite thoughts, with the aid of pieces of charcoal and of brick which I was collecting, I had soon covered the walls with a series of frescoes in which my impressions were embodied. One figure was always dominant: that of Aurélia, depicted with the features of a goddess, just as she had appeared to me in my dream. At her feet a wheel turned, and the gods passed before her in procession. I managed to color this group of figures by squeezing the juice of grasses and flowers. How many times I lost myself in dreams before that beloved idol![81]

With this account of Nerval's painting activity, and it is confirmed by Maxime du Camp, among others, we move from the imaginary drawings in Hogarth and Kaulbach to descriptions of actual paintings on hospital walls, paintings that in this case unfortunately no longer exist. Describing his visionary hallucinations, Nerval provides considerable insight into the process that for him awakened the impulse to draw on the walls of the asylum.

Thus, I believed myself to be in the midst of a vast charnelhouse where the history of the universe had been written in blood. A painting of the body of a gigantic woman faced me. Her various members had been cut asunder as with a saber. Other women of diverse races, whose bodies became more and more dominant, appeared on the other walls, a bloody excavation filled with heads and parts of bodies. . . . One had only to fix his eyes on one point [of the room] or another, to see drawn there a tragic representation.[82]

It seems that some of Nerval's hallucinations actually took the form of images drawn or painted on the walls. His effort to make these images more permanent becomes understandable. As he puts it, "I wanted to have

5.9. Dr. Emile Blanche.

a material sign of the apparition that had consoled me."[83]

Nerval was visited in the hospitals by numerous friends and acquaintances, many of them writers and artists, and his "frescoes" became famous well before the publication of *Aurélia*. As early as November 1843 an article appeared in *La revue de Paris* describing the "half-erased figures" in the hospital of Dr. Esprit Blanche in Montmartre:

One . . . represented the Queen of Sheba, and another, some sort of king. These drawings came from the hand of a distinguished young writer. . . . Illness had developed in him a new talent which had not existed in his state of sanity, or which had, at least, prior to this time, played a scarcely significant role.[84]

Around 1841–1842, another writer apparently referred to this same figure:

On the walls in this section are drawn, here and there, the most grotesque figures and bizarre symbols: a sort of kaleidoscope illuminated at times by a spark of intelligence. One of these figures struck us by its majestic character and by the accuracy of the drawing. It was a drawing of a woman crowned with a diadem. We wagered that it must be the work of a painter. Not at all! It was the work of a man who could scarcely draw, but a man whose eminently poetic imagination seemed to have intuited the secrets of this art which he had never studied: the drawing was by Gérard de Nerval.[85]

Both articles emphasize the development of a previously nonexistent talent—the secrets of the art of painting are engendered miraculously through madness. It is extraordinary to observe this idea already making an appearance in the 1840s.

Not all of Gérard de Nerval's drawings were confined to the wall. He tells us that he was given paper on which he wrote and drew. Some of these drawings were acquired by Maxime du Camp.

He had drawn on a sheet of paper complicated drawings, which he had colored with the juices of flowers, and to which he had added explanatory notes. This drawing, which I preserve as a precious thing, and which is the most curious specimen of the iconography of madness known to me, was intended to make known and to explain his cosmological ideas. It is a mixture of indecipherable ideas derived from literature, magic, and the Cabbala. Everything gravitates around a gigantic woman, crowned with seven stars, whose feet rest on the globe, about which a dragon coils, and which symbolizes at the same time Diane, Saint Rosalie, and Jenny Colon.[86]

In referring to the drawings as curious specimens of "the iconography of madness," du Camp reveals himself as more closely allied with the medical viewpoint. This is understandable in that he had collaborated in 1880 with the illustrious Cesaré Lombroso, an Italian physician, criminologist, and student of the art of the mentally ill, on one of the earliest scientific studies of the art of the insane (see chapter 6).[87]

Nerval's physician at Passy, Dr. Emile Blanche (Fig. 5.9), encouraged him to write and draw images and descriptions concerning his illness. As we have seen, the therapeutic value of this procedure was, if not understood, at least utilized well before the time of Dr. Blanche. Sheets of paper were given to Nerval, who filled them with accounts of dreams, drawings, and visions, and he then gave them to Dr. Blanche. During

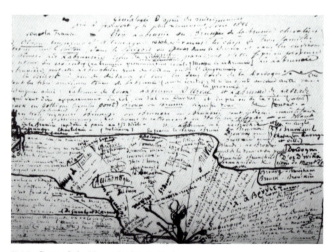

5.10. Gérard de Nerval, *Généalogie fantastique*. Collection Spoelberch de Lovenjoul, Chantilly.

the same period he also began to do sculptural pieces modeled in clay. "I did more, I attempted to represent in clay the body of her whom I loved. Each morning my work had to be redone, because the madmen, jealous of my happiness, took pleasure in destroying the image."[88]

Gérard de Nerval's surviving drawings have never been studied, nor is it possible to date them with any certainty. He included small vignette illustrations in several of his published collections of poems. These are of little interest to us. However, a small number of very different drawings relate to the period of his illness. References in du Camp to a genealogical system are accurate reflections of a "généalogie fantastique" that Nerval actually did elaborate during his illness. A page of manuscript illustrating the system exists and in its confused combination of drawings and text resembles the description of such pages in *Aurélia* (Fig. 5.10). That such a combination is not unusual in Nerval's work while ill is suggested by a further page that bears a few lines of a text entitled *Rêves fatals—Lilith*, and a depiction of two butterflies, one with its wings open, the other with the wings closed (Fig. 5.11).[89]

The most significant drawing attributed to Nerval is a sketch of an individual in oriental or Near Eastern dress entitled *Hacine* (Fig. 5.12). It has proved impossible to date this drawing, but it probably relates to the trip Nerval made to the Near East shortly after his first hospitalization. The style of the drawing is not at all bizarre. The only element that suggests an extreme

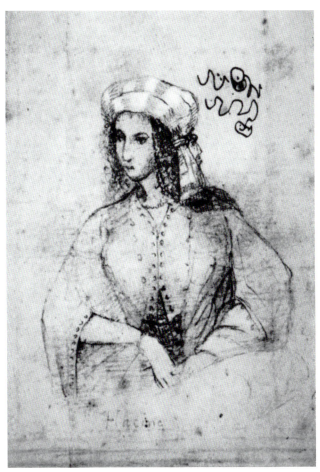

5.12. Gérard de Nerval, *Hacine*, Collection of Eric Buffetaud, Paris.

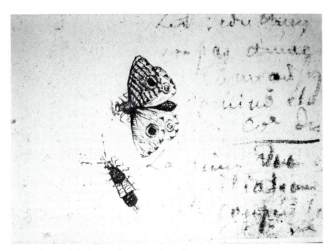

5.11. Gérard de Nerval, *Butterflies*, from the manuscript entitled *Rêves fatals—Lilith*, Collection, Jean Richer, Nice.

degree of mental disturbance is the heavy mark to the right of the turban. If this mark is the work of Nerval, it would almost certainly have been made during an acutely psychotic phase of his illness. Otherwise, the picture is only of interest in establishing the type of drawing that so amazed his contemporaries.

If I have dwelt so long on the work of Gérard de Nerval, it is principally because he represents a unique and little-known example of an individual who, although untrained as a painter, achieved considerable notoriety in his own day as an example of the insane artist. That Romanticism provided the motive force behind the curious reestimation of such images is suggested by the fact that the drawing *Hacine* was actually reproduced in 1887 in a publication that attempted to characterize the period that was then essentially at an end, entitled *L'age de romantisme*.[90]

If the drawings of Gérard de Nerval have been all but forgotten, overshadowed by his far more important contribution to French literature, another Parisian artist, of only slightly later date, can be seen as the draftsman equivalent of the writer Nerval—the engraver Charles Meryon (1821–1868).[91] To some extent the lives of these two men paralleled one another: both achieved considerable reputation while alive, and both experienced serious mental illness in the later part of their lives, manifesting prolonged psychotic mental processes that had a profound effect on their interpretation of reality and on their work as artists.

Meryon is of special importance in that, unlike Nerval, he provides an example of a highly trained visual artist responding in pictorial terms to the overwhelming impact of psychosis. Concentrating almost entirely during the 1850s and 1860s on making drawings and engravings, Meryon has been described as "probably the greatest French etcher of any time."[92] Traditionally his masterwork has been understood to be the series of twenty-two views of Paris known as the *Eaux-fortes sur Paris*, executed prior to the onset of his illness in 1858, when he was first committed to the Asylum at Charenton.

In 1855 (the year of Gérard de Nerval's death), there was a marked decline in Meryon's creative output, and he began to manifest unmistakable signs of psychiatric illness. Believing that he was condemned to death, and obsessed with paranoid fears about the Jesuits, he became suspicious even of his friends. He withdrew into near total isolation and began to elaborate strange ideas, which were reflected in prints of a very different and obviously pathological nature.[93] "Meryon refused to leave his bed, saying he could not cross a sea of blood, and threatened with a pistol those who approached him."[94] His friends had no doubt whatever that he had become insane. Philippe Burty, for example, described Meryon digging in his garden trying to exhume the cadavers he thought were buried there.[95]

At the height of this psychiatric crisis, in May 1858, the young artist Léopold Flameng (1831–1911) visited Meryon and drew the now famous portrait of him sitting in bed, his clothing and hair in disarray, his face emaciated from self-imposed fasting (Fig. 5.13). A unique document in the history of portraits of the insane, Flameng's picture depicts Meryon on the night before he was hospitalized at Charenton. An account of the making of this drawing has been preserved: "One evening M. Léopold Flameng (whose age was then only 27) came with a portfolio, a sheet of grey paper, and black crayons and, although Meryon did not really like

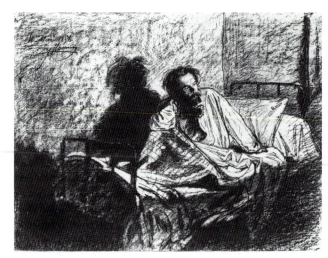

5.13. Léopold Flameng, *Charles Meryon Sitting Up in Bed*, 1858, heliogravure, Chicago Art Institute.

the idea, sketched a character portrait.... When the drawing was finished, Meryon asked to see it. Suddenly he jumped from his bed in order to tear it up, but Flameng upset his chair and ran away. The next morning, May 12, 1858, two policemen fetched Meryon, who without resistance, allowed himself to be taken to the Asylum of Charenton."[96]

The drawing, later reproduced as a heliogravure, represents a fusion of Romantic and Realist conceptions of insanity. In part it reflects the obvious concern of Meryon's friends, who were frightened and unsure of what to do in this increasingly dangerous situation. Undoubtedly it is an accurate portrayal of Meryon's appearance, capturing something of his detached and yet preoccupied state of mind. His disheveled hair and nightshirt, as well as the tangled bedclothes, convey the latent tension of a coiled spring. The looming darkness of the artist's shadow on the wall, almost a caricature of madness, embodies the Romantic ideal of the mad genius tormented by the vagaries of his uncontrolled and terrifying imagination.

Diagnosed as suffering from delirious melancholia, Meryon remained at the hospital for some sixteen months. During this time he made the acquaintance of several physicians, some of whom have left detailed accounts of the nature of his illness and his ideas.[97] At some time, either before or after this period, he also had come to know Dr. Paul Gachet, who was many years later the physician and friend of Vincent van Gogh. Gachet seems to have known Meryon, not as physician, but as an amateur of the art of etching. In

this role, he was inspired to depict the artist in a series of small portrait sketches. Later Gachet also depicted him in words:

Meryon was of small stature, bilious and nervous at the same time, dry and rather wizened. He dressed very simply. His gaze was distrustful and circumspect. He shunned pleasure and comradeship and was fond of solitude and work. Nobody seemed able to find him at home. To meet him or to entice him into a visit required long and elaborate preparations. His was an ailing and melancholy nature. He was sober, frugal, drank very little, and seemed perpetually on the alert and suffering from some obsession. . . . He was sensitive, straightforward, and full of delicacies, but with a limited brain. Art for him was a fetish, an ideal that nobody could attain. In fact, there were no artists—it was too difficult to be one. He himself was nothing at all. It was wrong to tell him that his work was good. He disliked this intensely, and praise was the surest way to turn him into an enemy.[98]

Inspired perhaps by the observations of Pinel on the treatment of the professional artist-patient, the Governor of Charenton provided Meryon with a small studio and allowed him access to the materials needed for the process of etching.[99] Only one work can be identified with certainty as originating in this unusual studio, the etching *Ruines du Chateau de Pierrefonds*, about which Meryon wrote, "J'ai fait à l'eau-forte ce petit paysage d'après un léger et spirituel croquis de M. Viollet-le-duc, étant à la maison impériale de Charenton."[100] Viollet-le-Duc (1814–1879), a major figure in the Romantic movement in France, visited Meryon at Charenton, bringing him as a gift the drawing that served as a basis for Meryon's etching. The etching itself, a copy of another artist's work, betrays no sign of mental abnormality. However, it would be of interest to know whether other drawings and prints, executed by Meryon at Charenton, once existed, but failed to be preserved precisely because they departed from his accustomed subject matter and style.

Although Meryon appeared to improve considerably while at Charenton, and was able to function minimally outside of the hospital, he never regained his sanity. He continued to be obsessed with delusional ideas that now made occasional, but dramatic, appearances in his graphic work. Unlike Gérard de Nerval, Meryon never attained lucidity sufficient to permit him to examine objectively the experience of psychosis. He remained deeply imbedded in his illness. He seems to have had little, and highly variable, control over the imagery now invading his etchings, beyond occasional attempts to account for it by scarcely plausible rationalizations. As a result, admirers of Meryon's work have to cope with a number of highly eccentric and inexplicable masterpieces that depart markedly from the norms of mid-nineteenth-century art.

The artist's friends, sadly aware of the seriousness of his illness and concerned about its effect on his life, tended to see his later work as inferior, marred by unmistakable signs of insanity. Philippe Burty, his closest friend, saw the "scènes fantastiques" as indicative of insanity and intimated his disapproval. Only Charles Baudelaire (1821–1867), with his great curiosity and visual sensitivity, was able to appreciate the more bizarre aspects of Meryon's symbolism.[101]

Later critics tended either to avoid all reference to the stranger works,[102] to describe them as inferior later productions,[103] or to invent rationalizations of their own with a view to denying the effect of Meryon's illness on his work.[104] Even in the early twentieth century, there were still attempts to link it with the theory of the insane genius.[105] However, there are rare individuals who can tolerate not understanding. "Considered psychologically, the work of Meryon is highly curious. It is thoughtful, reflective, intensely personal, and full of strange hints of a passionate fantasy, secret and subdued. This mental quality, far more than the manual dexterity of the artist, is the secret of his inexhaustible charm. He is a sort of enigma for us, which we are always trying to solve."[106]

What in fact was going on in his work? Possibly as early as 1855, Meryon had begun to rework the plates from which his earlier etchings were printed, adding new and unexpected elements to the streets and skies of Paris.[107] "The streets of all the etchings of the 1860's are filled with excited crowds or little groups of tall unnatural looking people, and all kinds of curious monsters and allegorical figures hover in the sky or swoop in rapid flight across it."[108]

Meryon was, of course, aware of the controversial nature of these additions and could, when asked provide elaborate rationalizations for their presence. Speaking of the plate *Tourelle, rue de l'école-de-médecine* of 1861, the sky of which, in the earliest states, is filled with a host of allegorical figures, he wrote:

This piece, although small, is in my opinion (And I have strong reasons to think so), my masterpiece: I speak of the state of the print in which is the composition of the sky: that is, on one side Justice who, in sight of Truth, shimmering in light, swoons, her balance and sword slip out of her hands; on the other, above, below the figure of a young child, seen from behind, the hair disheveled, the hands pressed to the forehead as though beneath the blow of an acute pain; stopped suddenly in her flight, rising, the two small wings fall away, detached, this very singular allusion, precise and direct, which compromises almost in itself all the interest of the subject, which I shall call finally Innocence wronged, violated.[109]

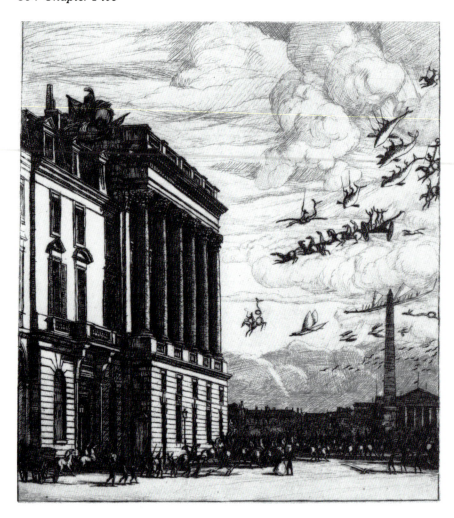

5.14. Charles Meryon, *Le ministère de la marine*, 1866, etching, Chicago Art Institute.

Clearly, the cryptic symbolism had enormous meaning for the artist, meaning that he only hints at in the allusion to "innocence wronged." If he was pushed to go further, the explanations could suddenly pass over into almost pure stream of consciousness, reflecting a complex, if somewhat contained, delusional system. Baudelaire, who knew Meryon well, asked him about the sudden appearance of great flocks of birds above the Pont au Change:

In one of his large plates, he substituted a flock of birds of prey for a small balloon, and when I remarked to him that it was unusual to put so many eagles in a Parisian sky, he replied that it was not groundless, since "those people" (the government of the Emperor) often released eagles to study omens after the rite; and that this had been put into print in the newspaper, even *Le Moniteur*. I should say that he doesn't conceal in any way his regard for all superstitions, but he interprets them poorly, and sees intrigue everywhere.[110]

Baudelaire then goes on to describe a series of very bizarre associations provided by Meryon, which ran from Edgar Allen Poe's *The Raven*, to delusions about two women killed by a monkey, to identification with the monkey, and finally to a conviction that Meryon had morally assassinated two women.[111] By pushing Meryon to comment on his symbolism, Baudelaire suddenly found himself immersed in profoundly personal and psychotic ideas. What is impressive is Baudelaire's powerful objectivity in this situation. He concludes his description of this event: "Don't scoff at this sorry fellow. I would not be prejudicial to this talented man for anything in the world."[112]

The most controversial of Meryon's etchings is the late print *Le ministère de la marine* (1866), which exists both in the form of an objective preparatory drawing of the building, and as an etching in which the sky is occupied by a host of totally mad figures: black birds,

a horse-drawn chariot, mounted warriors, war canoes, and enormous fish (Fig. 5.14). It is known that he worked on this plate for over a year. Dr. Gachet wrote: "This proof preoccupied and disturbed Meryon very much. I never knew why. He regretted, he said, to have given it to me, and begged me not to show it to anyone. I even think that he asked for it back, in vain, you understand."[113] Although the picture undoubtedly reflects attitudes that Meryon held in regard to the Ministry of the Navy, under which he served in his youth, efforts to explain this print as an objective political statement are naive.[114] What is of interest is the juxtaposition of objective topographical illustration and psychotic images originating in the unconscious, indicating an occasional breakthrough of intense delusional thought that overwhelms his rational judgment. There is also a change in the drawing style in these figures, which suggests a more primitive and compulsive internal

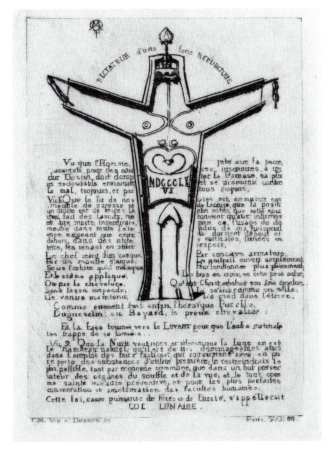

5.15. Charles Meryon, *La loi lunaire* (second plate), 1866, Chicago Art Institute.

force controlling the movement of his mind and hand. One would anticipate other pictures in which the delusional system would have taken over completely, but such images are nearly absent in Meryon's work, with one important exception.

In 1855, the onset of the initial acute phase of his illness was reflected in the creation of the print known as *La loi solaire*, followed in 1866 by *La loi lunaire*. This second print, in particular, reveals extremely crazy ideation matched with bizarre designs for an upright coffin within which Meryon recommended that men and women should be forced to sleep. This pathological morality, expressing severe disturbances in sexual functioning, continued to preoccupy him, to the extent that he later put it into effect, designing an upright structure consisting of two planks between which he slept, standing, his arms supported by loops of rope.

In 1866 he produced another etched version of *La loi lunaire* with a new drawing of the container for upright sleeping (Fig. 5.15). With this drawing we enter the realm of pure schizophrenic art free of rational admixture. Meryon seemed to know that these etchings provoked negative responses, and he preferred not to speak of them. "I have already had occasion to express several times, an opinion that is carefully thought out, that it is fitting neither to show these pieces, nor to discuss them except extremely discreetly and prudently, because they can cause great disorders, even great evils. There are but a small number of proofs and it is not necessary to multiply them."[115] This fear of causing great disorders is paralleled by delusional ideas that obsessed him while in the hospital, "that his return to Paris would be the signal for great disasters and that great unhappiness would be the fate of those who dared to accompany him in the streets."[116]

The design for an upright bed of 1866 is a further elaboration on that of 1856, demonstrating the persistence of this idea. It should not be thought of simply as a drawing, but as a plan for an actual structure to be built, probably of wood. The coffinlike container is enhanced by the addition of wings, which enable the sleeper to assume the position of Christ on the cross. Meryon's delusions in this later phase of his illness centered on an identification with Christ. Examination of the print reveals many characteristics that would later be recognized as typical of the art of schizophrenics. Particularly striking is the tendency for the overall form of the coffin-bed to suggest a huge face, while revealing major structures suggesting the erect phallus (below, between the legs), and the breast-vagina (above in the area of the heart). The primitive style of the drawing, unlike any other images in Meryon's

oeuvre, reflects the extreme deterioration in his mental state, which brought about his readmittance to the Hospital of Charenton in October of the same year.[117]

Not surprisingly, the drawing, occupying a place so remote from the evolution of nineteenth-century French art, has been all but ignored by students of Meryon's work.[118] Confronted with such bizarre and seemingly meaningless imagery, the fading Romanticism of the later part of the century was no longer sufficiently strong to incorporate such an image within its vision of the mad genius and his work.

In bringing this exploration of Romantic attitudes toward insanity and the insane to a close, I would like to discuss one last painting of a madhouse interior. Executed at the end of the century, in 1889, the picture, I believe, can best be understood as almost uninfluenced by the Romantic tradition. It might be described as a "realist" portrayal of a hospital deriving from an objective view of insanity based on intense personal experience.

Our examination of Romantic conceptions of insanity has tended to suggest that writers or artists who had no experience of the insane or of insanity were the most inclined to accept and cultivate with great imaginative enthusiasm the Romantic notions about mental illness and its relation to creativity.[119] Personal experience of mental illness, as in the case of Lamb or Nerval, led to a more conservative and empirical view of the problem, and to statements that avoided or opposed the genius–insanity theory. Nevertheless, the impact of Romantic conceptions of insanity was sufficiently pervasive to ensure that even the most experienced patient or physician was inclined to understand his experience of insanity in Romantic terms. Yet this was not necessarily a bad thing, for the insane and their art are as strongly influenced by the dominant ideas and modes of feeling and perceiving characteristic of their period as are other individuals.

The work in question is Van Gogh's *Hospital at Arles* (Plate 7), painted, in part, while he was a patient in this institution. At this period in his life the artist suffered from intermittent attacks of very severe mental illness.[120] However, his portrayal of the hospital ward and its patients shows no sign of mental disturbance. Van Gogh painted the interior of the psychiatric ward of the hospital just as he painted the town of Arles, his house, or the local pool hall. "I am working, and have just finished two pictures of the hospital, one of a ward, a very long ward, with rows of beds with white curtains, in which some figures of patients are moving. The walls, the ceiling with big beams, all in white, lilac-white or green-white. Here and there a window

with a pink or bright green curtain. The floor paved with red bricks. At the end a door with a crucifix over it. It is all very very simple."[121] In a letter to Theo, Vincent identifies the scene as "a study of the mad ward at the Arles Hospital."[122] Work on the picture continued despite the move to a new hospital at St. Rémy. "I am now working on a ward in the hospital. In the foreground a big black stove surrounded by a number of gray and black figures of patients. . . ."[123]

The artist's motive for continuing or resuming work on the picture is known. He stated that he had been inspired to do so by reading a book on Dostoevsky (1821–1881), which included a description of the novel *Souvenirs de la maison des morts*. The somewhat Romantic tone of the title belies the intensely realistic nature of Dostoevsky's description of life in a prison in Siberia. There is no doubt that at times van Gogh felt himself to be a prisoner trying to cope with his enforced existence in the strange new world of the hospital. "Anyhow here I am, shut up in a cell all the livelong day, under lock and key and with keeper, without my guilt being proved or even open to proof."[124] Van Gogh's descriptions in letters of the hospital and its inmates are strikingly similar in quality to the growing awareness and understanding of Alexandr Petrovitch in the Dostoevsky novel, and reflect his struggle to ascertain, in his own mind, his position within this new reality. The letters as a whole provide a most extensive record of the origin and development of a sequence of essentially non-Romantic attitudes to the insane.

I wanted to tell you that I think I have done well to come here; first of all, by seeing the reality of the life of the various madmen and lunatics in this menagerie, I am losing the vague dread, the fear of the thing. And little by little, I can come to look upon madness as a disease like any other.[125]

His descriptions of the hospital environment display the same objectivity that one feels in the painting.

The room where we stay on wet days is like a third-class waiting room in some stagnant village, the more so as there are some distinguished lunatics who always wear a hat, spectacles, and a cane, and travelling cloak, almost like at a watering place, and they represent the passengers.[126]

Van Gogh's perception of his fellow patients displays a similar objectivity.

The fear of madness is leaving me to a great extent, as I see at close quarters those who are affected by it in the same way as I may very easily be in the future. . . . For though there are some who howl or rave continually, there is so much of real friendship here among them: they say we must put up with others so that the others will put up with us . . . and amongst ourselves we understand each other very well. For

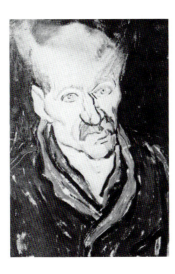

5.16. Vincent van Gogh, *Portrait of a Patient*, 1889, oil on canvas, Rijksmuseum Vincent van Gogh, Amsterdam.

instance, I can sometimes chat with one of them who can only answer in incoherent sounds, because he is not afraid of me.[127]

This growing perception of the insane as individuals is reflected in van Gogh's painting. During this period he began to paint portraits not only of his physicians, but of the patients as well. "At the moment I am working on a portrait of one of the patients here. It is curious that after one has been with them for some time and got used to them, one does not think of them as being mad any more"[128] (Fig. 5.16). Comparison of this portrait with others of the period—for example, that of the hospital attendant Trabu—suggests that van Gogh was very much involved with trying to capture something of the emotional quality of insanity without resorting to any of the traditional conventions for so doing. The painting is clearly a portrait of a specific individual and could easily go unrecognized as the depiction of a person suffering from mental illness. Knowledge of its origin, however, makes one aware of the patient's remoteness and lack of contact and his almost otherworldly preoccupation. The curiously undefined treatment of the contours of the head and forehead, where lines appear to radiate out into the surrounding space, might well suggest the source of the patient's mental involvement—hallucinatory voices or images experienced as coming from outside, experiences with which Vincent was personally familiar. In its restrained objectivity, the painting belongs firmly in the tradition of the portraits of the insane established by Géricault.

Van Gogh saw the experience of illness in terms of his identity not only as an individual but also as an artist. His concern about its effect on his art betrays vestiges of Romantic ideas about madness and creativity. His evolving understanding of his own condition (whose nature is not of significance to this discussion) can be described in terms of a rejection of the Romantic viewpoint.

Formerly I felt an aversion to these creatures (the insane), and it was a harrowing thought for me to reflect that so many of our profession, Troyon, Marechal, Méryon, Jundt, M. Maris, Monticelli, and many more had ended life like this. I could not even bring myself to picture them in that condition.[129]

Well I with my mental disease, I keep thinking of so many other artists suffering mentally, and I tell myself that this does not prevent one from exercising the painter's profession as if nothing were amiss.[130]

I really must make up my mind, it is only too true that lots of painters go mad, it is a life that makes you, to say the least, very absent minded. If I throw myself fully into my work again, very good, but I shall always be cracked.[131]

A French writer says that all painters are more or less crazy, and though quite a lot can be said against this, it is certain that one gets too distraught in it. Whatever the truth of it may be, I imagine that here, where I don't have to worry about anything, etc., the quality of my work is progressing.[132]

The enormous myth that has grown up around van Gogh as the "mad artist" was not a product of his own period. During his lifetime it would seem that his psychological condition, while known to his family and friends, was not spoken of beyond this circle, and was not associated with his work. The paintings were not seen as the product of a madman. The artist himself was deeply concerned with the possible effect of his illness on his work and suffered severe anxiety that his ability as an artist might be impaired. Writing to A. H. Koning he emphasizes, "I haven't wholly lost my equilibrium as a painter."[133] On the other hand, it is clear that he suspected that some of the paintings might betray his mental state, that they might in themselves be mad. Writing to his brother in May 1889 he says:

I hope you will destroy a lot of the things that are too bad in the bunch I have sent you, or at least only show what is most passable. As for the exhibition of the Independants, it's all one to me, just act as if I weren't here. So as not to be indifferent, and not to exhibit anything too mad.[134]

Let me go quietly on with my work: if it is that of a madman, well, so much the worse. I can't help it.[135]

Certainly van Gogh could never be accused of exploiting his psychological state as a means of gaining notoriety or fame, nor did he ever see himself in terms of the Romantic notion of the insane genius. In this sense

then, he represents a radical break with the prevalent Romantic conception at the time, and a fitting conclusion to a discussion of how this complex of fantasy and ideas evolved during the nineteenth century.

WHILE the discovery of the image-making activity of the insane had been made by artists, at least insofar as they were the first to record and to comment on this curious phenomenon, without the impetus provided by Romanticism it is doubtful whether this discovery would have gone beyond the simple observation that such activity occurred in the madhouse. The Romantic conception of the artist and of the creative act led irresistibly to a preoccupation with the insane, first on a purely imaginative level, then in the form of encounters with them, both in terms of actual visits to the asylums in which they were housed; in the form of paintings of asylum interiors and their inhabitants; and, finally, in terms of an interest in the artistic productions of these people, their writings, and their paintings, drawings, and sculpture. The Romantic world, that irrational and essentially internal climate of opinion and emotion, exerted its influence well beyond the artists and writers of the day. It is doubtful whether anyone remained untouched by it except perhaps those people whose total lack of contact with any degree of education or culture tied them in blind bondage to the earth. It is easiest to demonstrate the influence of these ideas in the case of artists and writers because they expose the workings of their minds and hearts more than the rest of us. But madmen too reveal their inner reality, perhaps against their will, and here too the influence of Romantic ideas, images, and feelings quickly became apparent. In later chapters it will be seen that the psychology and psychiatry of the era, such as it was, was strongly permeated by the ideals of Romanticism, and that the attitudes toward insanity engendered by the Romantic movement played a very major role in the development of these sciences and the preoccupation of scientists with certain areas of psychological investigation. Within the intellectual climate fostered by Romanticism, physicians and psychologists, artists, critics, and historians of art suddenly found themselves operating within areas of common interest and concern, possessed by an intense preoccupation with, and curiosity about, the art and the reality of the insane.

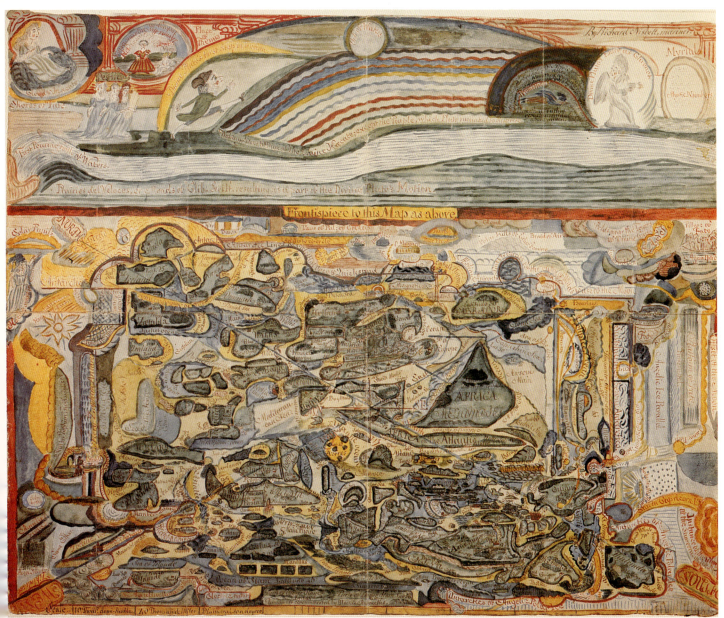

1

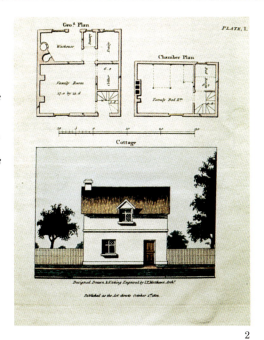

2

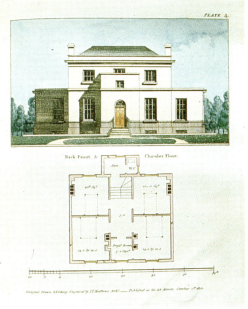

3

PLATE 1. Richard Nisbett, Mariner, psychotic map, watercolor, The Historical Society of Pennsylvania, Philadelphia.

PLATE 2. James Tilly Matthews, *A Small Cottage*, a hand-colored engraving, from *Useful Architecture* (London, 1812), Sir John Soane's Museum, London.

PLATE 3. James Tilly Matthews, *An Economical Villa*, a hand-colored engraving, from *Useful Architecture* (London, 1812), Sir John Soane's Museum, London.

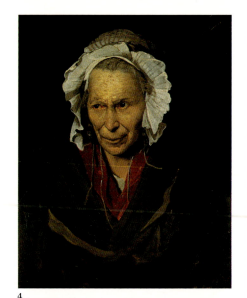

4

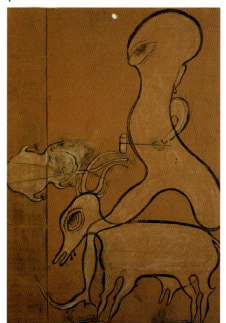

5

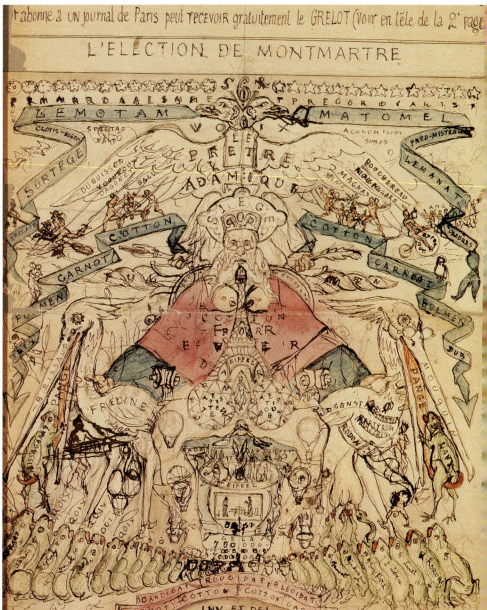

6

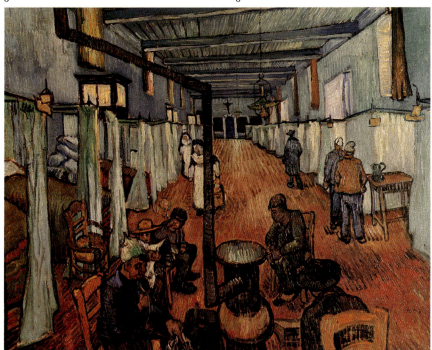

7

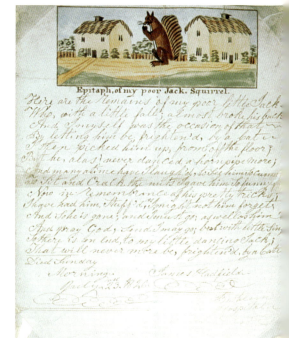

8

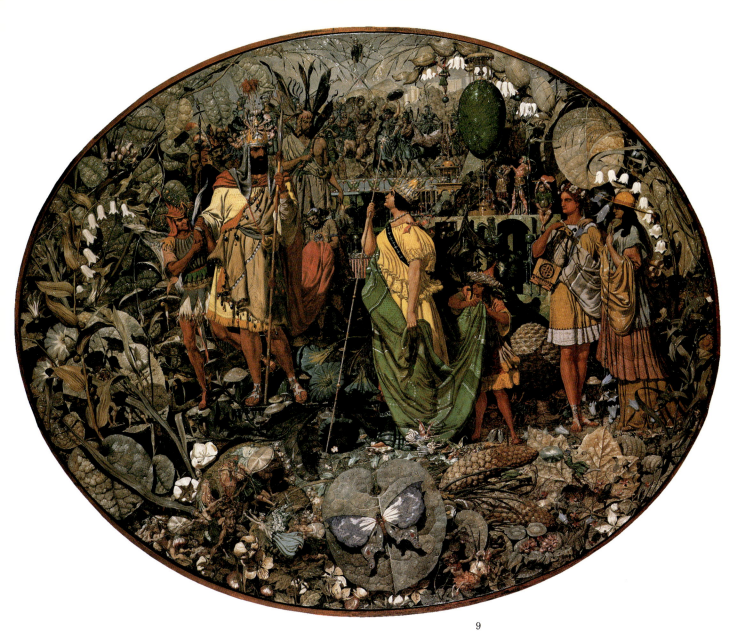

9

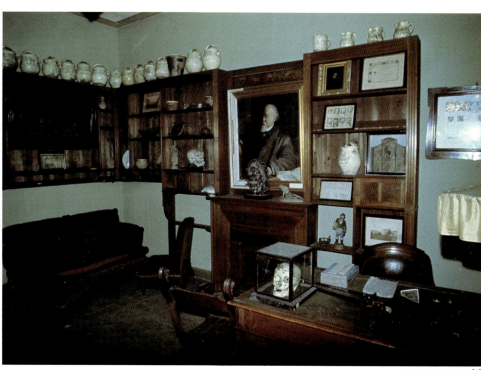

PLATE 4. Théodore Géricault, *"La folle" ou monomanie de l'envie*, oil on canvas, 1822–1823, Musée des Beaux-Arts, Lyon.

PLATE 5. Heinrich Anton Müller, *Personnage avec chèvre et grenouille*, black and white chalk over pencil on cardboard, Kunstmuseum, Bern.

PLATE 6. Xavier Cotton, *Election de Montmartre*, November 1890, Chinese ink with watercolor and colored crayon, Collection de l'Art Brut, Lausanne.

PLATE 7. Vincent van Gogh, *Hospital at Arles*, 1889, oil on canvas, Oskar Reinhart Collection, Winterthur, Switzerland.

PLATE 8. James Hatfield, *Epitaph of my poor Jack, Squirrel*, 1826, watercolor, The Bethlem Royal Hospital, London.

PLATE 9. Richard Dadd, *Contradiction. Oberon and Titania*, oil on canvas, 1854–1858, The Regis Collection, Minneapolis, Minnesota.

PLATE 10. The study of Cesare Lombroso, Museo di Antropologia criminale, Turin.

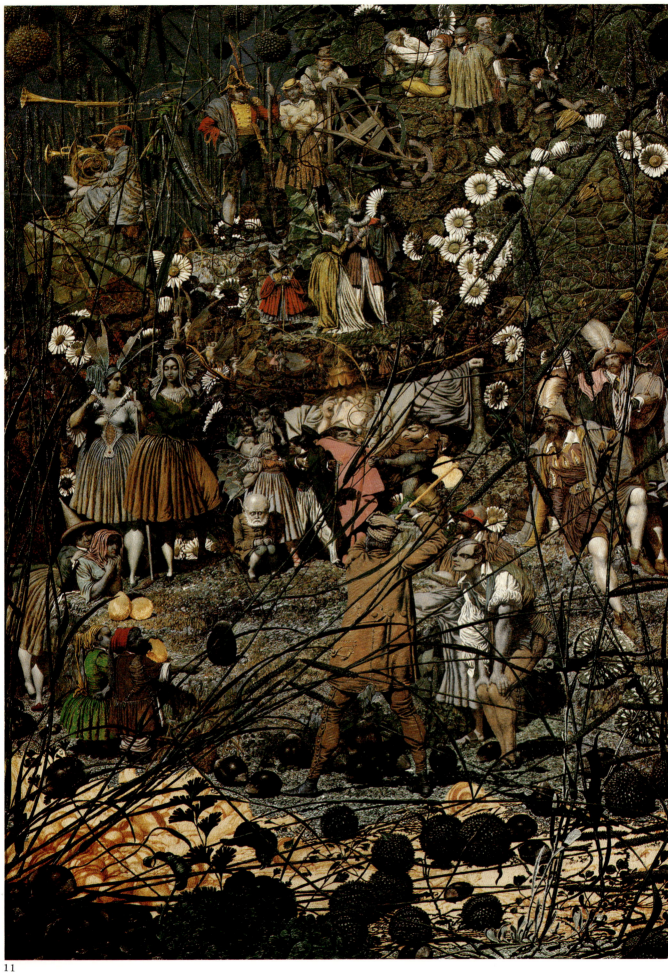

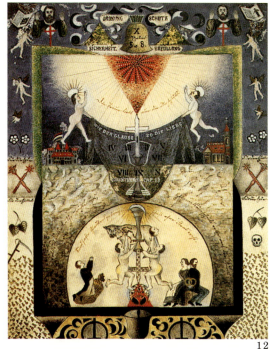

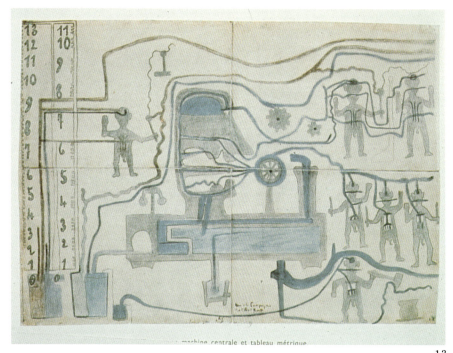

12

13

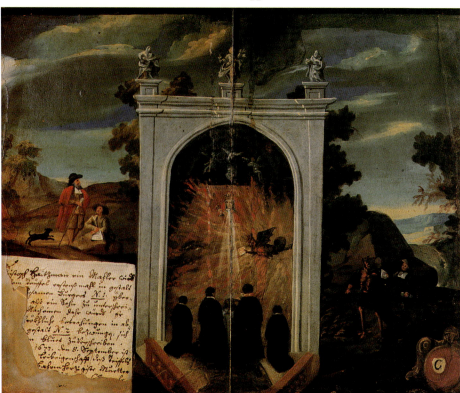

14

15

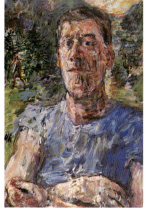

16

17

PLATE 11. Richard Dadd, *The Fairy Feller's Master Stroke*, oil on canvas, 1855–1864, The Tate Gallery, London.

PLATE 12. Hermann Heinrich Mebes, *Allegorical-Symbolic Work*, watercolor, Prinzhorn Collection, Heidelberg.

PLATE 13. Robert Gie, *Distribution d'effluves avec machine centrale et tableau métrique*, 1916, pencil, crayon, and ink on paper, Collection de l'Art Brut, Lausanne.

PLATE 14. After Christoph Haizmann, *The Return of the Pact with the Devil*, ca. 1729, Österreichische Nationalbibliothek, Vienna.

PLATE 15. Anonymous, sculptural portrait of Dr. A. Marie, Cesare Lombroso Collection, Museo di Antropologia criminale, Turin.

PLATE 16. Seraphine de Senlis, *L'arbre du paradis*, ca. 1929, Musée National d'Art Moderne, Centre Georges Pompidou, Paris.

PLATE 17. Oskar Kokoschka, *Self-Portrait of a Degenerate Artist*, 1937, oil on canvas, private collection, Scottish National Gallery of Modern Art, Edinburgh, © COSMOPRESS, Geneva, 1988.

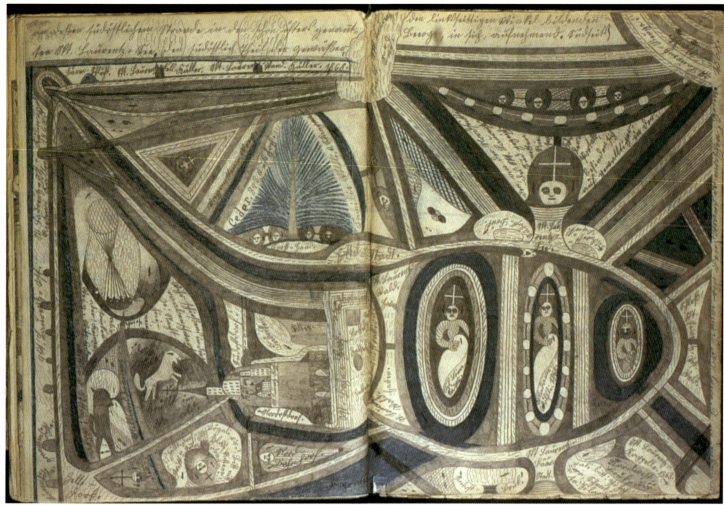

18

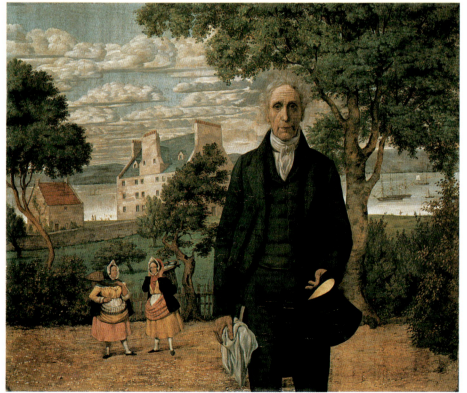

19

PLATE 18. Adolf Wölfli, *Sankt Laurentz-Stadt*, 1909, from *From the Cradle to the Graave*, 3: 401–2, Adolf Wölfli-Stiftung, Kunstmuseum, Bern.

PLATE 19. Richard Dadd, *Portrait of Sir Alexander Morrison*, 1852, oil on canvas, Scottish National Portrait Gallery, Edinburgh.

PLATE 20. "Le Voyageur Français," decorative composition, 1902–1905, watercolor, Collection de l'Art Brut, Lausanne.

PLATE 21. Ernst Josephson, *Portrait of Stage Director Ludvig Josephson*, 1893, oil on canvas, National Museum, Stockholm.

PLATE 22. Adolf Wölfli, Untitled, 1911, from *From the Cradle to the Graave*, 4: 346, Adolf Wölfli-Stiftung, Kunstmuseum, Bern.

PLATE 23. August Natterer, *Witch's Head*, Prinzhorn Collection, Heidelberg.

PLATE 24. Franz Karl Bühler, *Fabulous Animals*, chalk, Prinzhorn Collection, Heidelberg.

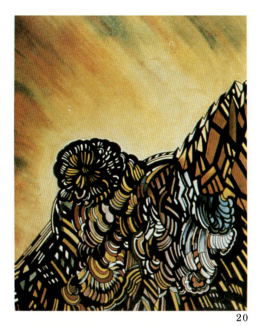

20

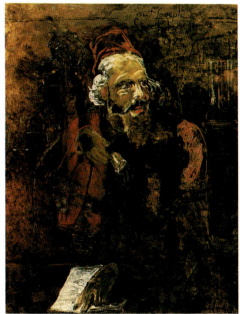

21

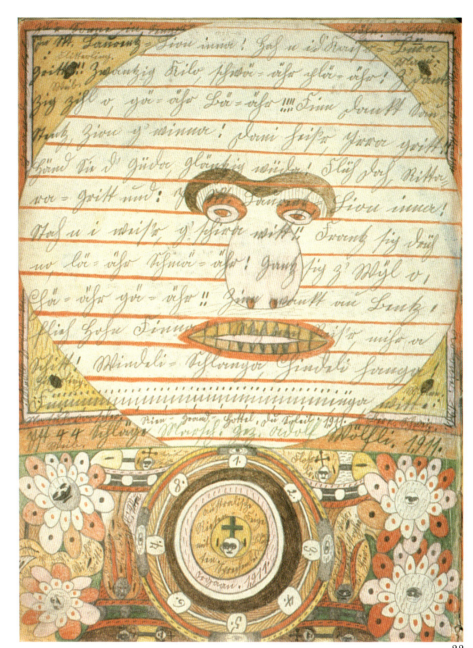

22

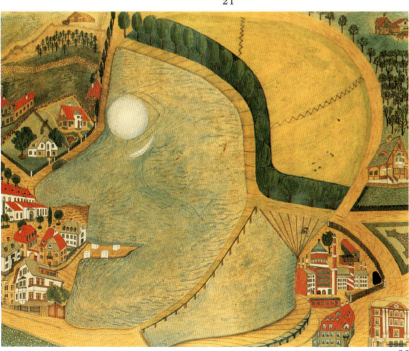

23

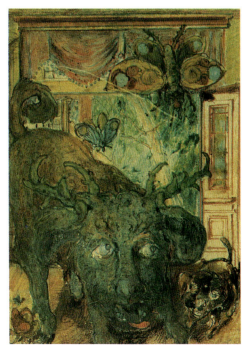

24

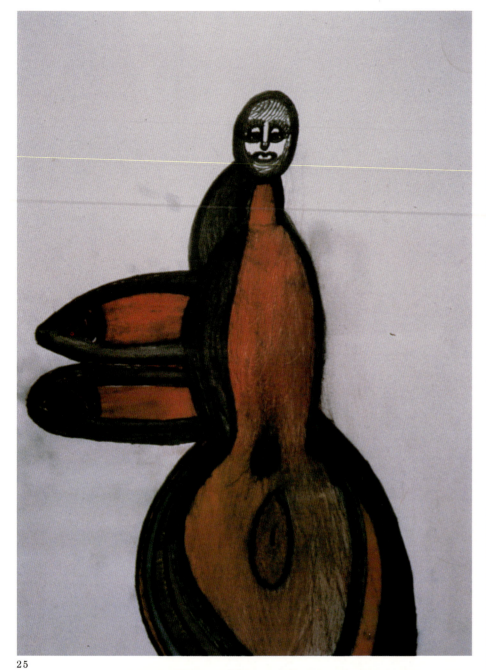

25

26

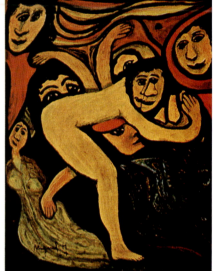

27

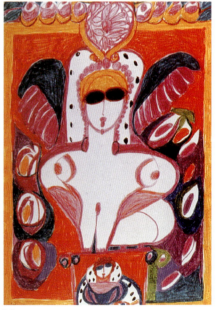

28

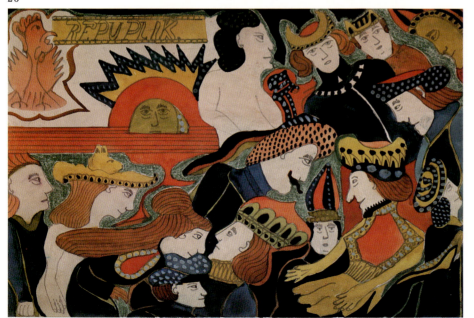

29

PLATE 25. Johann Hauser, *Woman*, 1985, pencil and colored pencil.

PLATE 26. Emil Nolde, *Dance around the Golden Calf*, 1910, oil on canvas, Stiftung Seebüll Ada and Emil Nolde, Seebüll.

PLATE 27. Miguel Hernandez, *Woman and Birds*, 1947, oil on canvas, Collection de l'Art Brut, Lausanne.

PLATE 28. Aloïse, *Sphinx–Maria Stuart*, Musée Cantonal des Beaux-Arts, Lausanne.

PLATE 29. August Klotz, *Repuplik*, gouache, Prinzhorn Collection, Heidelberg.

Cesare Lombroso: The Theory
of Genius and Insanity

The Romantic preoccupation with the idea of a link between genius and insanity was the strongest single factor motivating the investigation of the art of the mentally ill in the nineteenth century. It is not less important because it invariably led its exponents astray. The extreme tenacity of this pernicious idea demands explanation. It is by no means easy to account for its amazing popularity. To this day it continues to form part of the mental furniture of many people, contributing to the popular notion of the artist as a social outcast.

The prevalence in the later nineteenth century of this conception of the nature of genius can, in part, be explained by its wide acceptance in the scientific community. Originating in Plato, accepted as a central canon of Romanticism, it was also adopted with enthusiasm by scientists, physicians, and pseudoscientific biographers as the basis of their investigation of the phenomena of creativity and of the psychology of genius. The theory of the insanity of genius provides a significant example of how irrational prejudices erupt into the objectivity of scientific observation.[1] Modern science, usually portrayed as the product of the intellectual rigor and skepticism of the Enlightenment, was not unaffected by the occasional irrationality of Romanticism. A new field of study made its appearance at this time, quickly attaining immense popularity—the pseudoscience pathography.

Toward the end of the century, a veritable stream of books and articles was produced whose authors attempted to demonstrate the psychopathology of every major painter, poet, musician, and writer.[2] Not surprisingly, some creative individuals had suffered from mental illness at some time during their lives, and these cases, about which very little information was publicly available, provided the ammunition for uninhibited, usually wildly distorted, accounts of the supposed psychological anomalies of genius. These efforts at pathographic reconstruction are of little interest, and make rather dull reading today, although they inspired massive enthusiasm and occasional opposition at the time. For our purposes it will be unnecessary to wade through the endless verbiage and the long lists of names and matching syndromes that once purported to prove the insanity or degeneracy of one or another creative giant.

The genius–insanity theory did, however, raise some interesting questions which led scholars into more productive channels. After all, if genius was to be identified as a form of psychosis, or as an inherited psychopathological condition, it became vitally important to take a closer look at the creative activity and artistic productions of psychotic patients. Were there perhaps unrecognized geniuses concealed in the asylums? If the greatest painters and sculptors were in a dangerous state of mental imbalance, then clearly it became essential to examine the drawings and paintings of patients diagnosed and confined as insane.

As we have seen, throughout history, and well into the nineteenth century, these drawings had been treated as nothing more than the mindless antics of lunatics. When they were mentioned, it was only to comment on the fact of their existence, or to verify their bizarre or absurd qualities. However, the conviction that genius was related in some way to insanity, or was itself a psychotic illness, led physicians to examine the artistic productions of the insane with far greater interest and attention. The proponents and opponents of the theory sought to buttress their point of view with evidence collected in the hospitals in which they worked. The insane artist suddenly acquired an attentive audience.

AN IMPORTANT early example of an investigation of patient art produced in a single hospital was published in Italy in 1880. Written by a physician working in Pesaro, Dr. L. Frigerio, the article was entitled "Art and Artists in the Insane Asylum of Saint Benedetto."[3] This small hospital, which at the time the article was written housed 388 patients, seems to have possessed an unusually large number of active image makers, perhaps a consequence of the hospital's decision in 1872 to institute drawing classes for the inmates.[4]

Frigerio's investigation was not motivated by belief

in the artistic value of his patients' work, or by any involvement in the genius–insanity controversy. His expressed aim was fairly specific: "It seemed interesting to us to study, naturally without any pretension, the relationships that exist between the artistic product and the mental condition" (p. 22). His accomplishment in this regard was very limited, being confined to indicating similarities between the patients' delusional ideas and the images that appeared in their work. "Frequently the works of a lunatic are quite precisely nothing more than an aspect of the same delirium which affects them" (p. 23). He made no systematic effort to extend this insight by establishing links between the type of drawing and the specific illness from which its creator suffered. His real interest in the drawings was directed toward answering a different and fundamentally more important question, which obviously puzzled him: Why do these people draw? He was concerned not with the products of the hospital art class but rather with the spontaneous artistic activity that, as he pointed out, occurred even among poor people who, prior to falling ill, had had no involvement with art.

The first result of this inquiry was the striking observation that image making at S. Benedetto was almost entirely confined to the male inmates. "Among the female lunatics, either because of their limited intellectual training, or because of the special habits that are natural to their sex, artistic attitudes are found much more seldom: we know, in fact, only two lunatic ladies who draw" (p. 22). In terms of the type of illness most likely to produce artistic activity, he concluded, "the greatest number of works has been supplied by monomaniacal lunatics" (p. 22). He dismissed individuals affected by dementia as pseudoartists, pointing out that "in some cases of dementia there is a complete lack of coherence and common sense in the drawings, and in any other kind of work, as well as in the writings" (p. 23).

Having supplied these few statistical observations, he then turned to an examination of individual cases, in an attempt to understand what their purpose might be in drawing. Having raised so specific and intelligent a question, he was driven at once to an examination of the pictures themselves. What clues did they hold as to the patient's intention and motivation? He discussed eighteen individual cases very briefly, and then attempted to generalize from them.

The most intriguing of his patients, identified only as "M," seems to have stimulated him to think seriously about the problem, and led him to a number of insights.

M . . . , once a professor of humanities and a poet of some distinction, went through all the phases of ambitious delirium. He thought himself, at first, to be a great painter, and he illustrated his endless poems with thousands upon thousands of inexplicable daubs that represented animals of the strangest configurations, these animals coming to grips with men and women, all naked, in the most original positions, forming a whole of great imaginative strength expressed by the strangeness of the lines. Even the walls of his room were decorated by M . . . with obscene and disgusting figures. With the pretension of illustrating a new *Divina Commedia*, of his own creation, he joined friars and priests, more or less mitered, with naked women. Then, to avenge himself on the steward, who had refused him some tobacco, he painted his effigy, placing it among the above-mentioned figures, all of them immersed in the filthiest of sloughs. . . . Many of the sculptures made by M . . . , since he wanted to be a sculptor as well, besides being provided with the distinctive features already mentioned in the pictorial works, were characterized in a particular way, by their resemblance to bas-reliefs of a primitive style, others reminding one quite closely of pagan idols. (p. 22)

Frigerio was aware that boredom might provide a partial but significant explanation for his patients' involvement with art. Beyond that, he had begun to consider the role of certain kinds of psychological experience in fostering this sort of activity. For example, "M," whose perception of himself was enormously inflated, was motivated by a desire to demonstrate the artistic ability of which he had boasted. Megalomania, it appeared, enabled him to break down the inhibitions and lack of confidence that prevents normal adults from drawing. His anger at the hospital steward, toward whom he had no other means of expressing his feeling of rage, led him to use drawing as a means of obtaining symbolic revenge, the parallel with Dante providing a precedent. We are inevitably reminded of the drawing of the keeper included in the picture by Kaulbach. Frigerio stressed the importance of hatred and revenge as a very frequent motive behind his patients' drawing activity. Most important, "M" was able to express his sexual preoccupations through drawing, covering the walls with a veritable orgy of obscene and sacrilegious images. Frigerio seems not to have recognized the degree to which the frustrating environment of the hospital, and the realistic feelings of helplessness and impotence it engendered, contributed to, indeed necessitated, the discovery of a means of substitutive satisfaction. He was struck only by the fact that this patient's sexual imagery paralleled the erotic content of his delusions.

The necessity for a symbolic means of satisfaction was made clear in the case of "V," a young sailor, suf-

fering from intervals of melancholia, who built elegant little boats and small vessels. The patient explained that this form of work "made him relive the life on board and is a great comfort to him" (p. 23). Frigerio then observed that the kind of profession engaged in by patients prior to falling ill "would impart a special character to the artistic work of the lunatics" (p. 23). In passages like this, one senses quite directly the enormous distance that separated patient and physician, a terrible gap that empathy and identification seldom succeeded in bridging. Many of the early observations seem incredibly obvious to us. But we must be aware that we use empathy to feel out the reality of these people. Frigerio was still at the point of realizing that lunatics might be human. The strangeness of some of the imagery stood in the way of understanding. "R," for example, drew over and over again pictures of a bee gnawing at the cranium of an ant. Frigerio noticed that the drawings of these images, "extravagant beyond all possibility of description," were made at times of manic excitement (maniacal exaltation), which he linked with "sudden atmospheric changes." Other subjects seemed more understandable. Paulo P., a lunatic for many years, "convinced of having been killed by repeated shots of firearms, draws harquebuses and pistols everywhere" (p. 23). Marc., described as suffering from "erotic delirium," "having built a cloakstand, gave the peg a shape much similar to that of the male organ in full erection" (p. 23).

There is about Frigerio's report an element of naiveté coupled with the excitement of discovery. One can visualize him making the rounds of his small hospital, greeting the patients, all of whom would have been familiar to him. The objects and images they produced, some proudly, others secretly, puzzled him, and he obviously allowed himself to think about their function in the lives of these people, whose cases he knew so well. There is a comfortable intimacy about his description, which stems not from identification, but from a long period of contact with mad people. His interest in their work may have gone deeper than even he realized. Superficially, he was attracted by their strangeness, and involved in trying to approach them "scientifically." But, although he did not reproduce the drawings, it would seem that they possessed a curious power, not to be confused with "beauty," that could no longer be ignored.[5] Frigerio was content simply to describe the cases he had observed. We now turn to a far more famous student of the art of the insane, who, using almost identical material, some of it actually borrowed from Frigerio, constructs a vast theoretical framework around the concept of the insanity of genius.

CESARE LOMBROSO (1835–1909),[6] the enormously influential anthropologist, criminologist, and psychiatrist, was perhaps the foremost, and certainly the most prominent, scientifically trained exponent of the genius–insanity theory in the nineteenth century (Fig. 6.1). Very much a man of his time, Lombroso, apart from his studies of genius, was deeply preoccupied with problems of diagnosis and classification. He recognized the potential value of the drawings of the mentally ill in providing visual evidence of mental pathology and was one of the first psychiatrists to assemble a large collection of paintings and drawings executed by patients both in the hospitals in which he worked and other hospitals in Italy and Europe. In the relevant chapter of his book *L'Uomo di Genio* [*The Man of Genius*] he presented data on one hundred eight cases revealing what he referred to as "artistic tendencies." Of these, seventy-two were active in one or another of the visual arts. Given Lombroso's theoretical orientation, which stressed concepts such as heredity and physical degeneracy, only certain methods of approach were available. His thinking led to a generalized view of what he termed "l'arte nei pazzi," in which all of the drawings of the mentally ill had of necessity to be "insane."

Lombroso was an enormously productive scholar, with publications in every area of psychiatry and psychology. He was among the most influential and prominent figures in psychiatry in the generation preceding Sigmund Freud. However, his deep commitment to the

6.1. Cesare Lombroso.

now outmoded concept of degeneracy has led to the al-most total eclipse of his once great reputation. His chief contribution had been the application of this neg-ative diagnostic classification, first introduced by Benedict-Augustin Morel (1809–1873) in the 1850s, to the study of the psychology of criminals. Lombroso was convinced that criminals and lunatics were born rather than produced by social conditions. To some ex-tent psychiatry is still struggling against the intensely pessimistic conception of mental illness by which it was dominated in the last quarter of the nineteenth century.

Lombroso's chief contribution to the genius–insanity controversy was the book *L'Uomo di Genio*, first pub-lished in 1864 under the title *Genio e Follia*. The book was immensely popular, going through six editions in thirty years. It was translated into French in 1889, English in 1891, and German in 1894.[7] No single pub-lication has contributed more toward shaping the pop-ular conception of artistic genius.

In a series of books and articles, Lombroso and his followers piled up vast quantities of "evidence" to sup-port the thesis that genius was a form of "moral insan-ity," and that all geniuses should be diagnosed as suf-fering from a degenerative psychosis. No major figure in the arts, philosophy, or even natural science could escape the vilification of these mudslinging pathogra-phers. Lombroso's determination to attribute the crea-tivity of most artists, and particularly those he did not like, to hereditary insanity inevitably led to serious distortion and exaggeration in his study of the fine arts.

In 1880 Lombroso's article entitled "L'Arte nei pazzi" was published jointly with the French intellec-tual Maxime du Camp. This article represents Lom-broso's first published discussion of the drawings and paintings of patients as opposed to men of genius.[8] His large collection provided ample material for a detailed investigation, but his purpose in undertaking studies of the art of hospitalized mental patients resulted in a rather prejudiced view of their essential characteris-tics.

The collection assembled by Lombroso has miracu-lously survived intact as part of the Museum of Crim-inal Anthropology in Turin.[9] The original museum, as conceived and designed by Lombroso himself, has also been carefully preserved and represents the earliest surviving example of a nineteenth-century collection of the art of the insane.[10] Lombroso's spirit can be felt very strongly in these rooms, especially in the library, which remains exactly as it was in his day (Plate 10). Lombroso's involvement in the study of psychiatric art

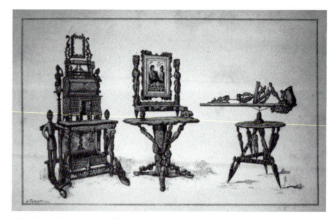

6.2. Furniture made by a paranoid patient, the Lombroso Collection, Museo di Antropologia criminale, Turin, from Lombroso, *Man of Genius* (Turin, 1882), plate 26.

led him to make contact with other workers in this field all over Europe, and even in America. There is a tendency to imagine these men as lonely pioneers working in isolation. Lombroso's files contain letters and drawings sent to Lombroso by Frigerio, by Paul-Max Simon, and others and are therefore of particular importance in documenting contacts between investi-gators of psychiatric art.

Lombroso's collection was, of course, far more exten-sive than the limited number of objects he was able to discuss and reproduce in his writings on the subject. He had acquired large pieces of furniture carved and painted by hospital inmates (Fig. 6.2). He studied the original costumes that patients invented, and the col-lection houses both the costumes and the photographs of the patients in them. Several photographs actually depict an insane painter at work on the walls of his cell.[11] Although Lombroso had to be content with re-producing only one or two drawings for each of the pa-tients he described, he was, in fact, collecting large numbers of drawings from some patients, even entire notebooks filled with drawings in some cases.

One of the more interesting and valuable cases in the collection, but not mentioned in Lombroso's writ-ings, is that of James Wanamacker of Philadelphia. There are a large number of drawings by this patient, most of them dated to specific days in the year 1895.[12] The majority of these curiously innocent drawings are of women with big, old-fashioned bosoms and fat legs, seen in various states of undress and in positions that make it quite certain that they were intended to be sexually, probably pornographically, significant. The elegant costumes and hairstyles convey the mood of

the 1890s. That the patient was preoccupied with fashion and high society is suggested by a newspaper clipping in one of the notebooks, with the caption "Fashionable Coiffures for Evening Dress." A drawing entitled "House Gown with Liberty Scarf" is identified as "copied by James Wanamacker," while another is inscribed, "copied from Popular Science Monthly."

Although he used pictures from magazines as models, the style is uniquely his own. The clothing and hairstyle remind one of the drawings of romantic young girls, but they are treated in an intricate obsessional manner, which can become quite bizarre in detail. The faces of the women are extremely simple, except for the eyes, which are heavily drawn and provided with emphatic brows. Men are not excluded from the drawings, but when they appear they are markedly square-shouldered, and no less elaborately dressed and coiffured. The world of these fashionable people is depicted in a series of pictures of carriages, paddle-wheel boats, pieces of furniture, and typical American houses carefully decorated with gingerbread.

There is also a group of far more bizarre drawings, quite strikingly different, though also drawn by this patient. They depict various indeterminate animals heavily scribbled in black pencil and similar in style to the much later work of Gaston Duf.[13] The several groups of drawings, all of them fairly small, amount to ninety-one separate pictures.

THE REALIZATION that the style and subject matter of some of the drawings of the mentally ill were in some way different led Lombroso to describe what he regarded as the typical features of the "art of the insane." In this undertaking he confronted a problem familiar to the art historian who wishes to come to grips with a new and different style. He would want to isolate and describe its distinguishing characteristics, to define what causes it to be recognizable as a unique pictorial language.

Lombroso isolated thirteen basic features commonly observed in the pictures made by the insane, or related to their picture-making activity. All thirteen were not to be found in every example; in fact, some of the traits appear to be mutually exclusive. By examining his thirteen characteristics, we may see the images with his eyes and get some idea of what held his attention. What were his descriptive criteria? How did he proceed in his analysis of the pictures available to him?[14] His analysis centered on three aspects of the phenomena: the formal aspects of the drawings, the subject matter of the pictures, and the behavior of the artists. He did not differentiate between these different approaches, but it is useful to group his thirteen characteristics in terms of these three essentially different modes of observation.

Lombroso was aware that only a few of his patients developed an interest in drawing, and he tried to determine the type of patient most likely to engage in this activity, arriving at the hypothesis that it was the congenital and less readily curable forms of mental illness that motivated patients to draw; he referred, as did Frigerio, to individuals suffering from monomania, moral insanity, and dementia. He also considered whether previous training or professional experience might explain the development of interest in creative activity. His conclusion was that "in only a few cases could the tendency be explained by profession or habits acquired before the appearance of the disease."[15]

Five of the thirteen characteristics relate essentially to the behavior of the patient:

1. *Originality*: He commented on the patients' inclination to make use of strange, even inappropriate, materials: coal, unraveled threads fastened with saliva, or chewed bread. Considering the poverty of the conditions prevalent in late nineteenth-century mental institutions, we might be less inclined to attribute this behavior to "originality," and to realize that it was largely the result of necessity. At other times this same descriptive classification is used to refer to the oddity of the conception underlying the image or object produced by the patient—for instance, a strange type of boot, or a cart powered by a rope attached to the axle, which enabled a person standing in the cart to propel the wheels.

2. *Uselessness*: Another criterion that seems to refer to behavior rather than to the product is his characterization of the patient's artistic endeavors as "useless." "Sometimes the work done, though very useful in itself, is of no advantage to the artist, and has no connection with his profession" (p. 202). He described patients who seemed possessed with "a strange energy in their work, just as if they had been paid for it. They cover the walls, the tables, and even the floor, with painting" (p. 180).

3. *Uniformity*: A particularly important trait that Frigerio also described is the tendency seen in some patients to repeat the same image again and again, often filling a single sheet of paper with repetitions of the same subject.

4. *Imitation*: Related to uniformity is Lombroso's observation that some individuals were capable of copying a model, but unable to produce anything original. He felt this to be particularly true of cretins and idiots.

6.3. Picture chosen by Lombroso to represent "minuteness of detail," from *Man of Genius*, plate 10.

5. *Criminality and moral insanity*: Essential to Lombroso's conception of degeneracy, and inextricably involved in his attitude to genius, is the concept of "moral insanity." Under this heading, he discusses "the co-existence of the artistic faculty and moral insanity," and refers to several cases with the intention of demonstrating that the artists were sexual perverts or criminals (pp. 201–2).

IN HIS ANALYSIS and description of formal characteristics or problems of style Lombroso was not very systematic. His approach to pictures reflects the aesthetic criteria of the nineteenth century, with an emphasis on "correct drawing," perspective, "harmonious colour," and a preoccupation with "naturalism." Nevertheless, certain unusual stylistic features occurring in a large number of paintings and drawings did engage his curiosity:

6. *Minuteness of detail*: A characteristic found with some frequency in the drawings of severely disturbed patients is a compulsive involvement with minute detail. Lombroso noticed this and associated it with a specific syndrome, "monomania." He felt that the trait derived from an excessive effort to attain complete verisimilitude; and he described the case of a patient who, in his lucid intervals, painted well but with extreme minuteness, but whose work during his "attacks" became grotesque as a result of the compulsive elaboration of detail (Fig. 6.3).

7. *Absurdity*: In terms of Lombroso's aesthetic conceptions, many of his patients' drawings appeared "absurd." He states, "One of the most salient characteristics of insane art is, as might be expected, absurdity, either in drawing or in colouring" (p. 204). The interjection, "as might be expected," provides a significant clue in regard to his mode of thinking about these drawings. He tended to presume that insane people could only produce insane art. He made few references to the large number of patients whose productions betray nothing of their illness. He referred to paralytic patients (general paralysis, now identified as syphilis of the brain), who draw objects without any sense of proportion. "Their hens are the size of horses, their cherries of melons" (p. 204). Another patient is de-

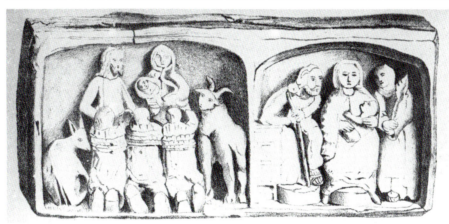

6.4. "Arabesques" with concealed figures, from Lombroso, *Man of Genius*, plate 8.

6.5. (at top) Works illustrative of "stylistic features belonging to earlier periods," from Lombroso, *Man of Genius*, plate 8.

6.6. "Atavism; a sculptural work by a patient recalling a work of the thirteenth century," from Lombroso, *Man of Genius*, plate 8.

scribed as drawing all his figures upside down.[16] One of the most curious observations in regard to color is the comment that "alcoholic maniacs" often make an excessive use of yellow in their pictures.

8. *Arabesques*: Of particular interest in terms of twentieth-century preoccupations is Lombroso's observation that many of his patients produced abstract or nonrepresentational pictures. He refers to works of this type with the term "arabesques" and indicates "a singular predilection for arabesques and ornaments which tend to assume a purely geometric form, without loss of elegance" (p. 200) (Fig. 6.4). This characteristic he also linked with monomania. He detected within these arabesques concealed representations. "In many arabesques, drawn by a megalomaniac, one can trace, carefully hidden among the curves, sometimes a ship, sometimes an animal, a human head, or a railway train, or even landscapes and towns, though the essential character of arabesques is the absence of the human figure" (p. 185).

9. *Atavism*: Another formal characteristic of special interest to the art historian is referred to by Lombroso as "atavism." He detected what he felt were references in the work of the insane to stylistic features belonging to earlier periods in history (Fig. 6.5). As an example of this atavistic tendency he described the case of a megalomaniac who "executed a coloured bas-relief, in which the disproportionate size of the feet and hands, the extreme smallness of the faces, and the stiffness of the limbs, completely recall the work of the thirteenth century" (p. 200) (Fig. 6.6). Since Lombroso, a vast quantity of similar material commenting on the superficial similarities between the drawings of the mentally ill, the painting of children and primitive peoples, and modern art has filled the literature. For Lombroso, this similarity with historical styles, also noticed by Frigerio, represented a psychological remnant of more "primitive" mental states, a hypothesis that contrasts with and yet anticipates the thinking of modern dynamic psychiatrists, who tend to emphasize psycho-

dynamic continuities between adult and child, between modern and primitive peoples.

LOMBROSO'S attention was chiefly focused on the subject matter of the pictures he studied. Subject matter is easier to describe, bizarre subjects are strikingly apparent, and it is possible to indicate some connection between the patient's disturbed mental condition and his choice of subject. Several of his characteristics refer directly to this aspect of the drawings:

10. *Eccentricity*: He indicated the extreme originality of some of the patients' artistic conceptions, and suggested that this quality frequently degenerated into mere eccentricity. A picture of the Marriage at Cana is described, in which the absurd element was the substitution of a bouquet of flowers for the figure of Christ. Such a substitution would not necessarily appear absurd to us in that we would at once consider the meaning of such a gesture. This change of attitude indicates clearly the distance that separates us from Lombroso. There is a confusing overlap between Lombroso's categories of originality, eccentricity, and absurdity, and it is neither easy nor even possible to determine what he intended in creating this division.

Two of the thirteen characteristics refer to types of subject that occur repeatedly.

11. *Insanity as a subject*: Some patients choose to depict other patients, themselves, or the extremes of insanity itself as a subject (Fig. 6.7). One group of unpublished drawings in the Lombroso collection appears to belong to the category of physiological records of the insane, which we have already discussed. A group of nine drawings in black chalk seems to preserve the appearance of patients, some of whom are very obviously mad. In one case the diagnosis is written on the drawing. It is quite certain that the artist responsible for

6.8. Drawings of an "erotomaniac," the Lombroso Collection, Museo di antropologia criminale, Turin, from Lombroso, *Man of Genius*, plate 15.

these portraits was well-trained, and a sensitive observer. The inclusion of these drawings in the files used for pictures by the insane probably suggests that the artist was also a hospital inmate.

12. *Obscenity*: Patients whose work dealt with erotic or obscene subjects were sufficiently common to attract Lombroso's attention (Fig. 6.8). In terms of his tendency to mix moralistic judgments with psychiatry, he tended to exaggerate the frequency of such cases. However, he dealt with this type of material in a remarkably straightforward manner, describing a number of cases in which this trait was dominant.[17] He pointed out the frequent relationship between the presence of this characteristic in a picture and what he identified as the patient's perverse sexual ideas. Extensive reading of Lombroso soon leads to the recognition that he tended to seek out such material, as though its discovery fulfilled a personal need. The conception of moral degeneracy then served to distance such people from

6.7. "Insanity itself as a subject," from Lombroso, *Man of Genius*, p. 307.

6.9. "Self-portrait of a megalomaniac, naked, among women, ejecting worlds," from Lombroso, *Man of Genius*, plate 14.

their observer. The most interesting case he chose to illustrate this characteristic is that of a patient, diagnosed as suffering from megalomania, who painted a full-length picture of himself, naked, among women, ejecting worlds, and surrounded by all the symbols of his power (Fig. 6.9).

13. *Symbolism*: The last of the characteristics that refers to subject matter and the one that would inspire by far the greatest interest in later investigators derived from Lombroso's awareness that many of his pa-

tients' subjects were intended symbolically. By this, Lombroso did not imply unconscious symbolism, but symbols consciously selected and used by the patient in an allegorical way. We might be inclined to refer to them as "signs"—that is, clear substitutions of one thing for another. On the other hand, Lombroso was aware that the logic behind such substitutions was not always rationally justified, and was in some cases deliberately obscure or personal. He devoted several pages to a detailed description of works of this type,

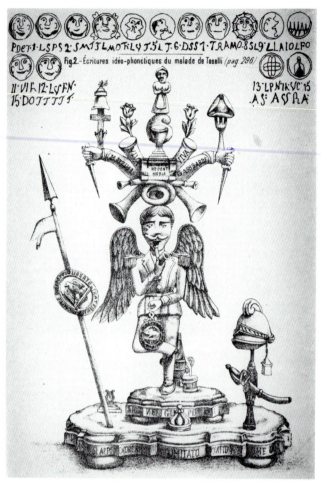

6.10. Ideo-phonetic writings (*top*); carved wooden figure by "A.T." (*bottom*), from Lombroso, *Man of Genius*, plate 10.

at demonstrating the early history of the development of written scripts from pictographs, in which, as usual, he intended to demonstrate what he felt were the links between primitive civilizations and the atavistic character of much insane art. His lengthy description of the case of "G.L." indicates the beginning of insight into the creative mechanism that motivated this patient.

In the present case, it is quite easy to understand by what mental process G.L. came to use this mode of writing. Under the megalomaniac delusion, believing himself Lord of the elements, superior to all known or imaginable forces, he could not make himself properly understood with the common words of ignorant and incredulous men; neither could ordinary writing suffice to express ideas so new and marvelous. The lion's claws, the eagle's beak, the serpent's tongue, the lightning-flash, the sun's rays, the arms of the savage, were much worthier of him, and more calculated to inspire men with fear and respect for his person. (p. 191)

Lombroso was not successful in penetrating the symbols that he observed in the work of his patients, though on occasion he was made aware that they attributed symbolic significance to certain images or elements. From this point of view the most striking case he described was that of "A.T.," a cabinetmaker skilled in wood-carving.[19] A small sculptured figure was reproduced and described in detail (Fig. 6.10, bottom). It depicted a man dressed as a soldier, provided with wings, and standing on a pedestal covered with allegorical inscriptions. Lombroso demonstrated convincingly the emblematic meaning of each object of which the piece was composed, and indicated symbol by symbol the specific aspect of "A.T." 's delusions thus represented. So personal are the associations linking the objects and the meanings attributed to them, obeying a deeply irrational and subjective logic, that we can be sure the explanations of the various symbols were provided by the patient himself, rather than representing Lombroso's insight. Lombroso, on the other hand, was evidently struck by the ingenuity and originality of some of the conceptions embodied in the wooden figure:

He is always drawing or carving, and his work generally takes the form of trophies or allegorical figures. The most curious of these is a piece of carving which represents a man dressed as a soldier. This figure has a trophy on its head, and other objects are carved on or around it, each of which expresses emblematically some one of T . . .'s delusions. For instance, the wings recall the fact that, when his first attack came on, he was in the square at Porto Recanati, selling his carvings, among which were several figures of angels, at a soldo a-piece. The "medal of the order of the pig" is a token of contempt, wherewith he would like to decorate all the rich and powerful of the earth. The helmet, with a lantern hang-

using extensively, in later editions of *The Man of Genius*, a case published in 1888 by William Noyes.[18] The symbolic aspect of many drawings clearly represented a possibility of gaining some degree of insight into the nature of the drawings themselves, their function, and the mental processes from which they derived. Lombroso was aware of this fact only to a very limited extent. His fundamental interest in the drawings did not lead toward an understanding of symbolism; nevertheless, he realized the necessity of gaining a foothold in this area. The possibility of penetrating the often obscure symbolic meaning of some pictures resided in the frequency with which the drawings were combined with inscriptions or covered with writings, often executed in a nonexistent script (Fig. 6.10, top).

Lombroso was particularly interested in these invented scripts, and he included a long digression aimed

ing to the visor, symbolizes the gendarmes who escorted him to the asylum. The cigar placed crosswise represents his disdain for kings and tyrants; and the position of the leg recalls a fracture of that limb sustained by him in his attempt at suicide. The inscriptions on the pedestal are scraps of verse or extracts from newspapers which T. is always quoting, and to which he attaches some mysterious significance. They always, however, refer to the state of slavery to which he is reduced (his detention in the asylum), and the vengeance he will one day wreak on his captors. (pp. 191–92)

Of particular interest was the discovery that the complex trophy resting on the head of the figure was "a graphic expression" of a song either written by the patient or adapted from some popular poem. Each phrase of the song had its symbol in the trophy. This case is unique in nineteenth-century studies of patient art in allowing us to penetrate some distance into the image, and to understand, if only on the most superficial level, the kind of symbolic mechanisms being used by the patient.

Lombroso seems to have been very conscious of his dependence on the patient's ability to explain the meaning of his own work, and the collection includes written accounts by patients of what they were attempting to express. A case about which one would wish to know more is that of Georges Asner. Only a single drawing by him is preserved, but attached to it are pages of notes in English entitled "Explanation, Monday 21,3-1895." The description of the little drawing of birds and animals, houses and clouds, is strongly reminiscent of the thinking of Jonathan Martin.

The picture Leithning Alpes
Tells hat by Schiller
From the clouds, the Hand of
God; sends his destructive fire.—
to the place of Idolatry—.—The
Church. The priests have forgotten
to be men. Or they won't imagine
themselves to forgive sins. About
that they are fooled. And all madhouses
are protesting, Against studied
nonsense. They always have been
heartless beasts. The Wolf and the
Steely ravens proof it.

All of the details mentioned are found in the drawing, and it is clear that Asner was attempting to provide a key to the understanding of his symbols.

In a number of cases Lombroso indicated that the patient's life experience was being reflected in his art. Of one patient referred to as "G." he states, "Her autobiography is, so to speak, traced in this embroidery, in every piece of work she has represented herself" (p. 184).

THE DIAGNOSTIC categories used by nineteenth-century investigators of the art of the mentally ill represent that aspect of their work that has become most clearly outmoded and irrelevant. Lombroso used the standard classifications of his period, many of which were, even then, in transition.[20] Little would be gained by examining systematically the various disease entities and the graphic characteristics that Lombroso felt corresponded with each of them. Confusion in nomenclature troubled even his thinking, and it is almost certain that a single drawing might have inspired any number of diagnoses. Lombroso failed to isolate specific groups of drawings characteristically correlated with the various syndromes; in fact, he made no systematic attempt to do so. The results of this aspect of his work inevitably appear simplistic today. He was, however, well aware of the challenge. In cases exhibiting acute persecution anxiety or megalomania, he thought he had succeeded in establishing some relationship between these symptoms and the type of imagery used by these patients. This is of historical interest in that paranoia remained for some time one of the more promising areas of investigation for students of the drawings of the mentally ill.

The thirteen characteristics outlined by Lombroso are of considerable interest when examined individually. Applied descriptively to any piece of graphic art, they provide a method of thinking about drawings and paintings that is still pertinent, although changes in twentieth-century art incline one to be far more careful in their application. It is now understood that artists can safely regress in the context of their work to very primitive mental states without bringing their sanity into question. As a means of identifying a special class of "insane art" these characteristics have ceased to have any value. His conviction that insanity necessarily influences the creative process led him to ignore the fact that seriously disturbed patients can, and often do, produce perfectly conventional representations.

Lombroso found no geniuses among his painter-patients. This negative evidence represented the most fundamental obstacle to his theory of the pathology of genius. It was a fact he chose to ignore, and even to disguise. Although he was unable to bring forward a single work of artistic value, and here we must not forget that we are speaking in terms of his aesthetic criteria and not the revised critical opinion of the twentieth century, he continued to speak of "genius induced by mental illness. . . . The most convincing proof of all is offered by the insane, who though not possessed of genius, apparently acquire it for a time, while under

treatment. These cases prove that geniality, originality, artistic and aesthetic creation may show themselves in the least predisposed natures as a consequence of mental alienation."[21] In the writings of the numerous followers of Lombroso any tendency to draw or paint was assumed to be a product of "genius" or, in more restrained enthusiasts, of "talent." Yet even Lombroso had to admit that in the case of accomplished artists who became insane, creative ability in terms of his criteria was seriously damaged or, at the very least, not improved.

Several of Lombroso's thirteen characteristics were introduced only as a means of buttressing the genius–insanity hypothesis—for example, his conviction that perverts, moral degenerates, or criminals draw and paint more than other types of patients. This patent misobservation can be accounted for in terms of the pathological phenomena, particularly sexual disturbances and evidence of "moral degeneracy," that he endeavored to demonstrate in the lives of men of genius.

It would seem that Lombroso's curiosity was aroused by the fact that, on occasion, hospitalized patients developed a desire, even a need, to paint or draw, or to express themselves in some way. Why? His attempts to answer this fundamental question went no further than Frigerio's, and were less firmly tied to observation. He was obviously struck by the compulsive necessity felt by some of these patients to create symbols or images. "Individuals who previously had not the remotest idea of art are impelled by disease to paint, es-pecially at the periods of strongest excitement" (p. 182). At times he felt it was a sufficient explanation simply to refer to his belief that genius is a form of insanity. "We have just been considering in mad men the substantial character of genius under the appearance of insanity."[22] Elsewhere he looked more deeply into the problem: "Often it is the tenacity and energy of the hallucinations which makes a painter of a man who never was one before. It is easier to reproduce clearly what one sees clearly. Moreover, the imagination is most unrestrained when reason is least dominant, for the latter, by repressing hallucinations and illusions, deprives the average man of a true source of artistic and literary inspiration" (p. 205).

The contribution of Lombroso that is still of interest today is his clinical awareness that in many cases the images depicted in the patients' drawings and paintings are related to their delusions, hallucinations, and symptoms, as well as to their altered experience of reality. In case after case he was able at least to indicate how the pathological ideas of individuals found expression in their work. Until symptoms and delusions were seen to have a function and a meaning, he could go no further. Essentially, the explanation of the symbolic productions of the mentally ill, graphic or otherwise, awaited the first explorations of the unconscious, explorations that were already well underway, although their findings appear to have remained unknown to Lombroso, caught up as he was in his love–hate obsession with the man of genius.

Paul-Max Simon and the Study
of Psychiatry and Art

The enormous productivity of Cesare Lombroso, the range of his interests and knowledge, and the substantial contribution he made to criminology and anthropology have led to a temporary overestimation of his achievement in the investigation of the pictorial productions of the mentally ill. His fame and, even in his own day, his notoriety have obscured the fact that the first psychiatrist to undertake a serious and extensive survey of the drawings and paintings of the insane was a little-known French alienist, Dr. Paul-Max Simon. Simon's contribution to the study of the art of the patient is to be found in two articles: "L'imagination dans la folie" (1876), and "Les écrits et les dessins des aliénés" (1888).[1] This chapter, devoted to Dr. Simon and his work, corrects the erroneous belief that Lombroso's investigations preceded those of Simon, and undertakes to establish Simon's priority in the study of psychiatry and art.

The decision to discuss Lombroso's contribution to such studies prior to that of Simon was made out of a conviction that Simon's achievement is best understood against the background of the Romantic conception of genius and in contrast to the later and more simplistic views of Lombroso. The persistence of Lombroso's perverted conception of genius, as well as his generalizations about "insane art," continue to prejudice the reader of psychiatric and psychological investigations of art today. It remains necessary to slay the Lombrosian dragon before beginning any serious discussion of the art of the mentally ill.

The few references to the historical origins of this field of investigation that exist have described Lombroso as the innovator who first undertook study of the art of the insane.[2] This error resulted from a failure to recognize the date of Lombroso's earliest publications dealing with the art of the hospitalized insane. For our purpose it is important to establish the year in which Lombroso first published the chapter on the art of the insane, entitled "L'Arte nei pazzi," which forms part of his book *Man of Genius*.

Man of Genius first appeared in 1864 in a far shorter version and with a different title, *Genio e follia*. This essay appeared again in 1872 and 1877. Then, in 1882, a fourth edition appeared, much enlarged, and bearing the new title *L'uomo di genio*. A new addition to this revised edition was the crucial chapter on art in the insane, which in 1880 Lombroso, with Maxime du Camp, had published as an article entitled "L'arte nei pazzi" in the periodical *Archivio di psichiatria, antropologia criminalé e scienze penali*.[3] This article was then added to the revised fourth edition of *L'uomo di genio*. As a result, Lombroso's work with the pictorial productions of psychotic patients, usually understood as beginning in 1864, actually began in or around 1880, some four years after the publication of Simon's pioneering article, "L'imagination dans la folie" (1876).

Simon's only significant predecessor is now seen to be the physician Ambroise-Auguste Tardieu (1818–1879), who had published a brief discussion of the work of two patients in 1872. The uniqueness of Tardieu's early contribution is established by the fact that a patient's drawing was reproduced in a psychiatric publication accompanied by the patient's explanation of its meaning and, perhaps more important, by a detailed description of the forces that led irresistibly to its creation.

Tardieu's book, *Etudes médico-légales sur la folie*, was the work of a highly respected French psychiatrist who had devoted himself to the study of mental illness from the beginning of his career.[4] He possessed unusually extensive first-hand knowledge of the behavior and mental processes of hospitalized patients.[5] His particular concern, and the subject of a long series of publications, was the problematic "no-man's land" between psychiatry and the law. As in our own day, the possibility of using a diagnosis of insanity as a means of removing individuals who were critical of, or hostile to, the reigning social order posed a serious threat to the liberty of many people, as well as a challenge to the integrity of the medical profession. Then as now, physicians could always be found to testify to the sanity, or lack of it, of accused individuals. Tardieu's intent in writing his *Etudes* was to establish objective criteria

for a legally acceptable diagnosis of insanity. An examination of the complex relationship between the functions of the physician and the more mundane concerns of the legal profession, Tardieu's scholarly discussion of the problem was very influential and established him as one of the more prominent psychiatric authorities in France.

Tardieu's involvement with the pictorial productions of mentally disturbed individuals was minimal. He was only led to examine this material because drawings and paintings might be used in the courtroom as documentary evidence of a person's mental condition. His book included a brief outline of what he felt were the basic characteristics of the graphic productions of the insane. The minor importance of this aspect of patient behavior in the task of diagnosis, as it was understood at the time, did not lead Tardieu beyond the most superficial observations; in fact, he was guilty of obvious oversimplification and exaggeration, which his direct experience of patients might have been expected to prevent. "No matter how hard you may try to imagine fantastic and impossible things, or the most bizarre images, you will never succeed in conceiving of the type of insane image which presents itself on canvas at the hand of a madman, those nightmare creations which make you dizzy."[6]

Tardieu's interest in patient art and his overly dramatic view of the material was seemingly inspired by his encounter with a patient whose work he followed over a lengthy period. His regrettably brief reference to the work of this individual is of importance to us in that it represents the first effort to describe the style and subject matter of drawings and paintings in the context of a specific case.

For many years I have been able to observe a patient who, though he had no talent whatever, spent all of his life in painting. I have seen more than five hundred of these pictures, some of quite large size. They reveal the wildest associations of color, green or scarlet faces, unusual proportions, yellow skies, extravagant effects of light, monstrous beings, fantastic animals, senseless landscapes, unrecognizable architecture, infernal flames; all expressing through unique forms, dreams of the most indescribable nature.[7]

It is evident that these powerful images produced in such large quantity by a single artist molded Tardieu's conception of the artistic productions of the mentally ill. His description of them seems to range over much of the art of the twentieth century, calling to mind the creations of one major artist after another. The work of this anonymous patient inevitably awakens thoughts of the Fauves, Gauguin, van Gogh, and the Surrealists, all of whom were so soon to trouble the sleep of French art and to make the critics "dizzy." Was this patient who spent his life at the easel perhaps another Rousseau? We will never know, in that no reproduction of his work was provided in Tardieu's text and his name is never mentioned.

Before condemning Tardieu for lack of perception or sensitivity, it is essential to remember the prevailing aesthetic criterion of his day with its insistence on a rather restricted naturalism. The experience of the Impressionists, whose first exhibition was to open two years later in 1874, can serve to indicate how conservative even the most advanced critical opinion was. They too were labeled insane and their art degenerate. Tardieu lacked tolerance for distortion in the service of expression, a tolerance we have only developed as a result of innovations in art from the beginning of the twentieth century. It is not likely that a physician raised in the environment of the Salon and the French Academy, schooled to appreciate the realism of Meissonier (1815–1891), Gérôme (1824–1904), and Bouguereau (1825–1905), would be in any position to accept the radical, expressive means used by this unknown painter. Nevertheless, Tardieu's dramatic language, as well as the fact that he apparently followed the patient's work over several years, suggests that on some level his interest had been caught and that he reacted with excitement to the imaginative world that unfolded in those five hundred paintings. In terms of his stated goal, "to demonstrate the importance of the writings and drawings of the insane from the point of view of determining their mental state," it was not necessary that he understand his patients' efforts at communication, or that he react emotionally to the intensity of feeling that undoubtedly motivated the creation of the pictures.[8] In his desire to provide the necessary evidence for a diagnosis of insanity, Tardieu tended to exaggerate the bizarre characteristics of drawings. He suggested, for example, that the majority of patients display a preference for erotic or obscene subject matter, a generalization later challenged by Paul-Max Simon.

Dr. Tardieu's second case is of unique importance to us. He reproduced, without comment, a drawing made by one of his patients (Fig. 7.1). Although he chose not to discuss the picture, he took the unusual step of including the patient's explanation of his own drawing, not because he felt the patient's description was of significance in understanding his behavior, but because the written description served to confirm his diagnosis. As in the case of Haslam's patient, James Tilly Matthews, we are brought closer to the reality of the individual who produced the drawing, and we are able to

7.1. Anonymous, *The Soul of the Earth*, drawing from A. A. Tardieu, *Etudes médico-légales sur la folie* (Paris, 1872), p. 102.

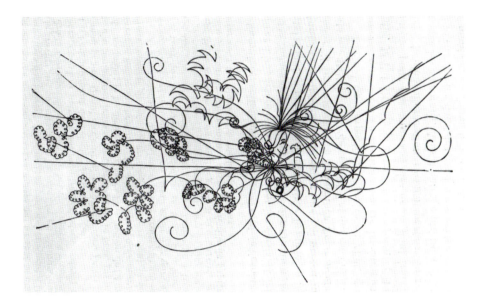

sense the intensity of the needs that forced him to go on drawing to the point of exhaustion. He describes his work as the result of divine guidance, an example of automatic drawing analogous to the more familiar phenomenon of automatic or mediumistic writing.[9]

THE SOUL OF THE EARTH

On several occasions during the last three weeks I have put pen to paper at God's disposal. He guided it in producing the drawing of which an example is here provided. It is in this way that I was able to perceive the aromas. Because the aromalized magnetism of Mrs. H. is a compound that does not occur on Earth, except in her organization and my own, the Soul of the Earth could not induce the fluids to leave her head, except by directing them toward me. Also, in order to deceive them, it was necessary to draw Octavie's head on the paper signaling them to approach. (These instruments of a superhuman mentality are almost thinking beings.) In truth, this rough portrait sketch was completed on the left side by a sphere that quickly repelled them. The Soul of the Earth caused me to follow their movements with my pen on the paper, and the electricity of the ink absorbed the fluids which had already been more or less completely denatured. If you examine the drawing that our ray-god-of-souls himself traced upon the wood, you will see that the feminine aroma is still recognizable in the several jets that emerge from Octavie's head and breast. Each of these ringlike forms represents, more or less exactly, ten fingers of a ray-god-of-souls; this, however, is no longer the superior feminine aroma, as it issued, all jagged, from our speaking trumpet. Those fluids that are neither utilized nor neutralized decompose. Almost all those that emanate from Octavie's head in the engraving, retain nothing of the aroma referred to as feminine, but the

straight line corresponding to its sudden escape after six groups of tight convolutions, at which point it is functioning normally. The others obviously aspire to the coiling up of the neutral electricity. These latter were obscured in my drawing. As for the others, still alive, I was often obliged to follow their movements with my arm even beyond the edge of my table. I directed them, following the instructions of the Soul of the Earth, toward the fire in the chimney, a hearth of energy where they disappeared. The best preserved of all the aromas, among those that I have included in my drawing, is the aromalized magnetism, a shower of leaping crescent forms. They originate from the reduction to which my wife's spiral had to submit in order that the lid would remain on her head. This aroma, of exceptional strength, was the most tiring for me to follow. The engraving included in this book reproduces one of the least intense aromal therapy sessions. It has happened on occasion that in carrying out this exercise, the piece of paper has been entirely covered with ink, and has been torn to pieces beneath my pen, leaving my arm totally exhausted.[10]

This lengthy and complicated description by a severely disturbed patient of the creative process involved in the making of his drawings is one of the most interesting documents in the study of spontaneous or automatic expression in the nineteenth century. Curiously, no later references to it occur in the literature of the period. The drawing consists of a variety of elegant curved, zigzag, straight, and convoluted lines proceeding from the head and breast of a female figure designated by the patient as "Octavie." These calligraphic lines are explained as representations of different aromas, or possibly of magnetic currents; the phrase used

is "magnétisme aromalisé." Executed at the bidding of a superhuman being, "the Soul of the Earth," the drawing seems to have had the function of influencing or attracting the magnetic odors. In this respect the act of drawing can be seen to have had a magical purpose. Despite the occasional obscurity of the passage, one senses the patient's earnest intention to account for his activity in a coherent fashion. His experience of intensely felt external compulsion suggests the reality of the forces that prompted him to draw. His effort to describe what was happening to him may imply that he was concerned to make contact with the people around him.

Again and again these artists, dismissed as mindless, undertook to explain the significance of their work, and the inner promptings that led to its creation. Because physicians such as Tardieu did not take these explanations into account, there was a long delay in attaining even a minimal degree of insight into the relationship between the life experience of these individuals and the graphic productions that they inspired. For much of the nineteenth century the most valuable writing about the image-making activity of the insane was that done by the patients themselves, though the importance of this readily available material went unrecognized and, for the most part, unpublished. The contribution of intelligent patients to the understanding of psychotic expression was to provide the most promising source of insight, once investigators found the courage to listen. But the psychiatric stance of physicians in the latter half of the nineteenth century stood in the way of understanding, or even of truly seeing or listening. Though burdened with this "scientific" point of view, Paul-Max Simon nevertheless was to achieve far more than his predecessor Tardieu in his systematic attempt to understand the art of the insane.

PAUL-MAX SIMON, Médecin adjoint at the asylum of Blois, and later Director of the Asylum of Bron, is a figure about whom little is known.[11] His studies of the art and literature of the insane convey an impression of an original, highly organized, and sensitive mind able to function in new and rather chaotic territory.

His involvement with the art and literature of his patients was the outcome of his curiously old-fashioned medical ideals, combined with a scientific orientation that was surprisingly forward-looking. Although it would be an error to assume that all nineteenth-century alienists emerged from the same mold, it is important for us to obtain a degree of insight into the self-image of a physician whose clinical interests were as unconventional as Simon's.

Simon's professional identity was constructed around his idealized image of the physician as a "médecin-gentleman."[12] Thoroughly trained in his chosen calling, this physician "worthy of the name" was to be an *homme du monde*: "A man of the world, and of the best society, a refined spirit, appreciative of things artistic and literary, whichever suits him. In sum, a person of superior nature, and of inherent distinction, subtle, but with the large heart and ardent faith of a true Christian."[13] Simon's insistence that his ideal physician be "a man of letters" derived from his own extensive involvement with literature. An artist himself, Dr. Simon was less inclined to associate creativity with pathology.

Between 1864 and 1903, Simon published a series of novels, short stories, and literary investigations that drew upon his experience as a physician working with the mentally ill. One might almost speak of a second career or, were his varied abilities not so well integrated, of a split personality. Unusual even among intellectuals in France at this time, Simon had an extensive acquaintance with English and American literature, publishing a number of critical studies in this area. The most important of these, his book on Jonathan Swift, is subtitled "A Psychological and Literary Study."[14] His discussion of Swift's life and work, based on a surprisingly detailed knowledge of the critical and biographical literature, is exceptional in presenting a generous and human picture of Swift, free of any of the weaknesses of pathographic investigation. Despite the fact that Swift died insane, Simon insists on the absolute sanity of his writing, and on the mental stability of the man until the final years of his life. Having arrived at a tentative diagnosis of Swift's condition as epilepsy, possibly complicated by Ménière's disease, he concludes: "The intellectual value of such men is neither denied, nor even contested, and, I repeat, the disease from which they suffer [epilepsy] in no way prevents them from accomplishing their work. None of them was as a result of it either less wise as a politician, less of a genius as a tactician, or a less great writer."[15] The distance between this point of view and that expressed on every page of Lombroso is infinitely great. Simon's goal was, as he states, "to portray the man as a living personality," and not in terms of a literary ideal or of a stereotyped and romanticized conception of artistic genius.

Simon's memoirs, *Temps passé: journal sans date*, provide a detailed account of his friendships with prominent writers of the day. If Lombroso's contribution was marred by the distorted influence of Romanticism, Simon's was undoubtedly enhanced if not en-

gendered by his involvement with Realism as a mode of perception. One of Simon's friends was the writer Gustave Flaubert (1821–1880). When as a young man Simon told him of his decision to become a physician, Flaubert was furious. He was only reconciled to the idea when Simon explained that his intention was "to become physician to an asylum in order to have at my disposal the numerous scientific facts which are readily available in a vast institution for the insane."[16] It is clear that Simon's style as a writer, as well as his clinical outlook, was influenced by Flaubert's obsession with objective observation. Writing of his friend many years later, Simon describes his attitude toward the task of the writer. "An essential characteristic of the writer, particularly of the novelist, was, according to Flaubert, impersonality. The novelist must see things from afar, hovering above it all, espousing no cause as his own, affiliated with no theory or point of view: observation, artistic truth, and nothing more."[17] This is precisely the attitude at work in Simon's case histories, and in his objective descriptions of his patients' fantasies or artistic productions.

Simon's attitude toward genius is a further expression of the Realist position. His goal in writing his memoirs was to function as "a simple spectator." Describing his many encounters with men of unusual ability, at times approaching "genius," he never succumbs to destructiveness or petty gossip. He deliberately avoided psychological speculation about genius, and looked upon the activity of pathographers with distaste. "I am always astonished by the relentless eagerness with which they pursue men of genius. It seems that they feel a personal hatred for them; the revenge of the mediocrity of the eternally envious crowd. This is still more odious and despicable because, although geniuses assuredly suffer from all the weaknesses of other men, most of them are kind, generous, and charitable, to the point of self-injury."[18]

Without mentioning the name of Lombroso, Simon criticizes his approach. "In recent years, an effort has been made to see genius, and even talent, as a derivative of insanity. As proof of this position they refer to the originality of the majority of great men. Is this convincing? No."[19] In opposition to the imaginative inventions of pathography, Simon was devoted to the scientific method, and to accurate observation. He speaks in his memoirs of the danger of "wanting to leave the circle of direct observation in order to throw oneself into the unbounded fields of speculation; of wanting to include everything in an overall view of the whole, and of thereby losing one's way; believing oneself to be standing on the solid ground of experimental philoso-

phy so precisely defined by Newton, and of venturing, all unknowing, into the territory of pure metaphysics."[20] Simon's accomplishment resided in his ability to limit himself to the role of observer. It was not given to him to go further.[21]

Although, as we have seen, the existence of spontaneously produced drawings and paintings by mental patients had often been commented on throughout the nineteenth century, it was Simon who recognized their unique importance, and who first developed systematic methods of studying them. The originality and difficulty of this step cannot be overemphasized. It is one thing for a physician to mention that his patient is indulging in a symptom of one sort or another, to characterize this form of behavior as bizarre or "insane," and then to pass on, unaware that this activity might possess a significance of its own, or that a closer examination of it might even provide a key to the deeper understanding of the human mind. To go further demands a tolerance of chaos, an ability to coexist with deep and pervasive irrationality, and to "listen" attentively to words and images that in their very nature can at times inspire fear and even revulsion. It is no small matter to study a subject traditionally seen as unworthy of attention, or as the insignificant and meaningless product of a sick mind. Simon's achievement lies in his decision to enter into this chaos and begin the task of imposing order.

Two sources motivated him in his decision to proceed with such an undertaking, and provided him with his methodology. Studies of the literary productions of the mentally ill, and graphological investigation of the links between handwriting and personality, had awakened his interest in using a similar approach to both the content and the formal aspects of "insane art."[22]

The primary task that Simon set for himself was to attempt to describe and classify the drawings in his collection in terms of the standard nosological groupings in use at the time, making extensive and careful use of case material to illustrate and confirm the observations. This preoccupation with classification and diagnosis can be seen as a logical extension of the systematic effort to describe and classify all types of symptomatic behavior and ideas that characterized much of eighteenth- and nineteenth-century French psychiatry. It should be remembered that our discussion of the origins of the psychiatric study of art in the nineteenth century is concerned, for the most part, with what Henri F. Ellenberger has termed "official" or "non-dynamic" psychiatry. In his brilliant book *The Discovery of the Unconscious: The History and Evolution of Dynamic Psychiatry*, he traced the early devel-

opment of a whole new school of French psychiatry that undeniably represented the path into the future.[23] Significantly, the men who made the earliest contributions to the investigation of the psychopathology of art did not belong to this promising psychiatric underground. Official or neurological psychiatry was preoccupied less with the development of methods of therapy or cure, and more with the systematic description of disease entities. On the other hand, this attachment to objective description and classification distinguishes Simon and separates him from scholars, such as Lombroso, whose manipulation of facts betrays a deep fear and hatred of genius, as well as a need to keep the insane at a distance from himself to avoid any possible contamination. This was the ultimate purpose of the concept of degeneracy. Lombroso's orientation was derived, as we have seen, from the Romantic attitude to genius and to insanity. But his conception of genius as a form of psychosis interfered profoundly with his examination of the visual images produced by his patients.

Simon was surprisingly free of the Romantic preconceptions that were to hinder Lombroso. He was not obliged to glorify the pictures he collected in the hospitals where he worked as the creations of genius. He never used the word *art* in referring to the drawings or paintings of the mentally ill that were available to him; in fact, he constantly refers to their lack of artistic significance. To his credit, he sought to investigate the expressive activity of his patients in the absence of any belief in their artistic ability. In this respect, as in so many others, he reveals the objectivity of the scientific observer. Although it is doubtful that his interest in the drawings of these people was motivated by any therapeutic considerations beyond diagnosis, his approach to the drawings represents the beginning of a method of investigation still used today. His conviction that drawings betray characteristic features that can be used in psychiatric diagnosis remains an essential assumption implicit in modern diagnostic techniques that utilize drawings—the Draw-A-Person test, the House-Tree-Person test, and the Draw-Your-Family test.

One of the most extraordinary features of Simon's research was his insistence on discussing not only the paintings and drawings of the patients, but also their improvised costumes.[24] He even carried his study into the patients' inner world, collecting and describing the imaginary visual experiences they reported, visions and hallucinations that he understood as the basis for many of the pictures they produced. Simon was aware that a common source underlay all of the patient's imaginative creations. The lengthy presentation of "verbal descriptions," what he referred to as "artistic conceptions not embodied in drawings," indicates his belief that these purely mental images are the origin of the less complex, but more concrete, costumes and pictures. Simon was the first to establish convincingly a connection between the ideas and delusions of the patient and the graphic productions that attempted to serve as the externalized expression of those ideas. The patient was now seen as attempting to communicate, a discovery that gave a new significance to the "random scribbles" of the insane.

The recognition of communication as an aspect of the patient's image-making activity may have resulted from Simon's being an observer of the creative process. Simon's was the first report of a drawing made "under the eyes" of a physician. It survives in a note that accompanied a set of drawings Simon sent to Lombroso. The drawings, which Simon refers to as "Arabesques," were done by a twenty-six-year-old patient in the Asylum of Vaucluse suffering from what Simon describes as "folie circulaire" (manic-depressive psychosis). Simon describes how he watched the patient for ten minutes, during which time the two drawings were produced.

LITTLE is gained today from examining Simon's various nosological classifications and the type of drawing he associated with each. Changes in psychiatric terminology and in the conception of the various diseases have consigned the majority of Simon's conclusions in this area to the realm of purely historical interest.[25] However, his method of approach and his attitude to the drawings were eventually to influence later workers and are therefore important in reconstructing the first efforts to explore the graphic productions of the mentally ill. In discussing Simon's methodology we will confine ourselves to his conclusions about the drawings by patients suffering from delusions of persecution and "manie chronique," a continuing psychotic state, in most cases to be equated with one form or another of schizophrenia. All discussions of the drawings of the mentally ill in the nineteenth century restrict themselves to the work of clearly psychotic patients, including under this classification the drawings of people suffering from organic brain diseases, particularly syphilis of the brain (paralysie générale), epilepsy, and mental retardation. The neurotic illnesses were not included in any discussion of patient art in this period.

Simon was particularly interested in the productions of patients with delusions of persecution, who were

classified as "les persécutés" in his two articles. He distinguished these cases from those in which ideas of persecution were accompanied by megalomania, in the conviction that delusions of grandeur usually represented a later development in the course of the illness. "Megalomania includes a whole series of forms of insanity among which the patients' delusions of grandeur are obvious to even the most inattentive observers. This form of delusion commonly follows upon the development of ideas of persecution; at times, however, ideas of persecution only become apparent as a secondary factor" (1876, p. 370). From the case descriptions provided by Simon, it would appear that most of his patients were suffering from some variety of paranoid schizophrenia.

In his discussion of the drawings of "les persécutés," Simon was concerned primarily with subject matter. The only observation contributing to the analysis of form is the statement that the pictures are usually complete compositions or little dramatic scenes. "The artistic productions of les persécutés have a completely unique character, closely related to the ideas which this type of patient ordinarily displays. They are commonly pictures in the complete sense of the word, little compositions, of doubtful value of course when considered as drawings, but very interesting for the physician and the psychologist" (1876, p. 360). Simon's major theoretical contribution was his recognition that the subject matter of many of the drawings could be related to the specific ideas that preoccupied the patients. "You can see that they are closely related to the delusions of the patient, that they are nothing but what one might call the images of his expression [l'expression imagée]" (1888, p. 337). His recognition that the drawings of the mentally ill were an externalization of their delusional preoccupations was to attract the attention and interest of future students, including, of course, Lombroso.[26]

THE CASES presented as characteristic examples of "les persécutés," divided into two categories, are disappointing as depictions of the terrible persecution of which these patients believed themselves to be the object. In the first type the patients illustrate "their misfortunes, the torments that they have endured, and the persecutions of which they imagine themselves to have been the object" (1876, p. 360). The case of Monsieur Dupont best represents this illustrative tendency. "Sometimes it is a court of law before which an accused man is pleading, who is no one else but the patient himself. At other times, a landscape surrounded by rocks among which one sees an injured lion, birds, and

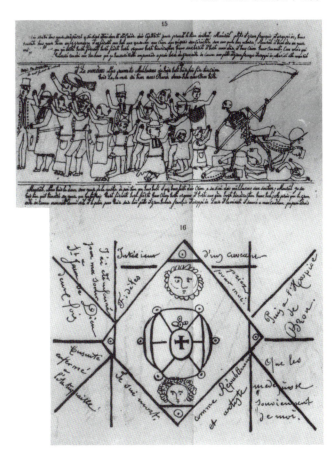

7.2. M. Dumont, *The Triumph of Death* (*above*), and symbolic diagram by a musician in the asylum at Bron (*below*), from P. M. Simon, *Archivo di antropologia criminelle* 3 (1888), plate 15.

animals of bizarre form surrounding the composition which is surmounted by the scales of justice. Here too, the patient is to be found at the center of the picture" (1876, p. 361). Simon's article of 1888 reproduced an extremely interesting picture by M. Dupont that depicts the figure of Death, armed with a scythe, slaying the evil and perverse people of the world, presumably to be identified with the enemies of the patient (Fig. 7.2, top). The picture is accompanied by an extensive written commentary that, unfortunately, is illegible. The subject, well known in the history of art, is the so-called Triumph of Death. In the famous fresco in the Campo Santo in Pisa, Death also appears with a scythe, cutting down wealthy citizens and wicked clergymen. In that version Death is depicted as a witch flying in the air, rather than as a skeleton. Death as a skeleton is typical of the "Dance of Death" engravings, which could easily have been available to the patient.

M. Dupont's work shows that French patients were also influenced by visual material in their environment. Here too the historical style of the period is as evident in the work of psychiatric patients as it is in the work of recognized artists. We are reminded as well of Lombroso's speculations concerning a possible stylistic "regression," which he referred to as an "atavistic tendency" in the productions of some patients. Investigation of the sources of the patient's imagery, particularly the religious images of his home environment, might have suggested a simpler solution to the problem of this curious reversion to earlier styles.

A passage in Simon's memoirs shows that his knowledge of art history was sufficient for him to recognize the contribution of religious art to his patients' imagery. "Christianity, that great revelation of the equality of all men, had sculpted on the porches of its cathedrals, or painted on the walls of its cloisters, various scenes of that terrible myth which the Middle Ages called the Dance of Death, in which one sees kings, potentates, popes, *manants*, and all the skeletons of those obsessed with hopeless desires. Physicians participate every day in the realization of this fiction in art."[27] It is a tribute to his humanity that he was able to admit that he too saw in this scene an aspect of his own reality, although it was not that of the patient. This ability to use one's own subjectivity to sense aspects of an inner reality within seemingly alien images was to lead to much deeper understanding.

M. Dupont's personal style is related to children's drawings of the period. This is to be seen in the choice of either full frontal views or profiles, the raised arms bent at the elbow in every case, as well as the emphasis on rows of buttons, aprons, and pockets, all of which appear in contemporary children's art. It is a style whose simple and direct narrative quality recalls the popular engravings of the period, inexpensive and widely available prints.[28]

All the remaining cases displaying delusions of persecution exemplify a second feature that Simon felt was characteristic of this group of patients, the use of symbolism or allegory. Lombroso later associated this feature with all drawings by the insane. Simon distinguished two different types of symbol; those with a generally understood meaning—"Again, sometimes it is traditional emblems that they represent: the lion as a symbol of strength, the scales representing justice, symbols of salvation, etc."—and symbols whose meaning was known only to the patient (1876, p. 360). The crucial point is that he realized they did possess meaning at least to their maker. The investigation of recurring symbols provided the first indication that the drawings of patients might possess a symbolic significance that, with effort, could be interpreted and understood. However, Simon could not proceed very far in this direction. Most of the images he encountered had a meaning known, if at all, to the patient alone. He described a case in which the patient produced writings interspersed with crosses, triangles, and signs of every sort, to which their creator attached private meanings. The use of diagrams to symbolize one's experience of reality was illustrated by Simon in the case of a musician confined in the asylum of Bron. He describes the man as "representing the circumstances of his life by a sort of emblematic schema" (1888, p. 337) (Fig. 7.2, bottom).

In the discussion of cases characterized by delusions of grandeur—"mégalomanie"—Simon's formulations are of greater interest. He understood that this symptom could occur in a number of different psychiatric illnesses. He shows an unusual awareness of the relationship between delusions of persecution and megalomania, and he attempted to formulate a principle that would indicate the influence of this relationship on patients' drawings. "In that delusions of grandeur form the basis of the delusional ideas of the patients with whom we are concerned at the moment, it is natural to assume that their drawings would deal with ambitious schemes, designs for palaces, cathedrals, machines, and gardens, and these are in fact the ordinary subjects of their compositions" (1876, p. 371). Simon suggested that the intensity of the delusions of persecution was closely related to the uniqueness and elaborateness of the patient's artistic conceptions, taking into account his imaginative powers before the onset of his illness, as well as his earlier experience and possible training in art.

Careful formulations such as these demonstrate Simon's superiority to Lombroso. Free of the assumptions relating insanity and genius, of the need to demonstrate the emergence of genius in response to the onset of mental illness, he could examine the productions of his patients with far greater objectivity. He did not exaggerate the talent of these individuals. Rather, he indicated clearly the necessity of studying their work in an effort to obtain greater understanding of their illness and their personality prior to its onset. He speaks of the "imagination of the patient which forms the subject of our investigation." He had begun to explore the relationship between the patient's inner experience, his ideas and internal images, and the drawings in which this inner reality found expression.

The analysis of the drawings of "les ambitieux" con-

cerns itself more specifically with formal problems. He postulated a relationship between the systematized, reasoned quality of their delusional ideas, and the clarity and precision of the drawings.

We observe in all of the drawings, as in the form of insanity which engenders them, a regularity, a logical character, and if I might risk saying it, of correctness, despite the fact that the conception which they reproduce is thoroughly mistaken and completely fantastic.

It would be easy for me to show by a greater number of examples to what extent within megalomania the ambitious character of the drawing, its coordination, and if I might put it thus, the correctness of the lines from which it is formed, remain constant. (1888, p. 341)

A fascinating case displaying these features is presented in the article of 1888. The patient, resident in the asylum at Bron, had been trained as a draftsman prior to his illness. "He is an inventor, and since he has been at the asylum of Bron, he has presented me with a number of designs, drawings of machines sufficient to compose a voluminous album. In that this patient was in earlier days a competent draftsman, his plates, characterized by the most complete insanity, are at the same time characterized by an absolute correctness of execution, offering to the eye a markedly harmonious effect" (1888, p. 340). Simon was intrigued by the unusual functions implicit in these extraordinary designs, and explained in their inscriptions. He describes these plans in detail, reproducing one of the many drawings, "a hermetically sealed apparatus for cooking, at high pressure—of several atmospheres" (Fig. 7.3, top left). This drawing of a nineteenth-century pressure cooker is essentially architectural, and the execution the work of an adequately trained draftsman of the period. Simon was always careful to distinguish between patients who had prior training and those whose fantasies surpassed their expressive ability. "The unaccustomed hand of our patient could not manage to trace the dreams which presented themselves to his imagination" (1876, p. 375).

SIMON's scrupulous objectivity, so typical of the French neuropsychiatry of the period, comes especially to the fore in his analysis of the drawings of patients diagnosed as suffering from "manie chronique." The bizarre productions of these severely ill people so intrigued Tardieu that he was led to characterize all art of the mentally ill on the basis of the work by these patients. For such investigators, the bizarre was a barrier beyond which they could not go, nor did they realize that a possibility of further understanding would ever arise. They were content merely to describe or ridicule. Simon recognized that Tardieu's description referred only to the work of chronic maniacs, and even then it was a one-sided exaggeration. Simon's investigation represents the first effort to unravel these images and, by looking at them intensively and with real curiosity, to penetrate their meaning. It is possible to observe him searching about for a means of access. His first move in this direction was the realization that disturbances of speech were related to disturbances of pictorial rendering. French psychiatry at this time excelled in precise descriptions of language dysfunctions. "In the same way that among these patients disorders of speech are at times extremely evident, the combinations of lines in their drawings can often be extremely complicated, or the colors which they use to illuminate their pictures can be absolutely untrue to nature" (1876, p. 366). This insight shows Simon's inclination to seek common origins behind a number of symptoms, the same inclination that had led him to study costume and imaginative descriptions of things visual, as well as graphic productions, as related phenomena. He resisted the temptation that confronts any investigator of such confusing and chaotic material to simplify the complexity of the masses of drawings with which he must deal. For example, he admitted that some "maniacs" produce unexceptional drawings, displaying no obvious distortions. "It can occur that chronic maniacs produce compositions in which the correctness of the lines, and the neat and finished quality of the drawing is fully apparent, especially when

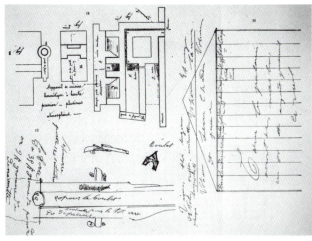

7.3. Anonymous, "A hermetically sealed apparatus for cooking" (*top left*), from P. M. Simon, *Archivo di antropologia criminelle* 3 (1888), plates 18–20.

7.4. Monsieur "H.," three drawings
expressive of different mental states
experienced by one individual, from
P. M. Simon, *Archivo di antropologia
criminelle* 3 (1888), plate 17.

they attempt no more than the depiction of a single object" (1876, p. 366).

In the context of "manie chronique" Simon presented a single case, that of Monsieur "H." His description and analysis of the case and the paintings related to it were unusually thorough. In this respect, therefore, the case represents the first investigation into the creative activity of a single patient. In the article of 1888, Simon reproduced three drawings by Monsieur H." (Fig. 7.4) to show that the patient was able to produce drawings in different styles. To admit that one patient was capable of a variety of styles was a unique and disturbing discovery, in that it questioned the essential hypothesis motivating the study of graphic productions by the mentally ill—namely, the conviction that specific syndromes exerted a consistent influence on both the form and the subject matter of the drawings.

Simon described the types of drawings produced by "H." very clearly. "He draws voluntarily. The drawings that he does, and which he gives us quite punctually, consist sometimes of badly arranged geographical maps, crossed by lines of all sorts and mixed together with useless references and bits of verse" (Fig. 7.4, left). However, his patient was also capable of highly ordered and coherent drawings or plans. "At other times, the figures drawn by our patient represent some sort of design, for example the design of a machine which he has invented. These drawings are then more clear, correct, and complete, although the idea remains generally eccentric" (1876, p. 366).

Simon's aesthetic, and his taste in drawing, were formed in an overtly academic mold. His drawing instructor at the Lycée in Rouen was a distinguished student of Ingres. He recounts how "not a week went by that he did not repeat a motto which Ingres had been in the habit of saying: 'Look after your line, make the contour correct, exact, irreproachable; and then . . . spit on it!' "[29]

Simon's attempt to account for the variations in formal coherence, while essentially speculative, reveals his awareness of the close tie between the structure of the patient's ideas and the form that he uses. The first hint of a theory of a conflict of ideas as the source of a conflict of superimposed images within a single picture can be seen here. The complexity of these drawings is explained, according to Simon's hypothesis, in a "double series of ideas, mixed together, or separate," which at times overlap or fuse in the patient's mind, producing the incoherent style of his drawings. At other times a single conception will seek to find expression and the drawings are characterized by clarity and logic.

In certain drawings of this patient whose work we are describing, one sees great incoherence, but this incoherence is not absolute. The lines, while often criss-crossing one another and confused, in the most incoherent of his compositions, reveal, in fact, in the spirit which has conceived them a double series of ideas: mystical ideas and scientific ideas. Moreover, in other drawings, these latter ideas are to be found without any admixture, at which time we encounter the inventor. A plow of special design drawn for us by H., or a model for a revolving cannon which is at the moment before our eyes, shows us very particularly this patient in this latter guise. (1876, p. 367) (Fig. 7.4, lower right)

How far this is from Lombroso's list of typical features of "insane art." Despite the simplicity of his theories, Simon's attempt to analyze even the most complex and seemingly meaningless images reveals a conviction that within these drawings, often no more than tangles of overlapping lines, there lay levels of meaning whose implications could be disentangled and understood. He concludes with a general principle:

However great the disorder and the confusion of the lines in the drawings of chronic maniacs, it will ordinarily correspond exactly with the extent of the insanity of the patient: the chronic maniac with multiple delusional ideas being more disordered in his productions than the chronic maniac with a single series of dominant delusional ideas. As for the patient suffering from acute mania, characterized by complete incoherence, excitation, and extreme restlessness, he is able to furnish us with very little in the way of drawings which can be studied. (1876, pp. 367–68)

More than a hundred years have passed since Simon

published his pioneering study. His work has inevitably been superseded and, in the light of accumulated evidence and experience, it is easy to criticize some of his findings and failures. It is difficult, however, to reconstruct the confused situation that confronted him and to realize the originality of what he was attempting to do. In one sense, his research logically continued the scientific preoccupation with accurate observation and description of symptoms, and the effort to classify them into systematized groupings that was characteristic of nineteenth-century French psychiatry. Simon's main theoretical contribution was the recognition and the clear enunciation of the relatedness of inner idea and outer image, of delusional thinking and pictorial subject matter, of confused or limited thinking and confused or puerile form, of symptom and symbol. Both Lombroso and Simon recognized the symbolic quality of some of the pictures they were examining, but beyond that they did not, and could not, go. There seemed to be little possibility of penetrating the private language of the patient's personal symbolism, just as there was little recognition that symptoms might have meaning. One does not find in the studies of either Lombroso or Simon a concern with the patient's products as an effort to communicate, or as expressions of an organized self-image. Simon had discovered that these random scrawls were in fact a language. The task of translation was left to others.

Simon was one of the first psychiatrists to form a large collection of paintings and drawings by the insane.[30] His intention was to impose order on this mass of chaotic material and discover ways of linking this visual evidence with the systems of nosological classifications in use at the time. In this task it must be admitted that his success was limited. Using Simon's descriptive classifications, one cannot divide a group of drawings made by a variety of patients into categories related to the syndromes identified by nineteenth-century physicians. This is at least partly due to Simon's inability to reproduce a sufficient sample of drawings. His system suffered from the artificiality and oversimplification of the nosology of the period. The most we can assume is that it worked for him.

Simon might be criticized for his failure to deal openly and adequately with the overt sexual imagery that is not uncommon in the drawings of the insane. In both of his publications he revealed a rather prissy attitude to sexual matters, which could not be said of Lombroso, and which was not characteristic of the age. As Henri Ellenberger in his discussion of the scientific milieu around 1880 points out, "contrary to present-day assumptions, sexual matters were treated frankly in medical and anthropological literature. They also were discreetly hinted at in literature."[31] An incident in which Simon actively interfered in the production of obscene drawings might be held up as an example of his lack of scientific objectivity. "I should also mention in connection with this repugnant subject a patient under my care obsessed with libidinous hallucinations. Incapable of drawing, he had drawings executed for him by another patient, drawings of the last word in obscenity. It is hardly necessary to add that, once informed of these very specialized works of art, I put an end to these licentious compositions" (1888, p. 351). However, in 1876 he did indicate his conviction that sexual themes were especially prevalent in the drawings of "les persécutés, "les déments," and "les imbéciles." He challenged Tardieu's contention that such subject matter was extremely frequent. In fact, his decision to avoid discussion of the subject was based not on prudery but on his awareness that he had insufficient information. "I have not observed a sufficient number of examples to permit me to express an opinion on this point with any degree of certainty." He recommended further study. "It would be useful to investigate whether the characteristic of obscenity in drawing is more prevalent in specific forms of insanity" (1876, p. 390). In his second publication he added a new diagnostic category, "erotic delirium," and he discussed sexual representations in much greater detail. He was probably influenced in this direction by the publication of Lombroso and du Camp's article, "L'arte nei pazzi," which appeared in 1880. Following Lombroso's emphasis on hereditary degeneracy, Simon was led to state, "Today, having been able to study the facts more closely, I am inclined to believe that this sort of patient generally reveals traces of an hereditary defect. I have collected information on several of these patients which permits me to put forward the opinion that I am presenting here; but concerning several others, I have not been able to obtain sufficient information" (1888, pp. 351–52). In this passage we encounter the seductive intensity of Lombroso's theories as Simon, the man of science, was about to succumb.

His sole concession to such subject matter was the inclusion of a single plate drawn by a lady whose preoccupations scarcely deserve the title "erotique," especially if one considers the vogue for Spanish fashions that swept France during the reign of the Empress Eugenie (1853–1871). "Things Spanish enjoyed enormous popularity in France during the reign of the beautiful Empress Eugenie. Not only were Spanish dancers and bull-fighters welcomed in the French capital, but Spanish themes were common in novels and plays, the

annual Salons were filled with paintings of Spanish subjects, and details of Spanish dress came and went in the changing world of fashions."[32] Small wonder then that the preoccupation with Spaniards had reached the hospital at Dijon, and that the art of the patients had begun to reflect the art of the Salon.

Passionate preoccupations of a less condemnable type find expression at times among the insane, especially among the ladies, in drawings about which a word might here be said: I speak of the amorous preoccupations which frequently lead the insane, and hysterics too, to draw, or rather to copy, portraits of young men of more or less perfect beauty. At times it is the conviction that they have of a resemblance to a beloved person which leads them to choose them as their model; at other times it is merely the satisfaction to be derived from copying a beautiful face. I have encountered several cases of this type, and I am reminded, among others, of a patient at Dijon who drew, or copied, with some facility, a vignette representing an individual in Andalusian costume. Beneath it she had inscribed these lines which indicated the preoccupations of the author clearly enough: "It's a pleasure to suffer for so beautiful an actor."[33] (Fig. 7.5, bottom right)

For the art historian Simon's work is of particular interest in that it represents an effort to come to grips with the difficult problems inherent in the analysis of nonverbal forms of expression. Simon's ability to write dispassionately and analytically about bizarre mate-

rial could have served as an example to the art critics of his day, who displayed far less objectivity and seriousness in their confrontation with the Impressionists. It is amusing to note that the paintings of the Impressionists were considered suitable evidence for the critics to arrive at a diagnosis of insanity. The following passage is taken from a review of a group show arranged by the painters in 1876:

The rue Le Peletier has bad luck. After the opera fire, here is a new disaster overwhelming the district. At Durand-Ruel's there has just opened an exhibition of so-called painting. The inoffensive passerby, attracted by the flags that decorate the facade, goes in, and a ruthless spectacle is offered to his dismayed eyes: five or six lunatics, among them a woman, a group of unfortunate creatures stricken with the mania of ambition, have met there to exhibit their works. Some people burst out laughing in front of these things, my heart is oppressed by them. Those self-styled artists give themselves the title of non-compromisers, impressionists; they take up canvas, paint, and brush, throw on a few tones haphazardly and sign the whole thing. . . . It is a frightening spectacle of human vanity gone astray to the point of madness.[34]

What would Simon have thought of all this?

Simon's lack of involvement in the genius–insanity controversy and his avoidance of any aesthetic evaluations of the drawings he was studying make it difficult to understand the nature of his aesthetic stan-

7.5. Ch...., drawing of a horse (*top left*); a beautiful actor (*bottom right*), from P. M. Simon, *Archivo di antropologia criminelle* 3 (1888), plates 20–25.

dards, or of his involvement with the visual art of his day. A wide and clearly demarcated gulf separated the drawings of the mentally ill from the "Fine Arts," a division that is somewhat less apparent today. As a result Simon was able to dismiss the pictures as of no artistic importance. He avoided using the word *art*, although he did refer to the nonpictorial descriptions of his patients as "les conceptions artistiques." He used evaluative terms rarely, referring occasionally to a drawing as badly drawn, or as executed "avec correction." We also find references to pictures being "very agreeably composed." One of his most interesting hypotheses, when he discussed the improvised costumes worn by some severely disturbed patients, is the idea that there is "among maniacs a disturbance of taste, just as there is a disturbance in behavior" (1876, p. 368). All of these evaluative judgments place Simon's aesthetic conceptions quite clearly within the academic and more conventional standards of taste of his period. He accepts without question the belief that standards exist by which art can be judged and separated off from non-art. His twentieth-century successors were not as fortunate in this respect.

Perhaps the best clue to Simon's personal preferences in art, and an indication of just how conservative they were, is provided by the one reference to a famous artistic personality that occurs in his article. Describing the work of a patient diagnosed as suffering from "paralysie générale," Simon told the story of a young soldier who displayed a whole range of delusions of grandeur. He described a wonderful palace he planned to build; convinced that he was a painter, he intended to ornament the walls with frescoes.

Ch . . . imagines himself, in fact, to have artistic talents equal at least to those of Horace Vernet. This belief led our patient to execute a drawing of a horse which was the most insignificant daub in the world; a child in his most imperfect attempt could not produce anything more insignificant. A curved line, with several strokes at either end of it representing the mane and the tail! There you see what the efforts and the pretentions of the poor paralytic resulted in, this man who, in his madness, sought to emulate one of our greatest painters of battle scenes.[35] (Fig. 7.5, top left)

The last phrase seems to suggest that one of Simon's artistic heroes may have been called to mind. Horace Vernet (1789–1863), like his father Carle, was indeed a specialist in the painting of horses, and might well have appealed to a conservative physician whose knowledge of painting may not have extended much beyond the doors of the Salon. The description of the drawing of "Ch." as "la chose la plus nulle du monde" could be mistaken as a vicious attack on the art of the mentally ill. Simon is trying here not to attack the young soldier, whom he in fact referred to as having an open and sympathetic character, but rather to differentiate as clearly as possible cases of psychologically induced delusions of grandeur from the organic diseases that resulted in a complete collapse of graphic control. Although this patient might display megalomanic delusional ideas, his ability to depict them had deteriorated to the point of puerility. This aspect of the drawings of patients diagnosed as suffering from "paralysie générale" and "imbécilité" led him to compare the drawings of these individuals and the art of children, thereby introducing yet another topic that would continue to stimulate discussion up to the present time.

In this analysis of Paul-Max Simon's approach to the graphic productions of the mentally ill, I have undertaken to remove him from the shadow of Cesare Lombroso, and to restore him to his rightful position as the creator of a significant new field of scientific investigation. Lombroso's influence was soon to make an impression upon a far wider public, overshadowing Simon's work completely with an endless series of pathographies of genius, biographies that displayed Lombroso's extraordinary gullibility, or carelessness, in regard to facts. Simon's more modest undertaking, which owed less to Romantic conceptions of genius, and more to the descriptive psychiatry of his day, can be understood now as far superior to that of Lombroso, an achievement that in its seriousness and objectivity was to provide an admirable prototype for all later explorations into the psychology of psychotic pictorial expression.

EIGHT

Victorian Bedlam:
The Case of Richard Dadd

Throughout the nineteenth century, the construction of a high wall was underway, a wall that, with increasing effectiveness, separated the insane from the world outside the asylum. The fundamental purpose of an asylum, once a place of refuge, had changed. It now offered the patient custodial care, and the public a guarantee of the invisibility of the insane. As a result, it became increasingly complicated and difficult for outsiders to come into contact with psychopathological art. This chapter, a survey of reactions to the work of the insane painter Richard Dadd (1817–1886) investigates the permeability of this wall—the degree to which images and information could pass both in and out.

Romanticism, as we have seen, while fostering and adding to the idea of the insane genius, also produced an attitude of intense expectation and curiosity, at times approaching reverential awe, toward the artistic products of the mad artist. Numerous artists, particularly in Romantic England, responded to this by cultivating extremes of eccentricity and imitating madness. Most critics, biographers, and amateurs of art in search of insanity, however, were content with idealized conceptions of the insane and an imaginative vision of the nature of their art.[1] It might be supposed that a single dramatic dose of reality would have awakened these admirers of madness from their reverie, an individual and a story of art and madness that would seize public and critical attention, confronting it with unanticipated facts. But such a supposition would underestimate the pervasive power of the Romantic imagination.

In the early years of the century, the English artist and poet William Blake (1757–1827) provided an admirable Romantic figure around whom the legend of the insane genius might crystallize, but Blake was far too sane to provide real material for correcting public and critical notions regarding the effects of insanity on the artistic faculty. He simply, and calculatedly, furnished richly embellished stories for the Romantic makers of myths.

Later in the century, a far more satisfactory case

emerged with dramatic suddenness, that of Richard Dadd, one of the most celebrated and notorious mad artists of his day. It is essential for our purpose to differentiate between the artist Richard Dadd as he appears to us today with his artistic reputation refurbished and reinterpreted, and the Richard Dadd of the second half of the nineteenth century. There can be no question that Dadd was, and remained, insane; nor is there any doubt that his insanity and his crimes captured public interest to an extraordinary degree. He was far more celebrated in his own day as an insane murderer than as an artist. Nevertheless, from the moment that his case attained national attention, it was interpreted and understood in the context of the insane genius.

Our concern is not with Dadd himself, or even primarily with his artistic productions. For our purposes it is essential only that from 1844 on Dadd was profoundly mentally ill and hospitalized, and that he was painting pictures that, to a limited extent, were known and talked about in the press and elsewhere. He therefore provides us with a superb opportunity to measure and analyze the extent and nature of public and private response to the art of the insane in Victorian England. His unique position as a highly trained painter of growing reputation who suddenly became an inmate of a madhouse ensured that he remained at least partially visible. His history can be followed from document to document, along with the varying responses to his life and work after his admission to Bethlem Hospital.[2] However, it should not be forgotten that Dadd owed his continuing fame not to his work but to his Romantic image as the mad artist of Bedlam. Other anonymous patients confined to Bethlem Hospital may be assumed to have made drawings and paintings of which no record or trace survives. We are exploring an atypical example when we investigate public response to the more visible Dadd and his work.

It is, of course, paradoxical that Richard Dadd should serve as the object of such an investigation, in that during the period of his life of concern to us (1844–1886) he was imprisoned in the ward for the criminally

insane at Bethlem Hospital, and later at Broadmoor, where it was intended that he would be permanently isolated from the world.[3] This isolation should also have effectively broken his connection to the world of art. Nevertheless, the wall behind which he lived was variously permeable, permitting Dadd to follow artistic developments in London to a limited extent, and allowing his work to be seen and discussed. A survey of this movement of ideas and images adds to our understanding of the various factors that contributed to the final form his works assumed—the influence of outside artistic sources, of psychiatric intervention and patronage, and of Dadd's prior training, as well as his psychopathology. It provides a useful corrective to the current tendency to understand psychiatric art only in terms of private imagery and mental disturbance, omitting any reference to historical and environmental factors.

Although the Victorian Age appears to have been suffocating in a wash of Romantic sentimentality, this was a mere surface veneer, beneath which one encounters an enormously objective pragmatism. Increasingly, one sees that Romantic sentiment declined in Victorian England prior to the enormous resurgence of the Romantic impulse, usually not so identified, in the early twentieth century. Critical and journalistic response to the life and work of Dadd illustrates a curious shifting between the Romantic view of the insane genius and a keen appreciation of the reality of his situation. The responses to his work reveal this ambivalence in its most extreme forms.

THE RELEVANT facts of Dadd's life are as follows: In 1843, following a lengthy trip to Europe and the Near East, Dadd returned to London in a mental state clearly recognizable to his family and acquaintances as insanity. He remained at liberty for a period of time, exhibiting occasional bizarre behavior, but continuing to paint. In August of that year he was seen by Dr. Alexander Sutherland, physician to St. Luke's Hospital and a prominent alienist of the day, and diagnosed as insane, dangerous, and no longer responsible for his actions, but he was not hospitalized. On August 28 he murdered his father with no apparent provocation and fled to France, where he attempted a second murder, this time of a stranger. He was apprehended and, after a few months in a French asylum at Clermont, was returned to England, and committed for life to the criminal lunatic ward at Bethlem Hospital, St. George's Field's, Southwark. He remained there from 1844 to 1864, when he was transferred to the new Broadmoor Hospital, where he died in 1886. He was twenty-six at the onset of his illness, and lived a total of forty-two years in the two hospitals.

Although the records relating to Dadd's case were poorly kept and contain few entries, it is certain that he suffered from a psychotic illness, which would be diagnosed today as a form of schizophrenia.[4] During the acute phase of his illness he was homicidal, acting in response to delusional instructions, auditory and visual hallucinations, that told him to kill. In the later stages of his illness he became more calm and certainly less dangerous, while continuing to hold to his convictions of having murdered the devil, and of being an envoy of Osiris and divinely inspired. His delusional beliefs appear to have been contained, permitting him to function in a fairly normal way so long as they were not touched upon. In terms of either the diagnostic thinking of his own day or in the context of modern psychiatric conceptions, he was and remained obviously and permanently insane.[5]

As early as May 1845, it was known in London art circles that Dadd was painting and drawing again, and his new work was being described in some detail in art magazines. He continued to paint during the forty-two years of his confinement, producing a body of work that, despite the fact that a good deal has been lost, still represents a respectable output for any artist. Dadd continued to see himself as an artist fully and actively committed to the production of pictures that he understood as not inferior to those being painted by his fellow artists outside the hospital.

Our concern is, however, not primarily with Dadd's estimation of the value and significance of his work, but with the attitude of others toward it—the popular press and art journals, and the critics and artists, some of whom had known him well—and the response of his physicians and other individuals living within the confines of the hospital. Dadd's official career as an artist ended when he entered the hospital. He ceased to participate in the world of art and artists. His work, with a few exceptions, ceased to appear in public exhibitions and could rarely be purchased, and by the time of his death in 1886, he was essentially forgotten. His reputation is a creation entirely of the twentieth century, the product of forces whose emergence we are investigating. Although prior to his illness he had begun to attain considerable reputation as a painter of fairy subjects, and had exhibited works that captured the public's imagination, it is fairly certain that in the absence of a group of works created during the years in the Bethlem and Broadmoor asylums, he would have vanished into obscurity. As one of Dadd's early twentieth-century admirers put it, "If Richard Dadd and his

father had not taken the walk on the September [*sic*] evening in Cobham Park that ended in murder, it is doubtful whether any particular interest would be shown in his paintings today."[6]

It is difficult to imagine the impact and the journalistic sensation inspired by Dadd's seemingly meaningless murder of his father—"One of the most appalling events recorded in the history of modern times."[7] Contemporary newspapers indulged in orgies of gory description and wild speculation, constructing from the first day the legend of Dadd as an insane genius. It was known that he had been insane for some time prior to the murder, and so the stage was set for an immediate retrospective evaluation of his early work in terms of approaching mental illness. It was to be expected that the whole range of contemporary attitudes toward insanity and art would surface around him. A new and largely imaginary Richard Dadd began to take shape at once. Curiously, the first effort in this direction was to declare him dead. In October 1843, an article appeared in the prestigious journal *The Art Union*, entitled "The Late Richard Dadd." "Alas! We must so preface the name of a youth of genius that promised to do honour to the world; for although the grave has not actually closed over him, he must be classed among the dead. . . . Alas! It is indeed, a heavy penalty—that which poor humanity pays for enjoying the gift of a fertile imagination."[8] While Dadd's early successes were real enough, his sudden elevation to the rank of genius was an invention of the newspapers. The *Kentish Independent* for September 2, 1843, reporting the murder for the first time, refers to Dadd as "the murderer, an artist of acknowledging genius."[9] The *Pictorial Times* stated, "No living artist possessed a more vivid or delicate imagination, and there is no doubt that the excess of this quality predisposes to the disease which has triumphed over him."[10]

Efforts to reassess the work Dadd did before the onset of his illness can also be observed in the earliest reports of the murder. Could evidence of insanity be found in his pictures? Attention focused on two works, a painting entitled *Caravan Halted by the Sea Shore*, which was executed after Dadd's return from the Near East and prior to the murder; and a large cartoon, *St. George After the Death of the Dragon*, which Dadd had submitted as an entry in the competition for historical frescoes to adorn the new Houses of Parliament at Westminster. The competition entries were on exhibition at the time of the murder, and public curiosity about Dadd's work was so intense that Westminster Hall was crowded to overflowing with visitors who had come to see and speculate on entry number 14. The *Kentish Independent* described the cartoon as "attest[ing] to the wreck of his fine faculties, display[ing] both in composition and finish evident signs of mental infirmity."[11] Several days later, a lengthy article summarizing the facts of Dadd's career appeared in the *Pictorial Times* of September 9. This article, an essential source for later knowledge of Dadd's life and work, also made reference to the Westminster Cartoon. "It was sent in against the earnest entreaties of his family and friends, who knew full well that it could do his reputation no service. For ourselves, when we saw it, we considered it as evidence of that insanity of which we had heard so many rumours, and our apprehensions for his ultimate fate increased.[12] Although the cartoon has not been located, a small study for it exists. The study does not suggest any pathological features, and one feels instead the critic's rather strained efforts to discover some bizarre feature indicating imminent insanity. The solution that found general acceptance was that the tail of the dragon was inordinately long.[13]

The work that might have been expected to reveal some psychological conflict, if not fully developed psychosis, was the elaborate oil painting *Caravan Halted by the Sea Shore* (Fig. 8.1). Although contemporary accounts of Dadd's behavior after his return to London make it certain he was at least intermittently psychotic, the painting reveals nothing of his disturbed mental state, a fact that perplexed the critics who examined it after the murder. "Immediately after his arrival in London, he commenced working, and strange to say, the pictures then produced are as admirable in design and execution as his earlier works. This is evidenced by a picture of "Arabs"—a work of rare and singular merit."[14] However, extremely contrasting accounts of this picture survive. In the autobiography of Dadd's closest friend, the painter William Powell Frith (1819–1909), we are told:

Dadd soon began to work as usual, without showing a trace of insanity in his pictures. The last time I saw him . . . he was painting a picture of a very prosaic scene, a group of Eastern people with camels, a view of Cairo in the background. The picture seemed to me spiritless and poor, rather the product of a sluggish mind than of one "all o'er-thrown."[15]

Frith was writing some fifty years after the event but his impression of Dadd's "last" work remained extremely clear. In his straightforward account, the myth of "insane art" is confronted with the pragmatic objectivity of the Victorian mind, and with the accurate visual memory of an artist noted for his photographic depictions of reality. His description contrasts sharply with a bizarre tale reported by yet another of

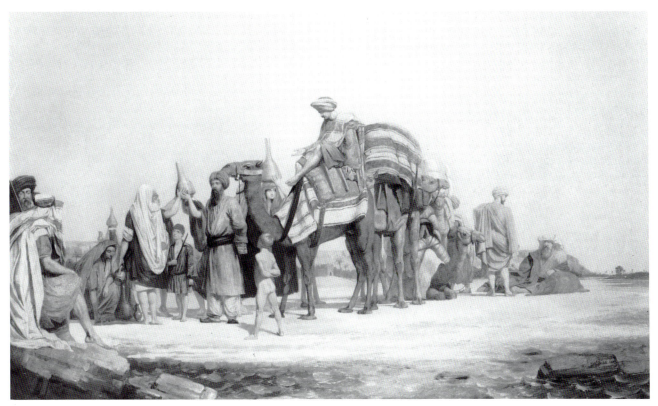

8.1. Richard Dadd, *Caravan Halted by the Sea Shore*, 1843, oil on canvas, collection of Miss V. R. Levine, Mathaf Gallery, London.

Dadd's contemporaries, the painter Frederick Goodall (1822–1904).

When I learned of his return to London, I called upon him, and found him in some respects eccentric. The first thing I noticed in a picture the artist was painting was, that all the living objects in the picture—human figures and camels—were all laid in with a bright purple. When I asked the reason, he answered, "it is my principle," which I thought very strange.[16]

It is most probable that across the space of sixty years, Goodall's memory had been embellished by the legend of Richard Dadd, the mad artist.

During the period when the foregoing comments were written, Dadd was not painting or drawing anything. To the extent that critics were discovering evidence of insanity in his work, they did so in pictures executed prior to his hospitalization, pictures with no hint of pathological processes. As a result, their comments betray what they expected from the art of the insane. As Dadd had established his early reputation as a painter of fairy subjects, this type of painting was now reexamined in the context of mental pathology.

Insanity, conceived of fairly generally as resulting from excess of imagination, was understood as a near inevitability for the painter of such fantastic scenes. While not the originator of this type of subject, Dadd was involved in its earlier development.[17] However, it is striking that as early as 1841, long before he had displayed any signs of mental disturbance, a critic in the *Art Union*, discussing one of his fairy paintings, admonished the young artist "to stop short of the boundaries which divide the imagination from the absurd."[18]

On May 1, 1844, the *Art Union* commented on Dadd's complete lack of involvement with art. His family had sent art supplies to the asylum in France but to no effect.

He took no notice whatever of the pencils, colours, and canvas they had sent him; retaining, it would appear, no sort of memory of his former pursuits, and never giving the slightest indication of a desire to produce a picture. His employment all day is to stand in the courtyard, with up-turned eyes, gazing at the sun, which he calls his father.[19]

It would seem that no one in 1843–1844 appears to have anticipated that Dadd would resume his artistic

activity again. There is no early expression of curiosity as to what he might produce if he did begin to paint. The following year, however, saw the beginning of the *Art Union*'s coverage of Dadd's renewed career, coverage that continued intermittently for some twenty years.

It is not generally known that this unhappy man is at present in Bedlam, having been removed to that hospital from Maidstone. He is in good health; and we have lately seen some drawings recently executed by him which exhibit all the power, fancy, and judgement for which his works were eminent previous to his insanity. They are absolutely wonderful in delicate finish. They consist principally of landscapes—memories of Eastern scenes, or wrought from a small sketch book in his possession. One is, however, of an avenue of close box-trees, terminated by the tall gate of a mansion. It is a marvelous production, such as scarcely any of our living painters could surpass. This drawing was, we believe, produced within the last few weeks.[20]

The objectivity of this simple report is worthy of respect. Faced with the painting of a madman who had been expected never to paint again or, if he did paint, would be expected to produce wild chaos, the critic found himself in a position to replace fantasy with fact, and to represent the madman Dadd as a master of undiminished ability, whose work, "wonderful in delicate finish," marvelous in power, fancy, and judgment, was worthy of comparison with that of any living painter. Although his enthusiasm was somewhat excessive, it is apparent that the writer was attempting forcefully to confront the readers of the *Art Union*, as he himself had been confronted, with the astonishing fact that Dadd's creative ability was intact, and that his work, far from being bizarre, could be seen as a continuation of his earlier endeavors. The announcement of his "death" had, therefore, been somewhat premature. He continued: "Two or three of his productions indicate the state of his mind. One describes a castle shattered by lightning. Underneath is written 'The Wrath of God.' Others contain brief written descriptions (on the back) in oddly mingled French and English."[21]

This refreshing clarity of vision was to remain the exception. The majority of viewers and reviewers saw what they expected to see in Dadd's work. In the same magazine three years later, another reporter recorded the more typical response to the problem.

The calamitous termination of the moral existence of Richard Dadd, was too impressive to be forgotten. Since the awful calamity that has consigned him for the remainder of his earthly existence to the abode of lunatics, he has not, in the absence of reason, forgotten that he was a painter. By the kindness of the governor of Bethlem Hospital, he has been furnished with canvasses, colours etc., and paints! But how?—with all the poetry of imagination and the fantasy of insanity—in parts eminently beautiful, but in other parts, in madness, without method. How singular these outpourings of disease and mind will be to future collectors.[22]

The prophetic tone of this final sentence should not be understood in the light of twentieth-century events. It is certain that they were cynically intended, referring to the perplexity such works would awaken in a collector unaware of their place of origin.[23] Although very few pictures belonging to Dadd's early years in Bethlem survive, Dadd probably never produced any works that could have inspired descriptions in terms of the frenzy of insanity. The earliest surviving work that can be said to contain elements of obvious psychopathology, the so-called *Flight out of Egypt*, was painted only in the following year.[24] One wonders whether the critic had actually seen any of Dadd's work. However, comments of this type remained common even among those few who knew Dadd's later pictures. They reflect the strong conviction that the art of the insane must inevitably exhibit marks of insanity.[25] While today we tend to respect the more objective version of the story, it must be remembered that the Romantic or imaginative view of the art of the insane had far more to do with inspiring and maintaining interest in the art of the asylum. It was a revival and intensification of such Romantic ideas that produced the sudden development of serious interest in the art of the insane among artists in the early years of the twentieth century.

In the years that followed these first reactions to Dadd's illness and work, the public image of Dadd underwent little change. Although a few interested individuals were able to see examples of his later work, such opportunities must have been rare. No reproductions of his work appeared. Nevertheless, his reputation as the mad painter of Bedlam persisted, as did curiosity about the work he produced there. Even his early paintings continued to inspire an almost morbid fascination, much as they do today in people who know his story.

In 1857, a major exhibition known as "The Art Treasures Exhibition" was held in Manchester. The paintings in the gallery devoted to modern British art appear to have been selected by Dadd's close friend, the artist Augustus Leopold Egg (1816–1863). Egg had been distressed by Dadd's illness, and in deciding to hang no fewer than six pictures by his friend, he undoubtedly selected work that in no way suggested the bizarre or pathological. He probably included no works from the Bethlem period, presenting only pictures painted during Dadd's youth, including the works

upon which Dadd's early success was based—*Titania Sleeping* (1841) and *Puck* (1841).²⁶

Two handbooks devoted to the exhibition refer to Dadd's work. They were compiled from reviews appearing in the *Manchester Guardian* and reveal a more fully developed preoccupation with the art of the insane. Although still distorted by Romantic imaginative conceptions, the reviews seem to consider the values of psychopathological art and again suggest a conflict between attraction and repulsion. One senses the writers' uncertainty about how to react, what to think, and what to say. In the arrangement of the handbooks, Dadd's works are discussed at the end, apart from those of his friends and contemporaries. "Lastly some words of sincere sympathy may be allowed over the pictures of poor Dadd in this gallery. They will never reach him in that Bedlam cell, where the rest of his life must pass, less unhappy in that he is allowed to ply his pencil even in that dreary place." The critic may not have known that the oil paintings he was describing belonged to Dadd's pre-Bedlam days. But here too, the fairy paintings were reinterpreted in terms of madness. "These fairy paintings have a melancholy interest, as the working of a teeming but disordered brain."²⁷ At this point the critics' own teeming brain was quite overcome with inventiveness and he created an apocryphal story, an inspired conflation of Dadd and Blake, indicating that the public imagined these two artists, so unlike in both life and work, were somehow related.

His friends used to banter the poor young painter, when he spoke of these gnomes and fairies, who swing within flower beds, and drink their dewdrops, and wanton in the cold streams of the moonray, as of familiar acquaintances, who come nightly to sit to him for their portraits. Alas they little knew what those visions portended, or how they were to end!²⁸

In the handbook to the watercolor section, the critic, probably a different writer, takes up much the same theme.

William Blake, . . . and R. Dadd . . . may be classed together as examples of painters in whom a disordered brain rather aided than impeded the workings of a fertile and original fancy. Do not be deterred by the strangeness of Blake's work or the sadness of Dadd's from looking closely into both. Both were mad, but the insanity of Blake was of the kind separated by a thin partition from great wit. It was rather from a preponderance of the imaginative faculty that he must be classed among lunatics, than from any ruin of mind such as hurried poor Dadd into parricide.²⁹

This passage provides the first instance in which actual paintings are brought forward to support the idea

that insanity, "a disordered brain," might actually lead to superior artistic results, at least in the realm of "fancy."

The individual pictures inspired rather more conservative press. Commenting on the *Caravan Halted by the Sea Shore*, the handbook describes it in very positive terms. "There is nothing of wildness, only a certain subdued key of colour which is curious and uncommon, and much sober good drawing, with a certain Biblical sentiment."³⁰ A watercolor entitled *Dead Camel* inspired rather different reactions in our two critics, the one finding it "full of gloomy madness," the other hailing it as "a ghastly little invention of desert horror, framed in by demons such as his disturbed brain alone could devise." This latter critic referred to the watercolors in general as "full of the lurid imagination of insanity, while they deserve careful examination for their impressive solemnity also,"³¹ a sentence that epitomizes the ambivalence. These descriptions of Dadd the madman, and his lurid work full of gloomy madness, could not help but awaken wild curiosity in visitors to the exhibition, an effect no doubt intended by the writers.

The paintings exhibited in the Manchester exhibition probably belonged to the period prior to Dadd's hospitalization. However, at least one major Dadd from the Bedlam years was publicly shown. Three years before his death, his *Caravanserai at Mylasa* was shown at the "Fine and Industrial Exhibition at Huddersfield" in 1883, the catalog stating specifically that Dadd painted the picture "at Bethlem Hospital, after he murdered his father."³² An inscription at bottom left reads "1845 Bethlem Hospital." It is not known how a picture painted inside the walls of the criminal ward at Bethlem came to be included in this exhibition.

More than a few examples of Dadd's work were making their way from the ward to the world. In 1902, Frederick Goodall referred to Dadd's Bedlam drawings in his *Reminiscences*:

Some years afterwards [after 1843] I was at a Chalcographic Societies meeting, and saw a remarkable collection of drawings. I was told whose they were; they showed that the poor fellow had retained some part of his artistic knowledge but mixed up with curious freaks of fancy. One of these drawings, I remember, he had called *The Difficult Path*. The scene was of a rugged mountain side; a zig-zag path was cut in the rock, and a knight in full armour was trying to find his way. . . . I never saw any other drawings but these I have mentioned, though I felt curious to see all he did in the asylum.³³

The drawing that Goodall referred to is probably the watercolor of 1866, entitled by the artist *The Crooked Path* and painted in Broadmoor Asylum. If this identi-

fication is correct, it indicates that even after Dadd left London for Broadmoor his work still continued to reach interested viewers in the city. Whose collection was displayed is not known, but it is of importance that a collection of Dadd's work was being assembled, possibly at Broadmoor. A hint of the intensity of Goodall's interest survives in his statement, written so many years after, "I felt curious to see all he did in the asylum." That he attempted to do so is implied by his visit to Dadd there, but in his account of the visit he makes no reference to any of Dadd's work.

Dadd's closest friend, William Powell Frith, does not appear to have seen Dadd after he entered Bethlem Hospital. Frith reveals the extent of his devotion to Dadd and of his loyalty to him by dedicating a full chapter of his autobiography to Dadd. His only reference to Dadd's work in hospital is confined to a single sentence. "He amused himself in painting pictures, in which may be traced evidences of genius, and, alas! of insanity."[34]

Although the artists of Dadd's circle were curious about his work, it is extremely unlikely that his later paintings and drawings influenced them. The Pre-Raphaelites, who might have reacted with sympathy to even his more unusual paintings, seem to have been unaware of the works that might have been of interest to them, such as the *Fairy Feller* or *Oberon and Titania*. Yet they must have known Dadd; the writer and art critic William Michael Rossetti (1829–1919), brother of the painter Dante Gabriel Rossetti (1828–1882), visited Dadd in Bethlem and saw at least one of his works, the lost painting *The Good Samaritan*.

I was once in a madhouse, Bedlam. . . . One inmate of the asylum whom I was curious to see was Richard Dadd, a painter of much talent, taking a rather fantastic turn, who was rising towards prominence about the date of 1847 [*sic*], when the seeds of madness developed in him, and in a ghastly moment of fancy he slew his father. I saw the ill-starred painter . . . his aspect was in no way impressive or peculiar; he seemed perfectly composed, but with an undercurrent of sullenness. He had painted a large picture, which I conjecture is still on the staircase of the asylum, of *The Good Samaritan*, a rational work, showing adequate artistic knowledge of an ordinary kind, but not marked by any of that superior talent which had once been his.[35]

The only artist known to be attracted to Dadd's later work enough to include it in his own collection is the landscape painter Miles Birket Foster (1825–1899), who owned the painting known as *A Dream of Fancy*. He received the painting as a gift from the steward at Bethlem, George Henry Haydon. Foster worked in watercolor and was noted for his extremely detailed, meticulously finished technique. Dadd's miniaturist precision no doubt appealed to him, but it is perhaps only coincidence that Foster began working extensively in watercolor in 1859, the year in which the *Dream of Fancy* was executed. Whether he was influenced in his very personal use of that medium by Dadd's watercolor style is uncertain.

In general, the few comments made by artists about Dadd's work are reserved and cautious. Because many of them had been friendly with Dadd, they tended to avoid mentioning his illness except in the most general terms. The more spectacular and exaggerated criticism originated for the most part with journalists with a taste for the sensational.

An exception to this rule is provided by a lengthy article, the last account of Dadd to appear during his lifetime, published in *The World*, December 26, 1877.[36] The anonymous writer seems to have been unusually well informed about Dadd's early life, and some details suggest that he may have discussed Dadd's case with Frith. The article is unusual in presenting an actual interview with Dadd, who was then living in the asylum for the criminally insane at Broadmoor. This sensitive, carefully written, and deeply human account of the artist, for the first time, provides an impression of the reality of his existence and of his own attitude to his life and work after so many years of captivity. While aware of the sensational aspects of Dadd's story, the interviewer seems to have been concerned to make contact with him as an artist, to discuss his work and life, very much as he might have done with any painter of reputation. In this interview, therefore, Dadd emerges as an artist first, a madman only coincidentally.

After a brief review of Dadd's early history and successes, and the story of the murder and its consequences, the interview begins:

A recluse doing the honours of his modest and unpretending abode; a pleasant visaged old man with a long and flowing snow-white beard, with mild blue eyes that beam benignly through spectacles when in conversation, or turn up when in reverie till their pupils are nearly lost to sight. He is dressed with extreme simplicity in gray "dittoes"; his manner is unassuming, but impressive and perfectly courteous; his utterance slow, not as though ideas were lacking, but as if he wished to weigh carefully his words before he spoke them.[37]

How skillfully the writer corrects mistaken notions of insanity, weaving a portrait of Dadd as a quiet and rational old man. Although Dadd was then sixty years old, we are inevitably reminded of the beautiful photograph of Dadd at the easel, made over twenty years earlier at Bethlem Hospital (Fig. 8.2). Suddenly we by-

pass the myth of the mad artist, and are in contact with a real and comprehensible human being. Compelled to satisfy public curiosity, the writer attempts to feed it with simple facts and to portray the artist as a man devoted to his art, a gentleman of calm and unassuming manner. Even in dealing with Dadd's delusional beliefs, about which they appear to have spoken openly, there is restraint and compassion in his presentation.

He says his views and those of society are at variance; that is all. His convictions differ from those of other men: they will not make allowances for him as he would for them; they do not recognize in all its intensity that which has become to him an ever-present and abiding law—the will of mighty Osiris—for since the first wild murder and his hasty flight, this Egyptian deity has been exalted by him into the Supreme Being. ... But although when pressed he will discourse lucidly and with animation upon all these points, recapitulating even with sickening exactitude the details of his crime, the spirit seldom moves him to talk spontaneously thus. His conversation is like the present even tenor of his life, quiet and inoffensive.[38]

Dadd's involvement with art is understood by the interviewer as his central concern, and he gives us a picture of an artist actively engaged in his work.

He is surrounded by specimens of his own handiwork: upon the narrow table, which is bookcase, guéridon, easel, all in one, lies an exquisitely executed painting on ivory, only a few inches square, the subject allegorical—a fair maiden in medieval attire, with a basket of flowers in her hand, is crowning her knight; in the foreground, jewelled meed, in the distance the walls and towers of an old world town. Every detail is given with a marvellous minuteness and finish which could have been attained only by the use of the magnifying glass he hands to enable his visitor to inspect this work of art.[39]

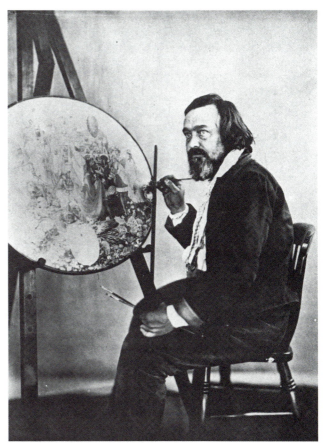

8.2. Richard Dadd at work on the painting *Contradiction. Oberon and Titania*, ca. 1856, photograph by Henry Hering, The Bethlem Royal Hospital, London.

The point is, of course, that Dadd was not engaging in wild and uncontrolled pictorial gestures, but was working with a technique far more precise than that used by most artists. Contrast this with the report of George Augustus Sala, another of Dadd's visitors, who described the work Dadd was doing as "designs of the wildest and most ghastly character."[40]

The World article contained still more detailed descriptions of individual paintings on which Dadd was working, but one final passage from the article stands out as a unique contribution to the evolution of interest in the art of the insane. The author refers to Dadd's continuing preoccupation with art: "Art is thus his mistress still—it is to his beloved brush that he clings, and wields continuously, with that enthusiasm and unwearying ardour the true painter can alone know. Many works will live after him, the product of these thirty odd years of absolute seclusion—melancholy monuments of a genius so early ship-wrecked, but which never went actually to ruin."[41] In this passage, it is suggested, if only tentatively, that Dadd's work, while the product of an individual suffering from undoubted mental illness, would survive after his death. He refers not to mere physical survival but to its survival as art—"monuments of genius." Made at a time when no hope existed of Dadd's work finding any recognition, this statement is a first hint of the rediscovery of Dadd, which was not to occur for seventy years. The author has constructed with great care a revised conception of Dadd and his work. Missing, of course, was the realization that precisely those works with the richest concentration of pathological elements, the most bizarre and strange of Dadd's pictures, were to serve in refurbishing Dadd's reputation. Nevertheless,

the tone of the article establishes a new standard of criticism of the art of the insane. Confronted with the man and his art, the interview and criticism could proceed on a serious and respectful level—intelligent, accurate, and sensitive.

As EARLY AS 1843, Dadd was being supplied by his family with painting and drawing materials. As mentioned earlier, during the acute phase of his illness, he made no use of these supplies. However, by 1845, he was hard at work producing elaborate and highly finished drawings. He was given paints and canvas by the governor of the hospital, an uncommon kindness in Bethlem of the 1840s. Because Dadd was not only a patient, but a prisoner and ward of the state, the provision of gifts or supplies of any type, once he had entered the hospital, was difficult. In addition, his family was probably not in a position to give him anything at this time. It is, therefore, of some interest to inquire as to the identity of this governor who undertook to supply Dadd with materials so that he could resume painting both in watercolor and in oils. Two men who occupied the position of physician to the hospital, the senior medical appointment at Bethlem, can be suggested as possible sources for this kindness: Dr. Edward Thomas Monro (1790–1856) and Dr. Alexander Morison (1779–1866). Other staff members may also have been involved in encouraging Dadd's artistic activities.

Dr. Edward Thomas Monro represented the fourth generation of his family to function as physician in charge of Bethlem hospital, succeeding his father, grandfather, and great grandfather in that position.[42] Despite his position at the end of a long line of physicians, all of whom specialized in the treatment of mental illness, the period of his activity at the hospital was characterized by extremely bad conditions; general negligence and mistreatment of the patients; and his own irresponsibility in diagnosis, treatment, record keeping, and general management of the hospital. His career terminated in a scandal that exposed conditions at the hospital to severe public and official scrutiny and criticism.[43] If, therefore, he was responsible for providing Dadd with painting materials, and this is hypothesis, it would not have been out of any therapeutic intention, but as a result of Dadd's celebrity as an artist of promise.

Edward Monro came from a family not only dedicated to the study of mental pathology, but actively involved with art and artists. Interest in art began with his grandfather John Monro (1715–1791), who was seriously involved with the study of engraving. His son, Dr. Thomas Monro (referred to in chapter 4), is known

in the history of art as the foremost patron of the English school of watercolor painting.[44] Dr. Edward Monro, growing up in an environment where art and artists were actively present, can be assumed to have had some degree of involvement with art. The problem is, as Patricia Allderidge points out, that although Dr. Edward "cannot have been indifferent to art, unfortunately, he was indifferent to record keeping, and it can only be surmised how far he was responsible for Dadd's return to work."[45]

Psychiatric justification for supplying an artist-patient with materials was, of course, to be found in Pinel, and Pinel's work remained the basis of treatment and hospital management, although his influence would have been hard to discover in the Bethlem Hospital of the 1840s. The ward where criminal lunatics were incarcerated during the early years of Dadd's confinement was notorious as a dark, overcrowded, and unwholesome environment. "The skeleton cupboards of Bethlem are the male criminal lunatic wards. These dens, for we can call them by no softer name, are the only remaining representatives of the old Bedlam."[46] It was not, therefore, a total exaggeration when a writer in the *Quarterly Review* referred to Dadd as "obliged to weave his fine fancies on the canvas amidst the most revolting conversation and the most brutal behaviour."[47] Dadd's ability to recommence work under such difficult conditions is a tribute to his creative drive, and it is not surprising that so little work survives from the early years of his hospitalization. Whether we can accept Dr. Edward Monro as in some sense the force behind Dadd's return to painting must remain a matter for further research; however, because he was only very infrequently present in the hospital and very rarely on the wards, he can have had little direct effect on the form or content of Dadd's early Bethlem pictures.[48]

IN 1852 Dr. Charles Hood, a young man of only twenty-eight, was appointed to Bethlem Hospital as its first "resident physician" (Fig. 8.3). His appointment was a partial response to the ugly revelations about conditions at the hospital. At the time of his appointment there was considerable controversy over the selection of a man of such youth and inexperience. However, Hood soon established himself as an innovator and pioneer in the treatment of the mentally ill. That he had the support of the government in carrying out his reforms is indicated by the significant changes he was able to make in the physical environment of the hospital. The surroundings and daily routines of all of the hospital inmates were drastically changed and im-

8.3. Charles Fréchou, *Portrait of Dr. Charles Hood*, 1851, oil on canvas, The Bethlem Royal Hospital, London.

proved soon after his arrival. An article in the *Illustrated London News* for March 31, 1860, identifies Hood as the instigator of change, ascribing some of the alterations as resulting from his "artistic taste": "One excellent and amiable man deserves much praise for the social revolution within the walls of this whilom mansion of misery. . . . To the energy of Doctor Charles Hood must be ascribed the admirable and highly useful improvements that have taken place. To his artistic taste the patients owe the innocent ornamentation of their former gloomy abode, which is now to them a source of solace and delight."[49]

Hood's innovations were not confined to alterations to the environment. He introduced a number of new staff members committed to his vision of reform, among them the steward George Henry Haydon (1822–1892), who was also to play a crucial role in the evolution of Dadd's art. An attempt was made to enrich the daily lives of the patients, to provide activity and mental stimulation. One of the new activities introduced by Hood and his staff was painting. A ladies' workroom is described as "fitted up with exquisite taste, where convalescent and docile patients amuse themselves, or employ themselves in embroidery, fancy work, and flower painting in watercolours."[50] That this activity was not confined to the ladies is indicated by a passage describing the male gallery: "The patients amuse themselves with games at Bagatella, cards, drawing, painting, and reading." That painting and drawing were now understood to be beneficial for patients in mental hospitals can be seen in an article published in 1853, entitled "On the Reading, Recreation and Amusements of the Insane," where it is recommended that "a taste for the fine arts should be fostered by providing the necessary means of pursuing them."[51] It is perhaps of some significance that the au-

thor suggests "allotting to each day of the week some particular mode of recreation or mental employment."

Dr. Hood's youthful enthusiasm and energy as a reformer in a position where it was really possible to institute reform, a rare situation, can be felt in every account of those years at Bethlem, including his own reports and case notes. One of the chief criticisms of the old administration had been the failure of Drs. Monro and Morison to keep any written case records. No real attempt had been made to diagnose patients or to group them in meaningful treatment categories. Dr. Hood was therefore faced with the immediate necessity of interviewing and examining the entire patient population of the hospital. His case reports, while brief and to the point, provide an excellent sample of psychiatric diagnostic procedure in England at that time. The reports on Dadd are the first indication of his psychological condition, of his general behavior, and of the attitude of the administration to his work.

March 21, 1854: For some years after his admission he was considered a violent and dangerous patient, for he would jump up and strike a violent blow without any aggravation, and then beg pardon for the deed. This arose from some vague idea that filled his mind, and still does so to a certain extent, that certain spirits have the power of possessing a man's body and compelling him to adopt a particular course whether he will or no. When he talks on this subject or on any other at all associated with the motives that influenced him to commit the crime for which he is confined here, he frequently becomes excited in his manner of speaking, and soon rambles from the subject and becomes quite unintelligible. He is very eccentric and glories that he is not influenced by motives that other men pride themselves on possessing—thus he pays no attention to decency in his acts or words, if he feels the least intention to be otherwise; he is perfectly a sensual being, a thorough animal, he will gorge himself with food till he actually vomits, and then again return to the meal.[52]

Thus far the case report reads as an objective and detailed discussion, such as would be prepared on any patient resident for a long period in a mental hospital. It describes the symptoms that necessitated his continuing hospitalization (though in Dadd's case he could not have left the hospital even if he had been cured) and accords well with the modern diagnosis of schizophrenia. But what of Dadd the artist? Does Dr. Hood discover this crucial aspect of his patient's identity; could he penetrate beyond the symptoms to the man?

With all these disgusting points in his conduct, he can be a very sensible and agreeable companion, and show in conversation, a mind once well educated and thoroughly informed in all the particulars of his profession in which he still shines, and would, it is thought, have preeminently excelled had circumstances not opposed.

In January 1860, a further entry reads:

No alteration in this man's symptoms have occurred since the last note was made in number 1 casebook. He still employs himself daily with his brush, but he is slower in completing any work he takes in hand. He associates very little with other patients, but is generally civil and well behaved to them. His mind is full of delusions.[53]

While it is clear from these reports that Dr. Hood was aware of Dadd's creative activity, and had obviously held sufficient discussion with him to ascertain that he was still interested in and knowledgeable about artistic matters, the reports fail to give us any really meaningful information concerning the actual nature of the relationship between Dr. Hood and his patient. That Hood was resident in the hospital, and would have seen Dadd frequently, perhaps daily, we know. However, it is essential not to project the intimacy and detailed knowledge of the patient typical of modern psychiatric and psychotherapeutic relationships backward onto psychiatric practices of the nineteenth century. It has been speculated that Hood's presence in the hospital inspired Dadd to increased activity, and to the creation of works of a totally different character from anything he had done before. This is thought to be the result of a kind of friendship having developed between Dadd and Dr. Hood, for which the only clear evidence is the curious reference to Dadd being "a very sensible and agreeable companion." Since we are also told that he associated little with the other patients, what could be the motivation for such an unusual observation?

Although the possibility of specific psychiatric influence on Dadd's creative activity must remain speculative, the facts that do exist to support such an idea—and here I refer to internal evidence provided by the pictures themselves—are very important in enabling us to consider some of the possible lines of contact and communication between this psychiatrist and this patient that may have more general significance for understanding psychopathological art produced in the second half of the nineteenth century.

Although Dr. Hood did not come from the rich artistic milieu that had nourished his predecessor, he appears to have had some interest in art, and possibly an awareness of the value of collecting examples of psychopathological expression. Whether for artistic or clinical reasons, or perhaps both, he assembled a personal collection of Dadd's paintings and drawings, which at his death comprised thirty-three examples. The sale catalog of Dr. Hood's collection provides considerable information concerning his artistic preferences and the range of his intellectual interests.[54] Of the thirty-three pictures by Dadd presented at auction, all but three were sold. The prices suggest that interest in Dadd was existent but declining from a high point reached just after the murder. Interestingly, the painting *Contradiction. Oberon and Titania* (Plate 9) obtained by far the highest price, selling at 136 guineas. Apart from his collection of paintings by Dadd, Hood owned a fairly large number of engravings by other artists. Printed versions of works by Landseer, Turner, Millais, and others, forming a group of thirty-five pictures, indicate, when taken together, that Hood's taste was extremely conventional and solidly Victorian. He owned no paintings other than those by Dadd.

The auction also disposed of Dr. Hood's library, which included no medical or psychological books, which would suggest that the medical books had been sold separately, unless we are prepared to believe that he never owned any. The books included in the sale present a picture of a well-educated man with fairly wide, if not strikingly original, interests. No art books were included, although a number of books dealing with architecture appear. This could imply that Hood's artistic taste was not very well developed. One book in Hood's library worthy of our attention is an edition of Octave Delapierre's *Histoire littéraire des fous* (1860), one of the earliest and richest collections of the literary productions of the insane. The author presents hundreds of examples of poetry and prose written by the insane. He is very precise in identifying these people not as eccentric intellectuals, but as inmates of madhouses. "We should begin by warning the reader that we will only concern ourselves with individuals who appear to have been truly insane, and who, if they were not confined in asylums, as were most of those individuals discussed here, have nevertheless manifested undeniable mental disturbance."[55] Many of Delapierre's examples were in fact collected in English asylums, including Bethlem, and were quoted in English. In the field of literature, the book provides a significant parallel to the progressive development that we are studying in the realm of the visual arts. Awareness and study of the literature of the insane preceded involvement with the painting of the mentally ill by many years.

Although the book was published in London only two years before Hood left Bethlem, it provides evidence that he was interested in the psychopathology of expression and was aware of the possibility of collecting and studying the art of the insane as a meaningful scientific activity. Restricted to a discussion of literature, the book nevertheless referred to the visual art of

the insane sufficiently often to suggest an alternative possibility for research. It even mentions a bazaar that had been established at the Hanwell asylum, where work written and drawn by patients was sold, the very first indication of a market dealing in the art of the insane.[56] It therefore seems possible that Dr. Hood was to some extent interested in visual manifestations of psychopathology and in the artistic productions of his mentally disturbed patient. It may not be a distortion to describe him as Dadd's foremost patron. It is worth considering at least tentatively that he fulfilled this function by commissioning works as well as collecting them.

The possibility that Hood requested Dadd to execute paintings and drawings illustrating specific subjects is usually put forward in connection with a set of related pictures that bear the collective title *Sketches to Illustrate the Passions*. The series of thirty-three pictures was executed between about 1852, the date of Hood's arrival at Bethlem, and 1856. Because some of the subjects depict violent emotions, including scenes close to Dadd's own experiences of homicide and insanity, it is sometimes thought that they may have been suggested or prompted in some way by Dr. Hood, with some therapeutic intent, a form of emotional release or catharsis.[57] Such speculation is based, however, on a rather too modern conception of nineteenth-century therapeutic insight. Although it was becoming common procedure to allow patients to draw and paint, there is no indication that cathartic forms of art therapy were understood or practiced. In fact, in that Dadd was no longer dangerously violent or homicidal, it would have been considered extremely unwise to encourage him to a return to thoughts of murder. Efforts were, on the contrary, typically devoted to distracting the patients from their delusional preoccupations, and drawing was seen principally as a method of relaxation and distraction, or else simply as a means of keeping patients busy and out of trouble. Nevertheless, the sketches to illustrate the passions were produced in the period of Dr. Hood's tenure, and many of them were in his personal collection at the time of his death.

That some sort of friendship had developed between Hood and his patient is also suggested by the fact that Dadd painted one of his most significant works as a gift for him, the painting entitled *Contradiction. Oberon and Titania* (Plate 9). Within the context of Dadd's total oeuvre, this picture, along with the *Fairy Feller's Master Stroke* (Plate 11), represents a unique creation. Both pictures were executed over a very long period of time, utilizing a technique that can justifiably be termed microscopic, and a degree of intense concentration that is obsessional.

WHEREAS the extent of Dr. Hood's involvement with Dadd and his art remains, at present, speculative, more specific information has come to light that verifies Dadd's shared artistic interests with Hood's assistant Haydon. This evidence now makes it certain that respectful and friendly contacts between the more intelligent and rational patients and the Bethlem staff were not unknown.

The friendship that developed between Dadd and George Henry Haydon (Fig. 8.4) was firmly based on a common interest and involvement in art. Haydon, who worked as head steward at Bethlem from 1852 until his retirement in 1889, is now known to have had a second and coexistent career as an artist. Whether he would have identified himself as such is doubtful, but the hundreds of extant drawings make it apparent that Haydon drew continuously and everywhere, including inside the hospital.[58] His original training as a draftsman probably stemmed from a period of apprenticeship to an architect. Most of his work consists of humorous illustrations and sketches that display considerable skill. Although he would correctly be termed an amateur, he illustrated several books and, in the early 1860s, was contributing drawings to *Punch*. He was a

8.4. George Henry Haydon.

8.5. Richard Dadd, *Hatred: Sketches to Illustrate the Passions*, 1853, water-color, The Bethlem Royal Hospital, London.

member of the Langham Sketching Club, which led to close friendships with George Cruikshank (1792–1878), Charles Keene (1823–1891), John Leech (1817–1864), and many other artists. Haydon was an extremely open, kindly, and amusing man, who at Bethlem "made numerous friends and no enemies during his term of office."[59] Through his brother, Samuel B. Haydon, a sculptor who shared rooms with William Michael Rossetti, he would have come into contact with most of the serious painters in London, including the members of the Pre-Raphaelite Brotherhood.[60]

Haydon's involvement with art was not restricted to that part of his day spent outside of the hospital. Like Hood, he is credited with introducing art to the wards. "The casts of statues from the studio of Mr. E. B. Stephens A.R.A. and many other objects of art or interest which help to decorate our wards and which were pre-

sented by him are an evidence of his constant desire to assist in improving the surroundings and adding to the pleasure of the patients."[61]

The quality and extent of Haydon's contacts with Dadd were originally suggested by the fact that Dadd dedicated one of his most important paintings to him, *The Fairy Feller's Master Stroke*, a picture on which he worked for nine years (Plate 11). The discovery of Dadd's written explanation for the origin and meaning of the picture has clarified the process by which it came into being. It is no exaggeration to state that the painting was a commission executed at Haydon's request and illustrating a subject supplied by him. An autographed copy of Dadd's *Elimination of a Picture and its Subject—Called the Feller's Master Stroke* has turned up among Haydon's effects, confirming that the explanatory poem was probably written for him and intended to accompany the painting.[62] Dadd describes how Haydon, impressed with the fairy picture he had executed for Hood, asked for something similar himself.

. . . business
led, an official person to this sight
Who with the picture pleased
As 'twere a jewel bright,
His mind of burden eased,
To have the like
Of which did strike
At Fancy's shrine well meant.

Some friends he had; who wrote in verse
About the fairies, sense as terse
As poets jam into a measured line
 . . . so of his rhymes
Possessed, he wished to see
A little sketch, slight as may be
To illustrate the same.[63]

Dadd's words, "a little sketch, slight as may be," probably echo Haydon's request just as the title "Sketches to Illustrate the Passions" may refer to Hood's original suggestion. Haydon provided Dadd with a poem and suggested he make an illustration for it. That the task grew into the most elaborate and personal painting of Dadd's career probably reflects Dadd's strong affection for his friend. The important point is that subjects were suggested to Dadd and, if it suited him to do so, he willingly accepted them.

Artistic influence occasionally flowed in the other direction, and, on at least one occasion, Haydon can be shown to have been influenced by Dadd's work. A curious wash drawing found among Haydon's sketches shows him working in Dadd's style. The picture, inscribed as an illustration of *Henry VIII*, Act 2, Scene 4,

may well copy one of the Passion series, now lost, or may have been produced in imitation of Dadd's style.[64] Radically unlike Haydon's usual work, this wash drawing is closest in subject to Dadd's *Hatred*, a subject also taken from Shakespeare (Fig. 8.5). Haydon's drawing indicates that he knew the Passion series well enough to reproduce the style at will.

The quality and content of the discussions about art and artists that Haydon shared with Dadd are suggested in a copy of B. R. Haydon's *Lectures on Painting and Design*, owned by Haydon but extensively annotated by Dadd's penciled marginalia.[65] That Haydon accepted these annotations as a valuable addition to the book is indicated by the fact that in 1877 he went to the trouble of rewriting them in ink so as to preserve them. Dadd's remarks provide the first detailed insight into his personality, his artistic preferences and opinions, and his self-image and conception of the creative process and madness.

In terms of Dadd's illness, which was many years later to be thought to result from a splitting of the mind, it is interesting to note that Dadd was preoccupied with similar notions:[66] "The double nature of human beings was known to the ancient Greeks among whom genius was as familiar as Christ with us. The two natures were supposed to be always contending for mastery and after death they were weighed. 'Thou art tried in the balance and found wanting,' somewhere in scripture seems to refer to this doctrine which was doubtless well understood also in the Egyptian. . . . Vide Egyptian painting."[67] Dadd was well aware that his involvement with devils was understood as evidence of madness by others. He had personal experience of his own "double nature" and the struggle waged within him in an effort to control his own devils. What is of particular interest to us is the fact that he understood his devils, his madness, as essential to artistic creativity. "I am of opinion that there is a great deal of secret in the matter and that it is explained by one's own second self which is perhaps as obstinate and vicious a devil as we could desire to oppose or thwart one and that few can overcome it, hence dissatisfaction etc. . . . A strong genius is most likely antagonised by a strong beast or devil a secret worth knowing."[68]

Dadd may well have seen himself as a genius plagued by an obstinate and vicious devil. The stronger the devil, the greater the genius. His isolation in a madhouse provided no obstacle to a self-image in terms of genius, a force holding the poor artist in its grip. "What more slavish than painting, what more hopeless? . . . One might fancy pictures are like monks secluded from and very little noticed by the world," a

state of affairs that can be understood as applying equally well to Dadd himself.[69]

That Dadd chose to dedicate the two most important paintings of his career to Hood and Haydon cannot be without significance. It is easily forgotten that the pictures in question are not merely two Dadds among many. They were the product of thirteen years of work, displaying an originality of vision, a complexity of imagery, and a meticulous handling of detail that makes of these works a coherent and fully elaborated microcosm. Dadd would have been well aware that in carrying out a project of this scope, even in miniature, he was reaching for the ultimate achievement of his artistic career. His willingness to invest years of labor in them is proof of their enormous significance to him.

The statement in Hood's case report that Dadd had little to do with the other patients is not surprising in that schizophrenia in its various forms is commonly characterized by an inability to relate with any degree of closeness to other people, a state that can approach complete withdrawal or icy remoteness. The success of Hood and Haydon in establishing some degree of friendship with Dadd was a considerable achievement. That he devoted much of his energy for many years to producing these very special pictures for them suggests that, at least in terms of his internal reality, they had taken on enormous human importance for him. The intensity of the relationship that can develop between physician and patient is well known in twentieth-century psychiatry; it is less expected in nineteenth-century psychiatric practice, but not unknown (see chapter 9).

Painting seems, at times, to have represented a means of communication for Dadd, an intermediate object in which he might safely embody and present his feelings and his reality to the significant other. Although the two pictures are inscrutable and impossible to penetrate, he reveals himself in them to a degree unknown in the rest of his work. The closer one came to the central reality of Dadd's inner world, the more opaque the symbolism, whether verbal or pictorial, would have become. Hood mentions that when Dadd approached the subject of his crime or the beliefs associated with it, he became increasingly dissociated and finally unintelligible. Significantly, these two paintings form part of a small group of works in which the formal pictorial characteristics associated with schizophrenia appear most fully.[70] They are unique in style, in no sense to be confused with the fairy paintings of 1841–1842. The endless buildup of tiny dotlike forms within forms, the breakdown of logical space, the flattening of form, while appropriate to the subject, is too

8.6. Richard Dadd, *Portrait of a Young Man*,
1853, oil on canvas, private collection.

typical of the artistic efforts of schizophrenic painters to have been a conscious decision by the artist. In them he is seen, obsessively elaborating his own autistic reality. To what extent he himself experienced them as attempts at communication we cannot know. What is certain is that neither Hood nor Haydon would have been able to understand.

That Dadd was to some extent aware of the difficulty of understanding his work, and also perhaps cultivating obscurity and confusion, can be seen in his poem *Elimination of a Picture and Its Subject*. Once again we encounter a patient attempting to unravel and clarify his own work, describing the motivation behind it, and the private meanings of some of the obscure symbolism. It is striking in this connection that Dadd, like Tardieu's patient, had become preoccupied with complicated spiral or curvilinear lines, which coil about over the surface of the picture. He identifies these lines as "representing vagary wild and mental aberration styled." The poem makes it quite clear that the *Fairy Feller* conceals within itself much of Dadd's private inner experience, a fact that could only have been guessed at prior to the poem's discovery; "some dubious point to fairies only known to exist, or to the lonely thoughtful man recluse."[71] But even in this effort to explain, Dadd seems aware that he has failed, perhaps deliberately, to clarify that which was obscure. He cannot risk revealing himself, and concludes his poem:

But whether it be or be not so,
You cannot afford to let this go,
For nought as nothing it explains
And nothing from nothing nothing gains.[72]

Dadd's varying relationships with members of the hospital staffs are more obviously reflected in paintings of a less obscure, more social nature, portraits of specific individuals working in the two institutions in which he was confined. While he never seems to have depicted other patients in his work, he did document the features of several hospital physicians and attendants. These depictions of prominent English alienists are among the earliest likenesses of psychiatrists executed by patient-artists, preceding van Gogh's portraits of his physicians by some thirty years.[73]

Especially important among these pictures is the rediscovered portrait of Sir Alexander Morison, visiting physician to Bethlem (Plate 19). To this can be added the portrait of Charles Neville, head-attendant at Bethlem and later at Broadmoor; that of Dr. William Orange (1833–1916), superintendent of Broadmoor; and, artistically most significant, the *Portrait of a Young Man*, which continues to resist identification,

though it can with some assurance be characterized as a member of the Bethlem Hospital staff, most probably an attendant (Fig. 8.6).[74]

These images not only reveal something of Dadd's attitude to important people in his environment, but also provide concrete evidence of the wide range of artistic styles in which he was capable of working. He remained able to paint pictures in an entirely conventional academic style such as that utilized in his portrait of Dr. Orange, a competent but rather dry performance (Fig. 8.7).

Far more interesting is the large picture depicting Dr. Morison in an extensive landscape, which is certainly far removed from that contained within the walls of Bethlem (Plate 19).[75] Recently, new information concerning the connection between the visiting physician and the artist has provided at least a partial context for the previously unknown portrait.[76] Morison's journals, preserved in the library of the Royal College of Physicians, Edinburgh, document his encounters with the artist and his growing interest in his work. The earliest entry relating to Dadd seems to be that of November 21, 1844, which simply states that an artist acquaintance of Morison's, Charles Gow, had visited the hospital and recognized Dadd, identifying him as "an extraordinary artist."[77] His curiosity obviously aroused, Morison began to take an interest in Dadd's work.

On September 4, 1850, he records a gift given to him by the artist. "Dadd gave me a drawing of an Egyptian female."[78] A week later we hear of a return gift, when Morison gave a small sum of money to an attendant for the purchase of "apples for Dadd–Artist." The evidence suggests that Morison built up, over time, a collection of Dadd's drawings, though their number and identity remain unknown.[79]

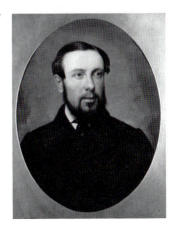

8.7. Richard Dadd, *Portrait of Dr. William Orange*, 1875, oil on canvas, Broadmoor Hospital Collection.

Two years later, in 1852, Morison's involvement with Bethlem Hospital ended officially amidst considerable scandal and the elimination of the post of visiting physician. Whether the portrait of Morison is connected with these events, and with his departure, remains uncertain. That the portrait was a commission, or at least a response to a request, for a specific type of portrait image of himself seems likely. On the other hand, despite the relative objectivity of the portrait, it is sufficiently idiosyncratic to embody a good deal of Dadd's personal attitude to this man whose kindness and interest, one assumes, went well beyond the occasional purchase of apples.

Dr. Morison was seventy-three years old when the picture was painted, an extraordinarily prominent physician and teacher, and a very wealthy landowner with several estates in Scotland. He is depicted outdoors on a bright summer day; in the distance the Firth of Forth, and behind him the buildings of his family estate, Anchorfield. Since Dadd's acquaintance with his physician was circumscribed by the walls of Bethlem, the choice of so specific a background must have been Morison's; in fact, Dadd explains, on the back of the canvas, that the source of his landscape setting was a painting of the estate made by Morison's daughter Ann.

More problematic is the source of the portrait image itself. Did Morison pose for the artist in the middle of the criminal lunatic department? Did Dadd work from a photograph of his physician? The old man is depicted with painful exactitude, his face ravaged by time and marked not by arrogance but by resignation, perhaps even exhaustion. This is particularly evident in the deeply shadowed eyes that stare out at us with undisguised pain. It is a moving portrait of a man only slightly older than Dadd's father would have been had he lived. Perhaps this paternal projection accounts for the undeniable intimacy of this portrait image, the gentle humanity and empathy that characterize this depiction of the aging physician whom Dadd could otherwise have known only superficially.

The picture is further enhanced, and certainly not marred, by the strange spatial construction that lends it something of the character of a puzzle. The doctor is presented frontally, standing in the extreme foreground (his legs cut by the frame), hat in hand, as though about to be introduced. He is utterly unconnected, either physically or psychologically, to the space that opens behind him, which is occupied by a variety of curious trees and two fisherwomen, whose position in space, and in relation to him, is utterly irrational. Though understandable as an attempt on the

part of the artist to identify the Newhaven region, and to add a bit of local color, these fishwives, so miniature in scale, seem to have escaped from Dadd's fairy world, "little people" who can scarcely have formed part of his physician's mental landscape.[80] This kind of bizarrely inappropriate positioning of figures is not unknown in other of Dadd's Bethlem landscapes and may, in so highly trained an artist, provide evidence of curiously irrational and unreconciled elements in his own inner world and in his emotional response to the people in his environment.[81] Without question, the strength and strangeness of Dadd's private psychological reality pervade and inspire the extreme originality and uniqueness of his rare Bethlem portraits.

The finest of Dadd's portraits is *Portrait of a Young Man*, a unique picture that deserves to be better known as one of the most powerful portraits of mid-nineteenth-century art (Fig. 8.6). Looking at the austerely unemotional countenance of this red-haired gentleman, almost unnerving in his imperturbability, one can easily understand the continuing efforts of scholars to identify the sitter.

What motivated Dadd to abandon all he knew of the Victorian portrait tradition, to undertake a kind of portrait that had no precedent in the history of art? Painted well before the portraits of Rousseau, or even of the Pre-Raphaelites, this strange picture can probably only be explained on the basis of Dadd's intense inner reality forcing him in the direction of almost Surrealist expression. The curiously restrained, withdrawn figure of the young man, recalling photographs of the period in its rigid pose and elegant costume, is set in a glowing green landscape, which seems almost threatening in an explosive profusion of gigantic leaves and twisting branches. The portrait is unforgettable, perhaps more responsive to Dadd's self-perception than to that of the sitter. The tormented boughs of the bench on which the young man sits, the gigantic lawn roller in the background, and the still life of flowers, fez, and crumpled handkerchief add to the mystery and suggest the intensity and strangeness of Dadd's inward perception.[82]

Throughout his career at Bethlem and Broadmoor, Dadd was encouraged to produce occasional works specifically for the hospital. At Bethlem, during the tenure of Dr. Hood, he painted the enormous picture of *The Good Samaritan* which, at least as early as 1859, was hanging on the main staircase.[83] The use of patient art as a means of decorating the bleak environment of asylums was not unknown. Before coming to Bethlem, Hood had worked at Colney Hatch Asylum, where the wards were embellished with patient art.

The walls of one of the wards of Colney Hatch are decorated throughout with well executed bas-relief pictures from Greek subjects by a patient. We are informed that the lunatics who are transferred here from the undecorated wards enter the apartment with expressions of delight, and are particularly careful to preserve the objects of their pleasure in good condition. In some metropolitan asylums the inmates have adorned their prison house with pieces of sculpture and pictures.[84]

This passage is unique in describing the reaction of other patients to the art of one of their fellows, an aspect of the reaction to Dadd's work about which there is no evidence.

At Broadmoor, besides executing the portrait of Dr. Orange, he carried out a decorative scheme for the theater, which included an elaborate drop curtain; panels for the stage, in which he once again utilized the theme of the passions; and murals for the walls, which may have taken up the motif of the swirling calligraphic lines observed in the *Fairy Feller*. "He has adorned and beautified the asylum walls; above all, upon the asylum theater he has lavished much decoration of a curiously florid kind, quaint arabesques and lines painted in a medley of vivid colour."[85]

The article in *The World* describes the drop curtain as "a masterpiece, [exhibiting] all the lurid imaginative power that might be looked for from a 'mind o'erthrown.'" A description of the work is followed by a curious criticism, to be taken seriously in light of the restrained tone so evident in the rest of the article. "In all this work—meritorious, nay, painfully excellent—there is but one fault—no single figure is perfectly drawn. Some detail is wrong—arm, leg, hand, head. There are few models available in Broadmoor—this may be a cause; or is it that in Dadd's art, as in his mind, there is a single terrible flaw."[86]

Dadd was commissioned by Dr. Orange to paint a mural for his home. This involved considerable effort, in that the superintendent's house was in a separate building, necessitating a special attendent who could bring Dadd to the house, remaining with him while he worked. As well, because the picture appears to have been executed on the wall itself, it is clear that Dr. Orange felt sufficiently attracted to Dadd's work to want to live permanently with it. The evidence permits us to separate the clinical interest in Dadd's work as illustrating some aspect of psychopathology, from an aesthetic response such as is suggested by Dr. Orange's desire to possess an enormous example in his own home. Although the painting was apparently destroyed, we are fortunate in possessing a description of it by Dr. Orange's son:

In the early eighties Dadd was allowed to occupy himself by painting a fresco [*sic*] about 10 feet high and say six feet broad, to cover a wall in the hall of the superintendent's house—The subject, (chosen I believe out of compliment to my mother whose name was Florence) was a large figure of Flora, bearing flowers and fruits—it was full of detail, some critics thought it was too full of detail. I am no art critic, but I admired the work, . . . I used to see Dadd at work on this when I was at home from school during the time when he was occupied on it; but I never had any conversation with him. He was, of course, accompanied by an attendant. He was a man of mild and dignified appearance, evidently absorbed in his work and taking pleasure in it.[87]

In general, the creative situation that emerges is of physicians and hospital staff members interested in and respectful of the work of this artist-inmate, anxious to collect or to commission examples of his work, and to employ it in the decoration of the hospital (the later destruction of most of the work executed for the hospital suggests that later physicians and directors were far less sensitive to these images). Although such an appreciative attitude toward the art of patients was rare at this time, it can easily be understood in terms of Dadd's prior reputation as an artist, his immense technical ability, and the obvious lack of bizarre features in the majority of his works.

TO SUGGEST a development from interest to influence on the part of Dadd's physicians is a serious move. Can the paintings of Richard Dadd be seen as in any sense a collaborative effort, the outcome of the mutual activity of painter and patron? The concept of patronage within an asylum has never been explored or even suggested. For most patients, spontaneously producing drawings in the absence of training or technical ability, this factor is less likely to have played a part. But because of the strong interest in Dadd's work, physicians may have been tempted to guide the process to some extent, in directions that accorded with their own aesthetic leanings and particular areas of scientific preoccupation. The sources of inspiration underlying psychopathological art can never be entirely restricted to the inner world of the patient. This is particularly true in Dadd's case, where a very rich range of external influences can be identified.

In 1853, shortly after Dr. Hood's arrival at Bethlem, a series of watercolors entitled *Sketches to Illustrate the Passions* was begun by Dadd. John Rickett was the first to make a connection between Dr. Hood and this series of paintings.

Dr. Hood took a particular interest in his unusual patient both from the extensive notes he made when first examining

him and from the frequency of their recorded subsequent meetings. . . . It seems likely that Hood suggested the subjects of various compositions to Dadd. In 1854, the drawings are dated to the day and often occur at weekly intervals as though part of a definite curriculum. Eleven of these drawings are still in the possession of the Bethlem Royal Hospital and it seems likely that their retention there was something other than accidental.[88]

The Passion series pictures differ demonstrably from Dadd's other work, both before and after. They are visually related to each other in format, technique, and content. That they were from the start intended as a series of related works is indicated by the fact that some of the drawings bear the inscription "Sketch for the Passions," which demonstrates Dadd's intention of producing an almost encyclopedic pictorial catalog of the varieties of human emotion, an intention he then systematically carried out over a period of four years. The question of interest to us is whether Hood initiated this strange project and, if so, what his purpose may have been. The theme of the passions is, of course, by no means a new subject in art. The depiction of the various human emotions had long been an established formal problem for aestheticians and artists, while still earlier on it had played a role in the depiction of the vices and virtues. For example, Giotto's grizaille figures of the virtues and vices from the Arena Chapel reflect a number of the subjects that form part of Dadd's series. The choice of dramatic narrative illustrations, many deriving from Shakespeare, accords with the Victorian taste for illustrative paintings, and with Dadd's early efforts as a young artist. However, a series of paintings on the human passions cannot be seen as a typical subject for a Victorian artist, except perhaps within the context of physiognomical studies, and here we might think again of Fuseli's illustrations for Lavater's *Physiognomy*, some of which consisted of whole scenes selected as representing one passion or another.

Less well known is the fact that the theme of the passions also played an important role in the study of psychiatry in the period under discussion. Studies in contemporary psychiatric journals were often devoted to "The Passions," just as, at a later period, debates raged over the number and identity of the basic human instincts. It is not surprising that psychiatry as an emerging medical speciality should have concerned itself with the study of the range of human affects. Less obviously understandable, to us, is the interest in their visual manifestations and the problem of their depiction in medical illustration. It is easily forgotten that prior to the development of the modern belief, essentially illusory, in the objectivity of the camera, scientists displayed a tremendous faith in the artist's ability to provide an accurate, objective depiction of visual material. To evaluate the possibility that Dr. Hood was himself interested in problems related to the depiction of human affects in both their normal and pathological forms, it is necessary for us to leave the problem of Dadd's Passion series briefly, and to explore the work of two other individuals who were also active at Bethlem Hospital during the same period, the artist-illustrator James Gow, and the physician Dr. Hugh W. Diamond (1809–1886).

James Gow was an artist of limited ability, best known for his work as a medical illustrator. W. P. Frith says of him, "Though he drew good likenesses, and, I think, exhibited occasionally, he never succeeded in 'making a name,' and I fear, lived and died poor."[89] Gow was actively employed at various times in visiting asylums and, in particular, Bethlem Hospital, with a commission to draw portrait studies of specific patients. He is known to have worked extensively in the ward that housed criminal lunatics, which would have brought him into contact with Dadd. In fact, their meeting was mentioned in the *Art Union* of May 1845. Dadd had known Gow prior to his illness and recognized him at once, asking him, "What brings you here? Have you killed your father?" He is then said to have studied the pictures in Gow's portfolio, commenting on the quality of the drawings, and stating, "Those fellows look mad, every one of them." Thus, as early as 1845, Dadd was aware of the possibility of an artist functioning within the context of a mental hospital as an illustrator of psychopathological physiognomy.

The patron responsible for Gow's assignment in the hospital was the visiting physician, Sir Alexander Morison, who shared the responsibility for overseeing the hospital with Dr. Monro. Morison had spent a good part of his life on the study of the effects of mental pathology on the human countenance. In 1838, he published his famous book, *The Physiognomy of Mental Disease*, which consists of a collection of portrait drawings of patients at Bethlem, including some shown after their recovery,[90] and brief case descriptions. The artists chiefly responsible for this publication were a Mr. Alexander Johnston (1815–1891), and a Mr. François Théodore Rochard. We know that Dr. Morison's involvement with physiognomy continued, and that he was the source of Gow's commission. The way in which interest in such scientific pursuits might lead to an involvement with art is indicated by the fact that Morison included as an appendix to his book reproductions

and a discussion of Cibber's figures and of Hogarth's depictions of mental illness in *The Rake's Progress.*

In 1856, four years after he had left Bethlem, Morison wrote to Dadd requesting some drawings from him and enclosing five pounds, which suggests his continued interest in the art of patients, and especially that of Dadd. His money was returned along with a letter of explanation, which clarifies the new administration's attitude to Dadd's work being allowed to go out of the hospital. "I am sorry we must not allow any more Dadds to leave the hospital. So long as they remain in hands such as yours, no objection can be made, but it is possible they may at some future time find their way into the market, a result which might lead to much inconvenience."[91] The letter reveals an awareness that Dadd's art would still have monetary value in the London art market despite the fact of his insanity being generally known.

Given Morison's deep involvement with the pathology of facial expression, one may understand the urgency that often seemed to motivate Gow's efforts. On one occasion, Gow is said to have remarked, "I had tried to get a patient at Bethlem to sit still. His face was much wanted, as it was the index, in quite a remarkable degree, of the peculiar form of insanity from which the man suffered."[92] That the drawing was urgently required and understood as serious evidence of psychopathology is apparent. A particularly vivid account of an encounter between Gow and a mad artist can serve to remind us that other patients besides Dadd were involved in making images, though perhaps not on Dadd's artistic level.

On one occasion [Gow] was admitted to a man in solitary confinement who had torn his clothes to pieces; and at the moment the artist entered the cell, the madman was engaged, having previously filled his mouth with ashes, in drawing faces with his tongue upon the wall. His mouth was blackened and his face smeared. After listening to the artist, he allowed the attendant to wipe his face, and he stood quietly for three quarters of an hour, looking at the drawing when it was finished, and made some just and sensible remarks upon it. He then shook hands with the artist, who had not gone ten paces from the door of the cell, before the awful ravings recommenced.[93]

It is doubtful that Dadd was influenced to any extent by his brief encounter with Gow or other artists commissioned to record the features of the insane. No examples of portraits by Dadd of his fellow patients survive, except insofar as he may occasionally have used them as models for subjects not connected with insanity. Insanity as a subject occurs rarely in his art, and when it does, it is treated so unrealistically as to sug-

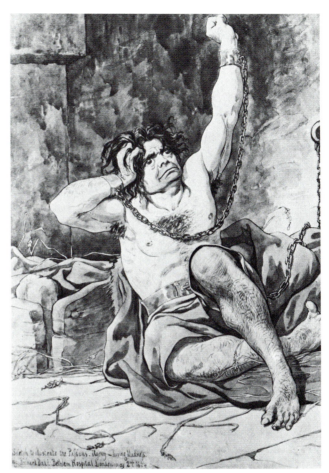

8.8. Richard Dadd, *Agony—Raving Madness: Sketches to Illustrate the Passions*, 1854, watercolor, The Bethlem Royal Hospital, London.

gest that he wanted nothing to do with it. When work on the Passion series necessitated depicting madness, he responded with the theatrical and highly imaginative *Agony—Raving Madness*, a scene that owes far more to Hogarth, Cibber, and even the *Beggar's Opera*, than to anything he could possibly have seen around him (Fig. 8.8). He dealt with the subject again in an illustration of the ballad *Crazy Jane* with elegant but completely unrealistic results. Clearly he had no desire to become portrait painter to his fellow inmates, or rival to Gow in this area of artistic specialization.

MORISON'S departure from the hospital, and Hood's arrival, resulted in yet another innovation: photography of the insane appears to have replaced drawing as a means of physiognomical investigation. An 1860 account of the hospital refers to a collection of photo-

graphs then in existence. "We went back to Dr. Hood's study, and I looked through an album of photographs taken from patients in their excesses of mania, and in their lucid moments."[94] The photographer whose work was being shown to the visitor was probably Dr. Hugh W. Diamond. He held a position similar to Hood's at the Surrey County Asylum from 1848 to 1858. Diamond's interest in photography was intense, and from 1853 on he functioned as secretary to the Photographic Society, and was the editor of its journal for many years. In 1856, he published the first report on the scientific use of photography as applied to psychiatry.[95] His photographs of the insane were looked upon as important scientific documents, and an effort was made to publish them as an ongoing project. An advertisement for them appeared in the Asylum Journal, offering "a series of photographic prints from the life by Dr. Hugh Diamond entitled 'Physiognomy of Insanity.' "[96] The project does not appear to have been a success, as no trace of such a publication has been found.[97]

Dr. Diamond had begun photographing the insane in 1852, the same year that similar experiments began in France. He perceived immediately the superiority of photography as a means of studying the transitory phenomena of mental illness. "The photographer catches in a moment the permanent cloud, or the passing storm or sunshine of the soul, and thus enables the metaphysician to witness and trace out the connection between the visible and the invisible in one important branch of his researches into the philosophy of the human mind."[98] He was surprisingly advanced in making therapeutic use of photographs by confronting patients with pictures of themselves. He described a case in which a twenty-year-old woman suffering from delusions of grandeur improved rapidly after seeing her own image in a photograph. "It was not without great persuasion that this patient was induced to allow herself to be photographed; but when she saw her likeness, and was led to converse on the subject of her delusion, an improvement took place, and she was eventually discharged perfectly cured."[99] An effort was made to photograph patients both during and after their illness in order to provide material for comparison. Diamond then included the photographs as part of the patient's permanent hospital record. Hood's interest in photography as an investigative tool is suggested by the fact that he owned one of the earliest collections of psychiatric photographs.

The use of photography in studying the behavior and physiognomy of the insane had, by the period of Hood's administration, rendered the task of medical illustrator in this area superfluous. While visual investigation remained an important preoccupation, photography was increasingly recognized as being better suited to fulfill clinicians' requirements. However, the possibility of owning physiognomical studies executed by a patient may have continued to seem unusual and valuable.

As late as 1880, drawings of patients executed by another patient were considered a valuable rarity. Dr. Forbes Winslow's collection, *Melancholy Records of Art in Madness*, contained fifty-five examples of such portrait drawings. In his article "Mad Artists," he points out that "were any scientific object to be gained by such an addition, the whole narrative of the case, from its beginning to its close, might be accessible, and in this respect surpassing the illustrations of mental diseases published many years ago by Sir A. Morison."[100] Of the artist we are told only that he had originally been an engraver.

Winslow's attitude to the aesthetic aspects of the drawings is suggested by a new term he introduced in describing them—"pseudo-art of lunatics." The introduction of this term is of particular importance as it represents a very early effort to grapple with the distinction between patient art and the fine arts. The term did not come into common usage, but the problem continued to trouble writers on the art of the insane for many years.

In contrast to Winslow's muddled reflections on the lives of artists, in which he was much influenced by Cesare Lombroso, his brief discussion of the pictures in the *Melancholy Records* was surprisingly objective. He pointed out that patients of the educated class found in the hospital where the collection was made were trained in painting and drawing as a regular part of their education. For such patients their artistic activities in the hospital formed a natural continuation of their life activity prior to the onset of illness. "It may easily be shown that of those who have received instruction in drawing, painting etc., many became of unsound mind but continue to exercise their acquired powers contemporary with the most advanced and appalling forms of disease."[101] In opposition to Lombroso, he reported that with a few obvious exceptions, "there cannot be detected in this large collection a trace or allusion or revelation of the place or circumstances under which the work was undertaken, or of the mental or moral lesion under which the workmen suffered."[102]

Dr. Winslow's article is of value in providing evidence that drawings by patients other than Dadd were being collected and studied. The collection consisted of three volumes, the first made up of the portrait sketches. The second included "one hundred and

twenty-four sketches, embracing every possible object except the physiognomy of the patients around. They were the work of persons labouring under erotomania, dipsomania, furious mania, manias of suspicion, fear, vanity, and almost every known form of mental disease except fatuity. The authors were, with two exceptions, unprofessional artists."[103] The third volume contained more extensive collections of the work of five artists, providing an opportunity to study the development of their art over a period of time. The description of the three volumes, particularly their organization and the inclusion of case material and diagnostic information, provides evidence that patient art was being collected in England with the specific intention of providing material for scientific investigation of the art of the insane.

FUNCTIONING within the context of scientific preoccupation with visual evidence of psychopathology, committed to the use of the new process of photography as a means of documenting physiognomy, Dr. Hood is not likely to have requested Dadd to make paintings of the insane or portraits of his fellow patients. Although Dadd was a competent portrait painter, such a project was in any case not suited to his personal leanings as an artist devoted to illustrative painting, and works of imagination. Nevertheless the possibility exists that Hood may have suggested the idea of a series of paintings of psychiatric interest, illustrating the whole range of human feeling. The encyclopedic nature of such a project would accord well with the urge to classify and identify that is so typical of eighteenth- and nineteenth-century psychiatry. In focusing on human feeling, as opposed to diagnostic categories, Hood would be seen as concerned with more advanced psychiatric trends emerging in the latter half of the nineteenth century. It may be that the Passion series represents a compromise between Dadd's own interest in dramatic illustration and the wishes of his physician, who may have desired to possess a collection of pictures with some psychiatric significance. The element of friendship is suggested by the possibility that Hood provided Dadd with the subjects, probably one at a time. Prior to his illness, Dadd had belonged to a group of artists, "The Clique," who had entertained themselves by meeting in the evening to draw or paint illustrations of a chosen topic, usually scenes from literature. Dadd was therefore fond of working to an externally supplied topic, and may well have asked Hood to provide a subject when they met, later showing him the visual illustration of the theme. It is not true that the pictures occur on a weekly basis, but the

general title, "Sketches to Illustrate the Passions," sounds as though it might well be an obsessionally exact rendering of Hood's original suggestion. Although a number of the paintings in the series may have been lost, it is notable that the subjects provided are, in all but five instances, negative human emotions. Where are joy, mother love, friendship, or generosity? Whoever provided the topics had a rather jaundiced view of human nature.[104]

If Hood did suggest and encourage such a project, what did he intend? Was he trying merely to keep his patient busy, interested, and cooperative? Did he use the occasion of the paintings and discussions about them from week to week as a means of maintaining human contact with a patient of whom he was fond? Was his decision to form a personal collection primarily scientific or aesthetic? Possibly all of these factors played a part. It would have been with some trepidation and hesitation that he risked suggesting titles such as murder and madness to a homicidal patient. Possibly he was motivated by some psychological curiosity as to how Dadd would react to subjects that approached so closely to his own life experience. In this connection, it is significant that passions such as anger, madness, and murder came rather later in the series.

Dadd's reaction to the task of depicting hate does in fact suggest that his own psychopathology had been activated, as was the case when his thoughts were directed in conversation to topics on which he still held ideas of delusional intensity. Here we may well be observing Dr. Hood as a psychologist probing beyond the standard ideas of the art of the insane. He may have been experimenting with Dadd, setting him tasks that deliberately led him step by step, topic by topic, into territory that might well trigger unusual or psychopathological processes. In this endeavor Hood too would have been exploring new territory.[105] What would happen if Dadd was asked to illustrate specific types of emotion, especially those familiar to him? Could he be brought to depict his own delusional beliefs, or the behavior resulting from them? Interest in this period would have centered on subject matter rather than formal factors. But if Hood was responsible for providing subjects for the Passion series, and if he was systematically setting topics with a view to exploring his patient's mind, then his endeavor would represent the first experimental approach to studying the art of the insane. In a detailed report covering the period 1846 to 1860 at Bethlem, Hood clarified the nature of his treatment of Dadd. "The attention of the patient must be diverted in every possible way, and by occu-

pying his mind with fresh ideas, impulses and scenes, a new career of thoughts and action will be provided which may ease the lingering delusions from the mind."[106]

While it would be a serious error to read modern psychiatric preoccupations into the activity of a psychiatrist whose only therapeutic efforts may have been to keep his patient busy, one must realize that Hood was a physician dedicated to work with the mentally ill. Study of the passions was a common topic of investigation in this period and it may, therefore, be appropriate to suggest that he was aware and interested in the implications of what he was doing. Given an insane artist of unusual ability, Hood may well have used the opportunity to explore the commonly held notions of the art of the insane, to obtain insight into the question of the relationship between artistic activity and insanity, between delusional systems and subject matter, between the pathology of affect and the depiction of the passions.

A FURTHER PROBLEM is to what extent Richard Dadd's work was influenced by pictorial material from outside the hospital. In more general terms it again raises the question of the extent to which the art of the insane is representative of, or modified by, the pictorial style of the period in which it is produced. Although the work of Dadd cannot be used to solve the problem for less highly trained and artistically aware patients, it is still fundamentally important in demonstrating the range of visual sources available to all patients. Far too much discussion of the art of the insane is conducted in ignorance of the fact that mental patients are influenced by the history of art and the stylistic language of their period and of their cultural milieu. There is no "pure" art of the insane. Many of the striking similarities so often stressed between the art of the insane and modern art result from the direct influence of exposure to modern art on the part of individuals who at the time, or subsequently, are mentally ill. The case of Richard Dadd provides examples of borrowings from available pictorial material, as well as an awareness of developments in art in London subsequent to his imprisonment in Bethlem Hospital.

In that Dadd was trained as an artist before the onset of insanity, he differs from patients who begin to paint only after they become mad. His visual vocabulary was richly supplied with the formal language and imagery of early Victorian art. He had an extensive knowledge of the history of art, stimulated by his travels in Europe and the Near East just prior to his hospitalization. Unquestionably, his primary pictorial

source was a sketch book made on that trip, which he somehow recovered after his arrival in Bethlem. Much of his work can be understood as elaboration and development of drawings contained in that book. But beyond these sources, which all originate prior to 1844, it has been suggested that Dadd created in isolation, that he was cut off from the art of his time and from artistic developments occurring in England in the second half of the century. In a very real sense this is true. There is no evidence to suggest that he was significantly aware of the emergence of the Pre-Raphaelite school, or of Impressionism, for example. Nevertheless, he was able to maintain a far greater degree of knowledge of events and pictures in the London art world than might be expected. Had he desired to remain within the fashion, and up-to-date, he might well have done so. That he chose to pursue his own goals and direction could have been less from a lack of opportunity to do otherwise, and more an outcome of his own stubborn independence of mind. "He is very eccentric and glories that he is not influenced by motives that other men pride themselves on possessing."[107] This attitude to the world, fostered by his economic independence, may well have extended to his art.

That Dadd was able to maintain some degree of contact with the world of art was probably due in part to the kindness of Dr. Hood, and more particularly, of Mr. Haydon. Haydon's continuing involvement with art and artists was obviously shared with Dadd, and he now emerges as the probable source of books and exhibition catalogs that are otherwise difficult to account for in the hospital environment. But beyond these personal kindnesses, which would have been reserved for Dadd, there was a range of visual material available to all patients in the hospital, at least after Hood's arrival.

In his description of a visit to the hospital in 1860, George Augustus Sala referred to the presence

in the interval between each window [of] either a bust or a print neatly framed and glazed. . . . The quantity of handsome busts and engravings distributed throughout the whole of the wards is as surprising as their presence is satisfactory. The engravings are the gift of the late Mr. Graves, the eminent publisher of Pall-Mall. The authorities cannot be too highly recommended for this introduction of an artistic element that mitigates and well nigh nullifies the depressing influence of the place.[108] (Fig. 8.9)

A description of Bethlem in 1857 refers to "the engravings of Landseer's pictures on the walls,"[109] and at least one example of Frith's work can be identified in a contemporary photograph of the hospital. While the presence of such engravings would scarcely provide Dadd

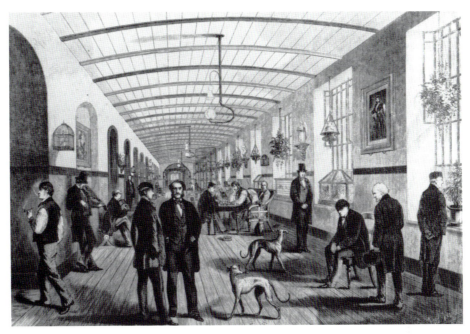

8.9. The interior of the male ward of Bethlem Hospital, ca. 1860, engraving, The Bethlem Royal Hospital, London.

with an awareness of current trends in art, they are a new factor in the mental hospital environment, and from this period on they must be taken into account in any investigation of the origins of patient art.

Information on more current happenings in the contemporary art scene would have been available to Dadd through the hospital library, which was sufficiently up-to-date that Sala, in his article on the hospital, refrained from giving any information concerning specific patients as a result of his awareness "that almost every patient in Bethlem Hospital will see this journal [the *Illustrated London News*], and look on these pictures. . . . The leading journals and periodicals of the day are to be found on the tables, and on the book-shelves is a capital collection of the standard works of modern literature."[110] The introduction of libraries was by no means unique to Bethlem. At the York Retreat was "a reading room with a select library and the books circulated throughout the asylum. Patients of more extensive requirements and literary tastes have the opportunity of procuring the works of nearly all the standard authors from two excellent subscription libraries in the city. The last-mentioned idea has been adopted elsewhere in Britain."[111]

Specific pictorial references in Dadd's work ranged from a painting that appears to derive from the lid of a fish paste jar (*The Fish Market by the Sea*) to an oil painting that copies fairly closely (though with enor-

mously significant additions) an engraving published in Thomas Dugdale's *England and Wales Delineated*.[112] A curious instance of multiple influence is supplied by the fact that Dadd knew and borrowed elements from *Titania Asleep* (1847), a work by the minor fairy painter Robert Huskisson (d. 1854) that owed its title and much of its form to Huskisson's reliance on Dadd's *Titania Sleeping* (c. 1841). Huskisson's picture was reproduced in the *Art Union* for 1848 and Dadd must have known of it from that source.

There is, so far as I know, no instance of any artist having been influenced in any specific way by Dadd's later work, with the possible exception of the nebulous influence of Dadd's watercolor style on Miles Birket Foster. In the interview in *The World*, we are told that Dadd maintained a strong interest in contemporary art, and in specific pictures then being exhibited.

Referring to a painting of Atalanta's race which he had painted at Broadmoor, Dadd says, "It is my version of the story. Oh yes; I have heard of Mr. Poynter's picture last year. Of course I have not seen it; but I have seen a small woodcut reproduction in an illustrated Academy-catalogue. His is a more ambitious treatment than mine. . . . Mr. Poynter's picture belongs to the historic period; mine to the heroic. . . . I prefer my own conception, but I do not withhold my respect from Mr. Poynter's. His must have been a successful picture. It gave him the rank of R.A., you tell me. There was a time when I aspired also to the rank. But that is past."[113]

Dadd emerges most strikingly here as aware of himself as an artist of stature. Although events had blocked his acceptance as a member of the Royal Academy, he continued to see himself as working at that level of accomplishment. An element of competition is obvious in his decision to paint a different version of the myth of Atalanta, modestly correcting Poynter's conception of the event. It is of interest that he possessed the catalog of a recent Royal Academy exhibition. Dadd's own words serve here to illustrate his deeply rooted and undiminished self-image as an artist seriously engaged in his professional pursuits. This sense of identity inclined him to examine carefully any pictorial material that came within his grasp, a curiosity that would not be observed to the same extent in artist-patients who began painting only after their hospitalization.

STUDY of the art of the insane has, from early in its history, centered on what effect mental illness had on pictorial expression. Attitudes toward Dadd's art ranged, as we have seen, from the premature opinion that he would never paint again, owing to the destruction of his mind; to wildly exaggerated descriptions of his work as bizarre and uncontrolled, obviously based on inability to see and on the unrestrained imagination of critics; to surprisingly accurate accounts of his current style as highly finished, rational, detailed, and similar to his earlier work.

What no contemporary observer appears to have noticed is the considerable variation in Dadd's style from one work to another, and the several distinct styles available to him at any given time. In the insistent search for evidence of madness in the pictures, no one recognized that a proportion of Dadd's paintings throughout the period of his hospitalization reveal nothing out of the ordinary. The portrait of Dr. William Orange is perhaps the outstanding example of this type. It is clear that Dadd's ego remained sufficiently intact to produce accomplished if unexceptional works in the conventional academic style of his youth. To these conservative works may be added a group of pictures characterized by a more imaginative and dreamlike quality, works of exceptional beauty and originality that nevertheless fall within the limits of late nineteenth-century taste. Among these are included the landscapes of the last years of Dadd's life, pictures that suggest nothing pathological, unless intense sensitivity and originality of vision can be so defined.

The Passion series represents a distinct category within Dadd's oeuvre. While the motivation for the series may owe its origin to Dr. Hood, the pictorial characteristics and some of the interpretations of the subjects undoubtedly originated with Dadd. In this series elements of Dadd's psychopathology make themselves felt. Most of these pictures have an atmosphere or feeling that can only be subjectively described as cold, and at times unnerving. As depictions of "the passions," they are curiously passionless. In this series the staring eyes so often remarked on in Dadd's work are most strongly apparent. Some of the pictures reveal disturbances of thought processes and the flight of ideas. This is particularly true of *The Child's Problem* and *Patriotism*, with its long text. On the other hand, the handling of form in the series does not break down into features typically associated with schizophrenia and commonly explained on the basis of disturbed perception.

These so-called schizophrenic characteristics are reserved for the small group of pictures: *The Flight out of Egypt, The Fairy Feller, Contradiction. Oberon and Titania, The Bacchanalian Scene*, and the *Portrait of a Young Man*. These works, the masterpieces of Dadd's oeuvre in terms of twentieth-century criticism, were never commented upon in any reference to Dadd's work at Bethlem. Here we discover the bizarre association of subjects and ideas, the shifting and flattening of the spatial plane, the use of extremely minute forms built up with almost microscopic dots of the brush, and strange distortions of the human form, which verge on the grotesque. The extreme originality of vision, which places these works well outside of the whole of Victorian art, would have placed them equally far outside the aesthetic tastes of the Victorian connoisseur, causing them to be dismissed as tragic evidence of Dadd's mental state. Yet in the absence of these works, the remainder of Dadd's oeuvre was not sufficiently remarkable to maintain his reputation as an artist of importance. At the sale of Dr. Hood's collection in 1870, the pictures failed to obtain prices anywhere near as high as they might have in the 1840s when Dadd's reputation was at its height. At the time of the murder, interest in Dadd's work caused his pictures to attain considerable value. Nevertheless, most of the paintings found buyers. Significantly, one of the bidders for the *Oberon and Titania* was a Dr. Tuke, perhaps Dr. Daniel Hack Tuke, another prominent psychiatrist of the period, suggesting that the psychiatric interest of the pictures continued to play a part in the response to them. From the time of *The World* article in 1877, interest in Dadd can be said to have declined, until he was almost forgotten.

In part, this chapter has reconstructed the way in which the work of the mad artist Richard Dadd was

received and understood in the latter half of the nineteenth century. A second chapter could be written exploring and explaining the changed attitude to Dadd's work in the twentieth century, using Dadd as a test case for demonstrating the radical aesthetic shift that brought about a climate of opinion in which Dadd's most bizarre works provided a basis for such an extreme reevaluation of his importance as to make one wary of exaggeration in the twentieth-century estimation of his art. Unquestionably Dadd's maddest works have established his reputation in this century. This is of extraordinary significance for without these few paintings that contain unmistakable evidence of psychopathology, no reevaluation of Richard Dadd's importance would have occurred.

Only in the twentieth century could Dadd's late work possibly have found its way into museums and found wide acceptance and appreciation as art. Dadd provides a very rare example of an insane artist who, in our century, has found acceptance as an artist in the fullest sense. Although it does not fit into our chronological survey of the processes that made such an event possible, a brief description of the birth of the "new Richard Dadd" may fittingly end this chapter.

The pioneer in the rediscovery of Dadd was Sir Sacheverell Sitwell. In his book *Narrative Pictures*, published in 1937, he announced the rediscovery of Richard Dadd, pointing out his originality in so doing.[114] How greatly taste had changed in the fifty years since Dadd's death can be inferred from Sitwell's description of him as "one of the two or three most interesting painters during the nineteenth century." The quality that attracted Sitwell was precisely the pathological element. He referred to Dadd as "the only good painter who worked through a lifetime of mental disease." Selecting Dadd's most unusual works, all paintings of the Bethlem years, he explored them with extreme sensitivity, unmarred by sensationalism, describing the most bizarre works as "having the breath of insanity upon them." His article provides clues to some of the forces that had most obviously prompted the changes in taste preparing the way for a new understanding of Dadd's work.

Richard Dadd, as well, has an especial appeal to the most recent fashions in painting, so that it is perhaps a fortunate thing for his permanent reputation that he has been so little noticed. The âme damnée, so much more truly than Lautréamont, could be revived and allowed the light. But the seekers in the obscure and the sensational have, so far, neglected this treasure that is under their eyes.[115]

Sitwell also recognized the importance and relevancy of Dadd's work to the new preoccupations of twentieth-century depth psychology, describing the *Fairy Feller* as "painted as though it were an introduction to the world of the subconscious." With these ringing phrases, a new Richard Dadd began to emerge—Dadd the precursor of Surrealism, the explorer of the unconscious, the voyager in the realms of madness.

In America, in the same year, Laurence Binyon published a brief essay on Dadd in the *Magazine of Art*.[116] Aware that Dadd had been an inmate of Bethlem, Binyon devoted his attention to what he termed "the main question. Was it insanity which released the original artist in Richard Dadd?" His answers to this question see him grappling not only with Dadd, but with currents then active in modern art.

Much of his work has been destroyed; but from what has survived it would seem that it was much more interesting and original after he became insane. . . . What seems probable is that Dadd would not have been capable of the felicity and fascination in design and color which he here and in some other works attained, if his malady had not somehow released the originality that was in him.

Having accepted Dadd as an artist whose unique vision could only be accounted for on the basis of insanity, Binyon then establishes the link that he intuitively felt between Dadd and the Surrealists. "But now we have the Surrealists consciously exploiting the subconscious, and imitating in their paintings the inconsequent images of dreams; seeking perhaps to have the advantages without the penalties of madness." Dadd is here presented as metal of a purer kind. Binyon too stressed Dadd's significance within the context of modern psychology, but he is careful to emphasize that Dadd's importance was not based solely on this consideration. Dadd's insanity "does give his work a special interest of a psychological kind, though it is not merely the work of a madman, but has, at least the best of it, rare qualities of its own," and later he observes that, "as so often in Dadd's work, there is a mingling of the extremely fantastic with touches of biting realism." Despite Binyon's uncertainty in the face of what he feels to be the necessity of reevaluating Dadd's reputation, and his apparent distaste for the then new productions of Surrealism, it remains probable that it required the advent of Surrealism to force the issue of Dadd's acceptance within the walls of the Museum and the realms of art. The processes that led to this dramatic evolution in aesthetic perception were present and active beneath the surface long before Richard Dadd was born. It was their final culmination in the early years of the twentieth century to which he owed his rebirth. The precise nature of these events form the content of the chapters that follow.

William Noyes and the Case of "G"

In many of the investigations of patients' drawings by nineteenth-century psychiatrists and physicians that we have examined so far, a curious omission has been felt. The men and women responsible for making the pictures have failed to emerge as sympathetic and believable individuals. While psychiatric interest was focused on description of pictures in terms of formal characteristics and subject matter, or on grouping them according to a schema of classification, the images, with rare exceptions, were not seen as a means of coming closer to the minds and experiences of their creators—a way to learn more about the individuals concealed behind the drawings and about the thoughts and motives that prompted them to make these visual statements. Paintings or drawings appeared simply as illustrations of material typifying a specific syndrome, or merely as proof that the patient who made them was mentally ill. The overemphasis on diagnosis and classification led to a greater concern with the illness than with the patient. An awareness that patients might be using these graphic means to say something, to communicate, was suggested only in the recognition that the delusional ideas and preoccupations of the patients, as well as their hallucinations, were occasionally depicted in the subject matter of their drawings.

What was needed was the examination of large numbers of drawings within the context of a single, extended case history, where the development both of the patient's delusional ideas and of his visual representations could be studied over a long period of time. This step was taken by an American physician, William Noyes (1857–1915).

From April 1884 to January 1889 Noyes supervised the care of a patient whom he identified only as "G." In his publication of the case, over sixty drawings, paintings, and sculptural works executed by "G" during his hospitalization were included as part of an elaborate discussion of the patient's illness.[1] Noyes's two articles on this patient represent the most extensive case history in the nineteenth century involving drawings.

The unique character of the case presentation is sug-

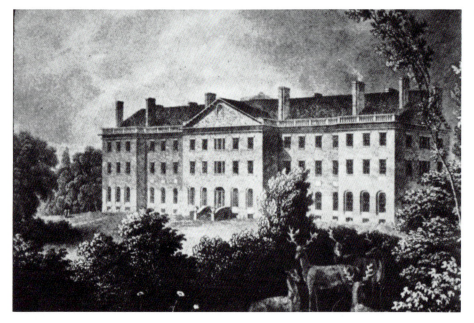

9.1. The Bloomingdale Asylum.

gested by the author's statement of his aim in publishing his observations. "It is not proposed to discuss the nature of the mental disease from which this remarkable and talented man is suffering, but merely to present as complete a record as possible of his disease" (1889, p. 375). What emerges throughout the lengthy account is Noyes's deep fascination with the personality of the man "G." Part of the explanation for this concern can be attributed to the nature of the Bloomingdale Asylum where "G" was confined (Fig. 9.1). The hospital was notable for its restrained and tolerant treatment of patients.[2] The freedom that "G" enjoyed in the Bloomingdale Asylum would be difficult to discover even in the most advanced treatment facilities and mental hospitals today. His physician had sufficient time and interest to concern himself with his patient in a friendly and humane manner. One senses as well the attraction exerted by a man of wide education and life experience, who, despite his delusional ideas, remained "bright and interesting in conversation, and possessed of a refined sense and appreciation of beauty" (1888, p. 478).

"G" was diagnosed as suffering from paranoia, a diagnosis that would probably not be disputed today, although Noyes's description of the case suggests that "G" suffered from a manic-depressive psychosis, with periods of near complete remission. Prior to the onset of his illness, he was an artist, employed as an illustrator in New York City. He had spent eight years in Paris as a pupil of the great academic master Jean Léon Gérome (1824–1904).[3] Noyes's fascination with the case was, at least in part, the result of his interest in art and artists, an interest we know only through his reaction to the artistic productions of this patient, whose painting intrigued and attracted him. He mentions having endeavored to get "G" to work more systematically at his art by offering him theater tickets in exchange for pictures. In this way he acquired the painting *Paradise and the Peri* for his collection (Fig. 9.2). A common ground of shared interest in poetry, literature, and painting seems to have united patient and physician in a relationship that stimulated more intensive, and yet spontaneous, observation on the part of the physician resulting in one of the most intimate and human accounts of the mind and art of a mental patient that exists from this period.

"G" entered the Bloomingdale Asylum at the age of thirty-nine after a series of events that made it quite clear that he was mentally unstable. He was troubled by megalomanic delusions of a religious nature, referring to "the great work which he was to do for the world." He was occasionally violent and noisy, conversing constantly about religious subjects. Periods of excitement were interspersed with intervals of depression. During the course of the first year of his hospitalization he developed delusions of persecution, complaining that his attendant had "put the evil eye on him," and, in general, exhibited behavior that confirmed Noyes's diagnosis of paranoia. His religious delusions suggest that he saw himself as involved in a special relationship with God, which had as its goal becoming part of the Deity. "The greater 'good' absorbs and refines the lesser lights, so a penny dip may eventually become a particle of the great and glorious 'orb of day'" (1889, p. 356). At many points in Noyes's description of his patient's behavior and ideas, one is reminded of Freud's Schreber case, especially in regard to the patient's preoccupation with sun symbolism.[4] The sun and its rays form an important part of his art and thought, and it is evident that he tended to equate

9.2. "G," *Paradise and the Peri,* watercolor, from William Noyes, *The American Journal of Psychology* 2 (1889): 348.

God the Father and the sun. "For his God in the Sky, Has him close to his eye" (1889, p. 358). "On the head-board of the bedstead he has placed a circle carved out of soft wood and with the rays gilded to represent the sun: and in the center of this in a somewhat intricate design are the symbols alpha and omega. This emblematic sun comes directly above his head when lying down. In photographing this, the camera had to be placed at the side so that the circle is distorted" (1888, p. 473).

Noyes's sensitivity to his patient's intelligence and creative ability was unfortunately rendered therapeutically ineffective by his pessimistic view of the case as incurable, the irreversible result of "a faulty physical development." If despite this negative attitude he troubled to keep extensive records, to inquire into the patient's childhood, as well as his life in Paris, and to study his writings and paintings with extraordinary attention to detail, one is led to believe that he was interested in the case for other than therapeutic or purely clinical reasons. The decision to reproduce a truly enormous number of paintings and drawings, a difficult task in the 1880s, might suggest that what attracted his attention was the fact that "G" was an artist of considerable skill, a representative of what Noyes referred to as "a typical example of the artistic temperament with its ready susceptibilities, its quick sympathies, and its appreciation of the beautiful" (1888, p. 462). "G" obviously provided an ideal opportunity to investigate the effect of severe mental illness on a talented creative individual. Surprisingly, despite the trite reference to the "typical artistic personality," Noyes avoided mentioning the prevalent theories of genius and insanity with which he would certainly have been familiar. He believed that "G" 's artistic activity was in no sense a form of behavior inspired by illness, but rather that painting and drawing represented a healthy fragment of the patient's life, which he sought to encourage. He was supported in this therapeutic decision by the writings of Philippe Pinel, whose work was still highly regarded. Noyes indicated clearly that his patient's inability to work systematically or to fulfill commissions demonstrated the destructive effect of illness on a promising artistic career. Working almost certainly under the influence of Paul-Max Simon, and restrained by what seems to have been a very sound, commonsense view of things artistic, he was well insulated from the more Romantic conception of art and genius held by many of his European and American colleagues.[5]

Noyes not only accepted his patient's artistic activity as a healthy manifestation; he also examined the prod-

9.3. "G," paintings and drawings done before the onset of his illness, from William Noyes, *The American Journal of Psychology* 2 (1889): 352.

ucts of that activity with great care to determine the extent to which they might actually be characterized as influenced by his present mental condition. He resisted the tendency to assume that the art of mental patients must necessarily be pathological art. In taking this restrained stance he was no doubt helped by the fact that "G" 's paintings and drawings were for the most part rather conventional illustrations not unlike a good deal of academic painting prevalent in French art of the late nineteenth century.[6] It was possible for Noyes to respond to them aesthetically, as "art," and to admire their allegorical content, literary allusions, and the skill with which they were executed. As a result he is among the first psychiatrists to display a real liking for the art of patients to the extent of being proud to own and exhibit it. His decision to publish the case was, at least in part, motivated by his

appreciation of what seemed to him to be very fine works of art.

In attempting to ascertain whether the paranoid condition had influenced the pictures, Noyes was led to yet another innovation. He published examples of the patient's work done before the onset of his illness (Fig. 9.3). He also described the visit of an artist friend of the patient who was able to confirm his impression that the pictures did not reveal any noticeable technical or formal deterioration. "They were said by this artist to be of the same general character as the patient's earlier work, strong and original in conception, but lacking in refinement and delicacy of finish" (1889, p. 351).[7] We are also furnished with the delightful information that, while in Paris, "G" had acquired the epithet, "the unfinished artist," an indication that his inability to complete commissions was not the result of his illness.

By publishing examples of his patient's earlier work for comparison, and by obtaining the critical opinion of a trained and objective outsider to augment his own, Noyes offered compelling evidence of the danger of accepting without question the prevailing view that mental patients' paintings and drawings must necessarily be bizarre or random. In terms of the academic training that the painter had received in Paris, the drawings are unexceptional and offer few surprises. Were we to encounter them in another context, as illustrations in a book or magazine, it is unlikely that they would inspire any comment.

Noyes's first publication focused primarily on a group of circular diagrams, which can quite appropriately be referred to as mandalas (Fig. 9.4). Two of them were reproduced along with extremely detailed explanations of the symbolism employed, written by the patient himself. They were executed in watercolor, the various colors chosen for their symbolic meaning. Twelve such diagrams were made, but the patient destroyed all but four. The symbolism was primarily religious and mythological, each chart representing a development or evolution, paralleling his conviction that he must undergo a spiritual development in preparation for his role as a chosen one of God. Later "G" became preoccupied with the seven coverings of the endosperm or center of the wheat berry, and with the seven seals of the book of Revelation. Inevitably we are reminded of Jung's conception of the function of the mandala:

A rearranging of the personality is involved, a kind of new centering. That is why mandalas mostly appear in connection with chaotic states of disorientation or panic. They then have the purpose of reducing the confusion to order, though this is

9.4. "G," *mandala*, watercolor, from William Noyes, *The American Journal of Psychology* 1 (1888): 469.

never the conscious intention of the patient. At all events they express order, balance, and wholeness. Usually the mandalas express religious, i.e., numinous, thoughts and ideas, or, in their stead, philosophical ones.[8]

It is unfortunate that Jung was unfamiliar with this case. Noyes characterized the general significance of the mandalas as representing "the complete systematization of his delusions and the complete theology that he has evolved through his years of study of the Bible" (1888, p. 467). They did involve an effort to organize a vast quantity of complicated ideas that formed the body of his delusional thinking.

Having familiarized himself with the type of allegory used by the patient, Noyes occasionally attempted to interpret symbols that "G" had omitted to explain. He was careful to indicate where the patient's elucidation left off and his own speculation began.

It is uncertain just what symbolism is connected with the serpent twining about the cross and the open book crossed by a sword and a pen, unless indeed this last may mean the Bible with the emblems of peace and war lying quietly within it, and it seems not unlikely that the serpent is emblematic of the betrayal. For the rest of the design, we need make no inferences, as it corresponds closely with his description. (1888, p. 470)

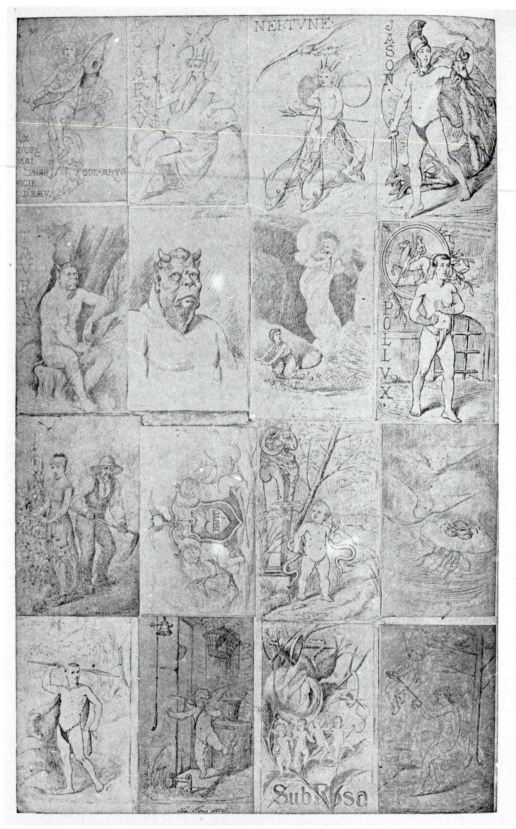

9.5. "G," watercolors from his book *Threads of Thought*, from William
Noyes, *The American Journal of Psychology* 2 (1889): 354.

While the formal and technical aspects of "G"'s work failed to reveal any changes as a result of illness, Noyes felt that the subject matter reflected what he referred to as "an original mental twist in the direction of the odd and fantastic in art" (1888, p. 478), and that some of the drawings quite obviously referred to the patient's growing delusional system. He mentioned that "G" believed his work was "directly controlled by a higher power and that the work of his fancy was really inspired" (1888, p. 469), concluding that "the odd and fantastic conceptions are sufficiently evident to need no further comment" (1889, p. 351).

The second article, published a year later, was inspired by an enormous book, *Threads of Thought*, written and extensively illustrated by the patient. The juxtaposition of text and pictures clearly represented an exceptional opportunity of penetrating more deeply into the allegorical images by providing a context for the drawings, linking them with "G"'s contemporary literary efforts. Very extensive quotations from the book are used to familiarize the reader with "G"'s preoccupations and to explain the presence of the various drawings at specific points in the text. Again, the emphasis focuses not on the understanding of the unconscious processes motivating the symbolic language, but rather on demonstrating the ties between the written and graphic productions. Noyes quite obviously enjoyed the intelligence and wide-ranging literary sources of the text, taking pleasure in sharing with his readers his awareness of his patient's unusual brilliance and wit. For example, Noyes indicated a connection between certain of the visual images and the patient's tendency to play with words and puns. One of the drawings (Fig. 9.5, second row, third from left) illustrates the story of the fisherman Khalifah and the Caliph's handmaiden from the Arabian Nights. It bears the inscription:

Vir man
Gin trap

a play on the Latin *vir*, or man, and the old English *gin*, or trap. The sexual allusion implied in both the pun and the subject matter of the illustration was not recognized as significant. Nothing concerning the patient's sexual identity was mentioned in the articles, despite the fact that "G" makes frequent reference to sexual material, and many of the drawings have an erotic overtone.

Threads of Thought was illustrated with thirty drawings, executed, it appears, in pen and ink. Despite the small size of the illustrations in Noyes's publication, the pictures permit, and are well worthy of, detailed study. "G"'s ideas as embodied in the mandalas appear to have involved an effort to reconcile Greek mythology, astrology, and Christian dogma, in an all-embracing whole. This is true of the material contained in *Threads of Thought* as well. But, whereas the text shows a great preoccupation with Christian morality, at times reading like a sermon, most of the book's illustrations depict subjects derived from pagan mythology, a split that may well have served to reflect a similar division in "G"'s inner world, with the inevitable conflict that would imply. In all the pictures Noyes has provided, religion plays a very minor role. Only five paintings are directly concerned with religious subject matter: in *Threads of Thought* the picture entitled *Sesame*, a depiction of the cherubim with the fiery sword who guards the entrance to the Garden of Eden, and perhaps the drawing of two putti entitled *Faith* (Fig. 9.5, third row, second to the right). In his watercolor paintings there are depictions of St. Michael, the Angel Sandelphon with the Holy Grail, and Shechinah or the Light of Love (Fig. 9.6).

Threads of Thought is divided into twelve parts, as were the mandalas, one section for each month. Each part is introduced by a picture and a discussion of a mythological personality associated by "G" with that month. The choice of pagan figures, mostly male, all portrayed in suitably classical states of undress, contrasts significantly with the heaviness of "G"'s Christian moralizing in the text. "If evil thoughts come into your heart don't give them house room, purge them out, and above all give them no utterance" (1889, p. 358). One senses that the illustrations may have served the purpose of "giving utterance" to what could not be said. Although the general mood of these figure drawings is far from overtly erotic, an adolescent sexuality pervades all of them. Only in the drawing entitled *The Maiden and the Gardener*, an illustration of a poem by Austin Dobson entitled "A Fancy from Fontenelle," does a more bizarre, even perverse, sexual fantasy seem to break through (Fig. 9.5, third row, at left).

"G"'s academic training is evident in his choice of subject and in the repetitious compositional schema in which full-length nudes, supplied with the appropriate identifying attributes and labels, assume poses easily recognizable as those of professional models of the Paris ateliers. That this was indeed the source of these figures is further suggested by the unclassical decision to clothe the gods in decorous and curiously detailed "modeling briefs." Although the figure drawings are mildly competent, there is something puerile about them. The poses are simplistic, the facial expressions absurdly adolescent. As a student of Gérome, Noyes

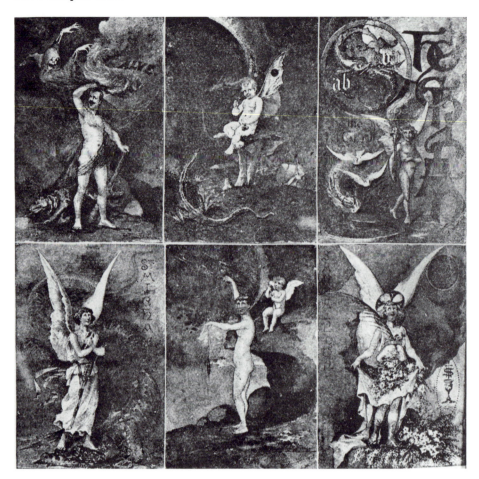

9.6. "G," watercolors from his book *Threads of Thought*, from William Noyes, *The American Journal of Psychology* 1 (1888): 474.

was not unaffected by the smoldering licentiousness often experienced in the work of his master. However, "G" was a provincial follower of Gérome not only in terms of technical mastery and creative originality, but in erotic innovation as well. "G" 's eroticism has all of the suggestive impact of sexual fantasies conceived in Sunday school.

Noyes also provided over twenty watercolor paintings produced by his patient in, and slightly before 1888. These pictures are different in feeling, slightly less tight and static. In these works we probably come closer to the type of image that "G" would have produced as a commercial illustrator. Unfortunately, the three paintings belonging to the period preceding his illness are landscapes and therefore difficult to compare with his later figure studies. The figure compositions, both in style and subject, reveal a superficial charm that held much appeal for the amateur of art. Dancing frogs, and gentle allegories such as *Pleasure,*

Time and Youth, or the vanished world of the Commédia del Arte seen in the two paintings of French cooks, and in the drawing of a maiden entitled *Life's Fitful Fille-vers*, suggest little that could be termed obviously pathological.

Not a few of the compositions illustrate poems written either by "G"—for example, "La Sonnette" (Fig. 9.5, bottom row, second from left)—or by minor poets of the period. "G" 's ability as an illustrator appears to have survived unimpaired much of the time. If "G" 's disturbed mental state is to be found anywhere in his graphic productions, it is in the group of pictures identified as witches and vampires (Fig. 9.7). Here a definite change of style is felt: expressionistic forms are pressed close to the surface and the facial features undergo bizarre distortions, with protruding eyes and elongated ears. Of course, these distortions may have been motivated by the subject, but the subject itself, given the mildness of the remainder of "G" 's work,

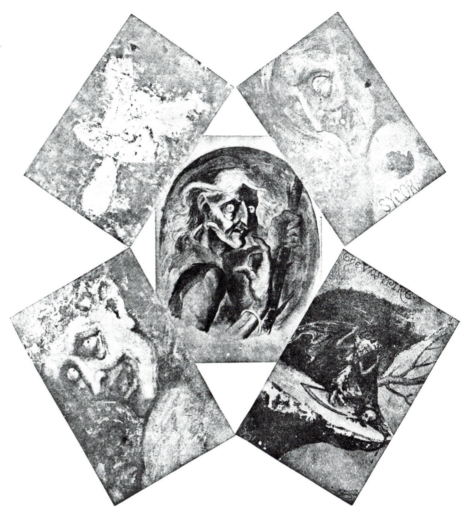

9.7. "G," *witches and vampires*, water-colors, from William Noyes, *The American Journal of Psychology* 2 (1889): 375.

suggests an inner reality underlying these violent pictures. Similar uncanny forms are visible in the two depictions of the bull-headed Taurus in *Threads of Thought* (Fig. 9.5, second row, first and second from left) and the same prominent, staring eyes are particularly evident in the bust portrait labeled "The Minotaur," a haunting image that is curiously out of place amidst the innocent classicism of the remaining drawings. Is this perhaps a reflection of "G" 's inner perception of himself?

Behind all of Noyes's thinking, as it is revealed in the two articles, was the profound conviction that the various symptoms and symbols produced by his patient were not the random and senseless activities of a disordered brain, but that they represented a coherent and interrelated body of material resulting from a highly developed and evolving system of delusional ideas. This belief in an underlying system of erroneous ideas manifesting themselves in a number of different forms was not original to Noyes. His attention to his patient's manner of dress, style of room decoration, writings, and artistic productions, as well as his eccentric behavior, suggests that he was familiar with Simon's essay of 1876, although he made no reference to it. However, his investigation of the whole range of symptomatic and symbolic phenomena in the context of a single case enabled him to demonstrate the range and complexity of the delusional system, the precise ways in which it found expression, and the significance of seemingly bizarre behavior. His achievement is not unlike that of the archaeologist who realizes that the apparently meaningless scribbles on a group of clay tablets are, in fact, a primitive script. That Noyes was not able to translate this new language should not incline us to underestimate his achievement. He frequently uses the words *allegorical* and *symbolic*, and he tells us that "symbolism" was one of "G" 's favorite words. He was aware that "G" was attempting to com-

municate ideas that preoccupied him. His failure to recognize the fact that these obsessional ideas, and their symbolic manifestations, contained within them the possibility of a deeper understanding of his patient's mental processes was, as we have seen, expressive of the dilemma of much of nineteenth-century psychiatry.

In his ability to observe with care and patience what he believed to be the systematic and irreversible errors of a diseased brain, and in his determined effort to demonstrate how each fragment of behavior, each gesture, word, or image, fit into a complex and coherent whole, all of which rested on a foundation of religious and persecutory delusions, one senses an increasing mastery of the clinical situation. Speaking of a particularly difficult phase of "G"'s illness, Noyes says, "His actions became more and more eccentric at this time but were all due to a consistent following out of his delusions on religious subjects" (1888, p. 464). Or, referring to the collection of odds and ends with which "G" ornamented his room, he concluded, "These, as is the case with everything he puts up, all had some symbolic meaning" (1888, p. 473). By following the development of the illness for almost five years, Noyes succeeded in demonstrating how changes and shifts in his patient's mental condition were paralleled by changes in the content of his art.

As in many of the early studies of the art of mental patients, the most profound insights into the meaning of the pictorial images were provided by the patient himself, rather than by his physician. "G" was occasionally willing to explain the allegorical subject matter he employed, thereby providing the links that Noyes sought between his patient's delusional ideas and the content of his drawings and paintings.

As we read through the case report, examining the quotations and the abundant illustrations, we come to know "G" as a very real person whose ideas, while strange, are not repellent, and whose drawings and paintings exert a strong attraction. In his ability to respond to this man as an utterly fascinating human being, and as a talented and sensitive artist, Noyes surpassed his limited and pessimistic organic neurological orientation, producing the finest descriptive case history involving patient art of the nineteenth century.

Let none erase, nor pen, or trace,
 Upon this book of mine;
In solitude I've writ it all,
 And thought upon each line;
There's much within that is my own,
 And much that is divine.
 —*Threads of Thought*

The Chicago Conference

On April 10, 1892, a paper delivered before the Chicago Academy of Medicine provoked a very lively and interesting discussion. The paper, "Art in the Insane," was the work of Dr. James G. Kiernan of Chicago, a much-published opponent of the genius–insanity theory. A number of American physicians attended the conference and their remarks were published along with Dr. Kiernan's paper. As a result, this meeting may be regarded as the first official congress in America concerned with psychopathology and art.

Although Dr. Kiernan's lecture contained little that was new or challenging, the arguments that it stimulated, which fortunately were published with the paper, provide an extraordinary opportunity to survey the level of development at which the study of the art of the mentally ill had arrived in North America in the 1890s. It provides, as well, some insight as to the general attitude to the genius–insanity theory in this country.[1] Everyone who spoke seemed to have had strong opinions concerning mental illness and art, and they were not inhibited in expressing them. What the discussion lacked in sophistication, it easily made up for in emphatic declarations for and against the "usefulness" of insanity as a means of provoking, or at least "encouraging," genius. There was a good deal of plain Yankee common sense present at this "round table" on psychiatry and art, and the views of Lombroso were debunked, as well as praised.

Kiernan's lengthy presentation was divided into two parts: a summary of the characteristics of "insane art," derived in every respect from Lombroso's thirteen points as presented in *L'uomo di genio*, and with illustrations taken from that book; and a biographical review of several English painters—Blake, Turner, Haydon, Flaxman, Romney, and Landseer—presented with a view to indicating how each had come to a bad end. Despite this negative goal, Kiernan attempted in both sections of his paper to support the extremely interesting thesis that artistic activity occurred in insanity not as a result of mental illness but as the representative of a "conservative element," a last stronghold of sanity or of health amidst the chaos of illness, a conception that would have sounded strangely familiar to Philippe Pinel. Kiernan's concluding sentence—"In the art, as in the literature, of the insane, evidence is found that insanity mars, but does not make, genius"—was accepted as a challenge by many of the physicians present in the audience (p. 275).

Although Kiernan accepted without reservation Lombroso's characteristics of "insane art," he was an impassioned opponent of the idea that genius was itself a degenerative psychosis. In three earlier papers, he had mounted a bold, reasoned attack on Lombroso and his followers, demonstrating the shallowness of their arguments and the intellectual sloppiness of their investigations of genius. His essential hypothesis was emphatically clear: "Genius is not a product of a morbid mind. In the exceptional cases where the two coexist, the genius is evidence of a healthy, conservative element, struggling with the incubus of disease. . . . The fundamental error is that so often made in medicine, individual cases are forced into a procrustean bed of nomenclatures. If the case doesn't fit, so much the worse for the patient."[2]

Throughout this discussion of the origins of the relationship between art and psychiatry, it has become apparent that biographical investigations of genius, whether intended to prove or disprove the Romantic theory of genius–insanity, were ill-adapted to developing a sincere concern with the art of the patient. For example, Kiernan challenges Lombroso on so many fronts, yet accepts and repeats without exception his list of characteristics of insane art. In this part of his paper he presents almost no new evidence; the same old cases are described once again and reillustrated with the same drawings, with only a few new examples added to confirm certain points. In this connection, it is amusing to note that since Kiernan did not possess either Lombroso's original pictures, or the plates from which they had been reproduced, he had to have new engravings cut. In the process the new engraver introduced very noticeable changes (Fig. 10.1).

A single new illustration was added from Kiernan's own collection, entitled *Paranoiac Landscape*. Curiously, the painting contained nothing that Kiernan could point to as pathological either in its form or subject matter, although he assures us that while "the symbolism is not apparent, the patient's delusions

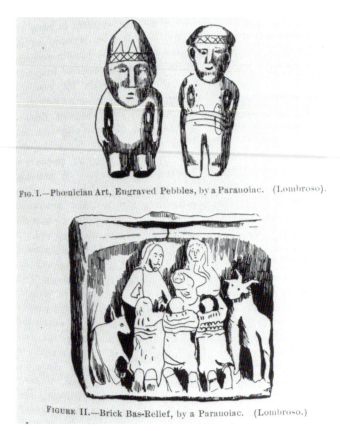

Fig. I.—Phœnician Art, Engraved Pebbles, by a Paranoiac. (Lombroso).

Figure II.—Brick Bas-Relief, by a Paranoiac. (Lombroso.)

10.1. Copy of a plate from Cesare Lombroso, *Man of Genius*, reproduced in J. G. Kiernan, *Alienist and Neurologist* 13 (1892).

were as skillfully hidden. . . . The landscape representing a Wisconsin lake was painted by a hysterical paranoiac under my care. Simply artistic as this landscape seems, the artist believed it to be symbolic of her innocence of certain attacks on her character, made by anonymous letters written by herself in the delusional state common to hysterics" (p. 250) (Fig. 10.2).

Particular emphasis in Kiernan's article falls on the similarities between the drawings of patients and primitive art, an idea that recalls Lombroso's conception of an "atavistic tendency." Kiernan's idea of a conservative tendency as the basis for artistic talent among the mentally ill is ingeniously related to the atavistic trend, so that the patient appears to revert to more and more primitive forms of expression almost as if being driven back through time by his illness. In this way Kiernan arrived at a facile explanation for the similarities often noted between the drawings of children, primitive man, and the mentally ill. His absorption in the task of ridding genius of the stigma of degeneracy did little to enlarge current opinion con-

cerning the drawings of individuals suffering from serious mental illness.

The debate that followed Kiernan's report also failed to throw any light on the artistic activities of patients.[3] Nevertheless, it indicated clearly that American physicians were examining the visual productions of their patients and were interested in the amount of "talent" they revealed and in the diagnostic or therapeutic value they might possess. The two opening speakers, Dr. G. Frank Lydston and Dr. C. G. Chaddock, most ably stated the radically opposed views on the question of the links between mental illness and creative genius. According to Lydston,

Genius may at times be the direct outcome of neurotic disturbances. [I have] always questioned the possibility of the fine creative frenzy of the novelist or poet being compatible with a perfect mental equilibrium. It is well known that insanity is often associated with exaltation of the imagination, why may not the peculiar state of the insane mind be a direct cause of artistic ability? It does not follow that every artist, poet, or novelist is mentally unsound, but it is obvious that he may be. Certain it is that he is usually temporarily so at the time his best work is produced. (pp. 684–85)

Dr. Lydston's remarks admirably represent the Romantic conception of the creative act, and of the mentality of the inspired genius. On this occasion Dr. Lydston's words were so completely inspired by Plato that one is inclined to imagine he had memorized the whole of the *Ion*.

It is particularly interesting to see how the individual physician's conception of "talent" influenced the arguments. Frequently, mere facility at naturalistic rendering of objects was accepted as an indication of real talent, or even of genius. This was a device used by Lombroso in overcoming the obstinate dearth of newly created geniuses among his patients. It is clear that considerable experience with art was needed if the psychiatrists were to make any headway with this problem, experience that was largely lacking among nineteenth-century physicians, as well as among many of their twentieth-century brethren. In this area, Kiernan's knowledge of contemporary writings on art, especially his interest in Ruskin, put him at a great advantage.

Dr. Chaddock's response to Kiernan and to Lydston was of unusual restraint and wisdom, for it was the first time anyone had thought to question the objectivity of the psychiatric investigator. Suddenly attention is shifted to the observing physician, to his prejudices and to his mental apparatus. In this unplanned and spontaneous discussion, a breakthrough occurred when Chaddock pointed out:

10.2. Anonymous, *Paranoiac Landscape*, from J. G. Kiernan, *Alienist and Neurologist* 13 (1892).

The specialist in any department of science should guard against a narrowness of view necessarily conditioned by his habitual mode of thought. It is a fact that psychiatrists seek to find abnormalities in all minds. This tendency of psychiatric thought is doubtless responsible for the prevalent view that genius is a morbid phenomenon, a manifestation dependent upon neuropathological degeneracy. . . . A man of genius may become insane; but an insane individual manifesting genius due to insanity is yet to be found. (pp. 686–87)

Another of the discussants, Dr. C. B. Burr, contributed a simple and yet exceedingly significant new system to classify the art of the mentally ill, which reveals wide pragmatic experience rather than armchair theorizing. Concerning himself with the paintings and drawings themselves, and ignoring the related symptoms temporarily, he arrived at five categories of patient art. These common sense groupings represent a marked advance, in that they move away from the sweeping generalizations that attempted to isolate characteristics supposedly typical of all of the graphic productions of the mentally ill.

His first group included examples of drawings that failed to reflect "any impaired mental action, but were the result of education and training in artistic lines"— in short, the unextraordinary work of patients who had painted prior to their illness, and who continued to paint after its onset in an unchanged manner (p. 692).

The second category was typified by "the inartistic product which arises from faulty education, but which is not necessarily evidence of mental weakness, being due entirely to absence of artistic skill" (p. 692). These two groups draw attention emphatically to the fact that a large part of the graphic production of patients is in no sense pathological and requires no psychiatric explanation. This simple observation, which can be verified in the art therapy department of any psychiatric hospital, bears repeating even today.

The third category included "the symbolic and inventive." He linked this type of production with paranoia and chronic delusional forms of mental illness, particularly those typified by delusions of persecution and megalomania. "As the assault, or the appearance of the persecutor shows itself to the subject of the delusion, he delineates it upon paper" (p. 692). He indicated that in such cases the patient makes use of whatever ability he may have.

The fourth group is perhaps the most difficult to delimit. It consisted of pictures drawn by patients experiencing "exaggerated feelings and sentiments during periods of elation; the picture represents the undue self-confidence of the patient in the line of art" (p. 693). Presumably he had in mind works that are enormously ambitious in intention, and childish or disappointing in execution. Without knowledge of the patient's behavior, some confusion with the second category would seem inevitable.

The final group is also familiar in modern psychiatric hospitals, in that it draws attention to those patients who "confine themselves to copying the work of others, and it is not, strictly speaking, inventive" (p. 693).[4] He added the qualification that patients often distort the picture they are copying, or add figures of their own.

The significance of these five categories in pointing up the wide variety of different types of visual material with which the student of the drawings of the mentally ill is confronted should not be underestimated. The groups emerge logically from the study of the pictures themselves, and not from a theoretical conception of the syndrome, or of mental illness in general. Study of the nineteenth-century literature dealing with the art of patients reveals that many physicians avoided confrontation with the drawings. Despite the fact that

there was obviously no lack of new case material, Lombroso's thirteen characteristics were repeatedly described, while the same cases and the same pictures served as illustrative material. There was apparent resistance reflecting an inability to cope with the chaotic variety of the drawings, combined with the anxiety provoked by the intensity and strangeness of at least some of the images. Burr's simple system of grouping the pictures made it evident that no single list of characteristics of "insane art" could hope to make sense of a body of paintings and drawings that revealed such a wide range of essential differences. The fact that the first two categories consisted of pictures that were in no sense pathological forced his listeners to reexamine their Romantic conceptions of psychopathological art.

Although Burr's five groups were not all-inclusive, his proposal had great merit because it represented yet another attempt to return to the primary material of observation, the drawings and paintings of men and women suffering from mental illness. The element of common sense is so strong in Burr's distinctions that it seems likely he spoke from long experience of a considerable collection of patient art, and that his five groups had been carefully thought out.

Before leaving Burr it is worth pausing a moment to take note of a case he used to illustrate his discussion of drawings typical of patients afflicted with delusions of persecution, in that it represents yet another early example of machine symbolism of the "influencing machine" type discussed by John Haslam. The case is described as follows:

The patient . . . is beset by "foes from above, making war," as he expresses it, "upon the order." The weapons that they use, the infernal machines which they employ, he attempts to depict, and in verbal descriptions of their appearance and form and outline, he shows an astonishing inventiveness in the matter of impossible words, so in his pictorial delineations and explanations of his figures there is an attempt at definition and exactitude, but the finished product is an impossible creation. His pencil drawings are not wholly lacking in artistic merit. His lines are good, and much of his work of a regular character. Inconceivable and impossible as it is, one is interested in spite of himself by the patient's intense earnestness and facility in description, and looks eagerly to discover what the patient sees in it. (pp. 692–93)

It is regrettable that Burr's description was not augmented with examples of the "infernal machines" drawn by the patient. But the intriguing nature of the patient's fantastic inventions is well communicated, as is the ability of the machine to "get at" the patient, in this case, "from above."

Another of the physicians participating in the discussion of Kiernan's paper was Dr. Daniel Clark of Toronto (1835–1912) (Fig. 10.3). Dr. Clark, who had become president of the American Medico-Psychological Association a year earlier, in 1891, is the only Canadian physician mentioned in the context of studies of the art of the mentally ill during the nineteenth century. His involvement with the art of the insane would have begun in 1875 when he was appointed Medical Superintendent of the Toronto Asylum for the Insane, a position he continued to hold until 1905 when he retired. In his remarks at the Chicago conference he stated that "he had been collecting the literary effusions and the mechanical work of the insane, and had given several popular lectures on the subject" (pp. 690–91). Research into his published writings has failed to disclose any lectures dealing with art and insanity.[5]

Clark's interest in "the literary effusions" of his patients is explained by his extensive personal involvement with creative writing. He was a poet and novelist of some small reputation in Canada.[6] The meaning of "the mechanical work of the insane" might seem unclear; however, his use of the phrase in his various publications on education indicates that he was referring to the whole range of objects produced by patients, not excluding drawings and paintings, but tending more toward utilitarian handicrafts—"work for idle hands." "The insane of the delusional class will do excellent work mentally or mechanically along the lines of thought which have been a life effort . . . but they are twisted into abnormal forms by the interjection of disease with its variations" (p. 691).

10.3. Dr. Daniel Clark of Toronto, Canada.

10.4. Landscape with waterfall by "a female paranoiac," from Ales Hrdlička, *American Journal of Insanity* 55 (1899).

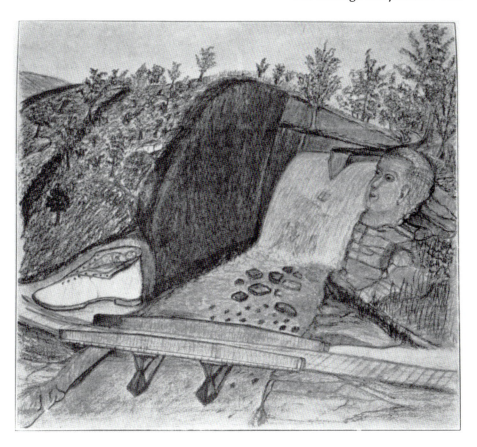

Despite the fact that the various comments of some eleven contributors were recorded and published, the effect of such an unsystematic and spontaneous discussion could not be very extensive. However, the surprising range of opinions and ideas displayed at this meeting in Chicago is sufficient to indicate that a number of American physicians were attentive to the problems presented by the graphic productions of their mentally ill patients. The work of the following century was to rest on this foundation of speculation and observation.

ALTHOUGH he is not mentioned as having been present at the Chicago conference, one further contributor to the problems raised at that meeting deserves mention. Seven years later, in 1899, Dr. Ales Hrdlička published a study entitled "Art and Literature in the Mentally Abnormal," in the *American Journal of Insanity*.[7] Hrdlička's effort, like that of many of the Chicago conference participants, was directed against the theories of Lombroso. It would almost seem that this had become the preoccupation of the American school of psychiatry.

Hrdlička's short essay did not represent much of an achievement in terms of presenting new ideas or significant case material. Nevertheless, his approach, which continued what is best characterized as "the American, hard-headed, practical point of view," was useful in reducing the influence of the curiously persistent Romantic conception of the mad genius as it survived in America.

The insane or the epileptic genius is a thing largely of romance, or, at least, is not to be found in the state institutions for these classes of patients. . . . What we do find and can study in our hospitals and asylums for the mentally abnormal, is principally the artistic and literary manifestations of persons who acquired more or less of these qualities by education while in their normal state. Thus the study of art and literature among the various classes of mentally abnormal resolves itself principally into a study of the effects of various abnormal mental conditions on the previously acquired abilities of the individual. (pp. 385–86)

Having established this refreshingly matter-of-fact attitude, Hrdlička might have been expected to undertake an original reexamination of the case material

available to him. However, he only presented a generalized list of "characteristics of insane art," differing little from that of his adversary Lombroso. We are told once again of some patients' preference for symbolism and allegory, the use of secret signs, religious objects, and occasional obscenity.

This unwillingness to go beyond Lombroso's conception is particularly unfortunate in that Hrdlička was in a good position to collect new evidence. He informs us that "the observations reviewed in this paper were commenced at the Middletown State Homeopathic Hospital, and later extended among several of the other New York State Hospitals and various institutions for the feeble-minded, epileptics and insane criminals" (p. 385).

Although his article was accompanied by six illustrations of pictures taken from his own collection, he chose to say very little about the drawings or the artists who made them. One of the drawings (Fig. 10.4) is among the most unusual works known from the period. It is a very strange landscape with a waterfall. A stream flows diagonally through the picture and is crossed in the foreground by a large bridge. The bridge and certain details in the landscape are so specific in feeling as to suggest that the scene reflects a locale the patient knew well. Yet two unexpected objects intrude upon this mundane bit of nature: at the left end of the bridge, just off the road, is an enormous boot, so huge that if its absent wearer were to step on the bridge it would collapse. Inside the shoe, lying face up with her arms folded on her breast, is a woman, perhaps the patient. Then, to the right of the falls, and forming part

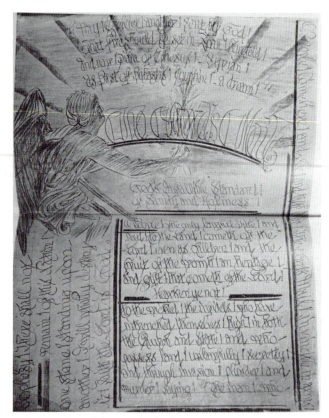

10.6. Illuminated manuscript by "a male paranoiac with religious delusions," from Ales Hrdlička, *American Journal of Insanity* 55 (1899).

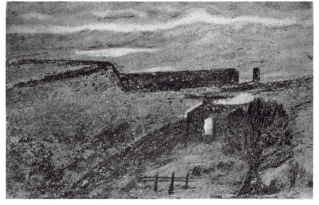

10.5. A scene from the Southwest by "a female paranoiac," from Ales Hrdlička, *American Journal of Insanity* 55 (1899).

of the stony escarpment, is the head of a child, probably male. His chest is composed of the rocks of the river bank; his massive head, whose eyes stare straight ahead as if in a trance, rises beside the falls like that of an ancient river god.

The longer one looks at this haunting work, the greater the tendency for forms to take shape until one begins to doubt that it is a landscape at all. Many forms are so ambivalent that it is difficult to decide whether they exist. An example is provided by the water nymph who appears amidst the waters of the falls. Hrdlička informs us only that "the patient, a female paranoiac, represents graphically some of her delusions about children," but he was aware that "the objects in drawings are often supernatural, intercalcated faces are very frequent, some of the figures are liable to represent fabulous creatures, either human or animal, mysterious objects, secret signs, letters, and strange words are not uncommon in the pictures" (p. 388). Clearly, this particular case and these unique

"surrealist" drawings merited a more detailed investigation.

There can be no doubt that Hrdlička was personally very interested in patient art. At the end of his article he issues a plea for further material. "The author will highly appreciate any specimens of writing or art, produced by mentally abnormal individuals with which he may be favored" (p. 404).[8] He describes one occasion at least on which he supplied his patients with paints. The results seem to have disappointed him. "The pictures of the insane are preferably done by colored pencils, in crayon, or in pen and ink. I have but very seldom observed among the insane any successful attempt at painting, and that although I went so far as to provide some of the patients, who could use them, with colors" (p. 389). He tried to obtain information from the artists about the meaning of their work, not always successfully. He reproduced a landscape by a "female paranoiac," which he identified as "a scene from the Southwest, a desolation, patient unapproachable and will not give any explanation about her drawings, all of which are of similar character to this one" (Fig. 10.5).

Another drawing, identified as the work of a "male paranoiac with religious delusions," takes the form of an illuminated manuscript (Fig. 10.6). A good deal of the text in this case can be read, though with difficulty. The patient refers to himself at several points in the text as "The Lord's Mail." "Oh, People, come here and see and talk with the Lord's Mail, invincible in arms." It is impossible to decipher the significance of these passages, as they represent only a small part of an elaborate case. Nevertheless, one phrase seems to suggest the reality that prompted the elaboration of his delusional structure. "Why, Oh People, why died my boy Emmanuel? You must know, you must learn all the facts touching the cause of his death."

Hrdlička was aware that art education and previous experience as an artist would influence the form of drawings produced after an individual became ill. He reproduced an elaborate series of drawings characterized by extreme visual complexity reminiscent of the work of Morgenthaler's patient, Adolf Wölfli (Fig. 10.7). Of this case we are told that the patient, "a male paranoic," had been "an artistic fresco-painter and decorator, confined in the insane asylum nine years, very incoherent and mystical, drawings very highly symbolical, principally mathematical and metaphysical refutations." Possessed of such unusual material, it is regrettable that Hrdlička chose not to enter into the details of the individual cases.

His ability to describe and analyze the style of the

10.7. Drawing by "an artistic fresco-painter and decorator," from Ales Hrdlička, *American Journal of Insanity* 55 (1899).

drawings was limited to making qualitative judgments, or to comparing them with other types of material. Drawings are dismissed as crude and childlike, or "lacking in detail and fine points." His inability to cope adequately with formal problems is made amusingly apparent in the marvelous critical phrase, "they very seldom produce anything truly harmonious, or exactly pleasing, or really beautiful." The absurdity of this sort of judgment only serves to emphasize that the psychiatric investigation of the art of the mentally ill was hopelessly confined by the aesthetic notions and taste of the late nineteenth century. The revolution in critical perception that followed upon the artistic revolution already underway in Europe was to open up new avenues of approach to the formal and stylistic inventions of the art of the patient. Thus, in both the study of symbolism and in the investigation of problems of form, the studies of nineteenth-century schol-

10.8. Ralph Albert Blakelock at the age of thirty.

ars and physicians had attained their maximum possible development.

In the same year that Dr. Ales Hrdlička published his observations on the art of the insane, based largely on examples collected from the Middletown State Homeopathic Hospital, a patient arrived there whose life and work were to do more to stimulate the myth of the mad genius in the United States than Hrdlička's article could do to refute it. The patient was Ralph Albert Blakelock (1847–1919), a professional artist whose story can be seen as an American counterpart to that of Richard Dadd (Fig. 10.8). Blakelock was a self-taught landscape painter whose early work was related to the poetic vision of the Hudson River School. His moonlit forests, mist filled and obscure, emerged from an imagination not unlike that of his contemporary Albert Pinkham Ryder (1847–1917).

It is unlikely that Hrdlička's involvement with the artistic activity of the insane was inspired by Blakelock's arrival at Middletown Hospital on June 25, 1901.[9] The artist's reputation at that time was far from firmly established, and he did no painting during the first years of hospitalization.[10] Nevertheless, it was only in that year that the myth of Blakelock the mad genius began to take shape. His enormous reputation in the early twentieth century was the product of madness—his own, or that of his public.

The legend was that Blakelock had been driven mad by failure and the greed of unscrupulous dealers. After a series of psychotic breakdowns, he was hospitalized in 1901, and, except for brief intervals, spent the remaining twenty years of his life in various asylums.

The Romantic diagnosis of the artist driven mad by his lack of success continues even now to be put forward as an explanation for his psychological condition. In fact, the case of Blakelock provides a magnificent example of the survival of the myth of the insane genius in our time. Within a few years of his confinement, Blakelock's fame had increased dramatically. The demand for his work, and the extraordinary prices it now fetched, was sufficient to necessitate the production of a host of forgeries and imitations. For a time, critical admiration for the artist's work somewhat outstripped its actual merit, the paintings taking on an unnatural luster, which derived from moonlight only in a roundabout way. "The country was flooded with 'genuine Blakelocks.' As a madman he was saleable and prices rose wildly: there was a Blakelock boom, inflated by hundreds of 'Blakelocks' he had never set his brush on."[11] The necessity that demanded the production of artificially produced Blakelocks was the general assumption that, having gone mad, he himself was unable to furnish the desired pictures. The assumption, familiar from the case of Richard Dadd, was quite unfounded. Blakelock resumed painting in the hospital, though in a slightly altered style. "Frequently he lacked proper materials: he painted on bits of paper, cardboard, pieces of cloth, window shades, pieces of wall paper and wood. Sometimes he made brushes from the hair of his head, sometimes from fibers stripped from a tree trunk—wired them onto a stick, a stick he had to whittle with a piece of tin since inmates were not allowed to have knives. He gave away much of his work to acquaintances and the staff."[12]

There is a great deal of material dating to the last years of the artist's life upon which a study of the American attitude toward the art of the insane at this period could be based.

I know of no other American artist who received more publicity in newspapers and magazines at any time than did Blakelock during the years 1916 to 1919. . . . For the great part however this massive publicity during this period had a tendency to hurt Blakelock and his large family more than it helped to promote and restore his creative talents. How? It repeatedly conveyed to the public an image of his poor destitute family, his mental illness was greatly over-emphasized, . . . above all his actual art during the period was greatly overlooked by many and given little attention by the collectors and art dealers. . . . His latest paintings were labeled crude and childlike by the art critics.[13]

This passage written by Blakelock's grandson reflects the disappointment and anger of the artist's family in the face of the unrealistic and distorted image the myth had imposed on the reality that they alone

knew.[14] While it would be of interest to explore the creative milieu within which the artist's final work materialized, and to reconstruct the story of his rise to fame on the wings of myth, we will confine ourselves to a brief survey of critical response to Blakelock's late work in our own day, as a prelude to our discussion of the art of the insane in the twentieth century, and as a reminder that the Romantic myth of the mad artist continues to exert a hold on the contemporary imagination.

In the second half of the twentieth century, large exhibitions of Blakelock's oeuvre, designed with a view to refurbishing the artist's reputation, which had declined once the context provided by his insanity had been forgotten, were held in 1947 at the Whitney Museum of American Art, in 1973 at the Knoedler Galleries in New York, and in 1975 at the Sheldon Memorial Art Gallery in Lincoln, Nebraska. Critical response to his work varies from the wildly imaginative to the coolly realistic, depending upon the observer's attitude toward the art of the insane. Whether Blakelock's late pictures are, or are not, influenced by his mental state is of little concern to us. Critics see in them what they expect to see. The paintings executed in the Middletown Asylum are not markedly suggestive of a psy-

chotic state, although they do depart from his prepsychotic style (Fig. 10.9).

As with Dadd, the phenomenon of retrospective evaluation of the artist's entire oeuvre is often present in Blakelock criticism. In his book *Nineteenth Century American Painting*, James T. Flexner describes the artist as "the poor, mad, repetitive, technically confused painter."[15] His concluding comment on the artist points very clearly to the source of his imaginative conception of the artist. "Yet, soberly and deliberately contemplated, Blakelock's canvases still emit a tiny flash of that rarest of all fires, genius."[16] Other observers are content to dwell on the way in which "his tragic fate hindered the full realization of his gifts."[17]

The Knoedler exhibition included a series of paintings from the final period of the artist's life.[18] The catalog attempted to describe the change in style and to assess the significance of his final achievement. Response to the exhibition, and particularly to the late paintings, varied tremendously. Some critics were content simply to describe the change in style. "The work of his last years, which has hardly been seen at all before this exhibit, is often highly coloured and seems to have abandoned the obscured precisions of his most famous works, the moonlit landscapes."[19] Other observ-

10.9. Ralph Albert Blakelock, *Reclining Figure*, private collection.

ers express disappointment, continuing the clear-headed approach of the Chicago conference.

Knoedler's exhibition tries to capitalize upon this lack of public and critical acclaim by gathering together the works produced during Blakelock's last years of confinement in a mental hospital. To a public now familiar with Art Brut and prison art, these last paintings seem pathetically mild, providing nothing more than a last insight into the deterioration of a mind and a fine hand, which was never fully understood or appreciated. . . . The confinement paintings . . . are at best a sad postscript against a critical onslaught that began more than a century ago. Interestingly enough, Blakelock's last works were executed at a time of frenetic activity in the arts; the Impressionists had come and gone, and Cubism had shattered the picture plane forever. What Blakelock would have done and how he would have reacted to these developments is an open question that will never be answered.[20]

The more enthusiastic critic, modern to the point of irrationality, sees Blakelock as another Frenhofer, a mad prophet and pioneer. "Observers of today will admire the forward look of his later work. Color and form merge to anticipate 20th century Abstract Expressionism."[21]

WE TURN NOW to the twentieth century, that period of "frenetic activity in the arts." While it is true that we can never answer the question concerning Blakelock's reaction to Cubism, or the varieties of Expressionism, we can at least explore the question in reverse: What would the artist revolutionaries of the twentieth century have thought of the art of Blakelock? What role did he and his mad brothers have to play in the "shattering of the picture plane," or in the revolutionary changes in the function of images that were now to disturb, perhaps forever, the tranquil surface of the world of art?

Marcel Réja: Critic of the Art of the Insane

In the early years of the twentieth century there was a notable increase in the number of articles devoted to discussion of psychopathological art. Many of these continued the tradition of psychiatric investigation begun in the late nineteenth century. Unique to this century, however, is the appearance of the first books on the subject, and the first studies of the art of the insane by individuals whose interest in the problem was not primarily medically or psychiatrically motivated. Inspired by the changing attitude to the art of madmen, which became increasingly apparent in the years before World War I, critics of art and literature began to investigate the subject from their viewpoint. These art critical studies fostered a sudden popular interest in and knowledge about the art of the insane. For the first time, drawings and paintings by the mentally ill were reproduced in books that were easily available to the public. The subject was increasingly understood to have implications well beyond psychiatry.

It would be naive to suppose that the new preoccupation with the art of the mentally ill was created by critics alone. Changes in taste and aesthetic awareness are not introduced by critics, but by artists. It was the avant-garde artists who, in the early years of this century, suddenly turned for pleasure and inspiration to the visual products of madmen, and who saw in the art of the insane, among other newly discovered "primitive" forms of expression, a purer and more intense reality. Nevertheless, perceptive critics contributed to the process of discovery.

The evolution of "modern art" in the first half of this century, and with slightly diminished intensity to the present, was accompanied by violent, indeed enraged, criticism. No art in history has inspired such hatred, or been attacked with such impassioned critical response. Beginning with the realist painting of Courbet, and attaining full intensity with the appearance of Impressionism, a growing wave of incomprehension and antagonism greeted every new artistic manifestation. The uniqueness of this response as a phenomenon within the history of art has not been sufficiently rec-

ognized. The form and force of the hatred felt not only by critics but by the public is a psychological and sociological manifestation worth independent investigation. This hatred of modern art, like the theory of genius–insanity, is part of the intellectual and emotional furniture in this century.

A single aspect of this mass reaction is of concern to us. The attack launched from every direction and in every country against the new art took two predominant forms. On the one hand modern art was criticized as somehow related to painting by children; on the other, it was "insane" and directly related to the art of the mentally ill. The comparison with the art of children would seem to be linked to the opinions of the less well educated, whereas the supposed relationship to the art of the insane may have been, at least in its origins, more typical of hostile, but slightly more highly educated, individuals. Although both concepts are clichés not based on any real critical reflection, they have influenced not only the evolution of popular taste in this century but in some degree the direction taken by modern art itself. And, like all clichés, they contain a particle of truth, however distorted or misunderstood.

We are faced with a paradox. A small but growing number of artists and critics were beginning to exhibit new and positive attitudes toward the pictorial and sculptural productions of the mentally ill; yet elsewhere hostility began to build chiefly owing to the supposed similarity between the art of the insane and that of the modern artist, a viewpoint that depended upon a negative opinion of both. The second of these approaches to psychopathological art was the more influential. Pseudopsychiatric discussions of modern art appeared in every newspaper, magazine, and art book. So extensive was this assault, and so strong the counter-reaction it provoked in individuals holding more favorable attitudes towards the avant-garde, that the positive involvement with the art of the insane by a few artists and critics early in the century has been almost entirely obscured. The possible influence of the art of the insane, as well as that of children, on the develop-

ment of art in this century remains a suspect topic to this day. Nevertheless, the contribution of psychotic expression to the development of modern art, while not as significant as that of primitive art, cannot be ignored. The long process that led to the "discovery" of the art of the insane in its final "overt" phase in the early twentieth century has been described in the earlier chapters. In many ways it can be seen to parallel other processes that are now understood to have prepared the way for what seemed a sudden change in art and aesthetics at the turn of the century. In this and the following chapters, we observe the impact of the discovery of psychotic art in artistic circles in the early years of the twentieth century.

LITTLE may be gained here by examining in detail the vast, repetitive literature attacking modern art, even when it was done in the name of psychiatry, or by a psychiatrist. It is remarkable to what extent clichés can present themselves as discoveries. However, examining one such article may help establish the peculiarities of this popular literary genre. "Post-Illusionism and Art in the Insane," by Theophilus Bulkeley Hyslop (d. 1933), which appeared in *The Nineteenth Century and After* in February 1911. This selection is apt, as Hyslop was Physician Superintendent to the Bethlem Royal Hospital between 1898 and 1910, and I have been able to discover a good deal about him and his collecting activity as a physician at Bethlem.

Apart from his professional training as a psychiatrist, Hyslop was an honorary member of the London Sketch Club and an occasional exhibitor at the Royal Academy.[1] He also published two books, *Mental Handicaps in Art* (1927), and *The Great Abnormals* (1925), thereby establishing himself as a late contributor to the genius–insanity controversy. In fact, he allied himself closely with Max Nordau (1849–1923), a chief exponent of the concept of mental degeneracy. In his article "Post-Illusionism and Art in the Insane," Hyslop aimed his remarks carefully, referring under separate headings to Impressionism, Analysts and Synthesists (presumably the various early manifestations of Cubism), and Symbolists and Mystics in art. The essay appeared in a popular literary magazine, and was not intended for a psychiatrically sophisticated audience. His intention in writing it was explained in the opening lines: "Of late we have both seen and heard so much of post-Impressionism in art, and there appears to be so much doubt in the public mind as to the real meaning and significance of the works which have been exhibited and heralded as indicating the approach of a new era in art, that the time seems oppor-

tune to discuss the subject of post-illusionism as met with in degeneracy and in the insane."[2]

His approach to the problem was skillful. Claiming to be unwilling, if not incompetent, to speak of art, he informed the reader that he would confine himself to a discussion of art produced in asylums, leaving it to the reader to draw the obvious parallels. But in fact his article reveals that he refers only to modern paintings and artists, while pretending to be describing the art of patients. The reader is then placed in the privileged position of recognizing extraordinary similarities between the pictures described by Hyslop and modern paintings. For the method to work, no reproductions could be included, and none were.

Hyslop's hatred of the contemporary art of his day was boundless. His outrage, and his paranoid fear of being "taken in," can be felt in every line.

Degenerates often turn their unhealthy impulses towards art, and not only do they sometimes attain to an extraordinary degree of prominence, but they may also be followed by enthusiastic admirers who herald them as creators of new eras in art. . . . When, however, the work is prompted by ideas which are repugnant to good taste, and depicted in all its ugliness by a technique devoid of all artistic merit, and stripped of all evidences of those finer coordinations and adjustments acquired through education and practice, then the predilection in its favour of any critic is open to the charge of dishonesty or degeneracy.[3]

Clearly degeneracy offered an effective weapon in the combat against artists and critics.

Hyslop has the unique merit of having introduced the term *borderland* to psychiatry, where it appears to have fallen at once into disuse.[4] Reluctant to refer explicitly to artists as insane, he preferred to identify them as degenerate, existing in the "borderland" between sanity and madness. He then enlarged on the group he had in mind: "this rabble of hysterics, neurasthenics, weaklings, and degenerates, including borderland critics and public."[5]

That the works of insane artists may be crude, absurd, or vile matters little so long as they exert no corrupting influence on society, and so long as society fully appreciates their pathological significance. Unfortunately, however, some creations which emanate from degenerates are revered by the borderland critics, blindly admired by the equally borderland public, and their real nature is not adequately dealt with by the correcting influence of the sane.[6]

As amusing as such nonsense is, one must remember that by referring to "degenerate art" in 1911, Hyslop was allying himself with forces that, under the banner of National Socialism, resulted in action—in the de-

struction of works of art, in the burning of books, and in the brutal persecution of artists. What such pseudopsychiatric criticism contributed to understanding the art of the insane was, quite obviously, nothing. Hyslop's writing betrays his ignorance of the art of patients and an attitude of contempt toward such work not different from his opinion of modern art. His references to the mentally ill show his disdain and near hatred of them as well, and one shudders to think of him as physician in charge of Bethlem Hospital. He writes of his patients and their art "Were it not that the condition is pathological, and that disease prevents these unfortunates from recognizing things as they really are, we should be tempted to lose our sense of toleration, and to say to them in parliamentary language, 'enough of this tomfoolery!' "[7] Such attitudes were unlikely to lead toward increased insight into the meaning of the patient's communications, or to a changed perception of the nature of the artistic function, either inside or outside the asylum.

To what extent such publications, written by psychiatrists, helped to form the popular conception of modern art as associated with mental pathology, it is difficult to ascertain. It must be remembered that the ground for this popular cliché had been prepared over centuries by the theory of the insanity of genius. Modern art was seen by an irritated public as incontrovertible evidence in support of this old belief. It is probable that psychiatric opponents of modern art merely added scientific authority to an idea that would have emerged even without their contribution. Nevertheless, the word of an "expert" served as excellent ammunition. Hyslop's article was reprinted in America in *Current Literature*, with the title, "The Insane Asylum as the Source of the Coming Craze in Art." Interestingly, the publishers felt the need of illustrations and supplied their own: a series of pictures by Alfred Kubin, who, it seems, they saw as representative of the kind of degeneracy described by Dr. Hyslop.

Early twentieth-century psychiatry can take no pride in having so consistently misused its insights, championing the derrière-garde in a state of utter blindness. But it is clear that to some extent the psychiatrists were used by reactionary artistic circles. Had this not been so they would have had little impact. Even Hyslop reflects this process. In a foreword to his book *Mental Handicaps in Art*, Arthur Thomson, professor of anatomy at the Royal Academy, joins Hyslop in condemning the degenerates: "When as sometimes now, the youth of the younger generation studying art select as their models from whom to acquire a knowledge of the figure those who are misshapen and dis-

eased, it seems time to enter a protest. . . . Is there a vogue of perverted taste, morbid in its cravings?"[8] At this point it is legitimate to ask who was influencing whom? Were Hyslop's reactionary artist friends simply using him to defend the academic fort?

FURTHER information concerning Hyslop's involvement with the art of patients, and particularly those at Bethlem, has been supplied by the discovery of a portfolio of patient art once owned by him.[9] It contains a number of drawings and paintings in watercolor dating from the 1870s on. Many of them have Dr. Hyslop's name on the reverse. Others have the name of George H. Savage, Hyslop's predecessor in the post of resident physician (1878–1888). The paintings are mounted as if for exhibition, and numbered. Some of them have a diagnostic indication on either the front or back.

A large body of work, thirty-six pictures, is by a patient who signed herself Queen Anne, and dedicated her work to her representatives in all parts of the British Empire. She worked in a very conventional watercolor style, with little or no sign of psychological disturbance. In fact, most of the material in the portfolio is unexceptional and almost academic. Nothing in it accords with Hyslop's "description" of the art of the insane in the article of 1911.

Hyslop's activity as a collector extended well beyond the walls of Bethlem. His portfolio included a set of photographs of the work of an American patient sent to him by the patient's family in Pennsylvania. Another interesting case collected by Hyslop is that of George Greenshields, a patient in a private English asylum called Hart Wood.[10] Greenshield's drawings of mine interiors, architectural fantasies, and abstract decorative patterns, done in colored pencil, are quite fantastic and deserve to be better known (Fig. 11.1).

The speculation that the drawings had been matted for the purpose of exhibiting them is, in fact, confirmed by an entry in the Bethlem annual report for 1900. "During October an exhibition of paintings, etc. [600 exhibits], was held in the common room and gave great pleasure to patients and several hundreds of visitors." This exhibition may be the first public exhibition of patient art ever held. It was almost certainly an exhibition of the collection of Drs. Hyslop and Savage, and probably included pictures from asylums all over England. In 1905, in connection with the opening of a museum of psychotic art in France, a reporter in the *Evening News* reminded his readers of Bethlem's lead in opening a "mad museum": "In the stir created by the opening of Professor Marie's 'mad museum' it appears likely to be forgotten that credit for the origination of

11.1. George Greenshields, *The Black Bull and A Mine*, The Bethlem Royal Hospital, London.

the idea of exhibiting the work of insane patients belongs to the Bethlem Royal Hospital, London, where an exhibition of pictures was opened to the public over five years ago."[11] This brief reference is of importance in establishing the fact that the exhibition of 1900 was devoted to the art of patients, and had sufficient impact that it continued to be spoken of five years later.

The Hyslop-Savage collection, most of which seems to have disappeared, was important as the first collection of psychiatric art to attain international promi-

nence. In August 1913 an international medical congress was held in London. Medical authorities from all over the world attended, and the various congress activities were followed closely in the press. The psychiatric branch of the profession was well represented and had its own meetings and activities, one of which was a large public exhibition of the art of the insane sponsored by Bethlem Hospital.[12] The idea of collecting and exhibiting the art of the insane, by no means a new idea in 1913, seems to have "caught on" at the con-

gress, and many European collections appear to have begun shortly thereafter. This was in part the result of the extensive coverage accorded to the exhibition in the international press, both in the medical journals and in popular newspapers and illustrated magazines. Similar exhibitions were held at succeeding international congresses in Berlin in 1913, and in Moscow in 1914.

Faced with the difficult task of making a medical convention interesting to the lay public, reporters in the popular press focused a lot of attention on the exhibition, which was open to the general public, describing the drawings in it in sensational terms.[13] For example, the *Daily Mirror* devoted its front page on Saturday, August 9, 1913, to a display of six of the works, beneath the headline, "Strange Pictures Drawn by Inmates of Asylum for the Insane: Are They More Artistic Than Cubists' Work?" (Fig. 11.2). Although its organizer, Sir George Savage, had undoubtedly conceived of it as appealing to members of the psychiatric profession, the exhibition became a popular success, and was visited by many artists and art lovers. The public saw it as an opportunity to investigate the truth of the ubiquitous comparisons between the art of the insane and modern art. The debate was fierce, and was extensively reported in the newspapers, even as far away as America.[14] Responses to the show varied in subtlety and insight, ranging from the *Daily Mirror*'s report that described "a tour of the strange 'art' gallery at Bethlem Royal Hospital,"[15] to a funereal announcement in *The Times* under the title "Art and Madness."

The one note of sadness in the garden party yesterday at Bethlem Royal Hospital, Lambeth, was the large hall filled chiefly with pictures and drawings by inmates of various asylums in this country. The exhibition, due largely to the efforts of Sir George Savage, appeals more to the student of mental diseases than to the art student. . . . The exhibition remains open until the beginning of next week, and will repay a visit from artists as well as from specialists in mental disease.[16]

The work of Richard Dadd was well represented in the exhibition, the picture *Raving Madness* from *Sketches to Illustrate the Passions* attracting considerable attention. By this time, Dadd had been forgotten and awaited rediscovery. His name was nowhere mentioned. He is described simply as "a Bedlamite who cut his father's throat. . . . It is his demented brain that he exhibits in all his pictures."[17]

The artist who attracted most attention, after Dadd, is referred to only as "the Cubist": "The picture of the girl's head and body is distinctly of the type of the cubist school, and was done by a man who had never before drawn pictures. That picture was greatly admired today by an expert cubist artist" (Fig. 11.2, top right). As the *Daily Mirror* pointed out, "Many of the visitors to this curious exhibition are moved to ask, 'Do the cubists draw any more intelligently?' "[18] *The British Medical Journal* raised some pointed questions: "It would be very interesting to the medical paper to know whether the patient who executed these Cubist drawings had seen the Post-Impressionism exhibitions or had heard of them, or whether he evolved the manner from his own inner consciousness."[19] This is the first time that consideration was given to the possibility that the art of the insane could be influenced by contemporary art. Another paper expressed the opinion that the patient's version of Cubism was superior to the real thing. "One is executed in squares, and is absolutely a 'cubist' drawing, though much more intelligible than many of those which recently found a place on the walls of the Grafton Gallery."[20] Futurism too came in for criticism: "The picture of the girl with the long neck [Fig. 11.2] is manifestly the work of a good artist, whose mind is deranged. Notice the swift firm lines. There is a curious blend of the futurist school expressed in the picture."[21] The same picture was reproduced in the *Illustrated London News* with the caption, "More eccentric than very many of those shown with it, a lunatic's drawing of a head—with an exaggerated neck."[22] The article was headed "Strange Pictures by Lunatics Admired by Cubists and Futurists."

While most of the papers used the Bethlem exhibition of patient art as an opportunity for launching yet another attack on "Modern Art," contemporary painting had its defenders too. On August 14, 1913, a lengthy article appeared in *The Times*.[23] It was unsigned, but the writer spoke with authority.

The exhibition of pictures and drawings by insane people lately held at the Bethlem Royal Hospital proved at least one thing—namely, that a great deal of nonsense has been talked about the art of the insane and about the connection between art and insanity. There are, for instance, people who wish to believe that artists whose work they dislike, are mad. For their purposes this exhibition proved either too much or too little. It contained one drawing at least that might be called cubist, and from this anyone who wished to do so might conclude that all cubists ought to be in an asylum. But then it also contained many works executed in a sound Academy style, and no one, we suppose, has concluded that all the artists working in the same style outside an asylum ought to be in one.

The writer was clearly an artist or critic extremely knowledgeable about contemporary painting, able to voice his opinions in forthright and lucid argument. He saw through the false comparisons, and defended both forms of expression against what he saw as the danger of misguided public opinion.

It has been said that lunatics in their art are inclined to revert to the primitive; and hence it has been argued that the primitive movement in modern art has something insane in it. . . . It is certainly true that some lunatics are primitive in their art with a simplicity and daring which we find very seldom in the modern art of the sane; and in those cases insanity seems to be a help rather than a hindrance. There were some pictures in the exhibition which seemed to us to be good because of the madness of those who painted them, and we felt pretty sure that they could not have been done so well if they had been sane. This, however, does not prove that all good artists are more or less mad. It seems to prove, rather, that many sane people have powers which they cannot exercise because of certain inhibitions imposed upon them by their sanity. . . . The lunatic, however, who suffers from the lack of these inhibitions in conduct may profit by it in art. It is, no doubt, a symptom of disease in him that he is not affected by public opinion; but where public opinion is wrong his very disease may give him a freedom that in itself is not irrational. Now, in matters of art public opinion is quite often wrong, and therefore harmful in its effects. . . . Among the sane it is only the great artist who frees himself thus in art from the inhibitions proper to conduct. His art, therefore, has more resemblance to the free art of lunatics than to the fettered art of sane men; but its freedom is the result, not of insanity, but of a higher order of sanity and of powers so great that they will not endure to be fettered. . . . All this may seem to prove that the primitive movement in modern art is a symptom of insanity. But that movement is the result not of mere indifference to public opinion, but of a sharp revolt against it. It may be right or wrong; but, even if wrong, it is not therefore insane. For it aims, quite consciously and rationally, at a removal of those inhibitions which for the lunatic do not exist.

This brief article in *The Times* is the finest piece of writing concerning the art of the insane to appear in England, a country not noted for its perceptiveness in this field. It is also an extraordinarily perceptive defense of contemporary art, its aims and attitudes. In clarifying the nature of the connections between modern artists and patient-artists, the author came remarkably close to the sophisticated thinking of the great Hans Prinzhorn (chapter 12). But the tone of youthful valiance mixed with authority sounds loud and clear in this statement. Who was this insightful writer who was so responsive to the art of the insane and who, in 1913, had so solid a grasp of the principles that informed the art of his day?[24]

IN FRANCE, unlike England, there was a tradition that supported study of the art of the insane. The topic had been seriously investigated by Simon, and was a recognized subject of medical study. The transition from psychiatric involvement to aesthetic response was, however, slow in coming, perhaps because of the slighter impact of Romanticism in France. Leadership in the study of the art of the insane was about to shift to Germany and the German-speaking countries. Nevertheless, early in the twentieth century the art of mental patients began to have an impact in artistic circles and to be remarked upon by the lay public. It was in France too that the work of an untrained psychotic artist first gained some recognition as art.

The first step toward an awakening of public interest came in 1905 with the opening of Professor Auguste Marie's (1865–1934) "Mad Museum," an event important enough to have been commented upon in the English press. The headline in the *Evening News* read: "France follows Bedlam's lead in opening a 'Mad Museum.'"

A "mad museum" has been collected of specimens of painting, sculpture, and needlework by Professor Marie, chief of the medical staff of Villejuif Asylum, and most famous of French alienists. It is now thrown open to the public.[25]

It would appear from what little is known of this event that the new museum was at the hospital at Villejuif, a southern suburb of Paris. Dr. Marie had begun to collect the art of patients around 1900, with the support of the Marquise de Ludre. He credits Bethlem Hospital for having inspired the idea, and we must assume that he had seen, or at least heard of, the Bethlem Exhibition of 1900. The museum was probably conceived of as an amusement for the patients, "a little museum where the patients classified prehistoric objects found in the area, and exhibited their own art work."[26]

A description of the new museum was published in *The Sketch*, November 22, 1905, along with extensive illustrations and a photograph of Dr. Marie in his museum (Fig. 11.3). The photograph of Dr. Marie shows him standing behind a large wooden figure that resembles him quite closely (Fig. 11.4). "Even ordinary objects are seen through distorted eyes, and this is shown in striking manner in the extraordinary statue of Professor Marie himself done by one of his patients; the likeness is there, but the kind and sensible face of the sitter is reproduced by the artist in almost diabolical form." The statue had disappeared for many years, and I was fortunate in rediscovering it in the collection of Dr. Cesare Lombroso in Turin, where its identity had been forgotten. Its benign expression suggests that the

The Daily Mirror

THE MORNING JOURNAL WITH THE SECOND LARGEST NET SALE.

No. 3,056. Registered at the G.P.O. as a Newspaper. SATURDAY, AUGUST 9, 1913 One Halfpenny.

STRANGE PICTURES DRAWN BY INMATES OF ASYLUMS FOR THE INSANE: ARE THEY MORE ARTISTIC THAN CUBISTS' WORK?

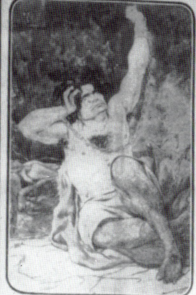

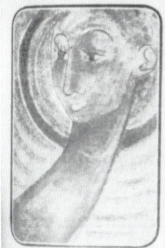

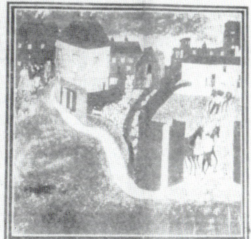

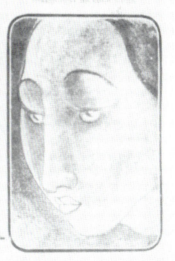

11.2. "Strange Pictures Drawn by Inmates of Asylum for the Insane," from *The Daily Mirror*, Saturday, August 9, 1913.

11.3. "A Mad Museum: The insane as Artists," from *The Sketch*, November 22, 1905.

EUM: THE INSANE AS ARTISTS.

LUNATICS WHO HAVE BEEN UNDER THE CARE OF PROFESSOR MARIE, OF THE VILLEJUIF ASYLUM.

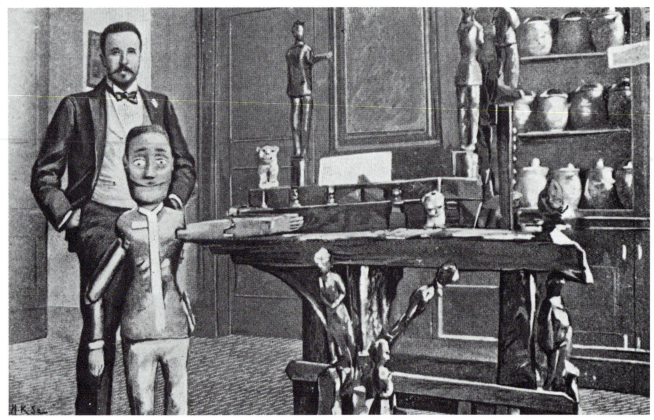

11.4. Doctor Marie with his portrait statue, from *Je sais tout*, October 15, 1905.

diabolical was, on this occasion at least, in the eye of the beholder (Plate 15).[27]

The Sketch article reproduces the work of at least seven different artists, with as many as four paintings by some. They are framed in a marvelous border of amusing animal–human hybrids by an English illustrator. These drawings suggest the sane artist's view of what the art of madmen ought to look like, the result falling somewhere between Lewis Carroll and Walt Disney.

The drawings, paintings, and sculpture from Dr. Marie's "Mad Museum" are works of considerable interest, especially the beautifully designed pages of writing and drawing by Théophile Leroy, with their stylized animals and insects (Fig. 11.5), which are described as "a treatise on the world, written and illustrated by a madman." The pieces of embroidery with the bird-headed human figures are of particular importance, because they were mentioned some years later in an article by Dr. Marie, who described the case and the significance of the beaked figures (Fig. 11.6). "A

woman embroidered her complaints, written with a needle on bandages, respecting the persecutions undergone by an imaginary person, a sort of zoanthropic monster, whom she depicted with the beak of a bird of prey."[28]

Dr. Auguste Marie was a student of Charcot. As early as 1892 he had founded a residential colony for the permanently insane at Dun-sur-Auron. He continued as physician-in-chief at the large asylum at Villejuif until 1920, when he became director of the Hospital of Saint-Anne in Paris and professor in charge of the psychopathology laboratory at the Ecole des Hautes Etudes. His numerous writings on the art of the insane were not particularly original, his significant contribution being the creation of the museum and its collection. However, Professor Marie had a tremendous impact on the study of the art of the insane through the students whom he gathered around him.[29] He was generous in making his collections available to interested people, including laymen. No other collection was more extensively reproduced or discussed

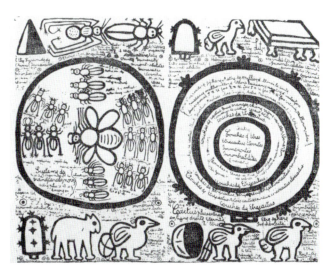

11.5. Théophile Leroy, metaphysical drawing, from Marcel Réja, *L'art chez les fous* (Paris, 1907).

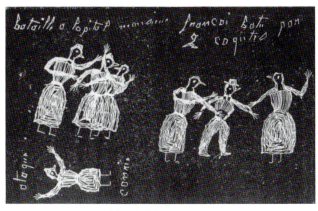

11.6. Anonymous, bird-headed figures, embroidery, from the Collection of Dr. A. Marie.

There are many paintings executed on newspaper or even toilet paper, drawn with such vehemence that they can be seen to manifest a real need to express the self. They find a way to procure all sorts of material when the storm of creation bursts upon them. I have seen a patient coloring his drawings with blood. A sculptor scraped wax off of the floors in order to model little statues, while another deprived the windows of putty for the same purpose. Another used clay from the courtyard and transformed crude rocks into small carvings just as prehistoric man did in the caves.[31]

Inherent in this activity Marie saw the search for a new language capable of embodying new experience, new form for the expression of a new reality.

We catch a glimpse here of moods and feelings never before experienced, and we sense in their unexpected expressive effects the immense torment of these new experiences. Our language, all mother tongues, fails to prepare us to translate feelings such as these. It is therefore necessary for the patient to create a new and very personal language to express himself, in order to embody these ideas in painting or sculpture.[32]

The most interesting of Dr. Marie's drawings was painted by a man known as Xavier Cotton (Fig. 11.7), a priest whose true name was Maurice N. He was hospitalized suffering from precocious dementia of a paranoid form (paranoid schizophrenia). Dated to 1890, the painting (Plate 6) was described in detail by Dr. Marie.

The author has drawn his apotheosis. He made the drawing to win the votes of the electors in an election in Montmartre in which Boulanger was running. This symbolic drawing by a megalomaniac represents the triumph of the candidate. He appears, supported by two of his followers, who are depicted as devoted pelicans eating the toads who personify his oppo-

prior to that of Prinzhorn at Heidelberg.[30] The collection at Villejuif was for many years the basis of all French studies of the art of the insane, as well as the main source of information and images for artists and art lovers interested in seeing this almost unknown form of art.

As a man of deep culture who himself drew and painted, Marie saw the connection between psychopathological art and that of normal artists. What compelled Dr. Marie to attend to the artistic expression of his patients was the force he felt behind their image-making activity, a force he saw as able to overcome all obstacles.

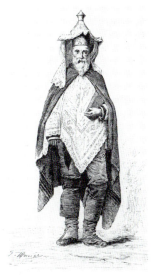

11.7. Anonymous, *Un monomane vaniteux*, portrait drawing of Xavier Cotton in his "robes of office" after a photograph, from Paul Regnard, *Les maladies épidémiques de l'esprit: Sorcellerie, magnetisme, délire des grandeurs* (Paris, 1887).

nents. The pierced throne collects the precious feces which consist of the symbolic fairy's locks of hair. On the horizon, his adversary Boulanger flees on his bicycle to Brussels, attracted by the charms of Madame X. He is accompanied by unequivocal sexual symbols which are intended to recall a memorable duel fought with monstrous sexual attributes. The Eiffel tower, and two captive balloons belonging to the candidate, symbolize breasts and an immense phallus.[33]

Such overt symbolism forced the physician to note the obvious sexual implications of the drawing. Marie was far from prudish. He could not, however, proceed further in interpreting the significance of the drawing and its associated ideas within the mental life of his patient. His organic and neurological orientation, with its emphasis on lesions of the brain, stood firmly in the way of understanding.

In later years Dr. Marie's collection was exhibited in Paris, and attracted enormous attention in artistic circles, particularly among artists of the Surrealist persuasion (see chapter 16). Of the famous exhibition at the Galerie Vavin in 1928, we are told, "All of Montparnasse came to see it."[34] The collection then sank into obscurity with the death of Dr. Marie in 1934. In 1966 a large part of it, probably all that remained, was given by his widow to the collection of the Compagnie de l'Art Brut. It now forms a significant part of the Museum in Lausanne (see chapter 17).

In 1905, the year the "Mad Museum" was opened, a book was published by a psychiatrist, Dr. J. Rogues de Fursac, one of Marie's students, entitled *Les écrits et les dessins dans les maladies nerveuses et mentales: Essai clinique*. The title conveys the essentially medical and diagnostic orientation of the book. Although it was a very large book, Rogues de Fursac's main interest was in the writing of the insane, and his discussion of drawing was confined to a brief chapter.[35] His ideas on the subject were not original, and he was very clearly uninterested in the material as art. I mention the book only as an effective contrast to another that appeared two years later, in every sense the opposite to that of Dr. Rogues de Fursac. Entitled *L'art chez les fous*, it was written by Marcel Réja (1873–1957), an art critic and man of letters (Fig. 11.8). Intended for artists and the general public, it was the first full-length book devoted to a study of the spontaneous image-making activity of patients considered from the standpoint of art criticism. In 1901, Réja had established himself as a specialist in this new area, with the publication of an article entitled "L'art malade: Dessins de fous," which appeared in the popular journal *Le revue universelle*.[36] In this turn-of-the-century version of *Life* magazine, Réja allowed his enthusiasm free reign. He wrote with

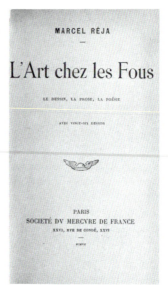

11.8. Title page from Marcel Réja, *L'art chez les fous* (Paris, 1907).

conviction of the power of this art, providing many illustrations in a magazine that had begun to establish itself as a source of new ideas and images.[37] The opening of Professor Marie's museum of the art of the insane may have encouraged Réja to enlarge his original article into a book.

Marcel Réja's intention in undertaking to write a book on the art of the insane was not to prepare a summary of current psychiatric opinion on the subject. In fact, he made no reference to any of the available literature. His approach was his own. In this book he sought to study this form of art almost entirely from the viewpoint of art criticism. In investigating the paintings and drawings of madmen, he was searching for answers to riddles posed by great works of art and their creators. As the first independent-minded intellectual to undertake such an investigation, Réja can be seen as an initiator of the emerging psychology of art. His methods of approach and his conception of the problem are, therefore, of particular importance. As a poet and writer, involved with theater and dance, Réja seems to have aimed his book at the members of his own artistic milieu. In a sense he might be seen as a popularizer of psychiatric art, a critic whose realistic and positive discussion of a new form of art could be expected to appeal to his literary colleagues and to anyone with an interest in the creative process. The originality of his approach and the seriousness of his critical analysis lifts him, however, well above the rather limited vision of a popularizer. He emerges as a man of sensitivity and penetrating intelligence seek-

ing in new territory for the answers to troubling questions.

It therefore comes as a surprise to discover that there was no Marcel Réja. Despite all the books, plays, poetry, and critical writings, careful biographical investigation yielded no historical personality, no inhabitant of the Parisian literary and artistic world, with the name Marcel Réja. Except for his writings, he was invisible.

And then a curiously anonymous double emerged, the physician and psychiatrist Dr. Paul Gaston Meunier (born on August 20, 1873, in Puiseaux; died in Paris, March 19, 1957).[38] Paul Meunier was Marcel Réja; the problem was solved. Or was it?

Dr. Paul Meunier is not a major figure in the history of French psychiatry. He received his doctorate in medicine in 1900 from the Faculty of Medicine of the University of Paris.[39] He is described at that time as an intern working in "les asiles de la Seine," demonstrating that his career as a physician working with the mentally ill was well underway by the age of twenty-seven. Later, he appears to have been associated with Dr. Marie at the hospital of Villejuif, a position that would have brought him into direct contact with the new collection being assembled there by Dr. Marie. A year later (1901), he published his first article on the art of the insane.

Under his own name (usually in collaboration with a physician coworker), he began to publish a series of clinically oriented books and articles dealing with the psychology of dreams. His particular interest lay in the dreams of patients and in the parallels he could observe between the dream state and those more lasting mental states grouped together under the label "insanity." In 1903 he published a paper entitled "Analogies du rêve et de la folie."[40] This work, which he identified as stemming from the research of the distinguished French alienist Moreau de Tours, was nevertheless an original contribution to the study of dreams, and one that would have brought him instantly to the attention of another well-known physician in Vienna, Dr. Sigmund Freud. In 1910, Meunier published his major contribution to dream studies, *Les rêves et leur interprétation: Essai de psychologie morbide*.[41]

This alone would have represented a respectable contribution for a young clinician and evidence that he was in touch with the more advanced psychological explorations of his day. It is extraordinary that this gifted physician-psychologist assumed, on occasion, a disguise. Relinquishing his medical orientation almost completely, he presented himself, on the literary stage, as writer, playwright, and perceptive critic. There is the still more intriguing puzzle of why Dr. Meunier chose to conceal his identity behind a pseudonym. For more than thirty years he published works that have no evident connection with psychiatry, works that betray a familiarity with the art and literature of the period, and which, despite the fact that he attained no position of prominence in French letters, nevertheless suggest that his real passion lay outside of the practice of medicine.[42]

In only one work, *L'art chez les fous*, did he succeed to a certain extent in bringing together the two sides of his puzzlingly divided personality. On every page of this book he betrays a degree of familiarity with the insane and their work that could only have been achieved by a physician in daily contact with the hospitalized mentally ill. Yet it is also in this book that it is possible to see him at work, systematically concealing his identity as psychiatrist, carefully avoiding the psychiatric point of view and presenting both himself and the creative work of patients in an almost completely nonmedical framework. It is equally clear that his critical message was aimed at a nonmedical audience of laymen whose interest centered on art and artists, and whose curiosity might be awakened in this almost unknown new field, the investigation of the artistic activity of the insane.

The brilliance of his achievement inevitably takes on greater luster when we realize the intellectual tour-de-force involved in erecting and maintaining an intellectual and critical position distinct from, if not opposed to, the discipline in which he had been trained. And yet, Meunier's whole life seems to have involved maintaining this double personality, as he lived in two distinct worlds. As we will see, in the somewhat analogous cases of Hans Prinzhorn (chapter 12) and Ernst Kris (chapter 15), it is precisely individuals of this type, uniquely possessed of specialized knowledge and sensitivity in a variety of seemingly unrelated disciplines, who were able to engage the art of the insane outside the stiffling terrain of psychopathology and of the hospital. This was the intention, and the achievement, of Réja-Meunier.

L'art chez les fous represents the first lengthy discussion and comparison of all of the art forms employed spontaneously by the insane: drawing, painting, sculpture, poetry and prose, and music and dance.[43] In his desire to comprehend the nature of these art forms he was led to include comparative material on the art of children and of primitive peoples, of spiritualist mediums and of adult prisoners. To penetrate more deeply the nature of creativity he was prepared to enter strange realms, but always intending to return with

insight into art. What idea, what sort of conception of the nature of art led him in this direction? Was his belief that the art of madmen contained clues pertinent to the understanding of art Réja's alone, or was it a point of view shared by the artists of his day, the product of a rapidly changing conception of the function and nature of art itself?

Réja was motivated in part by a misconception. He believed the art of the insane to be simpler or less complex than the work of genius, referring to it as "the more or less embryonic form of art" (1907, p. 231). In studying the art of the insane he sought to gain a foothold that would enable him to grasp the more complex productions of "great artists."

With a masterpiece we attack the study of art at its highest point of perfection, that is to say, at its greatest complexity. . . . There is no human science which has not obtained indispensable clarification and affirmation of its central principles from the study of more elementary phenomena. . . . If art criticism intends to teach us something of the nature of beauty, it is necessary that it turn to the study of simpler forms. Art was not born a masterpiece. Beside the work of art, which represents, by definition, the perfectly realized formula, there are a number of products of a more or less elementary kind; the work of children, of savages, of prisoners, and the insane. (1907, pp. 17–18)

This statement suggests going back to the beginnings of art, seeking the origins of the artistic impulse.[44] It was not a coincidence that Réja was writing his book in the same city and in the same year that Picasso was painting the *Demoiselles d'Avignon*, a work that can also be seen to proceed backward in time in search of more primitive forms of expression. Réja's unique contribution was to understand the so-called pathological products of the human mind as relevant to such an endeavor. Like Freud, he realized that the mental products of the insane are not different in kind from those of healthy individuals, and that there is no abrupt break between the two. The images and ideas of a madman are best understood as exaggerations of typical human feelings and thoughts, and as such can serve to make visible processes not usually perceptible in the normal state. In turning to psychotic art as a means of access to understanding nonpathological art, he was pursuing a correct and very advanced psychological procedure.

The drawings of the insane do not constitute an absolutely unique form, an isolated monstrosity among the productions of the rest of humanity. . . . The morbid quality of their work should not lead to them being considered as beyond the pale, without relationship to the norm. There is no monster in nature which is not an exaggeration, a caricature of the normal

type, the nature of which it often enables us to comprehend better. . . . The madman makes visible in an exaggeratedly amplified way that which in the normal artist appears only as a discrete indication. (1907, pp. 63, 19, 14)

At the moment when art historians and artists, motivated by similar intuitions, were about to turn to the investigation of the art of primitive people and naive painters, prehistoric art, children's art, and even street graffiti, Réja chose to focus on the art of madmen. Why? In terms of his identity as Paul Meunier, this question is easily answered. But it is Réja's answer that clarifies the accuracy of his critical methodology, and of his insight into the difficulties of using such material for the study of art.

The insane are unique in that, possessed with a contemporary and adult mentality, and driven by emotional necessity and the activity of an intellect conforming with their pathological state, they write or draw, most of the time, without any technical training. In form, therefore, their productions are relatively simple. . . . The systematic study of the work of the insane touches on an essential point: they illuminate with unique clarity the conditions governing the genesis of artistic activity. . . . it is in insanity, perhaps, that this genesis is to be recognized in its purest form. (1907, pp. 18, 16; 1901, p. 914)

Réja was not simply equating the art of the insane with fine art. "It no doubt appears excessive to utilize the word 'art' in speaking of such productions. But, to appreciate so unique a genre, it is indispensable that we lay aside the conventional ideas we may possess about beauty" (1907, p. 6). Réja was not using his knowledge of this art to attack modern painting and sculpture through psychiatric diagnosis, a literary sport that was soon to regain its popularity. Aware of the genius–insanity theory, he was careful to distinguish his endeavors from such misguided activity. "We are not attempting to find out the extent to which an artist is susceptible of becoming insane, but to what extent authentic insanity can be accompanied by artistic manifestations" (1907, p. 13).[45]

The attempt to lay aside traditional ideas of beauty was an endeavor known to Réja's artist contemporaries. In the search for a new aesthetic, French artists were insisting on this same procedure. Freed of the burden of deeply ingrained notions of the beautiful, the art of the insane was to appear in a new light.

While in the art practiced by normal artists with varying degrees of success, one finds without fail greater beauty and perfection, the element of sincerity is invariably present to a greater degree in the work of the individuals with whom we are concerned. The madman can not be suspected of realizing his works with a view to material advantage. His works are

most of the time produced spontaneously in order to satisfy an imperious need for activity; he very definitely has other concerns than satisfying critics or the public. (1901, p. 914)

This is a pure statement of a revolutionary new aesthetic written in 1901. Its presence in a popular journal readily available to artists suggests that Réja may have played an active role in the development of interest in the art of the insane among artists and critics of the French avant-garde.

IN UTILIZING the artistic activity of the insane as a means of inquiring into the nature and function of the creative process in the artist, Réja was at a disadvantage. He appears to have confined himself to an examination of the pictures, and to have had no opportunity of observing or talking with patients about their work.[46] How large Réja's collection of drawings by hospitalized patients was is not known. He comments on the difficulty of obtaining pictures by the mentally ill, expressing the opinion that their frequent destruction may account for the lack of systematic studies of the subject. Many of the pictures he reproduced are identified as coming from the private collections of prominent French psychiatrists who are known to have been interested in the art of the insane, particularly Drs. Marie, Rogues de Fursac, and Serieux. However, unlike the writings on the art of the insane by these psychiatric colleagues, Réja's conception of the function of image making by the mentally ill was surprisingly free of psychiatric assumptions, and based firmly upon the evidence supplied by the paintings and drawings themselves.

Réja is notable for his ability to notice parallels between processes and characteristics in the art of the insane and that of the more normal artist without equating them. "The general characteristics which are most frequently encountered in their work are," he said, "exactly as in the sane artist, sincerity, ingenuity and patience. If anything, these qualities occur to an exaggerated degree in the work of the insane" (1907, p. 24). Without inquiring deeply into the related case material, he seems to have intuited that in this pictorial material absolute sincerity was to be found. Even Hyslop had been forced to admit that "the insane artist is usually in dead earnest."[47] Réja, however, went further in trying to ascertain the function of drawing for the mentally ill. He realized that for many outsiders, the drawing activity of patients, because it had no material purpose, seemed to be in itself evidence of illness, a random sort of activity without apparent justification, at best a childish amusement for people with little else to do.

Réja's conviction of the emotional honesty of the pictures and of the terrible intensity prompting their creation led him to a clearer grasp of their function. Even the most rudimentary drawings he understood as deriving from a need to make internal images concrete and external. "Drawing is here nothing other than an *écriture idéographique*, a more concrete means of expressing his thought, more alive than would be possible with the written word" (1907, p. 37).[48] He draws a crucial distinction between sincerity and factual truthfulness. Patients suffer from delusions, but they believe in them with utter conviction. The strangeness of their ideas or of their experience of the world can be so great as to demand an art that departs from the factual depiction of nature. The art of the insane is often distorted, not only by the inability of the untrained amateur, but even in the case of the professional artist who, having entered a much changed reality, must find new means of expressing it. "It can happen that the madman is competent, to a greater or lesser extent, in the art in which he now seeks to express his new mental state" (1907, pp. 43–44). Here too the layman is inclined to equate distortion with madness, and is corrected by Réja: "All artists who are not involved in making photographs make use of stylization, and even in those cases where the result is infinitely remote from natural models, one has no right to speak of insanity" (1907, p. 48).

The effect of both illness and drugs on the creative process was of interest to Réja. He was one of the first to recognize the similarity of the effect of narcotics on image making to that of insanity. "Even the most firmly constituted brain can undergo more or less lengthy periods of artificial insanity under the influence of certain toxic agents: alcohol, morphine, or hashish. We know from literary descriptions the mental deformations that can be induced by this means" (1901, p. 944). He was aware that permanent mental illness could destroy or weaken the creative process and he admitted that it is only a happy accident if a trained artist, having become psychotic, is able to draw "correctly." What intrigued him, however, was the fact that in some cases madness unleashed creativity, lifting the mediocre artist above himself. "It can happen, that the terrible aggravation of suffering can break asunder the human faculties, drawing forth tormented sobbing and unexpected flashes of lightning. . . . It is the defects in the spirit of the author which themselves permit him to rise to this intensity of expression" (1907, pp. 151, 228). In these phrases we encounter the deep and lasting traces of Romanticism in the soul of a twentieth-century man.

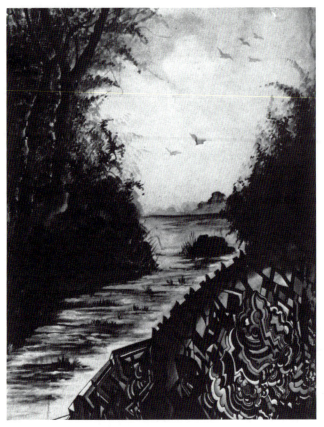

11.9. "Le Voyageur français," *The Country of Meteors*, July 1902, watercolor, Collection de l'Art Brut, Lausanne.

As an illustration of the possible positive effect of madness on creative ability, Réja describes the case of a commercial artist trained in the decoration of pottery with flowers. Under the influence of his illness,

delusions of grandeur led him to believe that he knew everything and could do anything. He liberated himself in this way from a hackneyed tradition, and breaking with his banal trade, abandoned himself to happy audacities of decoration in which the lines and colors possessed an aspect of such strangeness that the resulting works were, at times, curious in the extreme: at times a Japanese landscape of real decorative value because of its freshness, the bold brilliance of its tonality and the incontestable daring of its execution; at other times a watercolor in which the imagination rejoiced in unrealistic combinations, a conflict of bizarre curves illuminated with colors whose violence did not entirely exclude harmony. The total effect was tolerably bizarre and seemed to have the aim of resembling nothing, and yet one could not deny it a certain decorative allure. (Plate 20) (1907, pp. 44–45)

The artist, who has come to be known as "Le Voyageur français," is of particular importance in the history of the art of the insane in that he frequently combined his abstract, and supposedly psychotic, style with a very conventional realistic watercolor style that at times betrayed the influence of Japanese art (Fig. 11.9). One of the pictures reproduced in the collection of pictures from Dr. Marie's museum is probably his work (Fig. 11.3), and an enormous number of paintings by this artist survive in the Collection de l'Art Brut. Clearly, the so-called psychotic style was very much under his control and adapted to the expression of particular aspects of his reality. Dr. Vinchon, who has also published the work of this artist, has pointed out that the abstract areas in his pictures originate as an elaboration of the artist's signature. Although Réja was not able to reproduce these pictures in color, his description contains within it echoes of the revolution that was occurring in the studios of Paris, where many artists sought to free themselves from a burdensome tradition of illustration and to indulge in "heureuses audaces de décoration," making use of "lignes et couleurs avec un aspect d'étrangeté." Réja was clearly not unaware of the more advanced currents then troubling the depths of French art, nor, I believe, was he insensitive to their positive value.

Réja's conception of art and its function emphasized emotional content as an essential element. The strength of his response to the art of the insane was determined by the extent to which he could detect unusual intensity of feeling in these works. The picture to which he devoted the most attention attracted him because of the intensity of human experience embodied in it (Fig. 11.10). It formed part of a series of pictures entitled *L'histoire des malheurs d'un pauvre homme*, executed by a country postman. (For other examples, see Fig. 11.3). Obviously suffering from very severe delusions of persecution, the artist attempted in this series of pictures to convey something of his agonizing and very subjective history. Réja tells us that, in fact, none of the events depicted actually happened to him, and yet he was able to sense their inner reality, and to see the "history" as in some deeper sense true, a feat that was only beginning to be accomplished in early twentieth-century psychiatry. In the description of the pictures, which is enhanced by the author's obvious liking for them, it is possible to observe his readiness to overlook, or even to accept as necessary, all sorts of crudities of drawing, proportion, composition or naturalistic representation, in exchange for what he calls "expressive force." Here we encounter Réja, the committed critic.

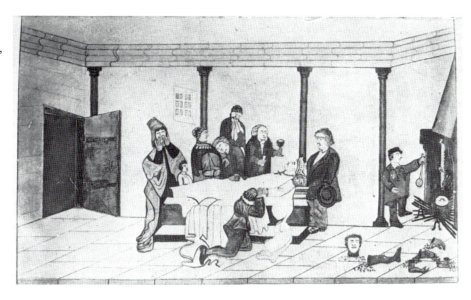

11.10. Anonymous, *L'histoire des malheurs d'un pauvre homme*, from Marcel Réja, *L'art chez les fous* (Paris, 1907).

Certainly the drawing in all of these compositions is crude, but what gives them a forceful originality is precisely the absence of all technical facility, that intuitive sense of the pose and grouping of the figures, and above all, that expressive force that penetrates us despite the worst imperfections. (1907, p. 43)

He seeks, through his drawings, to implant in our souls, in the most solid fashion, the reality of his torment. (1907, p. 41)

Their creator has an ardent belief in what he is doing. It is not, for him, an object of curiosity by which he is amused, but the truth of what he has suffered, which he naively seeks to convey with the limited means of the uninstructed. There is no evidence of training: so much the worse! There is something better: there is a soul! (1907, p. 43)

This statement, which might well have been adopted many years later by the Compagnie de l'Art Brut, establishes Marcel Réja as the first aesthetician of the art of the insane. He was aware of the audacity of what he was saying; at times he is evidently unsure of himself. The painting in question (Fig. 11.10) is by no means a revolutionary work; nevertheless, the passage reveals Réja as the pioneer of a new phase of aesthetic response to psychotic art.[49]

Like everyone else faced with the chaotic variety of types of drawings that emerge from mental hospitals, Réja was forced either to adopt or to develop a method of organization. Although he occasionally mentions the psychiatric label attached to a given patient, he was not interested in psychiatry but in art. Although we may assume that, as Meunier, he had read the more famous publications on the art of the mentally ill, as

Réja, he does not refer to them, and makes no use of previously developed systems of classification. As a critic he felt compelled to approach the problem without presuppositions, and to develop his own groupings in terms of the visual characteristics of the material. He was not afraid of judgments of quality, and his criteria were derived from the then revolutionary aesthetic of "modern" art.

The basic division he used can be observed indirectly in Pinel's thinking a century earlier. He felt it necessary to separate the work of those patients whose involvement with art developed only after the onset of illness, from those who, prior to falling ill, had had some professional involvement with art. The pictures themselves would have suggested such a division, in that, in most cases, the latter group displayed a degree of technical accomplishment not seen in the work of the spontaneous artist. On the other hand, Réja does not seem to have possessed pictures by professional artists of any real stature. His professional artists appear to have been merely men whose work had involved drawing or painting in some minor capacity. Having established this fairly traditional division, he insists that the classification of greatest importance to him is that of the untrained artist who spontaneously begins to paint in the hospital—"assuredly the purest case, and the most interesting" (1907, p. 25). This emphasis on purity of expression, on an art free of the trappings of traditional pictorial conceptions, again establishes his participation in the emerging taste for the primitive and barbaric. Where in the nineteenth

century interest tended, as we have seen, to focus on the pathological expressions of the highly trained artist, in the twentieth century the taste for the primitive in art led artists and critics to examine the art of cultural illiterates, the naive painter, and the untrained mad artist. At the same time, interest in the subject matter of the art of the insane was replaced by a concern with formal factors such as color, shape, composition, and texture.

Within each of the two basic divisions, Réja introduced three subcategories that reflect his critical thinking. First, he had to face the fact that much of the graphic activity of the mentally ill has no artistic value. As a critic concerned with questions of relative artistic value, he was forced to make aesthetic judgments, an activity that, while it should never have played a role in psychiatric study of the art of patients, was useful here. Accordingly, he set up a category that included drawings he felt reflected nothing but the deteriorated mental state of their creators. The category included what was little more than scribbling, or rudimentary doodling. He understood that certain types of mental illness involved the progressive deterioration of the intellect and of muscle coordination. The graphic activity of this type of patient does not seem to have interested him at all. As he put it, "There is nothing artistic about them, nothing of the beautiful. These madmen draw like someone who does not know how to draw" (1907, p. 27). "We withdraw into the night from which the child emerges" (1907, p. 60).[50]

His second group consisted of what he refers to as "decorative art," a term that in the French carries far more significance than in English. For Réja it would seem to have included all pictures in which the emphasis was on form as opposed to content. "An ornamental art which lives on a decorative impulse, without attempting to express in a direct way an idea or an emotion" (1907, p. 60). In its most extreme form it could consist of purely nonrepresentational pattern, but it also included elaborately stylized or geometricized depictions. He associated these "designs" with lack of emotion or clear subject matter, yet his discussion of these images is very extensive. In some sense the category can be seen as an extension of Lombroso's "arabesques," within which recognizable forms could occasionally be discovered.

The third category included what Réja termed, rather confusingly, "art properly speaking." This group was referred to as "the most interesting category of works in which sometimes an emotion, sometimes an idea, is expressed" (1907, p. 26). It must be remembered that abstract art had not been born in 1907, and

cubism was just emerging. The categories are the inventions of a sensitive critic concerned with pictures as opposed to psychiatric nosology. His six subgroups provide a logical means of discussing the drawings in a context meaningful to the general public for whom he was writing. The distinctions he draws reflect the concerns of artists of the time, and parallel to some extent categories that would become increasingly important in discussion of the art of the twentieth century—for example, abstraction versus realism, or naiveté versus a high degree of technical finish.[51]

Confronted with such a confusing variety of types of image, Réja avoided the tendency to list the characteristics of the art of the insane. He was aware of certain recurring elements and tendencies, and attempted to describe them without labeling them as features occurring only within the context of psychopathology. In omitting such lists he avoided the necessity of equating, in a simplistic way, the art of the insane and new trends in contemporary art. In his own way, he arrived at Wölfflin's postulate that in art, not everything is possible at all times. "Insanity is not, in fact, constituted at all, as some people seem to imagine, by a series of infinite variations, occurring outside of common sense. . . . While there is no reason to group them into schools, as is done with other artists, there are, nevertheless, a certain number of stereotyped formulas to be observed in their work, which serve as nuclei for their various digressions" (1907, p. 22). He was also aware that the art of the insane was not necessarily recognizable, and that perfectly unexceptional pictures could originate in an asylum. With such admissions, Réja demonstrated his determination to avoid any hint of the sensational in his presentation of this art, and to avoid as well naive characterization of "typical formal features" of psychotic art, which would inevitably include forms that normal artists use on a daily basis.

As an aspect of his belief that the art of the insane represents a less complex, less highly evolved form of artistic expression, Réja was particularly struck by the tendency, described earlier by Lombroso, for some of the pictures and sculptures to reflect earlier phases of the history of art. Unlike Lombroso, whose term *atavism* was linked with a belief in degeneracy, Réja was content simply to record instances in which he felt significant parallels could be observed. His taste for the primitive led him to discuss drawings and sculptural forms made by prehistoric people and by primitive tribes. He was one of the earliest critics to concern himself with primitive art at a time when examples of this type of art were still difficult to obtain. It would

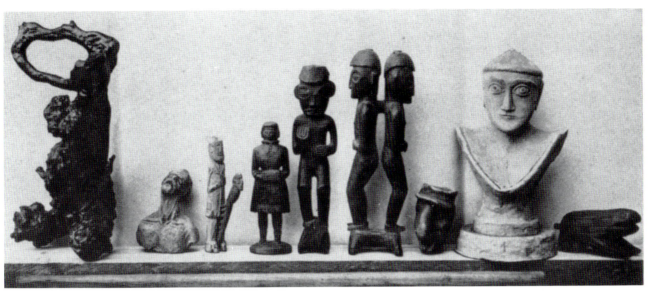

11.11. Sculptural works in primitive
style by the insane, from Marcel Réja,
L'art chez les fous (Paris, 1907).

appear that at this time it was as difficult to obtain information about, and examples of, primitive art as it was to see and study psychotic art. Réja depended upon "monographs, scattered here and there, the reports of travelers who, amidst descriptions of geographic, ethnographic and social factors, would furtively slip in brief hints about the artistic manifestations of the people they were studying or visiting" (1907, p. 89).[52]

Despite these limitations Réja was able to discuss the function of sculpting and drawing among primitive people, and to compare their image-making activity with that of the mentally ill in modern France. In both he was struck by "the hieroglyphic drawings which make use of bold distortions to express their ideas. There is a curious symbolism at work in them which can be varied in an infinite number of ways" (1907, p. 98). In the work of the untrained insane he sensed the search for sufficient means of expression. "They begin again on their own behalf the tentative efforts of the human spirit in search of its artistic voice" (1907, p. 31). It was this elemental search, this purity of expression and intention, that was to appeal so greatly to artists attempting to return to the origins of the creative act. The examples Réja provided of objects created by insane sculptors that paralleled African sculpture would have been very striking to artists just beginning to become aware of the beauty of primitive art (Fig. 11.11). "It is evident that these wooden sculptures are the work neither of a sculptor who knows his craft, nor of a child amusing himself. On the other hand they

bear an astonishing resemblance to the fetishes created by primitive people" (1907, p. 31).

Again and again, the quality that attracted him in the art of the insane was its intensity and its primitiveness. Speaking of a piece of embroidery, he refers to "the violent colors which provide a sensation of savagery which is closely related to the rudimentary execution of the drawing" (1907, p. 34). In other works he discovers elements that remind him of the values of folk art. "One sees here an attempt at the ornamental, anonymous like all popular art, and of a charming awkwardness" (1907, p. 33). Behind such critical description lurks a new aesthetic in which purity of vision and intensity of expression become the highest criterion of artistic excellence.

In undertaking to discuss, in a single book, the art of children, of primitive man, of naive and folk artists, as well as of the insane, Réja had to be very careful not to blur the distinctions between them. He was aware that the line of demarcation is not always clear, and he was convinced that the serious study of any one of these areas would lead inevitably to study of the other related forms. "This resemblance can go almost to identity, to the extent that these neighboring manifestations throw light on one another. To appreciate correctly the artistic productions of the insane, it is indispensable to be familiar with the related forms of art" (1907, pp. 63–64). Contemporary artists were becoming aware of the common ground that united these art forms, and in their search for a more basic and pure

visual language, they sought inspiration in all of these types of images. Their interest in primitive art extended to the discovery of the primitive in the art of children, and naive painters and to the unleashed primitive in the art of the contemporary insane. Réja was very much ahead of his time in including in this list the art of prisoners, and the automatic drawing of spiritualist mediums, the latter of which was to influence the development of Surrealism.

Réja's lengthy essay on the art of children represents an extremely intelligent and thorough discussion of the problems, establishing him as one of the early significant contributors in yet another emerging field of study. He explored the developmental stages characteristic of children's image-making activity, describing the evolution of human figure drawing in a way that anticipates recent investigations of the artistic activity of young children.

In the art of children, of primitives and, of naive painters, Réja was struck by what he believed to be a conscious and determined refusal to serve mere visual reality. "Although some primitive artists are admirable draftsmen, one senses everywhere in their work a determination not to stop at the materiality of the body . . . the firm intention not to be a slave to visual reality" (1907, p. 85). He saw the later stages of children's art as a decline toward the realistic copying of nature. His understanding of the nature of primitive art was similarly advanced: "In a general way, these objects do not give an impression of an effort in the direction of

'beauty.' . . . Unaware of the idea of art, in the sense which we understand it, these people have, nevertheless, a sense of beauty which is unique to them" (1907, pp. 90–91).

In this same period Matisse, Picasso, Braque, Derain, and many others were convinced of the need to reject the traditional notion of beauty. They were drawn to primitive art precisely because it came from a different conception of the beautiful and of the purpose of art. Within aesthetics the possibility that other, radically different, ideas about what is beautiful might exist was now finding acceptance, with the result that the theory of the historical development of Western art in terms of increasing perfection was permanently undermined. In this revolutionary atmosphere, the art of untrained amateurs, children, savages, and the insane suddenly emerged as profoundly beautiful expressions of the human image-making impulse, capable, in their finest moments, of rivaling the work of the masters. *L'art chez les fous* contributed significantly to the emergence of these new ideas and the new aesthetic that they represented.

In his enthusiasm for the formal characteristics of primitive sculpture, Réja arrived at a description that sounds like an analysis of the nature of Cubism. "This schematism, this reduction to geometric abstraction, represents the general characteristic of all of this art" (1907, p. 100). He was capable of conceptualizing the division between subject matter and form that was to become so significant to the art of this period. Using

11.12. Geometric abstraction by the insane, from Marcel Réja, *L'art chez les fous* (Paris, 1907).

the now outmoded term "decorative art," he explored drawings by the mentally ill that seemed to reveal a preoccupation with abstract form and, in particular, with geometric form. On one hand he saw the use of geometricized representation as a means of overcoming the difficulties of realistic representation: the insane artist "contents himself with infinite repetition of the same motif, a form which is extremely simple and taken from geometry. With such modest ambition, he attains in this way a simple effect which is not without a certain decorative grace" (1907, p. 29) (Fig. 11.12).

Réja was, however, keenly aware that the goal of these artists, as with all true primitives, was not verisimilitude. Geometry is seen as a means of freeing the imagination from any necessity of imitation. "They make use of geometric form in order to free themselves from the imitation of all real objects, in order to create in their own manner, to abandon themselves to the flow of their fantasy, without having to concern themselves with the resemblance or the visual correctness of their creations" (1907, p. 31). While it is tempting to link such ideas with the birth of the Cubist aesthetic, it is unlikely that Réja was aware in 1907 of what was still restricted to a single studio in Paris. If any influence existed it is likely to have flowed in the opposite direction. Whether Picasso knew Réja's book is not known.

IT IS NOT surprising that a critic so accepting of the primitive in art should have been able to accept sexuality in the art of the insane as natural. After so many clinical attempts to equate the expression of sexual feelings in the art of patients with psychopathology, criminality, and degeneracy, Réja's forthright attitude is refreshing. "The expression of sexual feelings, so frequent in normal men, is not a matter of indifference to the insane. The number of simple obscene drawings invented by the insane is prodigious. Here too all varieties are to be found, according to the artistic sense of the artist, ranging from the lowest obscenity to the most elegant stylization" (1907, p. 36). On this subject the poet in Réja makes himself felt, and here I quote his words in the original language: "Sous sa forme mystique, et sous sa forme charnelle, l'amour, l'éternel amour, hurle encore sa passion à travers ces âmes ravagées" (1907, p. 154).

In this connection Réja mentions the work of Xavier Cotton, already familiar through Dr. Marie's discussion of it. Réja appears to have been particularly intrigued by his pictures and regretted that the extreme obscenity of many of them made them impossible to reproduce. He provides only one example, the picture

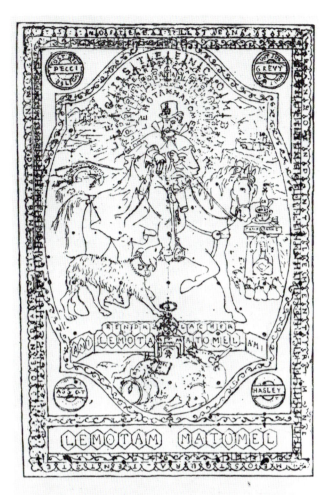

DESSIN D'UN MONOMANE VANITEUX.

11.13. Xavier Cotton, *Lemotam matomel*, from Paul Regnard, *Les maladies épidémiques de l'esprit* (Paris, 1887).

known as *Le prêtre adamique* (Plate 6). Although Cotton was not a professional artist, Réja thought highly of his ability. "An art characterized by firm drawing, harmoniously balanced distortions, and elegant stylization; it might be said that, without being masterpieces, his productions demonstrate very real talent" (1901, p. 914). Xavier Cotton appears to have led Réja into an increased awareness of the symbolic content of much of the art of the insane. The mysterious combination of sexual and mystical imagery in *Le prêtre adamique*, the strange inscription in an unknown language, the linking of animals and hermaphroditic deity in an obviously religious composition, forced Réja to recognize that the drawing held impenetrable meanings.

It represents a symbolic action of the very highest importance for the artist. The sad thing is that we understand nothing of it because it refers to an order of ideas which we are not in the habit of considering as reasonable. . . . One cannot avoid admitting that there is in this work, as well as in many others by the same artist, evidence of very real talent, and, at the same time, ideas more spiritual than judicious. (1907, pp. 37–38, 59)

Réja was aware that the secret of some of the symbolism could be unraveled by the patient—for example, through Cotton's use of inscriptions in an unknown tongue (see Fig. 11.13, what he calls a cryptographic text). Obviously, this patient was not totally devoted to the idea of communication. Although Réja was himself a writer, he seems to have preferred his pictures to be independent of literary explanation. Xavier Cotton appealed to him because "he expresses his ideas without the always tiresome use of literary commentary" (1907, p. 58).

On the other hand, Réja was by no means insensitive to patients' explanations when they helped to clarify the meaning of an image. He reproduced further pictures by the woman who embroidered her delusions of persecution (Fig. 11.6). The men and women with long beaks were her persecutors, and she explained that the length of the beak indicated the extent to which she saw each figure as a source of danger.

In other cases, text and image were combined on a single sheet, and the written word reinforced the drawing (Fig. 11.5). The case of this artist, Théophile Leroy, is familiar to us from the collection of Dr. Marie (see Fig. 11.3). Impressed with the elegance of his design, Réja commented, "These figures having been arrived at, they were repeated by the artist with scrupulous fidelity. Visibly, he had discovered the definitive expression of his thought, and was content to reproduce it with very slight variation" (1907, p. 55).

Réja's originality in writing a book devoted to the art of the insane, which established meaningful links between the image-making activity of children, prehistoric and primitive artists, and naive and folk artists, as well as the drawings of prisoners, mediums, and madmen, would have been a critical achievement at any time. The book's appearance in 1907 was extraordinarily important in that the visual expressions of these seemingly disparate groups could now be seen as connected and deeply relevant by artists discontented with the state of traditional art. Whether Réja's contribution played a part in initiating this shift in aesthetic values, or whether he simply drew on ideas that were very much in vogue at the time is difficult to deter-

mine. That the part of the book dealing with the graphic activity of the insane was largely present in his article of 1901 makes his achievement still more remarkable.

Our investigation of the history of the discovery and study of psychotic art has demonstrated that the development of interest in this art can no longer be seen as a totally spontaneous and inexplicable event occurring in the first years of the twentieth century. Nevertheless, the final act in this long drama, the acceptance by artists and critics of these images as viable works of art belonging to the tradition of modern art, was new and unexpected. It is reasonable to inquire to what extent *L'art chez les fous* and the article of 1901 contributed to this exceptional situation.

Although Réja wrote a book on the art of the insane, his attitude to the works he discusses remains unclear. He did not see his work as an effort to establish the pictures as masterpieces of contemporary art, or to suggest that the hospitals of France were filled with unrecognized geniuses. The final sentence of the chapter on the drawings of the insane is emphatic in rejecting such a notion: "Incontestably, they invariably lack something that would enable one to pronounce the word genius" (1907, p. 61). But having freed himself of the troubling notion of the mad genius, he adds, "While without doubt genius is not to be found there, there is very vibrant and intense artistic inspiration" (1907, p. 228).

In publishing the first art book on the art of the insane, the first critical evaluation of these pictures, Réja made available to the public and to artists detailed information about artistic activity among the insane, and provided them with examples of their work in the form of black and white reproductions of considerable power. The book was sufficiently well received to require a second printing within the year. Anyone reading it would be led irresistibly into a deeper involvement with this art, and a desire to see more examples of it. This raises the difficult question of how available such examples were in Paris at the turn of the century. The collections of patient art that Réja saw, particularly those of Drs. Marie and Serieux, do not appear to have included works of the highest quality. The "Mad Museum" was opened to the public in 1905. Réja reproduced many of the pictures in that collection in his article of 1901, and, as Dr. Meunier, may therefore have played a part in Dr. Marie's decision to make the collection available to the public and to artists. If the art of the insane was to influence modern art at this early date, examples of the highest quality had to be avail-

able. This problem awaits further investigation. For the present, it must be admitted that Réja, while a stimulus, was not a sufficient source of visual material.

Although the nature of Réja's contacts with, and knowledge of, the artistic world of his day remains unclear, it is certain that he was very far indeed from being the tradition-bound critic so frequently found among the members of the medical profession. His knowledge of art was extensive and his attitude to art and artists carefully thought out. What we would like to know, however, is the extent of his awareness of the more revolutionary currents emerging in Paris in the first decade of the twentieth century. As a man of the theater, a critic of the dance, a poet and writer, he might be expected to have played some part in the increasingly active avant-garde circles of the day. One would wish to link him with the Fauves, with Picasso and his circle, or, at the very least, with the later adherents of Postimpressionism or the Symbolist movement. But the name Marcel Réja, like the name Paul Meunier appears to have been forgotten, and his contacts with artists, as physician or critic, unexplored. Only a few pieces of evidence suggest that his involvement with art was somewhat unconventional. Describing the case of a peasant who believed himself to be the Holy Spirit, he mentioned a drawing whose style called to mind another artist. "The portrait of divers members of his family, which he saw as very beautiful, executed in an awkward and bizarre fashion which, setting aside questions of talent, resembles works by the Belgian painter James Ensor. The analogy is all the more curious because this painter is known for his hallucinatory and extravagant drawings" (1907, p. 35) (Fig. 11.14).

This is the only reference to a contemporary artist in Réja's book.[53] It is carefully phrased so as to avoid any tendency to equate Ensor's work with that of the insane. It does suggest some awareness of the more advanced art of the day, if not of the Parisian avant-garde. The process whereby a peasant would arrive at a drawing style related to that of Ensor is suggested by Réja: "This unskilled man adopted a graphic formula, which he perfected by himself, and which served him in place of style. The necessity of expressing something, idea or emotion, lent a sort of fantom-like existence to his characters" (1907, p. 35).

Réja's discussion of drawings done by untrained artists that fit into the category he termed "decorative" suggests a somewhat more conventional conception of art as representation. He appears to assume that an art emphasizing formal elements, as opposed to subject matter, was an art void of emotion or ideas. In this respect we are forced to realize that his artists, however mad, were intuitively well ahead of him and the rest of the art world in their awareness of the power of abstract form.

WITH THE PUBLICATION of Marcel Réja's book, the ongoing discovery of the art of the insane moved decisively into the territory of the "fine arts." The investigation of the artistic activity of the mentally ill was to continue in French psychiatric circles, but leadership in this field was soon to be assumed by the German-speaking peoples of Europe, with contributions of overwhelming importance emerging in Germany, Austria, and Switzerland. One final event, occurring in France in 1912, deserves mention: a discovery that was an important critical affirmation of the artistic worth of psychotic art—the discovery of the art of Séraphine de Senlis (1864–1934). Although Séraphine died in an asylum she functioned for most of her life as a domestic worker, earning her own living, and painting pictures for her own satisfaction.[54] She is usually discussed within the context of naive painting. However, her discoverer, William Uhde (1874–1947), the great theorist of naive art, was well aware of the profoundly disturbed mental condition of this artist, and of the distance between her work and that of other primitive, but otherwise normal, artists. In supporting her art, both critically and financially, he moved beyond the rather vague borders that separate naive and psychotic art, meriting recognition among the pioneering critics involved in the discovery of this new art form.

The story of the discovery of the work of Séraphine Louis represents the sort of miraculous occurrence of which every art historian or critic dreams. Uhde had rented a house in Senlis and hired an old peasant woman to come in as a domestic helper.

11.14. "The Holy Spirit," drawing of his family, from Marcel Réja, *L'art chez les fous* (Paris, 1907).

One day I had to visit some people in the little town—I forget their name—for some purpose or other. As I was leaving their place I noticed a picture of still life, and so vivid was the effect this painting produced on me that I was positively dumbfounded. Looking more closely into it, I became aware that this effect was not due to any adventitious cause, to "bluff," or chance, or a taking theme; it sprang uniquely from an artistic excellence that could bear the closest scrutiny. The picture showed some apples placed on a table, nothing more. . . . "Who painted this?" I asked my hosts. "Séraphine," they replied. "What Séraphine?" "Why, your charwoman."[55]

He purchased a number of Séraphine's pictures at the time, but World War I forced him to leave France, and he forgot about her. His first articles on her appeared only in the 1920s.[56] It is not without significance that almost twenty years passed before Uhde announced his discovery. In the interval his perception of her had shifted, from an emphasis on the naive to an appreciation of her as a psychotic master. He would also have come to know the work of Prinzhorn and Morgenthaler, with a resulting enlargement of his vision. By 1925 Séraphine's mental condition had become an essential aspect of his interest in her work. A new aesthetic now played its part in his response.

There was nothing of "fine art" about these canvases. Here natural talent, intelligence and good taste had doubtless played their parts, but they were not the mainspring of this work. Rather it was a strong and simple soul that, by a creative gesture, had called into physical existence all the love and ardent passion which possessed it. This materialization of a spiritual state moved me more deeply than the most finished product of artistic competence. This fine frenzy which blazed across her canvas was a grander thing than the amiable madness of the Fauves which twenty years ago scandalized the bourgeois and nowadays holds pride of place.[57]

Séraphine's work, painted secretly behind locked doors (even Uhde never saw her paint), is recognizably the work of a schizophrenic (Plate 16). Claiming divine inspiration, she painted gigantic bouquets of flowers and fruit, trees of paradise covered with seashells, leaves and grapes that are transformed into watching eyes. Her eroticism and sensuality found expression in a curiously botanical sexuality, and in unnerving still-life compositions that blaze and burn on the walls, a terrifyingly concrete embodiment of Baudelaire's *Fleurs de Mal*.[58]

Uhde referred to Séraphine as a psychotic. He was intrigued and amused by the paranoid ideas by which she was plagued, but he was also soberly aware of the impenetrable isolation in which she lived.

A frequent visitor is the chief of police. He admires her work and she has given him a fine picture, for she is in need of his help—so at least she thinks. For she has got it into her head that certain bad characters intend to steal her pictures. . . . She secures both her doors with four locks and a very elaborate system of chains. Not content with this, she has furnished the police officer with descriptions of the persons who have evil intentions against her.[59]

Séraphine's precarious balance eventually collapsed. "She began going from house to house in Senlis, prophesying the end of the world. . . . Finally she was committed to the insane asylum at Clermont, and there she died."[60]

Uhde's discovery of Séraphine, while delayed for some years, established her as an artist of considerable reputation. As early as 1931 he could state, "Newspapers and art reviews speak of her, and her paintings are now to be seen in reputable collections. The mocking voices of her little town have gradually been silenced by the louder praise of Paris."[61] It had taken twenty-five years for the work of psychotic painters to make the journey from the "mad museum" of Professor Marie to the art museums of Paris. Séraphine de Senlis, an illiterate peasant, was the first psychotic painter to gain public and critical recognition as an artist in the full sense of the word; her private vision had become part of the world of art.

TWELVE

Hans Prinzhorn and the German Contribution

On April 9, 1787, Johann Wolfgang von Goethe (1749–1832) and his friend the artist Christoph Kniep (1755–1825) paid a visit to the celebrated villa of the Prince of Pallagonia at Bagheria near Palermo.[1] Goethe described his impressions of this strange excursion into the monstrous in his *Italienische Reise*. The reaction of the two men to the fantastic environment created by Ferdinando Gravina, Prince of Pallagonia, and to the mind that the bizarre objects and images seemed to suggest, represents an early and significant reaction to the art of the insane in Germany.[2] Whether the Prince of Pallagonia was clinically mad is not of concern to us.[3] His importance resides in the fact that Goethe and his contemporaries clearly believed that he was insane.

In his description of the house and its contents, particularly the sculpture, Goethe's attitude approaches aesthetic, if not moral outrage (Fig. 12.1).

The drive to the house is unusually broad, and each wall has been transformed into an uninterrupted socle on which excellent pedestals sustain strange groups interspersed with vases. The repulsive appearance of these deformities, botched by inferior stonecutters, is reinforced by the crumbly shell-tufa of which they are made, but a better material would, no doubt, have made the worthlessness of the form still more conspicuous. I called them groups, but the word is inappropriate, for they are not the products of calculation or even of caprice; they are merely accidental jumbles. . . . These figures are mostly animal and human monsters . . . the following list will give you a better idea of what the Prince of Pallagonia

12.1. The villa of the Prince of Pallagonia at Bagheria, Sicily.

12.2. Christoph Heinrich Kniep, drawing of a sculptural caprice on the wall of the entrance drive to the villa of the Prince of Pallagonia, 1787, Goethe National Museum, Weimar.

has perpetrated in his madness. . . . Now imagine similar figures multiplied ad infinitum, designed without rhyme or reason, combined without discrimination or point, pedestals and monstrosities in one unending row, and the painful feelings they must inspire, and you will sympathize with anyone who has to run the gauntlet of this lunacy.[4]

Goethe had come to Italy in search of the classical world, a vision of pure and untroubled form and idea. Although already acclaimed as a writer and poet, he was still playing with the idea of becoming a painter, and while in Italy he was very much involved with drawing. His companion on the visit to Sicily was a young artist whose aversion toward the villa was even deeper. "It was the first time I had seen Kniep lose patience. His feelings as an artist were outraged by this madhouse, and when I tried to study the details of these misbegotten horrors, he hustled me away. But, good natured fellow that he is, he finally drew one of the groups, the only one that at least made some sort of picture. A woman with a horse's head is seated in a chair playing cards with her vis-à-vis, a cavalier in old-fashioned clothes" (Fig. 12.2).[5]

The emotional reaction of the two artists to the troubling world of Pallagonia was typical of the attitude of the Age of Reason to psychopathological art. Kniep saw it as threatening and morally monstrous, something to be avoided. And yet Goethe chose to spend a whole day exploring the villa and describing it in detail. Beneath his censure and disdain, lay the nascent sentiments of the Romantic. Faust-like, he was drawn into the darkness and sensed the power of Gravina's disturbed and disturbing vision. He seeks meaning in the chaos, searches the rooms for the creative force behind the monstrous inventions.

In the house the fever of the Prince rises to a delirium. The legs of the chairs have been unequally sawn off, so that no one can sit on them, and we were warned by the castellan himself not to use the normal chairs, for they have spikes hidden under their velvet cushioned seats. In corners stood candelabra of Chinese porcelain, which turned out, on closer inspection, to be made up of single bowls, cups, and saucers, all glued together. Some whimsical object stares out at you from every corner. . . . A description of the chapel would fill a book. Here lies a clue to the whole madness. Only in the brain of a religious fanatic could it have grown to such rampant proportions. I must leave you to imagine how many caricatures of a perverted piety have been assembled here, and only mention the most conspicuous one. A carved crucifix of considerable size, painted in realistic colors, and varnished and gilded in places, is fixed flat to the ceiling. Into the navel of the Crucified a hook has been screwed from which hangs a chain. The end of this chain is made fast to the head of a man, kneeling in prayer and painted and varnished like everything else. He hangs suspended in the air as a symbol of the ceaseless devotions of the present owner.[6]

Goethe was strongly ambivalent toward Romanticism. He had a horror of the formless, of the work of art shaped only by emotion. The spontaneous images of madness, while intriguing, could be perceived only as the shapeless products of the imagination gone astray, a "Pallagonian paroxysm," the unsettling expression of "the bad taste and folly of an eccentric mind."[7]

INHERENT in the new attitudes to the individual and to human emotion central to the development of German Romanticism were the seeds of more sympathetic insight into the art of the insane. German art had always burned with a peculiar, at times violent, intensity, but now, as the area where Romanticism was to reach its most unrestrained expressive and theoretical statements, Germany and the German-speaking countries were to witness the deepest and most rigorous and successful attempts to explore and understand the visual embodiments of the experience of madness.

The first half of the nineteenth century in Germany represented an era of major importance in the history of psychiatry, a period of revolutionary insight into the mind and its workings. Although the achievements of this extraordinary half-century were to some extent stillborn, obscured by the materialistic and more rigorously "scientific" orientation that dominated psychiatry all over the world in the latter half of the century, the pioneering insights of Romantic psychiatry laid a firm, if invisible, foundation for the psychological breakthrough represented by the development of psychoanalytic thought in the early years of the twentieth century. Dynamic psychiatry is rooted in the work of the pioneering physicians who emerged as an essential part of the Romantic movement in Germany. The wide culture of German physicians and psychiatrists of this period made it possible for these men to

participate not only in the scientific but also in the literary and artistic circles of the day. German psychiatry in this period was more closely linked with current developments within philosophy than any psychiatry before or since. The mind was being probed from numerous directions and, for a short time, the insights of artists and poets were understood to be as worthy of respect and acceptance as those of philosophers and psychiatrists. Often these usually distinct intellectual pursuits were combined in one individual. The result was a pronounced and very conscious shift away from a purely descriptive approach to mental disturbance, toward a first attempt at a psychology comprehensive enough to embrace the functioning of the mind in both its normal and its more unusual, even pathological, modes of functioning. Out of the Romantic preoccupation with introspection, the irrational, and the more private and intense emotions, came insights into the depths of the mind; the discovery of the unconscious and its profound role in the life of the individual, and an understanding of the role of psychological conflict in the genesis of mental disturbance. Madness was conceptualized as an essentially psychological phenomenon and the continuity between the ideas and affects of sane and insane individuals was clearly recognized. This period also witnessed the development of early forms of verbal psychotherapy and methods of treatment carefully adapted to the individual, as well as the first hints that music, art, and drama were useful therapeutic expressions in the treatment of hospitalized mental patients.[8]

If GOETHE's artist friend Kniep displayed the typical response of a rational, academic artist to psychopathology, another artist in Goethe's circle had no such limitations. Carl Gustav Carus (1789–1869), one of the most active participants in the German Romantic movement, a painter of considerable ability, and the foremost theoretician of the German school of Romantic landscape painting, was also one of the most significant and penetrating psychologists of the day. Carus played a major role in the elaboration of German Romantic psychiatry. Emerging from the milieu of Schelling and Goethe, a devoted follower of the painter Caspar David Friedrich, he was equally at home in scientific, literary, and artistic circles. Like Goethe, Carus displayed remarkable facility in every area of intellectual life.

Originally an obstetrician, he published influential works in comparative anatomy, physiognomy, philosophy, art theory and criticism, and psychology. In his psychological speculation he anticipated many of Freud's discoveries. In 1846, Carus outlined his understanding of the unique importance of unconscious mental processes to the functioning of the human mind.

The key to the knowledge of the soul's conscious life lies in the realm of the unconscious (*das Unbewuste*). This explains the difficulty, if not the impossibility, of getting a real comprehension of the soul's secret. If it were an absolute impossibility to find the unconscious in the conscious, then man should despair of ever getting a knowledge of his soul, that is a knowledge of himself. But if this impossibility is only apparent, then the first task of a science of the soul is to state how the spirit of man is able to descend into these depths.[9]

Given such insight into the future of psychological investigation, and his theories went beyond mere intuition, Carus as psychologist and artist might have been expected to contribute significantly to the study of the art of the insane. Interdisciplinary scholars were to make the most meaningful contributions to this field, and it is of considerable importance to investigate what prevented Carus from seeing this problem as admirably suited to his unique training and experience.

Perhaps part of the explanation lies in the fact that as a painter Carus's interest focused almost exclusively on landscape painting. Much of his work was derivative, excessively influenced by that of Caspar David Friedrich (1774–1840).[10] His philosophical orientation, based on the thought of Friedrich Schelling (1775–1854), was a continuation of Romantic Naturphilosophie. His art theory and criticism were intimately linked with this world view. Although his involvement with Romanticism led him into the mind, it was chiefly his own inner world that provided his most profound insights. "As far as mental disturbances were concerned, Carus had no first-hand experience. Not inhibited by clinical knowledge of the way mentally diseased persons behave, he was free to indulge in unlimited speculation. His book *Psyche* (1846) consistently espouses the Romantic position."[11]

While Romanticism provided the impetus for interest in that inward expression of the sublime represented by madness and dreams, it also offered its own vision of the reality of insanity, based on imaginative reconstruction and introspection. Carus's insight into madness was derived from this latter sort of experience. Although he knew the literature of insanity, both artistic and psychiatric, this did not provide any contact with the art of psychotic patients. Had his intellectual interests been augmented by clinical experience and actual case material, as was the situation with Hans Prinzhorn, he might well have contributed much to the study of the effect of mental illness on the crea-

tive process. Nevertheless, his introspective understanding of the functioning of his own creativity threw light on the therapeutic value of art as a means of relieving inner conflict. In his memoirs, published in 1865–1866, he described his "dark, misty pictures of churchyards deep in snow," painted, he informs us, "in order to purge the inmost recesses of the soul of deep gloom."[12] A passage such as this can be seen as anticipating the clinical application of art as expressive therapy, and goes well beyond the employment of drawing and painting in the hospital environment as a means of keeping the patients occupied. Within Romantic thought, art becomes an individual pursuit functioning within the soul rather than within the community. Carus had devised a therapy for his own soul, but failed to recognize its value for his patients.

THE EXTRAORDINARY flowering of psychiatric and psychological insight that formed part of the development of Romanticism in Germany was obscured by the emergence of different trends, which were essentially anti-Romantic and materialistic. During the second half of the nineteenth century, psychiatry and its younger brother neurology emerge as distinct fields of medical specialization provided with an experimental foundation and a body of carefully described clinical data that extends without interruption into the body of knowledge by which psychiatry, as opposed to psychoanalysis or depth psychology, is characterized today. Prompted in part by a shift of political and economic power from France to Germany, the German-speaking countries now emerged as dominant in medical studies. Psychiatry moved closer to medicine in order to participate in its enormous scientific prestige. The brain became the focus of almost all psychiatric investigation, and neurology appeared to replace psychology as the principal means of obtaining access to the secrets of the human mind. Mental disease was understood to be the result of abnormalities in the brain, and the source of emotional disorders was sought in physical lesions or irregularities in the anatomical structure of the brain.

The study of patient art could have no place in such a discipline, in that the imagery of the insane could be seen only as a product of physical disturbance without inherent meaning. Understanding of the symbolic content of the patient's artistic expressions, and of the mechanisms and laws underlying symbol and symptom formation, was postponed for fifty years. Nevertheless, the renewed emphasis on description of clinical entities and on rigorous observation characteristic

of the period contributed to the knowledge of image making as a form of behavior occasionally observed in mental illness, and led to description of the formal characteristics of this art.

Interest in pathology of the brain led to an involvement with very detailed description and analysis of disturbances of mental functioning, and to an attempt to link manifestations of disturbed perceptual, intellectual, emotional, and behavioral functioning with precise areas of the brain. Motor activities such as drawing and writing, as well as speech, could indicate neurophysiological malfunction, and formal characteristics of drawings made by patients now began to be explored in terms of possible alterations of perception. Renewed interest in psychiatric nosology led to the formulation of disease entities that are essentially those of today. As part of this process of diagnostic clarification, a final effort was made to associate specific styles of patient art with the major syndrome groupings, and with the detailed information that was being accumulated about the symptom clusters that characterized these individual forms of mental disorder. For the first time, groups of symptoms and disturbances of mental functioning fit together with types of pictorial expression in sensible ways. New experimental techniques of investigating patient art were developed at this time to verify the links between specific functional difficulties and motor and perceptual disturbances associated with drawing and painting. The result was an approach to psychopathological art that appears modern and scientific, and which continues to represent one of several contemporary modes of investigation.

The greatest representative of German neuropsychiatry was Emil Kraepelin (1856–1926), the founder of what Ellenberger has called "Imperial German Psychiatry." More than any other physician, Kraepelin defined the character of contemporary, nonpsychoanalytically oriented psychiatry in the twentieth century. His accurate and detailed study of individual cases in terms of manifest symptoms, and disturbances of behavior and intellect, led to the elaboration of the entire spectrum of psychiatric knowledge within a systematic framework dominated by his own clear conception of the basic disease entities. This body of information was then distributed throughout the world through his enormously influential psychiatric textbooks.

Inevitably the role of patient art within such a massive body of material was small, but equally evidently, it could not be left out. Kraepelin was nothing if not encyclopedic in his intellectual approach to the manifestations of mental disorders. In his *Lehrbuch der*

Psychiatrie (1883), the Bible of several generations of psychiatrists, he discussed the drawings of patients suffering from *dementia praecox* (his own term, the equivalent of the later term *schizophrenia*), distinguishing several subtypes, including drawings produced by catatonic patients, which he described as intricate; and drawings produced by some paranoid patients who depict machines by which they believe themselves to be persecuted. From this brief description, it can be seen that Kraepelin's involvement with patient art was superficial, as with the first attempts to account for the artistic activity of patients at the beginning of the century in France. Nevertheless, by mentioning drawings as an aspect of psychopathological disturbance, Kraepelin legitimized the study of patient art for the many psychiatrists who followed his lead.[13] To this day, the investigation of the graphic productions of psychiatric patients remains a viable, if somewhat peculiar and dilettantish, field for the psychiatrist who wishes to engage in research.

SERIOUS investigation of the art of the insane in Germany begins with the work of Dr. Fritz Mohr (1874–1966), a psychiatrist whose contribution is perhaps best understood as a continuation and refinement of the work of Paul-Max Simon. In 1906 he published an important article, "Über Zeichnungen von Geisteskranken und ihre diagnostische Verwertbarkeit." In 1908 a second article, "Zeichnungen von Geisteskranken," added little to what he had already published.[14] These publications established him at once as the dominant figure in the psychiatric and psychological study of patient art, a position that was not seriously challenged until the appearance of Hans Prinzhorn's *Bildnerei der Geisteskranken* in 1922.

Mohr illustrates the application of the Kraepelinian orientation to the study of the art of the insane. In the first quarter of the twentieth century interest in psychotic art, both in psychiatric and artistic circles, reached a peak. Articles on the subject became incredibly abundant, a rise in quantity not necessarily matched by quality.[15] Mohr's approach, more systematic and comprehensive than most, was adopted by students of the subject, most of whose articles added little to his findings. Among the exceptions are the important contributions of two major figures in the development of early twentieth-century psychiatry, Hermann Rorschach (1884–1922) and Karl Jaspers (1883–1969).[16]

The encyclopedic character of German scholarship is reflected in Mohr's thorough and objective review of the entire literature of psychiatry and art up to 1905. He knew all of the nineteenth-century periodical publications except for the important articles of William Noyes in America. He had also read Rogue de Fursac's new book, but dismissed it as useful only for its illustrations. As for his German predecessors, he could find little to mention, drawing attention to brief references in the writings of Sommer, Weygandt, and Näcke, all of whom mention the drawing of the insane only in the context of books devoted to other subjects.[17] In Germany the field was clearly wide open. Mohr saw himself, perhaps a bit presumptuously, as the pioneer, and dismissed all earlier contributions, particularly those of the French, as "merely descriptive." Would his own approach lead beyond mere description?

In accord with the newly established distinction between the disciplines of psychiatry, neurology, and psychology, Mohr differentiated between the use of drawings by patients within the essentially diagnostic preoccupations of the psychiatrist, and the far wider implications of these images for the investigation of mental functioning in general. His own stated aim was to carry out an exhaustive psychological analysis of the drawings, using an approach that was experimental rather than descriptive. He was aware of the continuity that extended from normal mental processes, through minor disturbances of function, to the severest psychological disturbances. He studied the art of the insane for insight into nonpathological mental processes, using psychiatric insights to answer questions about psychology. He felt that recent studies of the art of normal children had yielded new approaches that could be adapted to investigate psychotic art. Thus, the study of children's art, which had been developing all through the nineteenth century on a parallel but quite independent course, was characterized as more advanced or as a useful source of new methodology. He also drew upon the work of art historians and anthropologists, referring to publications on prehistoric and primitive art that he saw as bearing on his endeavors.

Mohr's unique contribution to the study of the graphic activity of psychotic patients lay in the development and use of an experimental approach. Faced with the difficulty of unraveling the complex spontaneous drawings of his patients, and wanting to isolate and identify specific areas of malfunction of the mental apparatus reflected in the more formal aspects of picture making, Mohr devised the first standardized tests to use drawings. In so doing, he moved into a different field of investigation, but with a view to obtaining insight into what he felt to be the almost impenetrable

complexity of the spontaneous images. His experimental approach was well and carefully conceived. Bypassing problems of symbolism and meaning, which lay outside of his organic and neurological conception of mental illness, he sought to relate disturbances in the ability to draw simple shapes to specific types of neurological malfunction, and to the main psychiatric syndromes.

His experimental procedures fall into two basic categories: first, the study of simple drawings done by the patient at the physician's request, and often involving copying rather than original work; and second, the study of the patient's response, either verbal or pictorial, to stimulus drawings chosen to provoke responses of specific types. To encourage other psychiatric researchers to follow his investigative procedures, he listed different experiments that he had carried out, commenting on their value in exploring various aspects of mental functioning.

1. The patient is requested to copy simple drawings composed of a few strokes, e.g. a church. [Fig. 12.3]
2. The patient is asked to draw a slightly more complex drawing, e.g. a geometric form.
3. The patient is asked to draw simple objects familiar to him, e.g. a table, a tree, a house.
4. The patient is asked to draw anything which occurs to him.
5. The patient is asked to illustrate simple stories from everyday life.
6. The patient is given the opportunity of making colored drawings by providing him with colored pencils or paints.
7. The patient is asked to complete "unfinished" drawings.
8. Patients are asked to comment on or "explain" their own pictures.
9. A series of drawings differing from one another in minor details is presented to the patient, and his ability to discern differences is studied.
10. The patient is provided with narrative illustrations and is asked to describe what is occurring in them.
11. The patient is provided with pictures calculated to provoke an emotional response, e.g. pictures of God, the devil, ghosts, machines, etc.
12. Patients are shown humorous drawings.
13. Drawings done prior to the onset of the illness are compared with those done during illness, and drawings illustrating the various stages of development of a psychosis are studied as a developmental series.

To anyone familiar with contemporary psychological tests that make use of drawings, Mohr's methods and thinking must inevitably seem very modern. Indeed, in several of his suggestions for research, he anticipated specific testing procedures in use today. His ex-

12.3. A drawing of a church copied by a patient, from Fritz Mohr, *Journal für Psycholgie und Neurologie* 8 (1906).

perimental approach conforms to the modern taste for objective, directly comparable, even quantifiable, investigative procedures and data. His tests resemble many of the drawing experiments carried out in departments of experimental psychology in this century. The problems he set out to explore, while confined largely to psychopathology, are essentially those dealt with now within the discipline of perceptual psychology.

The study of the ability to copy simple drawings or more complex geometric shapes demonstrates Mohr's concern not with patient art but with certain perceptual and motor skills involved in drawing. Mohr was preoccupied with the effect of perceptual disturbances on the patient's ability to see and represent the world. Do schizophrenics see the world differently? Is altered perception the basis for the characteristic forms observed in certain groups of drawings? In studying the ability to copy, he was searching for answers to these still troublesome questions.

Aware of the more advanced studies of disturbances of speech, Mohr devised similar experiments to see if similar types of disturbance occurred in the ability to draw. For example, he would provide patients with two or more of the simple model drawings to see if in copying them they tended to mix up elements from one image with those from another, a phenomenon known as "contamination." More complex copying assignments were designed to investigate the ability to focus attention and to perceive more subtle differences in form, as well as to provide insight into the patient's control of motor activity. Mohr's sophistication can be glimpsed in his recognition that even such an apparently "simple" drawing as that of a church might provoke emotional reactions in some patients, with resultant effects on the drawings they produced.

Mohr was aware that in asking patients to draw scenes from everyday life, he might be asking them to do something too difficult. He wanted to see what patients could do with such a problem, how they reacted, what they chose to represent. He is investigating the awareness patients have of their own limitations, as

well as their intellectual and problem-solving ability. His concern is to get at certain aspects of what in modern psychoanalytic terminology would be referred to as ego functions.

Even in areas that appear to touch on the content of the patient's mind, and on his emotional and personal preoccupations, Mohr's interest was focused primarily on the structure of the thought rather than on its meaning, on form as opposed to content. In asking for drawings out of the imagination ("aus dem Kopf"), he was looking for the presence of hallucinatory experience, delusions, and illusions. He was aware that patients could be provoked to reveal the presence of such mental products by providing suitable stimuli. Working in Koblenz, he seems to have been influenced by the similar experiments dealing with verbal associations to stimuli then underway in Zurich.[18] But his concern was more with formal disturbances in the thinking process than with the influence of emotionally toned "complexes."[19] "The more fragmentary the thought processes, the more fragmentary the picture."[20] Although he suggested the separate study of colored drawings, he does not appear to have been concerned with the emotional aspects of color usage, and does not clarify what area of mental functioning he associated with color.

In using narrative pictures as a means of getting patients to invent stories, and in providing the patient with unfinished drawings to be completed, Mohr anticipated two of the most famous psychological testing procedures in use today, the "Drawing Completion Test" and the "Thematic Apperception Test," both valuable for the investigation of the deeper strata of the psyche, although Mohr did not conceive of them with this goal in mind. He was well aware that drawing tests could be used to bypass the patient's defenses, and thus gain insight into his mind without his knowing that this was occurring. He knew also that patients could often illuminate certain peculiarities of their own pictures through their explanations. He understood that a series of drawings often related to one another just as a series of verbal associations does, a fact that led him to use drawings as a means of studying the responses of nonverbal patients. He also employed the sequence of drawings produced during the development of a psychotic illness in order to investigate which mental functions deteriorated first, and how changes in the form of drawings related to changes in psychological functions as the illness progressed.

In all of these preoccupations Mohr was a sophisticated follower of the experimental approach and of the kind of psychiatric conceptualization fundamental to

12.4. Drawings copied by a manic patient (*left*) and a schizophrenic patient (*right*), from Fritz Mohr, *Journal für Psychologie und Neurologie* 8 (1906).

Kraepelin and his school. His persistent involvement with specific disorders of thought and perception reflects Kraepelin's isolation of the group of disorders now known as the schizophrenias, in which such disturbances are particularly evident. Kraepelin was responsible for the sharp distinction between the schizophrenias and disorders of affect such as manic-depressive psychosis and melancholia. A brief look at Mohr's comments on two of the copy drawings produced by patients in the test situation provides more detailed insight into his aims and ideas, and demonstrates his interest in the distinction between these quite different types of disorder through the use of drawings.

In this picture [Fig. 12.4, left], the type of illness is very vividly revealed. It is the work of a patient in the manic phase of a manic-depressive psychosis. A picture of a church was shown to him with the urgent and repeated admonition that he must copy it exactly. The patient, in a continuous state of restlessness, jumped in and out of bed, gave military salutes, and laughed and talked without interruption. He came to the first interview with a great show of gestures, talk, and laughter. He nevertheless applied himself to making an exact copy of the drawing. However, as you can see, he did not confine himself to using single strokes, but rather tended to use a series of rapid, repeated strokes in the same direction, a style expressive of his motor restlessness. As soon as he had copied the essential contours of the model drawing, he immediately began, quite spontaneously, to add the cock, the weather vane, the spy-hole (above the door), the chimney with a cat scrambling up it, and the pattern at bottom right, which is supposed to be a spring. He also improved the perspective. He would have added still more if the drawing hadn't been taken away from him. But, apart from a line (above the window) which he left out, he followed the model quite correctly to begin with.

While the addition of the cock, etc., is characteristic of the "flight of ideas," the embellishments are certainly not inappropriate, and contribute to the liveliness of the scene, communicating a certain feeling of pleasure and vivacity such as is often encountered in the drawings of naive people and children. The whole picture conveys an impression of euphoria, if I may thus express it. It is also of interest that the patient, although seemingly agitated in the highest degree, still applied himself with genuine attention to the task of drawing,

and the related associations which he added did not appear until he had first achieved his representational goal. Obviously, he expended a lot of energy on it. . . . We have in this one drawing all the essential characteristics of the manic state: motor restlessness, flight of ideas, and the heightening of mood. It is to be noted that while the attentiveness of manic patients is enormously variable, it can, nevertheless, be very intense. Precisely this fact provides an unquestionable basis for the differential diagnosis between this drawing and the next. . . . A glance at the second drawing [Fig. 12.4, right], must lead one unavoidably to recognize the great difference between it and the drawing of a manic patient. This drawing conveys an impression of a confused, disorganized, agitated, and interrupted state of mind quite unlike that of our manic patient. It resembles drawings produced by patients suffering from dementia praecox, and I maintain on the basis of the characteristics I have just mentioned, that such a drawing could not be excluded as evidence for a diagnosis of dementia praecox.[21]

The systematizing of the testing procedure had provided Mohr the opportunity for making precise comparisons among the types of drawings produced by the different categories of patient. He is an attentive observer of his patient's behavior while drawing, and of the relation between the patient's other symptoms, mood, ability to concentrate, and the drawing that emerges in this context. The formal features of the drawing, as well as certain aspects of its content, could be correlated to his mental state. Mohr is also humanly responsive to the drawing, experiencing both it and the patient with empathy and emotion, even entering to some extent into his euphoric mood.

Test drawings of this type offered little or no stimulus for aesthetic response, and in fact nothing in Mohr's work would suggest that he responded to the beauty or expressive power in any of his patients' drawings. In devising experimental procedures for the study of drawing activity among the mentally ill, Mohr was inevitably moving away from spontaneous images. In this he initiated a tendency that was to dominate the psychiatric and psychological approach to patient art in the twentieth century. The complex spontaneous productions of patients were increasingly to be seen as too unsettling and confusing for the psychiatric researcher. In terms of the diagnostic requirements of the psychiatric clinic, such drawings were in any case too rare to be used systematically. Drawings produced under experimental conditions, on demand, and with precise and simple requirements offered the behavioral scientist more. The development of the psychological test had begun.

Mohr intended, as his first article indicated, to develop an effective diagnostic tool using drawings. He was a clinician and used drawings with this primary objective in mind. He understood, nevertheless, that his research with simple drawings done "on demand" might provide a means of access to the far more complicated drawings that some patients produced spontaneously. He accordingly returned to the problem of the spontaneous image at the end of his article, reproducing and discussing several important examples from his own clinical material. It is, however, in this area that his limitations become most apparent. He reproduced a series of drawings by a patient whom he diagnosed as suffering from the catatonic form of dementia praecox (Fig. 12.5). He began by describing the content of the drawing: a horse's body with a rider, stirrup, spurs, and all that is appropriate to such a subject. Other odd images then pushed themselves forward, out of the patient's rich, hallucinatory experience. A snake's head appeared in place of the horse's. A ghost can be seen in the horse's belly. The rider's spur is transformed into a mouse clinging to the horse's hoof. The original idea persists, but one of the stirrups is displaced to the upper right corner of the drawing and the rider's head appears suspended above the horse's body.

Mohr sees these shifting images in terms of a breakdown of logical thought processes, an accidental and random scattering of a once-coherent composition, and of the unified idea behind it. "In this drawing the contents are completely heterogeneous, and one senses that the images were thrown up without any single unifying principle, exactly as they emerged in the mind."[22] He draws parallels between the formal chaos of the pictorial structure and the disruption of the patient's ability to speak coherently, finding pictorial

12.5. Horse and rider by a catatonic patient, from Fritz Mohr, *Journal für Psychologie und Neurologie* 8 (1906).

equivalents for descriptive terms used in speech studies, such as contamination, substitution, perseveration, neologism, and poverty of ideas. But, although he had detailed knowledge of the patient, and the patient's explanation of his own drawing, he failed to explore what it might mean. The symbolic content of the drawing remained completely opaque. "The patient's explanations concerning his pictures bear only the slightest relationship to the picture. . . . For him it means something entirely different than for us. For him much meaning resides in it, as if a dominant representation were existing in it about which we can know nothing. In part this may be the case."[23]

Mohr reproduced a second drawing in which he felt sexuality and "the love of women" played an obvious role (Fig. 12.6). "In such a painting the patient desires to embody an evident and quite specific emotion; an aspect of terror seems to make itself visible in different forms."[24] Mohr's responsiveness to the intensity and mood of the pictures is revealed in his recognizing the strangeness of some images. "One feels too a definite tendency toward the uncanny inherent in all of the drawings of these patients, probably the result of the hallucinations of a most frightful kind from which they suffer."[25]

In general, although Mohr wished to go beyond the descriptive level in his analysis of the graphic activity of patients, he did not do so. His achievement was to have developed experimental techniques that enabled him to arrive at very much more precise and accurate modes of comparison and labeling. In his work, the almost pedantic precision characteristic of advances in psychiatric observation, diagnosis, and nomenclature carried out under Kraepelin and the German school, was applied with equal rigor to the graphic activity of patients and the formal qualities of their drawings. The sophistication of Mohr's experimental methods set the stage for the vast development of tests using drawings. A split had opened up in the study of patient art. The two approaches were now to develop along radically different lines: on the one side the essentially diagnostic and experimentally oriented investigation of nonspontaneous drawings, in no sense "art," and on the other, a continuing preoccupation with the spontaneous drawings of psychotic patients produced freely outside of any test situation, either in the hospital, at home, or in rare circumstances, as an aspect of a psychotherapeutic relationship.

As a result of this split, except for physicians who were trained within the psychoanalytic milieu, which involved modes of symbolic expression characteristic of that discipline, interest and serious involvement with

12.6. The love of women by a catatonic patient, from Fritz Mohr, *Journal für Psychologie und Neurologie* 8 (1906).

the spontaneous art of psychotic people tended increasingly to become the province of individuals attracted to its beauty, originality, and expressive intensity. In the twentieth century, the artist, the art historian, the critic, and the art collector have become the dominant force motivating and contributing to the discovery of the art of the insane. It was the task of these artists and critics to break through the barrier that divided these images from the world of art, and to recognize among the mad the presence of great artists and true art.

IN THE EARLY twentieth century, particularly in Germany, and largely as a result of the violent impact of Expressionist painting, literature, and aesthetics (see chapter 14), the ground was prepared for a major advance in the understanding and appreciation of psychotic art. Artists had once again opened up new possibilities of response and insight. Scholarly and scientific advances in this emerging field have been profoundly influenced by changes induced by the aesthetic revolution.

Only an individual convincingly at home in both camps could have been expected to extend the new aesthetic into the realm of art produced in the context of insanity. Hans Prinzhorn (1886–1933), fully trained in art history and psychiatry, was this man (Fig. 12.7). The publication in 1922 of his book *Bildnerei der Geisteskranken* in Berlin is an unequaled contribution to the study of the art of the mentally ill.[26]

The book never sunk into obscurity or ceased to be read, and anyone familiar with the study of psychotic art knows Prinzhorn well. Consequently, my discussion of Prinzhorn's contribution is restricted to a few

12.7. Dr. Hans Prinzhorn, Prinzhorn Collection, Heidelberg.

rather subjective comments on his work and omits any extended description of his findings, in particular his discussion of psychotic art as clinical material. Still, certain aspects of Prinzhorn's approach need to be clarified, and his impact upon his contemporaries considered. The effect of Prinzhorn's book was most strongly felt in artistic circles, and my concern is with Prinzhorn's art historical and aesthetic contribution, as reflected particularly in the Prinzhorn Collection in Heidelberg.[27]

Hans Prinzhorn was born in June 1886 in a family not notable for its involvement in the arts. His father was in paper manufacturing. The range and depth of Prinzhorn's intellectual and cultural interests is difficult to account for. Vienna, a city in the throes of an extraordinary intellectual and artistic ferment, may perhaps have stimulated the young Prinzhorn.[28] Certainly he was profoundly aware of and influenced by the artistic avant-garde so much in evidence in the early years of the century. At the University of Vienna he studied aesthetics and art history, obtaining a doctorate in the history of art in 1908. He then undertook serious voice studies in England with a view to an operatic and concert career. It was only in his late twenties that he turned, rather surprisingly, to the study of medicine and psychiatry. He was employed during World War I as an army surgeon. In 1919 he was invited to join the staff of the Heidelberg Psychiatric Clinic.[29]

The study of the spontaneous art of psychotic patients had begun at the Heidelberg clinic some time before Prinzhorn's arrival there. A small collection had come into existence at the instigation of the director of the clinic, Dr. Karl Wilmanns. The idea of enlarging the collection and of publishing a detailed study of it originated with Wilmanns. Prinzhorn's professional training in the study of visual material probably influenced his appointment to the clinic. Wilmanns fully supported Prinzhorn's research, providing him the time and money to search for new material. Wilmann's originality and foresight in conceiving of such a study, and in finding the one individual in Germany whose training uniquely qualified him to undertake serious research in the field, must be emphasized. That Prinzhorn was able to assemble the largest and finest collection in Europe, and that he was able to utilize this material for a revolutionary new publication, all within less than four years, is an achievement that could only have been carried out with the enthusiastic support of the institution in which he worked. Reaction to the book was such that Prinzhorn's reputation was established by it; he became famous overnight.

Prinzhorn left Heidelberg before his book was published. The collection seems to have stopped growing at this point. It then included some five thousand pictures and pieces of sculpture by about five hundred patient-artists, covering a period from about 1890 to 1920. It had been assembled from psychiatric hospitals and private sanatoria in Germany, Austria, Switzerland, Italy, the Netherlands, and even the United States and Japan. It was intended to function as a research tool for psychiatrists, psychologists, art theorists, art historians, and students of aesthetics. However, sometime after Prinzhorn's death in 1933, the collection, as a result of the difficult postwar years, was packed into boxes and deposited in the hospital attic in very poor condition. During this period of neglect some of the finer pieces disappeared, probably into the hands of interested physician-collectors. Other pieces, particularly sculptural works, were broken or deteriorated. In recent years owing to the efforts of Mrs. Rave-Schwank, the collection was removed from storage, recataloged, and provided with storage facilities that ensure its survival.[30]

The collection is once again available for study as Prinzhorn and Wilmanns originally intended. Its fortune, with a period of fame followed by years of neglect and a subsequent rebirth, reflects exactly the shifting pattern of interest in the art of the insane, with high points in the first quarter of the century, followed by a decline in attention and interest, with a very clear burst of renewed involvement in the last twenty years.

Neglect had the advantage of freezing the collection's growth and development at the point when Prinzhorn left it. In its present state it therefore conveys an accurate picture of Prinzhorn's activity as a

collector, as well as suggesting the nature of his activity in choosing certain artists, and certain works, as illustrative material for his book. One may follow Prinzhorn through the collection, noticing what he found interesting or significant, and what he omitted.

Before Prinzhorn arrived at Heidelberg there is no evidence to suggest that he had had any involvement with psychotic art. His first publication in the field is on the pictorial creativity of the mentally ill, in which he attempted to outline the direction of his research.[31] Traditional studies in art history would not have brought him into contact with such material. However, it is evident that Prinzhorn's interest in art extended to the art of his own day. In *Bildnerei der Geisteskranken* he speaks knowledgeably about Kokoschka, Nolde, Ensor, Kubin, Barlach, Pechstein, and Heckel, and, of course, van Gogh and Rousseau. His own aesthetic was deeply influenced by the ideas emerging from Expressionism. Inevitably he would have encountered art criticism in which forced and hostile comparisons were being made between the paintings of the insane and those of modern artists. He would have known as well of the extremely positive attitude of the Expressionists toward psychotic creations. The evolution of his interest, from art history and music toward psychiatry and psychology, would have made him aware of the increasingly tendentious use being made of psychiatry, and he may have welcomed an opportunity to see for himself the similarities and differences characteristic of these two forms of pictorial expression. By 1917 he was clear enough about his interests to inform Professor Wilmanns "that he was primarily fascinated by the border area between psychopathology and artistic composition."[32]

This statement may account for what might otherwise seem an inexplicable move from art history into psychiatry. The art historian working with the wildly intense creations of the Expressionists, who insisted on deeply personal and subjective symbolism and imagery, is soon drawn into psychological speculation. Prinzhorn, however, had the training to do more than speculate as an amateur. His curiosity extended into a preoccupation with human creativity, the relation between dream formation and art, and the creation of spontaneous images by children, primitive people, and naive painters. His interest in the borderland of art later led him to publish an important study of the art of prisoners.[33] Clearly Prinzhorn himself as a scholar occupied something of a no-man's land, between the disciplines. Maria Rave-Schwank described him as "abundantly talented, much sought after, attracted to everything that was beautiful, changeable in his moods, restless and full of antibourgeois sentiment, he always took up a position between the faculties, the disciplines, and individuals."[34] Dr. W. von Baeyer, past director of the Heidelberg Clinic, was still more blunt. "He took very badly to the rigid conventions of the university and its hierarchy. Thus, sad to say, he was precluded from promotion to the rank of a university teacher in Germany."[35]

David Watson, an American psychologist who knew him very well, saw him as a nonconformist within the scientific camp as well. "Among those who have most strongly stirred humanity to protest against the increasingly narrow interpretation of scientific modes of thought was Hans Prinzhorn."[36] Commenting on Prinzhorn's years of study of art and aesthetics, Watson states, "These led him at length to embark on a fundamental inquiry into the nature of man himself, and it was this program that brought Prinzhorn into medicine. . . . He devoted himself for a time to the art of the psychotic—which formed his bridge to psychotherapy. . . . Then he took up practice as an analyst."[37] In all of the interconnected problems with which he concerned himself, Prinzhorn is described as having had little patience with "those who were still immersed in what he regarded as 'the problems of the day before yesterday.' "[38] In the study of the spontaneous art of psychotic individuals, and its relation to contemporary art and aesthetics, Prinzhorn found the one area where his unusual range of training and experience could be applied as a whole.

Although Prinzhorn was familiar with most of the significant literature on the art of the insane, he felt himself to be working in "a new, or at least never seriously worked, field" (p. xvii). This dismissal of all previous scholarship was, I believe, based not on arrogance but on the fact that his task was one that had never been attempted and that differed fundamentally from any prior approach to the material.[39] The uniqueness of his approach derived primarily from his training in art history and aesthetics. It is easily forgotten that Prinzhorn was the first professional art historian to obtain training in psychiatry and psychoanalysis. The seriousness and the direction of his approach to this unusual visual material reflect his familiarity, confidence, and security in dealing with the whole range of human pictorial expression. His psychiatric training equipped him to extend his inquiries into forms of image-making activity that had, until then, been avoided by traditional art historians. But his goal was to capture these areas as fertile ground for the student of art.

As he pointed out on the first page of his book, "Most

of the reports published to date about the works of the insane were intended only for psychiatrists" (p. 1). Prinzhorn's study was aimed at a far wider audience, and was intended as a foundation upon which he might begin to construct a general psychology of art that would be relevant to all forms of human expression. He consciously sought a "basic, universal, human process behind the aesthetic and cultural surface of the configurative process. . . . That basic process would be essentially the same in the most sovereign drawing by Rembrandt as in the most miserable daubing by a paralytic: both would be expressions of the psyche" (p. xviii). Going beyond the recognition of a continuity in all human mental states from the "normal" to the extremes of pathology, Prinzhorn here postulates a continuity inherent in all forms of pictorial expression. This recognition had led him to seek solutions to problems posed by art history and the psychology of art in the drawings of psychotic patients, prisoners, children, and naive painters, as well as in the work of recognized masters. The extent of his undertaking is suggested by his puzzling and intriguing statement, "We nevertheless expect to establish new norms," an intention the nature of which he avoided clarifying until the end of the book.

Behind the surface of *Bildnerei der Geisteskranken*, this involvement with the creation of new norms, not in psychiatry but in art theory and criticism, can be felt as a major motivating force. The first step in this direction was his rejection in the opening lines of the book of the word *art*, not because it was unsuited to the description of psychiatric material, but because "the word 'art' includes a value judgment within its fixed emotional connotations. It sets up a distinction between one class of created objects and another very similar one which is dismissed as 'non-art' " (p. 1). In its place he introduced the archaic German term *bildnerei*, "image-making." Inherent in Prinzhorn's undertaking was a hidden but powerful determination to break down walls.

Prinzhorn's approach to the study of psychotic art is split into two goals reflected in the subtitle of the book—"an approach to the psychology and psychopathology of configuration (*Gestaltung*)." His attention was focused on psychopathology and his method involved "a descriptive catalogue of the pictures couched in the language of natural science and accompanied by a clinical and psychopathological description of the patients" (p. xvii). This approach was almost certainly dictated by Professor Wilmanns, whose original conception of the project was purely clinical, and involved a "plan which called for several researchers to treat in-dividual cases more as individual clinical case studies" (p. 3). On one level Prinzhorn's ten case histories can be seen as carrying out Wilmanns's intention.

His other goal, far more ambitious and essentially nonpsychiatric, was to carry out "a completely metaphysically based investigation of the process of pictorial composition" (p. xvii). "This book, in keeping with its subtitle, intends only to explore a borderland as a contribution to a future psychology of configuration" (p. 4).

The book suffers from an obvious and troubling split personality, which may well reflect the contradictory purposes of its two initiators. It is difficult to reconcile the first half of the book, which Prinzhorn called "the theoretical part," and the lengthy section entitled "Ten Schizophrenic Artists." Having decided to avoid symbolic interpretation of the pictures, and to attempt a study of psychological processes of configuration that operate at a supraindividual level, he then supplied, in a confusing and contradictory manner, a vast amount of biographical and clinical case material that he failed to make use of in any convincing way. It is perhaps not surprising that in his first book Prinzhorn could not forge a link between the art historian and the psychiatrist in himself. The art historian was to triumph.

FOR THE MODERN reader the distinction between psychological and psychiatric problems and methodology may seem tenuous. In the Germany of the 1920s they were absolutely distinct. Art history of the period, and for some time earlier, was deeply preoccupied with psychological questions, and much of the finest art historical scholarship of the time debated problems that were essentially psychological.[40] Prinzhorn identified the main influences contributing to his conception of the psychology of art. The list included most of the major art historians and aestheticians who had made a significant contribution to this field: Gottfried Semper (1803–1879), Alois Riegl (1858–1905), Franz Wickhoff (1853–1909), Wilhelm Worringer (1881–1965), August Schmarsow (1853–1936), Heinrich Wöfflin (1864–1945), and most important for Prinzhorn, Conrad Fiedler (1841–1895). Prinzhorn's psychological theories derived, therefore, not from psychiatry, but from an elaboration of ideas that formed part of "the psychology of expression" and, more generally, from the psychology of art. His unique contribution was to carry this body of ideas into psychiatry, and to explore the validity of psychological theory developed by art historians by applying it to the study of the art of schizophrenics.

The lengthy chapter "The Psychological Foundations of Pictorial Configuration" at first appears to have lit-

tle to do with the art of the insane. It is applicable to any artistic activity, and represents an effort, much influenced by the work of the psychologist-philosopher Ludwig Klages (1872–1956), to present a coherent and unified psychology of art—"normal art."[41] However, inherent in his psychology is a subtle revision of various assumptions about the nature and function of art and the creative process, the concealed purpose of which was to extend the definition of art to include psychotic art, as well as the art of children, primitives, and naive painters, within the confines of what was defined as art. It is Prinzhorn's personal aesthetic, the justification for his ventures into the "borderland of art." His aesthetic stance accorded well with the preoccupations and attitudes of contemporary artists, as did his interest in the art of the insane.

His aim in this section was to identify seemingly innate, basic psychological drives, or urges, which in varying proportions cause or determine the nature of pictorial configurations. He identified six such impulses, each of which for him represented "a final, irreducible, psychological fact."

The primary motivation behind any image-making activity he defined as "a drive towards expression," only one outcome of which would be the making of pictures. He saw this impulse not merely as self-expression, but as aimed primarily at establishing contact. "All expressive gestures as such are subordinate to one purpose: to actualize the psyche and thereby to build a bridge from the self to others" (p. 13).

Inherent in this powerful drive toward externalizing the "self," are a number of less fundamental but significant impulses. He spoke of "an urge to play" (p. ii), which is seen in its most obvious form in the life and art of children. It is reflected in the pure pleasure in physical movement embodied in children's scribbles and in the doodles of adults. Prinzhorn saw this play impulse in the playful identification or interpretation of accidental shapes, clouds, or ink-blots, which I have referred to in earlier chapters as the "Rorschach response." He prophetically recognized the fundamental connection that exists between play and creativity, a problem that has preoccupied psychoanalytic theorists in recent years. "We shall have the key to all that follows only when it becomes clear through the examples how far this aimless, rationally incomprehensible, playful attitude extends into the most complicated artistic creations."[42] He also postulated a similarly primitive "ornamental urge," which he defined as a tendency "towards the enrichment of the body, of objects, and of the environment by the addition of perceptual elements" (p. 21), and an "ordering tendency," which is

characterized by an urge to impose order upon random or chaotic form or experience through the use of regular pattern, symmetry, proportion, and rhythm. Recent psychiatric studies of psychotic art have followed Prinzhorn in stressing patients' use of art as a means of reasserting order upon their chaotically changed world.

In discussing his fifth impulse, what he referred to as "the tendency to imitate or copy," Prinzhorn pointed out that certain art historical periods have been dominated by a concern with pictorial verisimilitude, and that there was an undeniable pleasure involved in this achievement. He emphasized, however, that this single impulse has been seriously overestimated in art theory at the expense of the others, and that realism can in no way be seen as the goal of all art. In insisting on this point he was, of course, joining the controversy raging in the 1920s concerning the role of representation and realism in art on the side of the avant-garde of his day. In referring a few pages later to Oscar Kokoschka's great portrait of the psychiatrist Auguste Forel (1910), Prinzhorn was perhaps providing evidence through an act of symbolic identification as to where his sentiments lay.

After pointing to recent anthropological and psychoanalytic studies of the functions of magic and ritual in primitive societies as a basis for an understanding of the psychological origin of the "need for symbols," his sixth impulse, Prinzhorn defined the function of the symbol as understood by modern psychology. "The symbol remains alive with minor transformations to this day. . . . Psychologically it is the tendency to refer in representational configurations to emotional and preconceptual complexes which cannot themselves be visually presented" (pp. 26–27). One might expect such a profound conception of the psychological function of symbols to motivate an intensive investigation into the symbolic implications of the pictures and related case material available to him, an undertaking that Prinzhorn deliberately avoided.

Prinzhorn believed that the enormous range of types of pictorial expression typical of psychotic art could be better accounted for through the interaction and varying contributions of the six component drives, than by any attempt to relate the material to diagnostic categories. Such an attitude effectively removed psychotic art from the conceptual realm of psychiatry, in that the basic drives he postulated are in no sense pathological. Implicit in Prinzhorn's attitude to the art of the insane is the recognition that although insanity as an experience is vividly real, and is clearly reflected in the images that emerge from that experience, there is no "in-

sane art" and no psychopathology of expression. The expressive function in these individuals was intact, and in many ways enhanced as a result of illness. Paradoxically, Prinzhorn succeeded in discovering the "geniuses as a result of insanity" for which Lombroso with his reactionary conception of art had sought in vain.

Having identified most of the images that he was to discuss as the work of schizophrenics, he explained why he confined his attention to this category of patient. "The schizophrenic group is proportionately dominant, and its artistic qualities attract the observer so powerfully by their variety, charm, and abundance that the rest are used only for comparison." He added, "The psychology of schizophrenia is almost necessarily closest to the psychiatrist's heart. . . . The psychopathological interest of the investigation lies exclusively in the 'schizophrenic outlook' " (pp. 37–38). As a psychiatrist Prinzhorn was attracted and intrigued by the inner experience of the schizophrenic, experience that as he pointed out might well be invisible but for its embodiment in concrete images. "We rarely have access to the psyche of the strongly confused final [schizophrenic] state, but the pictures to which we now turn offer us such access" (p. 40).

Behind this scientific goal lurks another, less clearly defined, purpose that is reflected in Prinzhorn's admission that he was powerfully attracted by the variety and charm of the pictures. As an art historian, he aimed to communicate his enthusiasm and pleasure, to use his cultivated sensibility and literary skill to convince the reader of the artistic worth of the images he presented. And here, we meet with a seeming contradiction. In the introduction to the book Prinzhorn stated that his aim was to avoid value judgments: "The pictorial works with which this study is concerned and the problems they present are not measured according to their merits, but instead are viewed psychologically. . . . Our material itself will be the basis for our discussion; the pictures will not be measured or judged by any fixed standard. Instead we shall try to comprehend and analyze the pictures visually, as free of prejudice as possible" (pp. 1, 6). Prinzhorn freed himself of prejudice toward the art he was studying, but his nonjudgmental pose is betrayed on every page by his enthusiasm, his aesthetic delight, and his obvious, if somewhat underhanded, proselytizing for this art. The power of the book, and its impact on the nonpsychiatric, artistic, literary, and philosophical circles of his day can be accounted for in its impassioned presentation of the art of the "schizophrenic master."

Prinzhorn coined the term "schizophrenic master" in the closing sentences of the introduction to his book. He does so without drawing attention to it, and without defining it. Clearly it implies an act of judgment, for in selecting ten masters from among his five hundred artists for detailed presentation, his criteria derived from his own aesthetic sensibility and taste. In fact, he identified his criteria, and the unavoidability of making aesthetic judgments.

No matter how little we have to rely on artistic critical value judgments in analyzing our material we must nevertheless consider that they inevitably enter into the simplest description, which is why a very few must be briefly mentioned: that element which makes one picture among others more forceful we shall call the power of configuration of the originator, which means his ability to translate whatever moves him—whether an eidetic image or a mood—into a picture in such a way that a qualified viewer may participate in the experience as closely as possible. (p. 33)

The more completely a picture's individual expressive content ripens into commonly understandable and communicative configuration (which it does almost independently of technical skill), the higher we will rank it as a creative achievement. (p. 66)

As an art historian Prinzhorn was concerned with quality. His first reaction to the art of the insane was to recognize that it offered a tremendous variety of images, some of which were unforgettably beautiful, while others, although inevitably expressive, communicated little or nothing to the viewer. His criteria are identical whether he was confronted with a Natterer or a Nolde.[43] He sought in every work for intensity and richness of inner experience to which he could respond, and playing art critic among the insane, he identified artists of genius, his schizophrenic masters. In so doing, he turned away from his universal principles of expression, to an involvement with the individual and his art.

In presenting these artists to the cultural world, Prinzhorn acted as an art critic, not as a psychiatrist. It was an act of great courage, even foolhardiness, as it challenged the art historical establishment and questioned the nature of art itself. While these questions were very much in the air, Prinzhorn's book inevitably brought them to a focus and exposed him to all of the hostility that such problems inspired. His aesthetic awareness and critical freedom having been sharpened by exposure to the avant-garde art and criticism of his day, he now, in return, flung open the doors of his new world to the artist and perceptive viewer, making available for the first time a magnificent series of 187 reproductions of the art of the insane. The impact of

12.8. August Natterer, *Meine Augen*,
Prinzhorn Collection, Heidelberg.

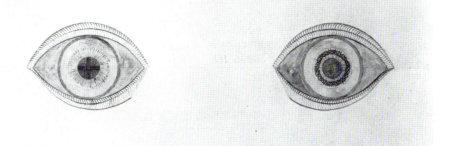

the pictures was enormous. The essential contribution of the book lay in its pictures, as art historian Prinzhorn well knew.

In selecting his ten schizophrenic masters he deliberately set out to mold artistic and critical opinion. In the choice of pictures he acted not as psychologist, but as critic, withholding those that might weaken the impact of his artists, emphasizing through size or color those images he knew would be unforgettable. Study of the Heidelberg collection reveals numerous cases of deliberate suppression of material. Prinzhorn's presentation of the work of August Natterer serves to illustrate this critical selectivity and, beyond this, his approach to an individual master.

PRINZHORN appears to have known Natterer, whose works at Heidelberg are far more extensive than the few pictures reproduced in the book. The presentation of his case is therefore more detailed than that of some of the other "masters," and the connections between his art and his personality are far more convincing. The brief biography and description of Natterer's character is, in part, a typical psychiatric case history, involving inquiries into the patient's family background, education, work experience, and marriage; proceeding to an account of the onset of illness, symptoms, and diagnosis; and followed by an account of the course of development of the illness, the emergence of a delusional system, of hallucinations, and of the patient's changed personality and behavior. It would be of interest to compare this type of history with the biographical information provided by the art historian. The impact of psychiatry and psychoanalysis on art history in this century has led inevitably to a considerable degree of overlap. Nevertheless, as Prinzhorn points out, the process whereby certain facts about an artist and his work are preserved is essentially random, and insufficient to understand the artist's intentions as embodied in the pictures.

No matter how fascinating many details and many surprising interrelations are in the biographies of our ten schizophrenics, they are simply insufficient as convincing experiential evidence. The facts we collected are a patchwork of the observations of many physicians; we are at the mercy of accidents and the whims of the observers for each of these "objective facts" . . . confidence in the objectivity of medical histories is easily shattered. Pictures on the other hand are objective, expressive representations, and an observer who clearly reveals his theoretical premises may achieve a higher degree of objectivity in their interpretation. (pp. 237–40)

This is the art historian speaking. Prinzhorn was prepared to accept the pictures as his fundamental evidence.

In the case of Natterer, Prinzhorn was provided with abundant evidence as to the ties that linked the man and his work: his cool, ordered, rather unemotional personality, which found expression both in his intensely systematized delusional beliefs, and in his pristine, geometric, linear art (Fig. 12.8). "Everything he does and thinks betrays a certain discipline, an almost objective logic, in practical matters as well as the delusional system. . . . Neter's pictures correspond completely in their appearance to the portrait of his personality as we have outlined it. His brush strokes always show a sober, clear objectivity, like those of a technical drawing. It seems that Neter is trying to render facts as precisely as possible" (pp. 162–63).

Natterer's pictures, drawings in pen and ink often enhanced with watercolor, were, according to the patient, illustrations of a single, extremely rich hallucinatory experience that he had had six years previously. The vision had appeared to him in the sky, which accounts for the blue background of much of his work. In Natterer's words:

At first I saw a white spot in the cloud, very nearby—the clouds all stood still—then the white spot withdrew and remained in the sky the whole time, like a board. On this board or screen or stage pictures followed one another like light-

ning, maybe 10,000 in half an hour, so that I could absorb the most important only with the greatest attention. The Lord himself appeared, the witch who created the world. In between there were worldly scenes: war pictures, parts of the earth, monuments, battle scenes from the Wars of Liberation, palaces, marvelous palaces, in short the beauties of the whole world. . . . Finally it was like a movie. The meaning became clear on first sight, even if one became conscious of the details only later while drawing them. (p. 160)

Prinzhorn was particularly intrigued by Natterer's work because it depicted hallucinatory experience, and because it reflected so precisely his delusional system. Natterer explained his pictures at length, and Prinzhorn was attentive to his interpretations, however bizarre. A single group of images known as the *Skirt Transformations* can serve as an example both of Natterer's insight into his own work, and of Prinzhorn's manner of dealing with pictures in the context of an extended discussion of the work of an individual artist (Fig. 12.9).[44] It would appear that Natterer's hallucinatory experience involved the metamorphosis of one image into another in the manner of the drawings of Grandville (1803–1847), a phenomenon that was influential in the development of Surrealism.

The skirt originated in several phases, at first in the form of organ pipes, then as musical instruments, as tablets of the law piled up like bricks, as rock, and as the stone pulpit. The piece in the center looked like an inverted basket; a face appeared on it, the dawn of the gods which changed into a devil's mask, into Moses, Christ, Napoleon I, and finally into the patient himself, specifically as a child. A figure of eight lying on its side formed the bottom of the skirt, then a snake, and finally a sea-shell like an umbrella. Furthermore, an "N" and an "A" as well as other wonderful inscriptions could be seen in the folds of the skirt, among them, "man—woman." (pp. 164–65)

Natterer was so preoccupied by the skirt transformations that he did numerous studies of the subject. The collection includes eight drawings of which Prinzhorn selected four.

The final development of the sequence would seem to be the drawing *Witch with Eagle*, the portrait of "the Lord himself, the witch who created the world" (Fig. 12.10). Natterer's own explanation is included:

The face appeared to me as a skull, but had life just the same . . . the joints of the skull formed a nightcap—a ruche appeared on the nightcap, made up of question marks, and these were changed into feathers—the eye looked like a glass

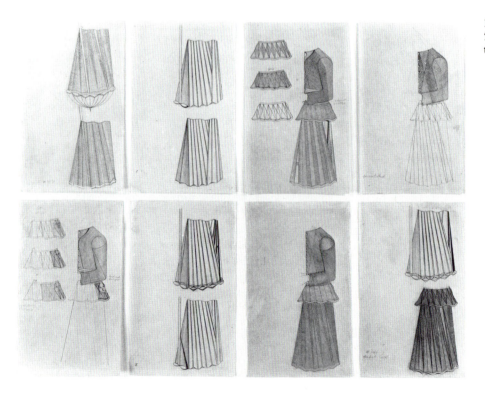

12.9. August Natterer, *Skirt Transformations*, Prinzhorn Collection, Heidelberg.

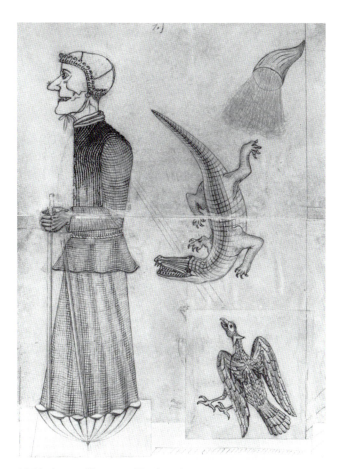

12.10. August Natterer, *Witch with Eagle*, Prinzhorn Collection, Heidelberg.

eye, it sparkled; it was loose in the socket. . . . Various changes also took place at the neck, in particular a place was symbolized there, the location of a mysterious place. . . . The whole figure is a witch: it symbolizes the creation of the world as witchcraft. . . . The two animals—eagle and crocodile—are the witch's messengers—they are always prepared and ready at the beck and call of the witch, always ready to jump. . . . The eagle was changed into all kinds of figures. The feathers were separated by black and white lines. On the eagle were all kinds of apparitions: two palaces, the locked palaces of Hell, in any case. . . . Then a cellar with two entrances, the gates of hell. . . . Once there was on it a beautiful skiff, this skiff had a feather as a sail; then a storm came and the skiff was upset, but it did not come to any harm. . . . One can compare the skiff with the small boat in which the disciplines of Jesus were and from which they fished, and from which St. Peter called the Lord. . . . A heart has formed on the neck of the eagle, and the eagle flew into the sky with the heart. The heart had been stabbed through, a sign that it had to suffer—and I was stuck inside! On the skiff was a 4rer [i.e. *vierer, Führer*, leader]: lead, I am to lead,—leading ship in the

world! The whole picture of the witch was like plaster of Paris for a while—and then it appeared in a glass case and looked like rock—and finally it was given a setting and—it was gone! And then came rain [funnel, upper right] as if from a watering can and poured on the crocodile—and that's how the crocodile got its shading. (pp. 165–66)

Natterer's drawings and paintings are remarkable in embodying so much of his internal experience; at the same time it is probable that the graphic image as it appeared on paper set off many of the associational sequences. Certainly in this case the visual images, whether in the mind or as drawings, seem to precede the verbal descriptions and explanations. Natterer's words, however, provide an extraordinary glimpse into his own creative experience.

Despite the beauty of Natterer's colored works, Prinzhorn decided not to reproduce any of his pictures in color. He also omitted one of the finest paintings, so-called *Witch's Head* (Plate 23),[45] which can be recognized as a further manifestation of the head of the witch, now contained by, and merging with, the world itself. The picture is a Surrealist double image: a toy-like German town set on the edge of a small lake with fields beyond. The houses and public buildings of the silent and empty village are adorned with vermilion roofs. Depicted from every angle, they are intensely individualized structures perhaps reflecting a real German town. But this peaceful townscape is occupied not by the inhabitants but by an enormous and terrifying presence. The lake has been transformed into the head of the world witch, a haunting specter who dominates the village as she dominates the picture. Her bonnet-skull is composed of the distant fields, the fences forming the cranial sutures. A row of trees has sprung up to form the bonnet's border, while its tie-strings are replaced by a curious bridge, which stretches across the lake. The face is chillingly unexpressive; the eye floating on the lake, like a giant beach ball, stares at nothing. The painting is the ultimate expression of the two worlds in which Natterer lived: the everyday village whose reality, unseen by the inhabitants, is pervaded by a metaphysical presence that only he knew. "The real world has no objective character for him but only provides him with materials which, in keeping with his urge to self-esteem, he treats arbitrarily. He has turned the world completely into himself and has become autistic. Schizophrenia allows him the co-existence without conflict of both his perceptual spheres" (p. 162).

The omission of this major picture can be understood in terms of lack of space. Prinzhorn had to choose from among thousands of pictures, many of which were mas-

terpieces. However, in the case of Natterer, he omitted a large body of work that reflected a very different aspect of the artist's personality, work executed in a totally different style, and yet dating to the same years. Natterer began to draw in 1911. At the same time that he was involved in making drawings and watercolors in a linear geometric style, he was executing finished paintings in what appears to be varnished watercolor, or tempera, in a brightly colored, very realistic, finicky style. There are many of these realistic works in the collection, and it is apparent that Prinzhorn omitted them because they are singularly ugly and banal. It is difficult to believe that they are the work of the same artist. To the psychologist they present challenging problems of interpretation, particularly because of the erotic imagery present in some. Prinzhorn, by omitting them, avoided the difficulty of incorporating them into Natterer's oeuvre. But clearly, his motives for this omission have nothing to do with psychology. He acted as a committed art critic determined to show his artists in their best light and to conceal any work that might weaken the powerful impact of their graphic productions. The sensitive observer would be intrigued and dazzled by the rigorous inner logic and consistency of the best of Natterer's work, by the beauty of the technique, and by the originality of vision. They are worthy of comparison with the finest Surrealist work. Prinzhorn knew that the same sensitive viewer would be repelled by Natterer's realism, and despite their psychological importance, he simply omitted all but the briefest allusion to them. "Besides these, however, he has painted a number of watercolors which are meant to be quite soberly realistic and whose detail was done with extreme patience and pedantry. Only the detail distinguishes them from the usual attempts by amateurs" (p. 163).

As one studies the collection, this critical decision-making process can be seen to motivate Prinzhorn again and again. It becomes obvious that the book was primarily designed for the lay public and the art lover, and that it had a concealed, but profoundly influential, purpose. As Prinzhorn saw the situation, "only those who gain access to our material because they are artists or friends of artists, or who immerse themselves deeply in the literature of artistic creation, stand on common ground with us" (p. 28, n. 18). It is no criticism of Prinzhorn to say that his absolute devotion to these artists and their art was the dominant factor motivating his book. His brilliance as a psychologist is best seen in his ability to convince without argument, to mold opinion while appearing to be objective, and to impose his own vision while discussing the visions of others. Having chosen the most powerful images he could find, he allowed them to speak for themselves, indulging only occasionally in the beautiful critical and descriptive prose of the art historian.

Natterer's explanations, far from explaining his work, merely provided the associative context upon which a convincing interpretive study might be based. Prinzhorn, however, adhered to his decision to avoid any interpretive activity. In part this decision was based on the recognition that the task of publishing the enormous collection he had assembled precluded detailed exploration of individual works. Prinzhorn intended to devote a second publication to a monograph on a single painter, the artist Hermann Heinrich Mebes (b. 1842) (Plate 12), and the investigation of symbols was to form an essential part of that monograph. "This case [that of Mebes] is especially rewarding because of the thoroughgoing parallels of its written, often concisely phrased, observations to the extremely finely executed pictures, and it will shortly be published in a monograph. However it imposes very difficult puzzles when it comes to the creation of symbols (p. 92, n. 27). He knew that symbolic interpretation was the fundamental problem inherent in the study and understanding of psychotic art, and the central task of any psychological investigation. "The major charm and also the real cognitive value of our pictures becomes clear only when we succeed in making progress in the interpretation of symbols. But the study of symbols is not yet so well grounded that we could simply rely on it" (p. 240, n. 31).

Prinzhorn made it quite clear that his approach to the task would involve applying psychoanalytic interpretive methods. His failure to undertake the task should not be seen as evidence of hostility to the psychoanalytic viewpoint. "A purely psychiatric approach is insufficient; a psychoanalytical one is rewarding particularly in thorough interpretation of symbols, but only when the analyst has a great deal of knowledge and critical ability" (p. 240). Perhaps Prinzhorn had in mind an analyst trained as an art historian?

Prinzhorn's familiarity with psychoanalysis went back to his student days in Vienna, and although he was not closely associated with the circle around Sigmund Freud, he was already reading the literature before World War I. In 1921 he spoke on the topic of the drawings of the mentally ill at the famous Wednesday meetings of the Vienna Psychoanalytical Society with Freud in the chair.[46] His attitude toward the psychoanalytic investigation of symbols is suggested by the following quotation.

The only impulse of any importance which has prepared the ground for the study of symbols once again came from Freud, Jung, and their followers. It does not matter what limits anyone believes he must set to any interpretation of symbols by members of this circle: if the desire for an investigation into the mysterious origins of symbols and their effectiveness in the lives of individuals as well as society once again interests a large number of people, at least one seed from Freud's school bears fruit, even in his opponents.[47]

In this first book Prinzhorn can already be seen pushing hard against the confines of psychiatry, trying to force the door open for a discussion of psychological problems within psychiatry. Prinzhorn brought to psychiatry a depth of human insight and of psychological curiosity that was ill-adapted to survival in the German psychiatric circles of the 1920s. That he abandoned psychiatry for the practice of psychotherapy and psychoanalysis after his departure from Heidelberg suggests that his consuming interest in the workings of the human mind was not finding sufficient outlet in the practice of hospital psychiatry. It is not impossible that his reluctance to make use of psychoanalysis in his study of psychotic art may have been due to the extremely hostile attitude of German psychiatry to the psychoanalytic school.

Prinzhorn's book was greeted with considerable interest in analytic circles. It was reviewed in positive terms by Oskar Pfister in *Imago*, Freud's journal of applied psychoanalysis,[48] who nevertheless pointed out:

Prinzhorn assumes a position friendly to psychoanalysis; he is, however, by no means willing to make use of it. While in terms of the stance of modern scholarship this may seem desirable, the result for him is that he is left standing at that point in his research where the most important, interesting, and rich sources of information begin. Methodologically it would have been more correct to have carefully analyzed at least a small number of representations, and to have revealed the underlying unconscious motivation.[49]

Pfister nevertheless expressed his high admiration of Prinzhorn's work, emphasizing its interest not only for psychiatric circles, "but for the art lover, and the whole cultural world."[50]

At times Prinzhorn appears to be moving toward a Jungian position in regard to the possibility of a phylogenetically determined content in psychotic art, a possibility that he raised in his discussion with the Vienna Psychoanalytic Society. "We avoid speaking of phylogenetic remains, regression, and archaic thinking because these concepts did not seem to us to do the facts full justice, no matter how significant they may be" (p. 273).[51] However he considered the possibility that "our patients are in contact, in a totally irrational

way, with the most profound truths, and have produced, unconsciously, pictures of transcendence as they perceive it. . . . There are psychic forms of expression and, corresponding to them, representational configurations which would necessarily be almost identical for all people under identical conditions, somewhat like physiological processes (p. 242). In expressing this idea Prinzhorn came close to identifying himself with the Jungian conception of the Archetype. He seems to have felt that the study of symbols might well carry him outside of the sphere of the individual, a possibility that he left essentially unexplored.

In the final section of the book entitled "Results and Problems," Prinzhorn fully assumes the role of art historian. In an effort to distinguish the fundamental differences and points of contact between the spontaneous art of psychotic patients and the pictorial creations of children, untrained adults, primitives, and contemporary artists, he was forced to handle the descriptive analysis of form and content with a degree of subtlety never before encountered in studies of the art of the insane. For the first time since Réja, these deceptively simple problems were approached with an understanding of their complexity, which promised some measure of success.

Again and again investigators of psychotic art have tried to categorize the essential features of "insane art." The question has dominated the history of the subject, absorbing the energy of otherwise excellent minds, and obstructing the development of more fertile approaches. In some cases it led to fallacious and glib attacks on modern art. In its more subtle form it led into the dead end of the diagnostic approach, with the attempt to group the drawings into psychiatric categories reflecting the various syndromes. Prinzhorn ridiculed the diagnostic use of drawings: "Anyone unable to make a diagnosis without the drawings will certainly not have an easier time with them" (p. 3). He refused to indulge in the making of quantifiable lists of formal characteristics and the typical subject matter of schizophrenic art. His psychological "urges" or "drives" are of no use in this regard in that they apply to all forms of artistic expression.[52]

While admitting that all of his pictures convey a common fundamental quality, which being affective is hard to put into words, he insisted that "it seems possible that we can find parallels to a great many types of drawings done by the mentally ill among those done by healthy people, and that it would be hard to distinguish between them" (pp. 249–50).

The final result of our survey is rather modest. We cannot say with certainty that any given picture comes from a mentally

ill person just because it bears certain traits. Nevertheless, we were immediately impressed by a disquieting feeling of strangeness in many of our pictures which we always believed to be due to the schizophrenic components . . . because we give the greatest importance to the direct resonance within our own receptive selves whenever we attempt to penetrate strange psychic life. . . . Let us try to identify, with the least possible systematization, the quality of those pictures which are most different from all other pictures. We cannot do this except by putting ourselves in the painter's place and trying to understand his total attitudes toward creative tendencies, his own self, and his surroundings. . . . We can finally distinguish the last and perhaps the only distinctive difference between typically schizophrenic configuration and all other configuration. It is essential to all art to seek resonance in other men. The certainty of such a resonance supports every artist and nourishes his creative urge. The confidence that "the world" will at least someday happily accept what the misunderstood artist, though filled with contempt for it, creates, lies behind even the most distorted, negative attitude toward the public. Given this outlook on the world, the loneliest artist still remains in contact with humanity. . . . The schizophrenic, on the other hand, is detached from humanity, and by definition is neither willing nor able to reestablish contact with it. If he were he would be healed. We sense in our pictures the complete autistic isolation and the gruesome solipsism which far exceeds the limits of psychopathic alienation, and believe that in it we have found the essence of schizophrenic configuration. (pp. 265–66)[53]

In straining to find words to encompass the kind of feelings awakened in him by this art, Prinzhorn was driven to exaggerate the autistic withdrawal of the schizophrenic and his lack of interest in communication. He was well aware that these paintings represented successful communications, and an effort "to build a bridge from the self to others" (p. 13). His interest and his primary goal lay outside of classification and characterization. "In any case we are much more interested in those characteristics which cannot under any circumstances be considered pathological, and in those which are the bearers of positive creative values rather than in the recognition of suspicious traits" (p. 234). Psychiatry having been dismissed, he was free to explore the masterpieces of psychotic painting as art.

As the book neared its conclusion Prinzhorn was led to clarify the implications of his aesthetic and critical attitude toward the art of the schizophrenic master. "The differentiation of our pictures from those of the fine arts is possible today only because of obsolete dogmatism. Otherwise there are no demarcation lines" (p. 274). "Some of our works are so clearly artistic that many an average 'healthy' work is left far behind" (p. 271). In the effort to force acceptance of the schizophrenic master and his work within the canon of art,

Prinzhorn anticipated many of the revolutionary principles of the later "Art Brut" movement (see chapter 17). As an art historian he belongs firmly within the avant-garde of his day. There is in him a healthy disrespect for tradition, academies of art, and aesthetic dogmatism. Opposed to art education at all levels, Prinzhorn enunciated his belief in the creative potential of all men.

The persons who produced our pictures are distinguished by having worked more or less autonomously, without being nourished by the tradition and schooling to which we attribute the majority of more customary works of art. . . . The configurative process, instinctive and free of purpose, breaks through in these people without any external stimulus or direction—they know not what they do. . . . Nowhere else do we find the components of the configurative process, which are subconsciously present in every man, in such an unadulterated state. . . . Tradition and schooling can influence the configurative process only peripherally, by promoting, through praise and reproach, rules and systems. There is, however, a kind of intrinsic process; the preconditions for its development are present in every person. . . . When the configurative instinct emerges spontaneously in mentally ill persons after years of hospitalization, . . . an ability common to all men which usually remains latent or withered is suddenly activated. (pp. 269–70)

Prinzhorn's aesthetic, his acceptance of the work of children and untrained adults, of primitive and psychotic artists, is an outcome of the revolutionary understanding of art postulated by the German Expressionist movement with its radical conception of the origin and function of human expression, its rejection of academic and bourgeois artistic ideals, and its openness to man-made images of the most primitive kind. The split that this opened in artistic circles in Germany is reflected in Prinzhorn's description of the reaction of professional painters to his pictures.

As far as the pictures' relationship to contemporary art is concerned, we were able to observe a succession of reactions which clearly showed the influence of emotions or personal interest on every individual judgment. Whereas culturally conservative and historically oriented persons either did not react to the individuality of the pictures at all or tried to reinterpret fleeting impressions into cultural and political tendencies, all the observers who live with the problems of pictorial configuration or are closely involved with abnormal psychology responded eagerly to the works. Some of the artists, among them conservatives and, on the other hand, extreme expressionists, gave themselves up to calm study of the pictures' peculiarities, admired numerous pictures without stint, and dismissed others, without even considering dividing them up into those that are healthy and those that are sick. Others again, belonging to very different schools, renounced all the material as non-art, but nevertheless paid

lively attention to all its nuances. A third group, finally, were shaken to their foundations and believed that they had found the original process of all configuration, pure inspiration, for which alone, after all, every artist thirsts. (pp. 270–71)

Prinzhorn knew that the advanced artists of his day rejected tradition and were starved for images of pure, almost barbaric intensity. Total subjectivity and the cultivation of extremely private personal styles were essential aspects of Expressionism as a movement. Psychosis too inspires the development of a personal style. "The habit of using all external things only as grist for their psychic mills immediately leads even relatively modest talents into a more or less symbolic but nevertheless firm and consistent language of form—into a personal style. . . . A highly valued artistic quality emerges from the autistic turn away from the world" (p. 236). Following their own evolutionary development the Expressionists had created an art that was on occasion strikingly similar to the art of the insane. To assume on the basis of this similarity that the artists themselves were mad was, as Prinzhorn pointed out, no less ridiculous than assuming "that Pechstein and Heckel are Africans from the Camerouns because they produced wooden figures like those by Africans from the Camerouns" (p. 271).[54]

In recognizing that artists might approach the inner world by totally different paths, and that the professional artist might attain to experience similar in intensity and quality to that of the psychotic by conscious and rational decision, was an insight that prepared the way for the psychoanalytic concept of creativity as controlled regression. On the other hand, Prinzhorn's speculation concerning the possibility that the art of his day might reflect a schizophrenic outlook present in the spirit of the times was a hypothesis that has continued to be advanced during the twentieth century, a century in which mass psychopathology found expression in two world wars and the slaughter of millions of human beings. To recognize that art serves as a sensitive inner barometer capable of reflecting disturbances in the human psyche is not the same as denigrating art as pathological. Prinzhorn's contribution was to have forced the recognition that there is no psychopathology of art or expression, and that man's images, to the extent that they embody and communicate human reality, however strange or pathological that reality may be, belong firmly and without qualification to that sequence of unforgettable images to which we give the name art.

The World of Adolf Wölfli

Of all the countries in Europe, Switzerland has a unique relationship with the art of the insane. Just as outcasts and exiles found sanctuary there, along with revolutionary ideas that were unacceptable elsewhere, the spontaneous art of psychotic people might be said to have found a home in Switzerland. In recent years Switzerland has opened its public art galleries to the work of schizophrenic masters on a scale and in a manner that suggest these images have found acceptance as art. In Lausanne the first art museum devoted primarily to the spontaneous art of the insane, the Collection de l'Art Brut, was opened in March 1976 (see chapter 17). However, Switzerland's contacts with this art can be traced to the beginning of the century, to early collections in hospitals outside of Bern and Geneva.

In this country psychiatry too appears to have been unusually receptive to the visual products of patients, and systematic collecting by members of the Swiss Psychiatric Association was underway well before World War II. While psychoanalysis was encountering ridicule and hostility in Austria and Germany, it found its first foreign adherents in Switzerland, and this fact is reflected in the early development of psychoanalytically influenced approaches to the symbolic productions of the insane. In the work of Carl Jung (1875–1961) there was from the beginning a sensitivity to visual images and symbols unknown in earlier psychology. The use of spontaneous pictures in the context of Jungian analysis can be traced to Jung's own experience of psychosis, and of the function of drawing and painting as an aspect of it.[1]

That psychotic art has found acceptance in Switzerland is in part accounted for by the fact that two of the greatest "schizophrenic masters," to use Prinzhorn's term, worked and were discovered in this country: Adolf Wölfli of Bern (1864–1930), and the woman painter Aloïse (1886–1964) (Plate 28). Both produced works of such extraordinary intensity that it was difficult to deny them the status of true artists. These two painters have slowly gained recognition as masters of painting, and their work, undeniably embodying their experience of the schizophrenic state, has forced its way into the permanent collections of public galleries in Switzerland: the paintings of Aloïse in the Cantonal Museum of Fine Arts, Lausanne; the work of Wölfli in the art museums of Bern and Basel.[2]

The unusual openness of the Swiss museum directors and collectors is not easily explained. Certainly Switzerland has been receptive to avant-garde art of all kinds, and the Swiss pride themselves, despite their conservative behavior in other directions, at being in the forefront culturally. The work of Swiss artists, particularly Paul Klee (1879–1940) and Alberto Giacometti (1901–1966), as well as the members of the Dada movement in Zurich, have also forced the Swiss to examine their aesthetic convictions. The nature of the work of these artists inevitably raised questions about the private or subjective aspect of symbols and the function of the extremely personal work of art. Klee directed the attention of his contemporaries to the art of the insane, and his own work, more than that of any artist, was calculated to awaken the sensitivity of a receptive public toward the art of children and psychotics (see chapter 14).

The works themselves command attention and respect. As an artist, Adolf Wölfli, madman or not, could not be ignored for long.[3] It is curiously just that the Wölfli Collection should have come to reside with the Klee Collection in the art museum of Bern. It is no exaggeration to view these two artists as Bern's most significant contribution to early twentieth-century art, and as artistic equals.

Before turning to these matters we should pause to consider the contribution of Dr. Charles Ladame (1871–1949) to the study of psychotic art.[4] A psychiatrist of considerable reputation, president of the Swiss Psychiatric Association, Dr. Ladame is known to have been collecting patient art from at least 1915 on. In 1925, when he assumed the post of medical director at Bel-Air, a private psychiatric clinic near Geneva, he was able to obtain space for the permanent exhibition of his collection. Arranged in three rooms in a villa that formed part of the hospital, the collection was open to interested visitors until 1938. The artistic quality of the works displayed is attested to by that part of the collection that has survived intact. The

elaborate pictorial structures of Robert Gie (b. 1869), for example, while undoubtedly related to a paranoid delusional system of the influencing machine type, are extraordinarily powerful images capable of independent existence (Plate 13). Other works in the collection are far more primitive, almost rudimentary, suggesting that Ladame's interest was focused on the psychiatric implications of the collection. He published at least one short article on the art of the insane, entitled "A propos des manifestations artistiques chez les aliénés."[5] A set of notes on the pictures in his collection, now in the possession of the Musée de l'Art Brut, throws further light on the nature of Ladame's interest in this art.

The case of Julie Bar (1868–1930) can serve as an example of his approach. She was transferred to the Bel-Air clinic in 1916. Diagnosed as suffering from severe epilepsy, her condition was complicated by her mental retardation. She died in the same year as Wölfli, 1930. Dr. Ladame writes, "She was unable to respond to schooling, and incapable of any sort of work (knit-

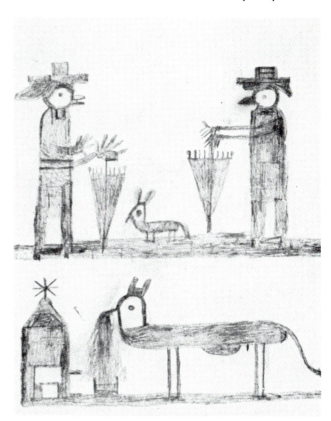

13.2. Julie Bar, two bird-headed people with umbrellas, ca. 1920, Collection de l'Art Brut, Lausanne.

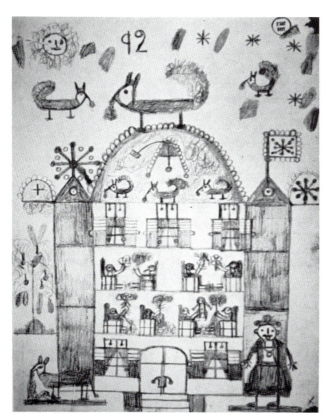

13.1. Julie Bar, the interior of a house, ca. 1920, pencil on paper, Collection de l'Art Brut, Lausanne.

ting, sewing etc.). Although she was willing to help with the housework, her good will largely surpassed her ability. Her parents had neglected her completely."[6] Her language ability was exceedingly limited, and she had a poor awareness of where she was, of time, and of the identity of the people around her. She is said to have had little interest in events in the environment. Thus far we have a fairly typical psychiatric description.

However, Bar was devoted to drawing. "In her better moments she drew ardently, and was very satisfied with her productions, beaming happily when someone complimented her on them."[7] The richness of the inner world made visible in her childlike drawings puzzled Dr. Ladame (Fig. 13.1).

One asks oneself, taking account of her extremely low position on the ladder of intelligence, how Julie could have conceived of the subjects which she drew, and particularly, how she was able to build pictorial compositions out of the scattered motifs which she habitually used. I never saw her take any interest in the pictures in books or illustrated magazines.

There seems to have existed in that brain with its rudimentary functions, an active, coordinating intelligence. One sees here, an example of the opening up of latent possibilities which mental illness can sometimes bring about.[8]

Bar drew in black pencil, only rarely using a little color. Her "trademark" was a tendency to supply her primitive drawings of the human figure with a beak-like nose, and she may have intended the heads to be bird heads. She also did extraordinary drawings of animals eating, which she repeated again and again (Fig. 13.2). Bar's inability to speak frustrated all attempts to discover the meaning of the drawings with which she filled countless notebooks, but it is clear from Ladame's notes that he was aware of the enormous importance of her drawings, and of image-making activity, in the all but empty life of their creator.

In 1921 Morgenthaler's *Ein Geisteskranker als Künstler* was published in Switzerland.[9] This book, both in its scholarly and art critical brilliance and in the extraordinary quality of the artist to whom it was devoted, must stand beside Prinzhorn's publication as a classic contribution to the literature of the art of the insane. Hans Prinzhorn died in 1933, at the age of 47, without having written his second book on psychotic art, the full-length study he had planned on the schizophrenic painter Hermann Mebes. Having created the concept of the schizophrenic master, he had hoped to embody it in an art historical and psychoanalytic investigation of the work of a talented artist-patient about whom he had amassed much information. Whatever prompted his departure from the Heidelberg Clinic, the loss of the material there ended the project.

Morgenthaler's book had appeared the year before Prinzhorn's publication. A deeply serious presentation and elucidation of the work of a patient, Adolf Wölfli of Bern, the book was an art historical monograph and biography that attracted enormous attention in European artistic circles. Aesthetic questions about the art of the insane came to a focus in this book, which prepared the way for Prinzhorn's wider and more theoretical treatment of the subject. The encyclopedic range and haunting formal power of Wölfli's work impressed artistically sensitive people, and Morgenthaler's account of his life, and of the role of artistic creation in it, demanded response and an enlargement of aesthetic opinion.

In 1921 Walter Morgenthaler (1882–1965) was a psychiatrist newly in charge of a private mental hospital at Münchenbuchsee near Bern (Fig. 13.3). He had come to know Wölfli while employed at the Waldau Asylum, a large psychiatric hospital also on the outskirts of Bern, at Bollingen. His association with the Waldau had begun in 1908 when he did his psychiatric internship at the hospital. In 1913 he was made physician in chief of the psychiatric clinic there, where he remained until 1919. During these years he came to know Wölfli, who had been a patient in the Waldau from 1895. *Ein Geisteskranker als Künstler* helped to establish Morgenthaler's reputation, as did his championing in 1921 the work of Hermann Rorschach, for whose famous psychological test he arranged publication.[10] Like Prinzhorn, Morgenthaler moved away from the practice of hospital psychiatry, developing into a psychotherapist of unusual accomplishment, a trend that was already evident in his unusual effort to relate to his patient Wölfli.[11]

Morgenthaler's interest in psychiatric art appears to go back to the time of his appointment as director of the Waldau clinic in 1913. Shortly after his arrival there he founded a small museum of patient art, the only such museum to survive today in its original form (Fig. 13.4). The museum became the repository not only of painting and sculpture produced by patients at the Waldau, but of material collected by members of the Swiss Psychiatric Association from other Swiss hospitals. The museum was also unique in that its decor was the work of a patient, having been elaborately decorated by Wölfli.[12] The founding of the museum and its collection predates the beginning of the Heidelberg collection by some years, a fact that emphasizes Morgenthaler's position not only as a major contributor to the study of psychiatric art, but as a pioneer as well.[13]

Morgenthaler's purpose in undertaking an elaborate study of Wölfli's work was twofold. On the one hand he

13.3. Dr. Walter Morgenthaler.

was a psychiatrist making an unusually rich case available to his professional colleagues. But this task was subordinate to a far more unconventional aim. Morgenthaler was convinced of the artistic worth of Wölfli's enormous literary and pictorial output, and in writing a biographical monograph he sought to share his appreciation of this man's art and life with the nonmedical public. Believing in Wölfli's great talent, he sought to reach beyond the walls of the asylum, and beyond the isolation in which Wölfli lived, to make his paintings and writings available to the public. The title of the book, *A Mental Patient as Artist*, conforms to this nonpsychiatric goal. In his essentially art-critical endeavor Morgenthaler succeeded brilliantly with the result that Wölfli achieved fame as an artist in Europe well before his death in 1930. Wölfli wanted his own name to be used in the book; he knew of his fame, and in fact was taken to see the first public exhibition of his pictures in Bern.[14]

Morgenthaler's psychiatric orientation was firmly based on the framework provided by Kraepelin, with whom he studied briefly in 1908, and on the Zurich school, which was profoundly under the influence of Eugen Bleuler (1857–1939). Bleuler was a psychiatrist whose insight into the nature of psychotic experience interested many physicians in such conditions, particularly in the reality of "schizophrenics," a term Bleuler introduced in 1911. Morgenthaler thus represents a very advanced psychiatric, but prepsychoanalytic, viewpoint. He knew the writings of Freud, and his book on Wölfli was probably inspired by his discovery of Freud's Leonardo study of 1910.[15] However, his discussion of Wölfli's work is little influenced by Freudian methodology or insight. As a psychiatrist, Morgenthaler was led to this investigation by the overwhelming conviction that "the mentally ill, from whom the veneer of convention has fallen away, would provide one with an opportunity to see deeper into the structure of humanness, and to penetrate the psyche more deeply, than would be possible with healthy people."[16] He begins his study with a quotation from Ebbinghaus, "Pathological phenomena represent, for the understanding of normal psychology, something similar to the way in which the magnifying glass allows us to see things which are difficult to perceive with the naked eye."[17] Morgenthaler thus understood that his research into the life and work of his patient had implications well beyond psychopathology. "The case was selected because it appears to throw light as well on problems which in more healthy artists are still obscure" (p. vii).

Morgenthaler's art historical and aesthetic knowl-

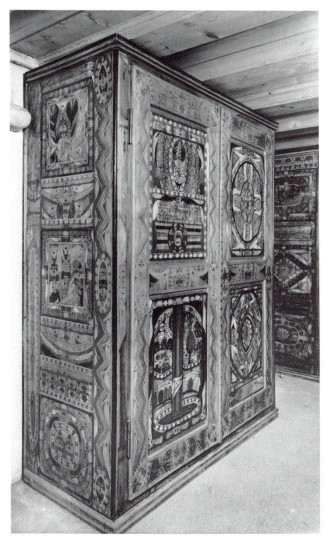

13.4. Interior of the Morgenthaler Museum, Old Waldau Asylum near Bern. Painted cabinets by Adolf Wölfli.

edge, while not as extensive or sophisticated as that of Prinzhorn, was far from superficial. Much of his study is written in the language of art scholarship, and he was familiar both with the contemporary literature of art criticism, and with the main artistic currents dominant in the art of the first quarter of the century. His acute visual perceptiveness is more than apparent in his brilliant analysis of Wölfli's personal style. His detailed knowledge of modern art and art theory is in part explained by the fact that his brother Ernst (1887–1962) was one of the leading contemporary Swiss painters. The book seems to reflect serious discussions of Wölfli's art by the two brothers and their

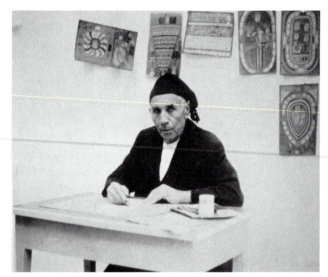

13.5. Adolf Wölfli at work, Adolf
Wölfli-Stiftung, Kunstmuseum, Bern.

circle of friends. Certainly, Morgenthaler introduced numerous artists to Wölfli's work, and was deeply interested in their reactions to it.

ADOLF WÖLFLI (Fig. 13.5) is one of the greatest psychotic artists. His significance is enhanced by the fact that his work has broken through the barrier separating the art of the insane from that of healthy painters. We will discuss the processes that led to this final revolutionary development in chapter 17. For the moment, our task is not to study Wölfli and his work, but to evaluate the scope and significance of Morgenthaler's approach to the work of a psychotic artist. We will touch on Wölfli only to the extent necessary to comprehend Morgenthaler's undertaking: the problems he faced, the questions he asked, and the procedures he developed to answer them.

Wölfli's creative drive was unbounded. Over a period of more than thirty years he produced a body of work so vast that its sheer mass presents a problem to scholars attempting to study it.[18] His creativity flowed in many directions. Apart from producing thousands of colored drawings of various sizes, he wrote prose and poetry and composed music. The most significant part of his oeuvre consists of forty-four enormous volumes of drawings, writings, and musical compositions, which incorporate his profoundly personal and yet encyclopedic world view. The transcription of his written production will require many years.[19] It is therefore

not surprising that Morgenthaler was forced to limit the scope of his investigation to a small part of Wölfli's output, concentrating his attention on only one of the forty-four volumes, from the period 1912–1914, and a small number of separate drawings. It must also be remembered that Wölfli continued to work for nine years after the publication of Morgenthaler's book.

In studying the artist's work Morgenthaler was assisted, and yet his task was rendered immensely more difficult, by the fact that he knew Wölfli well. Wölfli was motivated by a compulsive drive to embody his private world in concrete form, and to communicate the nature of his reality. At times he stepped from within his powerful delusional reality, recognizing the tragedy of his life situation, and the possible significance of his work to us. One of his books bears the statement, "In sum, all the content of this little book is that it reflects the spirit, the attitude, and the character of an insane person, as the title at the beginning suggests clearly. At bottom it is also a faithful representation. I hope in this way that the friendly reader will be able to appreciate, at its true value, this pastime executed in my cell in the insane asylum" (p. 16). In the light of this passage, Morgenthaler's book must be seen as a collaborative effort carried out with the cooperation of the artist. However, most of the time Wölfli was so deeply withdrawn from the world that he could sustain no contact with anyone. He could not step out of his autism to explain what was happening to him, or to elucidate the meaning of his vision. In that endeavor Morgenthaler was entirely alone.

Morgenthaler's monograph on Wölfli may be compared with a typical art historical biography of the life and work of a contemporary artist. Compared with Freud's Leonardo essay, which is clearly a psychological study, Morgenthaler's book approaches pure biography and art criticism. The book is divided into two parts, reflecting Morgenthaler's wish to distinguish between observed or documentary fact, and theory and speculation. The first half of the book is a detailed account of Wölfli's life before and during his hospitalization, and a precise characterization of the content and style of his work—a purely historical and phenomenological approach.[20]

In writing a case history, any psychiatrist becomes a biographer. Inquiring into his patient's past, trying to distinguish historical fact from delusional distortion and pure fantasy, he is forced to adopt the historian's critical methods. Morgenthaler drew heavily on the hospital records for his biography of Wölfli, but the account is so detailed that it goes well beyond the bounds

of a typical psychiatric history. He made inquiries of people who had known Wölfli, and sought documents that might throw light on obscure periods of his life, or confirm Wölfli's own accounts of his past. (Morgenthaler was experienced in historical research.)[21] Wölfli was obsessed with his own history, particularly his first eight years, and he wrote rambling, fantastic descriptions of his early life. Faced with the task of reconstructing these years, and the problem of separating fact from fantasy, Morgenthaler acted much as any art historian attempting to write a life of an artist.

As Wölfli was insane when Morgenthaler came to know him, a central part of his endeavor consisted in trying to outline Wölfli's unique vision of the world and of reality, his own and that outside himself. But in attempting to account for this kind of strange and increasingly private vision, it is not evident that psychiatrist and art historian select different types of facts. Modern biography has been so much influenced by psychology that if it differs at all from a case history, it is more in terms of the interpretation of biographical fact than in the facts selected. The psychiatrist has a certain advantage in that he is usually in a privileged position in terms of the extremely personal nature of his knowledge of the patient's life, and perhaps in his estimation of which facts are of importance. When the patient happens to be an artist of extraordinary ability, such detailed knowledge can provide a unique opportunity to see into the workings of the creative process. Because Wölfli was psychotic, layers of his personality that are normally invisible were exposed. Although Morgenthaler was not a psychoanalyst, he seems to have felt that it would be of primary importance to possess detailed knowledge of Wölfli's earliest years, and his interest in this period probably reflects the artist's own obsession with it. All of his work could be understood as an allegorical reconstruction in art of his infancy and childhood.

Wölfli was born in 1864 in Nüchtern, near Bern. He lived with his parents, mostly his mother, until the age of nine, when his mother died and he was abandoned to the care of a series of foster parents who used him as a farm laborer. He was mistreated and received little schooling. He appears to have been a deeply withdrawn boy, difficult to manage or to relate to.

As a consequence of a series of sexual assaults on young girls he was imprisoned in 1890 at the age of twenty-six. His hospitalization in 1895 was the result of a further sexual assault and the recognition by the judicial authorities that he was mentally ill and dangerous to society. In the hospital Wölfli deteriorated rapidly, retreating into a private delusional world. During the early years of his hospitalization he was extremely violent and had to be isolated to prevent his dangerous attacks on other patients and the hospital staff. He experienced both auditory and visual hallucinations, and periods of wild excitement and uncontrolled behavior, while living in a world full of delusional beliefs, ideas of persecution, and megalomania.

The first five years of his illness can be characterized as an acute phase during which he reacted with extremes of panic and violence to the new world into which he had been plunged. During the whole of this time he showed no interest in any artistic activity, which in fact would have been quite out of keeping with his former life-style and personality in that he had had no art training and, so far as is known, had never evinced any interest in drawing. It was in 1899 that he quite spontaneously began to draw and write.

In Morgenthaler's account of the case he carefully avoided the use of any diagnostic label. Only later in the book does he identify Wölfli as a schizophrenic. His purpose in doing this is evident. In writing the book he sought to go far beyond such generalities to a precise and penetrating analysis of the nature of his patient's world view, and in so doing to enlarge upon and refine the term *schizophrenia*. It is difficult to realize how fashionable the term introduced by Bleuler had become. Interest in this syndrome was intense, and in publishing a case that could be said to make the illness visible, Morgenthaler recognized that he had the opportunity of arriving at a more detailed characterization of the experience of this one individual, who because of the power of his creative drive could communicate something of his private perception of the world and himself. Wölfli's picture world remains an extraordinarily convincing embodiment of the schizophrenic experience.

Morgenthaler's phenomenological orientation endeavored to provide insight through exact and detailed observation and description. He provides abundant information that can help to answer several questions. What was Wölfli like? How did his illness manifest itself in his behavior? What were his days like? How did his artistic activities fit into his daily routine?

Morgenthaler often sat with Wölfli while he worked, hoping to obtain insight into the imagery by observing how the pictures came into being. Wölfli could sometimes be induced to talk about what he was doing, to explain the content of his pictures as it emerged. Morgenthaler was willing to listen. It is striking how this change comes over twentieth-century psychiatry: sud-

denly the reality of the patient begins to be perceived as valuable by physicians; they no longer dismiss it— but more than this, they are moved by it, curious about it, seeking imaginatively to enter into it. Empathy had now become the essential method of understanding.[22]

As Morgenthaler moves from a description of those aspects of Wölfli's life and illness that differ only in detail from those of other similar schizophrenic patients, to a consideration of Wölfli's work, it becomes difficult to distinguish between the psychologist and the art critic. Inevitably, in the discussion of pictures, as opposed to patients, the physician is led to draw upon the methods and insights of the specialist in visual studies, just as the art historian attempting to grasp the significance and uniqueness of the life of an individual artist is forced to use essentially psychological viewpoints. In the same way that psychiatric thinking had undergone a profound change in the direction of increased subtlety and sophistication, the discussion of pictures by a few rare psychiatrists begins to reveal a noticeable increase in critical and art historical knowledge. In the case of Prinzhorn and Morgenthaler, the degree of sophistication is such that one views them as masters of both disciplines, in the borderland between psychiatry and art. In writing a monograph on the art of Wölfli, Morgenthaler was strongly influenced by critical studies of normal artists. His discussion of Wölfli's artistic accomplishment, and his analysis of Wölfli's style, conforms to the highest standard of art criticism, raising questions of profound importance to any student of human expression and creativity.

In approaching Wölfli's pictures Morgenthaler continued to attempt to separate observed fact from speculation, confining his interpretive efforts and theoretical hypothesizing to the second part of his book. The opening discussion is limited therefore to pure description of content, and then of form. With remarkable tenacity he sought to find words to characterize Wölfli's personal style not as "schizophrenic" but simply as unique form.[23]

Discussion of Wölfli's pictorial subject matter was made extremely difficult because of the vastness of his delusional system. The changed reality in which he lived extended far beyond the confines of his personality and of the small cell within which he preferred to live. Although his interest in the immediate environment was minimal, his altered conception of the universe, of history and religion, and of his place in them, led to an encyclopedic revision of an extraordinarily large range of subjects. As Morgenthaler explained, "Everything is represented, not only that which can be depicted, but in a more general way all that one is capable of thinking and feeling" (p. 43). Wölfli stood at the center of everything, not so much God as victim, and the history of the universe takes on mythological characteristics as it is understood in the context of his enlarged experience and understanding. His drawings were intimately linked with his verbal and written conceptions (Plate 18). It is therefore impossible to comprehend the meaning of the pictures in the absence of the texts. Most of the pictures function as illustrations, a more satisfying and concrete embodiment of the written mythology. Morgenthaler attempted to establish the nature of the connections between text and picture, pointing out how in his writings Wölfli's taste for magnificence was expressed through the use of large numbers, while in the pictures the complexity and richness of the form served to embody his monumental vision far more convincingly. Wölfli's verbal descriptions become repetitive and bombastic; his drawings never do.

His phenomenological approach led Morgenthaler to list the types of objects that occur most commonly in the pictures: people, both human and divine; animals; plants; architecture; celestial bodies; mechanical objects; and even letters, numbers, and musical notation. He resisted the temptation to leap into symbolic interpretation before examining the pictures to see what was there. Apart from its symbolic and mythological content, Wölfli's art is rich in imagery, full of "things" that can awaken interest and curiosity. His architecture and townscapes, for example, are worthy of independent study (Fig. 13.6). Even without symbolic overtones, Wölfli's world is a curious place in which to wander.

Because Wölfli attributed symbolic meanings to his pictures and to individual objects in them, Morgenthaler distinguished between the artist's explanations, which to his consternation often fluctuated from day to day, and his own interpretive endeavors. "It is symbolic subjects which are by far the most common in his drawings; all that he represents has a symbolic value in his eyes, far more so than is the case with the normal artist" (p. 44). But, as Morgenthaler points out, in the absence of a title, no one would know the significance of any scene that involves more than two people.

The majority of Wölfli's pictures show historical events, illustrations of his own life story. Some of them touch on actual events, as when he depicts his trial, or his assaults on young girls. Others are fantasy elaborations of his life experience in terms of epic journeys through the universe; the discovery of new cities, and planets; his meetings and marriages with gods; and

scenes of sexual intercourse, and of punishment in which he undergoes repeated execution. In such scenes he appears in his celestial guise as St. Adolf II, the name he adopted after 1916. At the center of this mythology is the theme of destruction and rebirth. Wölfli is repeatedly killed, executed or destroyed as a result of catastrophic falls. The mode of representation used for the depiction of these events is curiously static, his conception of history taking the form of a series of icon-like frozen moments (Fig. 13.7).

Morgenthaler was remarkably astute in differentiating the levels on which a descriptive investigation of Wölfli's subject matter might occur. There is a considerable difference between Wölfli's "explanation" of the event or idea that he sought to embody in a particular picture (that is, its subject) and a possible symbolic content. There is, as well, the necessary distinction between Wölfli's interpretation of the symbolic implications of his pictures, in the context of his personal mythology, and a psychologically or psychoanalytically based interpretation in terms of meanings that were in most cases unknown to the artist. In the first, or descriptive, part of his book, Morgenthaler was content to present the former; in the second he sought to penetrate more deeply into the relationship between the levels and types of symbolic content.

Morgenthaler was ahead of his time in recognizing that his interest in Wölfli's art would unavoidably have an effect on the artist and his work, and that the attempt to understand would influence the creative process. Wölfli was actively involved with drawing from 1899 on.[24] Some of his finest work was executed prior to Morgenthaler's arrival in 1908. For Wölfli the primary benefit derived from his physician's interest was the possibility of obtaining materials, paper and colored pencils, with less effort. Well before his death, Wölfli knew that he was famous and that his pictures were actively sought after. The result was, as Morgenthaler points out, that two distinct groups of pictures can be distinguished: those that Wölfli executed out of internal necessity—pictures that invariably formed part of the large books—and a second group that consists of pictures, often on smaller sheets, executed for other people, and for sale. Morgenthaler refers to these as "Brotkunst," sheets drawn for others in order to obtain pencils, paper, tobacco, or just to please. Interestingly, Wölfli kept records of all the pictures that he sold to Morgenthaler, Dr. Forel, or others. These pictures are often inferior productions, created outside of the great mythological record, and frequently were little more than dry imitations of himself, or even direct copies. Morgenthaler was the first to realize that the

13.6. Adolf Wölfli, *The Parliament at Ottawa*, detail, 1910, Collection de l'Art Brut, Lausanne.

13.7. (at right) Adolf Wölfli, *The Fatal Fall of St. Adolf*, ca. 1922, colored pencil, Collection de l'Art Brut, Lausanne.

interest of physicians could have a destruction effect on patient art, a fact that has since been made obvious by the efforts of art therapists working in mental hospitals.

In that Wölfli spent most of his adult life in one mental hospital, and, more precisely, in a single room of that institution, it was of interest to Morgenthaler to investigate, as we have done in the chapters on Dadd and Martin, the objective links between Wölfli's art and the outside world, and the question of possible pictorial influences acting upon him. Although Wölfli showed little interest in events occurring in his environment, and they entered into the subject matter of his art very little, he was fascinated by photographs of more distant places. These served him as a reference source for his depictions of his travels all over the globe (Fig. 13.6). His depictions of the old Canadian Houses of Parliament derived from an engraving. Morgenthaler points to at least one essential source of Wölfli imagery during the first period of his stay, "a review called *Uber Land und Meer*, 1870–1880. He cut pictures out and pasted them into his own pictures. He also had an old atlas. His historical and geographical concepts came from these reviews, but these external sources are only minimally important" (p. 13).

STRIKINGLY for a psychiatrist, Morgenthaler's primary interest and attention was focused not on subject matter but on problems connected with form. His admiration of Wölfli's art was based on an appreciation of the abstract elements that ordered it, and on the perception that a profound harmony and unity was inherent in everything he produced. Reflecting the preoccupation with nonnaturalistic form typical of early twentieth-century European art, Morgenthaler found no difficulty in accepting Wölfli's complete lack of concern with natural appearances. What had once been seen as the hallmark of insanity and the object of ridicule were now understood as the fundamental basis of Wölfli's artistic language, and the essence of his originality as an artist. Merc verisimilitude would not have satisfied Morgenthaler in any art, whether it was the work of a patient or not. As does Prinzhorn, he reveals how profoundly contemporary developments in art and criticism could alter the psychiatrist's understanding of his patient's paintings and drawings. Wölfli's view of the world was abstract, deeply personal, and systematically stylized. "It was never a question of fidelity to natural form. Forms are treated, on the contrary, in a style of complete abstraction; they submit to a true stylization. The result is a very defined and personal style, a style which might be termed geometric" (p. 78).

Like an art historian Morgenthaler struggled to define and characterize the uniqueness of Wölfli's personal style. In his transcription of the world the third dimension was abandoned, modeling was largely avoided, and the surface of the picture was emphasized. Wölfli disliked empty space. He filled every part of a picture, and then wrote inscriptions on top of the pictorial forms (Plate 22). "The distaste for empty spaces was a characteristic trait in Wölfli's pictures, as well as his tendency to draw all over the paper, and then to cover the drawing with inscriptions. This "horror vacui" is particularly noticeable in the earlier drawings that we know from him, but less clearly than is the case with the more recent ones" (p. 51). He explores Wölfli's use of symmetry, his taste for repeated forms, and the rhythmic organization of the picture surface. Wölfli's preoccupation with music led him to impose a musical structure on his pictures, tying the large surfaces together with curvilinear bands of written music, and employing musical notation in purely decorative patterns.[25]

Morgenthaler describes Wölfli's characteristic mode of drawing the human face or hand, trees, and buildings. Every form was somehow submitted to an identical process of abstraction. Every picture is held together by a structure of pure ornament, which begins at the edge as a framing motif, and each figural motif is surrounded by a matrix of abstract form. Whether these ornaments were purely decorative or, at least in some cases, symbolic was a question Morgenthaler sought to understand. Many of the questions that trouble art historians investigating "pure form" were also provoked by Wölfli's art.

One of the most constant of Wölfli's ornaments was the so-called bell motif or as Wölfli called them, "Glöggli-Ring."

It is his favorite framing motif—a series of small disks or spots linked by a narrow band. The bell itself is a round form, semicircular or oval, white, black, or shaded. In some of his earliest drawings, one finds, in place of these forms, actual rows of bells with the clappers in them; in a few of the first drawings, the ring of bells is made up of a line of small trees, with oval crowns of foliage and short thick trunks, pyramid-shaped—these may also have inspired the bell design. Finally, the motif may have originated with the human head: several of the first rings of bells consist of heads seen from the back, showing a thick neck and part of the shoulders. (p. 49)

Morgenthaler was sufficiently familiar with the evolution of Wölfli's art to be able to trace the genesis of abstract forms and to witness the process whereby once representational images were metamorphosed into abstract ornament.[26]

Sitting at the table with Wölfli as he drew, Morgenthaler sought to gain insight into the creative process (Fig. 13.5). It was apparent that Wölfli, in beginning a drawing, had no overall plan, no sketch, and no conscious principle of organization.

It was rare, in fact, that Wölfli made a truth sketch. In most cases, after having scarcely indicated a few contours, he began at some point on the edge of the sheet, making first the frame, and then working in successive areas, moving towards the center. After having tried various methods, he said it went best this way. He knew how to distribute his colors with astonishing confidence. One noticed this especially when he was lacking certain colors. He would then distribute those which remained in such a way as to maintain constantly a harmonious ensemble, even if he had only one or two. . . . One noticed that despite the absence of any plan, detail was always subordinate to, or sacrificed to, the whole. (pp. 50, 78)

Morgenthaler questioned Wölfli about what he was doing, and was forced to recognize that whatever the process, it was unconscious.

It is quite certain that Wölfli was unaware of this harmony which he constructed. He had only a vague goal—to make something beautiful. How to go about this in detail, and why to do it in this way and not another, he hadn't the least idea. His attempts at explanation concerned only the subjects of

his pictures. If the meaning of a detail was unknown to him, he would say it was decoration, or refuse to explain. (p. 52)

Although he devoted hundreds of hours to such observation, Morgenthaler was obviously frustrated by his inability to see into the creative process unfolding so effortlessly before his eyes.

Another question to which he devoted his attention was whether Wölfli's art had changed over the years. Could one truly speak of a development in the vision of the world that was reflected in the pictures? In answering this question Morgenthaler reveals his integrity as a physician and his honesty as a critic. There was no evolution.

Wölfli nourished himself from the excess of psychic capital which he possessed from the beginnings of his illness, without being able to acquire anything new from that time on. Even today he searches with real tenacity for new place names in the atlas and old periodicals, in order to transform them and utilize them for his idea. But this doesn't represent an enrichment for him, and contributes nothing to his evolution. It is for this reason that one cannot truly speak of his drawings in terms of progress or of increasing perfection due to the enlarging or deepening of his personality. The endless variation of his drawings all originates in a few fundamental themes, which over tens of years have never changed. (p. 52)

The tenacity with which Wölfli held to his inner vision of reality astonished Morgenthaler. Wölfli's memory seemed at times to be photographic.

The earliest drawing of the sun which we possess was drawn in 1904. The drawing was taken from him and rested forgotten in a cupboard. In 1919 another sun appeared, exactly like the first, with seven rings in which two contained exactly the same number of bells, and the sixth was similarly decorated with polyhedrons. Around both suns he had arranged exactly sixteen stars etc.—and all this without having the slightest recollection of the first picture. This amazing resemblance between pictures separated by so great a time lag, during which he drew hundreds of others, can only be explained on the basis of an absence of any evolution. (p. 53)

The one element of change that Morgenthaler detected was a hardening of Wölfli's imagery, a quality of dry rigidity that seemed to creep over his art with the passage of time.

His earliest drawings are far more animated and usually of greater psychological interest. His complexes reveal themselves in them more often and more clearly. The drawings of the last few years are very much less comprehensible from a psychological point of view; the forms are stiff, and have become more conventionalized. They move further and further away from nature, and represent for us increasingly impenetrable symbols. But thanks to this increasing fixation, the pictures have acquired still greater formal unity, the drawing

and color are more systematized, and, in a word, they have become much more decorative. (p. 53)

Despite Morgenthaler's familiarity with contemporary art, and with the art historical and critical literature, he avoided the temptation to indulge in unnecessary debate as to whether Wölfli's work was art. He was content to allow Wölfli's pictures to speak for themselves. His act of faith was inherent in the decision to publish and reproduce the work, and he relied on the sensitivity and openness of the reader to establish the uniqueness and originality of the images. Throughout his study he resisted the tendency to draw easy comparisons between modern art and Wölfli's images. He does point out, however, that contemporary artists who saw Wölfli's work found no difficulty in accepting his vision as relevant to their pursuits. He warns against facile comparisons, reminding the reader that Wölfli was insane, and that his purpose in drawing the forms he did might well be very different.

If an architect chooses to pull an old house down in order to construct a better one in its place; and if on another occasion a house is destroyed by an earthquake, the field of ruins which results can appear to be exactly similar. Modern artists, most of whom are hyperintellectual, are oversated with traditional culture. They seek through systematic destruction of traditional forms to return to certain fundamental underlying elements. With Wölfli, however, due to a pathological process which destroyed his rationality, and other psychic functions, such fundamental elements were brought to light. These are raw and clumsy, but they are primordial too. In these works part of the powerful and fundamental artistic foundation lies uncovered, elements which certain modern artists, through their conscious demolition efforts, had been the first to search for. (pp. 89–90)

Wölfli's view of the world was undeniably pathological. Morgenthaler realized that Wölfli's essential contribution as an artist had been to embody this strange, alien, and at times terrifying reality in a completely unified, rich, and convincing form. Through Wölfli we glimpse the dark recesses of a buried world that, with courage, we can recognize as our own.

In Wölfli, thanks to the processes inherent in his illness, the unity of his personality underwent a sort of explosion, and was, in part, destroyed. But it was precisely thanks to this, thanks to the loosening and the dispersal of the superior strata of the mind, that a magnificent structure was made visible. The astonishing clarity of this vision shows to what extent Wölfli was possessed of a fundamentally artistic predisposition. Without doubt this expression of the experience of illness is disturbing to the viewer, but this in no way denies its artistic interest.[27]

Morgenthaler's belief in the importance of Wölfli's

work was not based on the misguided notion, which has dominated so much of twentieth-century criticism, that the originality of an artist's vision, the bizarre uniqueness of his forms and ideas, somehow merit recognition, as though insanity is somehow valuable of and for itself. As he points out, "In any large hospital a number of patients can be found who write poetry, or draw, and consider themselves on this basis to be great artists. . . . Bizarre new creations are a daily event with schizophrenics" (p. 81). He was well aware that Wölfli's extraordinary talent was not typical of schizophrenics, and that besides being a schizophrenic Wölfli was also an artist.

To demonstrate the great distance separating Wölfli from other visually productive patients, Morgenthaler asked a number of his schizophrenic patients to draw a man, woman, and child.

All the other patients drew either haphazardly on an accidentally chosen place on the sheet of paper, making three images according to one of the traditional schemas with which we are familiar from studies of the art of children, or they made entirely senseless scribbles. Wölfli, however, arranged it, placing the three heads as three circles with a relationship to each other, put a border around the sheet, filled up the remaining space decoratively, so that an harmonious whole was the result. (p. 82)

Morgenthaler particularly desired to understand this extraordinary ability to create coherent form, which he saw as the essential element relating Wölfli and the normal artist. In it he felt he could glimpse an essential characteristic of the creative process, in sickness and in health, a basic component in the "artistic personality."

In seeking to gain insight into essentially nonpathological features of Wölfli's personality, Morgenthaler moved consciously from psychiatry to psychology. It was in the area of what he termed an "ordering" or "normative" function that he felt the study of Wölfli's picture-making activity could throw light on the creative process in normal artists. Like Prinzhorn he was led to postulate certain innate or primary psychological mechanisms, the effect of whose operation could be traced in the drawings themselves. He begins with a universal expressive drive (*Willen zum Ausdruck*), an innate force found not only in artists, but in humanity in general. Beyond this, he was led, following Haberlin and Ebbinghaus, to postulate a force operating within the psyche that leads to a structuring of the mental contents and of expression.

Ebbinghaus has described, under the rather unfortunate term "objectivity function," certain psychological phenomena which organize and rule the contents of the mind, without which our consciousness would be nothing more than chaos. . . . It involves the functions of space perception, of time perception, of consciousness of similarity, of resemblance and difference, the perception of part and whole, of rhythm and number, of identity, and of movement and change. (pp. 85–86)

He envisioned this objectivity function as no less innate and primary in the mind than feeling or instinct, and felt that the clear operation of such an ordering principle dominated all of Wölfli's creative activity, subordinating part to whole, and producing a coherent and harmonious composition. The marked presence of such a fundamental order distinguished Wölfli's work from that of other patients.

In these speculative attempts to arrive at a psychology of creativity, Morgenthaler reveals his weakest side. Although he touches upon certain psychological functions that were later to be incorporated within psychoanalytic ego psychology, his efforts inevitably remained pure philosophic speculation in the presence of a process whose workings remain totally obscure.

By the beginning of the twentieth century, as a result of the work of the German school, psychiatry had become a sophisticated science characterized by a considerable body of knowledge, and a precise manner of observing pathological behavior and phenomena. In discussing the work of Mohr, Prinzhorn, and Morgenthaler, I have attempted to illustrate the contribution made by this psychiatry to the study of the art of psychotic patients. Their psychiatric viewpoint is essentially that of modern psychiatry, and their work is still the active basis for psychiatric, as opposed to psychoanalytic, studies. Yet, if Sigmund Freud's *Interpretation of Dreams* (1900), marks the birth of psychoanalysis, then it is evident that by the time Prinzhorn and Morgenthaler were carrying out their investigations, psychoanalytic insights and methods of investigation were readily available to them. What was Morgenthaler's attitude to Freud and psychoanalysis?[28]

That Morgenthaler was aware of psychoanalysis is evident from references to Freud's publications, which occur throughout the book. Morgenthaler's contacts with Bleuler and the Zurich School would have ensured that he was extensively acquainted with the literature of psychoanalysis, in that Freud's early work had had a considerable impact in Swiss psychiatric circles. It is probable that Freud's Leonardo essay of 1910 was a factor contributing to Morgenthaler's decision to publish a monograph on Wölfli, for Freud's conception of the relationship between Leonardo's childhood and

his later artistic activities influenced Morgenthaler's view of the Wölfli case. In this context, it is of some interest to discover that Freud knew of Wölfli's work, and had read the Morgenthaler study, although he nowhere mentions it in his published works. The book was brought to his attention by Lou Andreas-Salomé, who had learned of it from the poet Rainer-Maria Rilke, who was passionately interested in the art of Wölfli.[29]

Morgenthaler understood the relevance of psychoanalysis to understanding Wölfli's work, as indicated by specific, if somewhat ambivalent, references to it. For example, in discussing Wölfli's sound-poetry, much of which was obscure in the extreme, he observed, "It is impossible to grasp the meaning of his poetry unless perhaps with the light of psychoanalysis" (p. 38).[30] Morgenthaler's active involvement with verbal psychotherapy carried him beyond the frontiers of pure Kraepelinian psychiatry into an encounter with his patients that was inherently, if not specifically, psychoanalytic. That he was willing to listen to Wölfli over a period of years testifies to his tenacity as an observer. But Morgenthaler was attempting not merely to observe and describe, but to understand, to penetrate to the heart of Wölfli's delusions and his symbolism. One feels his consuming desire to enter into Wölfli's world, despite its strangeness, its complexity, and its contradictions. Again and again he seems to hover on the brink of understanding, only to stop, or turn back. Paradoxically, one senses in Morgenthaler something that made him reluctant to proceed, a curious unwillingness to come to grips with the meaning of Wölfli's symbolic expression. Morgenthaler's respect for Wölfli stands out on every page. His humanity and his belief that this man, in spite of his illness, had something of worth to communicate is evident throughout.

Morgenthaler's conception of the illness from which Wölfli suffered was completely psychological. Nowhere does he imply that Wölfli's illness was the result of neurological defect or brain pathology. He shared with Freud the conviction that the detailed investigation of pathological phenomena could lead to a more profound understanding of normal psychology. He sought to understand the course of Wölfli's life and illness in terms of his developmental history, and as the result of unbearable psychic trauma experienced in childhood, which led Wölfli irresistibly along the path of pathological introversion and regression.

The almost obsessive emphasis on the details of Wölfli's childhood that dominated Morgenthaler's approach to the case would be understandable to a psychoanalyst. Study of the case material leads one to see that Morgenthaler was forced into this mode of understanding by Wölfli himself. It was the patient who had the fundamental insight into his own experience. He was obsessed with the first years of his life. His world view, his vast mythology, and his art, all served to restore a lost paradise. "Oh, if only I could see it all once again . . . if I could see again all that once was, in the period of my life around the age of six, from my birth in 1864 up to 1870. I have seen and experienced the whole world round, and even a considerable part of the whole universe. I have learned and suffered, experiencing gigantic and countless catastrophes. Oh, Childhood, oh, time of happiness" (p. 32).

Morgenthaler was struck by the fact that Wölfli seemed to have moved further and further back into his past. "We seldom, to be sure, observe the strong preoccupation with one's own childhood so clearly as in our patient, who with increasing illness fell by degrees deeper and deeper backward into childhood" (p. 81). He realized that the key to Wölfli's mythology lay in events connected with the early years of his life, and lamented the lack of information covering precisely that period. It was apparent that behind the gods and goddesses of Wölfli's complex pantheon lay early memories of his parents and siblings.

His first great voyage was the sad departure which he made while still young with his sick mother. Now he makes the voyage in reverse, back to paradise, with a dazzling escort. His mother accompanies him on most of the splendid voyages. She is neither poor nor sick. She is a goddess who buys stars and worlds. Behind the undoubted powerlessness of God the Father—source of great disasters—is concealed, very probably, the terrible scenes of the drunkenness of his own father. (p. 76)

At this point Morgenthaler becomes a psychoanalyst.

Among the principal traits underlying the work, I would mention first the strength of Wölfli's attachment to his mother, then to his childhood in general, and third, his distant attitude in regard to his father. He never speaks of him, or of God, except in terms of admiration or to fearfully demand his protection. (p. 76)

Study of Wölfli's fantastic autobiography, in fact, reveals a typical, and yet individual oedipal structure. Again and again the material demanded a psychoanalytic approach. It is unfortunate that Morgenthaler could respond to this demand only to a very limited extent.

Morgenthaler was deeply interested in what he referred to as Wölfli's mysticism. "All of his works are impregnated with a mystical basis. This characteristic is profoundly anchored in his soul, and we can perhaps

13.8. Adolf Wölfli, *Hochalp-Stock-Rüchen des Santa-Maria-Störn-Hall-Nord*, colored pencil, Adolf Wölfli-Stiftung, Kunstmuseum, Basel.

see it as one of the motivations of his art" (p. 76). He saw parallels with Wölfli's world view in mythology and in primitive art. "Several passages in the chapter on primitive man in Worringer were written as if the author had taken Wölfli as his model" (p. 79). Immersed in the psychological milieu of Zurich in the 1920s, Morgenthaler exhibited some traces of Carl Jung's analytical psychology. Speaking of Wölfli's primitivism, he purports to find evidence of material deriving from suprapersonal experience, from the collective unconscious. "He even went beyond the limits of his personal childhood, he went beyond the personal strata, to speak like Jung, to attain the suprapersonal, the absolute unconscious. He returned to the original feeling-thoughts, to the primary representations, to the most ancient thoughts, the most general and most profound thoughts of humanity" (p. 68).[31] However, he makes no further references to Jung.

The area of Wölfli studies to which psychoanalysis might have been expected to make a worthwhile contribution was that of Wölfli's personal symbolism. Morgenthaler knew that Wölfli's pictorial imagery was intended symbolically, and that it raised difficult problems of interpretation. "Symbolic subjects . . . are by far the most common in his drawings. All that he represents has a symbolic value in his eyes, far more so than is the case with the normal artist" (p. 44). Nevertheless, despite his massive familiarity with Wölfli's life and ideas, it is precisely in this area that Morgenthaler betrays an uneasiness and uncertainty.

On the one hand he insists that his chief interest is in the formal aspect of Wölfli's art, and on the other hand he attempts a hesitant and unconvincing examination of Wölfli's symbolism. Here his uncertainty about his own interpretive ability, as well as his ambivalent attitude to psychoanalysis, comes most strongly to the fore. "One could write volumes on the significance of Wölfli's works. It would be particularly seductive to attempt an analysis and explanation of his works. But I prefer to leave this to more experienced specialists, who have already published a series of studies concerning the works of paranoid patients, or of certain of their symptoms" (p. 75). He then added a footnote referring to Freud's "Analysis of a Case of Chronic Paranoia" (1896), and to the famous Schreber analysis of 1911.[32] Whether his reference to a "more experienced specialist," obviously Freud, was intended respectfully or sarcastically is far from clear. He followed it, however, with a brief effort at psychoanalytic interpretation, which is the only section of the book that shows an embarrassing lack of psychological sophistication or insight.

Even if he doesn't say anything explicit, it is easy enough for an individual familiar with the Freudian mechanisms to figure out the significance of certain objects, or of certain actions. For example, the all-powerful trumpet with which he engenders not only goddesses, but whole universes, or the little birds, the snakes, the towers, the playing fountains, the rings, etc. If certain details of his life were known, one could equally easily identify other symbolic relations. (pp. 75–76)

The little birds to which Morgenthaler refers present a particular problem in terms of symbolism, because they occur far more frequently than any other symbol, and because they are pure inventions (Fig. 13.8). Morgenthaler recognized the crucial importance of this image but failed to come to grips with it. On one level, the formal, he attempted to explain it as a space filler.

These little birds, the only relation they have with birds is perhaps a suggestion of paws, and a sort of eye and ear. They are nothing other than fillers. Each time that he disposes of an empty space in the corner of a drawing, or between two motifs, he simply adds color, eyes and ear. They are also there to enliven the drawing. They don't only fill spaces, but enter into the forms of water, mountains, tree trunks, fountains. When he makes people, he doesn't neglect to place the symbol of the little bird in the hair at either side of the head. (p. 48)

In the same paragraph we are told that the birds appeared in a special position in Wölfli's early work. "In his first drawings it was the apron of women that he liked to decorate in this way, and in certain cases he represented this symbol vertically in the area of the genital." He did not mention the fact that in its genesis

the little bird may have been derived from a woman's boot (Fig. 13.9). Finally he describes a process whereby this image underwent a rather improbable evolution: "The little birds first served as forms to fill up empty spaces, then to decorate and animate, and finally they took on sexual implication" (p. 78).

Morgenthaler's reluctance to come to grips with Wölfli's symbols was not the result of sexual prudishness. He was willing to discuss sexual material where necessary, and he recognized without hesitation its central position in Wölfli's life and art. Deprived of any sexual life in the hospital, Wölfli used art as an important outlet for his sexual fantasies and energy. Morgenthaler devoted a section of his book to the place of sexuality in Wölfli's art and ideas. Rather surprisingly, he appears to have accepted Freud's conception of infantile sexuality, and to have recognized that much of Wölfli's infantile paradise involved incestuous fantasies directed toward his mother. "We can distinguish different levels in the evolution of Wölfli's sexuality. Firstly that belonging to the first eight years of his life with his parents. Unhappily, for that period in which the primary reactions are formed once and for all, we are reduced to mere supposition" (p. 57). Morgenthaler quotes Freud's description of the ties that bound Leonardo to his mother. "He had known in his earliest years an erotic pleasure never equaled by what followed."[33] It was in the context of his discussion of Wölfli's sexuality that he adopted Freud's term *regression* as implying, correctly, a return to earlier points of sexual fixation. "This constant, progressive return toward infancy (regression), indicates that certain deeper and more ancient layers of his psychic life revealed themselves as his illness progressed" (p. 60).

Wölfli was equally open about his sexual preoccupations, frequently demanding women, and depicting sexual intercourse in his drawings. As a result of prolonged celibacy in the asylum, his sexuality underwent a further modification. "Over a long time his sexual de-

sires and sensations have, little by little, invaded his other feelings, and his sexuality has been reinforced. The process is reflected both by his hallucinations and in his drawings, particularly in the symbol of the little bird, which now appears everywhere" (p. 61).

Morgenthaler was struck by the fact that Wölfli appeared to live in two worlds, his own and ours, and by the way in which truth broke into his delusional system from time to time. He seemed to alternate between the rich reality of his fantasy, and the tragedy of his actual role in life as a patient in the Waldau. At times these double realities appeared to coexist: "He could be, at one and the same time, Adolf Wölfli and the emperor, or God. In heaven he slept with a goddess in her bed, while his symbolic self lay in a cradle beside, and he was at the same time on earth as a poor unfortunate in his cell. He maintained an objective attitude in regard to these psychic contradictions, he played with them, and moved them back and forth like scenery in a theater" (p. 64). This strange mixture of theater and reality pervades Wölfli's art, lending an air of the concrete to even his wildest fantasy. Wölfli's art is not a world of fairy tale escapism, or of purely wishful fantasy. One senses that as creator he was very much in control. At times Morgenthaler might well have wondered who was mad, who was being taken in. But Wölfli had far too much invested in his delusional mythology to abandon it in favor of a world that had denied him every gratification, a world in which he was a nobody with no place to go. "Worse, now, look at me, fallen into the Waldau, crucified, dead and entombed" (p. 34) (Fig. 13.10).

One of the functions of his fantasy, which Morgenthaler recognized, was to defend him against an overwhelming fear of death. His mythology included an endless succession of deaths and resurrections: baby Adolf was killed, executed and murdered repeatedly, always to be miraculously reborn. "It is he himself who explains that all the capital executions, of himself or

13.9. Adolf Wölfli, *Composition with Boots*, detail, 1922, Collection de l'Art Brut, Lausanne.

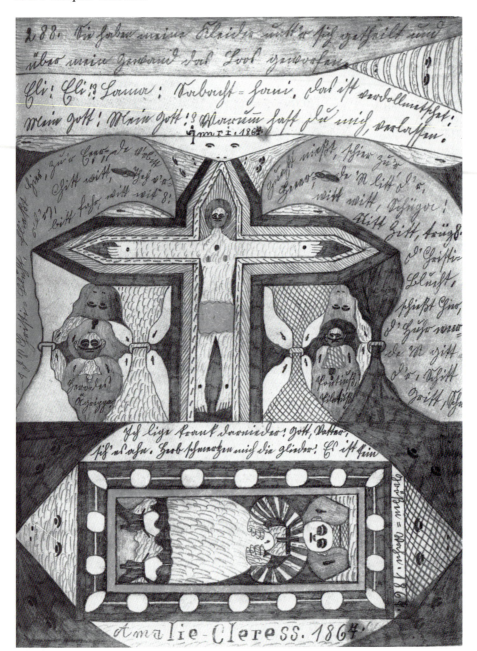

13.10. Adolf Wölfli, *Amalie＝Cleress*, 1908, from *From the Cradle to the Graave*, 1: 288, Adolf Wölfli-Stiftung, Kunstmuseum, Bern.

others, are the result of a sexual assault on a little girl. He says that one can see in the sky allegories of St. Adolf which are to be found at the same moment on earth in his cell" (p. 75). Here the truth of Wölfli's life breaks through; he is saint and sinner, in paradise and hell, and like all men, even in madness, he could not escape the reality of death. "All men must die, perhaps even me too."[34]

Given to writing lengthy last testaments leaving his limitless wealth to imaginary relations, Wölfli on one occasion, having decided to leave everything to his grandson, suddenly faced the cruel fact that he had no son. "Yes I myself, as the result of a grim catastrophe, engulfed in the Black anger-water-fall-crater-, unable even to make children of my own" (p. 31).

Wölfli's occasional ability to face the painful facts of

his earthly existence should not lead one to conclude that his delusional world was mere make-believe or playacting. Wölfli was trapped in his own theater and could not bring the play to a halt. The few fragments of blunt reality that forced themselves upon him were probably indications that part of his ego remained intact. The working of this fragmented but functioning ego particularly interested Morgenthaler. The "method" in Wölfli's madness intrigued him, the moments of calm at the center of the storm. He conceived of his psychological condition in terms of a powerful psychological conflict, a perpetual struggle between opposed forces. "Later it became evident that beside the instinctual forces, which knew no limits, there was always something which opposed itself to these forces, and which could be overcome temporarily at the most acute stages of his illness, but which reasserted itself— a sort of contrary force" (p. 72). On the one side, brutal instinct, forces expressed in unbounded and monstrous imaginative fantasy and delusion; and opposed to these, the "objective function," a tendency in the direction of order and coherence, "an opposed force leading toward a normative and controlled expression, a calm exterior, objectivity that can go as far as a feeling of obviousness or even indifference" (p. 77). At times he even refers to this tendency as an opposed instinct.

In conceptualizing Wölfli's existence in terms of a dynamic struggle between parts of his personality, Morgenthaler was operating within the framework of early psychoanalysis. His conception of the objectivity function accords well with aspects of psychoanalytic ego psychology. His criticism of psychoanalysis was precisely that it failed to accord sufficient attention to the role of organizing and ordering functions within the personality. Familiar with psychoanalysis in its early stages, he saw it correctly as focusing on the role of the instincts and their derivatives. He understood that the psychoanalytic emphasis on instinct was the result of an effort to correct the failure of earlier psychologies in this regard. "The reaction against this old, one-sided attitude was psychoanalysis. It now sees the artist predominantly as instinct ridden, and it must in this way naturally likewise be one-sided" (p. 85). Morgenthaler's criticism of psychoanalysis was well founded, if premature. In these very years Freud was at work on the additions to the theory that were to appear in his important essay *The Ego and the Id* of 1923, in which many of the problems raised by Morgenthaler concerning the operation of the ego (a term Morgenthaler did not use) were to be answered with far greater precision than he was able to muster. Nevertheless, it is apparent that, though not a psychoanalyst, Morgenthaler was familiar with most of the central ideas of that discipline, and that these ideas exerted a significant though limited influence on his understanding of Wölfli's life and art. His book therefore represents the first important move in the direction of a psychoanalytic approach to the art of the insane.

FOURTEEN

Expressionism and the Art of the Insane

In 1912 a large and important exhibition of international contemporary art was held in Cologne, Germany.[1] It was intended to demonstrate the extent and richness of the movement that had only recently come to be called Expressionism.[2] The work of Vincent van Gogh was accorded special prominence in the exhibition in that he was seen as the forerunner and stimulus behind Expressionism in its various manifestations. Karl Jaspers, existential philosopher and psychiatrist, saw the exhibition, and was impressed by what he felt to be a significant contrast between the works of van Gogh and those of the Expressionists: "In the Cologne exhibition of 1912, where strangely uniform Expressionist art from all over Europe was to be seen arranged around the wonderful van Goghs, I consistently had the feeling that van Gogh was sublimely the only unwilling madman among so many [artists] who wished to be insane but were, in fact, all too healthy."[3] In the context of discussing the deep attraction the schizophrenic state held for the contemporary mind, Jaspers put forward the opinion that the Expressionist painters desired and deliberately cultivated the appearance of madness in their work. Although as a psychiatrist he believed that their achievement in this direction did not measure up to the work of van Gogh, he had nevertheless raised the possibility that psychopathology was attractive to the Expressionist artist, and that one of the sources of their art might have been provided by the pictorial productions of the insane, among whom Jaspers included Vincent van Gogh. Unlike the many critics who assumed that the various pictorial styles associated with Expressionism were suitable evidence for a diagnosis of insanity, Jaspers considered that the artists were too healthy to succeed in attaining this sought-after mental state.

Is there any evidence of contact between Expressionist artists and psychotic artists, or any indication that the Expressionists had seen or were aware of the existence of psychiatric art?[4] Aside from other influences, can the art of the insane be said to contribute to the creative methods, or to the form and subject matter, of Expressionism?

The study of Expressionism in its various manifestations is complicated by the wide variety of artistic purposes and goals expressed and embodied by the artists who have been grouped together under this label. Even though some of the earliest manifestations of Expressionist art (produced in Dresden between 1905 and 1910 where the artists who identified themselves as members of Die Brücke actually lived and worked together) cannot on occasion be attributed to a specific artist, there is still a wide range of styles and subjects that make it difficult to generalize about the aims of the movement. Nevertheless, two trends seem to emerge from the majority of works associated with Expressionism: a deliberate cultivation of emotional intensity, and deliberate return to techniques, forms, and subjects that were seen as primitive.[5]

In the early years of the Brücke movement, the artists, in open revolt against all traditional conceptions of the nature of art, and in emulation of primitive artist-craftsmen, sought to capture the most violent extremes of emotion available to them—pure violence. They wanted to shock the bourgeois art lover and to launch an attack on art itself. Their paintings and prints convey a mood of feverish activity and excitement, achieving their impact through the use of grotesque and deliberately ugly forms and subjects. "The artist readily abandoned himself to the most violent and unexpected urges of his instincts; all sense of proportion was lost; nature and life seemed to be dominated by tumultuous, disunited forces, often calamitous and always dramatic."[6] Deliberately primitive media and techniques were exploited in the service of subject matter in which equally primitive experiences were embodied. Nudity and the blatant display of sexuality represented one aspect of the attack on bourgeois morality and aesthetics. Expressionism in both art and literature originated as an explicitly revolutionary endeavor. In its idealism and aggressive honesty it was clearly the art of young men in revolt. "Expressionism was not only a different style of painting, but an altogether new way of living, a return to mysticism and religion, a turning inward, a violent expression of racial memories."[7] Not surprisingly, the first exhibition of this new art in 1906 provoked critics and public to declare that the artists responsible for it were insane.

The emphasis on extremes of emotion continued as one of the goals of Expressionism even after the element of violence and sexuality diminished. In his book *Concerning the Spiritual in Art*, Kandinsky stated, "We may go as far as the artist is able to carry his emotion; and once more we see how immense is the need for cultivating this emotion."[8] Expressionism is an inward-turning art, a subjective art that views the outer world exclusively in terms of its inner reflections. It is an art that emphasizes feeling as opposed to thought, instinct and intuition as opposed to reason, the dream rather than reality. Peter Selz has indicated the context within which this art took shape. "Expressionism can be more fully understood if it is seen in relation to the relativistic and subjective trends in modern psychology, the sciences and philosophy—trends of which many of the Expressionist painters were acutely aware. The strong desire of the Expressionist artist for self-knowledge and for comprehension of the meaning of human existence in its loneliness and threat of death can be compared with parallel trends in Existentialism."[9] Kandinsky captured the intuitive nature of this drive and its entirely spontaneous emotional basis in his conception of "the principle of inner necessity." "That is beautiful which is produced by internal necessity, which springs from the soul."[10]

To the extent that Expressionist artists, free of all inhibition, created in response to this principle, their art moved closer to the art of the insane than any prior movement had ever come. If the insane could be said to share common goals in their art, a doubtful premise, these goals would not differ markedly from those put forward by the Expressionist painters. The Brücke painters clearly display what we may describe, using Dubuffet's term, as an anticultural position. In their attempt to create a pure and deeply revolutionary art, they sought to return to what they saw as the beginning. They were largely self-taught as well, and therefore not as heavily burdened with traditional ways of seeing and depicting. In his book *Primitivism in Modern Art*, Robert Goldwater characterized very precisely the extent and nature of Expressionist involvement with the primitive in its various manifestations. The members of the Brücke were deeply involved with the study of Oceanic and African sculpture, in the case of Kirchner and Heckel from as early as 1904; and clear evidence of the influence of specific examples of primitive art can be identified in their work. The crudity, the power, and the simplicity of this art inspired and justified them in their choice of direction. The discovery of primitive art can more correctly be said to occur in Germany than in France, in that this "new" art was accepted by the German artists at once as the equal of their own. But, as with all such discoveries, there had to be a readiness, a need within the discoverer, which necessitated the discovery. Expressionist artists found confirmation in primitive art for a direction they had already taken. "What fascinated them was the power and immediacy of primitive art, or, as Nolde said, its absolute primitiveness, its intense, often grotesque expression of strength and life in the very simplest form."[11] But Nolde is said to have become seriously involved with primitive art only around 1910 at a time when his own art had already attained an intensity of expression which rivaled that of the art which now so much intrigued him.

Although older than the other Brücke painters, Nolde achieved perhaps the purest and most violent embodiment of the aims of early Expressionism. His art, particularly in subjects connected with religion and dance, attains a state of utter abandon and frenzy unknown in any primitive art, though observable on occasion in primitive dance and ritual performance (Plate 26). "No one used colour with the delirious passion of this elemental mystic. Dauntlessly he unburdened his conscious and subconscious mind in pictures of virulent colour and bold line which bordered on ecstasy. Combining bad taste with sublimity, the divine with the satanic, grotesque and sacred, his work is the prototype of Dionysiac art carried to a paroxysm of pictorial and psychic exaltation."[12] Nolde understood the source of his images very well. "The quicker a painting is done, the better it is. ... In art I fight for unconscious creation. Labour destroys painting."[13] Psychologically somewhat withdrawn, but otherwise perfectly stable, Nolde had achieved an art with far greater resemblance to psychotic art than to the art of primitives (Plate 27). There is detailed evidence that Nolde had discovered the art of the insane at the same time as he had become aware of primitive art. His search for the primitive led him in more than one direction.

EXPRESSIONISM in Germany, particularly in its early phases, could not have come into being without the painting of Vincent van Gogh. He was the single, essential source behind Expressionism, the justification for the methods, style, and revolutionary aesthetic of the Brücke. So strong was the identification of these artists with van Gogh, that Emil Nolde in 1907, reacting critically to an exhibition of Brücke painting, suggested they should "not call themselves Brücke but van Goghiana."[14] In choosing to live in close association, and to work as a group, often to the extent of collaborating on one another's pictures, they fulfilled van

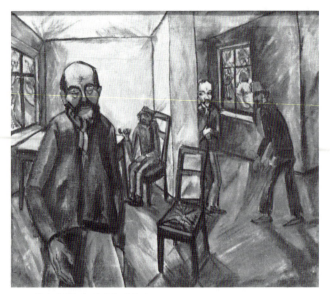

14.1. Erich Heckel, *The Madman*,
1914, oil on canvas, Städtliche
Kunstsammlung, Gelsenkirchen.

Gogh's dream of a colony of artists. But what was their conception of van Gogh and his work? To what extent were they identified with a real person, and to what extent with a myth?

It is not customary today to consider the work of van Gogh within the context of psychotic art. While to the general public he will always remain "the mad artist" par excellence, art criticism has so thoroughly absorbed him into "the mainstream of modern art" that it is difficult to examine his work in terms of psychopathology, nor do I intend to do so here. However, whether van Gogh's later paintings do or do not betray signs of mental disturbance or psychosis, it is of considerable significance for us to determine to what extent the Expressionist painters, who were so strongly influenced by his life and work, viewed him as insane, and to what extent they viewed his work as the result of his mental state.

Nolde claimed to have encountered the work of van Gogh in 1898. "I saw in Munich as early as 1898 his *Self-Portrait* with the cloth over the severed ear. Knowing nothing about him, I said, innocently, 'A little crazy.'"[15] The Brücke painters would all have known van Gogh's work prior to the formation of the group in 1905.[16] Will Grohmann, writing of E. L. Kirchner's artistic origins, points not only to the pictorial influence of van Gogh, but to the example of his life-style. "What might have had an effect was what he heard, read, and saw of Gauguin and van Gogh. The

fortunes of these two men moved everyone who had anything to do with art."[17] Speaking of his own experience of creativity, Kirchner stated, "One becomes an artist out of despair."[18] Werner Haftmann clarifies the effect of the van Gogh myth on the Expressionists. "In his own flesh he [van Gogh] lived the new conception of the artist's life, the new image of the artist, that radically changed our ideas concerning the psychology of the artist. This 'exemplary tragedy' became a hidden force behind the whole outlook of modern artists. And time and again, it was activated, particularly in the Germanic countries, in Nolde, in Kokoschka, in E. L. Kirchner."[19]

The phrase "exemplary tragedy" was taken by Haftmann from the diary of Paul Klee. Again and again Klee emphasized the meaning of van Gogh's work and life to contemporary art. Klee was of the opinion that the important paintings of van Gogh were those produced under the impact of insanity. "Too bad that the early van Gogh was so fine a human being, but not so good as a painter, and that the later wonderful artist is such a marked man. A mean should be found between these four points of the comparison: then, yes! Then one would want to be like that oneself."[20]

In the same year, 1908, after visiting an exhibition of van Gogh's work, Klee reacts more strongly and negatively to the artist's mental state. "Two van Gogh shows at Brakl's and Zimmermann's on Maximilianstrasse. Recognized the element of genius, but with a certain shudder at the pathological quality."[21] Klee's profoundly balanced art, measured and controlled in its manipulation of the irrational, provides an effective contrast with that of van Gogh and of the Brücke painters. Recognizing the attractive power of this artist, he describes the force that drew the more explosive exponents of Expressionism to him. "His pathos is alien to me, especially in my current phase, but he is certainly a genius. Pathetic to the point of being pathological, this endangered man can endanger one who does not see through him. Here a brain is consumed by the fire of a star. It frees itself in its work just before the catastrophe. Deepest tragedy takes place here, real tragedy, natural tragedy, exemplary tragedy. Permit me to be terrified."[22]

The Brücke painters, unlike the members of the Blaue Reiter, were not so much terrified as envious. Jaspers was probably correct in his belief that these artists sought to emulate the mad artist. Although they had encountered examples of psychotic art, and were strongly under the spell of van Gogh, their conception of the art of the insane was largely an imaginative creation. In the artists of the Blaue Reiter, one

encounters specific knowledge of psychiatric art, whereas in the case of the Brücke group it is a fantasy madness, which acts as stimulus and which is betrayed in their work. Their shattered form and raging color, their juxtapositions of sexuality and mysticism, violence and frenzy, are produced in emulation of an art of the insane that existed largely in their imagination. The cynicism of a contemporary critic in 1910 may well have contained a pale reflection of the truth: "There are only two possible ways to explain this absurd exhibition; either one assumes that the majority of the members and guests of the Association are incurably insane, or else that one deals here with brazen bluffers who know the desire for sensation of our time only too well, and are trying to make use of this boom. For my part, I tend toward the latter opinion—in spite of holy assurances to the contrary."[23]

The role of madness in the development of the Expressionist aesthetic is even more clearly demonstrated in literature and drama.

The madness theme . . . was much exploited at this time. It may be regarded as part of the Expressionist use of the grotesque and is to be associated with Freud's discovery of the subconscious. Later on Surrealism was to exploit this aspect of Expressionism. . . . It may be the expression of man's lost faith in the world of reality surrounding him; it may be his negation of finite reality in favour of a higher reality: it may be the expression of a desire to return to the original state of life—the "original chaos" of which Werfel speaks . . . in order to recreate life from its essentials in a purer form.[24]

The mental processes characteristic of psychotic illness are more accurately reflected in Expressionist drama, in the use of free-associational thought and neologisms, and in the themes of violence, torment, madness, and death. Expressionist literature is obsessed with the cult of the irrational and the world of the dream. Speaking of Oscar Kokoschka's play *Murder Hope of Women*, Richard Samuel points out how the play creates an atmosphere of total insanity. "Kokoschka dealt with experiences that lie outside the pale of rational life, and accordingly his plays lack even the semblance of logical development. The characters in *Mörder Hoffnung der Frauen* are driven by elemental passion and by 'mad desire from horror to horror.' "[25]

It has been suggested that the involvement with insanity that is characteristic of Expressionist drama is an expression not of a preoccupation with the psychopathology of the individual, but of society as a whole.[26] Expressionist painting and sculpture have repeatedly been interpreted as prophetic of the tormented state of the German psyche, which was to find expression in two world wars. A number of works executed by Brücke painters could be brought forward to support this interpretation. For example, a series of pictures by Erich Heckel, executed while he was serving as a medical worker during World War I, take up the theme of madness as a means of symbolizing the alienation and unreality of the situation in which he and all of mankind seemed to be trapped (Fig. 14.1). The painting *The Madman* recalls van Gogh's interiors of the Hospital at Arles, as well as his use of the symbol of the empty chair. The man who stands behind that chair in this painting is almost certainly Heckel himself.[27]

A NUMBER of Expressionist painters portrayed themselves in self-portraits that were implicitly or explicitly depictions of madmen. A series of profoundly disturbed and disturbing self-portraits of Ludwig Meidner (1884–1966), which date to the years 1912 to 1920, provide unnerving examples of the artist engaged in pictorial diagnosis (Fig. 14.2), nor was he alone in this endeavor. Kokoschka, as a young art student determined to shock the bourgeois Viennese artistic circles, depicted himself in what is probably his earliest self-portrait (1908) as old and insane (Fig. 14.3). Years later, in a gesture of defiance aimed at the self-appointed art critics of National Socialism, Kokoschka again depicted himself as a madman in his great *Self-Portrait of a "Degenerate Artist"* (1937) (Plate 17). For years the artist had consciously played the role of the mad genius. In Dresden he was known as Mad Kokoschka.

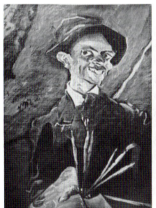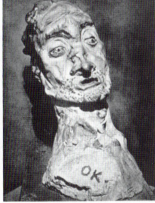

14.2. Ludwig Meidner, *Self-Portrait*, 1912, oil on canvas, location unknown.

14.3. (at right) Oskar Kokoschka, *Self-Portrait*, 1908, painted clay, private collection, New York, © COSMOPRESS, Geneva, 1988.

Nevertheless, this self-portrait was painted, during a period in his life when the painter was depressed and contemplating suicide. "He told me that for a long time he had carried a picture in his mind; he had tormented himself trying to paint it, but in the end it was spoiled. He yielded to despair. Then he painted himself on the canvas."[28]

THE PICTORIAL echoes of the self-portraits of van Gogh, and of his attitudes to the making of an image of himself, are in these artists and their work rarely a product of superficial identification with him—of imitation. Each of these portraits of artists as sick or mentally disturbed individuals reflects undeniable mental anguish and introspection. Perhaps the closest parallel with the van Gogh self-portraits is provided by a series of depictions of himself executed by Ernst Ludwig Kirchner, culminating in the ruthlessly confessional *Self-Portrait as a Sick Man* (1917) (Fig. 14.4). Painted during the period when Kirchner was undergoing treatment in a series of mental hospitals, it is one of a number of pictures the artist used as a means of struggling with his illness.[29] Unable to cope with the rigors of military service, Kirchner, in the years 1915–1917, entered a period of severe emotional disturbance. Although the precise nature of his psychological condition is not known, he experienced severe delusions of persecution and physical symptoms that were probably the result of hysterical paralysis and, at times, was so dangerously suicidal as to necessitate constant supervision. He was hospitalized on several occasions in a sanatorium in Königstein under the care of a Dr. Kohnstamm, as well as in a private asylum run by the famous Ludwig Binswanger at Kreuzlingen. It does not appear that he was truly psychotic, nor does his work at that time reflect any trace of psychotic experience. During the periods of hospitalization he continued to paint, later stating that he had used his work as a means of keeping himself alive.

While in the hospital at Königstein in 1916 Kirchner painted a series of large murals in a stairwell. The project was undertaken at the suggestion of Dr. Kohnstamm, whose request was explicitly therapeutic. The paintings that resulted, a series of beach scenes with nude bathers, represent a continuation of the artist's earlier subjects, and betray little or nothing of his disturbed mental state.[30] The hospital environment is more closely reflected in a number of portraits that Kirchner made of physicians and hospital attendants (Fig. 14.5).

Kirchner's earlier Romantic identification with van Gogh was now intensified and made concrete through shared experience. The *Self-Portrait as a Sick Man* is the pictorial expression of that intensified identification. Kirchner portrays himself in bed in a small room in the Alps. His state of anxiety and confusion is very evident. He seems restless, unable to sleep or even to lie down; his body scarcely fits into the tiny room. While reflecting an actual room in which Kirchner was living at the time, this space derives from van Gogh's depiction of his bedroom at Arles (1889). The narrow room, the tiny wooden bed, the bedside table and the window above it, are all familiar to us. The strangely plunging perspective, with a floor that seems to drop straight down, is derived from van Gogh's psychological use of spatial distortion. By placing himself, perhaps unconsciously, in van Gogh's room, Kirchner expresses his sense of participation in the experience of mental suffering. Van Gogh's room was empty; Kirchner has taken up residence in it. He is not alone.

WHILE the case of Vincent van Gogh provided the Expressionist movement with its most influential example of the effect of psychosis on pictorial expression, the work of yet another psychotic artist, Ernst Josephson (1851–1906), was also rediscovered and reevaluated within the context of Expressionist interest in the art of the insane. Josephson, a noted and accomplished Swedish painter, had become severely mentally ill and was hospitalized in 1888. During the early part of this century, his life and work represented a celebrated, intriguing, and unambiguous example of the effect of insanity on the work of a highly trained and very successful painter.[31]

Josephson, who had studied both in Sweden and Paris, had become famous by the age of thirty-seven. Working in a realist style influenced by Courbet and Manet, and consciously reflecting the example of Velázquez and Rembrandt, he had produced portraits and imaginative works that provoked both controversy and admiration in Paris at exhibitions of the Salon between 1881 and 1883. In the *Gazette des beaux-arts* of 1881, he is described as one of the most original portrait painters of the day, and a worthy successor to Velázquez and Hals.[32] Not unaware of the contribution of the Impressionists, he chose to work in a more restrained realist style, the strength and originality of which would have been sufficient to assure him a place in the history of Swedish nineteenth-century art.[33] While signs of underlying psychological disturbance can be detected in his poetry and painting as early as 1881, the fully developed psychosis that brought about

a radical departure from his original style erupted only in 1888.

Living in partial isolation on the island of Bréhat, Josephson began to develop elaborate religious and paranoid delusions, experiencing visual and auditory hallucinations, and an immensely inflated sense of his own importance, later accurately diagnosed as paranoid schizophrenia.[34] Identifying himself variously as St. Peter, Keeper of the Gates of Heaven, and as the God of Creation and the Son of the Sun, he was finally hospitalized in an asylum in Upsala.[35] Although his hospital stay lasted less than a year, Josephson remained harmlessly immersed in his private delusional world for the remainder of his life. Living in seclusion, he occasionally emerged to march at the head of the Stockholm Palace Guard, wearing a Scottish cap and carrying a wooden sword.

The initial impact of the experience of psychosis put an end temporarily to Josephson's activity as a painter; however, his ability to draw, although it underwent a dramatic change, continued to serve him in the task of exploring the new reality in which he found himself. Convinced that he was St. Peter, and that his room was the entrance to heaven, he conducted interviews with departed spirits, and drew pictures of them. Through his experiments with spiritualism, he had come to believe that a number of artists of the past—Raphael, Rembrandt, Hals, and Velázquez—were using him as the medium through which they might continue to draw, and he executed drawings signed by these masters. During the early period of his illness, he was preoccupied with the number seven, and most of the drawings are, therefore, executed with seven strokes.

Nevertheless, it was assumed for many years that Josephson's illness had destroyed his talent and put an end to a promising career. As late as 1912, articles discuss his work only up to 1888, making no mention of the later work.[36] Strindberg, who had known Josephson well, described him in later years as "one of the advance guard who fell in the front line." The truth is, however, that Josephson's creativity had been stimulated by his experience of a changed reality and his artistic output increased considerably. In the psychiatric hospital a sympathetic physician encouraged him to begin drawing again. Because of his extreme poverty in the years following, he often drew on sheets of wrapping paper. His interest in completed drawings was minimal and he left them lying about for anyone who wished to take them. Nevertheless, over a thousand drawings and some seventy oil paintings survive from

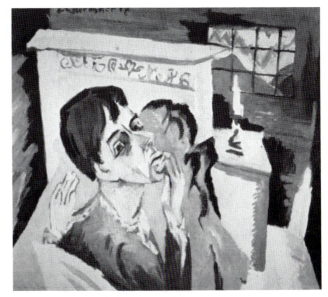

14.4. Ernst Ludwig Kirchner, *Self-Portrait as a Sick Man*, 1917, oil on canvas, Staatsgalerie moderner Kunst, Munich.

14.5. Ernst Ludwig Kirchner, *Hospital Attendant Bruhlmann*, 1917–1918, oil on canvas, Campione d'Italia, Switzerland.

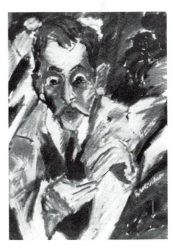

the eighteen years that remained to him. As early as 1893 his new work was being exhibited in Stockholm, and stimulating enormous interest and respect among the younger generation of Swedish painters.

The break that separates Josephson's early work from that done during his psychotic phase is an extreme one. The radical change of style that occurred rather suddenly in 1888 was only the outer manifestation of a dramatic inner process, which had completely modified his conception of the nature and function of images. To attempt to account for this change of subject and style in terms of conscious choice, or as a

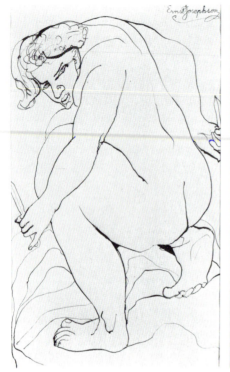

14.6. (far left) Ernst Josephson, *Man with Knives*, ink on paper, Bergen.

14.7. Ernst Josephson, *Head of a Girl*, drawing, location unknown.

response to developments within the history of art, would be a serious distortion. Josephson was responding to psychological forces that had nothing to do with artistic decisions, and for which all of his prior artistic training had done little to prepare him. The images he arrived at, extremely unusual in terms of the art of his time, bear a marked similarity to the works of untrained schizophrenics.

During the brief acute phase of his illness there was an evident weakening of his ability to draw. He was too excited, and relied on extremely simple contour drawings such as the frightening *Man with Knives*, in which the violence of the subject is echoed by the uncontrolled spontaneity of the form (Fig. 14.6). Later this untrammeled style of drawing alternated with a complex, indeed compulsive, texturing of the surface, such as is seen in the drawing *Head of a Girl* (Fig. 14.7), in which an obsessional involvement with surface intricacy, the rigid, curiously awkward distortion of the human form, and the bizarre details of the subject, all suggest the working of certain aspects of the schizophrenic process. Josephson never returned to his earlier manner of drawing. Having broken through

into a new pictorial world, there was seemingly no going back.

Art critics, writing of these revolutionary images, tend to see in them evidence of an unheard-of freedom. They are puzzled by the fact that his work so evidently anticipates the painting that was to be done some twenty years later. "It was not until he became mentally ill that Josephson's art completely achieved the new form language. Finally he was free from the restrictions of tradition, from conventional subject matter, and from the demands of model and patron."[37] "As he withdrew from the world of reality into the super reality of his own world of the imagination, he was free to exaggerate and distort likeness, anatomy, and proportion, for the greater expression of inner truth."[38]

It is doubtful that Josephson experienced his freedom in quite this way. Although the inspiration of his drawings liberated other artists who saw them, he himself was confined within the borders of his by-no-means voluntary mental state. Nevertheless, there is some evidence that he understood this new reality as offering some possibility of freedom from restraint. In a poem written prior to the onset of his psychosis, he

described the pain and the intensity of his experience of creation.

From my heart's heart I hear it rise,
A plaintive song that trembles pure.
As sadly as a cello string
It melts away and slowly dies.

Still it's the peg that tends the song,
And as the string is taken up,
For every time he's turned by her,
The deeper resonance comes on.

So that occasion hurt as well!
But still more beautiful the tone.
Oh, Lord God, if the string should break,
My soul, freed, would lift itself![39]

As he became accustomed to his changed perception of the world, Josephson began to paint again. One of the earliest of the new pictures was *The Holy Sacrament* (Fig. 14.8). Painted in 1889–1890, this work could be seen as the ancestor of a good deal of the painting of the next thirty years. Painted in bold strokes of a brush loaded with unmixed color, the image, unconventional in the extreme, embodies the artist's private vision. He himself appears as Christ, while his mother, long dead, is seen in the ghostlike form to his left. The staring blue eyes, the rays that, proceeding from Christ, spread out over the picture, the awkwardness of pose and drawing, the elongation of human form, the curious shifts of scale, and the arbitrary manner in which the paint is applied, all convey an impression of startling modernity. The picture brings to mind the religious paintings of Nolde executed some twenty years later, in which he too was to depict himself as Christ.

Josephson's masterpiece is probably the portrait of his uncle, the stage director Ludwig Josephson, painted in 1893 (Plate 21). Painted on top of an earlier picture, in a manner that still betrays his knowledge of the old masters, particularly Rembrandt, it is either one of the finest portraits in early modern art or a pathological aberration, depending on your point of view. Uncle Ludwig is depicted seated at a table, directing his actors in the rehearsal of Shakespeare's *Midsummer Night's Dream*, the script of which lies before him. The figure only half emerges from an obscurity troubled by half-suggested forms, graffiti-like writings scrawled on the back wall, and a figure in red tights, seen upside-down, a remnant from the earlier underlying picture. The loosely sketched figure, with its staring eyes and tense pose, conveys an impression of barely restrained excitement. In his hand, which

seems to float unconnected to the body, the director holds a bell, presumably used to attract the attention of his actors. The portrait, which resembles Josephson himself, was described by Ludwig Josephson as "a symbolic portrait, quite strange in both composition and accomplishment."[40]

The strangeness of Josephson's work and the implications it held for the psychiatrist did not go unnoticed. In his book *Le délire graphique et verbal*, W. Mayr illustrated a drawing by Josephson and discussed his case in a manner that implies that his readers were very familiar with the artist.

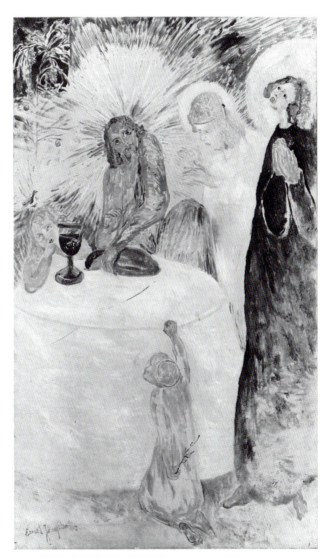

14.8. Ernst Josephson, *The Holy Sacrament*, 1889–1890, oil on canvas, National Museum, Stockholm.

Ernst Josephson did not begin to paint because he was insane, but more precisely, from the time that he became insane, he painted in an abstract or surrealist manner which corresponded to the new life into which he had been born at thirty-seven years of age. . . . His drawings are agreeable linear rhapsodies, skilfully executed, with a remarkable clarity of contour through which the fantasies of a maniac find expression and satisfaction in a gently idealized eroticism. The chastity of his bathing women reminds one of the voluntary nudity which one sometimes finds in the work of Picasso.[41]

Even the psychiatrist seeks to understand Josephson's work within the context of contemporary painting.

In 1918 the Swedish painter and follower of Matisse, Isaac Grünewald (1889–1946), published a book entitled *The New Renaissance in Art*. In it he spoke of Josephson as a significant figure in the evolution of modern art. "Ernst Josephson's artistic development presents a remarkable instance of the process whereby the artist's inner feelings, grappling with a subject, can bring forth new forms and new modes of expression. Josephson may well be called the first Expressionist."[42] This tribute may represent no more than an effort, in retrospect, to locate Josephson within the history of art, a history outside of which he essentially functioned; but it does raise the issue of Josephson's possible influence on the development of Expressionism. By 1918 Expressionism was an established style, beginning to make itself felt well beyond the borders of Germany. The Swedish Expressionist painters unquestionably recognized Josephson's later work as significant, and as anticipating their attitudes and goals. But if Josephson is to be seen as a seminal influence on the early development of Expressionism in Germany, it is necessary to reconstruct the process that led to a changed perception of his fate as an artist and to a radical reassessment of his work.

Josephson's work done prior to the onset of his psychotic illness in 1888 does not contribute significantly to the more advanced currents of contemporary art in Paris. Although he was an active and very vocal leader of the Swedish avant-garde, his work represented no radical departure from tradition. The sudden and dramatic change in his mental state in 1888, paralleled by an equally abrupt revolution in his image-making activity, was not seen as a meaningful contribution to the birth of a new style, but as evidence of a complete mental and artistic collapse. As was the case with Richard Dadd forty-five years earlier, Josephson's career was believed to have ended, "broken by insanity."

It is a surprise, therefore, that only five years later, in 1893, Josephson was accorded the honor of a retrospective exhibition in Stockholm, and that that exhibition included important examples of his later work. It was, in fact, these radical pictures that were greeted with enthusiasm by the younger generation of Swedish painters. Within his own country Josephson cannot be said to have sunk into obscurity as an artist. A new Josephson had emerged nevertheless, and it is necessary to account for the discovery of this "new" artist elsewhere in Europe. There was no continuity between the Josephson of the Salon of the 1880s, and the artist whose work aroused curiosity and excitement in Parisian art circles around 1920. In Germany, where his early work was little known, the new Josephson emerged as a unique and startling phenomenon engendered by insanity. To what extent was he seen as an Expressionist by the Expressionists?

It is difficult to account for the transmission of Josephson and his work from Sweden to Germany. The influence of the work of the Norwegian painter Edvard Munch on the early development of Expressionism has been well documented, but he actively made himself known in Germany. His popularity, as well as the enormous fame of the writings of August Strindberg (1849–1912) in Germany, may have helped to focus attention at this time on Scandinavia as the source of art of a particular type: intense, often morbid, Expressionist in style, and pathological in flavor. Books on Josephson had begun to appear as early as 1902 in Sweden, culminating in the detailed biography published by Wåhlin in 1911, a study that explored Josephson's later work and the details of his illness with remarkable candor. These publications, however, were written in Swedish and could have had little impact elsewhere. The first clear sign of an intensification of interest in Germany appeared in 1909 with the publication of an article by Wåhlin in *Kunst und Künstler*, and another by H. Struck in the *Zeitschrift für bildenden Kunst*.[43] Far more significant is the fact that in that same year drawings from Josephson's later period were included in the Spring Exhibition of the Berlin Secession. Numerous works by Brücke painters were included in that show, as well as a number of pictures by Munch. The Josephsons attracted considerable attention, and Emil Nolde was so highly interested in them that he bought three of the drawings for his own collection. Clearly, Josephson's "Expressionist" work was known to the German painters at least as early as 1909.

Had Nolde purchased three paintings by van Gogh or Ensor in this period, this would be accepted at once as indicating his artistic direction, and would be carefully evaluated, owing to the nature of his artistic development at that time, as an important factor in the

formation of his style. It is indicative of the continuing ambivalent attitude to psychotic art that the purchase of three Josephsons by a recent member of Die Brücke excited so little comment. Comparison of paintings by Nolde and far earlier pictures by Josephson suggests just how close these two painters were, and helps to account for the attraction Nolde felt for this Expressionist predecessor (Fig. 14.9). In 1909 Nolde launched his intense involvement with religious subjects, a preoccupation that he shared with Josephson. Whether by coincidence or knowledge, Nolde employs the same techniques—the same color, crudity, and directness—and achieves the same haunting intensity as Josephson had many years earlier. He stated that this series of religious paintings of 1909 was based on childhood memories. "The concepts of a small boy, who during the long winter months used to spend all his evenings earnestly reading the Bible, were reawakened. There were pictures of the richest Oriental fantasy. They kept rising in my imagination until the adult man and artist could paint them in dreamlike inspiration."[44]

By 1920 Josephson's role in the development of Expressionism had been recognized to the extent that his paintings and drawings were being extensively reproduced in periodicals devoted to Expressionist art and literature. Knowledge of his work now spread rapidly throughout Europe. Everywhere it was understood as an outstanding example of the liberating effect of insanity on the artistic faculty. Kokoschka, with whose work Josephson's is so often compared, is known to have owned a portfolio containing forty reproductions of Josephson's drawings.[45] The same drawings also attracted attention in Paris, where both Picasso and Modigliani are known to have studied them.[46]

More than any other contemporary writer, Strindberg voiced the conception of Josephson current in the early years of the twentieth century. His novel *Gothic Rooms* expressed his feelings about this man who had been his friend.

"The man who sits down there, out of it all, should be the foremost up here tonight, if it weren't that you and fellows like you have helped to destroy him—and you are not worthy of having him spit at you; no! You deprived him of his honor, his bread, his self-esteem—that time you know! Let Syrach sit there, in his dream world—he is better off than we can imagine, and besides that, he does not recognize any of us!" Syrach was left alone; he sat there with his eyes directed above the heads of the crowd gazing far off into space as if he were alone with the dreams and visions he could not communicate.

The discovery of the art of the insane by the Expressionist painters is paralleled by their discovery of the

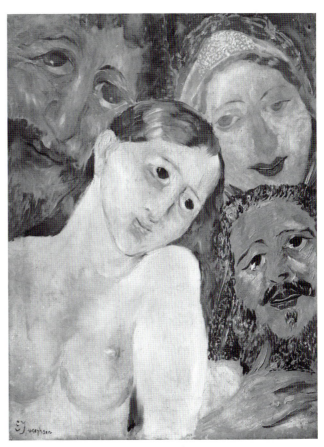

14.9. Ernst Josephson, *Ecstatic Heads*, oil on canvas, National Museum, Stockholm.

art of children. In a diary entry written in 1912 Paul Klee pointed to three unexpected sources as fundamental to the development of modern art.

For these are primitive beginnings in art, such as one usually finds in ethnographic collections or at home in one's nursery. Do not laugh, reader! Children also have artistic ability, and there is wisdom in their having it! The more helpless they are, the more instructive are the examples they furnish us; and they must be preserved free of corruption from an early age. Parallel phenomena are provided by the works of the mentally diseased; neither childish behavior nor madness are insulting words here, as they commonly are. All this is to be taken very seriously, more seriously than all the public galleries when it comes to reforming today's art.[47]

The influence of the art of children on the development of Expressionism throughout its evolution has received moderate attention because of Kandinsky's insistence upon it in his major theoretical writings. Within the Expressionist milieu, children's art found

recognition as art in the fullest sense. In terms of the "principle of inner necessity," his only criterion in judging the value of art, Kandinsky was able to state, "There is an enormous unconscious power in the child that expresses itself here, and that raises his work to the level of adult's work, sometimes even higher."[48] The publication of the *Blaue Reiter Almanac* demonstrated the intensity with which Kandinsky and Marc held this opinion. Children's art was reproduced in it next to the work of old masters, primitives, and contemporary French and German painters (Fig. 14.10). As early as June 1911, Kandinsky had formulated his intention to include the work of children in the *almanac* on equal terms with that of adult artists. It was, nevertheless, not a new idea. "The corrupt distinction of one art from another, furthermore of 'Art' from folk art and children's art, from 'ethnology'—all these firmly built walls rising between forms which in my eyes seem so closely related, indeed frequently identical; briefly, the synthetic relationship of art—left me no peace."[49]

Ernst Ludwig Kirchner had repeatedly emphasized the importance of his own childhood drawings, and reproduced and exhibited them next to his recent work. Klee collected his own early drawings and the work of his son Felix, and unashamedly expressed the opinion

that his son's work was superior to his own. "Their lordships, the critics, often say my pictures are like children's scribbles and smears. That's fine! The pictures my little Felix painted are better than mine, which all too often have trickled through the brain; unfortunately I can't prevent that completely because I tend to work over them too much. That criticism is true."[50] Kandinsky's interest in the art of children developed prior to his meeting with Klee in 1911, and may in fact have contributed to his decision to move in the direction of total abstraction at that time. Children's art, unlike the far more stylized and ordered art of primitives, does involve beautiful use of fully nonrepresentational composition in its early stages. Kandinsky's compositions ca. 1912 are not unrelated to the art of the child. His use of color and his color theory is always related in his writings to his infantile experiences of color. "The child is indifferent to practical meanings since he looks at everything with fresh eyes, and he still has the natural ability to absorb the thing as such. Only later does the child by many, often sad experiences, slowly learn about the practical meanings. Without exception, in each child's drawing the inner sound of the subject is revealed automatically."[51]

Klee's strong interest in the image-making activity of children was paralleled by, as he himself tells us, his

14.10. Children's art, from Wassily Kandinsky and Franz Marc, *Blaue Reiter Almanac* (1912).

involvement with the art of the insane. Among the artists of the Blaue Reiter, Klee must be credited with the discovery of psychotic art; in fact, his awareness of this form of expression would appear to predate his membership in that group. The influence of the spontaneous art of the mentally ill has been detected in works executed by Klee as early as 1904–1905. By 1912 he had come to feel that these images were of profound importance for the future development of modern art, far more significant than works exhibited in museums and accepted as "Art." To what extent this conviction was shared with and by his fellow artists remains obscure.[52] Also problematic is the question of the source of Klee's knowledge of psychiatric art. Where was he able to see examples of it in Switzerland or Germany? He tells us nothing of any such encounter during those years, nor is there any indication that he was reading those few books in which it was reproduced. Nevertheless, he must have seen outstanding examples of this art of sufficient quality to have inspired this perceptive and startling attitude toward it. One would like to think that he had come to know the work of Adolf Wölfli of Bern, whose pictures so often awaken thoughts of Klee, but no evidence of any such encounter exists, prior to 1912.[53] His knowledge and feelings about this form of art must have been based on experience rather than "imaginative reconstruction," and his encounter with these images confirmed the correctness of the profoundly individual direction that his art had begun to take.

The task of identifying instances in Klee's early work where he may have been directly influenced by the art of psychotic individuals is rendered difficult by our complete lack of knowledge of the type of pictures he may have seen. Klee's own inner journeying would have provided images paralleling the art of the insane even without any direct pictorial stimulus. It is only his own insistence on the seminal influence of this art that causes us to explore his early productions in search of specific sources. In his study of the influence of various types of "primitive art" on the development of modern painting and sculpture, Robert Goldwater dared to cite specific examples of Klee's work that might derive from such influence.

In other pictures Klee makes use of forms which have their clear analogies in drawings of the mentally ill, and are probably derived from this source: Characteristic are the extension of the human features, especially the eyes and the mouth, into ornamental linear motifs which are then, in neglect of their original intention, elaborated for their own decorative value; the use of a close all-over pattern made up either of dots or of a minute linear scheme which the eye can-

14.11. Paul Klee, *Threatening Head (Drohendes Haupt)*, 1905, etching, San Francisco Museum of Modern Art, COSMOPRESS, Geneva, 1988.

not follow in detail and designed in such a way that the eye has equal and yet exact demands on its attention from the whole picture surface, thus creating a tremendous strain; and the repetition of the face in other parts of the body.[54]

Goldwater sees the sour etchings of 1903–1905 as possible instances of the influence of schizophrenic drawings on Klee's early development (Fig. 14.11). He points to the fact that Klee employed "the tight, overall technique, so minute as to appear compulsive and give the impression of stripped flesh."[55]

Goldwater is accurate in his description of a specific type of drawing style often employed by schizophrenics. Yet such work was by no means easily available. The early etchings reveal striking similarities to the obsessional style of Ernst Josephson, both in formal means and in expressive quality (Fig. 14.7). That Klee would have known Josephson's work by 1909 is almost

certain. That he knew of it earlier than this has not been documented. Most of the other Klee pictures singled out by Goldwater as deriving from his knowledge of the art of the insane belong to the period after 1922, and reflect the artist's interest in Prinzhorn's *Bildnerei der Geisteskranken*, a copy of which he kept in his studio.[56] However, Klee was familiar with some of the pictures in the Prinzhorn Collection at least as early as 1920, two years before the publication of Prinzhorn's book, and prior to his arrival at the Bauhaus. Nor was he the only member of the future Bauhaus staff to have seen parts of that collection.

Early in July 1920, Oskar Schlemmer (1888–1943), then resident in Cannstatt outside of Stuttgart, attended a social gathering at which Prinzhorn, gave a talk on the drawings of the insane. Schlemmer noted that Klee had seen this material and was enthusiastic. Schlemmer's response to the pictures shown by Prinzhorn was no less enthusiastic. He immediately understood the implications of this art in terms of the investigation of the inner world that he and Klee were engaged in, and he envied the intensity and purity of the psychotic's vision of that world.

For a whole day I imagined I was going to go mad, and was even pleased at the thought, because then I would have everything I have been wanting; I would exist totally in a world of ideas, of introspection—what the mystics seek.

The Doctor also displayed a drawing with the caption: "Dangerous to look at!" This keeps going through my mind. The drawing showed delicate symbolic signs for love, life, childhood, humor, systematically arranged. Of course the whole business is used as an indictment of modern artists: see, they paint just like the insane! But that is not so, despite the similarity; the madman lives in the realm of ideas which the sane artist tries to reach; for the madman it is purer, because completely separate from external reality.[57]

Although the reference to Klee's contact with these works is regrettably vague, I am inclined to think that he had made contact with Prinzhorn, and parts of his emergent collection, at some time prior to July 1920. Certainly the reference to Klee's enthusiasm, implies that he and Schlemmer had discussed this very special art form at sufficient length for Schlemmer to be aware of his feelings about it. The publication of *Bildnerei der Geisteskranken* in 1922 only confirmed Klee's interest, and made permanently available a larger range of works from that collection. From that point on, he would have known specific psychotic artists by name, and would have had the opportunity of relating to specific works by individual masters, rather than to "psychotic art" in general.

Thus, from at least 1922 on, it should be possible to point to specific influences on Klee's work stemming from prolonged study of individual pictures in the Prinzhorn Collection. An impressive attempt to establish connections of this kind was first made by the American art historian James Smith Pierce, who demonstrated the necessity of going beyond Goldwater's pioneering references to "the drawings of the mentally ill," to careful discussion of individual psychotic masters, and specific examples of their work, in terms of possible influences on certain twentieth-century artists, such as Klee.[58] Pierce clearly understood that the adoption of certain subjects, motifs, or formal devices from psychotic artists would never be simply a matter of copying or uncritical borrowing. As with the parallel case of tribal art, the artist's discovery of psychotic art is always the result of his work having arrived at a point at which the discovery is needed. The psychotic master who then attracts his attention is likely to work in a style, or mood, similar to that of his artist-discoverer. This was evidently the case with Heinrich Welz (HH. v. Wieser, b. 1883), whose work and ideas Klee seems to have admired. Pierce demonstrated even deeper underlying affinities between the mind and work of the sculptor Karl Brendel (Carl Genzel, b. 1871) and Klee.

The negative comparison of Klee's work with that of psychotics began early. In 1928, in Mayr's *Le délire graphique et verbal*, a drawing after Klee was reproduced with the suggestion that it represented a form of "pseudoprimitivism" or cultivated insanity (Fig. 14.12). Other critics were less restrained, and Klee was accustomed to attacks of this sort. His reaction to them is described by Lothar Schreyer, an artist colleague, in his account of a conversation he had with Klee in his studio at the Bauhaus.

14.12. Anonymous, drawing after a watercolor by Paul Klee, from W. Mayr, *Le délire graphique et verbal* (Paris, 1928).

"The scribes and pharisees say that my pictures are the product of a diseased brain." A mood of excited gaiety took possession of Klee. He took from a shelf Prinzhorn's recently published book of pictures by the insane, *Bildnerei der Geisteskranken*. It was at that time going the rounds in the Bauhaus. "You know this excellent piece of work by Prinzhorn, don't you? Let's see for ourselves. This picture is a fine Klee. So is this, and this one too. Look at these religious paintings. There's a depth and power of expression that I never achieve in religious subjects. Really sublime art. Direct spiritual vision. Now can you say that I'm on the way to the madhouse? Aside from the fact that the whole world is an insane asylum."[59]

Klee's respect for the pictures in Prinzhorn is apparent. He reveled in the parallels there with his own work, qualifying it only to the extent that he felt himself unable to reach such pure intensity of vision (see, e.g., Fig. 14.13). In such resemblances, Klee found confirmation of the success of his own effort to "make visible the invisible." It was not chance similarities of form that intrigued Klee, but the shared psychological insights, the spiritual territory they had explored in common.

I say it often, but sometimes it isn't taken seriously enough, that in our time worlds have opened up which not everybody can see into, although they too are a part of nature. Perhaps it's really true that only children, madmen and savages see into them. I mean, for example, the realm of the unborn and the dead, the realm of what can be, might be, but need not necessarily be. An in-between world. At least for me it's an in-between world. I call it that because I feel it exists between the worlds our senses can perceive, and I absorb it inwardly to the extent that I can project it outwardly in symbolic correspondences. Children, madmen and savages can still, or again, look into it. And what they see and picture is for me the most precious kind of confirmation. For we all see the same things, though from different angles. On the whole and in details it's the same over this whole planet of ours—These things aren't fancies, but facts.[60]

If, in the case of Klee, we are forced to guess at which of Prinzhorn's schizophrenic masters he admired and identified with—"This picture is a fine Klee. So is this, and this one too"—another member of the former Blaue Reiter group has provided precise information on his encounter with these same artists. In 1922, Alfred Kubin (1877–1959) traveled to Heidelberg to see the collection, later recording his impressions in a short article entitled, "The Art of the Insane."[61]

Kubin's personal reactions to the vast range of images he was shown are very specific, consisting of references to the work of only thirteen artists. They were seemingly recorded shortly after the visit, when his excitement and enthusiasm were still intensely felt, and

while the works were fresh in his mind. He refers repeatedly to things he saw, "which especially impressed themselves upon my memory." His notes show the response of a major artist to specific artists and works in the collection, clarifying the ways in which his perceptions and associations differ from those of a lay visitor. With his notes as a guide, one can follow him through the mass of drawings, paintings, and sculpture.

It should be noted that Kubin's own initial creative drive had been propelled by the nearly overwhelming psychological disturbance of his early years. For a time he had been at the mercy of a flood of hallucinatory images erupting from the unconscious, images he sought to subdue through compulsive writing and drawing.[62] By 1922, the flood was over. Speaking of this period of calm, he later wrote, "This period of my life was dearer to me than the gloomy and stormy times of my youth and the wild years of my early manhood."[63] No longer overwhelmed by irrational images which he could neither understand nor stop, he now settled into a career as a book illustrator.

It would seem that the diminution of his creative drive brought some sense of loss, and thus he turned to the exploration of his dreams, approaching them now as illustrator of *The Dreamland*, rather than as victim. In the year he visited Heidelberg he was completing work on two collections of illustrated accounts of his own dreams.[64] It becomes apparent that the meaningful encounter with psychotic art is dependent upon the artist-discoverer being somehow prepared for the event, in that he seeks among the images he encounters those that accord best with his own work and with the psychological state motivating it.

As with the other Expressionists who were drawn to this "new" art, Kubin was intrigued by the schizophrenic state precisely because it involved a rich fantasy life evolved by individuals, "permanently and completely closed up within themselves,"[65] "closed off from outer experience. . . . Confined within the impenetrable circle of his imagination."[66]

Kubin's notes convey his excitement and profound sense of mystery before these images. "The works, in themselves (as opposed to the associated psychotic writings), affected me, and my art-loving friend, immensely strongly, through their hidden adherence to formal order. We were standing before miracles of the artistic spirit, which are summoned up from the depths, free of any intellectual overlay; the creation and contemplation of which must give happiness."[67] As he moved amazed from artist to artist, he used his knowledge of modern art to orient himself amidst the chaos of new and unnerving images, drawing parallels

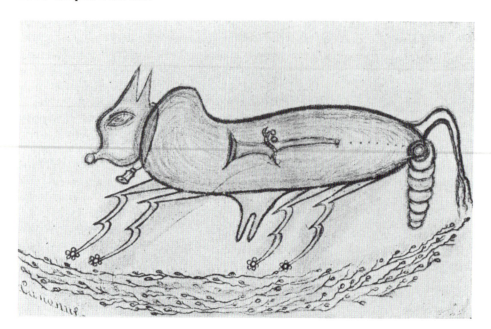

14.13. Heinrich Anton Müller, *Cannon*, Prinzhorn collection, Heidelberg.

with Expressionism, and even with specific artists such as Klee. At one point he paused before a picture that he described as "a fabulously grotesque Kaiser Wilhelm," to announce, "These things remind one, in part, of Paul Klee, and would certainly have interested him."[68]

However, it was not primarily the Klee-like works that most attracted Kubin. He was seemingly less strongly drawn to the more controlled, somewhat reticent, linear style of draughtsmen such as Heinrich Welz, August Natterer, or Johann Knüpfer (J. Knopf, b. 1866), searching instead for works suggestive of unusual, almost brutal, emotional intensity, or reflective of more chaotic mental disorganization. Professional art training and technical control he saw as factors destructive of the vital force to be found in "pure" (self-taught) psychotic artists. It was the highly colored, markedly Expressionist, style of a painter such as August Klotz (August Klett) that awakened his enthusiasm (Plate 29). "Here, strident color, raw power; hairdressers and buffet ladies, and an entirely unrelated text; but a very great wealth of ornamental invention, amongst which birds and fishes. The whole (characterized by) the most extreme excitement."[69]

Unafraid of sexual or obscene subject matter, he described overtly erotic pictures by a "sexual criminal." He was obviously delighted by the famous *Cannon* of Heinrich Anton Müller (Fig. 14.13) and the sometimes explicit carvings of Karl Brendel. Doubtless because of

his own early hallucinatory experience, he was undismayed by even the most chaotic pictorial assemblages, such as the *Holy Sweat Miracle on the Insole* drawings of Carle Lange, with their bizarre juxtapositions of "heads, limbs and eyes" (Fig. 14.14).

Kubin's most intense aesthetic response was stimulated by the paintings and drawings of Prinzhorn's favorite schizophrenic master, Franz Pohl (Franz Karl Buhler, b. 1864, hospitalized 1898), an individual permanently and completely enclosed within the autistic isolation of the most extreme schizophrenic state. Kubin made little reference to the artist's mental illness, having become absorbed in the beauty of his work and in the incomprehensible creative ability implied by it (Plate 24). "Unquestionably a gift of genius (in which) an exceptional power of invention in color and form finds expression. One senses an unmistakable development, an intensification of the ability to make use of the means of painterly expression, to the point of unheard of symphonies of color."[70]

Kubin's account of his visit to the Prinzhorn Collection bears witness to the impact of these masterpieces of psychotic art on an extremely sensitive artist. Perhaps with Klee or Kirchner, its influence is to be found, instead, in their work.

Armed with an acute critical and historical awareness, Kubin concluded his article on the art of the insane by raising the broader issue of the fate of the collection. He saw that it was deteriorating from lack of

care, and he realized that its significance merited recognition far beyond the confines of the psychiatric clinic within which it was housed. "When, one must ask, will the treasures of this outstanding collection, the finest of its kind, be made available to the public? Art dealers have no interest in these unsalable objects, and the institution lacks sufficient money to exhibit them on any regular basis. Sooner or later, a benefactor will be found to intervene, so that a space for the permanent exhibition of the collection could be made available. Then, from this place where things created out of spiritual illness would be gathered together, spiritual refreshment could pour forth."[71]

WHILE THE ART of untrained psychotics was clearly of interest to Expressionist painters, and contributed to the origins and development of German Expressionism, a strange preoccupation with the "psychopathology of art" can also be shown to have played a part in the final destruction of that movement. In concluding this chapter, we must turn once again to the negative side of the process of discovery, to observe the final, tragic outcome of those theories that claimed to see pathology in genius, and evidence of disease in unconventional images. These pseudoscientific ideas, most clearly embodied in the work of Cesare Lombroso, found their most influential expression in the aesthetic theories of National Socialism, and specifically in the doctrine of "degenerate art" (*entartete Kunst*).

That Expressionist painters found in the powerful, sometimes violent images of the insane certain parallels with their own work, suggesting a spiritual ground or community of feeling, does not imply that they were themselves mentally disturbed. Nevertheless, it was the fate of all of these artists during the Nazi era to be denounced as suffering from psychological or racial degeneracy, while their work was exhibited with that of the retarded or insane as evidence of mental disease. Paul Klee's open admiration for the painting of the insane could, only a few years later, be used to demonstrate, falsely, his disturbed mental state or his deliberate artistic chicanery in emulating the works of madmen. Supposed psychopathology in art or creativity had by 1933 become grounds, not for hospitalization, but for political and legal persecution by the state.

It is a striking paradox that the same country that produced Hans Prinzhorn should, only a few years later, have developed "scientific theories" so naive, so distorted, and so dangerous. As we have seen, Prinzhorn's immense appreciation of the art of the insane derived from his intimate acquaintance with modern art. *Bildnerei der Geisteskranken* was written under the impact of Expressionism, and could almost be seen as one of the intellectual offshoots of this movement. The growth of the collection at Heidelberg occurred at the same time as the acquisition by German museums of the work of the Expressionist painters, and was motivated as much by aesthetic as by scientific preoccupations. Prinzhorn died in 1933, the year in which the Nazi attack on modern art began. His work and his writings on psychotic art were abandoned because they could not be used to prop up the new scientific theories of National Socialism. Psychiatry was now to be used to support doctrines of racial superiority and applied as the main weapon in an all-out attack on contemporary art and artists. Interest in the art of the insane now centered on using it as proof of the diseased state of "degenerate" artists and their work.[72]

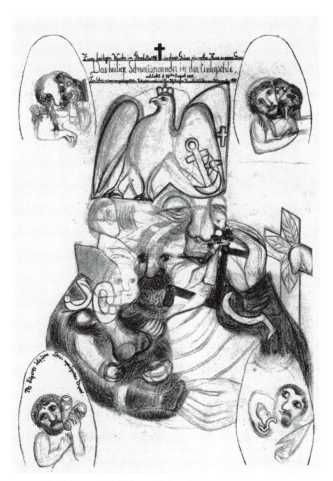

14.14. Carl Lange, *Holy Sweat Miracle on the Insole*, pencil, Prinzhorn Collection, Heidelberg.

The concept of the "degeneracy" of art and artists was not the creation of National Socialism. However, within the development of a specifically Nazi aesthetic, the term *degenerate art* took on new and important meanings. On one level it meant no more than art disapproved of by Hitler and his followers. Hitler's personal taste, and his profound interest in the visual arts, played a leading role in the development of National Socialist policy in regard to the arts.[73] As Herbert Read pointed out in 1937, never before had the supreme head of one of the great nations concerned himself so directly with the formulation of taste and activity in the fine arts.[74]

Very early, Hitler's views on art, good and bad, were being expressed in terms of "healthy and diseased" art, and mentally sound or degenerate artists.

For whatever scores we had to settle with our criminals of the world of culture, we did not spend too much time in bringing to book these destroyers of our art. From the first our determination held the field: we will not let ourselves be drawn into endless debates with men who—to judge from their achievements—were either fools or knaves. In fact, we have always regarded the actions of the leaders of these cultural Herostratuses as nothing but crimes. Every personal dispute with them must, therefore, have ended in bringing them either into the prison or the madhouse according as they really believed that these creations of a diseased imagination represented their own inner experiences or admitted that these productions themselves were but a melancholy concession to an equally melancholy fashion.[75]

It was the aim of Hitler and his representatives to identify this diseased art and its creators, and to purify German culture by destroying both. In the world of art as in the sphere of race, Hitler believed in final solutions.

Although the concept of degenerate art has been much discussed, its origin within the field of psychiatry, and its essentially psychiatric, as opposed to aesthetic, significance, has been little appreciated. Degenerate art did not simply mean bad art, false art, politically dangerous art, Jewish art, or decadent art. It meant psychopathological art: the product of painters and sculptors suffering from the psychiatric state of mental degeneracy. The uniqueness of the Nazi position did not rest so much in making this diagnostic assessment, as in seeing this art as culturally dangerous, and in making the decision to destroy it.

The term *degeneracy* entered psychiatric thinking, as we have seen, in the writing of the French psychiatrist Bénédict-Augustin Morel. It was not originally conceived of as having anything to do with art. In the hands of Cesare Lombroso it was directed against men of genius, and most frequently against creative artists. The tremendous popularity of Lombroso's work in this area was, in part, a result of its perceived value to many aestheticians and writers on art and literature as a formidable weapon in the attack on advanced or innovative art.

Lombroso's foremost German disciple, Max Nordau, used his work specifically with this purpose in mind, developing a pseudopsychiatric aesthetic, which he employed against the artists, writers, and musicians of his own day, particularly the Pre-Raphaelite painters and the Symbolists. His books, among which was *Degeneracy* [*Entartung*] (1892), were enormously successful.

Degenerates are not always criminals, prostitutes, anarchists and pronounced lunatics; they are often authors and artists. . . . Some among these degenerates in literature, music, and painting have in recent years come into extraordinary prominence, and are revered by numerous admirers as creators of a new art and heralds of the coming centuries. This phenomenon is not to be disregarded. Books and works of art exercise a powerful suggestion on the masses. It is from these productions that an age derives its ideals of morality and beauty. If they are absurd and anti-social they exert a disturbing and corrupting influence on the views of a whole generation. Hence, the latter, especially the impressionable youth, easily excited to enthusiasm for all that is strange and seemingly new, must be warned and enlightened as to the real nature of the creations so blindly admired. This warning the ordinary critic does not give. Exclusively literary and aesthetic culture is, moreover, the worst preparation conceivable for a true knowledge of the pathological character of the works of degenerates. Now I have undertaken the work of investigating the tendencies of the fashions in art and literature; of proving they have their source in the degeneracy of their authors, and that the enthusiasm of their admirers is for manifestations of more or less pronounced moral insanity, imbecility, and dementia. Thus, this book is an attempt at a really scientific criticism.[76]

It was Nordau who provided the psychiatric basis for the Nazi concept of degeneracy. The racial and eugenic side of the concept was then elaborated by a number of pre-Nazi German thinkers, particularly Hans F. K. Guenther and Paul Schultze-Naumberg.[77] But even in Lombroso, the idea of degeneracy had obvious racist implications. Nazi writings concerned with racial inferiority and specifically anti-Semitism make it very clear that racial superiority involved a state of superior mental health, as well as physical perfection, inferior racial strains being characterized by psychological disease. Expressionist works of art were seen as embodiments of specific psychopathology, the product of either racially determined degeneracy or, in the case

14.15. Photographic comparisons of mentally ill, retarded, and deformed individuals with self-portraits and portraits by Expressionist artists, from P. Schultze Naumberg, *Kunst und Rasse* (Munich, 1928).

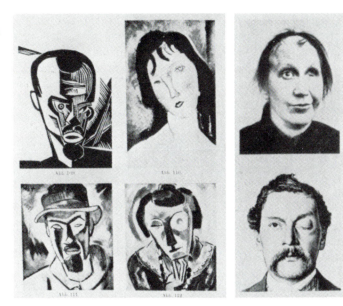

of Aryan artists such as Nolde, as the result of nonhereditary mental disease. However determined, modern art was seen as "sick art" of a highly contagious nature.

From the very beginning the concept of degeneracy involved physical appearance as well as mental symptoms. Degenerates could be identified by specific physical traits. Within Nazi thinking physical beauty and perfection were seen as Aryan features, while ugliness or physical oddity were signs of racial degeneracy. Not surprisingly, the self-portraits of Expressionist painters were used as evidence against them. As early as 1928, Schultze-Naumberg provided his readers with pictorial comparisons, placing the self-portraits of modern artists opposite photographs of mentally disturbed or retarded individuals (Fig. 14.15). In that a number of the Expressionist painters had deliberately portrayed themselves as deranged or insane, the Nazi authorities had little difficulty in obtaining examples demonstrating physical and mental abnormalities. Kokoschka even went so far as to paint his celebrated self-portrait as a degenerate artist, a heroic gesture provoked by intense suffering (Plate 17).

The National Socialist aesthetic contained nothing that was truly new. Incoherent in the extreme, inspired by blind prejudice and deep-seated hatred of modern art, variations of its theories could be found in every country of Europe and in America. The dictatorial methods of its totalitarian leader toward modern art were viewed with sympathy well beyond the borders of Germany. Everywhere modern art was under attack. Described at times as a huge hoax perpetrated by unscrupulous artists and dealers, at other times as the perverse product of unbalanced minds, it was seen as socially and culturally disruptive, and therefore dangerous. The use of psychiatry as a weapon of attack was by no means confined to Germany. As late as 1946 the Australian painter-critic Sir Lionel Lindsay (1874–1961) felt called upon to defend art from attack by Jews, international swine, Bedlamites, degenerates, Negroes, and women: "Now every kind of folly flew from the asylum cage. Cubism, Purism, Constructivism, Neoplasticism, Vorticism, Expressionism, and Surrealism—. . . the culture-cretin and the snob-in-a-hurry can resist no stimulus—which is a typical and immediate proof of degeneracy."[78] Having discussed the "Jewish problem" at length, ingeniously including Picasso in this group, he mentions with evident relish that modern art ended in Paris with the arrival of the Nazis. "Yet I fear, since the flight of Jewish dealers from Paris when the Nazis arrived, that all is again busy in New York."[79]

Nor was it only amateur psychiatrists who dabbled in diagnosis. As eminent a physician as Carl Gustav Jung felt called upon to concern himself with modern art. In 1932 he published an article on Picasso describing him as a latent schizophrenic—an artist

fatefully drawn into the dark, who follows not the accepted ideals of goodness and beauty, but the demoniacal attraction

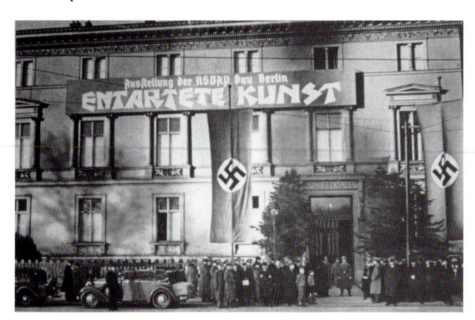

14.16. Entrance to the exhibition of "Entartete Kunst," Berlin showing, 1937.

of ugliness and evil. It is these anti-Christian and Luciferian forces that well up in modern man and engender an all-pervading sense of doom—veiling the bright world of day with the mists of Hades, infecting it with deadly decay, and finally, like an earthquake, dissolving it into fragments, fractures, discarded remnants, debris, shreds, and disorganized units. Picasso and his exhibition are a sign of the times, just as much as the twenty-eight thousand people who came to look at his picture.[80]

It was, however, in Germany that the attempt was made to exterminate modern art and artists. Beginning in 1933 a series of carefully organized events signaled the end of artistic freedom in the Third Reich. The Bauhaus, having been brought to its knees, was now closed; museum directors and art teachers began to be dismissed; and exhibitions of modern art were shut down, and the work confiscated. In July 1937 the seizure of works of "degenerate art" began under the direction of Professor Adolf Ziegler. Some sixteen thousand works of art were removed from public collections, all of them identified as degenerate. This included almost all of the works of Expressionist painters owned by the German museums. Some four thousand pictures were burned in 1939; the remainder were sold abroad. Aside from seeing their life work vilified and destroyed, the supposedly degenerate artists were hounded and persecuted by the state. Laws were expressly designed to interfere with their creative ability, depriving them of the right to teach (Lehrverbot), to exhibit their work (Ausstellungsver-

bot) and, most tragic, to paint, even in the privacy of their own homes (Malverbot). Painters were visited by members of the Gestapo who searched their houses for fresh paintings or wet brushes. The threat of imprisonment was very real. Armed with absolute dictatorial power, Hitler and his minister of culture, Dr. Joseph Goebbels, were able to all but obliterate the last traces of the German Expressionist movement.

The effect on serious study of psychiatric art was equally devastating. Only those authors who investigated the art of the mentally ill to seek support for theories of the inferiority of non-Aryan races could get their work published. In addition, the misuse of this material in attacking modern art brought psychiatric study of art of any kind into such disrepute that Germany has never regained its leadership in this field. The discussion of psychotic art as an important aspect of human creativity or as a stimulus for the development of modern art became so painful a topic that much of the evidence concerning its influence on the history of art has never been examined, and is difficult to obtain. The celebrated Prinzhorn collection disappeared into packing cases from which it has only recently emerged. The discovery of the art of the insane had been set back by fifty years.

The attack on contemporary art in Germany reached its apex with the carefully staged exhibition of "Entartete Kunst," which opened on July 19, 1937, in Munich (Fig. 14.16).[81] The exhibition was referred to by Hitler as "a useful lesson illustrating the depths of the de-

cline into which the [German] people had fallen."[82] Works of art and their creators were exposed to public humiliation and vilification. The feelings of the German people were carefully manipulated, so that their already strong antagonism to contemporary art could be turned to the advantage of the party. As usual, Hitler knew his audience well. The exhibition, attended by two million people, was an unequaled success. Specifically labeled an exhibition of degenerate art, it can rightly be described as the largest exhibition ever devoted to supposed examples of the art of the insane. It represented in some ways a continuation of Bedlam's practice of exhibiting insanity for the amusement and edification of a curious and largely hostile public. The exhibit contained, of course, little that could be correctly identified as psychotic art.[83]

The design of the exhibition clarified for the first time precisely what was meant by the term *entartete Kunst*. The vast mass of material, painting and sculpture, was divided into nine categories, a system of classification reflected in the catalog of the exhibition.[84] Separate rooms were devoted to the following subjects:

1. Works in which form and color had been willfully distorted.
2. A room devoted to religious painting and sculpture seen as indicating a Jewish attack on the Christian religion.
3. Graphics of a political nature seen as connected with the communist and anarchist point of view.
4. Works that undermined respect for military activity and its goals.
5. Works illustrating the moral perversity of degenerate art.
6. Works influenced by African and South Sea Island art (understood as racially inferior).
7. Comparison of the work of modern artists with that of retarded or mentally disturbed individuals.
8. The work of Jewish artists.
9. A final large room entitled Utter Madness, devoted to international movements in modern art.[85]

Clearly, certain aspects of the Nazi concept of Degenerate Art—stretched to include racial, religious, political, and aesthetic implications—cannot be described as reflecting a purely psychiatric concept. Yet its pseudopsychiatric implications were very prominent, particularly in rooms five, seven, and nine. Room nine was also the largest in the exhibition and represented its culmination.

The idea of an exhibition of the art of mental degenerates is said to have originated with Joseph Goebbels. The show was organized by Adolf Ziegler, artist and head of the Chamber of Fine Arts, using paintings confiscated from public museums all over Germany. Paintings and sculpture, prints and drawings, by all of

the major Expressionist painters were included, as well as works by non-German painters associated with the Modern movement. The Expressionist painters, who dominated the show, were exposed to particularly intense ridicule and attack. Portraits and self-portraits of many of them were exhibited with the aim of drawing attention to their degenerate mental state in terms of the supposed physical stigma associated with degeneracy. Professor Ziegler's opening remarks emphasized that the disturbed mental condition of the artists was reflected in the works shown. "You see around you the aborted offspring of madness, of impudence, of ineptitude and degeneracy. This show produces in all of us feelings of shock and disgust."[86] According to Ziegler, the exhibition showed how German museum directors had betrayed the trust of the German people by collecting and exhibiting the work of sick and degenerate artists, produced as a result of neurological impairment, senility, spiritual collapse, or a state of mental illness. To illustrate his point, he referred to the case of Louis Corinth whose "healthy work" was rejected, but who attracted the attention of museum directors only after he had suffered a stroke and could produce only pathological and incomprehensible scribbles. Having provided this edifying example of degenerate art, Ziegler warned the artists of Germany that the patience of the German people and their leaders was at an end.

The intention of the exhibition's organizers to present modern art as the work of mental degenerates was reflected in the manner in which the works were displayed. Working from a very primitive concept of the nature of mental illness, they attempted to create an environment expressive of psychopathology, extending

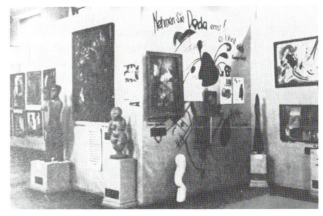

14.17. Exhibition of "Entartete Kunst," 1937, Berlin.

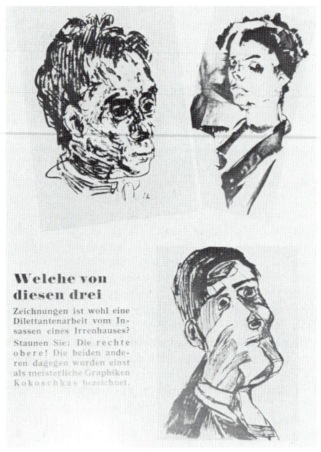

Welche von diesen drei

Zeichnungen ist wohl eine Dilettantenarbeit vom Insassen eines Irrenhauses? Staunen Sie: Die rechte obere! Die beiden anderen dagegen wurden einst als meisterliche Graphiken Kokoschkas bezeichnet.

14.18. Two drawings by Oskar Kokoschka and one by a psychotic patient (?), from *Entartete "Kunst": Führer durch die Ausstellung* (Berlin, 1937).

the chaos they detected in the paintings out beyond their frames. Pictures were hung at all levels and in curious groupings, and works of sculpture were placed on the floor or at inappropriate heights. Crudely written graffiti slanderously attacking both the art and artists covered the walls, which may reflect the organizers' knowledge of the tendency of some psychotic painters to mix inscriptions and drawings. Certainly, the intention was to convey the impression of a madhouse (Fig. 14.17). This intention is also reflected in the design of room seven, where Expressionist works were juxtaposed with pictures by psychotic and retarded individuals, obviously with the intention of deriding both. The catalog carried this comparison still further, reproducing two drawings by Kokoschka on the same page with the work of an asylum inmate, and asking the reader to decide which was which (Fig. 14.18). Other than loans from the Prinzhorn Collection provided by Carl Schneider, it is not known where Ziegler obtained the pictures in the exhibition said to have been the work of mentally ill individuals.

Paul Ortwin Rave, in his book on the cultural policies of National Socialism, asks an essential question: "How could it happen, so we must ask ourselves, that a very few who did not like a certain kind of art fought so passionately against this art, and that when they themselves came to power, and sat on the high horse, they sought completely to suppress and to eradicate it, and that they succeeded in bringing about this reversal?"[87] The Nazi attack on modern art and artists cannot be explained by pointing to anything in either that was objectively a source of danger to them. Clearly, there was a determination to control everything, to eliminate the possibility of individual thought and feeling at every level of the society. That the visual arts were seen as particularly significant and influential, and therefore deserving of serious attention and intervention, can, in part, be explained as the result of Adolf Hitler's deep personal involvement with them. The intense dislike of modern art so apparent in his speeches on the subject may well derive from the fact that he was twice rejected as a candidate for admission to the painting classes of the Vienna Academy. The element of revenge on the art establishment was certainly present. The exhibition of Degenerate Art was in part designed to please the Führer and to pander to his taste in art. He saw himself as chosen by destiny to purify German art, his cleansing of the temple of art paralleling his purification of German blood. Rave is wrong, however, in suggesting that it was only a few who disliked this art. In carrying out his task, Hitler knew that he had the support of the majority of the German people. The exhibition of degenerate art was understood as a means of currying favor with that majority.

Yet none of this necessitated the emphasis on psychiatric diagnosis, or comparison of modern German art with the art of the insane. Art can be bad without being pathological. The word degenerate was not casually chosen and, as we have seen, was directly linked to the Nazi obsession with racial superiority. For the Nazis mental disturbance was seen less as a form of illness than as a mark of genetic inferiority. For this reason the insane, along with other socially disruptive or undesirable elements, were sent to the death camps. The final solution was to involve the radical elimination of mental illness. The effort to link the contemporary artist with his insane brother had deadly implications. But why was this link so consistently

emphasized? Why was modern art again and again, both inside and outside of Germany, constantly identified with the art of the madman, and seen as a threat to mental health and social stability? I believe that the connection is neither accidental nor casually made. The intensity with which it was put forward betrays a deep conviction and an equally deep distaste. Behind the violent assault on Expressionist art lay something very real, something resembling pure terror.

Hitler saw modern art as dangerous because it endangered the mental health of the German people. It represented an assault on reason, on truth, and on clarity of thought. "I would state a law. To be German is to be clear, to be German is to be logical and true."[88] But modern art was dangerous not because it lied, but because it forced one to confront aspects of the self that were obscure, difficult, and profoundly irrational. Much of the art of the twentieth century, and particularly the form of art known as Expressionism, has concerned itself with the inner world in all of its instinctive violence and uncontrolled intensity. Expressionism is the art of instinct, of primitive emotion, of uncontrolled and spontaneous display of the unconscious. There are, accordingly, undeniable similarities between this art and that of the insane. The problem is not to demonstrate these similarities but to account for the violent aversion they awaken. At first sight it seems paradoxical that in Nazi Germany, where a near total breakthrough of destructive instinctual drives had already begun to occur, there should have been so determined an effort to wipe out evidence of instinct in art. Hitler was carrying out his purification of art in a charnel house. It was precisely because of the mass psychosis about to unleash itself in Germany that modern art had become too dangerous to be tolerated. One can do, but not bear to see what one does. Only by insisting on its separateness, only by isolating it as a product of the insane, of "the other," could it be rendered harmless and then burnt. Art was a mirror presenting something that could not be permitted to be seen. The Expressionist artist had discovered the insanity not of the madhouse, but the madness that had possessed mankind.

As EARLY AS 1922, Karl Jaspers had recognized the presence within European culture of a significant and increasing preoccupation with the art and literature of the insane. In his book *Strindberg und Van Gogh*, he attempted to describe the nature and the underlying causes of this extraordinary involvement.[89] As a psychiatrist and philosopher of worldwide reputation, he was in a unique position to assess the significance of what seemed the new and strange fascination with insanity and the artistic productions of the insane. The phenomenological approach, and the point of view inherent in Existentialism, of which Jaspers was one of the founders, provided an objective framework within which this phenomenon could be examined. As one of the first psychiatrists to make use of an existential approach in investigating unusual mental states, Jaspers was relatively free of the clinical and diagnostic prejudices of his day. Working in Heidelberg he was able to familiarize himself with the collection of the art of the insane being assembled by Prinzhorn.[90]

What intrigued Jaspers, however, was the highly trained artist or writer who at some point in his life becomes schizophrenic, and who then creates highly unusual works. He was struck by the fact that the importance and influence of these artists was the result of the works they had produced during the period of mental illness. He mentions Josephson as a case in point: "We have seen that Josephson's drawings, made during his schizophrenic period, are admired today, despite the fact that in 1909 they were regarded as of no particular importance. Today we are of the opinion that the art of the insane can be accepted as Art and not merely as suitable psychological material for psychiatric investigation" (p. 180).

As we saw earlier, Jaspers was aware of the efforts being made by some of the artists of his day to emulate the creative productions of the insane and even to cultivate mental states resembling madness. Jasper's unique contribution was to see in this preoccupation more than mere aesthetic fashion or artistic charlatanry. Conscious of how widespread this interest in psychotic art was, he was deeply curious about its underlying causes. He sought to explore its nature, first by investigating the works themselves, focusing on the creations of Strindberg, van Gogh, Swedenborg, and Hölderlin; and then by speculating on possible connections between the spirit of the age in which he lived, and those mental states subsumed under the term *schizophrenia*. His speculations escape the dryness of mere theoretical discussion because of his extensive experience in dealing with schizophrenic patients, as well as his impressive grasp of the cultural and intellectual currents active in twentieth-century Europe.

Jaspers was not careless in his use of the term schizophrenic. He distinguished carefully between works created in specifically psychotic mental states and works that only betray aspects of twentieth-century experience that might be termed schizoid. "It should be pointed out that the identification of certain unique works as conditioned by schizophrenia implies

in no way any depreciation of them" (p. 183). Looking back through history, Jaspers was unable to find periods in which the productions of psychotic individuals were valued. He pointed out, however, that hysteria, a neurotic rather than psychotic illness, had played an important role in the development of Western thought, particularly within the mystical tradition, but that the positive value attached to psychotic experience and creation is a new phenomenon unique to our time.

Unlike other writers of the day, Jaspers was not content to account for this involvement in terms of a taste for the exotic or a return to the primitive. He mentioned the interest in Oriental and African art, as well as the art of children. He was aware of the search for new beginnings, for forms of expression characterized by extremes of emotional intensity and cultural innocence, but these parallel activities explain nothing, and make the underlying question still more urgent. In attempting to formulate speculative answers to this question, he referred to certain pervasive needs that seemed characteristic of the psychological and spiritual position of advanced thinkers, writers and artists in the first quarter of the century in Europe. He saw within his contemporaries, and doubtless in himself as well, an urgent, indeed consuming need for experiences of emotional integrity and genuineness, for experience that is pure, direct, even violent, and a willingness to sacrifice anything to get them.

Our epoch exhorts us to ask the fundamental questions, and to seek immediate experience. We are, due to the orientation of our whole culture, able to an astonishing degree to open our soul to things which are most foreign to it, to the extent to which they appear to us authentic and relevant to our existence. But this situation drives us at the same time to premature expectations, to imitations without sincerity, to submission to sensational revelations, and to violent emotional experience at any cost. We want to cry out to the point of going mad. (pp. 181–82)

With this sought-after state of genuineness and intensity of feeling, he contrasted the reality of life in Germany of the 1920s, which he saw as a spiritual wasteland.

We live in a time of artifice and imitation, in which all spirituality has transformed itself into business and official institutions, in which pure will has been changed into a means of earning a living and in which everything is arranged with a view to making a profit, in which life is theatre, in a time when man knows all too well what he is, in which simplicity is desired, and in which Dionysiac ecstasy is counterfeit, as well as the discipline which characterizes it, in which the artist is too conscious, and too satisfied with being so. (p. 182)

Given this existential malaise, he raises a crucial question.

Have we not reached the point of believing that true authenticity, real depth of feeling, where the self is obliterated and a consciousness of Divine presence obtained, can only be encountered in mental illness? . . . In an age such as this does not the schizophrenic state become a condition of absolute sincerity? (p. 182)

In describing his deep attraction to the late work of Vincent van Gogh, Jaspers makes his own feelings in this matter quite clear.

Before him, I experience with greater clarity, although less materially, something I have but rarely sensed in the presence of my schizophrenic patients, and which I have attempted to describe. It seems to me that an ultimate wellspring of existence is opened up to us momentarily, as if the obscure ground of all being is here directly revealed. There is in his work a violent emotion which we are unable to withstand for very long, and which we gladly avoid. . . . It is extremely exciting, but it is not our world. One senses in it a radical questioning, a call addressed to our own existence. Its effect is beneficial, it provokes transformation in us . . . we feel ourselves shaken to the foundations of our being. (p. 181)

Jaspers understood psychotic art in terms of integrity, of honesty, as well as a source of otherwise unattainable psychological depth. But he sees a danger in it too. He visualizes the quest for the primitive and genuine as "a frantic dance, a foolish quest of the primitive which goes so far as a declared hostility to culture" (p. 182). The danger as he saw it lay in imitation and in the cultivation of insanity, which, because it is impossible, could lead only toward deeper falsehood and artifice in both art and artist. Writing toward the end of the Expressionist movement, and before the onset of the madness that was National Socialism, Jaspers had sensed the intensity of the need underlying the reevaluation of the art of the insane, as well as the social and individual crisis that was to lead inevitably to the destruction of the people and culture whose reality he had sought to describe.

FIFTEEN

Psychoanalysis and the Study of Psychotic Art

In 1948, Hans Sedlmayr, in his book *Art in Crisis*, attempted to characterize certain important tendencies in modern art that he felt had their origin in the painting of Francisco Goya.

The new element in his art has no connection with the public sphere, but derives from a completely subjective province of experience, from the dream. For the first time an artist, taking refuge neither in disguise nor pretext, gives visible form to the irrational. . . . The original titles were for the most part probably unintelligible to Goya himself, and were doubtless based on associations or "disguises" of the dream world which so often prove meaningless to the waking mind. They must, as must the dreams themselves, be psychologically interpreted; they must, that is to say, be referred, not to some general and recognized association of ideas, but to a purely individual one, which is valid for this one man alone. . . . This is the link with all those modern movements whose "iconography" derives similarly not from some universal association, but from some purely individual working of the dreaming self. . . . Psychoanalysis will one day attempt to write their "iconography."[1]

The violent change in the nature and function of image making that Sedlmayr here describes, the shift of art away from its public and social function toward the pictorial revelation of private, deeply subjective, and at times incomprehensible, symbols presents traditional critics and historians of art with problems that lie beyond their professional experience and training. Iconographic investigation is transformed into dream interpretation, and Sedlmayr either willingly, or in desperation, assigns the study of this new iconography to the psychoanalysts. Whether they will accept the challenge remains to be seen.[2]

A strange response to art criticism of this kind is not uncommon. It sees Sedlmayr's description of Goya's work as a distortion based on the retroactive application of psychoanalysis, a creation of the twentieth century, to the work of a painter of the early nineteenth century: Goya could have had no such thoughts because he had never heard of psychoanalysis. Once again we encounter a deeply rooted popular conception that, despite its irrationality, is worthy of examina-

tion. Freud is credited not only with the creation of psychoanalysis, but with the invention of the unconscious mind and of the whole of humanity's inner world.

It is not merely as a result of fashion, or of events occurring within psychology, that psychiatrists, and particularly psychoanalysts, have concerned themselves with art. Although certain factors within psychoanalysis led it from the beginning to be concerned with the entire range of human culture, there were even earlier developments within art itself that demanded psychological consideration and elucidation. "It was as though a door had opened in man, a door leading down into the world of the sub-human—the world which threatened with madness those who have seen too much of it."[3] Historical and psychological processes were at work in the nineteenth century that operated simultaneously in art and in psychology, forcing the emergence of psychoanalysis, just as they had earlier necessitated the painting of Goya. The dynamic irrationality of the unconscious was calling attention to itself in every field of human endeavor. The discovery of the art of the insane was a minor, but not insignificant, event in this far broader historical process. Goya and Freud, though armed with very different weapons, were voyagers in the same territory.

From its inception, psychoanalysis as a scientific method of inquiry has extended its sphere of investigation well beyond the traditionally accepted borders of psychology. As Anna Freud (1895–1982) has pointed out,

Psychoanalysts have always had the reputation of straying in their work beyond their own confines and, with the aim of "applying" their theories, of making contact with other disciplines. Psychiatry, education, the social sciences, mythology, religion, literature, art, etc., are among the earlier realms of application. . . . On every one of these occasions, the gradual approach between the two fields depended upon a few pioneering figures, rooted either on one side or on the other.[4]

These "pioneering figures" were in every case able to make contact with another discipline because of their extensive training in it. In the same way that the art

15.1. José, *Portrait of the Analyst,*
from Oskar Pfister, *Expressionism in
Art* (New York, 1922), fig. 2.

historian wishing to work seriously with material deriving from the subjective and "private" activity of the individual unconscious as reflected in art requires psychological training, so the psychoanalyst seeking to reach out to other disciplines must familiarize himself in detail with their findings and modes of procedure.[5] This chapter concerns itself with the work of a number of these "pioneers" who sought to use psychoanalytic insights as a means of obtaining a firmer foothold in the investigation of psychotic art. In particular, it focuses on the life and work of Ernst Kris, art historian and psychoanalyst, who sought to construct a bridge between these two disciplines in an area of obvious concern to both of them, the study of the art of the insane.

ALTHOUGH psychoanalysis, following in the footsteps of its initiator Sigmund Freud (1856–1939), has concerned itself very extensively with art and artists, its involvement with true psychotic art has been quite limited.[6] It is, in fact, paradoxical that psychoanalysis, having betrayed so little interest in the art of the insane, should nevertheless have provided the basis for an entirely new and deeper understanding of this form of human expression.

The seeming lack of interest by psychoanalysts in the art of the insane was the result of Freud's insis-

tence that as a method of psychological treatment it was unsuited for work with psychotic individuals. Most of the early analysts had little or no experience with this type of patient, and there is no doubt that the newly developing science suffered from the failure to make contact with the material provided by the psychoses. The psychological processes characteristic of insanity would have provided an additional, and particularly valuable, means of access to the unconscious, a fact that Carl Jung (1875–1961) perceived early in his career. Unlike Freud, Jung, through his hospital affiliation, could have regular access to psychotic patients.[7]

Freud was intrigued by the more extreme forms of mental disturbance, particularly melancholia and the paranoid forms of schizophrenia. His detailed investigation of the case of Daniel Paul Schreber remains the basis of all later psychoanalytic attempts to understand psychotic processes.[8] But his insight into the case was, unfortunately, based solely on Schreber's published memoirs, and although exceedingly rich in other respects, the evidence involved no pictorial material or image-making activity.

Freud's only venture into true psychotic art was his discussion of the case of the painter Christoph Haizmann (d. 1700).[9] He reproduced a number of Haizmann's paintings (Pl. 14) created in the context of what was probably a transitory but severe psychotic illness; yet the case presentation is not primarily concerned with these images, though it draws upon them for factual information.[10] In general, one senses that Freud did not feel entirely at ease in discussing pictorial material. "A preference for verbal symbols was shown consistently by Freud; in his own words he emphasized 'the universality of speech symbolism,' while he tended to minimize the importance of the visual symbol which precedes the verbal."[11] His occasional ventures into the field of art history, such as the studies of Leonardo da Vinci and of the Moses of Michelangelo, are, nevertheless, respectable forays into territory not his own. In reference to a book by Oskar Pfister, Freud admitted his lack of interest in contemporary art, particularly Expressionism. "So far as these artists are concerned, I am actually one of those whom you brand at the outset as philistines and barbarians."[12] It is also possible that Freud did not feel at ease with psychotics and so directed his practice as a physician and researcher toward the less severely disturbed neurotic patients.

Among Freud's immediate followers, Jung and Dr. Paul Federn both displayed a pronounced interest in the study and treatment of psychotics. Paul Federn

(1871–1950) was the first analyst to concern himself in detail with the modification of psychoanalytic technique for use with psychotic patients. In 1933 he published an important study, *The Analysis of Psychotics: On Technique*, which describes his work with these patients. It includes a brief account of his work with a schizophrenic artist, a woman whom he took into his home during the course of treatment.[13]

The first analyst to publish an extensive report on the psychoanalytic treatment of an artist was Oskar Pfister (1873–1956). In his book *Expressionism in Art: Its Psychological and Biological Basis*, Pfister described his work with a French artist, identified only as José, providing detailed analyses of individual drawings based on his patient's associations to them during the course of the analysis (Fig. 15.1).[14] Pfister, who displayed an unusual willingness to include drawings in psychoanalytic treatment, clearly understood how essential this could be in the psychoanalysis of a professional artist.[15] Pfister's use of his patient's drawings, as well as other examples by true psychotics, including Wölfli, as a means of criticizing the work of Expressionist painters, is a sad instance of the misuse of psychoanalysis in the service of an ill-conceived and feeble attack on the contemporary art of the period.[16]

For psychoanalysis to make a real contribution to the study of psychotic art and to an understanding of the psychotic experience in general, it had to make contact with people who are psychotic. As D. W. Winnicott expresses it, "Schizophrenia is about something. But what is it about? Very good clinical descriptions exist, but how to get further? No doubt the best way to learn more is to be involved with a schizoid or a schizophrenic person."[17] Carl Jung's experience of the psychoses, particularly during the early period of his life, was very extensive. It is probable that the differences of opinion that divided Freud and Jung were, in part, the result of the very different types of patients with whom they worked. The experiences that most deeply influenced Jung's thinking came from two main sources: his experience of the delusional ideas of deeply psychotic patients and, perhaps more important, his encounter with his own unconscious, which for a brief period of his life led him into a mental state approximating psychosis.[18] During this period of "creative illness," Jung attempted to gain some degree of control over the flood of fantasies that threatened to inundate his mind by drawing them, as well as writing them down.

I wrote these fantasies down first in the Black Book; later, I transferred them to the Red Book, which I also embellished with drawings. It contains most of my Mandala drawings....

I saw that so much fantasy needed firm ground underfoot, and that I must first return wholly to reality. For me, reality meant scientific comprehension. I had to draw concrete conclusions from the insights the unconscious had given me— and that task was to become a life work. It is of course ironical that I, a psychiatrist, should at almost every step of my experiment have run into the same psychic material which is the stuff of psychosis and is found in the insane. This is the fund of unconscious images which fatally confuse the mental patient.[19]

This experience of personal psychotic material and of the compulsive need to give it concrete shape in the form of drawings and paintings made Jung responsive for the rest of his life to pictorial representations of the unconscious. As a result, Jungian analysts have made a conscious and determined effort to utilize drawings as an aspect of analytic treatment, and have undertaken extensive study of the function and meaning of visual symbols and image-making activity in the context of psychological disturbance and growth.[20] As an aspect of this systematic investigation of patient art, the Jung Institute in Zurich houses a picture archive, which incorporates the case histories and paintings of numerous patients, including several cases identified as psychotic.[21]

The most elaborate Jungian investigation of psychotic art in the context of an analysis must be that published by Dr. H. G. Baynes. In his book *Mythology of the Soul: a Research into the Unconscious from Schizophrenic Dreams and Drawings*, he presented two extensive case histories, both of which involved the making and interpretation of drawings (Fig. 15.2).[22] Baynes's respect for these two individuals is clear. He turns to the schizophrenic experience as a source of knowledge. These patients were his instructors, far more knowledgeable than he in the psychology of the unconscious.

It should also be understood that borderline patients, who need to create their myth, are by no means weak neurotics. Their abnormality may consist merely in their inability to stay moored to a ring in the harbour wall for the rest of their lives. But if one has to navigate the treacherous sea, two possible factors may be one's undoing. On the one hand, the boat may be too small and weak to withstand heavy seas; on the other hand, notwithstanding the most vigilant seamanship, the boat may suddenly be overwhelmed by a violent storm and swamped.... There is something, and he knows it, in the schizophrenic subject's blood which seeks out and responds to the violence and dread of the daemonic unconscious forces. Something in him shouts the devil's laughter as the ship is battered and broken by the attacking seas.... My two patients would be like divers risking themselves, but to good purpose, under the sea. Similar contents to those which they

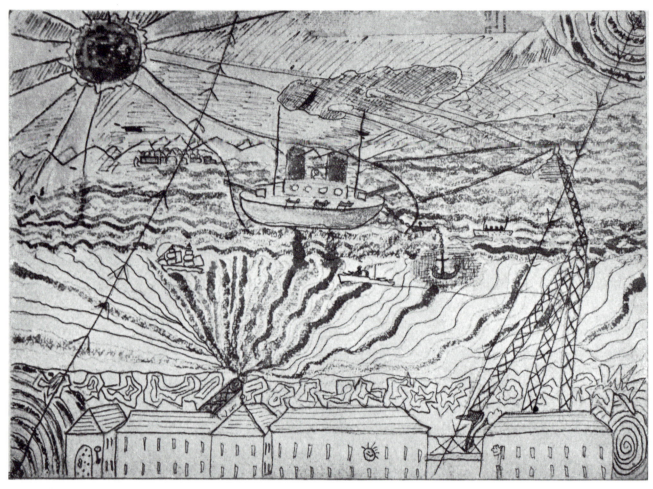

15.2. Drawing by a patient, from H. G.
Baynes, *Mythology of the Soul*
(London, 1969).

have portrayed [in their drawings] are to be found in the unconscious of the majority of educated Westerners today.[23]

In psychoanalytic writing such as this, one senses as profound a shift in attitude toward the art and life experience of the insane as that which we encounter in the changed aesthetic judgment of this art by artists and critics during the same period. In both camps psychotic experience was beginning to be seen as positive and valuable, a source of insight and self-understanding of importance not only to the psychotic individual, but to "normal" men and women as well. Like Jaspers, Baynes recognized that psychotic imagery gratified a deeply felt need not restricted to inmates of psychiatric hospitals. Jung described how, in the midst of his encounter with the strange imagery of the unconscious, he attempted to grasp the significance of the material confronting him. "I once asked myself, 'What am I

really doing? Certainly this has nothing to do with science. But then what is it?' Whereupon a voice within me said, 'It is art.' "[24]

THE GROWING awareness of continuities and similarities between the spontaneous productions of the insane and images traditionally accepted as art, the emergence of which we have observed, as well as the recurrence of images and symbols in mythology, religion, literature, and the history of art, both "normal" and "psychotic," stimulated both Freud and Jung to efforts at explanation. Having made every effort to account for the content and functioning of the human mind in terms of individual experience, Freud was forced to accept the existence of "fixed dream symbols" common to all mankind and coexisting with the far more common private symbols forged in the individual

unconscious, and was led, all unwilling, to postulate as explanation the possibility of a "phylogenetic inheritance" to account for this universally shared mental content.

In the first place we are faced by the fact that the dreamer has a symbolic mode of expression at his disposal which he does not know in waking life and does not recognize. This is as extraordinary as if you were to discover that your house maid understood Sanskrit, though you know she was born in a Bavarian village, and never heard it. It is not easy to account for this fact by the help of our psychological views. We can only say that the knowledge of symbolism is unconscious to the dreamer, that it belongs to his unconscious life. . . . What can be the origin of these symbolic relations? This same symbolism is employed by myths and fairy tales, by the people in their sayings and songs, by colloquial linguistic usage, and by the poetic imagination.[25]

Freud is speaking here of the normal individual made "psychotic" by sleep. His ability to understand and employ the language of the dream underlies and may help to explain his intense, if ambivalent, response to the appearance of the dream language in psychotic art. Each of us, in sleep, is a psychotic image maker. "One gets an impression that what we are faced with here is an ancient but extinct mode of expression."[26]

Lombroso's early insistence on the existence of an "atavistic tendency" in the art of the insane—the appearance in this art of symbols and images that reflect the art of earlier periods in human history—is echoed in Freud's theory of a "phylogenetic heritage."[27] "Analytic experience has force on us a conviction that even particular psychical contents such as symbolism have no other sources than hereditary transmission."[28] "It seems to me, for instance, that symbolic connections which the individual has never acquired by learning, may justly claim to be regarded as a phylogenetic heritage."[29]

Investigation of this shared or "collective" aspect of the human mind formed the basis of the later work of Carl Jung, who, faced with otherwise unexplainable similarities between the visual imagery of modern psychotics and material derived from late Classical and Medieval sources, was led to propose the existence of a "collective unconscious" underlying the "personal unconscious" of the individual.[30] Margaret Naumburg has put forward the interesting suggestion that Jung's far more extensive preoccupation with collective aspects of the unconscious mind can be accounted for, in part, by his far greater involvement with pictorial and visual images, produced both by his patients and historically, as opposed to the verbal associational material used almost exclusively by Freud.[31] The possibility

is that the "ancient but extinct mode of expression" referred to by Freud may have been primarily a nonverbal means of visualization and communication. The survival of this language of images in the human unconscious is demonstrated by its constant appearance both in dreams and in psychotic art, where it is invariably connected to mental contents of a primitive and emotionally highly charged nature.

The problem facing the analyst or the admirer of psychotic art is to disentangle the personal from the collective element in a complex image that has spontaneously arisen from within the psychotic mind. "Shall we succeed in distinguishing which portion of the latent mental process is derived from the individual prehistoric period, and which portion from the phylogenetic one? It is not, I believe, impossible that we shall."[32] As far as the study of psychotic art is concerned, this bold prophecy remains essentially unfulfilled. The great difference between Freudian and Jungian attempts to interpret and understand the images produced by psychotic patients results from disagreement about the extent of the contribution made by "nonpersonal aspects" of the unconscious to the production of images. Jungian interpretive procedures, particularly in the context of psychotic imagery and ideas, tend frequently to overestimate the collective aspect of the symbols used, in the absence of sufficiently detailed knowledge of the artist's individual life experience. Freud emphasized that this was precisely the area in which he found himself in disagreement with Jung. "I fully agree with Jung in recognizing the existence of this phylogenetic heritage, but I regard it as a methodological error to seize on a phylogenetic explanation before the ontogenetic possibilities have been exhausted."[33] For the student of the psychology of pictorial images, whether psychotic or otherwise, this problem remains deeply troubling. Inherent in it are still unanswered questions that hinder deeper understanding of the changed and changing attitudes toward the art of the insane. Although it is apparent that the strong aesthetic response to this art characteristic of many individuals in the twentieth century is not merely the result of "fashion," or an accidental byproduct of events occurring in the history of contemporary art, we are still not in a position to account for it either in terms of aesthetic or psychological theory.

IN THE EARLY YEARS of its development, psychoanalysis, in its examination of art, contented itself with pointing out similarities between the processes and symbols observed in dreams, in the formation of symp-

toms, and in works of literature and art. Our understanding of image-making processes, whether "psychotic" or "normal," was immeasurably enhanced by Freud's description of the quite different modes of mental functioning characteristic of the unconscious (the primary process). *The Interpretation of Dreams* will, in time, make as much of an impact upon the study of art and the creative process as it has in the field of investigation for which it was primarily intended. Freud's own studies in art, anthropology, religion, and literature pointed the way for the application of psychoanalytic insight to nonclinical material. The further development of the psychoanalytic investigation of pictorial imagery and its functions was dependent upon the emergence of analytically trained specialists in art history, criticism, and aesthetics: the pioneers who, as Anna Freud indicated, would be capable of establishing productive and stimulating connections between psychoanalysis and the humanities and social sciences.

THE APPLICATION of psychoanalytic theory, methodology, and insight to the investigation of art and artists attained full maturity and significance in the work of Ernst Kris (1900–1957) (Fig. 15.3). His writings in the field of psychoanalysis and art raised the subject to a new and vastly more serious level of accomplishment, establishing a scholarly and scientific standard that has seldom been equaled. His description of the nature and range of problems upon which psychoanalysis might legitimately be brought to bear provided a foundation for all further psychoanalytic investigations of art and creativity.[34] His discussions of psychotic art represent the first successful attempt to employ psychoanalytic insight in the understanding of a form of image and human experience about which Freud and his immediate followers had little to say. The psychoanalytic investigation of the art of the insane can rightfully be said to have been pioneered by Ernst Kris.

Kris represents a further and deeply significant step in the history of the growing relationship between art and psychiatry. What had begun as a confrontation between two very different worlds had developed into the possibility of understanding, and to the building of bridges, often frail and at times untrustworthy, between the two realms. Kris's ability to construct a more solid bridge lay in his deep, masterful, knowledge of the terrain on either side. For the first time an individual emerged whose training and level of accomplishment in psychoanalysis and art history commanded respect from both camps.

Ernst Kris's involvement with art and its history be-

gan at an unusually early age. The tendency to involve himself in intellectual pursuits may have been fostered by a serious illness, which forced him to remain quiescent for months at a time, and which appears to have permanently damaged his heart. An older cousin and her husband seem to have been responsible for his first contacts with this challenging world of images and ideas.[35]

During World War I, as a result of a curious sequence of events, he managed to obtain permission to attend a graduate seminar in art history at the University of Vienna, despite the fact that he had not yet graduated from the gymnasium. His already considerable knowledge and seriousness won the respect of Professor Julius von Schlosser, a major figure in Viennese art historical circles. He climaxed his precocious career at the university by obtaining a doctorate in the history of art at the age of twenty-two. In the same year he was appointed Assistant Curator and Junior Keeper in the Department of Sculpture and Applied Art at the Kunsthistorisches Museum in Vienna. This appointment, an incredible honor for one so young, determined to a considerable extent the direction of his development as an art historian. The director of his department, Dr. Leo Planiscig, had established his field of interest in the area of Renaissance sculpture. Kris accordingly assumed responsibility for the less spectacular and indeed somewhat rarified area of the applied arts, acquainting himself with the work and careers of, for the most part, little-known artist-craftsmen of the Renaissance and Baroque periods who worked in stone

15.3. Ernst Kris.

and precious metals. In this field of specialization he soon established himself as a brilliant if somewhat pedantic scholar. His first article, published in 1921–1922, was devoted to discussion of a small sculptural work by the Austrian-born engraver and goldsmith Wenzel Jamnitzers (1508–1585).

In his museum work and publications, Kris concerned himself with meticulous examination of small things. The preciousness of the objects he studied was paralleled by a certain preciousness in his discussion of them; but no one could quarrel with the clarity and precision of his publications. In 1929 he established himself as one of the leading figures in his field with the publication of his two-volume study, *Meister und Meisterwerke der Steinschneide Kunst in der italienischen Renaissance.*[36] The extent of his reputation is suggested by the fact that in the same year he was invited to travel to New York in order to prepare a catalog of the newly acquired collection of postclassical cameos and intaglios at the Metropolitan Museum.[37]

Apart from a continuing stream of art historical publications, Kris's outstanding accomplishment at the Kunsthistorisches Museum was the complete reorganization of the collections for which he was responsible. During this early period of his life he was deeply preoccupied with objects: with arranging for their care, display, and interpretation. His written work was devoted to providing a correct historical context within which they could best be understood. He was very much a "museum man," and though undeniably brilliant and highly respected, he was unlikely to disturb the tranquil world of art history in which he had so successfully established himself. As Ernst Gombrich explained it, "in his art historical interests Kris remained for a long time wedded to the period between 1400 and 1600."[38] Had fate, and more probably something within Kris himself, not intervened, he might have remained there for the rest of his life.

Fate, however, announced herself in the person of a young woman, Marianne Rie (1900–1980), a medical student and daughter of one of Sigmund Freud's closest friends. Rie brought Kris into contact with Freud and, more important, into contact with her own intense enthusiasm for and involvement with psychoanalysis. Kris's penetrating mind was exposed to a whole new world of ideas irresistibly presented by a woman with whom he was soon very much in love. The story of Kris's conversion to psychoanalysis is an amusing one best told in Mrs. Kris's own words.

I became interested in psychoanalysis in the early twenties, and decided that I wanted to become an analyst. I talked with Freud about my wanting to become an analyst, and whether that was terrible or not. Freud warned me that if a woman is analyzed and her husband isn't, it might cause trouble. Ernst and I were already good friends, though not yet married. Nevertheless, when he heard of Freud's pronouncement, he decided to undergo analysis too.[39]

Freud had made the acquaintance of the young Kris one evening in 1921 while accompanying his friend Oskar Rie home from one of his famous Saturday evening card parties. The brief meeting turned into friendship, not in terms of a shared interest in psychoanalysis, but as a result of their passionate taste for antiquities. The extent of Freud's involvement with art and archaeology has never been sufficiently emphasized. Study of his huge private collection and of his library makes it clear that he was deeply committed to and involved with these disciplines.[40] Anyone visiting Freud's study, as Kris often did, would have been impressed by the striking and unexpected fact that it was the environment not only of a psychologist, but of a serious student of art and of the earlier phases of human culture. He owned the "last word" in scholarly publications in the field of archaeology, and obviously bought them as soon as they appeared. His investigations in the field of Renaissance art, carried out in connection with his studies of Leonardo and Michelangelo, provided him with a respectable foothold in Kris's own area of specialization. Despite their great age difference, Freud discovered in Kris a friend able to share and indeed to enrich his love of art objects and of history. Ernst became involved in Freud's collecting, advising him on purchases, and occasionally locating new pieces for him. The two men spent hours together in pursuit of antiquity, and an atmosphere of trust and respect developed between them, which had the advantage of originating outside of the growing complexity and tension in Freud's analytic circle.

In 1924, Kris had begun his own analysis with Helene Deutsch (1884–1982). His interest in the new field deepened, and he soon realized that he wished to become an analyst himself. He accordingly began systematic study at the Vienna Institute of Psychoanalysis, and started to see patients while continuing to hold his full-time position at the Kunsthistorisches Museum. For a long period, from approximately 1927 until 1938, when he left Vienna, he seemed to be a curiously double personality, as though there were two Ernst Krises, or perhaps an old Kris who had not yet been superseded, and a new Kris not yet confident of his identity. Nevertheless, Kris's own analysis appeared to change him markedly, liberating quantities of energy and of self-awareness that had the effect of shifting his interests from objects to human beings.

His involvement with art underwent profound change. His experience of analysis, combined with his growing knowledge of psychoanalytic methods of thought and observation, freed him to look at art from a vastly different perspective, to ask fundamental questions about its nature and function, about the creative process, and about the nature of the aesthetic experience. Kris slowly began to seek viable footholds for a psychoanalytic approach to art. At the same time, it would appear that he kept his two worlds quite separate, not permitting his new identity as an analyst to interfere with or even to influence his work at the museum. Despite the fact that by the 1930s public reaction to psychoanalysis in Vienna had grown considerably less hostile, it may be that Kris deliberately avoided antagonizing his art historical colleagues by exposing them to new ways of thinking that might have jeopardized his hard-won reputation. Until 1938 when the Nazi occupation of Vienna made it impossible for a person of Jewish origin to hold so conspicuous a public position, Kris continued to publish conservative and strictly art historical papers conforming to the nature of his task as curator. It is not without significance that the production of such papers ended abruptly with his departure from Vienna.

How did Kris himself understand the changes in his personality as he moved from the role of art historian to that of psychoanalytic therapist and theoretician? Unlike many art historians who are attracted to psychoanalysis as a tool that they can bring to bear on art historical problems, it would seem that in the beginning Kris approached psychoanalysis as a distinctly new field that offered him the possibility of a new kind of human involvement and of a very different kind of work. For many years he attempted to play both roles, possibly because his position at the museum was necessary for his financial security.

His involvement with psychoanalysis became increasingly demanding. In 1933 he began medical studies, possibly as a result of his growing interest in psychotic experience, and in psychotic art. This involvement with a third major field of specialization ended when Freud asked him to assume the editorship of *Imago*, a journal devoted to the application of psychoanalysis to problems in the humanities and social sciences.[41] The appointment confirmed Kris's emerging identity as an individual uniquely qualified to function in the difficult and vitally important territory that exists between, and links together, the sciences and the humanities. *Imago* thereupon became the focus of his newly liberated creativity, and the ground from which his new ideas could spring.

KRIS's first publication that applied psychoanalytic psychology to a problem in the history of art was a lengthy essay on a puzzling group of sculpted heads executed toward the end of the eighteenth century by the Viennese sculptor Franz Xaver Messerschmidt (1736–1784) (Fig. 15.4). Kris became interested in these curious pieces while on a Sunday morning museum visit with his wife. Marianne Kris's intuition led her to speculate that their creator might possibly have executed them under the impact of a psychotic illness. His curiosity aroused, Kris looked into the biographical material on the artist and discovered that Messerschmidt had, in fact, become mentally ill in the later years of his life (1771–1784), the period during which he had created the series of sixty-nine busts.

In deciding to undertake an extensive study of these sculptural works, Kris departed radically from his customary art historical concerns. In the context of his earlier publications, the topic seems strangely out of place, too psychologically and historically problematic to be open to the conventional methods of art historical research.[42] Perhaps he had been seeking a task ideally suited to the unique knowledge and training that he now possessed. He was ready to make a double debut in a new guise: as a psychoanalytically oriented art historian and, separately, as a member of the Vienna Psychoanalytic Institute particularly concerned with the application of psychoanalysis to studies in art.[43]

Kris's Messerschmidt study appeared in the *Jahrbuch der Kunsthistorischen Sammlungen in Wien* in 1932.[44] His decision to publish his first psychoanalytic paper not in one of the psychoanalytic journals but in a prestigious art historical periodical suggests a determination to construct a bridge both within himself and in the scholarly community, between art history and psychoanalysis. On November 24, 1932, he had delivered a paper on the same subject at a meeting of the Vienna Psychoanalytic Society. This lecture was subsequently published in *Imago* in 1933.[45]

By comparing how these two versions of the Messerschmidt study differ, we may gain insight into the processes going on within Kris during the period of his emergence as an art historian specializing in the application of psychoanalysis to the investigation of problems in art. Each of the two articles begins with a passage that introduces a specialized audience to a new topic of investigation, and to the unfamiliar methodology being employed. These very different introductory sections—one written for art historians, the other for psychoanalysts—suggest the difficulties that Kris foresaw in undertaking interdisciplinary studies in the fields of art history and psychoanalysis.

In addressing the members of the Psychoanalytic Institute, Kris inevitably spoke as a younger colleague. In this his first psychoanalytic paper, he presented Messerschmidt as a case history, seeking the advice and insight of clinicians of far greater experience. Aware of their skepticism about the successful application of psychoanalysis to problems originating in the humanities, he sought to clarify the nature of his undertaking. Although the attempt to apply psychoanalysis to the solution of problems originating in other disciplines was not new, Kris differentiated between the goals of the so-called heroic phase of psychoanalysis (the first twenty years) and those of the present. Originally, the investigation of cultural material, as opposed to clinical data, was undertaken as a means of testing psychoanalytic hypotheses against material that originated outside of the therapeutic encounter. Mythology, literature, art, and history provided material derived from the deeper strata of the mind, material uninfluenced by processes of illness, or by analysis itself. It also had the advantage of being able to be talked about openly with no fear of revealing confidential information about a living patient.

The tremendous growth of psychoanalysis, and of psychoanalytic research, had rendered this original use of cultural material less important. However, the success of the new science had led workers in adjacent fields to see it as a potentially valuable tool for investigating problems within their disciplines, which their own methods of approach were unable to solve. Kris compared it to a reserve troop to be thrown into the breach wherever scholarship was willing to acknowledge its inability. The study of the psychotic period in the life and work of Franz Xaver Messerschmidt remains a clear example of a problem that art history alone could not be expected to solve.

In speaking to a group of psychoanalysts, Kris sought to clarify some of the fundamental difficulties inherent in the application of psychoanalytic methods of investigation to historical material. Using an analogy derived from the history of psychiatry itself, he pointed out how reluctant a modern clinician would be to use case material compiled by a physician unacquainted with psychoanalysis or depth psychology. The earlier physician, although he would have done his best to collect the relevant information, will inevitably have failed to obtain, or even have suppressed, the very facts upon which psychoanalytic insight depends. The psychoanalytic investigator using historical material from traditional biographical sources, and from contemporary documents, is also faced with the likelihood that the information he needs is unavailable, or

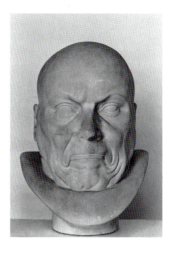

15.4. Franz Xaver Messerschmidt, *Man Afflicted with Constipation*, plaster, Österreichische Galerie, Schloss Belvedere, Vienna.

has been overlooked or suppressed. For this reason, Kris emphasized that the psychoanalytically oriented historian must reassess all of the primary sources and, if necessary, obtain new documentary evidence before undertaking interpretation. He referred to the article in the *Jahrbuch* as an example of a thorough reassessment of the available historical sources of Messerschmidt's life, done "to prepare the ground for the posing of psychological questions."[46] Despite his relative inexperience as a clinician and theorist, Kris spoke to his colleagues in a relaxed and straightforward manner, with all the assurance of a fully trained scholar familiar with the methods of historical investigation.

By contrast, his prologue to the *Jahrbuch* paper of 1932 is a complex and tormented piece of prose, written as though its author anticipated an almost limitless number of traps and pitfalls, and a degree of hostility and suspiciousness on the part of his art historical colleagues that necessitated almost obsessional rationalization and defensiveness.[47]

Detailed investigation of contemporary historical references to Messerschmidt's life and teaching had made it clear that he suffered in his later years from paranoid schizophrenia, and that even after the acute phase of his illness had subsided, he remained sufficiently disturbed as to be unable to resume teaching. The character heads, created within the context of a psychotic delusional system, present an impenetrable problem to the art historian. Traditionally, the heads had been understood as *Charakterköpfe*, physiognomical studies or exercises in the depiction of various human expressions. Soon after Messerschmidt's death they had been supplied with "suitable" titles to rationalize their strangeness, with labels such as "Just Res-

cued from Drowning," "A Strong Odor," or "Afflicted with Constipation."

Faced with these bizarre, though technically magnificent, artistic productions, and equipped with the knowledge that Messerschmidt was mentally disturbed, the contemporary art critic or historian is able either to deny the presence of psychotic illness, or to state that they are very strange and must somehow be connected to the artist's mental condition.[48] "It is no accident that the historical method generally, and the method of thinking characteristic of art history in particular, is not in a position, out of its own strength, to answer the questions which more detailed investigation of the busts leads to. It would seem necessary to augment the historical method with a psychological approach" (p. 169). Kris's goal was to investigate this group of related works from both a historical and a psychological standpoint. "It will only be possible to understand the heads when we are able to comprehend how elements deriving from Messerschmidt's own psychic structure are tied together with those deriving from the historical situation" (p. 169). The necessity of considering how these two aspects of the problem interact seems obvious today. But even the passage of a few decades is sufficient to have obscured the historical situation within which Kris operated. Keenly aware of the contemporary scholarly climate, and of the incomprehension his undertaking might be expected to encounter, Kris reviewed the events that had led up to the current hostility to psychological investigations within the field of art history.

The efforts of the nineteenth-century pathographers Lombroso, Nordau, Möbius (1853–1907), and others had been strongly felt in the German-speaking countries.[49] Efforts to account for any aspect of an artist's work or creative activity in terms of psychological disturbance were therefore looked upon with deep hostility. But, as Kris indicates, the response to such an undertaking was rendered even more unfavorable by the fact that biographical investigations of any kind were seen as "unscientific," and lying outside of pure art historical methodology.

In the first quarter of the twentieth century, German art history had carved out its own territory in an attempt to force art historical investigation into a rigidly scientific framework. One of the mottos of this new science was "art history in place of artist's history." The goal of this science was to explain all events occurring in art in terms of a history of styles, and an evolution of objective artistic problems. "The role of the artist has been understood (within recent art history) in terms of the historical situation, and his work has been viewed in the context of processes of art historical development. Knowledge of his human characteristics must inevitably have appeared insignificant when seen in the light of these assumptions" (p. 169). Inevitably, such a stance limited the ability of the art historian of the period to investigate, or even to "see," pictorial and sculptural productions of the insane. Messerschmidt's mental state had either to be ignored or denied; or else his later work had to be excluded from art historical consideration, a difficult task in light of its enormous importance to the history of late eighteenth-century Austrian art. What Kris was insisting upon was that since Messerschmidt's psychic reality could not be modified, art history itself would have to change. He was subtly calling attention to the reality and value of psychotic art, and demanding that art history enlarge its overly narrow framework by including techniques of psychological investigation within its methodology. Messerschmidt, because of his historical position and significance within Austrian art history, provided an ideal "test case."

The second problem Kris anticipated was that likely to be provoked by psychoanalysis itself. Although the period of intense rejection of Freud's work was more or less over in Viennese medical circles, the appearance of psychoanalytic modes of thought and procedure in so conservative a field as art history could still be expected to provoke resistance and, in terms of the specific character of Messerschmidt's illness, reactions of horror and disgust. Equipped with detailed knowledge of the furious struggle waged against Freud, Kris had reason to expect an equally strong reaction to his efforts on behalf of psychoanalysis within art history.

Biographical efforts within art history prior to the advent of psychoanalysis had been marred, if not rendered worthless, by reliance on outmoded forms of "popular psychologizing."

Where an effort was made . . . to forge a link between the human being and his work, it occurred in terms of a more or less complex popular psychology, that is to say, according to the unwritten principles of that kind of understanding of man which we are all accustomed to rely upon. The conclusions drawn from it are then apparently dependent upon the degree of respect you have for the biographer. Conclusions which can be rigorously formulated are, however, not to be expected with this approach. (p. 169)

Interpretation of psychotic art in terms of popular or commonsense psychology could not be expected to lead very far. Kris therefore proposed to employ the methods and theories of psychoanalysis to investigate the psychological aspects of the problem. Unique among investigators of psychotic art, he also proposed to pay

no less serious attention to the art historical side of the problem, a decision that emphasizes the unique importance of his training in the two areas.

By publishing the Messerschmidt study in the *Jahrbuch*, Kris aimed at something far more extensive than the elucidation of the Messerschmidt problem. He very consciously raised the question of a renewed cooperation between the two sciences. He referred to his essay as an experiment in ideas (*ein Gedankenexperiment*), noting that "on this point we encounter in its fullest extent the question of the relationship between psychology and history. There would be real value in terms of current scholarship were we to address ourselves to this question" (p. 170).

The basis for his confidence that a reexamination of the possibility of cooperation was overdue, and would be fruitful, lay in his conviction that psychology had progressed to a point that it now had something very concrete to offer to the cultural and social sciences. Aware that psychoanalytic psychology was uniquely suited to the solution of problems within art history, Kris courageously took his stand beside Sigmund Freud. The sophistication of psychoanalytic theory and methodology in this advanced stage of its development permitted the trained scholar to proceed far beyond the undisciplined and one-sided maneuvering of the pathographic approach. The danger for Kris, as for any worker in this kind of interdisciplinary work, was that his psychologically unsophisticated audience would immediately assume that psychoanalytic investigation of a biographical or historical problem was simply a variant of pathographic muckraking.

For this reason Kris had to stress the essential differences between his approach and that of earlier psychiatrically trained biographers.[50] He emphasized that discussion of works of art created within the context of a psychotic mental state did not involve moral or value judgments either about the artist or his work. The old concept of degeneracy was clearly hovering in the background. Its revival in Nazi Germany was imminent. Kris was therefore wise in emphasizing that "the health or illness of the artist in no way implies a judgment of his work" (p. 171).

Attempting to differentiate psychoanalytic psychology from its less sophisticated predecessors, Kris pointed to one of the essential principles upon which it is based: the belief in an assumed regularity and continuity underlying all manifestations of human psychic experience. For the psychoanalyst, there is no sharp distinction in kind between states of psychological health or illness, the latter being seen only as an intensification of processes readily apparent in so-called normal individuals. As a result, findings derived from clinical investigations of individuals suffering from various types of psychological disturbance could be utilized in the understanding of psychological processes occurring in perfectly healthy individuals. Kris also differentiated the piecemeal approach of earlier psychology from the holistic approach of psychoanalysis. "In place of the investigation of individual bits and isolated details of behavior, understanding of psychological life as a unified whole has moved into the foreground" (p. 170). To this observation, Kris added his own original contribution in insisting that study of this unified whole must also include historical and social factors that play a no less important part in the development of the individual and in the interpretation of his expressive behavior.

As an art historian using psychoanalysis as an extension of the more traditional historical methods, Kris was well aware that he was traveling on "a side road of art historical research" (p. 172). Clearly, only rare problems in art history require, or are approachable in terms of, psychoanalytic techniques. Although the psychoanalytic study of art extends far beyond cases in which serious psychopathology plays a significant part, the psychoanalytically oriented art historian is invariably limited by the relative scarcity of the kind of historical information essential to psychoanalytic research, a fact to which Kris had also drawn the attention of his analyst coworkers. In this first example of a true interdisciplinary investigation in the area of art and psychoanalysis, Kris was careful to avoid arousing the antipathy of his fellow art historians, assuring them in the concluding paragraph of his introduction that his goals were carefully defined and strictly limited. "That in a segment of our investigation the protected ground of historical research will be abandoned, should not be seen as an attempt to penetrate further into the problematic territory of psychological investigation than is necessary in order to complete the historical interpretation of the work of art" (p. 173). Despite the reassuring tone of this sentence, the analysis of Messerschmidt's creative activity that followed would inevitably have been deeply disturbing and indeed offensive to some of Kris's psychologically unsophisticated colleagues, a fact of which he was painfully aware.

ERNST KRIS's contribution to art history, aesthetics, and the psychology of art extended over thirty-five years and an enormous range of topics. Our concern with his work is limited to his involvement with the art of psychotic individuals. Having explored in detail

the factors that encouraged or obstructed his effort to reestablish contact between art history and modern depth psychology, we must now consider his involvement with Messerschmidt as a psychotic artist. Equipped with a thorough knowledge and experience of psychoanalysis, as well as a superb art historical background, what was Kris able to add to the discussion of the art of the insane?

The first task in approaching Messerschmidt as a psychotic artist was to confirm that the artist was indeed insane during the last twelve years of his life, and to establish the nature of the illness from which he suffered. By careful scrutiny of contemporary documents which he had unearthed, Kris diagnosed Messerschmidt as having become schizophrenic in 1771. The illness had involved an acute phase lasting for some three years, and had then moved into a more stable state, still recognized as schizophrenic but with the delusional symptoms, particularly of persecution, confined to specific areas of his experience.

As an art historian, Kris's interest was primarily aimed at determining the effect of the psychotic state on Messerschmidt's work. It was, after all, in his activity as an artist that he is distinguished from other schizophrenic individuals, whose cases are otherwise strikingly similar. Kris was able to point to changes in style that accompanied Messerschmidt's move into the psychotic experience, particularly tendencies in the direction of stereotypy, rigidity of structure, and loss of expression and affect. "We believe that in representational creations of schizophrenics we rarely find human faces rendered in such a way that we can 'understand' them; they do not supply a clue to the moods or the personality or its characteristics and thus do not invite identification."[51] However, in his revised essay on Messerschmidt, Kris was careful to indicate that, "even in the works of his later period his sovereign mastery of depicting likeness, his supreme skill as a portraitist, remained unimpaired."[52] Messerschmidt's creative activity continued throughout his illness, the psychotic features of the work being restricted to specific elements of his obsessional involvement with the self-portrait. Equipped with detailed knowledge of the period style within which Messerschmidt created, Kris was able to disentangle the historical contribution from that deriving from Messerschmidt's personal involvement with psychosis.[53] For the first time, a careful evaluation of the extent to which psychotic elements entered into individual pieces of sculpture was undertaken.

Never one to indulge in unalloyed enthusiasm for psychotic art simply because it was psychotic, Kris was

nevertheless convinced of the value of Messerschmidt's later work as art. As in so many similar cases, the artist's reputation was chiefly based on the work done during his period of illness. His overwhelming experience of psychosis lifted Messerschmidt as an artist above the high, but unexceptional, level of performance that he had attained, and distinguishes him from other German and Austrian sculptors of the period. Part of Kris's originality resides in the fact that, having identified Messerschmidt as a psychotic artist, he was nevertheless prepared to examine his work with the full range of art historical techniques, and with the respect and seriousness with which he would have approached any other artist. His monograph—at that time the only extended study of Messerschmidt's complete oeuvre—included a lengthy discussion of the artist's development, and of the major influences on the formation of his style, and provided an assessment of the nature and extent of his influence on the art of his time. Despite his deep involvement with hallucinatory experience, and with a personal delusional system, Messerschmidt appears to have maintained contact with the advanced artistic currents of the period, and all of his work, no matter how bizarre, made a valuable contribution to contemporary art. This is important to note, because even today a diagnosis of schizophrenia is assumed to preclude artistic achievement of the highest order, within the mainstream of artistic development. The value of Messerschmidt's contribution is not in question. His illness in effect directed him into certain channels that he might otherwise not have entered, markedly limiting the range of his activity, but intensifying his involvement with certain problems with astonishing results.

Our knowledge of the historical evolution of psychiatric involvement with the art of the insane is now sufficient to enable us to differentiate the new and original elements of Kris's contribution from the layers of psychiatric insight that belong to the past. Kris characterized his approach as deriving specifically from that aspect of psychoanalysis known as Ego psychology.

Kris's analysis of the meaning of Messerschmidt's image-making activity and its products is dependent upon an eighteenth-century source: the description of a visit to the artist written by an enormously productive contemporary scholar and man of letters, Christoph Friedrich Nicolai (1733–1811). Examination of other documents makes it clear that Messerschmidt was understood by his contemporaries to be suffering from the continuing effects of mental illness.[54] Nicolai's account is unusual in providing a cool and percep-

tive discussion of the content of Messerschmidt's delusional beliefs and of the resultant oddity of his behavior. Although not a physician, Nicolai appears to have been "on the whole more concerned with the illness than with the artist" (p. 132). His description can be understood as an account of Messerschmidt's insanity in terms of the state of psychiatric knowledge toward the end of the eighteenth century. It is confined to a list of symptoms, largely delusional beliefs probably inspired by hallucinatory experience, which can be summarized as follows:

1. Messerschmidt believed himself to be persecuted by demons who visited him at night and who inflicted tortures upon him. The most prominent of these he described as the demon of proportion.
2. Most of his disturbances centered upon the mouth, and he was distressed by the fact that, unlike animals, men display the red of the lips.
3. His preoccupation with the mouth appears to have derived from the fact that he associated it with an analogous area in the lower part of the body—the anus.
4. He used total sexual abstinence as a means of attempting to rid himself of demons.
5. He suffered painful sensations in his lower abdomen while working.
6. While working, he pinched himself repeatedly in certain parts of his body, combining this with violently contorted facial expressions (grimaces), both aimed at exerting magical control over the demons.
7. His image-making activity was largely confined to self-portraiture based on these distorted facial expressions as seen in a mirror.
8. Two of his works were said by the artist to depict the demon of proportion, and can be understood as illustrations of hallucinatory experience.[55]

In conformity with the psychiatric insight characteristic of the late eighteenth century, Nicolai's account is confined to listing mad ideas and beliefs. He nevertheless made an effort to link the content and appearance of Messerschmidt's work to the content of his delusional beliefs.

Building on Nicolai's account of Messerschmidt's statements about himself and his experience, Kris proceeds to what can be identified as the level of understanding attained by students of psychotic art in the late nineteenth century. He begins to inquire into the function of Messerschmidt's behavior and artistic activity in terms of an analogy derived from anthropology. The strange gestures and grimaces, as well as the sculptural images that embody them in more permanent form, are understood in the context of primitive apotropaic magical acts designed to ward off or intimidate demons. The busts function as masks and guard-

ian images. Kris points to the fact that regression to more "primitive" types of behavior, and even to magical activities, is not unusual within schizophrenia.[56] Lombroso too had understood certain aspects of the phenomenon of "regression," using the term *atavism* to refer to the tendency of patients to return, as a result of illness, to more primitive mental states, and to embody these experiences in sculptural works that resemble those of earlier periods in the history of art. This rather generalized explanation of the function of Messerschmidt's activity and the resultant images was well within the scope of late nineteenth-century descriptive psychiatry. But behind these phenomena the nineteenth-century physician saw nothing but meaningless and inexplicable insanity.

The next layer of Kris's investigation of the Messerschmidt case belongs to the twentieth century, but to the field of psychiatry and psychopathology as opposed to psychoanalysis. It recalls the work of Prinzhorn. He commented at length on the uniformity of the series of busts, and on a certain "rigidity and emptiness of expression" that characterizes all of them. "The impression grows that the artist's activity has been severely limited by special conditions, that spontaneity has given way to stereotypy, which even without knowledge of the specific determining factors, tends to be experienced as pathological" (p. 140). "In the majority of the busts, however, a comprehensible expression has not been achieved—a fact which can be demonstrated only if the entire series of busts is examined" (p. 136). This predominant feature of the series of images is associated by Kris with the modern conception of schizophrenia as an illness involving a near complete breakdown in the person's ability to make contact with others, as well as a tendency to perceive the self as empty, or fragmented. The obsessional involvement with the self-portrait becomes meaningful as an attempt to resist this loss of contact and the agonizing experience of depersonalization. "On the basis of what we know about the psychology of schizophrenics, we can conceive of these variations as the artist's attempt to prove the existence of his own person again and again. . . . We are dealing with a person who struggles before the mirror for a genuine facial expression in order to retain the rapidly vanishing contact with the environment. It is an attempt in which he fails" (p. 144).

The psychoanalytic viewpoint makes itself felt in the awareness that Messerschmidt's image making represented an indirect and unsuccessful attempt at communication. We can feel Kris endeavoring to reach across the two-hundred-year interval that separates him from this man, in the conviction that he can un-

derstand. What intrigues him most is not Messerschmidt's madness, but rather the intact vestiges of the artist's personality that enabled him to continue functioning at such a high level. The image-making process was in Messerschmidt's case an attempt at self-healing.[57]

Kris's understanding of Messerschmidt's hallucinatory and delusional experiences derives from a suggestion advanced in Freud's discussion of the Schreber case (1911)—that psychotic delusions of persecution are not uncommonly associated with unconscious homosexual drives, which have been split off from the ego, and which make their return in the form of simultaneously seductive and persecutory enemies or demons. These enemies are then either identified with actual people in the environment via the mechanism of projection, or perceived, in the absence of suitable external objects, in the form of hallucinations. (The case of James Tilly Matthews provides another example of this same mechanism.)

It is not possible or necessary here to summarize Kris's interpretive activity in all its complexity. He is able to clarify how deeply personal elements of Messerschmidt's internal world entered into and distorted the objective task of portraiture. "We must conceive of the mimic constellations on Messerschmidt's busts as manifestations of unconscious processes and try to elucidate their meaning by psychoanalytic interpretations" (p. 137). Within individual works, Kris is able to demonstrate the coexistence of areas of relatively undisturbed functioning and of emotionally charged conflict. The mouth, for example, becomes in many of the pieces the bearer of profoundly irrational and ambivalent feelings. Given Messerschmidt's anxiety concerning the red of the lips, derived from a largely unconscious equation between the mouth and the similarly colored anus, it becomes apparent that the depiction of this area in a self-portrait became extremely problematic. His solution, in a number of the busts, was to use a beltlike band concealing and sealing the lips. Here the defensive aspect of the struggle becomes more prominent, as he resists the possibility of penetration at every gate.

In the most bizarre of the pieces, the so-called beak figures (Fig. 15.5), the opposite side of the psychic conflict breaks through as the demon himself is portrayed. Here the role of the mouth retains its importance, but the lips are forced beyond natural possibility in the direction of unrestrained, though displaced, phallic exhibitionism. "The artist's transformation of reality, to which the beak heads owe their effect, seems to be related to the fact that we find in them the clearest expression of the sexual nucleus of Messerschmidt's delusions" (p. 141). This is the demon Messerschmidt feared and desired, which he embodied in sculptural form and could not look at. Again and again, Kris demonstrates how each symbol is forced to serve, either simultaneously, or in turn, the two sides of Messerschmidt's conflict, simultaneously satisfying the repressed wishes and/or symbolically defending him against them. Facial and pictorial areas not caught up in this internal war remained essentially naturalistic, though emotionally cold. "We are led to recognize that the artist tended to abandon the natural rendering of those parts of the face whose magical meaning predominated" (p. 142). Analysis of the unconscious basis of the more bizarre forms in individual pieces led Kris to the edge of a theory describing the psychological functions of style.

Messerschmidt belongs to the small category of professional artists who, having become insane, continue to create, though in a somewhat changed style. It would seem that a part, but by no means all, of his image-making activity had been commandeered by the psychotic elements in his personality. In Messerschmidt's case the delusional system was more or less encapsulated, leaving the artist free to function relatively normally in those areas untouched by his experience of the demons. Kris, in accord with developments within psychoanalysis introduced by Freud in the 1920s, was particularly interested in these intact areas, which he later referred to as "conflict-free spheres of the ego." Because areas of his personality were untouched by conflict, Messerschmidt could retain in the work produced during this strange period in his life meanings acceptable to the public, meanings quite different from the private ideas that motivated him. At some level of his mind, he may have even rationalized the busts as physiognomical studies and, except in the case of the two beak heads, have succeeded in maintaining at least a semblance of relationship to such an explanation. Had the psychotic process led to a more extensive collapse of the ego functions, Messerschmidt's work might have looked dramatically different, assuming, of course, that he had been able to continue to work. The situation would be extremely different in the case of an untrained individual whose spontaneous creative activity would have its origin in, and would function far more exclusively in the service of, his new psychotic "reality."

This interplay between the private meaning of the work of art, a meaning that is frequently unknown to the artist, and the public function of the images corresponds to various different aspects or levels of the art-

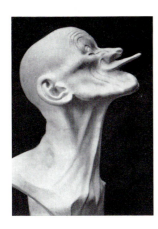

15.5. Franz Xaver Messerschmidt, *Beak-Headed Figure*, location unknown (probably destroyed).

an area of art history within which he felt most at home. He was a very conservative art historian. Unlike Prinzhorn, Kris betrayed little interest in modern art, and little appreciation of the Expressionist aesthetic. Confronted with the purer spontaneous creations of a less confined psychotic state, his catholic tastes inclined him in the direction of a far from enthusiastic aesthetic response. In that the taste of his Viennese colleagues, both psychoanalytic and art historical, was probably no less conservative, the choice of Franz Xaver Messerschmidt for this first psychoanalytic and art historical venture into the territory of psychotic art was well made.[59]

THE PUBLICATION of the Messerschmidt study in the *Jahrbuch* does not appear to have unleashed a critical storm in art historical circles. "Kris was so highly esteemed in Vienna, and his reputation so firmly established by his more traditional art historical studies, that his dabbling in psychoanalysis was perceived merely as slightly strange."[60] Most of his colleagues were no doubt unaware of how serious his involvement with psychoanalysis had become. It is, nevertheless, significant that while he continued until 1937 to publish art historical papers, he never again published a psychoanalytically oriented study in a journal devoted to traditional art history.[61]

The nature of Kris's personal response to the "purer" forms of psychotic art is made clear in a paper he published in 1945, "The Function of Drawings and the Meaning of the 'Creative Spell' in a Schizophrenic Artist."[62] Unlike the Messerschmidt study, this paper, a clinical investigation of the work of a living artist-patient with whom the author had become acquainted, necessitated little historical reconstruction. It is obvious that Kris valued the opportunity of getting to know a psychotic artist, and of verifying the hypotheses he had put forward in the Messerschmidt study.

The patient, who is identified only as "F.W." (b. 1889), was confined in 1938 in the University Hospital for Nervous and Mental Diseases in Vienna, with the diagnosis paranoid schizophrenia. A highly trained architect, F.W. had also studied painting and drawing at the Vienna Academy of Fine Arts. His reputation in the city seems to have been established fairly early, in that Kris had been aware of his work from about 1920. Kris's clinical involvement with F.W. extended only from January to March of 1938, when it was terminated suddenly by the Nazi occupation of Vienna.

F.W. was clearly psychotic during the period when the drawings of interest to Kris were made. He be-

ist's personality, psychic realities that in Messerschmidt's case were split apart and irreconcilable. Here, too, Kris believed that findings derived from the exaggerated characteristics of psychosis may be extended to the creative process in "normal" artists.

May we not assume that private or "secret" meanings are attached to all or many elements of the artist's work, and particularly to the formal elements for which he shows preference in one way or another. . . . It seems reasonable to assume that the manner in which the "private meanings" are integrated into the structure of the artistic product is of decisive importance for the nature (and perhaps the "value") of the artistic creation. The capacity of the artist for using derivatives of unconscious processes in a socially and historically adequate way may well constitute a significant factor in his endowment. (p. 148)

In this brief passage, Kris has provided the basis for a psychoanalytic approach to art that would integrate the methods of the psychoanalytically trained observer with those of the art historian. He also provides a glimpse of his own aesthetic response to psychotic art.

A truly psychotic production involves a near complete failure of the ego to adapt the artist's activity to the external world. The symbolism becomes excessively private and unintelligible. The work is imbued with "secret meaning." "In extreme cases, the works of psychotics are 'unintelligible,' as is their speech. Depending on the extent of their disturbance, their commentary may facilitate, or may fail to further, our understanding."[58] Kris was unwilling, or unable, to accept the product of such a "failure" as "art." His appreciation for Messerschmidt's work would seem to have been, at least in part, the result of the closeness of the busts to more traditional examples of Baroque and early Neoclassical sculpture. This was, after all,

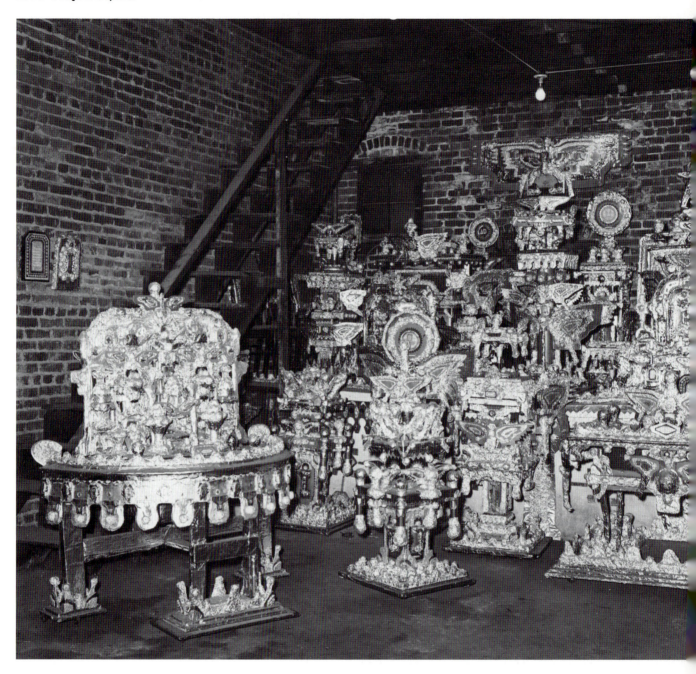

lieved himself to be the son of God, and all-powerful. Unlike Messerschmidt's, his delusions, although confined to a restricted area, interfered far more extensively both with the day-to-day functioning of his life and with his activity as an artist. His elaborate and highly organized conception of himself and his place in history had led to the breakdown of his career and his ability to cope with life outside the hospital. Kris de-

scribes him as an imposing figure. "Though he accompanied his speech with theatrical gestures, he never lost a certain dignity. He spoke about himself with obvious satisfaction and with a certain unctuous pomposity, even at moments of anger or excitement. He often appeared suspicious and cautious, yet he rarely lost an air of condescending amiability" (p. 155).

Functioning in the place of Christoph Friedrich Ni-

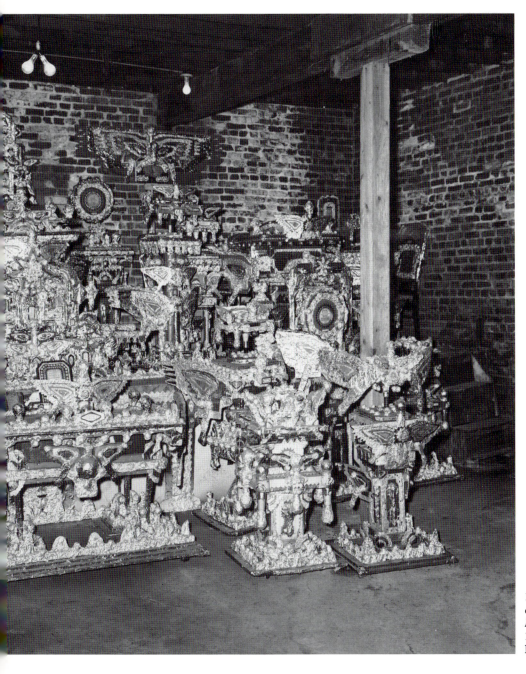

15.6. James Hampton, *The Throne of Third Heaven of the Nations' Millennium General Assembly*, 1964, (two views), Smithsonian Institution, Washington, D.C.

colai, Kris now had the opportunity of determining for himself the nature of the psychotic's involvement with image making. Kris had become interested in what he termed "the creative spell," which very occasionally forms an aspect of the psychotic experience.[63] He hoped to understand the function of the drawings made during these sudden outbursts of creativity, which usually occur after the acute phase of the illness has subsided.

In that F.W. was an artist, for whom drawing would have been a normal life activity, Kris sought to learn whether, as a result of the onset of the psychotic state, the purpose of drawing had changed. In solving this problem, Kris not only threw light on the nature of creativity within the psychotic experience, but provided insight, as well, as to his own conception of the nature and function of art. Our concern in exploring

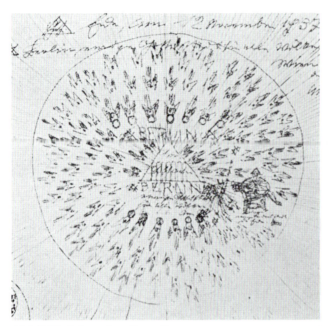

15.7. F.W., *Sphera*, from Ernst Kris,
Psychoanalytic Explorations in Art
(New York, 1952), fig. 55.

this paper is with Kris rather than with the artist F.W.

Through discussion with the artist, combined with meticulous observation of his behavior, as well as his work and ideas, Kris concluded that image making had begun to play a new and very different role in F.W.'s life. Drawings had ceased to serve as a means of communication and were made without any aesthetic or "artistic" intention. "The drawings are not meant for admiration by a public; they are not produced with any artistic intention in mind. They have, the patient said in reply to one of our questions, 'no artistic value' and are not drawings but 'written drawings' " (p. 159). On the other hand, Kris knew that the patient treasured his drawings, preserving them carefully. However, "his interest was exclusively directed to their content" (p. 159).

The new function of drawing was, as Kris understood it, related to the patient's belief in his ability to change the world through magic and ritual. The drawings were to be understood as a form of prophecy. "What the drawings contain will happen one day" (p. 159). At other times they actually depict the new world already realized: "He also brings about magical changes in the world by the very act of drawing" (p. 168). Kris's conviction that drawing served a magical purpose in the life of this man was enhanced by a visit

to his studio. There he discovered an altar and the holy sword.

The drawings were part of an elaborate magical ritual. Its main tool was the holy Sword, made out of cardboard and covered with gilded paper. Whosoever name he touched with the sword was lost. He ruled the world with it. We found it in his studio on a shabby desk, leaning against the wall. The wall space behind it was covered by layers of drawings, a self-portrait uppermost. The whole arrangement clearly suggested an altar: the holy Sword lying on what represented the mensa of the altar, as its center. It was flanked by two wooden busts, one of them portraying his fiancée. (p. 159)

This description inevitably calls to mind the far more elaborate altar known as the *Throne of Third Heaven of the Nations' Millennium General Assembly*, secretly constructed in a Washington warehouse by another psychotic creator, James Hampton (1911–1964) (Fig. 15.6)—a complex and beautiful ritual environment now housed in the National Museum of Fine Arts of the Smithsonian Institution, the first major psychotic creation to enter an American museum.[64]

On several occasions Kris was able to observe the actual moment when ritual drawing was called upon as a means of "correcting" reality. The patient received the news that as a result of his mental illness he was to be evicted from his studio. "Anger and disappointment gave way to ecstasy. He went around smiling, shook hands with everybody, and proclaimed that now he was fully God. He asked for paper and drew the sphera, calling it 'the kingdom of heaven with the doors of paradise' " (p. 165). Kris believed that the drawing was used at this moment because the patient was threatened by an imminent invasion of painful reality into the fantasy world he had constructed. Drawing served the psychotic part of his personality in reasserting the delusion. The delusional reality was made concrete and real through the presence of the drawing, and through the act of drawing itself. Kris differentiated two types of magical activity: one aimed at the destruction of enemies; the other, more positive, was directed toward the creation of a new world.

The drawing entitled *Sphera* (Fig. 15.7), one of many similar drawings, was explained by the artist as a depiction of the entrance to Paradise:

The city of light with angels flying toward it or from it. In it there is a detail, a triangle containing the letter "F" and the date. . . . Sometimes we find instead of the letter "F" the word God in the triangle. The triangle clearly serves as signature. . . . In the center there is "the throne of God," an upright triangle with seven arcs. The inscription reads, "Berlin, eternal city of God for all the people on earth." From this center radiate rays of light, crossing the borders of the sphera. Angels

are flying toward the center on these rays, those closest to the center carrying the victor's wreath. There are several triangles with his signature above and beneath the drawing. (pp. 158–60)

As an art historian, Kris was aware that this drawing, however "psychotic," would still have an origin in the pictorial tradition within which its creator was trained. He suggested that the artist may have been influenced by Italian ceiling decorations of the seventeenth century. "On the ceiling of many a rotund chapel one sees angels flying towards a celestial center, thus conveying the impression of centripetal movement. The patient seems to have elaborated on such a model" (p. 160). The central triangle, Kris believed, is derived from depictions of the eye of God in a triangle, a common symbol in Austrian Baroque religious art. To this limited extent, the art of this patient still bore some relationship to the traditional language of art. But to a far greater extent than was the case with Messerschmidt, the art of F.W. functioned almost entirely in the service of his psychosis. Nevertheless, Kris was able to identify a remnant of the original function that drawing had once had for this patient. F.W. had been trained as an architect. "Architects' plans are not primarily imagery but plans for future action. One might therefore say that the patient has simply drawn the plans not of real objects he wishes to construct, but of a delusional world that he wishes to bring about" (p. 168).

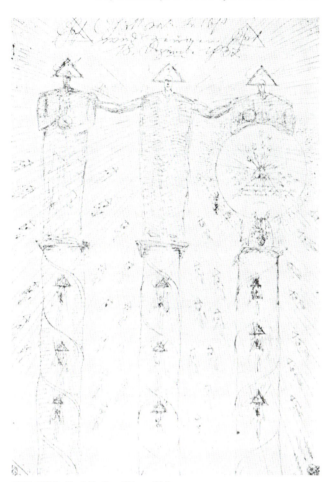

15.9. F.W., *God-Father Himself*, from Ernst Kris, *Psychoanalytic Explorations in Art* (New York, 1952), fig. 58.

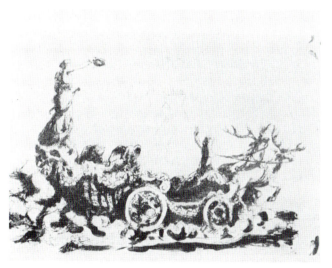

15.8. F.W., *Victory*, from Ernst Kris, *Psychoanalytic Explorations in Art* (New York, 1952), fig. 51.

Following his predecessors in the study of the art of the insane, Kris provided an example of the patient's work done prior to the onset of the psychosis (Fig. 15.8). The drawing of *Victory* on a Baroque chariot drawn by deer was executed in 1920 as a design for the theater. The faint lines in the background were added many years later during his illness.[65]

Kris was surprised to discover that, despite his pathological condition, F.W. retained his ability to draw in his conventional style if requested to do so. "In the midst of one of our interviews during which he occasionally and with great rapidity sketched one or another of his 'motifs,' he drew at our request a human torso with the skill of the professional draftsman. However, such performances no longer interested him" (p. 159). The radical change of style that separates the drawings of his prepsychotic period from his later work

(Fig. 15.9) is seen not as a direct result of his psychosis, or as the outcome of a vastly modified perception of the world, but rather as a reflection of the changed function of image-making activity in his life: its old purpose no longer concerned him.

In describing the function of drawing within F.W.'s experience of psychosis, Kris has provided a detailed and convincing picture of the new and drastically changed purpose that image making had assumed for him. There was now no concern with "art," with aesthetics, or with communication. Image making had become a means of making concrete a new reality, and of obliterating the old. "The patient, identified with the Creator God, omnipotent and omniscient, produces no works of art" (p. 167).

In undertaking this study of a living schizophrenic artist, Kris presented his own aesthetic position in opposition to that of his Viennese predecessor Hans Prinzhorn. He saw Prinzhorn operating within the context of art rather than psychology, and as too strongly influenced by the artistic and aesthetic environment within which he lived. "Under the influence of the Expressionist and Surrealist movements in contemporary art there has been a search for genius in the insane. . . . This point of view dominates Prinzhorn's volume on the subject, but there is reason to believe that his eloquent aesthetic partisanship during the last two decades has delayed rather than accelerated interest in the clinical problems with which the study of the productions of the insane confront us" (p. 151). He saw Prinzhorn's book as an effort to "plead the cause of German Expressionist art."[66] Kris's position in regard to the art of the insane was radically opposed to that of Prinzhorn. By 1945, he had removed himself from art historical involvement and saw himself as a clinician and psychoanalytic theorist. In this context, the art of the insane was now to be understood as a "clinical problem" and not as "art."

Kris's position, based on the study of the case of F.W. and many other published cases including that of Wölfli, is fairly simple, if surprising. He rejected the pictorial productions of the insane as art. Curiously, this decision, an aesthetic rather than a psychological judgment, was based not on evaluation of the pictures themselves, but on the artist's intention in making them. Given the undeniable fact that the psychotic image maker does not intend to make "art," Kris assumed that the resultant image was therefore not art. Because the patient F.W. did not concern himself with communication and did not draw with "aesthetic intent," the product of his activity must therefore fail to communicate, and have no aesthetic impact on others.

"The normal artist creates not to transform the outer world but to depict it for others he wishes to influence; second, the task of production has a definite realistic meaning. . . . Clinical experience demonstrates that art as an aesthetic—and therefore as a social—phenomenon is linked to the intactness of the ego."[67]

Behind this conclusion lies a rigorously traditional and very limited conception of the function of art in the "normal world," and of the nature of the creative act in the "normal artist," a conception that bears little relation to the creative experience and aesthetic opinions of contemporary artists. Given so conservative a view of the functions of the creative process, it is not surprising that Kris was led to deny the artistic value of the image making of psychotic individuals. Significantly, his stance would have forced him to deny the value of all of primitive art, as well as of much of the avant-garde art of his own day. His viewpoint contrasts dramatically, for example, with that of Jean Dubuffet, who believes that it is precisely the intention to make "art" that prevents art from being made (see chapter 17). Kris seems unaware that F.W., under the impact of the psychotic state, created images that, in terms of contemporary aesthetic criteria, far surpass the mediocre work he executed while sane. His deep affection for, and intellectual involvement with, Renaissance and Baroque art, failed to provide him with a basis for understanding or responding to these images, which only the art of the twentieth century has made visible. Although he knew that the finest examples of the art of the insane were recognized by the Expressionists and Surrealists as art in the fullest sense, he could not agree.[68] On the rare occasions that he responded to psychotic art, elements in it that he could identify as evidence of a still functioning ego were what attracted his attention.

One is reminded of Freud's reputed remark to Salvador Dali, the Surrealist painter, that in classic painting, he looked for the subconscious—in a Surrealist painting, for the conscious (see chapter 16). Like Freud, Kris was drawn to the presence of the ego in psychotic art. Speaking of the work of Ernst Josephson, for example, he was forced to admit that there was something of undeniable value in the pictures produced during his psychotic period. "There is no doubt that, however apparent to the psychiatrically trained observer the characteristics of a schizophrenic expression are in this drawing [Josephson's Adam], an artist speaks to us. . . . The intact part of the personality reaches us in spite of the pathological process, and, possibly because we react to the ambiguities of the disjuncted expression, he reaches us even more force-

fully."[69] Here Kris seems to recognize the possibility that there might be something inherent in the psychotic experience itself, and in its embodiment in visual form, that could exert an attraction. He seemed puzzled that certain periods in history might seek out such chaotic and undisciplined imagery, might search for the darkness of the unconscious, might be drawn to that which was not of the surface and could not be understood.

In the art of his own day he sensed the demand for images that were admittedly pathological when viewed from the standpoint of tradition and the history of art. "For certain historical reasons the very emphasis on conflict, or some obvious contrast which we may clinically attribute to the upsurge of id impulses and the defense against them, gains high social approval. Such an evaluation was characteristic particularly of the peak of the Expressionist movement in Germany, when Josephson was rediscovered. Admiration was devoted exclusively to works created during his illness."[70] In such an aesthetic climate, which he may have seen as pathological in itself, Kris understood that "even those traits in artistic creation which are linked to what we can clinically describe as pathological processes may actually enhance the effect."[71] Kris's personal aesthetic was, however, far removed from the taste for the unintelligible and the primitive. Without evidence of the controlling ego he was not prepared to recognize a true work of art.

THROUGHOUT its history psychoanalysis has depended for its achievements upon lengthy, intensive, and deeply probing exploration of the individual human mind in the context of a long-lasting interpersonal relationship between patient and analyst. If it is to make a contribution to the study of psychotic art, it must involve itself in the application of psychoanalytically oriented forms of therapy to the treatment of psychotic individuals in whose lives image making has spontaneously become an important matter. The image-making process must enter the therapeutic environment, and eventually the therapeutic relationship. Only in this way can psychoanalysis really lend its unique methods to the understanding both of the nature of the creative activity, and of the resultant images.

Study of this kind, never more than a byproduct of the therapeutic encounter, has only begun. It is filled with problems. The presence of the analytic investigator fundamentally changes the nature of the activity, perhaps so extensively as to invalidate conclusions obtained in this manner. Our study has focused almost entirely on the spontaneously produced art of the insane. To what extent are paintings or drawings produced in the context of the therapeutic encounter spontaneous? The power of much psychotic art resides precisely in the fact that it was produced secretly, with no intention that it be seen, or it was the creation of individuals who had ceased almost entirely to concern themselves with other human beings. It is the art of people who are profoundly alone. In the therapeutic situation, another individual is attempting to be present, to be involved, to be in contact and, eventually, in communication. Although this can be terribly difficult to achieve with psychotic patients, it is nevertheless the goal.

The psychoanalytic involvement with patient art differs from the approach of art therapy in that the patient's image-making activity must make its appearance spontaneously—be unsolicited. The appearance of concrete images in the analytic hour, as opposed to verbal associations, would be an unexpected event. With the rare analyst who would feel comfortable with such images, it could occasionally form an acceptable means of furthering communication.

Kris seems never to have had the opportunity of engaging in analytic work with a productive psychotic artist.[72] He functioned as no more than an outside observer in the case of F.W., and it is highly unlikely that any kind of analytic relationship could have been established with this man had Kris wished to make the effort. Nevertheless, Kris understood that the key to what he described as the "picture riddle" presented by psychotic art lay precisely in a form of analytically oriented therapy in which interpretation of pictures would function alongside of the interpretation of dreams. "How to interpret such riddles has been repeatedly demonstrated in cases in which schizophrenics in therapy were encouraged to draw and then to comment on their productions."[73]

Kris understood that the presence of a therapist in the image-making process would inevitably change the nature of the patient's activity. "In drawings produced during therapy, the drawing usually serves a different function. It is, as a rule, made for the therapist and meant to convey something to him."[74] This change in the function of the drawings is, almost invariably, immediately apparent, resulting in most cases in drawings and paintings that lack all of the intensity and originality encountered in the art of deeply regressed psychotic patients. We are reminded of the effect that Morgenthaler's interest in Wölfli eventually had on his work.[75] Is this collapse of creative intensity as a result of therapeutic intervention inevitable? It would seem so. The patient's power as a creative individual may

reside in his ability to maintain his autistic world, and to function in absolute isolation.

There are, however, a number of unique cases in which the therapist appears to have been present without undermining the force and spontaneity of the patient's image-making activity. Kris seems to have glimpsed a possible reason for the unusual capability of such an analyst. They are unique in possessing the ability to function as image makers themselves, combining the role of artist with that of therapist. Such an ability implies far more than an amateurish involvement with Sunday painting as a pastime.

One of the most successful analysts to make use of drawing within the context of the therapeutic encounter was Donald Woods Winnicott (1896–1971). Although Winnicott seldom involved himself with deeply psychotic individuals, his use of visual images as a means of contact between himself and the patient and, more than this, as a means of "symbolic realization," was unusual in the extreme. His personal involvement with image making was so free, so fluid, that he was able to enter into the patient's activity as a participant. The result was his invention of so-called squiggle drawings, in the making of which he and the patient collaborated (Fig. 15.10).[76] This is the first instance of a physician involving himself so intensively in the patient's graphic production, and it could only work because Winnicott was capable of true "graphic free-association." His involvement with image making was not artificially cultivated during the analytic hour. At home, he filled the house with drawings produced spontaneously as part of his own life activity.[77] We are reminded of the constant involvement with drawing of another English "physician," the Bethlem steward George Henry Haydon, who through his relaxed involvement with image making was able to establish a unique relationship with Richard Dadd.

It would seem that only an individual who has attained this sort of creative freedom can act as witness and midwife at the birth of dream images. Nor is this surprising. The analytic technique of verbal free-association is not easily mastered. Its existence is similarly dependent upon the analyst's having himself experienced it over the many years of his own analysis. It is extremely doubtful that, in the absence of such personal experience, he could create an environment in which the patient could permit himself, or be permitted, the total spontaneity that true verbal free-association implies. Is there perhaps a graphic variant of free-association? There may be. Whereas the psychotic arrives at such freedom only through the "collapse" of the controlling ego, as Kris has pointed out, similar

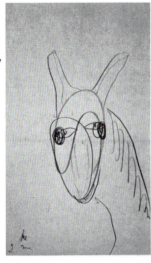

15.10. D. W. Winnicott and patient George, collaborative squiggle drawing, pencil, from D. W. Winnicott, *Therapeutic Consultations in Child Psychiatry* (New York, 1971), p. 382.

territory can be reached through the mechanism of "regression in the service of the ego."[78] He identifies the artist as a man uniquely possessed of this ability. Perhaps psychiatrists or psychoanalysts who undertake to work with psychotic patients must also be capable of such "controlled regression," while being blessed with the solidly constituted ego that such rare ability implies. This observation adds additional meaning to a side of our investigation that we have neglected somewhat, the relationship between the artist and the psychiatrist.

IT IS CURIOUS that a number of prominent analysts have come to this profession only after years of serious involvement with art, either as artists or as art historians. Besides Winnicott and Kris, one thinks of Erik H. Erikson, Bruno Bettelheim, and perhaps most important in the context of a study of the psychoanalytic investigation of psychotic art, Marion Milner.[79]

No analyst has succeeded in penetrating the world of the psychotic artist and his images as profoundly and with such insight as has Dr. Marion Milner, whose work with a schizophrenic girl, Susan, was published in 1969, under the title *The Hands of the Living God*.[80] Although Susan was by no means so deeply psychotic as to be termed "insane," she had been hospitalized as schizophrenic and was incapable of living on her own. Milner's decision to take so deeply disturbed an individual into a "classical analysis" would have been considered extremely unwise. There was no intention of using art activity in the treatment, and Susan had not been involved with painting and drawing since child-

hood. The arrival of her "doodle drawings" in the analytic hour was unsought, and yet accepted. "It was in this session (6 March 1950) that she begins to draw during the session, making scribbled shapes that seemed to me to be totally without any sign of aesthetic sensibility. . . . This day's drawings looked like those of someone who has never been interested at all in beauty of line or form; they were crudely physiological, without any attempt at symbolization" (pp. 63–64).

Although unsought and unexpected, a process identifiable in terms of Kris's concept of the "creative spell" had clearly been set in motion. In the nine months that followed, Susan, working on her own outside of the analytic hour, was to bring over four thousand drawings to her analyst, drawings that functioned as the central focus around which an intensive therapeutic encounter evolved. Inevitably such an enormous quantity of visual material presented Dr. Milner with serious procedural problems. "One continuous concern was naturally with the tremendous amount of drawings. Many of them I had not even been able to look at, since . . . she sometimes brought ninety in one day, and then another batch on the next day, before I had even had time to glance through those from the previous days. So I had simply filed most of them away in boxes, not knowing what I would eventually do with them, only attending to those we had actually talked about in sessions" (p. 240).

In deciding to publish this lengthy case (1943–1959), Dr. Milner was faced with an enormously complex conceptual task. The drawings provided the solution. "I decided to make the account center on the drawings, since I did come to look upon them as containing, in highly condensed form, the essence of what we were trying to understand. In fact, I came to see them as my patient's private language which anyone who tried to help her must learn how to read—and speak" (pp. xx–xxi). We must remind ourselves that Dr. Milner was by no means unique in having a patient who provided her with thousands of drawings. This was one of the factors that discouraged physicians who sought to gain insight into the image-making activity of their patients. Milner's uniqueness resided in her recognition that the drawings, though crude and insignificant, were to be the source of the deep-lying material that this difficult analysis would require, and in her rare ability to foster, and later to enter into, the unfolding of a spontaneous "creative spell."

The explanation for the success of this unconventional analytic venture is to be found in what Dr. Milner refers to as a remarkable coincidence. Prior to the beginning of her training as an analyst, but during the course of her own therapeutic analysis, she had herself stumbled upon the making of "doodle drawings" as a deeply important and meaningful activity. "I had found it was possible to do 'doodle drawing' which turned out to have meaning for me far beyond anything that my deliberate mind was aware of while doing them. It was the sheer surprise of this that led me in 1939 to begin writing a book around them, in order to try and explore something of the field of psychic creativity" (p. xxviii). That book, entitled *On Not Being Able to Paint*, was, in fact, a courageous account of her personal struggle to unleash her own inner potential as a maker of images.[81] Writing of this book, Anna Freud said, "It is fascinating for the reader to follow the author's attempts to rid herself of the obstacles which prevent her painting, and to compare this fight for freedom of artistic expression with the battle for free association and the uncovering of the unconscious mind which make up the core of an analyst's therapeutic work."[82] Milner succeeded in this personal struggle, and was therefore uniquely "ready" to accept the pictorial free-associations that her patient now brought to her. Her own experience of the unconscious and its images had prepared her for the unsettling, and perhaps to some, revolting, content of the material embodied in the drawings.

It was on Tuesday, March 28 that she first brought several sheets of pencil drawings, all quite different from the blatant scribbles of genitalia that she had done on the 6th of March. The sheets are covered with what she calls "black things," and she says that the first one she did (middle right) looks like an ear, but the others she now thinks are penises and testicles. The head with a halo she says is an apostle or Christ. In the middle left there are grapes; she says she deliberately thought of that when drawing them, but with the others she did not think about what they were—she just drew. (Fig. 15.11) (pp. 69–70)

Inherent in Milner's method of working with this schizoid patient was an absolute belief in the value of so-called psychotic experience. She sought to create an environment in which a natural process could begin to occur, a process (psychotic if seen from outside) of growth or unfolding in which the making of images was to play a far more central role than any active intervention by the therapist. Dr. Masud Khan refers to Milner's approach to the case as "a research into how to let oneself be used, to become a servant of a process" (p. xxxi). Failure to enter into the process, to let themselves be "used," had effectively blocked the efforts of earlier investigators to understand psychotic imagery. As one watches the evolution of the drawings, one is

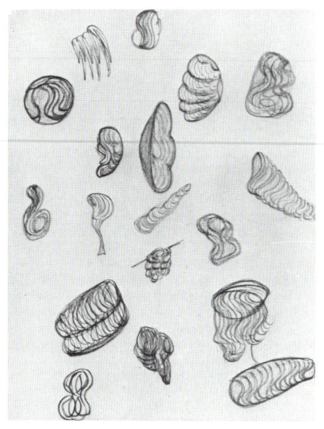

15.11. Susan, *Black Things*, March 28, 1950, pencil drawing, from Marion Milner, *The Hands of the Living God* (London, 1969), p. 69, fig. 2.

aware that in this "facilitating environment," the creative act becomes therapeutic rather than stereotyped and obsessional. Using the images arising from within herself, Susan was able to obtain and to incorporate a new and deeper awareness of herself. Through this seemingly autistic process of "communicating" with herself, she was able to allow herself to begin to feel and understand. As she did so, the drawings developed and changed, becoming more "beautiful" without any conscious striving after "beauty."

From her experience with this case, and to a lesser extent from her own graphic free-associations, Dr. Milner had become convinced of the existence of what she terms "an unconscious sense of form."

I had myself discovered the capacity to do doodle drawings that had meaning and order, and that appeared when I was able to forgo all insistence on knowing beforehand what I was going to draw; and this discovery had so shaken my previous beliefs that order can only come from consciousness and be imposed from above. . . . Even though I had not, as I came to see later, made contact with the authentic personal unconscious sense of form, or only very fleetingly, for the drawings were poor as works of art, yet I had experienced enough to convince me that there was such a thing as an unconscious sense of form. So also Susan was to give herself the same experience, though in a much deeper way than my first attempts, in that some of her drawings did turn out to be genuine works of art, although she could never bring herself to believe this.[83] (Fig. 15.12)

Dr. Milner's aesthetic response to her patient's work went far beyond mere pleasure in form and color, or in the strangeness of the images. It was based upon a clear-headed awareness of the meaning of the images, of the layer after layer of unconscious content beneath the pictorial surface of each drawing. Out of Susan's experience of near complete withdrawal into herself, had come a kind of knowing. "I did realize that this woman knew a lot and that if she ever got well, in the sense of becoming able to take her place in society, earn a living, need no special care, she might quite easily lose something of what she knew; for instance, she actually said once that if she ever got well, she thought she would not be able to draw in the same way" (p. xxix).

Susan also knew that her unique experience was of value, that in her isolation, in her madness, there was something important, something beautiful. Shortly before beginning therapy with Dr. Milner, Susan had been forced by her physician "Dr. F." to undergo several sessions of electroconvulsive therapy. She had fought against submitting to this procedure, out of the conviction that what she was experiencing, however painful, was not without meaning and should not be destroyed. "Over the years in analysis we pieced together a vivid picture over her conflict about whether to have the E.C.T. On the one hand, she felt that she

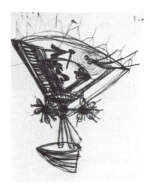

15.12. Susan, *Piano Keyboard and Dagger*, December 1, 1950, pencil drawing, from Marion Milner, *The Hands of the Living God* (London, 1969) p. 213, fig. 91.

had something that was very valuable and that the others did not have and that Dr. F. did not have, and so was jealous of her. . . . The last thing she thought of before the fit was, 'Here goes all that beauty' " (pp. 13–14).

Susan's belief in Dr. F's jealousy echoes Antonin Artaud's conviction that the majority of psychiatrists are innately hostile toward creativity, and jealous of their patients' ability to see into the depths. Much of psychiatric endeavor, to a far greater extent today than in the past, is devoted to putting a stop to psychotic experience, to preventing the spontaneous but slow processes of self-healing and self-knowledge, which Susan's history reveals so clearly. This profound hatred of unconscious images and symbols and ways of functioning is to be found occasionally even within psychoanalysis, although such an attitude stands in absolute and violent contrast with what psychoanalysis is. Milner's account of her work with Susan, and of her simultaneous struggle to utilize her own image-making processes, provides an exemplary illustration of the psychoanalytic process at its nonviolent, nonmanipulative best.

It is impossible in this brief account of Milner's attempt to join with her patient in understanding the significance of the images she created, to describe the insights that were obtained into the meaning and functions of the long series of drawings. Milner's book is the most extensive case study involving drawings in the literature of psychoanalysis. No other study goes as far in elucidating the symbolic content of the art of an individual patient, or in casting light on the role of image making in human conflict and growth. As one reads the case, it becomes overwhelmingly apparent that without the analytic process, and the commitment to the long hard task of seeing and understanding, no one, neither patient, nor analyst, and certainly not anyone outside, could ever hope to guess at the private meanings embodied in even the simplest of psychotic images. Like dreams, without the cooperation of the dreamer in providing associations, they remain opaque. This is not to deny the intense aesthetic response to psychotic art (or to any other art) that is possible in the absence of such understanding.

Despite the fact that Susan made the drawings herself, she was quite unable to account for them or to grasp their significance. Only years of work enabled her to arrive at the meaning of individual drawings and to accept and integrate them into her evolving sense of self. Few artists are so fortunate as to exist in an environment which assists and encourages them in comprehending and accepting the meaning of the images they create, although many of them are convinced that there might be enormous value in so doing.

Susan's very survival depended upon the slowly expanding awareness that her drawings carried meaning. They appear like seeds enfolding within them all that was needed for growth.

Their primary function was . . . to serve as a kind of bridge toward her acceptance of this otherness, of the external world; through the very fact that they had real existence in the outer world and at the same time, in their content and their form, came entirely from herself and her inner world, they were a non-discursive affirmation of her own reality. (pp. 242–43)

Through communication with the medium, the paper and pencil, and with the symbols she created upon the paper, she did, I felt, lay the foundations for communicating with those deep levels of her self-knowledge. (p. 241)

The understanding of the drawings' content was entirely dependent upon Susan's ability to confront herself in the images to which she gave birth. Nevertheless, Dr. Milner struggled too, to understand, to learn the language, to participate in the moments of discovery. At times she failed. Something about a drawing occasionally aroused resistance in her, making it impossible to proceed. "On looking back I realized that the impact of this drawing had been so intense that I had been unable at first to bring myself to concentrate upon its meaning. It produced such a complex state of feeling to do with anguish and tragedy that it seems I did not really know what to do with it" (pp. 250–51). In this passage Dr. Milner's introspective ability permits us to see the intensity of the feelings that so often obstructed the efforts of physicians attempting to study and understand the spontaneous creations of their psychotic patients. Her tenacity and commitment forced her again and again to return to the same drawing.

One of the methods she arrived at in coming to grips with this task was entirely new. In a somewhat detached state of mind she occasionally found herself copying Susan's drawings from memory, and in the midst of this rather unconscious and automatic play with the forms, she obtained insight into their significance. At times one feels that her interpretations are deeply subjective, as unconsciously realized as those of her patient. Both of these women were capable of a poetic language, which their long work together eventually brought into congruence.

The extent of Milner's commitment to Susan's struggle is glimpsed in her endeavor to use empathy as a means of understanding.

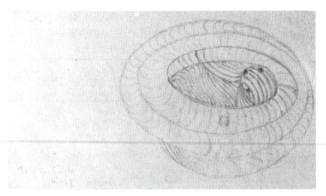

15.13. Susan, *Baby Seal in a Coiled Serpent Nest*, July 10, 1950, pencil drawing, from Marion Milner, *The Hands of the Living God* (London, 1969), p. 154, fig. 51.

There was one drawing amongst this day's batch that I came to call the baby seal [Fig. 15.13]. It develops the theme of the protecting cowl that surrounds so many of her faces, but now this has become a spiral form with a little animal embedded in it. She herself made no comment about it, but what I seem to have said was that it looked like a tiny creature in a nest just waking to consciousness of the outside world. Certainly my first impression of it was that it was a cosy nest, but soon I became more and more impressed by the sense of tremendous power in the encircling snake-like coil. It might even be a boa-constrictor, the baby animal its prey. It was this baby seal drawing that in fact came to be for me a kind of pivot for many of my speculations about psychoanalytic theory. (pp. 153–54)

Milner realized, as did Kris, that the act of drawing formed part of the experience of schizoid isolation: as her patient began to make contact with, and to function in, the outside world, her need to draw, seemingly dependent upon her "pathological" contact with her own inner depths, would diminish and, quite possibly,

cease. In fact, in the later phases of the analysis Susan stopped drawing at home and could work only in the ambience of the therapeutic hour. She was being reclaimed by the world. "The difficulty during all this period from the point of view of her analysis, was that, in her efforts to keep going as a useful member of the household, earning her keep and living actively in the common sense world, she had become again much more alienated from the deeper levels of her psyche" (p. 237).

This form of alienation from one's own inner world, a form of pathology currently conceived of as "normal," is the tragic state of the majority of men and women in our modern society. Psychoanalysis and contemporary art can both be seen as participating in a determined effort to reconcile these two worlds: to enrich the world of the surface with the dark gold of humanity's inner depths. This century has been characterized by a curiously unstable awareness that we can ignore that inner world only at our peril, and by a hunger, at times terrifyingly intense, for images dredged up from the deepest caverns of the mind. It is this longing that underlies so much of the art of the twentieth century and that has provided the prime motivation for the discovery of the art of the insane.

Having abandoned the strenuous attempt to reconcile himself to the demands and sacrifices of day-to-day existence in the world, the psychotic withdraws into the utter isolation of the self. Within that altered state of consciousness, for reasons that we understand no better than we understand any creativity, the psychotic begins to form images that, paradoxically, may be aimed, in part, at reestablishing contact with the outer world. The artist and the madman seem intent on building a bridge, each from his own standpoint, in the world or out of it, erecting a structure between the self and other, between the world and the mind, between the surface and the depth.

SIXTEEN

Psychosis and Surrealism

On July 19, 1938, Sigmund Freud, then living in exile in London, received a visit from an artist-admirer suffering from, what seemed to Freud, the peculiar delusion that psychoanalysis had a significant role to play in the creation of works of art. The artist was the already famous and accomplished Surrealist painter Salvador Dali (b. 1904) who, having spent years participating in imaginary conversations with the eminent professor, now found himself face to face with the founder of psychoanalysis. Dali's visit was a purely social one, arranged by the writer Stefan Zweig (1881–1942), more with a view to entertaining Freud than with any intention of contributing to the development of either science or art. In a letter to Freud he nevertheless indicates a sense of the historical meaning of the event.

Salvador Dali, in my opinion, (strange as many of his works may appear) is the only painter of genius of our epoch, and the only one who will survive—a fanatic of his conviction, and the most faithful and most grateful disciple of your ideas among the artists. For years it has been the desire of this real genius to meet you. He says that he owes to you more in his art than to anybody else. ... I think that a man like you should see once an artist who has been influenced by you as nobody else, and whom to know and to estimate I have always regarded as a privilege.[1]

Freud seems to have enjoyed the encounter, to which he alluded in a letter to Zweig written the following day.

I really have reason to thank you for the introduction which brought me yesterday's visitors. For until then I was inclined to look upon Surrealists, who have apparently chosen me for their patron saint, as absolute (let us say 95 percent, like alcohol) cranks. The young Spaniard, however, with his candid fanatical eyes and his undeniable technical mastery, has made me reconsider my opinion.[2]

Despite his almost complete lack of interest in contemporary artistic movements, Freud was well aware of his particular importance to the artists who grouped themselves, in considerable disarray, under the banner of Surrealism. Dali, already excommunicated from the official body, was, after all, only following in the footsteps of its leader, André Breton, who visited Freud, much earlier, in 1921. Dali's visit, though it had no historical repercussions, is significant as a symbol of the rather one-sided alliance between psychoanalysis and art, which had given birth, quite directly, to a profoundly important international literary and artistic movement. Whatever Dali expected from this visit, there is no doubt that he acknowledged in this gesture his recognition of the preeminent significance of Freud's thought to the development of Surrealism.

Freud's changed attitude to the Surrealists, at least in regard to their technical accomplishment, may have been a response to the painting of *Narcissus*, which Dali brought with him to the interview, and to the portrait drawings of him that the artist executed during the visit, in which Freud's brain was metamorphosed into a snail (Fig. 16.1).[3] For Dali, the encounter was something of a disappointment. Nevertheless, he continued to write of it for many years, seeing it in retrospect as significant, if not for himself, for Freud.

Contrary to my hopes we spoke little, but we devoured each other with our eyes. Freud knew nothing of me except my painting, which he admired, but suddenly I had the whim of trying to appear in his eyes as a kind of dandy of "universal

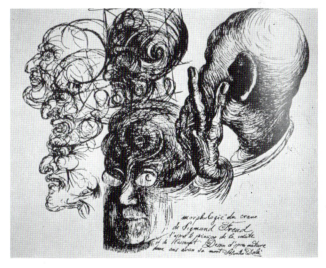

16.1. Salvador Dali, *Morphology of the Skull of Sigmund Freud*, 1937, Salvador Dali Collection, New York.

271

intellectualism." I learned later that the effect I produced was exactly the opposite. Before leaving I wanted to give him a magazine containing an article I had written on Paranoia. I therefore opened the magazine at the page of my text, begging him to read it if he had time. Freud continued to stare at me without paying the slightest attention to my magazine. Trying to interest him I explained that it was not a surrealist diversion, but was really an ambitiously scientific article, and I repeated the title, pointing to it at the same time with my finger. Before his imperturbable indifference, my voice became involuntarily sharper and more insistent. Then, continuing to stare at me with a fixity in which his whole being seemed to converge, Freud exclaimed, addressing Stefan Zweig, "I have never seem a more complete example of a Spaniard. What a fanatic!"[4]

Dali later described the interview in more condescending terms as an effort on his part to educate Freud.

Two geniuses had met without making sparks. His ideas spoke for him. To me, they were useful crutches that reinforced my confidence in my genius and the authenticity of my freedom, and I had more to teach him than I could get from him.... I am convinced that our meeting was a turning point in Freud's artistic conception. I am persuaded that I forced the great master of the subconscious to rethink his attitude. Before me, Dali, Freud had never met any really modern artist. Before our meeting he thought—as he wrote—that the Surrealists were "crazy"; after me, he "reconsidered" his opinion. Freud had a hunch that the Surrealists, and the Expressionists along with them, took the mechanics of art for art itself. My work—my technical mastery—and my person, showed him that his conception had been foolhardy. Yes, I am convinced that if we had met earlier, or several times, some of his views on art might have been modified. My paranoid-critical method would have opened new vistas to him.... Freud was probably too old to reopen his theses and make way for new experiments.[5]

However old Freud was in body, his mind was astute. One remark, attributed to him by Dali, suggests that he saw deeply into the weakness of the Surrealist position, Dali's in particular. "In classic paintings, I look for the sub-conscious—in a Surrealist painting, for the conscious."[6] It would seem that Freud had seen through the psychotic veneer and detected the presence of calculation and of the controlling ego.

Although the meeting between Dali and Freud was of merely symbolic significance, Breton's much earlier encounter with psychoanalysis and its creator had been a crucial element motivating the origin and early development of Surrealism. In its original form, Surrealism, as conceived by Breton, was largely derived from the writings of Freud or, at least, from accounts of Freud's ideas available to him in France in the early 1920s.[7] Breton's understanding of the implications and meaning of Freud's thought was, however, obtained not only from reading the theoretical work (a disadvantage commonly observed in intellectuals who make use of Freud for one purpose or another), but from actual experience with the method as a means of treating people suffering from various types of psychological disturbance. Following a period of medical study, Breton had been assigned during World War I to serve as a medical assistant in psychiatric hospitals established to deal with cases of psychiatric disturbance induced by the experience of the military and of war. Working at the psychiatric center of the Second Army at Saint-Dizier, as assistant to Dr. Raoul Leroy, he was brought into contact with a wide range of mental disturbances, including psychotic states of various kinds. He was impressed by the altered reality of the insane and developed a respect for this other reality, which remained a motivating force for the rest of his life (Fig. 16.2).

Through Dr. Leroy, Breton had been led to discover the ideas of Freud. Surrounded with individuals whose behavior and experiences seemed frighteningly inexplicable, he set out to understand and perhaps, to be of help. Still in his early twenties, he approached the phenomenon of insanity with curiosity and intelligence. He was intrigued by the strange ideas he encountered, struck by the power and beauty of the thoughts and images the patients expressed. He attempted to use the Freudian technique of verbal free-association as a means of exploring the inner world of his patients, and it was in this spontaneously produced material that he first glimpsed what for him was to be the poetry of the future.

This concrete experience of the individual worlds of insane individuals protected Breton from the pseudo-psychoanalytic theorizing and game playing indulged in by some of the other Surrealists. He spoke of the imaginative worlds of madness from the standpoint of knowledge; he knew the truth of the varied situations of the insane, the freedom and joy, the pain and confusion, as well as the cruelty, domination, and incomprehension to which they were exposed. It must be remembered that although Breton was studying Freud and attempting to use his insights and methods to understand the cases he encountered, he was working in a psychiatric setting whose orientation would have been anything but Freudian, in a type of clinic where physical and psychological manipulation and enforced conformity to military standards and ideals would have been the norm. His profound hatred of psychiatrists and physicians was born at this time. For Breton the ideas of Freud represented a possibility of freedom

and of respect for the individual of which he could see no example in either the hospital or the world around him.

Writing of the faculty of imagination as it appears in the insane, he conveys very clearly his deep respect for their spiritual position and his awareness of the incomprehension that surrounds them.

There remains madness, "the madness that one locks up," as it has aptly been described. . . . We all know, in fact, that the insane owe their incarceration to a tiny number of legally reprehensible acts and that, were it not for these acts, their freedom (or what we see as their freedom) would not be threatened. I am willing to admit that they are, to some degree, victims of their imagination, in that it induces them not to pay attention to certain rules—outside of which the species feels itself threatened—which we are all supposed to know and respect. But their profound indifference to the way in which we judge them, and even to the various punishments meted out to them, allows us to suppose that they derive a great deal of comfort and consolation from their imagination, that they enjoy their madness sufficiently to endure the thought that its validity does not extend beyond themselves. And, indeed, hallucinations, illusions, etc., are not a source of trifling pleasure. . . . I could spend my whole life prying loose the secrets of the insane. These people are honest to a fault, and their naiveté has no peer but my own.[8]

The birth of Surrealism followed immediately upon Breton's experience of the psychiatric hospital and the individuals whom he met there, and was the direct outcome of what had been for him a profoundly disturbing and yet meaningful encounter. Breton's natural tendency was to act rather than to study or to classify; he responded to the creativity of the insane with his own creative activity.[9] Impressed by the beauty of their images, he sought to explore his own inner world with the same tools he had employed with them. Emulating Freud in the truest sense, he turned the method of free-association on himself, using it as a means of illuminating the darkness of his own psyche.

Completely occupied as I still was with Freud at that time, and familiar as I was with his methods of examination which I had some slight occasion to use on some patients during the war, I resolved to obtain from myself what we were trying to obtain from them, namely a monologue spoken as rapidly as possible without any intervention on the part of the critical faculties, a monologue consequently unencumbered by the slightest inhibition and which was, as closely as possible, akin to spoken thought.[10]

Breton is describing the analytical procedure outlined by Freud in *The Interpretation of Dreams*, and termed by him "free-association." Breton and a group of friends had decided to participate in an experiment that, if properly carried out, would have amounted to

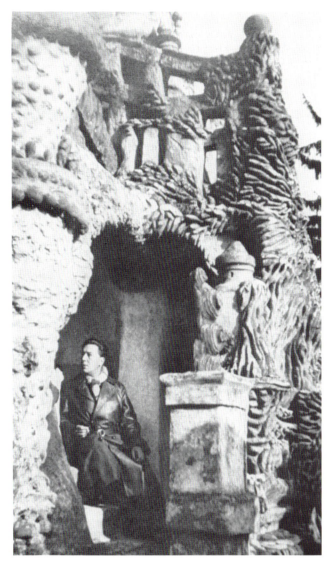

16.2. André Breton at the Palais Ideal of Ferdinand Cheval, 1931.

a self-analysis. In its earliest stages their goal was therapeutic, aimed at providing the participants with a deeper insight into themselves, and not primarily with the production of poetry. Following Freud, Breton also stressed the importance of dreams as a means of exploring the inner world and of liberating the imagination. He was seriously involved in dream recording and interpretation using the methods suggested by Freud. His unique contribution was to publish the dreams and interpretations in periodicals devoted to literature. As he pointed out, "Freud very rightly brought his critical faculties to bear upon the dream.

It is, in fact, inadmissible that this considerable portion of psychic activity ... has still today been so grossly neglected. I have always been amazed at the way an ordinary observer lends so much more credence and attaches so much more importance to waking events than to those occurring in dreams."[11] Breton rectified this imbalance by using the Surrealist periodicals, particularly *La révolution surréaliste*, to publish numerous dreams and interpretations.

The first manifesto of Surrealism of 1924 contains little that does not derive from *The Interpretation of Dreams* and other early works of Freud. Never before had a branch of psychiatry contributed so directly to the origins and development of a purely artistic movement. With the exception of the therapeutic goals, psychoanalysis and early surrealism shared a preoccupation with identical material. As a form of creative activity, Surrealism originated as a game, more or less sincerely played depending on the player, that in all respects was similar to a self-analysis based, as was Freud's, on the analysis of dreams and of associations to them. The originality of the first manifesto lay only in the suggestion that this activity was the proper work of poets, and in the belief that it might lead to images and ideas worthy of being shared and published.

It was apparently by pure chance that a part of our mental world which we pretended not to be concerned with any longer—and, in my opinion, by far the most important part—has been brought back to light. For this we must give thanks to the discoveries of Sigmund Freud. On the basis of these discoveries a current of opinion is finally forming by means of which the human explorer will be able to carry his investigations much further, authorized as he will henceforth be not to confine himself solely to the most summary realities. The imagination is perhaps on the point of reasserting itself, of reclaiming its rights. If the depths of our mind contain within it strange forces capable of augmenting those on the surface, or of waging a victorious battle against them, there is every reason to seize them—first to seize them, then, if need be, to submit them to the control of our reason. The analysts themselves have everything to gain by it. But it is worth noting that no means has been designated a priori for carrying out this undertaking, that until further notice it can be construed to be the province of poets as well as scholars. ... I believe in the future resolution of these two states, dream and reality, which are seemingly so contradictory, into a kind of absolute reality, a surreality, if one may so speak. It is in quest of this surreality that I am going.[12]

From its earliest stages of development Surrealism emphasized two forms of rather dissimilar activity as its procedural basis: methods of automatic writing and drawing; and the representation, in either written or pictorial form, of dreams. These two activities are related by the significant fact discovered by Freud, and emphasized by Breton, that automatic writing (free-association) is the essential method used in interpreting dreams. Nevertheless, these two areas of emphasis, recording and interpreting, led to the development of two distinct branches of "pictorial Surrealism": what might be termed "abstract Surrealism," the result of automatic drawing experiments, most clearly demonstrated by the early work of André Masson (b. 1896); and "illusionistic Surrealism," in which all the techniques of pictorial illusionism are employed in illustrating actual dreams, the best example of which is provided by the early work of Salvador Dali. In a lecture given in 1935, Breton again identified the goal of both of these procedures as psychological rather than artistic.

Thus the whole technical effort of Surrealism, from its very beginning up to the present day, has consisted in multiplying the ways to penetrate the deepest layers of the mental. ... In the first rank of these means whose effectiveness has been fully proved in the last few years is psychic automatism in all its forms (the painter is offered a world of possibilities that goes from pure and simple abandon to graphic impulse and the fixing of dream-images through trompe-l'oeil).[13]

In its beginnings, as Breton admits, Surrealism was conceived of as an experiment involving the written word rather than pictorial images. He was not unconscious of its implications for the painter-draftsman. "Were I a painter," he notes,

this visual depiction [a hypnagogic image he experienced while in a drowsy state] would doubtless have become more important for me than the other [an accompanying verbal hallucination]. It was most certainly my previous predispositions which decided the matter. Since that day, I have had occasion to concentrate my attention voluntarily on similar apparitions, and I know they are fully as clear as auditory phenomena. With a pencil and white sheet of paper to hand, I could easily trace their outlines.[14]

What influenced Breton to focus his attention on verbal automatisms was the fact that they provided a means of approximating the powerful verbal imagery of the psychotic patients with whom he had worked. His absolute conviction of the artistic value of such spontaneous and irrational verbal utterances was derived not from reading Freudian theory, but from hearing the speech, the verbal descriptions, the innovative language, and the richly inventive associations of the mad. So impressed was he by the intensity and evocative power of their unconventional language and images, that he sought to emulate their experience in his

own work. The experience of the inner world of madness was vastly more important for Breton than reading Freud. Freud provided intellectual justification for his obsessional interest in irrationality, and techniques for exploring that inner world at will, without the prior qualification of being insane. Breton was straightforward about the direction in which his research was leading. "Let it be clearly understood that we are not talking about a simple regrouping of words or a capricious redistribution of visual images, but of the re-creation of a state which can only be fairly compared to that of madness."[15]

There is no clear evidence that in the early years of the Surrealist experiment Breton was aware of or interested in the drawings and paintings of the insane. However, the growing awareness that automatic techniques could be employed by the visual artist, and of the fact that dreams are essentially visual rather than verbal phenomena, led to an ever-increasing role for the pictorial image maker within Surrealism. For these artists the pictorial productions of the insane were immediately seen to have significance and value. Nevertheless, the first Surrealist manifesto made only passing reference to the spontaneous drawings of psychotic patients.[16]

IN THE PASSAGE already referred to in which he indicated that it was only his personal involvement with poetry that led him to emphasize verbal rather than pictorial aspects of the expressive activity of the insane and of free-association as a technique, Breton referred to an article published in *Les feuilles libres*, which contained pictorial illusions purporting to be the work of a madman, but which were, in fact, drawings by the Surrealist poet Robert Desnos (1900–1945). The article in question, not identified by Breton, was an essay by Paul Eluard (1895–1952), entitled "Le génie sans miroir."[17] This short essay is of importance to us in that it concerned itself, in part, with the drawings and paintings of the hospitalized insane. Eluard's conception of the value of this art was similar to the point of view soon to be put forward by André Breton, and is the first clear statement concerning the importance of psychotic pictorial art to the Surrealist artist.

The insane are locked up in pompous cells, and our delicate hands inflict scholarly tortures upon them. Don't imagine, however, that they will succumb! The country which they have discovered is so beautiful that nothing is capable of diverting their spirit. Sicknesses! Neuroses! Divine methods of liberation unknown to the Christians. . . . We who love them understand that the insane refuse to be cured. We know well, that it is we who are locked up when the asylum door is shut:

the prison is outside of the asylum, liberty is to be found inside.[18]

Eluard's article included thirteen pictures and several poems, which he identified as the work of patients confined in a mental hospital in Poland. He described a number of individual pictures, identifying the artists by name and characterizing the essential qualities that led him to value them as representing a unique and important form of art.

The drawings of the insane transport us directly and unwittingly to cities and countrysides where the wind of revelation moves. Cocaine- and morphine-induced visions are scarcely a reflection of these charming anatomies. Behold an eminently spiritual art. A madman never attempts to copy an apple. Poetic vision superimposes itself always upon reality. In the smoke of a cigarette resting on the edge of a table, he discovers the disordered fall of the rebel angels. The least significant of their sketches vibrates with intense emotion. They do nothing without imposing upon it the absolute integrity of their meaning. . . . Open your eyes, I beg you, upon this virgin landscape! Accept as a postulate the principle of absolute liberty, and recognize, with me, that the world of the insane cannot be matched in our age.[19]

At first glance Eluard's article might be dismissed as a joke. The poems he included as the work of inmates of a Polish asylum were, in fact, written by members of the Surrealist circle in Paris. Of the thirteen drawings three were by insane artists and ten by Desnos. The editors of the magazine were seemingly unaware of the hoax, and the article was accepted as a serious contribution to the study of the art of the insane.[20] Eluard, no doubt, enjoyed fooling the French intellectual community in this way; nevertheless, the ideas put forward in the essay were accepted as Surrealist doctrine, and the works reproduced, though they were not what they purported to be, were serious compositions. The Surrealists repeatedly sought to emulate the art of the madman. They measured themselves against the unvarying honesty of the psychotic artist, and used his experiences as a means of validating their own. Eluard's attempt to pass off Surrealist poetry and drawing as the work of madmen was therefore a deadly serious game. In identifying Robert Desnos as the actual source of the drawings, Breton was announcing the success of this uniquely Surrealistic experiment.

Robert Desnos, as an early member of the Surrealist circle, was one of the first to involve himself intensively with automatic drawing. He developed the ability to enter into trance states, bordering on deep hypnosis, in which he spoke and drew without conscious control, producing images that Breton accepted as the pictorial equivalent of his own experiences (Fig. 16.3).

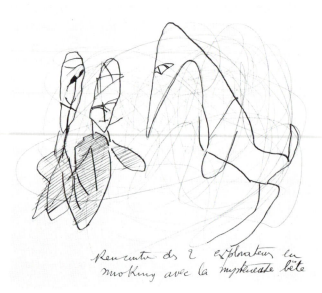

16.3. Robert Desnos, *Automatic Drawing*, from *The Night of Loveless Nights*, The Museum of Modern Art, New York.

"Desnos continues seeing what I do not see, what I see only after he shows it to me."[21] Desnos was not mentally ill. However, as a result of his experiments with automatism and self-hypnosis, he is said to have become ever more reluctant to abandon the unconscious state. Breton seems to have become aware for the first time of the danger involved for some people in the experiments that he inspired, and he withdrew his support for the sort of trance activities in which Desnos was engaged. Breton appears to have had a considerable ability to enter into and to withstand the irrational. His profound interest in insanity and altered states of consciousness was coupled with an unusual degree of psychological stability, which made him at times unaware of, or unwilling to see, the risks that the encounter with the unconscious might entail.

A tragic example of Breton's tendency to accompany others into realms they could not handle is seen in the autobiographical novel *Nadja*, published by him in 1928. It tells the story of Breton's intense involvement with a seriously disturbed girl who called herself Nadja. The deep attraction that her strange world exerted upon him may have led him to ignore the implications of the encounter for her. His description of Nadja's continually diminishing contact with the outer world is a chillingly objective account of a relationship that for her may have represented a last effort at hu-

man contact. There was something icy cold in Breton the psychologist, and Nadja was afraid. "Now she tells me of my power over her, of my faculty for making her think and do whatever I desire, perhaps more than I think I desire. Because of this, she begs me to do nothing against her."[22]

The story of Nadja ended tragically. She disappeared; Breton made no effort to find her, only later learning that she had been put away in an asylum.

I was told, several months ago, that Nadja was mad. After the eccentricities in which it seems she had indulged herself in the hallways of her hotel, she had to be committed to the Vaucluse Sanatorium. Others will provide their useless epilogues on this fact, which they will inevitably interpret as the fatal result of all that has gone before. The more enlightened will certainly stigmatize the role which must be attributed, in what I have related of Nadja, to ideas already frenzied and will perhaps set a terribly decisive value to my role in her life, a role favorable, in practice, to the development of such ideas. . . . The essential thing is that I do not suppose there can be much difference for Nadja between the inside of a sanatorium and the outside.[23]

With this passage, a new and highly dangerous attitude toward the insane emerges, a tendency to exploit and manipulate individuals who are mentally unstable or even psychotic in the belief that their artistic productions are far more significant than their psychological condition, justifying manipulating the one with a view to obtaining the other.

The account of Breton's relationship with Nadja provides the most detailed illustration of the nature of his involvement with madness and the mind. We must believe him when he says, "I could spend my whole life prying loose the secrets of the insane." Toward the end of his involvement with her she began to draw. Breton reproduced ten of these pictures and provided a good deal of information about their meaning derived from her explanations. Given the detailed information we have about her, and the knowledge that she was not an artist, one may recognize in the drawings a clear indication that Nadja was schizophrenic. Breton's comment on this question is curiously irresponsible for a person as knowledgeable about psychiatry as he was. "Nor could Nadja's letters which I read the same way I read all kinds of Surrealist texts—with the same eye— show me anything alarming."[24]

Nadja's drawings represent the beginning of Breton's involvement with the pictorial art of the insane. Although he had probably encountered Prinzhorn's *Bildnerei der Geisteskranken* at about this time, it would seem that the personal contact between picture and patient was necessary for him. From this point on

the pictorial art of the insane was to play an increasingly important part in the evolution of Surrealism. It was as if he had become aware of these drawings as a means of communication. Certainly for Nadja they were. She drew specifically for Breton, and was willing to explain the meaning of the drawings as far as she understood it. There was an almost pitiful willingness on her part to use her psychopathology as a means of pleasing and attracting the attention of Breton.

Nadja has invented a marvelous flower for me: "The Lovers Flower" [Fig. 16.4]. It is during a lunch in the country that this flower appeared to her and that I saw her trying—quite clumsily—to reproduce it. She comes back to it several times, afterwards, to improve the drawing and give each of the two pairs of eyes a different expression. It is essentially under this sign that the time we spent together should be placed, and it remains the graphic symbol which has given Nadja the key to all the rest.[25]

Nadja's feelings about the relationship that had become so important a part of her life (she was undoubtedly deeply in love with, and dependent upon, Breton) can be seen in her drawings where the link between these two people is explored in various ways. Breton identified one of the drawings dated November 18, 1926, as "a symbolic portrait of the two of us" (Fig. 16.5). Nadja explained its symbolic content. "The siren, which is how she saw herself always from behind and from this angle, holds a scroll in her hand, the monster with the gleaming eyes has the front of its body caught in a kind of eagle-head vase, filled with feathers representing ideas."[26] The bonds that tie the two figures together are the intertwined fish tails, a convincing portrayal of physical love. Beyond this the two protagonists seem curiously unattached. The ter-

rifying eyes of the catlike monster Breton express better than words her experience of his probing, almost sadistic, curiosity. "How much I admire those men who decide to be shut up at night in a museum in order to examine at their own discretion, at an illicit time, some portrait of a woman they illuminate with a dark lantern. Inevitably, afterwards, they must know much more about such a woman than we do. Perhaps life needs to be deciphered like a cryptogram."[27] Nadja's drawings, far more convincingly than Breton's biographical notes, provide that portrait of a woman, an image that remained for Breton frustratingly indecipherable. His portrait of himself, on the other hand, provides our deepest insight into the kind of inner motivation and the incredible force that often lies beneath a seemingly innocent and casual interest in the art of madness.

DESPITE Breton's interest in the drawings of Desnos and Nadja, the surrealist most seriously involved in the spontaneous pictorial art of the insane was Max Ernst (1891–1976). His preoccupation with this art can be traced as far back as 1910 when, at the age of nineteen, he began studying at the University of Bonn. In his autobiographical writings, Ernst described his own discovery of psychotic art:

Near Bonn there was a group of gloomy buildings which in many respects resembled the Hospital of St. Anne in Paris. At this clinic for the mentally ill, students could attend courses and obtain practical experience. In one of these buildings there was an astonishing collection of sculpture and pictures which the unwilling inhabitants of this frightful place had made, most particularly, figures made from bread crumbs. They touched the young man very deeply and he sought to understand these flashes of genius, and to inquire

16.4. Nadja, *The Lover's Flower*, from André Breton, *Nadja* (Paris, 1928), plate 29.

16.5. (far right) Nadja, *A Symbolic Portrait of the Two of Us*, November 18, 1926, from André Breton, *Nadja* (Paris, 1928), plate 30.

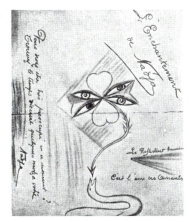

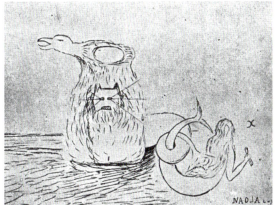

into the vague and perilous territory on the borders of insanity. Only much later was he to discover certain techniques which helped him to advance into this no-man's-land."[28]

Largely because of its influence on the early development of Max Ernst, serious efforts have been made to discover the whereabouts of this collection, or to determine, more precisely, the nature of its contents. The clinic referred to would seem to be the Provincial Healing and Care Hospital (Provinzial Heil und Pflegeanstalt), at number 20, Kaiser-Karl-Ring in Bonn. Although this institution still exists, no trace of any collection of psychiatric art is to be found.[29]

The experience of original pieces of sculpture, and of drawings and paintings, made by the hospitalized insane seems to have had an enormous impact on the young student, at the very moment when his own, very personal involvement with image making was beginning, and when his serious preoccupation with the study of psychology and psychiatry was just getting underway. For the visually sensitive young man, interested in both art and psychiatry, these images provided a particularly important focus of study and an ongoing problem in understanding. It is regrettable that we do not know the precise nature of the material he was working with, or the identity of the artists whose work he was encountering for the first time.

Although Ernst entered the university with the intention of studying philology, the list of courses that he attended while there reveals that two areas of study outside of philology had become surprisingly important to him; art history, and psychology-psychiatry. He took introductory courses in psychology, and in experimental psychology, and the psychology of speech. At the psychiatric clinic he also attended courses on the psychology of emotionally disturbed children, a course on the "Origins and Social Implications of Mental Illness," as well as a more specialized course entitled "Selected Topics in Criminal Psychology." It is no exaggeration to suggest that Ernst was tentatively preparing himself for advanced study in clinical psychiatry.[30] Among the Surrealist artists, no one, not even Breton, could claim as serious an academic background in the related fields of psychology and psychiatry. While no formal courses in psychoanalytic theory were offered, Ernst has stated that he had begun study of Freud's writings as early as 1913, when he read *The Interpretation of Dreams* (1900) and *Wit and Its Relation to the Unconscious* (1905)[31] His response to psychotic art would therefore have been increasingly influenced by his knowledge of mental illness and of psychiatric and psychoanalytic theory. The thoroughness of his education both in art history and psychiatry brought him close to the experience of Hans Prinzhorn (five years his senior) or of Ernst Kris (nine years his junior) in terms of his response to the art of the insane, though it is not known how much his involvement with the psychiatric clinic included contact with hospitalized patients.[32]

Ten years prior to the publication of Prinzhorn's *Bildnerei der Geisteskranken*, Max Ernst thought of writing a book on the art of the mentally ill, a clear indication that he was attempting to find a means of bringing together his major fields of interest and training. This project is said to have been abandoned, not because of his involvement with art, but because of the publication of the Prinzhorn book.[33] One can only regret that an opportunity to obtain insight into Ernst's personal understanding of psychotic art, and perhaps of specific artists, was thereby lost. However, the influence of this art, and of specific schizophrenic artists, can be detected with certainty in his later work, and this is of far greater interest to us.

It is important to note that Max Ernst, as artist, lacked the formal academic training provided in art schools. His university education included only a single practical course devoted to "drawing and modeling from nature and the antique." This lack of academic training markedly influenced his career as an artist, as well as his mode of utilizing images derived from other sources. At the center of his early work is a serious interest in collage, but of a unique kind. He became preoccupied with the assembling of diverse pictorial fragments, borrowed from various illustrated sources, brought together in bizarre and unnerving juxtapositions. "At the time he worked it out, in 1919, it enabled him to largely delegate the task of painting and drawing to the other people whose pictures he quoted."[34] It is in terms of this unique working procedure that we must understand Ernst's "borrowings" from primitive art and from psychotic art, among other more mundane sources that he utilized. Even in his later painting and sculpture, he frequently adopted things whole, undisguised, bringing together easily identified fragments from meaningfully selected pictorial sources. A recent study of his concurrent involvement with various tribal arts makes this particularly clear.[35] In no other artist are the borrowings from the "primitive" so specific and so readily identified. He frequently used quotations from specific pieces, rather than revealing vague formal influences or echoes of unidentified content. This very specific kind of borrowing is also to be found in his no less extensive use, or incorporation, of psychotic art and images.

The appearance of Prinzhorn's book in 1922 was greeted by Ernst with considerable excitement. He alone among the early Surrealists was able to read the text and to understand its revolutionary significance, not only for the psychiatric investigation of schizophrenic art, but for the development of modern art and aesthetics. It is known that he took the book with him to Paris in that year, presenting a copy of it to Paul Eluard.[36] It is not impossible that this was the first copy of the book to reach the Surrealist circle in Paris, an event that was to prove very important to the development of pictorial Surrealism. Its impact on Ernst's own work is easily detectable and continues throughout his career, providing "a positive, hitherto untapped source of subjects and compositions."[37] More significant, it seems to have encouraged, or more correctly, deepened, an earlier identification, as artist, both with the role of psychiatrist and with the creative stance of the psychotic artist.

Ernst's extensive knowledge of the Prinzhorn collection, and particularly of the sculptural works in it by Karl Brendel, raises the question of his possible contact with it either before, or after, the appearance of the book. No document appears to prove such contact, but I believe it to be highly probable. Both of these young men moved in university and clinical circles in which the study of art, and of psychiatric art in particular, had special importance. If there was a major collection of psychotic art in Bonn, Prinzhorn would undoubtedly have visited it. He was, in any case, lecturing widely on the topic before 1922. The similarity of interest and education shared by these two men would have all but necessitated their coming in contact, with a subsequent visit to Heidelberg by Ernst a natural corollary. Only personal experience of the collection, and particularly of the sculptural pieces that it contained, is sufficient to account for its profound influence on Ernst's later work.[38]

In 1919, the year Prinzhorn arrived in Heidelberg, Ernst too was involved, though on a much smaller scale, in bringing together a group of works made by the insane. These were to be exhibited in the Cologne Dada Exhibition of that year, an exhibition that included children's drawings, African sculpture, found objects, and drawings by the insane.[39] Once again one would like to know which psychotic artists, and which images, were included in this important show, and from which collection they came. Without this information, it is possible only to point out that Ernst preceded Prinzhorn in forcing the art of the insane to be considered, not as evidence of mental illness, but as worthy of inclusion in a major exhibition of avant-garde art. The breaking down of these aesthetic and art historical boundaries is once again seen to be an essential aspect of the revolutionary movement known as Dada (see n. 16).

However, it is within the context of Ernst's later Surrealistic works that specific influences deriving from schizophrenic art can be identified. The German critic Werner Spies discovered a specific instance of "borrowing" from Prinzhorn and, more important, evidence of influence stemming from a specific artist, August Natterer, and a specific work, *The Miraculous Shepherd (Der Wunderhirte)* (Fig. 16.6).[40] In 1931 Ernst produced an extremely important collage as part of a group entitled *8 poèmes visibles*. This same collage was reproduced separately in 1933 with the title *Oedipe*.[41] Not just one collage among many, this particular work seems to have assumed unique importance for Ernst who chose it himself in 1937 to adorn the cover of the first book dedicated to his pictorial oeuvre (Fig. 16.7).[42] Spies points to "the key position of this collage in the work as a whole," suggesting, as a result of careful analysis of the picture, that it functioned for Ernst as "a veiled self-portrait."[43]

Spies' essay on the collage is devoted to presenting a number of pictorial sources utilized by Ernst in arriving at his new image: in particular Natterer's *Miraculous Shepherd* (reproduced as pl. 123 in Prinzhorn), and an engraving of the well-known sculpture *Boy Extracting a Thorn*.[44] The derivation from the engraving is strikingly close: the influence of the *Miraculous Shepherd*, however, is more distant and yet possibly more important for the meaning of the work as self-image. He begins by pointing to a number of formal features connecting the two images in terms of "a certain morphological kinship." "Here are the rigid silhouette, the figure seated in mid-air, bearing an animal on its chest like *Oedipe* holds a lion's head in his hands, the strongly exaggerated legs and feet,"[45] to which one would like to add the curious headdress that flows out from behind the head of the main seated figure. Not content with indicating these compositional parallels, he then shifts to the meaning of the work as an embodiment of both Oedipus and Sphinx, male and female, poser and solver of riddles—a multiple self-image of Ernst as artist.

If Ernst, indeed, created an original variant of *The Miraculous Shepherd*, he did so with very precise, largely conscious motivation. Its use on the cover of the *Cahiers d'Art* edition of his work would imply an almost programmatic choice of self-image as Oedipus solver of riddles. The choice of this aspect of Oedipus as self-image was not limited to Max Ernst. Sigmund

16.6. August Natterer, *The Miraculous Shepherd (Der Wunderhirte)*, pencil, Prinzhorn Collection, Heidelberg.

16.7. Max Ernst, *Oedipe (Das Auge am Tatort)*, collage, 1931, cover of special issue of *Cahiers d'art* (Paris, 1937).

Freud is also known to have consciously identified with this aspect of the youthful Oedipus, seeing it as a powerful symbolic image of the psychoanalyst in his struggle with the obscure and destructive forces of the unconscious. Ernst, because of his training in psychiatry and his early knowledge of psychoanalysis, may well have experienced a similar identification with Oedipus solver of riddles, as well as with the father of psychoanalysis himself.[46]

However, by the 1930s Ernst had turned his back on psychiatry as a profession, having committed himself to the far less secure and prestigious role of the artist. It is therefore of some interest that he chose to depict himself in terms of an image derived to some extent from the work of August Natterer, one of Prinzhorn's schizophrenic masters. If the psychology of identification is still understood to have played a part in this process, then Ernst is presenting himself in the guise, not of psychiatrist but of artist-patient. His profound belief in the importance of the psychotic image maker

surfaces, as it was to surface in so many of the Parisian Surrealists who sought in every way to emulate their mad brother in their creative stance. We are reminded of Ernst's claim to have discovered (through Surrealism), "certain techniques which helped him to advance into this no-man's-land." In depicting himself in the guise of *The Miraculous Shepherd*, he may have sought to assert his familiarity with the dark territory of the unconscious, and his partial identity with those artists who, at the beginning of his career, had initiated him into "the vague and perilous territory on the borders of insanity."

A second work, the bronze sculpture entitled *The Imbecile (Der Schwachsinnige*, 1961) can serve to demonstrate the influence of yet another work from the Prinzhorn Collection at a much later point in Ernst's career and in a different medium (Fig. 16.8). Ernst's use of the traditional portrait bust, with a curiously elongated, wedge-shaped head adorned with birdlike forms, is almost certainly derived from Karl Brendel's

wood carving of the *Devil* (reproduced as pl. 100 in Prinzhorn), the elongated head, the prominent ears, horns, and neck of which are strikingly echoed in the overall contour of Ernst's bust (Fig. 16.9).[47] Once again, the parallel goes well beyond mere compositional influences. Desiring to construct an image of a feeble-minded individual, Ernst quite naturally drew upon his early experience, not of human physiognomy, but of the self-depiction of such a person. Working in sculpture, he used the memory image of one of the most unforgettable of Brendel's works, altering it so as to exchange Brendel's preoccupation with the devil for his own obsessional involvement with bird symbolism, arriving once again, through identification, at a powerful self-image of the artist as a man possessed. Brendel's influence is not, however, limited to this one example. It is to be felt throughout Ernst's sculpture, in which whole pieces, as well as details, can be observed to echo various examples from Brendel's oeuvre so accurately that one is led to postulate personal contact with the collection in Heidelberg.[48]

The arrival of Hans Prinzhorn's *Bildnerei der Geisteskranken* in Paris in 1922 unleashed a considerable reaction among the painters who were involved with the creation of a pictorial version of the Surrealist image. It would seem to have become, for a time, something of an underground Bible. Never before had the French painters been exposed to psychotic art of such extraordinary quality. Their own efforts at psychic automatism on the drawing pad would have seemed insignificant by comparison. A new world had opened before their eyes. For the first time they could see clearly into the dark universe in which they imagined themselves to be serious travelers. Their confidence in their own abilities must have been sorely troubled. This might account for the fact that the importance of the book to the development of Surrealism has been somewhat underestimated. Only rarely is its historical influence clearly stated. The Surrealist painter Hans Bellmer went so far as to refer to the book as "one of the major intellectual events of the century."[49]

One indication of the impact of Prinzhorn's book in Paris is to be seen in the exhibitions of the art of the insane that suddenly began to be organized by Parisian galleries. Perhaps the most significant of these was an exhibition held in 1928 at the Galerie Vavin, which is said to have been attended by all of Montparnasse.[50] The following year a second show was arranged at the Galerie Max Bine, 48, avenue d'Iéna. Entitled "Manifestations artistiques des malades du cerveau," it included some two hundred pieces, some of which had already been included in the exhibition of

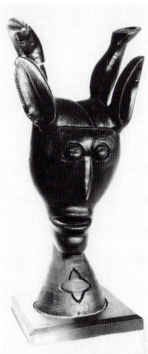

16.8. Max Ernst, *The Imbecile (Der Schwachsinnige)*, 1961, bronze, Collection of Jerome Stern, New York.

16.9. (at right) Karl Brendel, *Devil (Der Teufel)*, woodcarving, Prinzhorn Collection, Heidelberg.

1928, others coming from the private collections of numerous French psychiatrists.[51] The collecting of works of art by psychotic individuals was becoming fashionable. The Marquise de Ludre loaned works from a collection that she had assembled over the years with Dr. A. Marie. Both of these exhibitions were intended to present the art of the insane not as clinical material, but as a profoundly beautiful form of human expression. Some of the pieces were for sale. The connection with Prinzhorn's book is amply demonstrated by the fact that he agreed to send to Paris examples of the work of his "schizophrenic masters" from his own collection in Heidelberg.[52] French psychiatrists were stimulated by this renewal of interest in the art of the insane to write their own books on the subject, the most important of which was Jean Vinchon's *L'art et la folie*, published in Paris in 1924.[53]

THE INTEREST of Surrealist writers and artists in the artistic productions of the insane did not extend, except in the case of Breton and Ernst, to realistic appreciation of the psychological states out of which these

works emerged. Although actual experience of this art had almost completely replaced the Romantic conception of the imagery of madness, the conception of insanity as an existential reality held by many of the Surrealists still bore the stamp of Romantic idealism. Most of the artists had had little or no contact with inmates of psychiatric hospitals and were, therefore, still able to conceive of insanity as a marvelous state of total creative freedom and unrestrained imagination. If anything, the possibility of meaningful contact between artist and madman had diminished in the twentieth century. There was nothing in the paintings or drawings of the insane to contradict the Romantic conception. What was needed was an unforgettable and personal experience of the massive change in personality induced by psychosis. This experience was provided, with terrifying intensity, by the tragic case of the Surrealist writer Antonin Artaud (1896–1948).

Artaud attached himself to the Surrealist group in Paris in 1924 and was accepted without question.[54] In his manner and in his mode of thought and expression, he could be seen, even then, as a reincarnation of Gérard de Nerval. Extremely handsome, talented to the point of genius, inspired and explosive, he awakened love and terror in all who knew him. His private journey into hell, undeniably real, would act as a painful reminder to the group of certain facts they preferred to forget. As Susan Sontag has pointed out, "The Surrealists heralded the benefits that would accrue from unlocking the gates of reason, and ignored the abominations."[55]

Artaud's objective contribution to the movement, the creation of a Surrealist theater, was carried out despite the active opposition of the Surrealists. Between 1926 and 1937, he wrote and directed a series of plays representative of a new form of drama, which he called "The Theater of Cruelty." Despite physical and mental suffering, and a severe addiction to drugs, he was able to function during this period of ten years at an astonishing level of creative intensity. His behavior became, however, more and more bizarre, his ideas more and more strange, until he entered that area of experience and of functioning that is defined by society as madness.

Artaud had the misfortune to fall into the hands of the French psychiatric establishment at a time when it had nothing to recommend it. He spent nine years in a series of mental hospitals: Sainte-Anne, where he remained for three years; Ville Evrard, from February 1939 to January 1943; and finally, the Hospital at Rodez. Whether as a result of inner forces, or in response to the incredible and inhuman conditions that

characterized the institutions in which he found himself, he sank into a state of near complete autism. Diagnosed as schizophrenic, he was considered absolutely unreachable and incurable. There can be no doubt that in the initial phase of his illness he was completely and utterly insane.[56]

Two years after the onset of his illness, Artaud began to emerge from this silence, writing a seemingly endless stream of letters to his friends in Paris. These letters forced the Surrealists to attend to the reality of the new Antonin Artaud. They represent perhaps his greatest contribution to Surrealism: confronting the artists with his world and that of the "hospitals" in which he was imprisoned, they challenged their faith in the unbounded freedom of the insane. Those who visited him during this period found him obsessed with religious and sexual delusions, fighting against the sexual temptations of the devil and Christ, acting out wildly, or silent and withdrawn. Robert Desnos, his closest friend, tells of a visit to him: 'I found him in a state of complete delirium, speaking like Saint Jerome, and no longer wanting to leave [the hospital] because he was being moved from the magic forces that were working for him. . . . It had been five years since I had seen him, and his exaltation and madness were a painful sight for me."[57]

As a result of efforts by Desnos and other Parisian artists and intellectuals, Artaud was placed under the care of Dr. Gaston Ferdière, director of the asylum at Rodez. Dr. Ferdière had been chosen because he was an amateur poet who moved to some extent in the Surrealist milieu. His role might be compared with that of Dr. Gachet in the artistic circles of his day. Artaud had in fact known him before the onset of his illness and may, therefore, have felt a degree of confidence in his new physician. The forms of treatment to which Artaud was exposed at Rodez, which included over fifty sessions of electroconvulsive therapy, as well as experiments with insulin-induced convulsions, continue to be the subject of violent controversy in French intellectual and medical circles, and the cause of a deep rift between the French artistic and psychiatric communities.[58] Dr. Ferdière treated his patient with the therapeutic techniques available at the time. He appears to have attempted to relate to his patient as a human being, and an artist, encouraging him to write and to paint.

At Rodez, Artaud began to write the letters that represent one of the most profound and moving portrayals of the inner experience of madness in this century. These documents, *The Letters from Rodez*, provide a powerful antidote to the naive Romanticism of much of

16.10. Antonin Artaud's room at the clinic of Ivry-sur-Seine.

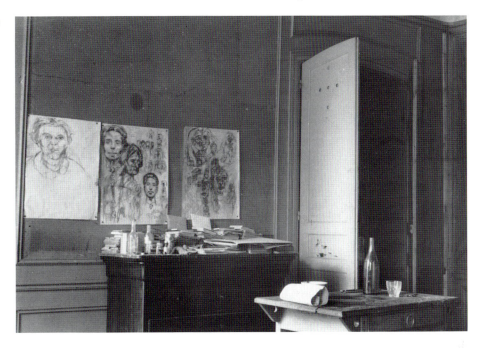

the Surrealist aesthetic. They are Surrealist in the sense that no Surrealist work ever managed to be. While living at Rodez, he also began to draw and paint, seemingly at the instigation of Frédéric Delanglade, a minor Surrealist painter living in the town in which the hospital was situated. Dr. Ferdière recognized Artaud's artistic activity as therapeutic, and indeed essential, if he was to regain his identity as an artist. Artaud had made extensive use of drawing during an earlier period of mental illness, when he had been hospitalized in Switzerland (1918–20). A photograph of his room in the clinic at Ivry-sur-Seine, where he lived after his release from Rodez, shows the walls covered with sheets of drawings (Fig. 16.10). Dr. Ferdière's involvement with his image-making activity is reflected in a letter that Artaud wrote to him on February 5, 1944.

My very dear friend, I am very happy that you liked my drawing, because it is over twenty years since I have done any drawing and I never made any attempt at imaginative drawing, and scarcely two weeks ago I did not believe myself capable of expressing my ideas in that manner. And it was at the urgent instigation of F. Delanglade who is a real friend and a very great one that I tried my hand at it.

I shall make you a gouache since you like this means of expression. If I was silent for a moment when you mentioned it to me it was not because I did not want to follow your suggestion, on the contrary. It was because not having touched a paintbrush for years I was simply wondering whether I could succeed in creating something that would please you enough. . . . But as I have told and written you several times, I know that with Will one can do anything; and I shall make this effort for you, since you believe in me.

As a result of close confinement, solitude, isolation, I had lapsed into a stupor and shall never tire of telling you the astonishing good that you and F. Delanglade have done me in sharing your faith in and admiration for my writing and my work. You have not only helped me to live, you have invited me to live when I was atrophying.[59]

The drawings executed at Rodez were known to the Surrealists and were, in fact, exhibited in Paris at the Galarie Pierre in 1947.[60] In style they reflect what Naomi Greene, one of Artaud's biographers, describes in reference to his writing style at this time, as a curious mixture of lucidity and aberration. The self-portraits are strikingly honest, indeed unflinching, depictions of his wrecked and ravaged physical appearance, the product of his terrible suffering. In making these drawings he consciously identified with Vincent van Gogh, an artist for whom he felt an intense affinity amounting to near complete identification. Other pictures seem to betray a far more disturbed mental state associated with his sexual and religious delusions, such as the drawing entitled *L'exécration du père-mère* (Fig. 16.11). The Surrealists became aware of these draw-

ings within the realistic context provided by knowledge of Artaud's profoundly disturbed mental state, and with the insight that his own descriptions of madness made possible. Their appearance in the late 1940s coincided with a second period of vastly intensified interest in the art of the insane stimulated by Dubuffet's exhibitions and collections of the work of hospitalized patients. The great exhibition of the work of Vincent van Gogh that opened in the Orangerie in Paris in January of 1947 also contributed to the revival of interest in this subject.

Artaud had been released from the hospital in March 1946. He was to live for the remainder of his life, two years, in voluntary residence in a pavilion in the Clinic of Ivry-sur-Seine. In February 1947 he visited the van Gogh exhibition and recorded his reactions to the work in the moving essay "Van Gogh: The Man Suicided by Society."[61] The decision to write this essay was made by Artaud in response to an article on

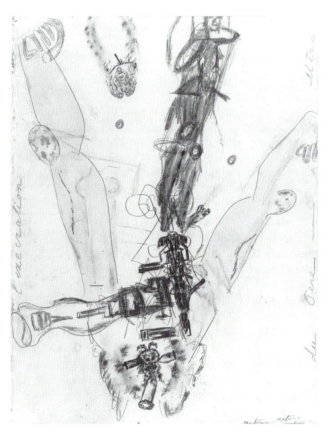

16.11. Antonin Artaud, *Exécration du père-mère*, 1946, Musée National d'Art Moderne, Centre Georges Pompidou, Paris.

van Gogh written by a psychiatrist, Dr. Joachim Beer, who referred to the artist as "a degenerate of the type described by Magnan."[62] Artaud, incensed by the dismissal of van Gogh as a psychopathic personality, plunged into a spirited defense. An insightful, sensitive interpretation of van Gogh, the essay throws even more light on Artaud's conception of himself in relation to art, society, and psychiatrists. In the violence of its images and language it represents a new form of criticism, an explosion of words and images equal in intensity to the paintings it describes.

Artaud's conception of van Gogh involved an attack on society. He saw the artist as the voice of revelation and of true sanity in a world gone mad, and psychiatry as society's defense against the painful depiction of its own state. "In comparison with the lucidity of van Gogh, which is a dynamic force, psychiatry is no better than a den of apes who are themselves obsessed and persecuted and who possess nothing to mitigate the most appalling states of anguish and human suffocation but a ridiculous terminology, worthy product of their damaged brains."[63] His conception of the artist as a madman, "all the geniuses of the earth, the authentic madmen of the asylums," was expressed in terms of conscious and total revolt. Artaud was here echoing the idea of the madman as a rebel against a sick society, which had been enunciated earlier by Breton and Eluard.

What is an authentic madman? It is a man who preferred to become mad, in the socially accepted sense of the word, rather than forfeit a certain superior idea of human honor. So society has strangled in its asylums all those it wanted to get rid of or protect itself from, because they refused to become its accomplices in certain great nastinesses. For a madman is also a man whom society did not want to hear and whom it prevented from uttering certain intolerable truths.[64]

The rebel artist, van Gogh an example, becomes the victim.

He did not commit suicide in a fit of madness, in dread of not succeeding; on the contrary, he had just succeeded and discovered who he was and what he was, when the collective consciousness of society, to punish him for escaping from its clutches, suicided him.[65]

Artaud's prose, which constantly threatens to break into poetry, reveals the mixture of lucidity and aberration referred to earlier. He is explosively angry. Having merged with the subject of his defense, he accuses society of all the crimes carried out on himself during his long imprisonment. The brilliance of the essay lies completely in his near total identification with its subject. "I too, am like poor van Gogh, I no longer think

but I direct, every day at closer hand, formidable internal ebullitions."[66]

Artaud's delirious response to the paintings of van Gogh represents the elaboration of a new critical form, a psychotic criticism. (In using this term I intend no negative implication.) Artaud's description of the painting *Wheatfield with Crows*, while full of errors of fact, is supremely worthy of the painting.

These crows painted two days before his death did not, any more than his other paintings, open the door for him to a certain posthumous glory, but they do open to painterly painting, or rather to unpainted nature, the secret door to a possible beyond, to a possible permanent reality, through the door opened by van Gogh to an enigmatic and sinister beyond.

It is not usual to see a man with the shot that killed him already in his belly, crowding black crows onto a canvas, and under them a kind of meadow—perhaps livid, at any rate empty—in which the wine color of the earth is juxtaposed wildly with the dirty yellow of the wheat.

But no other painter beside van Gogh would have known how to find, as he did, in order to paint his crows, that truffle black, that "rich banquet" black which is at the same time, as it were, excremental, of the wings of crows surprised in the fading gleam of evening. . . . And yet the whole painting is rich. Rich, sumptuous, and calm. Worthy accompaniment to the death of a man who during his life set so many drunken suns whirling over so many unruly haystacks and who, desperate, with a bullet in his belly, had no choice but to flood a landscape with blood and wine, to drench the earth with a final emulsion, both dark and joyous, with a taste of bitter wine and spoiled vinegar.[67]

Artaud focuses his anger at a terrible injustice on the person of Dr. Gachet. With little evidence he accuses him of responsibility for van Gogh's death. The passage is of interest in reflecting his own experience of the psychiatric profession.

When I read van Gogh's letters to his brother, I was left with the firm and severe conviction that Dr. Gachet, "psychiatrist," actually detested van Gogh, painter, and that he detested him as a painter, but above all as a genius. It is almost impossible to be a doctor and an honest man, but is obscenely impossible to be a psychiatrist without at the same time bearing the stamp of the most incontestable madness: that of being unable to resist that old atavistic reflex of the mass of humanity, which makes any man of science who is absorbed by this mass a kind of natural and inborn enemy of all genius.[68]

(One is inevitably reminded of Cesare Lombroso, of whom this criticism appears most apt.) A few sentences later, Artaud makes it quite clear that Drs. Gachet and Ferdière were associated in his mind.

I myself spend nine years in an insane asylum and I never had the obsession of suicide, but I know that each conversation with a psychiatrist, every morning at the time of his visit, made me want to hang myself, realizing that I would not be able to cut his throat.[69]

To this violent observation he adds the agonizingly simple statement that represents the heart of his argument and of his experience: "No one has ever written, painted, sculpted, modeled, built, or invented except literally to get out of hell."[70]

HAVING EXAMINED the impact of true insanity on a Surrealist artist, it would be of value to compare the deeply subjective, almost completely involuntary creative activity of Antonin Artaud with the somewhat artificial, often consciously calculated creative pursuits, of Salvador Dali. Arriving on the scene in the late 1920s, Dali was at once perceived as the painter most capable of embodying the Surrealist vision in pictorial terms. His work was understood by Breton as a convincing expression of the dream world and of the irrationality of inner processes. Dali is correct in stating that Surrealism, at least in its pictorial form, can be divided into pre-Dalian and post-Dalian phases.[71] His contribution extended to the development of new forms of activity or creative procedure, and to the elaboration of theoretical positions that were accepted as important additions to the Surrealist aesthetic.

Dali's evolution as an artist began with the acceptance of the early premises of Surrealism, including the exploration of automatic techniques and of dream recording. His early Surrealist works are essentially dream illustrations, or as he refers to them, "hand-painted dream photographs." His success in this form of activity resided partly in his technical virtuosity but more significantly in the intensity with which he pursued the dream into its darkest and most unpleasant manifestations. "To me the dream remained the great vocabulary of Surrealism and delirium the most magnificent means of poetic expression. I had painted both Lenin and Hitler on the basis of dreams. . . . I was a total Surrealist that no censorship or logic would ever stop. No morality, no fear, no cataclysm dictated their law to me. When you are a Surrealist you have to be consistent about it."[72]

Nevertheless, the passive recording of dreams soon appeared to Dali as a useful phase of activity that had been surpassed. "Nothing now appeared more boring, more out of place and anachronistic, than to relate one's dreams or to write fantastic and incongruous tales to the automatic dictate of the unconscious."[73] Lacking the lucidly objective intelligence of a Breton, Dali most likely never embraced the goal of psycholog-

ical observation and understanding that motivated his French colleague. Dali's brilliance was of another order. The fanaticism that Freud detected in him pushed him invariably to assume extreme positions, and to attempt to take the inner world by storm.

As early as 1929 Dali was consciously and systematically attempting to cultivate insanity in himself. He saw in the Surrealist endeavor only a form of game playing on the edge of the abyss. His activity in this early period was designed to carry him over the edge into the changed reality of madness. He describes himself in retrospect as

grown to manhood, and trying by every possible means to go mad—or rather, doing everything in my conscious power to welcome and help that madness which I felt clearly intended to take up its abode in my spirit. . . . At the time when I had my first and only hallucination I derived satisfaction from each of the phenomena of my growing psychic abnormality, to such a point that everything served to stimulate them. I made desperate efforts to repeat each of them, adding each morning a little fuel to my folly.[74]

In 1939 he published his own manifesto, *Declaration of Independence of the Imagination and Man's Right to His Own Madness.* Never had madness been pursued with such conscious fervor. It remained, nevertheless, curiously elusive. Dali describes this period of his life as characterized by a growing mental instability and distress, which suggests that something in him sought to respond to his outer, conscious will to madness.

There was integrity in these early investigations and in some of the works that resulted from them. Dali was attempting to elaborate a new stance in regard to creativity, a theoretical position and a procedure that would push the Surrealist endeavor to its ultimate conclusions. The reality of the insane had become for him an enviable state that held out to the artist the possibility of unadulterated vision. As James T. Soby pointed out, "Dali regarded it [madness] as an ideal state. He seems to have had no fear that, having identified himself with madness, his communication of its mysteries would be limited to the insane, or to those with scientific knowledge of insanity."[75] The basis of his artistic activity at this time is expressed in his belief that "all men are equal in their madness (visceral cosmos of the subconscious), madness constitutes the common base of the human spirit."[76] It is clear that Dali always visualized himself going mad with his ego intact—he would enter the abyss in a protective diving suit. His approach to the problem, and his failure, are both reflected in his proud but unconvincing statement, "The sole difference between myself and a madman is the fact that I am not mad!"[77] This is precisely

the distance that separates the accomplishment of Artaud from that of Dali.

The initial phase of Dali's activity as a Surrealist evolved into later and quite different forms of activity, a development that he has characterized as a shift from the cultivation of "the irrational for the sake of the irrational," to "the conquest of the irrational," a change of theoretical position that the artist identifies as part of an effort to recover his psychological equilibrium. "I myself, the angry rationalist, I shall never submit to the irrational for the sake of the irrational, nor to the narcissistic irrationality such as others are practising. I shall give battle for the conquest of the irrational."[78] The result of this new determination was the doctrine and the procedure to which Dali has given the somewhat ambiguous title "the paranoid-critical method," and which he defines as "a spontaneous method of irrational knowledge based upon the interpretive-critical association of delirious phenomena."[79]

The significance of this body of theory lies in the fact that it represents the first attempt within Surrealism to recognize the perceptual and ideational processes of the insane as providing a basis for the creative procedure of the artist. Breton had recognized the beauty of psychotic productions but had sought to attain similar ends by different avenues. He tended, in fact, to obstruct experiments that led too close to pathological states. The fanatic in Dali prompted him to attempt to go further, and to develop techniques designed to induce in himself and others temporary states resembling paranoid mental functioning. (By paranoia Dali is referring to true psychotic states in which paranoid suspiciousness and megalomania play a dominant part, and not merely to the mild suspiciousness observed in otherwise sane individuals.) He was influenced in this endeavor by the writing of the French psychoanalyst, Dr. Jacques Lacan (1901–1981), another psychiatrist who moved in Surrealist circles. Dr. Lacan was particularly interested in this period in paranoid states.[80]

Certain elements within the paranoid experience intrigued Dali: the tremendously increased perceptual acuity of the paranoid individual, and the near total breakdown of control over the associational process— combined with the well-defined and systematized nature of the resulting delusions. All of these characteristics had appeared to Dr. Noyes in his study of the patient "G" many years before. But for Dali the functioning of the paranoid individual was something to be emulated if not actually duplicated. In paranoia the intellect is often unharmed; except in the areas of the pa-

tient's delusion, the psychosis can be contained, and can even be observed by the rest of the personality. In this amazing capacity for self-observation within the psychotic experience, Dali saw the possibility of creative activity, and a means of harnessing madness to the task of image making.

As Dali visualizes it, the paranoid element in the paranoid-critical process is utilized in the production of an image, or a series of images—for example, the visual association between the lacemaker of Vermeer and the horn of a rhinoceros. Having allowed this deeply irrational equation to arise in his mind, he then pursues the implications of the image with all the powers of his intellect, trying to grasp its meaning. The equation is instantaneous and in no sense contrived. The critical response that follows is highly conscious and manipulative.

The near hallucinatory tendency to misread the objective world in line with subjective assumptions so characteristic of paranoia led Dali to the creation of ambiguous double images. He describes the process that led, for example, to the painting *Paranoid Face* (Fig. 16.12):

Following on a period of study in the course of which I had been preoccupied with thoughts about Picasso's depiction of faces, particularly those of his "Negro period," I was looking for an address in a pile of papers, when I was suddenly struck by a reproduction of a face which I recognized as being by Picasso, a face which was unknown to me. Suddenly, the face disappeared, and I realized it was merely an illusion. The analysis of this paranoid image led me to recover, by means of symbolic interpretation, all of the ideas which had preceded the vision of the face.[81]

The uncanny experience of being tricked by one's own perceptual apparatus is not regarded by Dali as accidental, nor can it be regarded as merely an error. A projection of one's own inner world, sufficiently strong to interfere with perception, represents an example of "concrete irrationality."

My whole ambition in the pictorial domain is to materialize the images of concrete irrationality with the most imperialist fury of precision—in order that the world of the imagination and of concrete irrationality may be as objectively evident, of the same consistency, of the same durability, of the same persuasive, cognoscitive and communicable thickness as that of the exterior world of phenomenal reality. The important thing is what one wishes to communicate: the concrete irrational subject. The means of pictorial expression are placed at the service of this subject.[82]

As early as 1934, Breton was emphasizing the importance of Dali's ideas to the development of Surrealism. "Dali has endowed Surrealism with an instru-

16.12. Salvador Dali, a version of the painting *Paranoid Face*, location unknown.

ment of primary importance; in particular, the paranoid-critical method, which has immediately shown itself capable of being applied equally to painting, poetry, the cinema, to the construction of typical Surrealist objects, to fashion, to sculpture, to the history of art, and even, if necessary, to all manner of exegesis."[83] The extension of the paranoid-critical method to aesthetics, criticism and art historical investigation has been demonstrated by Dali in his discussions of works of art whose existence has come into contact with his own inner processes. The result, subjective and deeply irrational as it may be, nevertheless illuminates these images in strikingly rich and stimulating ways.[84] One is reminded of the obsessionally intense appeal of certain images to psychotic individuals, and of the profound, if irrational, significance they attach to them. Dali's approach can be seen as an early and deliberate attempt to make use of psychotic modes of thought in the critical discussion and understanding of works of art. "Thus the history of art in particular is to be rewritten according to the method of the paranoid-critical activity."[85] Artaud's essay on van Gogh is perhaps the best example of the direction such criticism might take.

Response to Dali's artistic achievement has always been ambivalent, and most frequently hostile. The calculated eccentricity of his behavior has tended to obscure the significance of his work. The same might equally be said of the insane. From early in his career speculation concerning his sanity, or lack of it, characterized much critical and journalistic discussion of his work. His dazzling ability to utilize public irrationality as a means of self-promotion led to a general belief that his madness was simulated, his work counterfeit pathology. A caption in *Life* in September 1945 conveys the cynicism that Dali's work inspired. "Dali:

an excitable Spanish artist, now scorned by his fellow Surrealists, has succeeded in making deliberate lunacy a paying proposition."[86] But despite the efforts of amateur diagnosticians, Dali's work bears no resemblance to that of the insane artist. He has been influenced far more by his reading of Freud, Krafft-Ebing, and textbooks on abnormal psychology then by knowledge of the image-making activity of the insane. The pictorial images deriving from his application of the paranoid-critical method are unlike the unique yet totally coherent world picture of any of the great psychotic masters. Nor was this his goal.

THE DECISION to exhibit the drawings made by Antonin Artaud during his hospitalization at Rodez reflected a heightened interest in the art of the insane in Parisian cultural circles during the late 1940s.[87] This interest, particularly evident in the Surrealist milieu, can be attributed almost entirely to the influence of Jean Dubuffet, who as early as 1945 had begun to make systematic and very energetic efforts to collect, study, and display the art of the insane. Working outside of the Surrealist framework, and yet deeply influenced by Breton and his collaborators, Dubuffet sought to force acceptance of this form of image by creating a theoretical context within which it would be understood as a major art form.

In 1948, just after his return from exile in America, André Breton agreed to become a member of Dubuffet's Compagnie de l'Art Brut.[88] A strong though rather short-lived friendship had developed between the two artists, both of whom were passionately concerned with the art of the mentally ill. Breton undertook to assist Dubuffet in collecting examples of this art, and wrote a number of articles on psychotic art destined for a periodical that Dubuffet proposed to create. Tension developed, however, as Dubuffet became aware that for Breton, "l'Art Brut" was only another aspect of Surrealism, and that he wished to absorb the collection within the far larger cultural "machine" that Surrealism had become. Dubuffet, on the other hand, was keenly aware of the distance separating the art of professional artists from the spontaneous art of the insane, which he saw as artistically superior, and he had no desire to merge these distinct entities. Describing this difficult situation, Dubuffet commented, "Unfortunately Breton saw l'Art Brut as an extention of Surrealism. I opposed that. I never liked Surrealism. I was very interested in Breton and I loved to talk to him. He was very active but in a bad sense. He wanted to pull me and l'Art Brut into Surrealism, and when he couldn't, he was disappointed and angry."[89]

The attempted assimilation of the art of the insane by Surrealism had begun as early as 1936 when the work of untrained, hospitalized psychotic patients was included in the two major exhibitions of Surrealist art held in that year: The International Surrealist Exhibition in London, and the exhibition entitled, "Fantastic Art, Dada, Surrealism," which opened in December in New York. The format of these exhibitions, and of the Surrealist show that opened in Paris in January 1938, was largely inspired by the artists themselves and reflected the structure of their own private collections as well as their conception of the nature of Surrealism. Breton had begun collecting the art of the insane at least as early as 1929 when he purchased an assemblage from the exhibition held that year at the Galerie Max Bine (Fig. 16.13). His collection grew rapidly and included important paintings and drawings

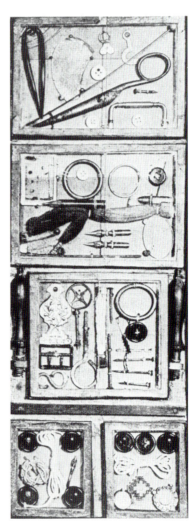

16.13. Assemblage by a psychotic artist, André Breton Collection, Paris.

by the greatest of the psychotic masters, Aloïse and Wölfli.[90] Not surprisingly several of the eighteen examples of the art of the insane included in the New York exhibition were borrowed for the occasion from the collections of Breton and Paul Eluard. The remainder came from a local collection owned by Ladislaus Szecsi, which included at least one piece that was originally in the Prinzhorn Collection (Fig. 16.14).[91] The whole of the Szecsi collection of psychotic art had been exhibited at the Midtown Galleries in New York the previous year, an indication that this form of expression had begun to stimulate interest in American art circles.[92]

In Europe the art of the insane was accepted by the Surrealists as an aspect of Surrealist art and worthy of exhibition with it. It was never included in their exhibitions with any intention of being humorous or merely shocking. The Surrealist exhibition in Paris in 1938 forced the emotional reality of the insane upon the viewer in yet another way. "There were recordings of hysterical laughter by inmates of an insane asylum, coming out of a hidden phonograph, which cut short any desire on the part of the visitors to laugh and joke."[93]

Breton's most serious publication on the pictorial art of the insane appeared in 1948. Entitled "L'art des fous: La clé des champs," it was written in response to a manifesto published by Dubuffet in October of that year, which signaled his determined stance in relation to the artistic importance of Art Brut.[94] Breton stated quite simply, "It goes without saying that I fully agree with his viewpoint." In this article Breton directs the reader's attention to the historical process that we have been examining. He was the first to recognize clearly the changed attitude toward the art of the insane as an evolutionary process. He refers to the book written by Réja in 1907, pointing out that the author "showed himself sensitive to the beauty of some of these works." He also indicates Prinzhorn's unique decision to present the work of his artist-patients "in a manner which was for the first time worthy of them, comparing them with other contemporary works, a confrontation which," he points out, "was to the disadvantage of the latter." Breton is struck by the fact that even in psychiatric circles, where the art of patients had for so long been seen as having merely clinical significance, an awareness of the artistic importance of these works was slowly beginning to make itself felt. Nevertheless, no lover of the psychiatric establishment, he issued a determined call to battle: "We will not cease to fight until justice is pronounced against the blind and intolerable prejucice under which works

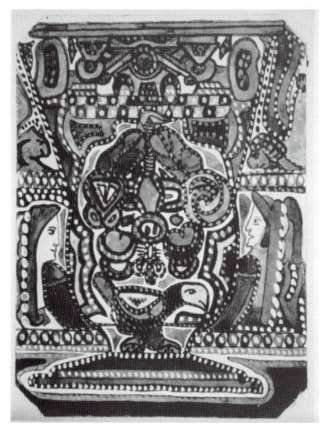

16.14. August Klotz, untitled, watercolor, Collection of Ladislaus Szecsi, New York.

of art produced in asylums have for so long suffered, and until we have freed them from the ambiance of worthlessness which has been created around them." This rallying cry opened the Surrealist periodicals to psychotic art.[95] Like Jaspers, Breton tended to see the art of the insane as an art free of exterior influence and restrictions, free of calculated efforts intended to lead to profit or prestige. In the creative process as it reveals itself spontaneously under the impact of psychosis, he saw "a guarantee of total authenticity to be found nowhere else." Its importance for Surrealism was in providing a means of validation by means of which all Surrealist creation might be evaluated. But beyond that, he saw in this art a means of human growth and change. "I do not hesitate to put forward the idea, paradoxical only at first sight, that the art of those individuals who are included today in the category of the mentally ill, constitutes a reservoir of moral health."[96]

In April 1925, in *La révolution Surréaliste*, Pierre Naville, one of its two editors, had declared that a genuine Surrealist visual art did not exist. "No one is ignorant of the fact that there is no Surrealist painting. It is well understood that pencil lines produced by chance movement, or images reproducing the forms of dreams or imaginative fantasies, are not for that reason admissible. . . . The state of abandon is so easily reproduced in words, while the plastic arts seem unable to reach it, or, at best, permit it to be seen only dimly, or in an extremely ambiguous fashion."[97] In the following issue, Breton assumed the editorship and began publication of his book *Le surréalisme et la peinture*, which was intended as a response to Naville's brief article, and a denial of its thesis. Curiously, Breton's defense involved a discussion of the work of Picasso. Except for the automatic drawings of Robert Desnos and André Masson, Surrealism had not, at that time, produced a significant pictorial equivalent to its achievements in literature. To some extent it can be said that Surrealist painting was invented to fill the void. Although Surrealism is often thought of today, at least by the public, as an essentially visual art form, one is, nevertheless, justified in questioning whether the world of images that originate within the context of the Surrealist ethic and aesthetic can be said to have embodied the aims and ideals central to Surrealism.

Surrealism had originated as a psychological experiment with little or no artistic intention, aimed at reaching the powerful and consistent inner world of words and images that Breton had first seen in the expressive activity of the insane. Using different avenues, largely dependent on forms of automatism, Breton and his colleagues sought to achieve a similar intensity of form and vision. At times, deliberate simulation of psychotic ideas and modes of expression were consciously attempted, as, for example, in Breton and Eluard's *L'Immaculée Conception* of 1930, which sought to duplicate the verbal form and content of a series of well-known psychiatric syndromes. Breton was too knowledgeable and too honest not to recognize the vast gulf that separated Surrealist productions from the imagery of madness. In the first Surrealist manifesto he warned, "We are still living under the reign of logic," and he sought to provide means of getting around this formidable obstruction.[98] But the difficulty of the task was enormous. "Our brains are dulled by the incurable mania of wanting to make the unknown known, classifiable. The desire for analysis wins out over the sentiments."[99] He demands of himself and others the effort to give free reign to fantasy, to "really live by our fantasies," and he knew that this

is what the insane, and the insane alone, do.[100] They are unique in having the courage to accept the full consequences of their "decision" to carry imagination into life.

In Surrealist productions, Breton was disturbingly aware of "the presence of conscious elements that defeated the purpose of the experiment."[101] Too often Surrealist activity degenerated into game playing. The insane, totally serious and committed, were the true Princes of the imagination whom the Surrealists could emulate, but never equal. However much the later Surrealists attempted to obscure the boundary between the products of insanity and their own work, it was and remains true that these objects and images, derived from the very distinct states of mind of the madman and the Surrealist, belong to two distinctly separate realms of existence and experience. Surrealism sought to embody the images of the inner world without paying for the privilege. As a result, the Surrealist almost invariably appears as something of a playboy in the madhouse, a visitor rather than an inmate of Bedlam. There is about most Surrealist work an aura of make-believe, or of outright pretense. Despite the fact that the Surrealists, like every other group of modern artists in the last hundred years, were accused by critics of being insane, the accusation appears more feeble, more preposterous, in their case than in any other. Although they sought to devise methods of entry into the world of the madman, there is little evidence in either their literary or pictorial output to suggest that they succeeded.

In the first manifesto, Breton had rejoiced in the fact that Surrealist drawings by Robert Desnos had been presented by the editors of *Les feuilles libres* as the drawings of a madman. What is, however, more significant is that, in an article devoted to a discussion of the beauty and importance of the art of the insane, the actual poetry and drawings of psychotic artists were omitted in favor of simulations by Surrealist artists and writers. Was there a tendency within early Surrealism to avoid comparison with true psychotic art by avoiding mention or illustration of it? As Breton was later to admit, the professional artist might well come off a poor second in any such encounter. The Surrealist painters and writers had rivals in the asylum, and they knew it. It is significant that in *La révolution surréaliste*, between December 1924 and December 1929, only one work by a hospitalized patient was reproduced.[102] There may be some truth in Jean Dubuffet's suggestion that, although all of the French Surrealists knew Prinzhorn's book and were much influenced by it, they tended to avoid reference to it. "Prinzhorn's

book was hardly known in France. It hadn't been translated. The public didn't know of it at all. But Breton and the others knew it well. The Surrealists hid their knowledge of it, but it was a very strong influence on them. That is certain."[103] In fairness to the Surrealists, it should be pointed out that drawings by Ernst Josephson were reproduced in *Les feuilles libres* in 1926 with a brief article by Tristan Tzara, in which they were identified as the work of a madman, living "at the extremity of human existence."[104]

THE PARADOX is that the Surrealists sought to create a pictorial art that already existed. While the visual artists among the Surrealists experimented with techniques of automatic drawing and frottage, with dream illustration and games such as the exquisite corpse, a slightly larger body of dedicated artists was at work in psychiatric institutions around the world, producing pictorial images beside which the creations of the Surrealist painter seem pale and vapid. The art of the insane conforms exactly to the ideal art that the Surrealists envisaged. It surpasses the art that they created as reality surpasses artifice.

However, whatever one may think of the artistic productions of the Surrealist artists, it is clear, and of enormous importance to us, that within the impressive body of Surrealist theory is to be found a completely coherent and convincing argument for the acceptance of the art of the insane, both written and pictorial, within the boundaries of "Art." The elaboration of Surrealist theory preceded the birth of Surrealist art. Most of the artistic productions of the artists associated with that movement were created with a view to embodying, or at least conforming to, the theory. But in its beginning, Breton had developed his theoretical position with reference to, and in response to, the expressive productions and activities of the insane. They provided the inspiring example of what could be done, an example that was neither surpassed nor equaled. The Surrealists were to remain unsuccessful invaders of territory already fully occupied. Breton's achievement was to have begun the elaboration of a theoretical position, and of an aesthetic, that demonstrated the enormous value and importance of what went on within this territory to those who lived on the edge of its boundaries. His failure was to have neglected to act in terms of his insight, to have accorded the art of the insane the recognition and respect that it deserved. That task was to become the life work of the painter Jean Dubuffet.

SEVENTEEN

Dubuffet and the Aesthetic of Art Brut

In attempting to examine the impact of the drawings and paintings of the insane on two major twentieth-century artistic movements, we have been hampered by the lack of sufficiently extensive and detailed information, and of clear instances where the influence of these images can be identified. The nature of the encounter, the identity of the pictures or artists seen, and, most important, the feelings and reactions of the contemporary artist, particularly as reflected in his work, remain, for the most part, unknown or at least unclear. Was the experience of this new art form profoundly, or merely superficially, important for the individual artist encountering it for the first time? Was the reality of the psychotic image perceived as a revelation, as relevant to the task of the artist and his needs, or was it merely enjoyed as a passing phenomenon and forgotten?

In one case, the history of the encounter of an artist with this art has been extensively recorded. Jean Dubuffet (1901–1985) was more deeply involved with the art of the insane than any other artist in this century (Fig. 17.1). His thought, his aesthetic, his approach to his own work, and the work itself, all reveal the intensity and importance of his long relationship with "psychotic art" and artists.[1] With Hans Prinzhorn, Dubuffet did more than any other individual to forge a new awareness in us of the human significance of these images, of their artistic worth, and of their profound importance within the context of humanity's image-making activity. This final chapter, like the first, is therefore devoted to an examination of the encounter between the artist and the art of the insane.

Dubuffet's early development as an artist, beginning in 1918 when he arrived in Paris to study painting, was a curiously spasmodic process, characterized by what might appear to be a series of false starts. Until Dubuffet was forty, his involvement with his own internal creative processes was extremely ambivalent. The history of this early period, were it to be investigated, would provide material essential to a more satisfactory understanding of his intensely private art, while permitting insight into the processes that led him to develop a radical, indeed revolutionary, conception of the nature and function of image-making activ-

ity that places the art of the insane at the center rather than on the outer fringes of art.[2] Despite the sparsity of information about Dubuffet's early artistic development, the fundamental importance of one fact has been generally recognized, the impact on him of his discovery of Hans Prinzhorn's *Bildnerei der Geisteskranken* in 1922.[3] The book appears to have acted as the essential catalyst in changing his conception of the nature of art and of culture, forcing him to an agonizing reexamination of his identity as an artist. Nor was he alone in experiencing this book as a catalyst. "Prinzhorn's book struck me very strongly when I was young. It showed me the way and was a liberating influence. I realized that all was permitted, all was possible. I wasn't the only one. Interest in the art of the insane and the rejection of established culture was very much 'in the air' in the 1920s. The book had an enormous influence on modern art."[4] As Dubuffet did not read German, the effect of the book was derived entirely from the pictures themselves.

The precise nature of Dubuffet's personal spiritual evolution must remain obscure, but it is clear that by 1942, when he moved with decisive firmness in the direction of his own unique artistic identity, his commitment to the spontaneous art of the insane was incredibly intense. In the years that followed, Dubuffet had two related careers. As is well known, his artistic productivity after 1942 was rich and copious. However, it is little recognized how much of his time during the same period was devoted to exhaustive study of the art of the insane. Fighting on behalf of those individuals whose activity as image makers was rejected or ignored by the guardians of contemporary cultural values, Dubuffet accepted their cause as his own, committing vast amounts of time, energy, and money to discovering, collecting, preserving, and publishing the work of obscure eccentrics and madmen. The record of this long struggle is preserved in the daybooks that he kept.[5] These documents reveal an amount of work that would have consumed all of the energy of a lesser man. I stress this side of Dubuffet's activity because it is all too easy to imagine that his involvement with "psychotic" art and artists amounted to skimming through Prinzhorn, or visiting a collection in a single psychiat-

ric hospital. The establishment of the Collection de l'Art Brut, with its collection of over five thousand outstanding objects, the culmination of Dubuffet's work in this field, is an achievement that may in time be recognized as even greater than his contribution as an individual artist. The history of this aspect of Dubuffet's career therefore deserves careful study and reconstruction.[6]

DUBUFFET'S activity as a collector and student of the art of the insane can be said to begin in 1945 when he made a three-week tour of psychiatric hospitals in Switzerland.[7] The trip was undertaken with the intention of accumulating information and photographs for a series of publications on this "new" form of expression to be published by Editions Gallimard Paris.[8] Dubuffet had no intention of attempting to form a collection, although he was interested in arranging for the pictures to be exhibited in Paris. "I had the idea of doing research on the art of the insane. I was so excited by the pictures in Prinzhorn, and I felt it might be possible to discover more."[9] It was during this trip that Dubuffet came to know Wölfli's work in the original, a discovery that appears to have finalized his commitment to this art. He visited the Waldau and in Bern, became very friendly with Dr. Morgenthaler, whose passion for Wölfli's vision accorded with his own. He also encountered there the work of Anton Heinrich Müller, an artist whose creative power was sufficient to convert all but the blind to the extraordinary power and integrity of the psychotic artist (Plate 5).

In 1945, despite the prior activity of Prinzhorn, Dubuffet could still collect pictures of extraordinary quality. The enthusiasm and seriousness of the young French artist seems to have won the respect of the Swiss hospital directors who assisted him in acquiring the beginnings of a superb collection. "The Swiss psychiatrists were little interested in this art, and not looking after the work. But they were friendly and helpful. They gave me things. In those days people had no sense of the value of these things."[10] This happy situation was to change very quickly. Dubuffet's second period of collecting in the 1960s involved the expenditure of large sums of money.

By 1947 the collections had become so extensive as to require space in which they could be stored, as well as a location in which public exhibitions of the work of individual artists could be held. After Dubuffet's dealer at this time, René Drouin, offered the basement of his gallery in the Place Vendôme, Paris, for this purpose, Dubuffet, with the intention of attracting a wider audience for this "new" art, organized the Foyer de

l'Art Brut in November 1947. Exhibitions of the work of Wölfli, Aloïse, and other artists were held, and interest in the collection was growing. Thus, it appeared advisable to include a number of other responsive people in the organizational activity and research involved in the day-to-day operation of what was becoming a successful but laborious undertaking. In addition, the decision having been made to build up a representative study collection, it was thought best to dissociate the collection from Dubuffet's personal ownership.[11] Accordingly, in July 1948, the Compagnie de l'Art Brut was founded with some fifty active members, and over one hundred "adherents." The founders were, besides Dubuffet, André Breton, Charles Ratton, Jean Paulhan, Henri-Pierre Roché, and the painter Michel Tapié.[12] Significantly, the founding members included several artists, but no psychiatrists. Among the "adherent" members, however, we find the names of Dr. Charles Ladame and Dr. Max Müller of Switzerland. André Malraux, although he played no active part, was a member.[13] The founding members formed an administrative council, which was intended to see to the overall functioning of the collection and its activities, while the artist Slavko Kopac was appointed on a part-

17.1. Jean Dubuffet, ca. 1959,
photograph by Jean Weber, Paris,
Foundation Jean Dubuffet, Paris.

time basis to function as conservator and archivist of the collection. It was intended that members would be charged a small membership fee to help with expenses, but in fact Dubuffet, though poor in those years, assumed most of the cost of the organization himself, even paying the yearly dues for many of the members.

In 1948 the collections were moved to a building owned by the Gallimard Press at 17, rue de l'Université, Paris, where exhibitions continued to be organized regularly, including one-man shows of the work of Wölfli, Aloïse, Anton Heinrich Müller, and others. The Compagnie de l'Art Brut continued in this form until 1951 when, as a result of financial difficulties combined with the excessive burden that Dubuffet no longer felt able to assume, the decision was reached to dissolve the organization and ship the collection to America.

While these organizational details are of little significance in themselves, they provide our first glimpse into the origins of the only collection of largely psychiatric art to emerge outside of a medical setting. Even in those first years the problems were enormous. Having made the decision to involve other individuals in the functioning of what had been essentially his private collection, Dubuffet was faced with the inevitable difficulties of getting a group of rather powerful personalities to cooperate in a task the nature of which he himself had defined. He conceived the purpose of the Compagnie as that of helping to develop the collection in terms of his original ideas. He was not prepared to allow it to change into something different at the hands of his collaborators. The concept of Art Brut, as formulated by Dubuffet, provided both an aesthetic and a rationale for the existence of the collection, as well as a dogma with which some individuals, particularly André Breton, were to find it increasingly difficult to identify.[14] In retrospect it might appear that the idea of founding a group devoted to the development of the concept of Art Brut and the collection was a mistake. At least in its formative phase the concept was too closely identified with Dubuffet's own artistic development and needs to make real collaboration a possibility.

However, it was not the political organization or controversies that gave the collection its significance in those years. The real excitement was provided by the works themselves, and by the visitors who came to see the collection. For the first time in discussing such a collection, we have detailed records of visitors, among them some illustrious names in art. On September 15, 1948, Jean Cocteau came to visit, and on the following day André Breton. In March 1950 Johannes Itten and two days later the young Canadian painter Joseph Plaskett came to see the collection. Individuals involved in art as dealers and historians also paid a visit to the gallery on rue de Université: in 1948 Sydney Janis, and in 1949 Pierre Matisse. Psychiatrists involved in the study of psychotic art used a visit to Paris as an opportunity to see the collection: in 1948 Dr. Steck, the individual responsible for the discovery of Aloïse, and in 1950 Dr. Morgenthaler of Berne. These are only a few of the names recorded in the daybooks for those years, but they convey some of the excitement that the collection inspired. Nevertheless, the existence of Art Brut, and of the exhibitions devoted to it, was known only to a select company. Clearly these men were all ahead of their time in recognizing its importance and in seeking out the Compagnie de l'Art Brut long before the rest of the world had awakened to its existence. In this formative period the name Dubuffet lent no special luster to the concept of Art Brut in that he was still struggling for recognition as an artist in his own right, and his art too was the center of storms of abuse and controversy. Dubuffet had hoped that the formation of the Compagnie would lead to the spread of interest in Art Brut and to the arrival of new enthusiasts, a hope that proved vain.

Unquestionably, the culminating event of those first years was the important public exhibition of Art Brut held in October 1949 in the main exhibition rooms of the Galerie René Drouin. Some two-hundred works were included, the finest pieces in the collection; a small but incendiary catalog written by Dubuffet, *L'art brut préféré aux arts culturels*, was designed to provide a theoretical context within which they might be understood (Fig. 17.2).[15] The concept "l'Art Brut," as defined in Dubuffet's revolutionary manifesto, may be said to have begun to enter public and critical consciousness at this point.

The later history of the collection is less important for us. In 1951, the Compagnie de l'Art Brut was disbanded at the request of Dubuffet and despite the objections of Breton. It was sent to America, where it found temporary shelter in the home of the painter Alfonso Ossorio (b. 1916) in East Hampton, Long Island. At that time it included some one thousand pieces by a hundred individual artists. Dubuffet was seriously contemplating a permanent move to America, and, in fact, he lived for some time on the Bowery in New York. He also planned to write a book on the collection, financed by Ossorio, and to undertake further collecting activity in American hospitals, but both endeavors failed to materialize, and he returned to Paris. However, while in America he wrote and delivered an im-

L'ART
BRUT
PRÉFÉRÉ
AUX ARTS
CULTURELS

17.2. Cover of *L'art brut préféré aux arts culturels* (Paris, 1947).

portant lecture that extended and clarified his unique aesthetic viewpoint—"*Anticultural Positions*," given at the Chicago Art Club on December 20, 1951. He also wrote the lengthy essay "Honneur aux valeurs sauvages."[16] Part of the collection was exhibited in New York in February 1962 at the Cordier-Eckström Gallery, while many American artists and museum directors were able to see it in its entirety displayed in Ossorio's home.

There is no doubt that for some eight years Dubuffet's commitment to his own art superseded his involvement with Art Brut. "I hadn't lost interest in Art Brut . . . but perhaps in my feelings there was the fear that too much involvement would be prejudicial to my own work; I was happy to be free of this. I needed all my time for my own work."[17]

Nevertheless, for whatever reasons, by June 1959 Dubuffet's interest in the collection was reawakened. He now had the money to collect on a grander scale, purchasing whole private collections at very considerable expense. In 1962, after some difficulty, the collection was returned to Paris, and in September the Compagnie de l'Art Brut was reconstituted.[18] A new building at 137, rue de Sèvres provided space for the systematic preservation and exhibition of the collection, which was now growing very rapidly. Dubuffet had begun to travel again in search of new material. The daybooks for those years provide evidence of his increased activity, and allow one to observe, for the first time, the day-to-day evolution of such a collection. In March 1962 eleven drawings by the Serbian soldier Jean Radovic were purchased, along with over one hundred drawings by the newly discovered artist-patient Jules Doudin (Fig. 17.3).[19] In 1963 seventy drawings by Wölfli were purchased in Switzerland, and in January 1965, thirty drawings by Aloïse. In 1966 the early French collection of Dr. Marie was given to the Compagnie by his widow.

Dubuffet was well aware that historians would one day wish to explore the history of the collection's development, and, despite his ambivalent attitude toward intellectuals, he provided for their needs. The new set of daybooks begun on April 29, 1963, bears the inscription, "The factual details which should be remembered are to be recorded here, from this date on."[20] He was now in a position to undertake the publication of the collection, and, beginning in 1964, a series of elegant volumes entitled *L'art brut* began to appear, richly illustrated books devoted to detailed discussion of the artists whose work was represented in the collection. These essays, most of the early ones researched and written by Dubuffet himself, provide essential material for the study of psychotic art in this century. More important, they provide an extended, if unintentional, rationale for the inclusion of these images and artists within the boundaries of contemporary art. Dubuffet is one of a restricted group of artists whose abilities as theoreticians and writers on art demand profound respect. His ideas represent an effective challenge to the whole artistic establishment, a challenge that has been ignored rather than examined or refuted.[21]

Dubuffet's collecting activity during the 1960s resulted in the formation of a coherent body of works, which included over five thousand objects. Official recognition of his achievement, while slow in coming, was finally accorded with the decision of the Musée des Arts Décoratifs in Paris to mount a major exhibition of

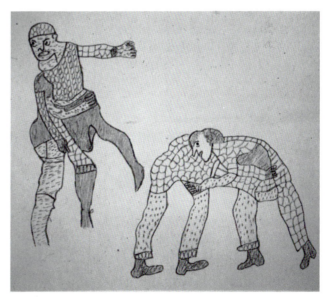

17.3. Jules Doudin, *Wrestling in the Light of the Moon*, 1927–1928, pencil on wrapping paper, Collection de l'Art Brut, Lausanne.

Art Brut in April–June 1967.[22] Such a clear mark of official approbation might have been expected to result in financial support from the French government. Clearly, an individual alone could not be expected to maintain and house a public collection of this size without assistance. Dubuffet, now sixty-six years old, was beginning to fear for the future of the collection should he no longer be able to care for it. A permanent solution had to be found. A museum devoted to the survival of what was a unique collection was needed. The French authorities, however, despite the presence of André Malraux as minister of culture, were uninterested. After numerous approaches to city governments in France as well as other countries had failed, contact was made with a representative of the city of Lausanne, M. André Chevallaz.[23] In 1972, an act, signed by the municipality of Lausanne and the Communal Council, undertook to accept the gift of the Collection of the Compagnie de l'Art Brut, and provided for the reconstruction of the Château de Beaulieu in the center of Lausanne as a permanent museum and research center for the collection Dubuffet had built. In February 1976 the Collection de l'Art Brut was opened to the public. Dubuffet's struggle on behalf of his poor and unrecognized artist friends was at an end. The first public museum devoted, in large part, to the art of the insane had become a reality.

DUBUFFET'S activity as a collector and theorist of the art of the insane cannot be readily separated from his work as an artist. His own paintings, drawings and sculpture, particularly those of the 1940s and 1950s, have been profoundly influenced by this art, to such an extent that he has on occasion been accused of imitation. While the history of modern art is seen by art historians as a sequence of evolutionary steps that can readily be characterized as a pattern of influences in which innovations introduced by one artist inspire further developments in the next, the game has been seen as taking place within the restricted circle of images recognized as "art." It is well known that late nineteenth- and twentieth-century artists tended to turn to images deriving from cultures other than their own, from the Far East, particularly Japan, and from the "primitive art" of Africa and Oceania. In earlier chapters we have explored influences stemming from other "primitive" sources, the art of children and of the insane. These sources have tended to be deemphasized in the historical picture because these art forms, as opposed to primitive or Asian art, are seen as being not really art and, therefore, as not fitting into the pattern of borrowings by which the development of modern art

has, up to now, been characterized. The development of Pop Art forced critics and historians to recognize for the first time that influences on contemporary painting might well come from outside of the charmed circle of "art." The art of Dubuffet makes similar demands. If his art is to be understood in the context of influences and reactions, a game of questionable worth, the detective work is going to lead away from "the mainstream of modern art," to roads unexplored and territory uncharted until now. Critics who desire a more than superficial grasp of Dubuffet's language will have to take more than a passing glance at the art of children, graffiti, automatic drawing, and the art of the insane. Our interest, restricted as it is to the discovery of "psychotic art," may tend to make us forget that Dubuffet's interests ranged well beyond the art of the insane, and beyond the still wider territory of Art Brut. He is deeply knowledgeable about the art of children. He, with Brassai, was an early student of graffiti, the pictorial language of the street and washroom.[24] The tendency to lump these forms of human expression together, and to point to them in passing as influences on the art of Dubuffet, is plainly insufficient. Dubuffet devoted years of his life to studying each of these distinct spontaneous phenomena, and while the critic may be inclined to lump them together, underestimating their importance and value, Dubuffet was not. He pointed out how these distinct forms of human expression

are rejected with the condescending label "art of children, of primitives, and of the insane," which conveys a very false idea of awkward or aberrant stammerings standing at the very beginning of the great road which culminates in "cultural art." The common character which certain individuals believe they can identify in all of the products which are subsumed under this label is illusory. These works have nothing in common except a rejection of the narrow rut within which ordinary art is confined, and a tendency to trace freely their own pathways in the immense territory which the highroad of culture has allowed to fall into disuse to the point of forgetting that other possibilities exist.[25]

In seeking for an artistic language that might be truly his own, and at the same time relevant to other human beings whose vision is not totally clouded with traditional delusions of "art and beauty," Dubuffet tried to free himself of the burden of culture. Unlike the artists whose work he admired, he was neither a madman nor an innocent. One might well ask whether it is possible for a man as deeply knowledgeable and sophisticated as Dubuffet was to break out of the culture and the pictorial tradition within which he developed. Mere reaction against it is not enough. Toward the end of his life his view of the situation changed and

he began to feel that intensive knowledge of the culture is a means of escaping from it. "It seems to me that the only possibility there is of escaping from cultural conditioning resides in becoming aware of it and in an active determination to remove oneself from it."[26]

Dubuffet's evolution over the last forty years can be seen as a consistent struggle to find means of reaching within himself in search of a purely personal language and of images reflective of his own being. In this search he turned again and again to the forms of art that he respected as having effortlessly achieved that goal. Not infrequently, I believe, he was influenced by the languages and forms he found there. He lived and worked amidst Art Brut, avoiding exposure to "cultural art" at the same time. Art Brut is his cultural milieu. "Other artists identified with da Vinci or Michelangelo—in my head I had the names Wölfli and Müller etc. It was these artists whom I loved and admired. I was never influenced directly by Art Brut. I was influenced by the freedom, the liberty, which helped me very much. I took their example."[27] No other artist has sought so intensively to grasp the different mechanisms at work within the spontaneous art of children, of adults, and of the insane. Inevitably, perhaps unconsciously, he absorbed their forms, their methods of working, their languages.

From the beginning (ca. 1942) Dubuffet's art has been attacked either as insane or as calculatedly insane.[28] As late as 1946, a Dubuffet exhibition could provoke blind fury in Parisian artistic circles. "Paintings were slashed by infuriated spectators. Many of the critics were wildly antagonistic, and in fact, nothing had so enraged the Paris art world in a great many years."[29] Not surprisingly, criticism centered on comparison of Dubuffet's work with that of children and the insane. "Whether these conscious apings of the works of children have any meaning beyond their exploitation of coarse and unexpected mediums is, perhaps, a question for the psychiatrist."[30]

Dubuffet's art in the early 1940s does betray a debt to the paintings of children. "In 1942 I was looking a lot at the drawings of children, and liked them very much. I was influenced by them."[31] At times he may well have attempted quite deliberately to imitate the style, in search of the freedom that underlay it (Fig. 17.4). Critics recognizing only the superficial similarities of the surface accused him of copying, describing his work as "graphic demonstration of a laboriously achieved infantilism." A marvelous review in *La gazette des letters* (October 18, 1947) recognized his sources and accused him of a new type of academicism. "M. Dubuffet is in all honesty only an academic painter, a 'Pompier' of infant painting."[32]

Only critical ignorance of psychotic art prevented recognition of even more specific similarities. For example, the painting L'homme à la Rose of 1949 can be usefully compared with a drawing by Anton Heinrich Müller, which was included in the Art Brut exhibition of 1948, and in the one-man show devoted to Müller in 1949 (Figs. 17.5 and 17.6).[33] This is not mere imitation, but it is a clear instance of a shared vision. Georges Limbour, the first critic to concern himself extensively with Dubuffet's work, refers to Dubuffet's preoccupation with Müller.

In this period (1948), this painter, working outside of culture, if you had asked him, not which artist (an unacceptable term), but which craftsman of magic objects he would like to resemble, would have answered, "All that I desire is to do as well as Heinrich Anton or Jeanne the Medium" (two inmates of Swiss asylums). It appears that certain figures in the landscapes of this period are rather closely related to the figures depicted by Heinrich Anton.[34]

Dubuffet's erotic drawings of the same year, published under the collective title *Labonfam abeber*, derive from similar mental territory as sexual drawings by psychotic patients (Fig. 17.7), while works such as *Les pisseurs au mur* of January 1945 reveal a conscious attempt to assimilate the emotional intensity of spontaneous drawings on walls.

Although such one-to-one comparisons are possible,

17.4. Jean Dubuffet, *Vue de Paris, la vie de plaisir*, February 1944, oil on canvas, private collection, New York.

they prove nothing. The whole of Dubuffet's oeuvre, from 1942 on, reflects his deep involvement with spontaneous art created in the absence of aesthetic intention and cultural influence. Knowledge of the date at which he discovered specific artists might well make it possible to detect and describe the evolution of his work in terms of a sequence of specific influences, rather than vague references to "the art of children and the insane." It would be legitimate to ask: Which child, or which patient? Dubuffet willingly admitted his debt to the individual image makers whose work he loved and respected. He was well aware that on occasion their influence was so strong as to justify accusations of an imitative art.[35]

In the struggle to find a way back into himself, Dubuffet was driven by a consuming desire to invent new materials and methods that would permit, indeed necessitate, the expression of the deepest and most rudimentary feeling-states.

I have always tried to represent any object, transcribing it in a most summary manner, hardly descriptive at all, very far removed from the actual objective measurement of things, making many people speak of children's drawings. Indeed, my persistent curiosity about children's drawings, and those of anyone who never learned to draw, is due to my hope of finding in them a method of reinstating objects derived, not from some false position of the eyes arbitrarily focused on them, but from a whole compass of unconscious glances, of finding those involuntary traces inscribed on the memory of every ordinary human being, and the affective reactions that link each individual to the things that surround him and happen to catch his eye.[36]

Dubuffet's honesty led him to entertain the possibility that images created in response to his internal situation at a given moment may well have had meaning only for himself.

It is very possible that these effects are an entirely personal matter and function for me alone. In that case, the people, and they are numerous, who see in them only an attempt (to them inexplicable) to imitate the drawings that children scribble on walls, would be quite right in finding them devoid of any power at all.[37]

The essential connection between Dubuffet's own work and his interest in the art of the insane is to be found in his conviction that art is exclusively the expression of the individual, free of the stamp of society and culture, the ultimate act of rebellion and nonconformism. Image making has as its aim the externalization of otherwise inexplicable and unreachable human experience. Art, if it exists at all, exists as an expression of our deepest inner selves, of our being, a

reality for which Dubuffet invented the term *paysages mentaux*. "A work of art is of no interest, to me, unless it is an absolutely immediate and direct projection of what is occurring in the depths of an individual. . . . In my view, art consists essentially in the externalization of the most intimate internal events occurring within the depths of the artist."[38] He described his own pictorial embodiments of this inner world as suggesting mental derangement. "They are no longer, or almost no longer, descriptive of external sites, but rather of facts which inhabit the painter's mind. They are landscapes of the brain. They aim to show the immaterial world which dwells in the mind of man: disorder of images, of beginnings of images, of fading images where they cross and mingle, in a turmoil, tatters borrowed from memories of the outside world, and facts purely cerebral and internal, visceral perhaps."[39] His utter determination to find a way of reaching and of depicting, at whatever cost, his own intense experience of his self is what represents the real influence of the art of the insane on Dubuffet. Aware of the extent of their sacrifice and, more important, of their commitment, he was prepared to accept them as his masters, and to follow them into the depths.

The real impact of the art of the insane on Dubuffet is not to be found by examining his work and theirs in search of similarities of form or content, but rather in the effect that it had on the development of his thinking about art. Dubuffet was neither insane nor naive. His aesthetic theory is the expression of a sophisticated mind capable of examining the cultural milieu within which we exist, with objectivity and originality. Not to be confused with mere intellectual maneuvering, it is the credo of a committed artist, the foundation upon which he stood, and within which the meaning of his work resides. Dubuffet's art and his aesthetic are closely dependent on each other. His theories, while deriving from insight into the profound importance of the spontaneous art of the insane, and other individuals creating outside of the context of traditional cultures, can and should equally be understood as an intensely felt justification of his own activity as an artist. Nevertheless, in terms of our specific concerns, Dubuffet's conception of the nature of creativity and of "art" represents the most far-reaching attempt to demonstrate the importance of the art of the insane, if not within contemporary culture, then in terms of the deeply felt human needs of everyday men and women.

For our purposes, Dubuffet's position as an artist and theorist can be artificially split into two standpoints: a body of essentially negative opinion that represents a consistent and fundamentally hostile attitude toward

17.5. Heinrich Anton Müller, *A ma femme*, ca. 1914, chalk, pencil, and pen on cardboard, Kunstmuseum, Bern.

17.6. Jean Dubuffet, *L'homme à la rose*, May 1949, Foundation Jean Dubuffet, Paris.

17.7. Jean Dubuffet, *Conjugaison I*, frontispiece for *Labonfam Abeber* (Paris, 1949), Foundation Jean Dubuffet, Paris.

Western art and culture; and, opposed to this, a deeply positive belief in the art of individuals who, for whatever reason, are able, or are forced, to create outside of this pervasive world view. For Dubuffet these two bodies of ideas are not separable. His attack on the values of Western culture is justified only because he was able to point to other values that he saw as more truly human, alive, and suited to our inner reality and needs.

Dubuffet's anticultural position, though radically stated, is not new. Within the history of art, from at least the time of Courbet, there has been an increasing discontent with the assumptions, often amounting to dogma, of "official art," whether represented by the Academy, the Salon, the art schools, or the self-appointed critics and historians of art. Emerging within Romanticism, at first as mere nostalgia, was an awareness, most clearly formulated by Rousseau, that so-called primitive cultures might well contain something of importance for civilized cultures—indeed, that the vaunted glories of civilization could represent a distortion of human nature, and a denial of humanity's fundamental identity. In art the Romantic idealism of Rousseau's noble savage was perhaps best expressed by Gauguin's tentative return to the primitive, while

the extreme anticultural stance was voiced and embodied in the ideas and gestures of artists associated with the Futurist and Dada movements. If Dubuffet did not recommend the burning of museums, or the destruction of works of art, it is not because he no longer saw them as a significant threat.[40] His attack was aimed both at the art of the past and at the art establishment of the present, at the vast apparatus of professionals—professional intellectuals, critics, historians, educators, museum curators, dealers, and artists—all of whom he saw as devoted to upholding a dead and irrelevant conception of the nature of art and artists, and a catalog of works certified with the label "art" and identified with the vacuous notion of "beauty." Against these purveyors of culture and the art that they promote, Dubuffet directed his well-sharpened arrows.

In a series of essays beginning in 1949, and culminating in the book *Asphyxiante Culture* (1968), Dubuffet outlined what he himself termed his anticultural position. Opposed to the whole of Western culture, and indeed to any overly elaborate and sophisticated civilization, he identified its art as *l'art culturel*, a term that Cardinal has translated "official art"— "the art of museums, galleries, salons," "the activity of

a very specific clan of career intellectuals."[41] As an image maker firmly committed to the present and future, alive to the human needs of the person in the street or factory, and opposed to those of the jaded sophisticate, Dubuffet was intensely suspicious of the word *art*, and of the body of ideas inherent in it, viewing the art museum as a zoo for tame and well-behaved, if not dead and embalmed, animals. "True art is always to be found where one least expects it, there where no one is thinking of it, or mentioning its name. Art detests being recognized or called by its name. It escapes immediately it is identified. Art is an entity passionately fond of going incognito."[42]

In his use of words Dubuffet struggles to break out of the strictures of thought imposed by an essentially verbal culture, and to communicate his ideas in images that can be felt and understood. This is the language of a committed artist, warning of the appeal of false prophets and seductive images, suspicious of the church and its priests, yet convinced of the existence of a true art, dwelling everywhere and nowhere, whose name cannot be pronounced. His conviction that true art must arise where it is not expected, and must go unrecognized, is in contrast to the absolute conviction of the pedants of contemporary criticism that the significant art of our day is beneath their microscopes, or exhibited in their museums, and that never again will they make the error of rejecting the real thing.

Like so many twentieth-century artists, Dubuffet was attracted by the primitive, drawn back not into the history of civilization but into its precivilized state. In his thought, as in his art, he searched for humanity's origins. He descended the evolutionary ladder in quest of primary images, requiring the liberating transfusion of pure emotion, instinct, and experience.

Without doubt we possess [at present] the best understanding that has been available in fifty years, of civilizations referred to as primitive, and of their ways of thinking. Their works of art strongly disconcert and preoccupy Western man. We have begun to ask ourselves whether Western civilization might not profit from lessons provided by these savages. It could be that in many areas, their solutions and their ways, which were once seen as so simplistic, could in the long run be more far-seeing than our own. As for me, I hold the values of the savage in high esteem: instinct, passion, caprice, violence, insanity.[43]

The word insanity (*délire*) is of particular importance, in that it indicates precisely the nature of Dubuffet's conception of the primitive. Unlike artists who turned to African or Oceanic sculpture for contact with the primitive, Dubuffet sought his pure savage on the edges of his own world, among the unrecognized—the outcasts and rejects of the society in which we live. His involvement with the art of the insane was never a result of a preoccupation with morbid psychology or with the bizarre. It was the result of an intense hunger for images free of the pathology of Western civilization, images expressive of human nature in its purest and most individualistic state. For Dubuffet, Art Brut is an art free of the sickness of Western rationalism, untouched by the perverse notion of "beauty."

The attack on the concept "beauty" is at the center of Dubuffet's anticultural position. In his extreme hostility to conventional ideas regarding the beautiful, his humanism is most clearly revealed.

For these people there exist objects which are considered beautiful, and others which are ugly, beautiful people and ugly people, beautiful places and ugly ones. None of this for me! Beauty doesn't exist for me. I hold the notion of beauty to be completely erroneous. I refuse absolutely to acquiesce to the idea that there are ugly people or objects. I react to it with consternation, and I am revolted by it.[44]

The idea that there are beautiful objects and ugly objects, people endowed with beauty and others who haven't got it, has surely no other foundation than convention, old poppycock, and I declare that convention unhealthy. . . . I intend to sweep away everything we have been taught to consider—without question—as grace and beauty . . . [and] in my work to substitute another and vaster beauty, touching all objects and beings, not excluding the most despised.[45]

Dubuffet reserves particular scorn for the formalist position.

The aim of art, since the Greeks, is supposed to be the invention of beautiful lines and beautiful harmonies of color. Abolish this notion, and what would become of art? I will tell you. Art would then return to its true function, a far more effective one than arranging forms and colors for an imagined pleasure of the eyes. I don't find the act of assembling colors in pleasant arrangements to be a particularly noble function. If that was what painting consisted of, I wouldn't devote a single hour to such activity. Art addresses itself to the spirit and not to the eyes. It has always been considered from this angle by "primitive" societies, and they are right. Art is a language, an instrument of understanding and an instrument of communication.[46]

For Dubuffet there were no objective standards for measuring beauty, and no means of identifying "art."

While this rewriting of aesthetics may at first seem remote from our concerns, we are witnessing the forging, at white heat, of a mode of perception and awareness, within which the art of the insane could be evaluated in a new light. Dubuffet fought here, as well, for the survival of his own art. As an artist he identified himself totally with creative mechanisms that have,

up to this point, been defined as insane. Faced with a century of art criticism that purported to recognize insanity in everything from Impressionism to Abstract Expressionism, Dubuffet responded by creating an art that forced the issue, demanding inclusion within the "borderland" of psychopathology. His art stands or falls with the art of the insane, and he would have been the first to insist that it should. To accept the art of Dubuffet is to accept the art of his mad brothers and sisters in the asylum. He demanded nothing less. Dubuffet aspired to the state of madness; only his humility prevented him from listing himself among the creators of Art Brut.[47]

IN THE 1930s Carl Jung began to develop the idea that outside the official and dominant Christian world view—with its characteristic morality, philosophic stance, and conception of humanity and reality—was a hidden but parallel conception of the nature of things that had persisted in the officially unrecognized body of ideas known as alchemy. For Jung these two world views were complementary, but the unexplored realm of alchemy, with its hidden yet profound significance for the understanding of history and human nature, demanded particular attention precisely because it was hidden (unconscious), the official world view having imposed blindness to this dark side of the moon. Dubuffet's position was curiously similar. He insisted that parallel to the accepted art of the West, there is and always has been an unrecognized "underground art," to which he gave the name *art brut*. "I believe that this *art brut*, this art which has never ceased to be made in Europe parallel to the other, this savage art to which no one has paid attention, and which often enough itself failed to recognize that it was art, that it is here that one can, on the contrary, discover the true and living art of Europe."[48]

The process whereby this "alternate art" remained in the shadow, unseen and unrecognized, is only partly explained in the essay "Place a l'incivisme" of 1967:

In our time, as in others, certain avenues of expression, as a result of fashion or circumstances, prevail; certain kinds of art receive attention and consideration to the exclusion of all others, and they are finally wrongly regarded as being the only kind that is legitimate, the only possibility. A channel is cut out which all artists then make use of, without retaining consciousness of their own uniqueness, and losing sight of the innumerable other pathways which are also admissible. So strong is the power of attraction exerted by this narrow rut—which represents the position of "cultural art"—that products arising from other approaches are not even perceived, as though they existed outside of the spectral range.

They are rejected with a condescending label, "the art of children, primitives and the insane."[49]

The belief that this culturally promoted blindness is to be accounted for by references to fashion or circumstances, or to a cultural rut, is naive. The massive defenses within the individual and within civilization against the pure products of the unconscious are far more profoundly based than Dubuffet recognized. It was Freud who, confronted with the full force of this resistance, was forced to comprehend the nature of man's blindness and of his implacable hatred of the forces within himself, and the images or symbols that they awakened in him, in his dreams and in his art. It was Freud too who pointed out the immense, perhaps impossible, sacrifices that society and civilization demand of us. Freud, however, differed with Dubuffet in allying himself firmly on the side of civilization, and in being pessimistic about the untamed nature of the inner, or primitive, man.[50]

Dubuffet, in his art and in his activity as a writer and collector, championed this "other art," "les oeuvres des irreguliers," bestowing upon it the name "Art Brut."[51] The term, which does not define a school or artistic movement, has achieved international recognition and acceptance. Having been provided with a suitable label, the art of the insane can now be said to exist. But what is concealed behind this curious label? What is Dubuffet's conception of Art Brut, and how does the art of the insane fit into this new category?

As defined by Dubuffet, Art Brut is the spontaneous creative activity of artistically untrained men and women, working alone, outside of any artistic movement or cultural influence, motivated only by an intense inner need to make images, and free of any concern with art. Two criteria are essential in identifying Art Brut: intensity of expression, and freedom from cultural influence. "The collections of Art Brut are composed of works created by individuals working outside of the cultural milieu and protected from its influence. The authors of these works are for the most part uneducated . . . and their works arise from spiritual states of a truly original kind, profoundly different from those to which we are accustomed."[52]

There is no difficulty in distinguishing Art Brut from conventional art, for the simple reason that the work of professional artists is excluded by definition. This restriction would exclude the work of Dubuffet himself. The creator of this art is an amateur in the sense that he is untrained. He exists on the edge of our society, exiled as a madman, an eccentric, a criminal, or a fool. A more difficult and yet essential distinction

that must be made, and at times it can appear arbitrary, is that between "naive art," folk art, and Art Brut. In regard to the paintings of the naive artist Dubuffet clarifies the essential difference.

I must stress that this Art Brut which I am alluding to is not to be confused with that form of activity which has become so fashionable in recent years in cultural circles, and which is known as "naive art" or the art of Sunday painters. These individuals are people who are filled with respect for cultural art, and their work is strongly influenced by its traditions. They desire to form part of cultural art, and borrow from it their methods, imitating it to the best of their ability. (They do so badly, of course, because of their inexperience, a fact which results in their efforts being of more interest than the originals which inspire them.) The works with which I am concerned are, however, far more "brutal" than the works of "naive painters." They are totally free of cultural influence, and uninfluenced by its methods. Their authors invent everything themselves, their subjects and their methods, out of their own depths.[53]

The irresistible impulse that forces a man who has not drawn since childhood to scratch a crude sexual image on the wall of a public toilet is quite obviously not to be confused with the gentle ambition of the naive painter. Dubuffet's creator is not in the least concerned with making "art." However he may explain his image-making activity, the works themselves betray a violent origin, an irresistible impulse producing images of raw intensity borne upward with volcanic force from deep within the central core of the individual.

At the beginning Dubuffet sought his creators in the mental hospitals of Europe. A large part of the collection always consisted of the work of individuals diagnosed as insane and hospitalized over long periods of time. However, he was not long in realizing that equally intense work of the same kind could be found outside of asylums, the product of so-called eccentrics who had opted out of society, or been rejected by it. As a result, Art Brut can never be equated with the art of the "insane." It is not to be identified on the basis of psychiatric or medical criteria. For the psychiatrist obsessed with clinical diagnosis, all of the Art Brut collection could be described as the product of psychotic mental states, and all of the artists as insane. For Dubuffet, on the contrary, none of the art is psychopathological, and psychiatric thinking is in itself evidence of a form of social pathology.

Dubuffet's position, independently attained, is as much antipsychiatry as anticultural.[54]

The notion of psychotic art is absolutely false! Psychiatrists emphasize it because they wish to believe they are in a position to differentiate, to tell who is sane and who isn't. They reject the idea that "psychiatric art" can be equal or superior to "fine art"; they want a firm barrier, and are therefore hostile to my view of psychiatry and of the art of their patients. They want to cure creativity.[55]

I must explain that our position in regard to that particular state of affairs, that situation which is referred to as "insanity" is as follows. We tend to ignore it completely. Having absolutely no interest in such categories, we simply investigate works characterized by a very strong personal character, works created outside of all influence from traditional art, and which at the same time (because without this there can be no art) derive from the most profound depths of the human spirit, from savage depths which find expression in a language of fire. Apart from this, it is a matter of absolute indifference to us that the author of these works is, for reasons foreign to our concerns, reputed to be sane or mad.[56]

Dubuffet was an impassioned opponent of a psychiatry based on false analogies deriving from physical medicine, a psychiatry that views psychotic experience as meaningless and dangerous, and aims at its removal or destruction at whatever cost, and with whatever methods, not excluding imprisonment, physical mutilation (neurosurgery), and torture (such as electro-convulsive therapy). He opposed the exclusion of the "insane" from our society, either by imprisoning them in hospitals, or by invalidating their experience and their utterances as "crazy" and worthless.

These unique people, the hypersensitive, maniacs, visionaries, and constructors of strange myths, who are called by us "the insane," are not *aliénés*.[57]

They are not strangers, and their mental mechanisms are not foreign to us. They are in every respect our equals and our brothers, and I feel it is terribly unjust and cruel that Europeans regard them in a way which permits them to be treated as less than animals.[58]

It is a deplorable fact, that once they are declared by the physician to be different from the norm, nothing that they think, say, or produce can any longer be taken seriously. It is against this that we protest![59]

Dubuffet's ideas concerning the insane cannot be dismissed as mere Romanticism based on a naive and idealized conception of mental illness. As early as 1945 he was visiting asylums, getting to know psychiatrists and artist-inmates, and maintaining contact with them over the years. Nor was he ignorant of contemporary psychiatric theory and practice. Many of his ideas reflect advanced psychiatric thinking and betray an awareness of the struggle being waged by humanistic psychiatry in its effort to grasp at the meaning and importance of psychological processes and experience clinically identified as psychotic.

It is quite obvious that in regard to what is called insanity, European man has formulated the problem incorrectly. He approaches insanity with the idea that it is something radically different in nature from normal mentality, that it is in fact its opposite (in-sanity), that it possesses a bad or negative value, and that one should aim at its destruction. This is not my way of looking at it. Insanity is, in the first place, so incredibly varied and different from one case to another, that it is senseless to include all cases under such a vague classification. One identifies as insanity anything which departs from "normality," or a prototype of normality. There are many ways of departing from this normality. . . . All of the mental mechanisms which exist in a madman exist also (more or less in a state of sleep) in the sane man, and they are far more similar to each other than they realize. . . . It is largely a question of quantity and of degree. . . . I believe that it has been an error to regard insanity as a negative experience. I believe that it has a positive value, that it is fecund, highly useful, and very precious.[60]

The significance of these ideas for us resides, not in their contribution to psychiatric theory, but in the fact that they represent the determined struggle of an artist and a sensitive human being to wrest the art of "the insane" out of the hands of the psychiatric profession. Dubuffet's determination to create a museum of the art of these people, outside of any medical or psychiatric setting, was based on the realization that these images could only be perceived once they had been freed of a milieu that denigrated them and denied their validity, or saw them only as evidence of psychopathology. As much as he disliked the term *art*, he incorporated it in the new concept of Art Brut precisely because he wished to establish the profound human significance of these images. "Not only do we refuse to give respect to a single cultural art, and to consider as less than acceptable, the works which are presented here [in the exhibition of 1967]; but we feel, on the contrary, that these works, the fruit of solitude and of a pure and authentic creative drive (where concerns about competition, praise, or social advancement do not interfere), are for this reason more precious than the products of professional artists."[61]

In providing these disparate works with a label identifying them as art rather than psychiatric material, Dubuffet moved from the madhouse to the museum, a far from ideal resting place, but at this point the lesser of two evils. The museum ensured at least their physical survival. However, this new artistic category should not be thought of as a coherent group of works, or a movement, linked together in terms of subjects, methodology, or style. It is a totally heterogeneous collection of images and artists, with no underlying unity or common purpose. As Dubuffet points out, "The

impression of diversity within cultural art, and of the uniformity of all forms of art which are foreign to it, has as its cause an optical illusion, a lack of perspective resulting from customary ways of seeing. . . . It is in reality cultural art which is specious and uniform, while those forms of art originating elsewhere offer infinite variety."[62]

For Dubuffet the essence of Art Brut resides in the intense individuality of each creator. A strong belief in the individual lies at the center of all of his thinking. He accepted no art that is not intensely private and personal. His preoccupation with the art of the insane derives from his awareness that they represent the extreme of individualism. Having abandoned life in society, they are driven by an irresistible need to explore their own inner reality to its farthest reaches. "People like Wölfli and Aloïse pursued their art as far as possible. It was artistic creation pushed as far as it could go. They lived their art, and were locked up because they were artists. Professional artists only half believe in their art, and are content to live conventional lives outside of it. Insanity is the great art."[63] For Dubuffet insanity represents a rebellion, a revolt against imposed reality.

I believe that the creation of art is intimately linked with the spirit of revolt. Insanity represents a refusal to adopt a view of reality that is imposed by custom. Art consists in constructing or inventing a mirror in which all of the universe is reflected. An artist is a man who creates a parallel universe, who doesn't want an imposed universe inflicted on him. He wants to do it himself. That is a definition of insanity. The insane are individuals who push creativity further than professional artists, who believe in it totally. You can refuse to use perspective in drawing and its OK, but live your beliefs, and they lock you up.[64]

For Dubuffet true art represents the greatest possibility of freedom available. Civilization, culture, education, and professionalism in art represent a denial of freedom, and an interference with the essential individuality of the artist.

At this point we touch on Dubuffet's conception of creativity. Rejecting completely the notion of "genius" or "talent," he was convinced of the presence in all of us of image-making ability. It is essential to understand that he was not indulging in the charming idea that everybody should take up Sunday painting, or dabble at art as an amusing pastime. He put forward the radical view that image making in the most profound sense is a normal human function, differing from the psychological mechanism of dreaming only in terms of its greater concreteness. It is a curious fact that no one yet is self-proclaimed as an artist of the

dream, an especially gifted dreamer, whose dreams are somehow more significant, or more "beautiful," than those of other people. Civilization, while leaving the process of dream formation untouched, has interfered massively in the related process of art making. The natural creative ability of the average human being living in our society is almost totally obstructed. His confidence in his image-making ability is disturbed, both by the overemphasis on technique and representational skill that is fostered by art schools and professional artists, and by a perverse idea of art and beauty that convinces him that image making is a job for experts or those with God-given talent. Only the impact of violent psychological conflict or psychotic processes seems able to overcome this general inhibition.

If the so-called "gifts" attributed to "artists" are, in our way of looking at things, very widely spread, those who possess the courage and strength to exercise them in complete freedom and purity are rare, extremely rare. In order to do so they must free themselves of social conditioning, or at least assume a position towards it of considerable distance. It is necessary to notice that this freedom implies an asocial attitude, a position which sociologists term "alienation."[65]

For Dubuffet the truly creative individual in the context of contemporary civilization, and in terms of modern psychiatric categories, must unavoidably appear "disturbed," or "insane," whether he is creating inside or outside of an asylum. Impatient with the pseudodiagnostic stance of psychiatrists, and amateur psychiatrists, in the face of truly original forms of expression, he dismisses the problem quite simply.

The best, the most coherent, position would be to state, in order to finish with the problem, that the creation of art, whenever it manifests itself, is always, and in all cases, pathological.[66]

All the contacts that we have had (numerous) with those of our comrades more or less *coiffées des Grélots*, have convinced us that the mechanisms of artistic creation are in their hands exactly the same as is the case with people reputed to be normal; and in any case, the distinction between normal and abnormal seems to us unacceptable. Who is normal? Where is he to be found, this normal man? Show him to us. The act of art with the extreme tension which it implies, the high fever which accompanies it, can it ever be normal?[67]

For Dubuffet, therefore, there is no psychopathology of expression.

THE CONTRAST between the psychiatric viewpoint and that of Dubuffet is most clearly displayed in situations where the two approaches are brought to bear on a single individual. To illustrate Dubuffet's approach to an individual artist I have selected the draftsman Hein-

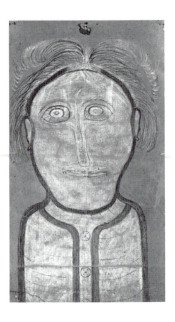

17.8. Heinrich Anton Müller, *Portrait of a Woman*, pencil and chalk on cardboard, Kunstmuseum, Bern.

rich Anton Müller of Berne (1865–1930), another of the early twentieth-century schizophrenic masters first discussed by Hans Prinzhorn (Fig. 17.8). Admitted to the psychiatric hospital at Münsingen at the age of forty, Müller lived there for the remainder of his life. Dubuffet never met him, and was therefore forced to obtain what little information he could about his life from physicians who remembered the case, or who had access to the hospital records. It can be seen that this means of obtaining information would be highly unsatisfactory from Dubuffet's point of view. He was forced to see his artist through a psychiatric filter. The kind of information available to him was limited to those facts that appeared significant to physicians, conforming to their prejudices and ways of thinking. In his publication of Müller's work, Dubuffet provided both his own comments and those of two psychiatrists who had known Müller. He also allowed Heinrich Anton to speak for himself.[68] In that the body of information available to Dubuffet was supplied by the physicians, we can see how Dubuffet's interpretation of the facts differs from theirs.

Conforming to the wishes of the physicians, Dubuffet concealed Müller's name, referring to him only as Heinrich Anton M.[69] Dubuffet objected strongly to this enforced anonymity. "These admirable works are worthy of being associated with the name of their creator, a name which far from needing to be hidden, should, on the contrary, be famous. The old and absurd stigma associated with 'insanity' which is the basis for this en-

forced anonymity appears to us to be in the situation particularly unjust."[70] Clearly this disagreement about the publication of Müller's name underlines a fundamental difference of opinion as to the social and cultural implications of Müller's mental state.

Having established the basic facts of Müller's life— his dates, nationality, period of hospitalization and supposed cause of the onset of his illness—Dubuffet proceeded to explore what to him seemed significant. This did not include any reference to diagnostic categories or labels. Müller had been committed to an asylum for reasons not explained in the article, but we are told enough to make it certain that in terms of contemporary diagnostic thinking he would have been described as paranoid schizophrenic. Dubuffet was, of course, well aware of this. However, his understanding of the implications of this label was quite different from that of the psychiatrist. Discussing the word *aliénation*, he explained:

We understand this word in its true sense, in terms of a distance established between [the individual], and other people and the world, and of a rejection, on a large scale, of the ordinary view of things in all areas, the traditional way of understanding the world having been recognized, once and for all, as a dead end, and replaced by a deliberate revision, a new system of insights and practices which, instead of leading inevitably, as is the case with the common view of things, to a declaration of spiritual bankruptcy and of resigned acceptance, opens on exaltation and jubilation. It is this state of intense joy which the "insane" person aims at, so-called reality being, in his eyes, merely the result of mistaken views which can be corrected. The madman is a reformer, an inventor of new systems, intoxicated with invention. Having begun by inventing a machine for cutting vines, [Müller] aspired to go even further with his machines, erecting castles in the air, built entirely with his own hands, capable of endowing life with intense value. This is exactly what is required of the artist, and explains why the creation of art is so worthless when it does not originate in a state of alienation, and when it fails to offer a new conception of the world, and new principles for living.[71]

Dubuffet is here maintaining the unique value of the individual in opposition to society. His conception of creativity derives from the conviction that one man, by himself, can renew the world. His conception of history would also, no doubt be a history of innovation and transformation resulting from the actions of individuals. Not surprisingly he described his own art as "an ardent celebration."

It must be pointed out that few cases of "mental illness" approximate Dubuffet's conception of this state, and that jubilation, except in cases of manic excitement, is as rare among the insane as among the "normal." The terror, the anguish amounting to horror and revulsion, the despair and unbearable emptiness so often experienced as part of the psychotic state cannot be so easily forgotten or dismissed. By restricting his experience of the insane to those rare individuals who master the experience of psychosis, and function creatively within it, Dubuffet arrived at as idealistic a conception of insanity as a sociologist would of "normal" society were he to restrict his investigation to artists and writers. Only a unique individual can create a new world out of chaos. Dubuffet knew this.

One should not assume that anyone, from the moment he becomes insane is, as a result of this fact, a good painter. Certainly not. Psychiatrists in recent years have organized exhibitions of drawings and paintings made by patients, and it can be said that their works are not on the whole much more original, more inventive, or more interesting, than drawings and paintings commonly produced by "normal" people.... Genuine artists are almost as rare among the insane as among the "normal" population, or perhaps just a little more frequent.[72]

For this reason, Dubuffet wished to inquire as thoroughly as possible into the nature of Müller's creative impulse and activity.

At the age of fifty-two, he had begun to draw, having had no education in this area, and no prior involvement with drawing. He had been hospitalized for six years and, as was the case with Wölfli, the interest in drawing was accompanied by a change in behavior, which suggested that he had established some sort of order in his inner experience. During this period he was occupied with the design and construction of perpetual motion machines, and with covering the walls of his room with drawings of a symbolic nature (Fig. 17.9). An interruption in his creative activity was recorded in 1924, and when he resumed drawing in 1925 his style had undergone a considerable change.

The report written by Professor Wyrsch, director of the Waldau Asylum, represents a fairly typical psychiatric case report, with its references to delusions of grandeur and of persecution, bodily hallucinations, and so on. The interview with Dr. Max Müller of the Münsingen Hospital is of far greater interest, because in talking with him personally Dubuffet was able to pursue more significant questions, and to arrive at something closer to a convincing human being. In this interview, Müller's life-style emerges, and we are able to see how he might truly be said to have lived his art, pursuing his creative impulse into the creation of ritual activity. We learn, for example that in 1912 Müller had dug a deep hole in the garden of the hospital in which he spent considerable time. "In 1926 he built an

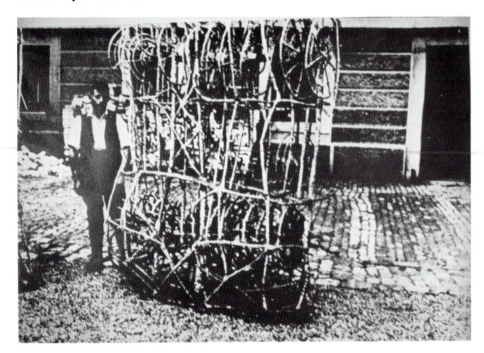

17.9. Heinrich Anton Müller with his "machine," 1914–1925, Kunstmuseum, Bern.

enormous 'telescope,' through which he watched for days on end a singular object of considerable size which he had built with stones and all sorts of material, an object which was said to resemble the female sexual organ."[73]

It is, however, Müller's own writings, derived from inscriptions written in French on the drawings, that convey most powerfully the nature of his altered and unique perception of reality. The text reproduced by Dubuffet entitled "The Free Republic" provides a superb illustration and justification of Dubuffet's somewhat idealized conception of insanity. Once again, it is the patient who acts as teacher.

REPUBLIQUE LA LIBRE

République La Libre En Partie Brisée ou La Pas D'erreur La Somnambule Sommereuse. C'est une baraque absolue à n'y rien comprendre qui n'a rien à voir avec nous, c'est un peuple secret et rêveur ils ont par moments des idées baroques et diverses ils disent aussi la bonne aventure c'est des espèces de sorciers ils sont grands comme de grands Anglais à allure svelte et élancée aux idées imaginaires. Ils ne sont pas tous fous mais guère il s'en faut c'est toutefois une erreur.

O!! O!!! O. Quelle erreur, viens dans mon bonheur. O!!! O. Belle République La Libre En Partie Brisée. O!!! O. Belle République La Pas D'erreur La Somnambule Sommereuse sois mes amours.

Ils sont comme ça par l'idée c'est une mode à eux et ils ne peuvent s'en empêcher ils ne savent ce qu'ils veulent ils sont toutefois aussi fins que nous ils suivent une politique d'aplanisseurs. C'est comme qui dirait une toupie ou rabot, ils ont cette précision dans l'âme c'est une idée à eux c'est nos fils pour sûr il n'y a pas d'erreur. O!!! O!!! O. Quelle Erreur, viens dans mon bonheur. O!!! O!!! O. Belle République La Libre En Partie Brisée. O!!! O. Belle République La Pas d'erreur La Somnambule Sommereuse, sois mes amours.

C'est une Belle République assise leurs modes c'est les fils de leurs pères ils ont dans l'âme des secrets et des idées baroques il ne faut pas jouer avec eux, ils ont recours aux armes blanches. Leur secret de guerre n'est pas écrit ils le cachent dans leurs esprits c'est un fusil a précision nouveau modèle que personne ne sait c'est des fusils de sorcier en bois, ne faites pas Erreur.

O!!! O!!! O. Quelle Erreur, viens dans mon bonheur. O!!! O! Belle République La Pas D'erreur Somnambule Sommereuse, sois mes amours.

C'est une génération nouvelle aux armes blanches sans poudre et sans fumée ils marchent sur la terre sans bruit c'est un caprice à eux c'est honneur à rendre.[74]

Dubuffet was struck by "the method in Müller's madness," the degree of control, and of what appeared to be conscious choice in the ordering of this text, and of the drawings as well.

It seems certain to us that not a single stroke in the drawings of Heinrich Anton, not a word in his texts, not a line in his impressive (and so painstaking) calligraphy, has been achieved by chance or has escaped his watchful eye. He desired, with total lucidity, to which we respond, to produce objects of the "most extreme strangeness." He sought an extremity of strangeness. . . . It is very evident that Heinrich Anton loved nothing so much as his madness, it represented his reason for living; nothing enchanted him so much as to project it onto his sheets of paper, and then to fix it to the wall and to regard it for hours, the fruits and the flowers, and to establish (with great ingenuity and care) those images which most accurately confirmed him in his chosen path and which permitted him to continue to move farther and farther along it. Should we, in the face of a man so evidently content with his life, speak of an illness of which it would be desirable to cure him?[75]

It is perhaps significant that Dubuffet avoided discussion of Müller's pictures. His text was accompanied by twelve reproductions that are allowed to speak for themselves. Clearly, he was not interested in interpretation. However, it is equally clear that he sought to understand the work in the context of a life. "It isn't so important to link the work with biographies etc., they can stand on their own. But I am always intensely curious. Who was this person?"[76]

IT IS PARADOXICAL that Dubuffet, through his writings and efforts on behalf of Art Brut, carved out a place for the art of the insane in the world of art. It is astonishing how readily museum directors, dealers, and critics have accepted the term Art Brut, and begun to exhibit and discuss works associated with it. They only needed to be told by an artist of reputation that it was "all right," that it was "art," and they rushed right in.[77] Having rejected cultural art and its institutions, Dubuffet, as a result of his own theoretical position and activity, was condemned to watch the assimilation of Art Brut by the cultural elite. This was certainly not his intention. It is not a proof of the value of Art Brut that it is hung in museums. It is merely an indication that to a very limited degree changes are occurring in the world of the art establishment. Were these changes fundamental, one might well speak of Dubuffet's goal being achieved. But what is needed is a radical rethinking and enlargement of the meaning of art, and the establishment of a new, alive, and human relation to it. Dubuffet fought to break down barriers. The developments he is responsible for inducing in the world of official culture and museums are just gestures aimed at suggesting change, without changing.

The incorporation of African tribal sculpture within the canon of "art" illustrates the nature of the process.

Hung in a Western museum, it is celebrated for its formal beauty. In our sophistication, it is quite clear that we see the beauty of this art far more accurately than the poor superstitious savages who made it. Primitive art has found acceptance at the cost of losing its significance and meaning. What significance can the art of the insane have within a museum of contemporary art? Is this not merely taming the lion? Even if one cannot join Dubuffet in rejecting all of Western culture, is it to be the fate of psychotic art merely to be incorporated within this culture as a peculiar manifestation on the edge of art? It is no accomplishment to incorporate these images into "art," by ignoring or suppressing their real nature, and politely stressing their formal elegance or "primitive" charm. Adolf Wölfli is not to be confused with Grandma Moses.

Dubuffet's position in regard to encouraging knowledge about and acceptance of the art of the insane can appear somewhat contradictory. Hostile to the official dissemination of culture and to the multiplicity of museums and exhibitions, galleries and dealers, he nevertheless, devoted his time and energy to organizing exhibitions of Art Brut and familiarizing the public with the life and work of artists who were once unknown, and he is responsible for creating a superb public museum to house the collection he assembled. On the other hand, he was attracted by the idea of the secret work of art, of images created in response to the needs of the individual, works whose existence is concealed. "I feel that art is always too much honored, and that one would be doing it a great service to leave it alone in its corner, and to speak of it as little as possible. I dislike even the word art, and I would prefer that it didn't exist, allowing the thing to exist without a name. . . . I feel that works of art, like so many other things, lose much of their original value as soon as they arrive at a certain level of notoriety."[78] Clearly it would be preferable, from Dubuffet's point of view, if Art Brut, as a countercultural phenomenon, could be kept outside of the framework of the art establishment. His own efforts to acquaint the public with it were devoted to providing a separate context for this art, with its own galleries, study center, and publications. The Collection de l'Art Brut in Lausanne is a continuation of this position. Its policies and its administration aim at the creation of an environment free of the sanctity of the traditional museum, a meeting place where discussion, research, and thoughtful encounters with new images and ideas may occur.[79]

The public that Dubuffet desired to reach, both in terms of his own art and Art Brut, is not that of the traditional art lover. Speaking of his own work in 1946

he explained that he aimed "not at the gratification of a handful of specialists. [He] would much rather amuse and interest the man in the street when he comes home from work. . . . It is the man in the street that I'm after, whom I feel closest to, with whom I want to make friends, and enter into confidence and connivance with. he is the one I want to please and enchant by means of my work." He referred to Art Brut as "the voice of the common man." However, this goal has been difficult to reach. "Perhaps in the 1940s I had more confidence in the man in the street. Now I'm more discouraged. He is more strongly conditioned by cultural ideas than are the intellectuals. It is far more difficult to decondition him."[80]

Dubuffet's whole activity as a writer can be seen as an attempt to liberate individual human beings from the burden of an artificial and irrelevant aesthetic. Having aligned himself with a group of image makers whose works are free of an imposed culture and languages, individuals who are capable of thinking and creating alone, for and out of themselves, he sought a public capable of seeing and responding with the same freedom, individuals whose emotional and intellectual ability to respond to images is capable of functioning outside of the artifically imposed barriers that separate the art of children, or of primitives, or the insane, from the realm of "real art," or who impose an artificial and foolish hierarchy that values art in terms of its cultural content. For the truly independent viewer, the whole of man's image-making activity is the subject of his curiosity and response. It is always the task of the artist to break down and rethink our idea of what art is. Dubuffet forced us to look at all kinds of man-made images denied the title art, and to show us how little they need it, in their capacity to speak to us, one to one, with a human voice that, in moments of freedom and silence, we recognize as our own.

Conclusion

The preceding chapters have had as their task the historical reconstruction of a process of discovery: attempting to describe how a form of art that has always existed entered consciousness for the first time as a reality of scientific and aesthetic significance. Throughout the nineteenth and twentieth centuries, parallel to the officially recognized art of the period, a body of strange and disparate images was being created in secret. We have endeavored to document and to illuminate the slow and painful process through which these unknown and unrecognized images found their way into the light of day, managing, despite their "invisibility," to trouble and delight the minds and hearts of many men and women, and demanding recognition within the curiously undefined group of man-made images and objects to which we give the name "art." I have attempted to demonstrate that the "discovery" of the art of the insane was actually a long and complex process, an event that can, in some sense, be said to have occurred over and over again, in different places and disciplines, and in different minds, until it achieved its present degree of intellectual and aesthetic permanence. This observation is not intended to diminish the individual "acts of discovery" of the men and women—the physicians, artists, scientists, critics, and historians—whose accomplishments have formed the basis of our investigation. We have sought, rather, to understand the nature and significance of each of these individual encounters with the art of the insane, occurring in many places over some two hundred years, and to demonstrate the essential "connectedness" that makes all of them manifestations of an underlying historical process.

Beneath all of these "acts of discovery" two motivating factors can invariably be recognized: the tremendous power and beauty of the images themselves, which in their profound strangeness and integrity possess pictorial presence sufficient to compel attention; and the existence of a deep-seated human need for images of this kind, which first makes itself felt within Romanticism and which reaches a peak of intensity in the twentieth century. These two factors together explain the fact that images once seen as worthless are now understood to be uniquely valuable, and worthy of

study, collection, and aesthetic contemplation. We have attempted to reconstruct the history of this slow but meaningful process of transformation, despite the fact that it is far from complete. In conclusion, I want to examine some implications which seem to arise from this discovery, not in terms of the past, but for the future.

To REJECT the art of a people (or to say it is not art, which is the same thing) is in the deepest sense to deny their reality. The long invisibility of the art of the insane was the result of a determined effort to ignore, or deny, the existence of the insane. Their sculpture, their paintings and drawings, were dismissed as valueless because the men and women who made them were understood to be either inferior human beings, or even "inhuman" human beings. Because of the label they wore, their ability to speak for themselves was taken away, and the truthfulness of all they said was denied.

For this reason, the depiction of the insane, as a subject and later in portrait studies, long preceded acceptance of their self-depiction, their art. A deepening awareness on the part of artists of their responsibility in portraying the reality of these people was the first sign of a change in attitude toward them. A similar process was to be observed in psychiatry as more and more serious efforts were made to describe the experience of insanity—from outside. So long as a group of people is seen as less than human—an endeavor that seriously undermines our own humanity—we feel justified in ignoring their efforts to inform us about themselves and seek instead to understand them from outside.[1]

The process of discovery we have been examining was only a byproduct of a historical development of far greater human significance: the reintegration of an exiled people into the social fabric, a result of a related but far more obscure process of psychological reintegration whereby a split-off portion of the individual human mind, long exiled (the unconscious), was also finding its way into awareness.

Toward the end of the nineteenth century, Sigmund Freud recognized that there might be value in attend-

ing to the utterances of his neurotic patients. Although he began this activity with a therapeutic aim, he soon realized the extraordinary value of what they were saying as a means of obtaining access to the deeper reaches of the human mind. From the very beginning not he but his patients became the guides downward into the darkness. It is no disservice to Freud or his followers to insist that all of the insight and understanding of the mind attained by depth psychology in this century has been contributed by patients labeled neurotic or psychotic. As Freud pointed out, only terrible suffering can force an individual to find the courage to explore the darkness and chaos within himself.

One of the principal contributions of psychoanalysis has been its sometimes infuriating insistence that the findings obtained from this very private process of inner exploration have validity extending far beyond the life of the individual most directly concerned. We have come to understand that the worlds within which the insane wander are not alien worlds, but our own. They make visible what is in all of us. However obscure their art may be, our fundamental response to it, as to all art, is the feeling of recognition.

To value insights derived from psychotic experience is not to indulge in uncritical enthusiasm for insanity. The fashionable cultivation of madness is invariably, as I have tried to show, the result of a naively imaginative conception of what insanity is. The real experience of van Gogh, or Artaud, of Wölfli or Aloïse, was far different. The visionary insight they brought to us was won only at a cost few of us would be prepared to pay. Whereas for us the art of the insane represents an enormously important aesthetic and intellectual experience that can lead us deep into our own inner life, for its makers it often was material evidence of an agonizing struggle to make sense of drastically altered life experience within which they themselves were lost.

I have also tried to clarify some of the factors involved in the intense hostility toward the art of the insane encountered in some quarters, a negative attitude that is commonly linked to an implacable hatred of modern art. There is no doubt that for some individuals the encounter with images originating in the unconscious from either of these sources produces intense anxiety and discomfort, provoking them to astonishing displays of destructive rage.

This fear of the unconscious and its images is not restricted to artistic circles. Similar efforts aimed at the destruction of the art of the insane are also found within psychiatry, where the tendency to deny the validity of psychotic experience is once again felt. The disappearance of image-making activity among the hospitalized insane seems imminent.[2]

The hospitalized insane have never been less visible than they are today. We assume that they are being "looked after," and abandon them to the experts. But there is great danger in allowing psychiatry to become an arcane science of interest only to specialists. What goes on within psychiatry, and within psychiatric hospitals, is a matter of profound concern to all of us.[3] It is doubtful that the disappearance of image-making activity by psychotic patients is really an indication of more successful therapeutic intervention. More likely, it is the result of the fact that "mental patients" are being treated so radically today that the possibility of creative activity has once again ceased to exist. The destruction of the art of the insane is the result of psychiatric procedures aimed not at "cure" but at preventing the necessary processes of self-cure from occurring. The attempt to characterize the behavior and expressive activity of the insane as the meaningless product of neurochemical disturbance is nothing more than the most recent expression of the terrifyingly intense need felt by some psychiatrists to put a stop to all "abnormal manifestations"—to "put the lid" on psychotic experience as quickly as possible, using any means whatever, including electroconvulsive therapy and the massive misuse of powerful and little-understood drugs. Although techniques of manipulation and intimidation may not be characteristic of psychiatry at its best, they are far more typical of what is actually occurring in psychiatric institutions, and in the psychiatric wards of general hospitals, than we would like to realize.

THE ART of the insane, today no less than in the past, challenges the sensitive physician to understand. However, changes in the nature of psychiatric and medical education make it far less likely that the modern physician possesses the breadth of culture necessary to respond. The average psychiatrist today, completely uncreative, is uncomfortable with any artistic manifestation, whether in patients or elsewhere. He or she tends either to be actively hostile to image-making activity (because it is inclined to take the lid off rather than holding it firmly on), or to view it condescendingly as a means of keeping patients occupied and out of mischief by allowing them to dabble at "art."

Few contemporary physicians would be capable, as Morgenthaler was, of recognizing that the new reality, the new personality and world, that Wölfli forged for himself, was immeasurably superior to the one from which he had used madness to escape. However "abnormal" or "pathological" Wölfli's new world was, it was richer by far than anything likely to be encountered within the confines of "normality." The awareness that individuals who are clinically identified as

insane are capable of spontaneous artistic activity on a par with that of the greatest modern masters has unavoidable implications for the sensitive physician. These images, works of art in every sense, challenge the physician to respect the truth and value of the psychotic experience manifest in them, to learn to listen rather than to interfere, to understand rather than to manipulate.

Only the insensitive psychiatrist is not on occasion deeply moved by the disturbing beauty of some manifestation of the unconscious, whether in dreams, in delusional ideas, or in the far more rare traces of image-making activity. Ideally, physicians have been drawn into this odd profession through an attraction to the less superficial aspects of the mind, and can encounter the strangeness, the originality, and intensity of the inner world, either in themselves or the other, with at least some sense of acceptance or curiosity. Few physicians today have the privilege of witnessing the emergence of a "schizophrenic master." Nevertheless, it remains their responsibility to anticipate the possibility of such an occurrence, and to attempt to create an environment in which creativity and independent growth exists, whatever form it may take.

One of Dr. Milner's reasons for writing an account of her work with Susan was to make clear the extent to which psychiatric hospitals had damaged her patient, depriving her experience of psychosis of any meaning, and exposing her to the irreversible destructive effects of electroshock. "I thought I wanted to show to anyone who would listen the urgent need of places other than mental hospitals where certain kinds of mentally ill people can be sure of a roof over their heads. I wanted the book to be my contribution towards the establishing of such places."[4]

In the past madness had a place of asylum where it could rightfully exist. It has no such place now, except the streets of our cities. We cannot assume that psychiatric hospitals in the past were without exception "hell holes," and that in the present all is well. In the Kafkaesque bureaucracy of the modern psychiatric hospital, attitudes of disrespect and condescension toward patients and their experience and feelings are no less pervasive. That madness may be a necessary experience through which the individual called "patient" must pass is given no consideration. By insisting upon the isolation of the "mentally ill," as though insanity were a contagious disease, it appears that we have deprived society of an aspect of reality that it desperately needs. As Jean Dubuffet has again and again pointed out, we need our insane brothers and sisters with us in our communities. We must provide safe places in the immediate environment where types of mental experi-

ence other than those categorized as "normal" can exist, and where life experience referred to as "psychotic" can be lived through with support and understanding from individuals who recognize that "the journey through madness," however extreme and frightening it may appear from outside, is necessary and of value not only to the individual, but to all of us.

Dr. R. D. Laing has described, and indeed created, small residential environments in the community where madness can find acceptance and meaning. In an account of her own profound experience of psychosis, Mary Barnes, a resident in Laing's hostel, in collaboration with her physician, Dr. Joseph Berke, has made clear the complex and important role that image making can play in such an environment.[5] Miss Barnes's account is unique in providing an extensive description of the function of painting and drawing during a deeply psychotic period of her life. The book is also unique in describing the effect of her image-making activity and the resultant pictures on the whole environment in which she lived and worked. For the first time we learn of the highly ambivalent reception these images may receive from other psychotic individuals who are exposed to them, the jealousy that spontaneous creativity can stir up in others, the failures as well as successes in communication that can occur, and finally the sense of achievement and pride that the whole community shared in as Mary's paintings found acceptance as art.[6]

Our discussion of the image making of psychotic individuals has made little reference to the activities of "art therapists." This is, in part, because the historical development of the wide range of activities presently included within the field of art therapy would require independent investigation, but it is also a result of the author's belief that much of what is done in the name of art therapy has little to do with either therapy or art.[7] Nevertheless, it is clear that a real need exists for fully trained psychotherapists who are sufficiently at ease with pictorial images and image-making activity to be available to create an interpersonal environment in which psychotic individuals can use image making as an aspect of their efforts to orient themselves in the world, and to make contact with themselves and others.

Unquestionably the finest preparation for such an endeavor would be a full psychoanalytic training. Psychoanalysis still preserves its original attitude of respect and of attentiveness toward the expressive activity and the personality of the patient. Through carefully considered modifications of the classical technique, psychoanalysis has proved itself capable of extending its therapeutic endeavors to include psychotic

individuals.[8] The use of graphic images and symbols as a means of establishing and facilitating communication is a particularly valuable addition to psychoanalytic technique in this aspect of its application. The concreteness and symbolic potential of pictorial images, both as a means of self-exploration and of interpersonal communication, give them great value, providing the analyst can accept them, as a means of satisfying the patient's need to relive and to "feel" the memories and experiences emerging from him. They also have the advantage of providing a material record of the ongoing experience of analysis useful both to the therapist and the patient.[9]

In terms of the study and understanding of psychotic art, psychoanalysis continues to offer the greatest possibility of access and of insight into the problems. In the early phases of its development, it undoubtedly suffered from a tendency to indulge in "reductionist interpretation," to engage in simplistic interpretation of symbols, confusing them with "signs" and announcing that "this" merely implied "that," often reducing a vast and beautiful symbolic structure to a commonplace derivative of the Id.[10] The evolution of psychoanalysis into a sophisticated and subtle observational and therapeutic tool, as well as its insufficient but nonetheless significant encounter with psychotic mental states, has led to an enormous deepening of its interpretive endeavors far more closely attuned to the reality of the individual patient. Dr. Milner's long discussion of the implications of the image-making activity of her patient Susan is an example of the application of psychoanalytic insight at a more advanced stage in its development. It is only a matter of time before the full potential of psychoanalysis as a means of understanding is brought to bear on a psychotic artist of the quality of a Wölfli or an Aloïse.

Psychoanalysis has always shown itself to be open to the application of its methods and insights to other disciplines, and to the involvement of workers trained in other fields of specialization. By insisting upon the necessity of training lay analysts, Freud made clear his desire that individuals educated in the sciences and the humanities should seek analytic training, both as clinicians and as researchers, thereby enriching analysis as well as their respective fields. A need exists for the development of institutes of applied psychoanalysis as part of existing training institutes, so that ongoing contact between clinicians and research workers might be possible. Within such a setting, the study of psychotic art could provide a particularly fruitful subject of investigation, particularly in the context of a continuing case study of a productive psychotic patient. In

the investigation of psychotic art, or indeed of any pictorial imagery, psychoanalysis can only benefit from the collaboration of analytically trained art historians, critics, aestheticians, and, perhaps most important, artists.[11]

To a limited extent, our account of the discovery of the art of the insane has illuminated a small side road in the history of psychiatry. Ernst Kris once referred to the fact that "the trends in the selection of problems and in the interpretation of data [in the study of psychotic art] reflect so clearly the changing approaches of investigators from many lands that one might well be tempted to consider a survey of their studies as a fitting introduction to the history of psychiatry in this century."[12] Although our aim was by no means so extensive, we have been able to characterize the changing attitudes of psychiatrists and physicians toward an important aspect of the self-expressive endeavors of their patients. The attempt to unravel the mystery of psychotic image-making activity is one of the most intriguing chapters in the study of the history of human communication. Nor is this endeavor at an end.

In examining the history of this complex field, I have attempted to provide a historical foundation for future workers, and to assist them in familiarizing themselves with what has been done. Over one hundred fifty years of serious labor has succeeded in establishing the investigation of psychotic image-making activity as a legitimate and worthwhile subject of scientific research within psychiatry and psychology. But no scientific endeavor can proceed without a sophisticated awareness of where it has come from. Psychiatry as a discipline has been unusually careless in documenting its past. That this was and is particularly true of the art of the insane is understandable, if tragic. But, incomprehensibly, the tragedy goes on. Works of art of extraordinary quality are still being destroyed because of the insensitivity of hospital administrators and individual physicians. Examples of psychotic art created over the last two hundred years are still to be found, but stories of their destruction are so common as to make one aware that the unconscious fear of these images is still an active force. We must arrive at the point of recognizing that no one has the right to destroy an image made by another human being, no matter how trivial or inconsequential that image may seem to him.

The superb archive and restoration unit established at Bethlem Royal Hospital, Kent, and the associated collection of psychiatric art assembled at the Maudsley Hospital, London, and now housed at Bethlem, provide an example of what is required of psychiatric institu-

tions throughout the world if this important historical material is to be preserved and made available.[13] Once the stigma associated with insanity has become a thing of the past, these repositories will provide not only a resource for psychiatric research, but a source of some of the most powerful and significant images of humanity.

I HAVE TRIED to demonstrate that the art of the insane itself has a history, a pattern of change in form, subject matter, and style, which to some extent parallels that of the history of art, but which involves curious "regressions" or descents into the origins of image making. It is significant that the extended encounter with one's inner self, and with one's personal history, whether as a result of psychosis or through some other means, almost invariably drives one into an involvement with the past of the human race. For some psychiatrists and analysts—Freud is an example—the continuing encounter with the unconscious results in a preoccupation with archaeology and early history. In others, such as Carl Jung, it leads to an involvement with mythology or even cosmology. In the case of psychotic individuals, it may produce unexplained pictorial archaisms that incline one to weigh the hypothesis of inherited phylogenetic memory traces more carefully than would be the case if only verbal imagery and conceptions were considered.

Questions relating to the interaction of historical style, personal style, and stylistic elements associated with the experience of psychosis offer challenging problems to the visually sensitive and historically knowledgeable student. These problems, as Kris made clear, could provide an ideal starting point for an assault on the more general questions involved in establishing a general psychology of style. But here we touch on problems that extend well beyond the confines of psychiatric or psychological research.

AS THE FIRST extended survey of the history of encounters with the art of the insane, this investigation can make no claim to completeness.[14] Parts of the story, yet untold, are to be found in every older psychiatric institution in the world, and in the homes of many people whose family harbors what they may still consider to be "skeletons in the closet." The awareness that out of "insanity" true works of art can emerge may yet lead to the repatriation of numerous mad or "eccentric" black sheep, and to the discovery of artists of importance, not to say "genius."[15] It is to be hoped that this first attempt at a history of the discovery of psychotic art will lead to the compiling of similar his-

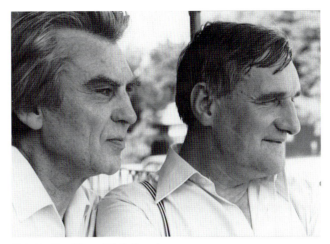

C.1. Dr. Leo Navratil (*left*) and Johann Hauser (*right*), 1980, photographed by Heinz Butler.

tories of this subject in many older psychiatric hospitals, and to the rediscovery of as yet unrecognized scientific and aesthetic "pioneers" in the investigation of this form of expression.[16]

In that this study was conceived of as a piece of historical reconstruction, I have deliberately avoided discussion of individuals who are currently active in the exploration and critical evaluation of psychotic art. It would be presumptuous to describe or explain the activity of superbly competent workers in the field such as Alfred Bader, Irene Jakab, Roger Cardinal, Leo Navratil, Inge Jádi, Michel Thévoz, Elka Spoerri, Vittorino Andreoli, Claude Wiart, and many others, all of whom are more than capable of explaining their own endeavors and motivations. They represent the present and future of this field of investigation. Anyone seeking to deepen his knowledge of this area will, quite naturally, read them in the original.

Among these individuals I would like to single out one who, because I have had the chance to come to know him in person, as well as through his ideas, represents for me a most extraordinary living example of a pioneer or discoverer. In April 1976, I was able to spend some time with Dr. Leo Navratil, director of the Neiderösterreichisches Psychiatric Hospital at Klosterneuburg, outside of Vienna (Fig. C.1). Dr. Navratil (b. 1921) has devoted his life to the study of psychotic art and the psychotic experience. He is one of the foremost contributors to this field in the second half of the twentieth century. Either through the intervention of the muses, or through his unique ability to stimulate

creative activity in deeply psychotic patients, he has managed to surround himself with a group of psychotic image makers of extraordinary ability. I had the privilege of watching him at work among his patients, and experienced something of the creative climate that he is able to evoke, a spiritual environment that renders image making a profoundly serious and valuable form of life activity for these artists. Navratil works with these patients himself, shunning the intervention of art therapists. It is very clear that his patients draw for him, using drawing both as a form of self-validation and communication. Image making is not understood by these people as "therapy" but as their work, the serious activity that gives meaning to their lives.[17]

Dr. Navratil is, with justification, seriously critical of the term, and the concept, of a "psychopathology of expression." In the presence of expressive ability surpassing anything encountered in "normal" individuals, it is preposterous to speak of a psychopathological disturbance of expression.[18] Nevertheless, Navratil is well aware that, in the context of a deep and long-lasting psychotic condition, image making does not serve as a way out of madness. It is used by these individuals rather as a means of ordering the new world in which they will probably remain forever. This awareness has led him to put forward a new term that, despite its cumbersome length, carries real meaning. He refers to works of art produced within the psychotic experience as "zustandsgebundene Kunst" (state-bound art). Much of his intellectual activity during recent decades has been devoted to defining and gaining insight into the nature of this art, produced within the confines of a unique and humanly valuable mental state.[19]

Among the fine draftsmen and printmakers working with Dr. Navratil, the most extraordinary is Johann Hauser (b. 1926), who may well be the most important living psychotic artist. In talking with Hauser, despite the almost insurmountable barrier of language, I sensed that this man sees himself not as an inmate of an asylum, but as an individual uniquely in touch with the deeper levels of himself, and keenly aware of the fact that his vision of the world, his images of his own reality, have meaning and importance to others, allowing him, in spite of his enforced, and probably permanent, residence in a psychiatric hospital, to reach out to other human beings around the world (Plate 25).[20]

In that our investigation of the discovery of the art of the insane set out to explore the implications of this form of art for three groups of people—the patients themselves, their physicians, and, finally, artists who for one reason or another came into contact with these images—this account of contemporary psychotic art in

a hospital in Austria should include a third figure who plays a crucial part in the relationship between the patient Hauser and the physician Navratil: the artist Arnulf Rainer (b. 1929). The most famous of contemporary Viennese painters, Rainer willingly admits to having been deeply influenced by the art of the insane (Fig. C.2).[21] Following in the footsteps of Dubuffet, he established a large and extremely fine collection of psychotic art, containing some five hundred works, most of which originated in Eastern Europe, as well as an extensive library on the subject.[22] His incorporation of elements of psychotic imagery or experience into his work is by no means naive or accidental. These are the masters to whom he turns for inspiration and confirmation.

The friendship that has sprung up between these three men has changed all of them. Dr. Navratil freely admits to being deeply indebted to Rainer for his sharpened awareness of the tremendous artistic signif-

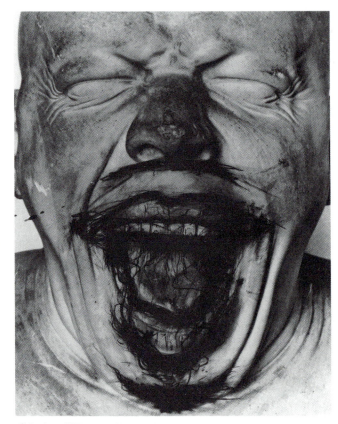

C.2. Arnulf Rainer, *Untitled*, 1975, oilstick on photograph, Galerie Ulysses, Vienna.

icance of psychotic art. Rainer's influence has, in part, freed Navratil from the strictly clinical involvement with the art of his patients, making him responsive, very much in the style of Morgenthaler, to the aesthetic implications of their work.

Rainer has grown through the encounter with Navratil into a deeper awareness of the meaning and inner significance of the images whose beauty so attracts him, a fact that has protected him from the superficial imitation of their surface characteristics. Breaking through the barrier that commonly isolates the insane from the community, Rainer has become a close friend of Johann Hauser. They meet as artists and equals. Hauser has been influenced by Rainer's work, and, in fact, they have even collaborated on drawings. Like Dubuffet, Rainer ranks the art of the insane slightly above his own, and he is therefore proud to hang his work side by side with that of Hauser. A deep and lasting involvement with images reflective of the inner world, our inner world, has united these three men, whose origins and world view are otherwise so different, in an uncommon, and yet shared, voyage of discovery.

THE EXISTENCE of a form of pictorial expression that emerges spontaneously from the psychotic experience has enormous implications for our understanding of all art and artistic creativity. The artist and the art historian are challenged to a far greater degree by these images than is the psychiatrist or psychoanalyst. It is the artist who has had to come to grips with the image-making activity of the insane as art, and who has established its significance outside of the clinical setting.

The discovery of the art of the insane was not merely an intellectual operation. Twentieth-century artists in particular were challenged by this new art, and their own image-making activity changed in response to it. Certainly, the art of this century was influenced by the discovery of the art of the insane. The encounter of artists with this art, and their varying intellectual and pictorial responses to it, is part of the story of its discovery. Artists, unlike scientists, react by doing; discoveries are to be discerned most clearly in their work. In some cases it has been possible to point to clear pictorial evidence of influence from this source. But the primary influence of the art of the insane on modern art is to be found not in superficial formal similarities or coincidences of subject matter, but rather in the increasingly close proximity of these two forms of art, and in terms of the territory they both explore.

The absolute integrity and the pictorial strength that they saw in the art of the untrained insane en-

couraged many modern artists to risk opening up and giving expression to similar areas in themselves. Throughout the nineteenth century, and with vastly increasing speed in the twentieth, the subject matter of the artist becomes increasingly himself. Abandoning all outer pretext or rationalization, he sets out to explore his inner reality and to present it in images that are frequently utterly private and incomprehensible. This movement away from the surface was not the result of the artist's contact with the art of the insane. As I have tried to demonstrate, the discovery of this new art form was merely an outcome of processes occurring in both art and psychiatry that were leading irresistibly toward the encounter with the unconscious.

Once the artist has set out on this journey, it is no longer possible to determine whether the powerful images that result are the product of the encounter with psychotic art, or are derived from the fact that the artist and the madman are voyagers in the same strange landscape of the mind. The world of the unconscious, into which the madman falls and the artist descends, is one world. The images they bring back are for this reason often strikingly similar. The discovery that this was so was vital to modern artists because it served to confirm the success of their perilous journeying. More important, only the fact that they had been "there" enabled them to evaluate correctly, and for the first time, the truthfulness and the supreme value of the images that the insane had been producing for so long. Through an act of recognition, the images of the insane were at last identified as art.

It is inherent in the nature of art that our conception of what art is undergoes constant change and redefinition. The history of art is in the deepest sense a history of humanity's changing relationship to its own images, an account of their varying function in society and in the life of the individual. This century, more than any prior period in history, has extended our understanding of the meaning and purpose of art. The range of images and objects now accepted as art would have been unimaginable and, indeed, unacceptable even at the beginning of the century. The courage needed to bring about this vastly enlarged conception of art has come from the artists themselves. They have forced the issue, and they alone were in a position to do so.

Most art objects are identified as such by their maker—the artist—an observation epitomized by Marcel Duchamp's belief that the artist's selection of any object is sufficient to establish it as art.[23] However, it is undeniable that most images and objects currently accepted as "works of art" and housed in art museums

were not created as art, nor perceived as such by the artist or the society that produced them. An Egyptian Ka statue, or an African ritual mask, were in no sense intended as art. It is also clear that every new form of art has had to go through a period of discovery, often preceded by a period of rejection during which it is firmly stated by those who are supposed to know that it is "not art." For this reason it would be no less valid to reconstruct the "discovery" of Cubism or Impressionism.

The art of the insane, however, provides a striking and extremely important example of the process whereby a form of image in no way intended as art comes to be recognized as a work of art. While the artist seems, at present, to be the only individual in our society capable of initiating this change in aesthetic perception, it is, nevertheless, the object itself that, through time, demands its place in the world of art.

In contemporary society the word *art* has come to possess meanings and implications that seem to obstruct or interfere with the natural and necessary processes of aesthetic response. This interchange between the art object and the spectator, this experience of self-recognition and of enlarged perception, is not assisted by the vast machinery of museums, publications, and interpreters, who claim special knowledge of what art is. It is useful to bear in mind Dubuffet's injunction that one must look for art in unexpected places where the word "art" is not spoken, and to recognize that the meaning of the word is redefined in every generation.

This study has been carried out and is justified by the author's belief that the art of the insane possesses enormous human and artistic significance.[24] It attempts to demonstrate the process whereby many other people have, from different points of view, arrived at the same conclusion. In the twentieth century, as an outcome and further development of attitudes engendered by Romanticism, art has come to be understood as a body of images that serve to interpret one human being to another, and which, by revealing aspects of the artist's and our, more private experience of reality, function as a common ground between the otherwise unattainable and "unsharable" awareness of self. A work of art is an image that says to another human being, "This is who I am and what I feel inside. This is how I perceive the outer world. Have we anything in common?" In terms of such a broad definition, it can be seen that there is no deep gulf between the art of the insane and so-called fine art. The preoccupation of both with a pure and unadulterated statement of inner reality is a response to a deep-seated human need, which in this century has made itself felt with terrifying, and at times dangerous, intensity.

The insistence of numerous contemporary artists, particularly in Expressionist and Surrealist circles, that the art of children and of the insane be accepted as art in the fullest sense of the word has until very recently been ignored, or seen as an effort at paradox or Surrealist posing. However, if Klee's declaration that the art of children and of the insane "is to be taken seriously, more seriously than all the public galleries when it comes to reforming today's art," is, as he suggests, "taken seriously," then it is evident that it carries momentous implications for the student of twentieth-century art, implications that art history and criticism have almost completely failed to take into account in their attempts to construct a history of modern art. Art history as an academic discipline has traditionally confined itself to the study of visual images and objects characterized by the curiously nebulous term "art." Nevertheless, in this century it has shown itself capable of responding to the revolutionary changes in the conception of what art is, by enlarging its field of study to include the "new" areas of primitive art, naive art, and even, to a limited extent, psychotic art. Art historians who specialize in modern art have the responsibility of identifying and characterizing new forms of visual expression as they emerge, and of keeping abreast of events occurring at the cutting edge of the avant-garde. All too often the contemporary art historian is in the embarrassing position of having to wait to be told by the artist, the art critic, or even the art dealer, what is or is not art, before proceeding to study it. The transformation of images created outside of circles normally associated with the production of art, of objects created in the absence of any aesthetic intent, into works of art represents a particularly complex and valuable illustration of this problem. Confronted with these new images, how, and to what extent, will the student of contemporary art prove capable of responding?

The significant symbols of our age are not only to be found within the confines of professionally produced art. The art historian today must abandon the narrow involvement with objects that critics and fashion at any given moment deign to call art, and must include within the scope of research all man-made images: advertising illustrations, photographs, zerography, cartoons, the visual aspects of television and cinema, children's art, pornography and pictorial graffiti, and so on—all the pictorial productions that are the product of humanity's image-making activity and that throw light on the human mind and on society. Such a widening of the field of art historical research is already underway.

For this to be possible, art scholarship (*Kunstwissen-*

schaft) will have to make use of many disciplines not contained within traditional art history, and will have to be open to the development of new fields of art historical specialization. We are inevitably reminded of Roger Fry's observation, "If ever there was a study which, needing as it does the cooperation of so many sciences, would benefit by sharing the life of the university, it is surely that of art history."[25] Having obtained the academic recognition of which Fry spoke, art history has proved surprisingly reluctant to involve itself in interdisciplinary study, or to make use of disciplines such as political science, economics, sociology, anthropology, comparative religion, psychology, and psychoanalysis as a means of extending its scope and depth of penetration into man-made images.

Works of art produced within the highly unusual context of the psychotic experience challenge the ingenuity, and integrity, of anyone wishing to study them, but not to a greater extent than many of the profoundly subjective works of art produced in this century. Serious attempts to understand either of them will involve extensive interdisciplinary study and cooperation. Ernst Kris was the first art historian to respond to the unique demands of this material by obtaining thorough training in psychology and psychoanalysis. It remains to be seen whether other research workers in the field will follow his example. But clearly the investigation of psychotic art, and of the various responses to it entailed in its discovery, necessitates an interdisciplinary approach. A purely art historical discussion of psychotic image making, whether it is understood as art or not, would be impossible.

THIS HISTORICAL enquiry into the discovery of the art of the insane was originally undertaken to account for the fact that, despite having obtained the interest and acceptance of numerous avant-garde artists and critics as a new and important aspect of art, the spontaneous images produced by psychotic individuals had failed to find a place in histories of contemporary art, or in public art museums. Paradoxically, during the course of the investigation, the situation has begun to change. The art of the insane began to enter major public collections of modern art, and enthusiasm for this art is experiencing a strong and surprisingly extensive revival in art circles, largely as a result of the determined efforts of one man, the artist Jean Dubuffet. It remains to be seen whether this public acceptance, this conversion of Art Brut into "museum art" will be to its, or to our, advantage.

This art, like so much of twentieth-century art, requires an environment supportive of its human significance, one that facilitates the encounter between it and the individual in a manner that in no way obscures its meaning. As with "primitive" or tribal art, it benefits little from being reduced to the subject of an exercise in formalist criticism, or the object of aesthetic titilation. The art of the insane is preeminently "painting in the service of the mind."[26] Psychotic art challenges the museum to respond to it by creating a new and unique environment supportive of the deeply private and yet richly evocative and powerful vision of the men and women who created it.[27]

For the artist the question of the survival of the image-making activity of the insane is a matter of supreme importance because it touches on the more general question of the freedom of the individual in our society to create, to be the bearer of images. It came as a great surprise to artists at the beginning of this century to realize that people with no art training, little culture, and no interest in drawing and painting could, seemingly as a result of madness, become image makers of extraordinary ability. Not all of the insane become artists, or use pictorial images as a form of expression and communication; but for the twentieth-century artist it was strikingly clear that some of them possessed spontaneously acquired creative power of which they, as trained painters, stood in awe. Artistic talent, once understood as a rare gift bestowed by the gods, was now seen as a general, but inhibited, possession of all. Driven by inner forces seemingly productive of their own destruction, these madmen began to speak with the tongues of angels. Freed of the necessity of conforming to society's laws and strictures, relieved of the heavy weight of reason and traditional logic, these "patients" became the bearers of a pure art, beside which even the most freely produced images of the professional artist often seemed curiously lacking in strength and integrity.

Despite the progress of psychological insight and understanding in this century, we are no closer to being able to "explain" the occurrence of artistic creativity in the insane artist than we are in the case of the sane. The "schizophrenic master" remains a rare and unexplained miracle. Nevertheless, spontaneous image making within the experience of psychosis raises important questions about the nature of human creativity and the function of image making. For the "normal" artist, it is of fundamental significance that in the absolute extremity of human anguish represented by mental illness, when the mind is overwhelmed by images and emotions, the creative drive can play a part in the struggle to hold on, and to make order out of chaos. Unlike other people, artists experience image making as a matter of terrible urgency, an impulse emerging from the center of their existence. The art of

the insane reminds everyone that art making is not a decorative gesture performed somewhere on the periphery of human existence, but a permanent and deeply important psychic necessity, a fundamental aspect of humanness that continues to function when all else is lost.

For the woman artist, the art of the insane provides confirmation that pictorial creativity is no less integral to the female psyche than to the male. The art of Aloïse may well be the most significant series of images painted by a woman in this century, a profoundly feminine statement created by an individual freed by madness from the confines imposed upon her by education and a narrowly circumscribed social role. Nevertheless, there is some evidence that even in regard to the art of the insane, there has been a tendency on the part of physicians and others to overemphasize the contribution of male patients, with the resultant imbalance visible in this historical study. However, if we include all of the artists presently identified as outsiders, the artists of Art Brut both inside and outside of hospital settings, then we will immediately be struck by the fact that women are at least as creatively active as men, perhaps more so, with many of the finest outsider artists included in their ranks. Free of all obstacles placed in the path of creative women in the world of official art, the female outsider is often driven to create with almost explosive intensity, exemplifying what Michel Thévoz has termed "the creative return of the socially repressed." "One accordingly finds that women get their own back in forbidden spheres which lie outside the cultural domain. They are gifted for Art Brut, just as they are for magic, clairvoyance, mediumism and, more generally, for the exercise of all those irrational powers which a male-dominated society runs down and medicalizes under the sarcastic term of 'hysteria.' "[28] Precisely because they are ignored, and their creative activity not taken seriously, they are uniquely free to give voice, as Outsiders, to all that is within, the numinous images they create, often in secret, providing powerful proof that human creativity is not determined by gender.

Psychotic art also confronts the art educator with serious questions. If untrained schizophrenics can spontaneously produce powerful and convincing statements of almost infinite variety and elaborateness, why must young artists spend years in art schools? Much of the activity imposed upon students of drawing and paint-

ing has little or nothing to do with "unlocking" creativity, and may in fact hinder the young creators' attempt to discover their own voice and language. Far too much image making in our society is being carried out and encouraged in response to a variety of "outer necessities," and in conformity with formulas promoted by teachers, critics, and writers on contemporary art. The art of the insane remains a crucial point of comparison against which an artist can measure her own artistic integrity and commitment. An art that is not produced out of "inner necessity" is still unworthy of the name.

The existence of psychotic art raises questions too concerning the absence of image-making activity in the lives of most "normal" individuals. Intensity of human experience and feeling is not the unique possession of the insane. Has society become so constricting that we must go mad to experience our own depths? It is a tragic circumstance that most of us are profoundly unsure of our own creativity, and willing to leave image making to professionals. A dangerous situation exists when art is reduced to a spectator sport. I am not implying here that Sunday painting should become a universal pastime. "Amateur art" exists only when a trivialized view of art is dominant. Nevertheless, for some individuals the making of "secret images" may yet remain a possible, if dangerous, source of self-knowledge.

More than ever before, we are aware of the fact that the unconscious is the source of numinous images and symbols that possess the power to change us. The artist's most valuable possession is the ability to reach this realm and to emerge from the encounter intact. On the other hand, their knowledge of this inner world has taught us to respect and to value the experience and the contribution of those who do not, or cannot, emerge, for their visions, and the images in which they are embodied, enable us to make contact with otherwise invisible aspects of the deepest layers of our own reality.

Whether we call a person an artist or a madman matters little. In this century the two terms have been curiously interchangeable. What is essential is that the creative freedom of both is maintained and protected, that within our society a way is kept open for those unique and courageous individuals, who, shunning the surface and the light, seek, at the bidding of inner necessity, to descend into the darkness in search of themselves.

Notes

INTRODUCTION

1. Unquestionably, the finest early contribution in this area is Robert J. Goldwater's *Primitivism in Modern Art* (New York, 1967); first published in 1936, its bibliography constituted for many years the most extensive list of studies of the discovery and influence of primitive tribal art. See also John Golding, *Cubism: A History and Analysis* (London, 1968). In recent years a number of important additional contributions to the investigation of the discovery of primitive art have been made. Among these should be mentioned the studies of Paul Stover Wingert, particularly his book *Primitive Art: Its Traditions and Styles* (New York, 1962), and Douglas F. Frazer, "The Discovery of Primitive Art," *Arts Yearbook* 1 (1957); 119–33. In 1984, The Museum of Modern Art in New York staged an exhibition, "Primitivism in Twentieth Century Art," which provided an exhaustive survey of interconnections between modern art of this century and tribal arts. The enormous catalog, the work of William Rubin and his collaborators, surpasses all previous studies of this subject, exploring the problem with such all-encompassing scholarly authority that I can only hope to emulate their thoroughness and insight in carrying out this study in a related field.

2. Goldwater describes in detail the earlier contribution of explorers and ethnologists to the discovery of primitive art and attempts to ascertain the nature and extent of their aesthetic involvement in the objects. The availability of ethnological collections of curios was the prerequisite for the discovery of primitive art by European artists. Gauguin's contribution was limited to the discovery of some examples of Oceanic sculpture. The discovery of African art appears to have begun with the Fauves, particularly Vlaminck and Derain around 1904. The influence of primitive art reached its most intense point in the work of Picasso and the German Expressionists prior to World War I. Golding states, "Negro sculpture and the paintings of Cezanne . . . were to be the two major influences in the creation of Cubism" (*Cubism*, p. 57).

3. The rediscovery of Chinese art can, of course, be traced further back as an aspect of Rococo involvement with Chinoiserie. However this taste for Chinese decorative art and motifs did not result in a change of opinion toward the major arts of China, painting and calligraphy, which were still described in the nineteenth century as the art of an inferior and primitive people unacquainted with such advanced technical accomplishments as perspective and shading.

4. Beginning with the admirable contribution of Wilhelm Uhde (1874–1947), *Henri Rousseau* (Düsseldorf, 1914), a lengthy series of studies devoted to the discovery and development of naive art have appeared. Of particular importance is the work of Oto Bihalji-Merin, *Modern Primitives* (London, 1971), and *The Art of the Naive Painters of Yugoslavia* (Belgrade, 1958). A very extensive study of the origins of the taste for the primitive in both the literature of art and in the visual documents themselves exists in Italian: Lionello Venturi, *Il gusto dei primitivi* (Turin, 1972).

5. Erwin Panofsky, *Renaissance and Renascences in Western Art* (Stockholm, 1960).

6. Georges Braque, quoted in *Arts primitifs dans les ateliers d'artistes* (Paris, 1967), p. 13.

7. Dora Vallier, *Henri Rousseau* (New York, 1962), p. 104.

8. Bernard Dorival, *Twentieth Century Painters*, trans. Arnold Rosin (Paris, 1958), p. 8.

9. The discovery of the art of children in the nineteenth and early twentieth century is a phenomenon in the history of culture and of art that deserves independent investigation. Although the contribution of artists, educators, and psychologists to the discovery and extensive reevaluation of children's artistic activities and products has been studied to a limited extent, the exploration of the historical roots of this subject of investigation still remains essentially untouched, as does the far more elusive problem of the influence of these visual images on the art and artists of the twentieth century. That many artists were significantly influenced by the art of children is no longer disputed. See Robert Goldwater's chapter, "The Child Cult," in *Primitivism*, for the most extensive contribution thus far to the problem. See also George Boas, *The Cult of Childhood* (London, 1966). To some extent, the reception and influence of the art of the insane parallels that of the art of children; however, comparative investigation of their respective histories has convinced me that the motivation underlying the emergence of interest in these areas is quite distinct in each.

10. The term *schizophrenic master* was introduced by Hans Prinzhorn in his famous study, *Bildnerei der Geisteskranken* (Berlin, 1922), but it has never found general acceptance in art historical circles.

11. The word art as used in studies of the art of the insane is employed in various ways. In general it can be said that in earlier sources it implies nothing more than some sort of activity that results in a picture or a sculptural form. The images themselves were at first dismissed as pictorial aberrations unworthy of attention, much less of being termed art.

12. Recently this situation has begun to change. These new developments are discussed in chapter 17.

13. One exception is the Department of Liberal Arts at the Ontario College of Art in Toronto, which offered, for 15 years, several courses dealing with the psychopathology of art and the psychiatric investigation of art. During this period I was employed as Lecturer in Art and Psychiatry, a position unique in Canada.

14. Michel Foucault, *Madness and Civilization* (New York, 1965).

15. A similar situation exists today in the case of prisons and their inmates. Contact with these people is difficult to arrange, and the art of prisons remains essentially unknown and unavailable; only a few serious studies have been published. An important early study is Prinzhorn's *Bildnerei der Gefangenen* (Berlin, 1926).

16. In rationalizing his extensive discussion of the reception of primitive art within the developing science of ethnology, Gold-

water (*Primitivism*, p. xxii) states: "By an analysis of the opinions of ethnologists towards their artistic subject matter, and of the evaluations latent in their discussions, we can determine the relationship of the slowly expanding scientific interest to the sudden fascination of the purely artistic. We shall see that though in isolated instances the scientists appreciated their objects as "art" long before the artists, the general ethnological revaluation was due to the influence of painters and sculptors."

17. Margaret Miller, "Géricault's Paintings of the Insane," *Journal of the Warburg and Courtauld Institutes* 4 (1940–1941): 151–63.

18. The most extensive contribution thus far to the psychiatric history of the study of the art of mental patients is the annotated bibliography prepared by Anne Anastasi and John P. Foley, Jr.: "A Survey of the Literature on Artistic Behavior in the Abnormal: 1. Historical and Theoretical Background," *The Journal of General Psychology* 25 (1941): 111–42. A far more advanced bibliographical tool is provided in the volume published by Norman Kiell, *Psychiatry and Psychology in the Visual Arts and Aesthetics: A Bibliography* (Madison, Wis., 1965). Brief discussions of some of the historical background to contemporary studies of psychopathological art are contained in Hans Prinzhorn, *Bildnerei der Geisteskranken*; in Margaret Naumberg, *Schizophrenic Art: Its Meaning in Psychotherapy* (New York, 1950); in Wolfgang Born, "Art and Mental Disease," *Ciba Symposia* 7 (January 1946): 202–36; and in James L. Foy's introduction to the English edition of Prinzhorn's *Bildnerei der Geisteskranken—Artistry of the Mentally Ill*, trans. Eric von Brockdorff (New York, 1972). See also Maria Meurer-Keldenich, *Medizinische Literatur zur Bildnerei von Geisteskranken* (Cologne, 1979).

19. Until he died in 1975, Dr. Raymond Stites of Washington, D.C., had been working on a study of the historical origins of art therapy; presumably the project was never completed.

20. The struggle for the academic recognition of these new fields of endeavor can be seen as an aspect of the ambivalent reception of the art of the insane within the wider concept of "art." It also offers a curious historical repetition of the long struggle waged by art history itself to obtain recognition as an academic discipline worthy of inclusion as part of the university curriculum. In 1933, in a lecture entitled, "Art History as an Academic Study," Roger Fry attempted to justify the place of art historical studies in the academic community. "If ever there was a study which, needing as it does the cooperation of so many sciences, would benefit by sharing the life of the university, it is surely that of art history, and I would make bold to claim that the benefits it would confer would be at least equal to those it would receive." The science that Fry had particularly in mind was psychology, and his lecture contained several curiously ambivalent references that indicate his conviction that the study of art would make increasing use of the findings of the psychologist. "At many points it [art history] is in close touch with psychology. Sometimes we suspect the psychologists of rather unwarranted intrusions, as when Dr. Freud explained the whole nature of the artist in a small pamphlet some years ago, but in the main it is we art historians who are more anxious to ask questions of the psychologists than they are to give us answers." See "Art History as an Academic Study," in *Last Lectures* (Cambridge, 1939), pp. 1–21.

21. Champfleury, *Histoire de la caricature antique* (Paris, 1965), p. 193.

22. An interesting example is provided by Carl Jung's psychiatric study of Picasso, which first appeared in the *Neue Zürcher Zeitung* of November 13, 1932 (see [New York, 1957], *Collected*

Works 15: 135–41). However, psychiatric mudslinging in the form of pathographical investigation of the lives of artists was well established by the end of the nineteenth century.

23. Representative examples of this tendency within art history and criticism are Hans Sedlmayr, *Art in Crisis* (London, 1957); and Erich Kahler, *The Tower and the Abyss* (London, 1958), and *The Disintegration of Form in the Arts* (New York, 1968).

24. Reference is made here to the art of the hospitalized mentally ill. Individuals whose life experience and thought might clinically be described as psychotic will, I hope, continue to live among us and contribute their graphic and sculptural creations to our society. Experiments with psychomimetic drugs will also continue to permit study of image making in the context of artificially produced psychoses. The problem of image making under the influence of the various hallucinogenic drugs has not been included in this study.

ONE. THE CONFRONTATION: THE ARTIST AND THE MADMAN

1. The epigraph to this chapter is the first stanza of a poem by Hogarth's friend Dr. John Hoadly (1711–1776), engraved beneath the final plate of *The Rake's Progress*.

2. The engravings are based on a series of oil paintings executed by Hogarth in 1734 and now in Sir John Soane's Museum in London. The prints were completed in 1735 and reworked by the artist in 1763. There is an unfinished proof, and two distinct states. I was able to study an impression of the first state in the Print Room of the Princeton University Museum, and the detail photographs were made from this impression.

3. This hospital, the second Bethlem, located in Moorfields, was built in 1674–1676 and torn down in 1816. The design is the work of the amateur architect Robert Hooke (1635–1703). For further information, see Daniel Hack Tuke, *Chapters in the History of the Insane in the British Isles* (London, 1882). The hospital was known as Bethlem Hospital, having been founded by a religious order known as Saint Mary of Bethlem. The word Bethlem soon degenerated into Bedlam, and by the time of Henry VIII *bedlam* was in common use in referring both to madhouses in general and to madmen as well. The hospital still exists as an institution and is known as Bethlem Royal Hospital. The finest contemporary source of information on the history of Bethlem is the hospital archivist Patricia Allderidge. See her publication (with Malcolm Lader), *The SK&F History of British Psychiatry 1700 to the Present*, Smith Kline and French (London, n.d.).

4. "As late as 1815 the Hospital of Bethlem exhibited lunatics for a penny every Sunday. The annual revenue from these exhibitions amounted to almost 400 pounds, which suggests the astonishingly high number of 96,000 visits a year. Ned Ward in *The London Spy* (London, 1700) cites the figure of two pence" (Michel Foucault, *Madness and Civilization* [New York, 1965], pp. 64, 233). Other sources state that the practice of exhibiting patients ended in 1770.

5. The Rake's end was by no means a melodramatic impossibility, in that he might have acquired syphilis, which in time would have resulted in insanity. This outcome, however, would have required more time than Hogarth seems to allow.

6. For a detailed discussion of depictions of insanity in Christian art from a psychiatric viewpoint, see J. M. Charcot and Paul Richer, *Les démoniaques dans l'art* (Paris, 1887). The most extensive study of the depiction of insanity in art through the ages is Sander L. Gilman's *Seeing the Insane* (New York, 1982), which includes discussion of the Hogarth picture.

7. The inspiration for the picture is usually suggested to be the famous satirical poem "Narrenschiff" by Sebastian Brant, published in 1494. However, there is some possibility that the painting predates the poem's publication.

8. It has been frequently claimed that ships loaded with the insane set sail from European cities during the Middle Ages (see Foucault, *Madness and Civilization*, pp. 1–41). This mistaken idea has been corrected by Winifred B. Maher and Brendan Maher, "The Ship of Fools: Stultifera Navis or Ignis Fatuus?" *American Psychologist* 37 (July 1982): 756–61.

9. See Raymond Klibansky, Erwin Panofsky, and Fritz Saxl, *Saturn and Melancholy* (London, 1964), pp. 284–393, for an extensive discussion of the history of depictions of melancholy in the context of the four temperaments, as well as early pictorial representations of the melancholic as an insane person.

10. These stone figures were executed for the entrance gate of Bethlem Hospital around 1670. They were removed to the Guildhall Museum following the move of 1930, but have now been returned to the Museum of the Archives of the Hospital. The two figures were probably inspired by Michelangelo's reclining figures for the Medici tomb. Margaret Whinney has raised the possibility that they were studied from life, describing them as "powerful nudes, horrifying in their realism." Cibber's life experience paralleled that of Tom Rakewell to some extent, in that he was also imprisoned for debt, though not in Bedlam. See Margaret Whinney, *Sculpture in Britain: 1530–1830* (Harmondsworth, 1964). D. H. Tuke (*Chapters*, p. 72) says, "As works of art, the governors and officers cannot but be proud of them. . . . I would here observe that the figure of the maniac is superior to that of the melancholiac, whose expression is rather that of dementia than melancholia. I think that when Bacon in 1820 repaired this statue, he must have altered the mouth, because in the engravings by Stothard, this feature, and perhaps others, are more expressive." The cleaning of these extraordinary sculptural pieces, which involved the removal of many layers of black paint, has made it possible to evaluate Tuke's suggestion. The figures have not been modified by restoration but by the effects of extreme weathering. His observation about the titles traditionally associated with them was perfectly correct. The figure known as Melancholia is in fact more likely to have been a depiction of Dementia, or some form of mental retardation. Sir Alexander Morrison, M.D., in his book *The Physiognomy of Mental Diseases* (London, 1840), provides drawings of both of the figures and discusses the psychological states involved. He also includes a discussion of all of the figures in the Hogarth print. A maquette for *Raving Madness* exists in the Kaiser Friedrich Museum in Berlin. A superb study of the two figures was published by Patricia Allderidge ("Cibber's Figures from the Gates of Bedlam," *Victoria and Albert Masterpieces* [London, 1977]) during the temporary exhibition of the two figures at that museum. This publication includes excellent photographs of the figures and a number of engravings showing them in position on the gates of Bethlem.

11. The frontispiece to Burton's *The Anatomy of Melancholy* (Oxford, 1638) includes representations of Melancholy in the figure of Democritus with his cheek resting on his hand, of the melancholy of the lover, the hypochondriac, the religious madman, and the raving maniac. For a more extensive discussion of nineteenth-century psychiatric classifications, see Karl Menninger and Paul Pruyser, *The Vital Balance* (New York, 1967), appendix, pp. 419–89.

12. Jonathan Swift, *A Tale of a Tub*, 5th ed. (London, 1710), was the first illustrated edition. For an extensive discussion of the illustrations added to this edition of Swift's book, see A. C. Guthkelch and D. Nichol Smith, *A Tale of a Tub*, 2nd ed. (Oxford, 1958), pp. xxv–xxviii. The engravings were the work of two well-known London artists, Bernard Lens and John Sturt. The artist responsible for the original drawings, five of which survive (though not that for the Bedlam picture), has not been identified. Swift, who was a governor of Bethlem, visited the hospital on December 13, 1710, while touring places of entertainment in London. See also Melvin Waldfogel, "Narrative Painting," in *The Mind and Art of Victorian England*, ed. Joseph L. Altholz (Minneapolis, 1976), pp. 159–74; Michael M. Cohen, "Hogarth's 'A Rakes's Progress,' and the Technique of Verse Satire," in *Studies in Iconography* 5 (Murray, Ky., 1979), pp. 159–72; Diane Karp, "Madness, Mania, Melancholy: The Artist as Observer," *Bulletin of the Philadelphia Museum of Art* 80, no. 342 (Spring 1984): 1–22; and Carl Zigrosser, *Medicine and the Artist* (New York, 1970).

13. For a detailed discussion of the meaning of the signs and symbols present in this print, and in particular the explanation of the patient's drawing in terms of contemporary social history, see Ronald Paulson, *Hogarth's Graphic Works* (New Haven, 1965), 1: 169–70, and 2: 126.

14. William Whiston, *A new method for discovering the longitude both at sea and land, humbly proposed to the consideration of the public* (London, 1714).

15. The initials L.E. have been suggested as belonging to the dramatist Nathaniel Lee (1653–1692), who was confined in Bedlam between 1684 and 1689, an identification that seems far less plausible than the association of the drawing with Whiston.

16. Poets and writers too were inspired by Hogarth's print. The best-known literary offshoot is Jonathan Swift's "The Legion Club," which uses a tour of a madhouse to make fun of politicians. The poem, published in 1736, was inspired by Hogarth's view of Bedlam, and in fact mentions Hogarth at length. See "A Character, Panegyric, and Description of the Legion Club," in *The Poems of Jonathan Swift*, ed. William Ernst Browning (London, 1910), 2: 264–71.

17. I am obliged to Ms. Dorothy Stroud, Director of Sir John Soane's Museum, for concerning herself with this problem and arranging for me to study the picture and also sets of photographs made during its recent restoration. Another possible identification of the horned figure is to be found in Jonathan Swift's *Tale of a Tub*, where there is a reference to one of the inmates of Bethlem having, "like Moses, Ecce cornuta erat ejus facies," demonstrating that Swift's account of Bethlem's inmates was a major source for all later depictions of life in Bethlem, including Hogarth's.

18. I was able to examine a copy of this print in the Philadelphia Museum, and the photographs were made from this impression. The print measures about 20 by 26 inches. There does not appear to have ever been a painting of the Narrenhaus, but a detailed pencil drawing without any background exists in the National Gallery in Berlin. For a recent sociohistorical evaluation of this picture, see Werner Hofmann, "D'une aliénation à l'autre: L'artiste allemand et son public au XIXᵉ siècle," *Gazette des beaux-arts* ser. 6, 90 (October 1977): 124–36. Also Rudolf Lemke, *Psychiatrische Themen in Malerei und Graphik* (Jena, 1958). There is, as well, a detailed discussion in Gilman, *Seeing the Insane*, pp. 138–39.

19. Josefa Dürek-Kaulbach, *Erinnerungen an Wilhelm von Kaulbach und sein Haus* (Munich, 1918).

20. Guido Görres, *Das Narrenhaus von Wilhelm von Kaulbach:*

Erläutet von Guido Görres (Koblenz, 1836). See also Johann August Schilling, *Psychiatrische Briefe oder die Irren, das Irresein und das Irrenhaus* (Augsberg, 1863), pp. 387–473 for a detailed discussion of the Kaulbach picture from a mid-nineteenth-century psychiatric viewpoint.

21. That Kaulbach was familiar with the Düsseldorf Asylum during his student years in that city (1822–1826) is further verified by the existence of paintings executed by him in the asylum chapel. See Thieme-Becker, *Künstler Lexicon*, vol. 20. The major murals in the asylum were those of Kaulbach's teacher Peter Cornelius executed ca. 1826. There is an account in Kaulbach's own words of a visit to the asylum in his student years that made an overwhelming impression on him, an impression so powerful that years later in Munich he was still attempting to rid himself of the memory. The picture was the visual result of these experiences. See Dürek-Kaulbach, *Errinerungen an Wilhelm von Kaulbach und sein Haus.*

22. Examination of the various figures in the engraving reveals the very strong influence of Renaissance art without any of the figures being exact copies of specific paintings. In 1835 Kaulbach made his first trip to Italy and the picture probably reflects the intensity of this first exposure to the art that was to become the basis of all of his later work. The most striking of the borrowings is seen in the male figure, who grasps a bunch of weeds in his fist and appears about to spring forward in considerable agitation. He may be derived from the Portinari Altarpiece of Hugo van der Goes, some of whose figures seem similarly excited. Hugo van der Goes too suffered from severe depression, a fact that may have led Kaulbach to identify with him. The figure in the foreground with a wooden baby in her arms may reflect Kaulbach's encounter with the Sistine Ceiling, while the man who stares out of the picture with his head resting on his hand may derive from the Last Judgment in the same room. Other figures bear an affinity to Raphael's *School of Athens* and, less specifically, to depictions of St. John the Baptist (Kaulbach's figure of a man holding a cross and pointing to himself), or to Mary Magdalene (the woman next to that figure whose hair falls in front of her face). It is typical of Kaulbach that no figure is an exact copy of anything, and that Renaissance forms are adapted to new purposes, in this case a completely contemporary depiction of a mental hospital in Düsseldorf. In this work, the intensity of the artist's personal experience of mental illness caused him to surpass his usually dull Renaissance reconstructions, thereby creating one of the most powerful works of his career.

TWO. THE PHYSICIAN AND THE ART OF THE PATIENT

1. The best-known classical graffiti have been collected by R. Garrucci and L. Correra: *Graffiti di Pompei* (Paris, 1856) and *Graffiti di Roma* (Rome, 1895). The term was in fact adopted by archaeologists to refer to markings on ancient monuments of a casual sort, such as scrawls by boys or street idlers, rude drawings, election addresses, and lines of poetry. The most famous ancient example is that generally accepted as a caricature of Christ on the cross, as a donkey. It was found on the walls of the Domus Gelatiana on the Palatine Hill in 1857. Medieval pictorial graffiti are discussed in an excellent book by V. Pritchard: *English Medieval Graffiti* (Cambridge, 1967). The discovery of graffiti is an equally important and little-documented field of historical study. For an excellent discussion of this problem see Aaron Sheon, "The Discovery of Graffiti," *Art Journal* 36, no. 1: 16–22.

2. For a full discussion of the Messerschmidt case, see Ernst

Kris, "A Psychotic Sculptor of the Eighteenth Century," in *Psychoanalytic Explorations in Art* (New York, 1952), pp. 128–50. This case is discussed in greater detail in Chapter 15.

3. Sigmund Freud, "A Seventeenth-Century Demonological Neurosis," in *The Standard Edition of the Complete Psychological Works of Sigmund Freud*, ed. and trans. James Strachey (London, 1956–1974), 19: 72–105. For a critical evaluation of Freud's study, see Roy Porter, *A Social History of Madness: The World through the Eyes of the Insane* (New York, 1987), pp. 83–89.

4. Ernst Kris, "A Psychotic Artist of the Middle Ages," in *Psychoanalytic Explorations in Art*, pp. 118–27. For further information on this case see Richard G. Salomon, *Opicinus de Canistris* (London, 1936), and "A Newly Discovered Manuscript of Opicinus de Canistris," *Journal of the Warburg and Courtauld Institutes* 16, nos. 1–2 (1953): 45–57, and "Aftermath to Opicinus de Canistris," *Journal of the Warburg and Courtauld Institutes* 25, nos. 1–2 (1962): 137–46. See also Paolo Marconi, "Opicinus de Canistris: Un contributo medioevale all'arte della memoria," *Ricerche di storia dell'arte* 4 (1977): 3–36, where Kris's psychiatric diagnosis is questioned. A new manuscript deriving from Opicinus de Canistris has recently been identified in the Vatican library, Codex Vat. lat. 6435. Paolo Marconi, in his book *La città come forma simbolica* (Rome, 1973), p. 105, n. 39, has, on the basis of the study of this manuscript, raised questions concerning the validity of Kris's diagnosis of Opicinus as a psychotic.

5. Philippe Pinel, *Traité médico-philosophique sur l'aliénation mentale, ou la manie* (Paris, 1801). An English edition was published by D. D. Davis, entitled *A Treatise on Insanity* (London, 1806), and this edition has been reprinted in a paperback edition by the New York Academy of Medicine (New York, 1962). I have consulted this edition in preparing my own translations.

6. For a thorough description of the historical importance of Pinel, see Evelyn A. Woods and Eric T. Carlson, "The Psychiatry of Philippe Pinel," *Bulletin of the History of Medicine* 35 (1961): 14–25; and Dora B. Weiner, "The Apprenticeship of Philippe Pinel: A New Document 'Observations of Citizen Pussin on the Insane,'" *American Journal of Psychiatry* 136 (1979): 1128–34.

7. Pinel, "Heureux expédient employé pour la guérison d'un maniaque," in *Traité*, pp. 66–70. English version: sec. 2, chap. 11, pp. 68–72.

8. Pinel, *Traité*, p. 68.

9. Ibid., p. 24.

10. Ibid., p. 201.

11. Pinel refers to "the celebrated Lemoine." In the English edition of 1806 the spelling of the name is changed to Lemoin. Pinel may be referring to the mural painter and decorator François Lemoine (1688–1737), decorator of the Salon d'Hercule at Versailles, as well as the churches of St. Sulspice and St. Thomas d'Aquin in Paris. His pupils included François Boucher and Charles Natoire. However, if Pinel's patient was a student of this Lemoine who died in 1737, the case would be over sixty years old at the time it was written. Possibly Pinel changed the spelling from Lemoyne, in which case he might be referring to Jean Baptiste Lemoyne (1704–1778), official sculptor to Louis XV. This would still push the case back over twenty years.

Another Lemoyne that could be involved is Jean Louis Le-Moyne (1665–1755), the father of J. B. Lemoyne, but this would introduce problems similar to those involved in F. Lemoine. Thus, until I discover another possibility, I am inclined to favor Jean Baptiste Lemoyne, who was after all a sculptor like Pinel's patient. He specialized in portrait sculpture and equestrian monuments. We would then have to suppose that Pinel's patient had

been a student some twenty-three years prior to the date of publication of his case, when Pinel was a young man of thirty-three, hardly an impossibility.

12. Pinel, "Aigreur et emportement d'un aliéné convalescent dont on négligea de seconder le goût primitif pour les beaux-arts," in *Traité*, pp. 203–5.

13. Alexis-Vincent-Charles Berbiguier de Terre-Neuve du Thym, *Les farfadets: Ou tous les démons ne sont pas de l'autre monde*, 3 vols. (Paris, 1821). This detailed description of every event in the life of a paranoid schizophrenic provides an interesting parallel to Freud's Haizmann case. Chapter 70 in vol. 3 is devoted to explaining the subject matter of all of the lithographs.

14. For further discussion of the case, see Eric John Dingwall, *Some Human Oddities* (London, 1947); Alphonse Alkan, *Berbiguier: Un halluciné et son livre, les "Farfadets" ou tous les démons ne sont pas de l'autre monde* (Paris, 1889); Marie Mauron, *Berbiguier de Carpentras* (Paris, 1959); and Jean Vinchon and M. Laignel-Lavastine, *Les malades de l'esprit* (Paris, 1930).

15. Benjamin Rush, *Medical Inquiries and Observations upon the Diseases of the Mind* (Philadelphia, 1812). Reprinted in a facsimile edition by the Library of the New York Academy of Medicine in paperback (New York, 1962). For a brief discussion of Rush's contribution, see Robert E. Jones, "Franklin and Rush: American Psychiatry's Two Revolutionaries," *Hospital and Community Psychiatry* 27, no. 7 (July 1976): 461–63.

16. Rush, *Medical Inquiries*, pp. 153–54.

17. I am grateful to Professor Sander L. Gilman for drawing my attention to the existence of the Nisbett pictures, and to their link with Rush. As he does not indicate the location and number of the pictures he found, it is not possible to determine whether he refers to the same maps and paintings that I discuss here. See Sander L. Gilman, "Madness and Representation: Hans Prinzhorn's Study of Madness and Art in its Historical Context," in *The Prinzhorn Collection*, Krannert Art Museum Catalog (Urbana-Champaign, Ill., 1984), p. 8.

18. I would like to thank Mrs. Linda Stanley, Manuscripts and Archives Curator of The Historical Society of Pennsylvania, for her swift and enthusiastic cooperation in the search for surviving bits and pieces of the life and work of Richard Nisbett.

19. The Rush papers at The Library Company were presented as part of the estate of Benjamin's son, Dr. James Rush (1786–1869). A note on the back of our picture reads "This picture was painted by a man named Nesbit [*sic*] a maniac in the Pennsylvania Hospital, and given to Dr. James Rush by him in the year 1816." Since this was three years after Benjamin's death, it is probable that he never saw this particular example of Nisbett's work. Dr. Gilman has, however, found examples of Nisbett's painting and poetry that he indicates were preserved by Rush: "For Rush, Nisbett's art must have provided some type of opening into the nature of madness or else he would not have preserved it" (Gilman, *The Prinzhorn Collection*, p. 8). I would like to express my appreciation to Mr. Ken Finkel of The Library Company of Philadelphia for locating Nisbett's painting and poetry preserved in this collection and for making photographs available to me for study purposes.

20. A detailed account of the contribution of Mesmer and Puységur is contained in Henri F. Ellenberger, *The Discovery of the Unconscious* (New York, 1970).

21. The most famous of these early accounts of double personality is found in a publication by Eberhardt Gmelin, *Materialen für die Anthropologie* (Tübingen, 1791), where he describes the case of a young German girl who developed a second personality

much the superior of the first. "In 1789, at the beginning of the French Revolution, aristocratic refugees arrived in Stuttgart. Impressed by their sight, a twenty-year-old German young woman suddenly 'exchanged' her personality for the manners and ways of a French born lady, imitating her and speaking French perfectly and German as would a French woman. These 'French' states repeated themselves. In her French personality, the subject had complete memory of all that she had said and done during her previous French states. As a German, she knew nothing of her French personality. With a motion of his hand, Gmelin was easily able to make her shift from one personality to the other."

22. Tuke was a Quaker who reacted strongly to the violence of the mental hospitals of his day. In 1792, under the auspices of the Society of Friends, he opened the York Retreat.

23. Franz G. Alexander and Sheldon T. Selesnick, *The History of Psychiatry* (New York, 1966), p. 112.

24. John Haslam, *Illustrations of Madness: Exhibiting a Singular Case of Insanity and a No Less Remarkable Difference in Medical Opinion* (London, 1810). The edition of 1809 had a different title, *Observations on Madness and Melancholy* and included other material as well. It is regrettable that Victor Tausk did not know of this case when he wrote his psychoanalytic study "On the Origin of the Influencing Machine in Schizophrenia," *Psychoanalytic Quarterly* 2 (1933): 519–56, originally published in German in 1919. This study, which throws a great deal of light on the curious problem of the influencing machine, is essential to an understanding of the Matthews case. For new information on Matthews's case, see Porter, *Social History of Madness*, pp. 54–59.

25. The Bethlem archives contain several pages in Matthews's hand that appear to have formed part of his notebooks. The content of these pages, while not identical with that in Haslam's book, is sufficiently close in style to make it quite certain that Haslam merely transcribed large sections of Matthews's notebooks, simply editing them for his publication. The pages preserved in the archives are numbered 25 through 28.

26. Quoted from the manuscript pages preserved in the Bethlem Hospital archives, and containing information not available in the Haslam book.

27. Ibid.

28. Matthews's case is discussed and compared with a modern influencing-machine case in a recent article by Leo Navratil, "Matthews—Sein Wahn," in *Protokolle 76: Wiener Halbjahresschrift für Literatur, bildende Kunst und Musik* (Vienna and Munich, 1976), 1: 293–314. The case is also discussed in Anthony Masters, *Bedlam* (London, 1977). See also J. E. Meyer and Ruth Meyer, "Selbstzeugnisse eines Schizophrenen um 1800," *Confinia Psychiatrica* 12 (1969): 130–43; D. Leigh, "John Haslam, M.D.," *Journal of the History of Medicine* 10 (1955): 17–43; John Henzell, "Art and Psychopathology: A History of Its Study and Applications," in *The Inner Eye: An Exhibition of Work Made in Psychiatric Hospitals* (Oxford, 1978), pp. 27–34. Henzell agrees in identifying the Haslam book as the source of the first picture drawn by a patient that was reproduced. The problem of influencing machine delusions has generally been understood in the context of the body-image theory of Paul Schilder. See his book, *The Image and Appearance of the Human Body* (New York, 1950). Recently, Gilles Deleuze and Félix Guattari have challenged Tausk's conception of the meaning of the delusion in their book, *L'anti-Oedipe: Capitalisme et schizophrénie* (Paris, 1972).

29. Mesmer conceived of the power he exerted as being a kind

of fluid, which he termed animal magnetism. The fluid could be conveyed to other people in various ways. The fluid existed in several forms—not only as animal magnetism, but also as electricity and as a magnet. His whole conception of the way in which animal magnetism worked was derived from electricity. Mesmer imagined his fluid as having poles, streams, discharges, conductors, isolators, and accumulators. He also invented a machine that very definitely influenced people, though not from a distance. It was called the baquet, and was supposed to concentrate the fluid. In design it was influenced by the recently invented Leyden jar. "In the middle of the room is placed a vessel of about a foot and a half high. It is so large that twenty people can easily sit round it. Near the edge of the lid which covers it, there are holes pierced corresponding to the number of persons who are to surround it. Into these holes are introduced iron rods, bent at right angles outwards, and of different heights, so as to answer to the part of the body to which they are to be applied. Besides these rods there is a rope which communicates between the Baquet and one of the patients." Given the success of this curious machine, Matthews's air-loom begins to sound quite acceptable. This description of Mesmer's Baquet is taken from Ellenberger, *The Discovery of the Unconscious*, pp. 63–64.

30. The term "air-loom," which Matthews insisted was to be found in Chambers's Dictionary under the entry for "loom" is, in fact, found there in a curious metamorphosis. At the end of the brief article on looms, the editor mentions the related term heirloom, and directs the reader to an entry discussing this term. Typical of schizophrenics, Matthews has indulged in a bit of wordplay via clang associations, heirloom being transformed into a new concept, the air-loom.

31. A copy of this handbill and of the first number of *Useful Architecture* is preserved in Sir John Soane's Museum, London. I am grateful to the trustees of the museum for permission to reproduce two of Matthews's engravings.

32. An exhibition documenting the role of Dr. Monro in the development of the English watercolor school was held in 1976 at the Victoria and Albert Museum, London. The catalog was written by F.J.G. Jefferiss, who is presently preparing a biography of Dr. Monro.

33. Bethlem Sub-committee Book, 1805–1814, Archives, Bethlem Royal Hospital, London.

34. Letter from John Haslam to Sir John Soane, January 4, 1826, preserved in Sir John Soane's Museum, London.

35. Detailed descriptions of Matthews's submission and of the complicated procedure for entry are preserved in Matthews's own hand in the archives at Bethlem. Matthews states that he entered the competition at the request of his daughter Justina. Unfortunately, the drawings themselves seem to have been lost.

36. Matthews was moved from Bethlem to a private asylum at Huxton, where he died in 1814.

THREE. GEORGET AND GÉRICAULT: THE PORTRAITS OF THE INSANE

1. The material in this chapter is derived from an unpublished manuscript by the author entitled "In the Face of Death: A Psychological Examination of the Art of Théodore Géricault" (1967), and the brilliant study by Margaret Miller, "Géricault's Paintings of the Insane," *Journal of the Warburg and Courtauld Institutes* 4 (1940–1941): 151–63. See also Jerome Schneck, "Etienne Georget, Théodore Géricault and the Portraits of the Insane," *New York State Journal of Medicine* 78 (1978): 668–71.

2. An extraordinary attempt to account for changes in attitude toward the insane in the context of historical change, and particularly economic development in England, is to be found in Andrew T. Scull, *Museums of Madness: The Social Organization of Insanity in Nineteenth-Century England* (London, 1979).

3. Etienne Georget, *De la folie* (Paris, 1820). For further information on Georget the reader should consult René Semelaigne, *Les pionniers de la psychiatrie française avant et après Pinel*, 2 vols. (Paris, 1930–1932).

4. Karl A. Menninger and Paul Pruyser, *The Vital Balance* (New York, 1967), provides a valuable contribution to the history of the development of nosological systems and attempts to replace them with a far simpler and more pragmatic means of evaluating the degree of disturbance present in individual cases.

5. Franz Alexander and Sheldon T. Selesnick, *The History of Psychiatry* (New York, 1966), p. 138.

6. Karl A. Menninger, *A Manual for Psychiatric Case Study* (New York, 1962), p. 68.

7. *Dictionnaire de la médecine*, vol. 3 (Paris, 1821), s.v. "Ataxie." Georget contributed many of the articles on mental illness to this encyclopedia of medicine.

8. Ibid., vol. 4, s.v. "Catalepsie."

9. Ibid.

10. Ibid., vol. 6, s.v. "Délire."

11. This historical development and the parallel evolution in depictions of psychiatric patients in art is very thoroughly described in Sander L. Gilman, *Seeing the Insane* (New York, 1982), pp. 72–101.

12. Jean Etienne Dominique Esquirol, *Des maladies mentales* (Paris, 1838), p. 167.

13. See Jean Adhémar, "Un dessinateur passionné pour le visage humain: Georges-François-Marie Gabriel," in *Omagiu lui George Oprescu* (Bucharest, 1961), pp. 1–4; also Aaron Sheon, "Caricature and the Physiognomy of the Insane," *Gazette des beaux-arts* ser. 6, 88 (October 1976): 145–50. A sketchbook used by Gabriel at the Salpêtrière in the 1820s is preserved in the Bibliothèque Nationale, Paris.

14. The titles associated with the five surviving paintings are found in the *Catalogue raisonné*, published by Charles Clément in 1868. They are listed as follows: *Monomanie du commandement militaire*, in the Oskar Reinhart Collection, Winterthur; *Monomanie du vol des enfants*, New York, collection of Dr. Leo Gerstle; *Monomanie du vol*, Museum of Ghent; *Monomanie du jeu*, Louvre, Paris; *Monomanie de l'envie*, Museum of Lyons. The five portraits that have disappeared were sold to a Dr. Marechal who lived in Brittany. There is a very good possibility that they will eventually be rediscovered. Various attempts have been made to identify other portraits by Géricault as belonging to the series but with little success.

15. Sir Kenneth Clark, in his book, *The Romantic Rebellion* (London, 1973), pp. 195–97, stresses the enormous importance of these pictures to the development of nineteenth-century European art. See also Germain Bazin, "Géricault: The Hope of an Entire Century," *Connaissance des arts* 340 (June 1980): 80–86.

16. Klaus Berger, *Géricault and His Work* (Lawrence, Kan., 1955), p. 41.

17. A Dr. Savigny, one of the survivers of the Medusa, provided Géricault with extremely detailed accounts of the experiences and appearance of the victims on the raft.

18. This information is contained in a biography of Géricault's friend Charlet, written by Colonel de la Combe: *Charlet, sa vie et ses lettres* (Paris, 1856), p. 19. The seriousness of Géricault's emo-

tional disturbance following the completion of *The Raft of the Medusa* is supported by new evidence brought forward by Lorenz Eitner in *Géricault's* Raft of the Medusa (London, 1972), pp. 57 and 65.

19. Our information on this point is obtained from Géricault's biographer Clément, who states that the artist kept the head of a thief, which he had obtained from the hospital, for fifteen days. During this time he painted and drew a series of representations of it as seen from various angles. See Eitner, *Géricault's* Raft of the Medusa, pls. 85–88.

20. The other four were manie, stupidité, démense, and l'idiotie.

21. The surviving original drawings made in the hospital by G.F.M. Gabriel provide excellent examples of the style of drawing used by an artist in preparation for the engraver. See the very useful plates in Gilman, *Seeing the Insane*, pp. 76–84, where detailed comparison is made between the original drawing style, engravings, and recut engravings used by Esquirol in the various versions of his publications. It is not unlikely that Géricault would have had an opportunity to see the Gabriel studies in Esquirol's collection and the engravings derived from them. In 1838, Esquirol published his major work, *Des maladies mentales*, which included an illustrated atlas with twenty-seven engravings depicting his patients. Some of the engravings were recut versions of the old Gabriel plates, others were new. Significantly, no evidence of influence can be felt from the Géricault portraits of the insane. The artists Esquirol employed for these plates were, if anything, more obscure and less able than Gabriel. The illustrations are signed only by the engraver Ambrose Tardieu. The first plate depicting an epileptic is identified as the work of an artist by the name of Desmaison. In one case, a drawing of a family of idiots, the artist was a man of some reputation, M. Roques de Toulouse, the teacher of Ingres. In general, the Esquirol engravings, while conveying an unforgettable impression of an early nineteenth-century mental hospital, are inevitably weak and anecdotal when compared with the portraits of the insane by Géricault.

22. The studies of Duchenne de Boulogne were published under the title: *Mécanisme de la physionomie humaine ou analyse électro-physiologique de l'expression des passions* (Paris, 1862). For further information on this collaboration, see André Jammes and Robert Sobieszek, *French Primitive Photography* (New York, 1970). For extensive information on the early use of photography in physiognomic study of the insane, see Gilman, *Seeing the Insane*, pp. 164–91.

23. Forbes Winslow, "Mad Artists," *Journal of Psychological Medicine and Mental Pathology* n.s. 6 (1880): 33–75. We will return to Forbes Winslow's contribution in chapter 11.

24. Ibid., pp. 33–35.

25. It is by no means a foregone conclusion that Géricault should have reacted to his own psychological difficulties by developing a more open and understanding attitude toward mental illness. He might have responded in a variety of very different ways. However, study of the biographical material relevant to this problem has led me to the conclusion that certain artistic preoccupations of Géricault, particularly during the last years of his life, were the result of deeper insight brought about in the artist by intense psychological suffering.

26. Alexander and Selesnick, *The History of Psychiatry*, p. 3.

27. Berger, *Géricault and His Work*, p. 38.

28. Proof that the portraits supply no easy means of identification is supplied by the repeated and unconvincing efforts to identify the five missing pictures in various other portraits by, or attributed to, the artist.

29. It is particularly interesting to compare this portrait of a woman, known at the hospital as la Hyène, with Gabriel's engraving of the demonomaniac who, at first glance, might almost be the same woman a few years earlier, but whose image lacks any profound sense of inner mental activity or of menace.

FOUR. JONATHAN MARTIN OF BEDLAM

1. I am indebted to Miss Patricia Allderidge, archivist of Bethlem Royal Hospital, for drawing my attention to this case and to the surviving drawings; and to the principal collector of Jonathan Martin's drawings, who wishes to remain anonymous, but whose kindness and hospitality added to the pleasure of long hours spent in contemplation of Martin's work and ideas.

2. In the case of James Matthews, it must be remembered that his work was preserved only because it was reproduced in books. No original examples of his drawings are known to survive. In contrast, Jonathan Martin's work was never reproduced in his own day.

3. The building, erected in 1812–1815 in St. George's Fields, still exists, although it has been much truncated. The wing that housed the criminal lunatics was, however, demolished. What is left of the building now houses the Imperial War Museum, all evidence of its original function having been obliterated.

4. The innovations introduced in 1815 were derived quite specifically from Pinel's example and represent the first clear indication of his influence at Bethlem.

5. See chapters 2 and 8 for further references to Dr. Edward Thomas Monro and his family, and their extensive involvement with art and artists, both sane and insane.

6. "He makes handsome straw baskets; which he is permitted to sell to visitors, and for which he obtains from 3 shillings to 7 shillings each." See *Sketches in Bedlam: or Characteristic Traits of Insanity as displayed in the cases of one hundred and forty patients of both sexes, now, or recently, confined in New Bethlem. By a constant observer* (London, 1823), p. 18. Hatfield's unsuccessful attempt on the life of King George III led to significant changes in the handling of the violent insane. See Andrew T. Scull, *Museums of Madness* (London, 1979), p. 55.

7. In terms of the development of the neurological orientation that was to dominate psychiatry so oppressively in the 1860s and later, it is of interest that the physicians at Bethlem sought to penetrate beneath the face. After Martin's death an autopsy was performed in the hope of discovering some telltale sign of his mental condition in the brain itself. Record of the Autopsy of J. Martin, The Surgeon's Book, Bethlem Archives.

8. Norah Gillow, "Jonathan Martin: Life and Drawings," *York City Art Gallery Bulletin* 24 (1971): 859–63, indicates what she feels are visual traits of mental instability evident in Brown's portrayal of Jonathan. "Brown's interest in the strange dual personality of Martin's character is summed up in his portrayal of the face, framed by its bushy red side whiskers. The thin lips, finely bridged nose and averted gaze give an air of almost aristocratic hauteur, but this apparent composure is belied by the high flush of the cheeks, indicative of Martin's easily excited and unstable nature, again emphasized in the modelling round the mouth and eyes suggesting the underlying tension and fanaticism."

9. From the transcript of Martin's trial: "Question: 'I need hardly ask you, whether persons acquainted with medical sub-

jects of this sort, look to the eye of the patient as a test of their state of mind?' Answer: 'The eye is frequently observed certainly, and the countenance generally.' " Frazer, *Report of the Trial of Jonathan Martin* (London, 1829), p. 66.

10. The inscription appears on the front face of the drawing, and is in Martin's handwriting. The self-portrait is only a detail from a larger picture, but a full discussion of its various themes is beyond the scope of a brief study.

11. York Minster, one of the masterpieces of English Gothic, was not fully destroyed. The fire consumed much of the choir, the organ, and 131 feet of the roof. Restoration began almost at once, and no evidence of the fire is now visible in the church. In July 1984, the Cathedral was again severely damaged by fire, this one of natural cause, lightning.

12. Jonathan Martin, *The Life of Jonathan Martin of Darlington, Tanner*, 3rd ed. (Lincoln, 1828), p. 53. All further references are to this edition unless specifically indicated.

13. The first edition of *The Life of Jonathan Martin* appeared in 1825 and sold some five thousand copies. The second edition appeared in 1826, and is of importance to us in that it was "improved" by the addition of three engraved pictures illustrating Martin's adventures. A third edition appeared in 1828. Each of the editions contains slightly different material, particularly as regards Martin's accounts of his early life.

14. Martin, *The Life*, p. 12.

15. Ibid., p. 23.

16. From the transcript of Martin's trial (Frazer, *Transcript*, p. 65): "Question: 'In the first place, I would ask you, what appears to be the state of his mind?' Answer: 'I consider him to be what is denominated a "monomaniac." ' Question: 'Just state, for the information of the jury, what that is.' Answer: 'It is a degree of species of insanity, that can be confined to one idea only, or to one train of ideas, upon one particular subject.' " The physician being interviewed was Caleb Williams, a surgeon in the city of York, and physician to the lunatic asylum known as "The Friend's Retreat."

17. Quoted in the *Yorkshire Gazette*, Saturday, March 28, 1829, p. 1.

18. Ibid., p. 3, col. 2.

19. Martin, *The Life*, 1st ed. of 1825 only, p. 12.

20. Ibid., p. 12.

21. Martin, *The Life*, p. 14.

22. Ibid., pp. 20–21.

23. Letter written at Stockton, March 16, 1829, and produced by Martin's defense counsel at his trial. Author unknown. Reproduced in Frazer, *Transcript*, p. 89.

24. *York Herald*, April 11, 1829, p. 2, col. 5.

25. *Yorkshire Gazette*, Saturday, April 18, 1829, p. 2, col. 6.

26. *Casebook on Criminal Lunatics*, Bethlem Archives, entry 181. The letter of admission committing Martin "at the King's pleasure" to Bethlem Hospital also survives, but provides no additional information.

27. In the Bethlem Hospital Sub-committee minutes of Thursday, May 20, 1830, there is a reference to an escape attempt by Martin. "Jonathan Martin, belt and gloves and wrist locked and leg locked at night attempting his escape on the 14th." Because of his training in the navy, Martin's potential as a possible escapee was taken very seriously.

28. This inscription appears on the back of the self-portrait drawing discussed earlier. It dates to May 1829.

29. Information included in Martin's obituary in the *Times* (London), June 7, 1838, p. 6, col. 3.

30. A total of ten original drawings are presently known to the author: one in the York City Art Gallery, four in a private collection in London, three in the Library of York Minster, and one in a second private collection in London. A tenth, small drawing by Martin has recently been given to the Bethlem Royal Hospital Archive. The author is deeply interested in obtaining information about any further Martin drawings.

31. This drawing is presently housed in the Library of York Minster.

32. Letter of May 31, 1838, from Richard to Jonathan's brother William. Quoted in Balston, *The Life of Jonathan Martin, Incendiary of York Minster* (London, 1945), pp. 101–2. The letter was originally published in the *Newcastle Chronicle* by William Martin. The location of the drawing described by Richard is not known.

33. *The Monthly Magazine* 15 no. 87 (March 1833): 244–49. Reproduced in Balston, *Jonathan Martin*, pp. 98–100.

34. Balston, *Jonathan Martin*, pp. 98–99.

35. Ibid., p. 100.

36. Ibid., p. 99.

37. Ibid., pp. 99–100.

38. From the transcript of Martin's trial (Frazer, *Transcript*, p. 55): "Question: 'Did you ever hear him talk as to dreams?' Answer: 'Many times.' Question: 'Did you ever hear him say anything as to those dreams?' Answer: 'I think one day he said to me, "Master, I dreamt that Bonaparte's son is bound to take England," that he was to land between Sunderland and Newcastle, and if England did not repent, it would be conquered.' Question: 'Did he say how he was bound to act upon his dreams?' Answer: 'It was his impression that when he dreamt of anything at any time, that thing was to be accomplished, and that it was his duty to do so.' Question: 'Did these dreams appear to make a strong impression on his mind?' Answer: 'Very much so.' "

39. Martin's interest in dreams was evidently shared by his keepers in Bethlem, whose dreams Martin occasionally interpreted and recorded. For this reason, the case is of enormous interest to the psychoanalytically trained reader; however, it has never been examined in this light.

40. Martin, *The Life*, p. 62.

41. Napoleon I had only one son, François Charles Joseph Bonaparte, Duke of Reichstadt (1811–1832), known as Napoleon II. Napoleon III was, of course, not a son but a nephew of Napoleon I. It is not clear whether, after the death of the son of Napoleon, in July of 1832, Jonathan Martin continued to entertain his delusional belief in the imminent invasion of England.

42. H. Bellerby, *A Full and Authentic Report of the Trial of Jonathan Martin, with an Account of the Life of the Lunatic* (York, 1829), p. 35.

43. Two editions of *The Life* were illustrated with three plates: the second edition, of 1826, with engravings on copper, and the third, of 1828, with wood engravings. It would appear that the copper engravings were the work of Jonathan Martin's brother William, who is known to have studied engraving, and who did the plates for his own very numerous publications in a style identical to those in Jonathan's *Life*. The woodcuts in the edition of 1828 are identified on the title page as "engraved by the author," and their quality leaves no doubt that Jonathan did them himself. As the original drawings, on which the engravings were based, do not survive, it is not absolutely certain whether William or Jonathan was responsible for the original design of the illustrations for the autobiography. However, as their content is typical of Jonathan's thinking, and the style of the compositions

not unlike the autograph drawings we possess, I have attributed the drawings in *The Life* to Jonathan, William having acted as engraver in 1826, but not artist.

44. *Yorkshire Gazette*, Saturday, April 4, 1829, p. 2, col. 4.

45. Heinrich Wölfflin, *Principles of Art History*, trans. M. D. Hottinger (London, 1932), p. 11.

46. The inscription appears on the front face of the drawing. I have corrected the spelling.

47. I am grateful to Mr. John Ingamells, Curator of the York Art Gallery, for arranging for the second version of the drawing to be borrowed from the library of York Minster so that the two drawings could be examined together, revealing, for the first time, that the one is a tracing copy of the other, and making strikingly evident the extent to which the two drawings nevertheless differ in style.

48. In most cases the provenance of Martin's drawings is not known. In the case of the York Art Gallery drawing, a letter survives in its archives that describes the history of the drawing as it descended through various hands. On the drawing itself is the note, "Given to me by Mrs. Maria Martin the wife of Jonathan Martin this 27th. day of April, 1829, the day on which he was removed to London. F. Hen. Anderson." The letter, dated May 1, 1937, was written by J.J.A. Dale. "Subsequent to the trial Mrs. Martin gave Martin's advocate a pen and ink sketch of Samson slaying the lion with the debtors' prison as a background. Martin's brother was I believe an artist of some note but Martin himself is but crude in this pen and ink work. However, the picture was passed down the generations and ultimately the late Mr. F. H. Anderson had it framed and gave it to my father."

49. Inscription from the front face of the drawing known as *London's Overthrow*.

50. William Martin was no less mentally ill than his brother. He was never hospitalized and retained sufficient control over his behavior to avoid contact with the law. Living for most of his life in Newcastle, he was a celebrated local landmark. "Wearing a tortoise shell mounted with brass as a hat, and a military surtout buttoned up to the throat, he paraded the principal streets of Newcastle continually, and hawked his pamphlets to passersby. If anyone spoke to him, he lifted his head-dress with a flourish, and said, 'Gratified to meet you, Sir, I am the Philosophical Conqueror of All Nations, that is what I am, and this is my badge.' He then threw open his surtout, and revealed a medal as large as a saucer hung round his neck" (Balston, *Jonathan Martin*). In his early life William demonstrated undeniable brilliance as an inventor. Balston, who has studied the lives of all four of the Martin brothers extensively, is of the opinion that his mental deterioration became pronounced at the time of Jonathan's trial. In that year he published his pamphlet, "William Martin's Challenge to the Whole Terrestrial Globe as a Philosopher and Critic and Poet and Prophet." Although William had some artistic training, most of his creative power found expression not in drawing but in poetry. One of his poems, which celebrates the burning of York Minster, characterizes Jonathan in an image that confirms the identification with the lion. "Martin has rushed out on a sudden, like a lion from his den."

51. William Martin, *A Short Outline of the Philosopher's Life* (Newcastle, 1833). The autograph inscription appears in a copy of the pamphlet owned by the British Library.

52. Jonathan Martin's truthfulness is absolute and can be trusted. Whether he was actually visited by the Duke of Orleans, or was simply told that one of his visitors was the Duke, is not known. He was visited by numerous members of the aristocracy and the illustration may well record an historical encounter.

53. As early as 1923, Mary L. Pendered had published a book on John entitled *John Martin: His Life and Times* (London, 1923). It contained a brief description of Jonathan, but no references to surviving pictures by him. Thomas Balston has also published a book on John, *John Martin: His Life and Works* (London, 1947), as well as publishing a complete biographical study on Jonathan Martin that included the first reproduction and discussion of a drawing. In recent years William Feaver has done most to refurbish John Martin's reputation, though his recent book, *The Art of John Martin* (Oxford, 1975), fails to discuss the relationship between the art of the two brothers. See also Christopher Johnstone, *John Martin* (London, 1974).

54. Martin, *The Life*, title page.

55. Martin's poetic and pictorial preoccupation with cataclysm has found embodiment in terms of the more scientific concerns of the twentieth century in the vision of Immanuel Velikovsky. For a discussion of the psychological implications of the psychotic preoccupation with world destruction, see my paper "Psychological Aspects of the Work of Immanuel Velikovsky," in *Recollections of a Fallen Sky*, ed. E. R. Milton (Lethbridge, Alberta, 1977), pp. 45–66.

56. The imagery of the underworld is most clearly embodied in Martin's marvelous illustrations of Milton's *Paradise Lost* (London, 1827).

57. John's proud boast is quoted in Feaver, *John Martin*, p. 49, while Jonathan's remark was quoted in the *Yorkshire Gazette* of Saturday, March 28, 1829, p. 1.

58. The incident is described in the *Yorkshire Gazette*, Saturday, March 28, 1829, p. 3.

59. Haydon was reacting to John's mezzotint illustration of The Creation. *The Diary of Benjamin Robert Haydon*, ed. W. B. Pope (Cambridge, Mass., 1960–1963), 3: 10–11.

60. S. C. Hall, quoted in Balston, *John Martin: His Life and Works*, p. 159.

61. The series of mezzotint engravings was begun in 1825, and published in 1827: *The Paradise Lost*, with illustrations, designed and engraved by John Martin (London: Septimus Prowett, 1827).

62. Jonathan's debt to the Hogarth painting, probably via the engraving of 1767, was discovered by David Bindman, and discussed briefly in his article, "Hogarth's 'Satan, Sin and Death' and its Influence," *Burlington Magazine* 112 (1970): 153–59, where Jonathan's drawing is reproduced. How Jonathan obtained a copy of the engraving is not known, but the close similarity between Hogarth's picture and Jonathan's drawing would suggest that he had the Townley engraving available as a model.

63. From an inscription on the front face of the picture.

64. From an inscription on the front face of the drawing, *London's Overthrow*.

65. Ibid.

66. The depiction of modern cities and buildings in ruins or decay was not unknown to the Romantic imagination. The American painter Thomas Cole (1801–1848), a follower of John Martin, in a series of paintings entitled *The Course of Empire* (1836), depicted the stages in the decay of a great city of the past. Much earlier the French painter Hubert Robert (1733–1808) depicted the Great Gallery of the Louvre in a state of ruin (ca. 1796). Emerson, recognizing the moral lesson inherent in John's visions of destructions past, said, "Martin's pictures of Babylon are faithful copies of the west part of London, light, darkness, architec-

ture and all." Letter to Lucia Emerson October 27, 1847, in *Letters of Ralph Waldo Emerson* (New York, 1939), 3: 425.

67. Inscription on the reverse side of the drawing.

68. Descriptive catalog of the picture of *The Fall of Nineveh* by John Martin (London, 1828).

69. *The Fall of Nineveh* was exhibited in 1828. Prior to this, and after, Jonathan could have studied the original in John's studio. However, so closely does he follow the details in the picture that we must suppose he had a copy of the print available to him. This presents some problems. Jonathan's drawing bears two separate dates, neither referring specifically to the drawing. On the verso is an enormously long mathematical calculation of the money Jonathan felt the British government owed him. The date is June 26, 1830. On October 20, 1830, he recorded two dreams. John's print was published in July 1830. Possibly Jonathan received an artist's proof sometime prior to the date of publication, or the drawing was done on the back of a piece of paper used earlier for other purposes.

70. The fact that Jonathan's sky is reminiscent of the later Van Gogh skies should not immediately be assumed to indicate similarities of underlying psychopathology. Van Gogh's sophistication as a professional artist may well have led him to similar motifs and compositional devices for very different and nonpsychological reasons. For an art historically based discussion of this problem, see Patrick A. Heelan, "Toward a New Analysis of the Pictorial Space of Vincent Van Gogh," *The Art Bulletin* 54 (December 1972): 478–92; and John L. Ward, "A Reexamination of Van Gogh's Pictorial Space," *The Art Bulletin* 58 (December 1976): 593–604.

71. Inscription on the front face of the picture.

72. Letter of May 28, 1838, from John Martin to Mr. Nicholls of Bethlem Hospital. Entered in the Bethlem Sub-committee minutes of June 1, 1838. May 28 was the date of Jonathan's death.

73. It is known that John reacted to his brother's death and to the suicide of his nephew Richard with obvious signs of psychological disturbance. An account of this difficult period in his life as described by his wife to a family friend survives. "Martin, she fears, may go out of his mind, and she is afraid to speak to him. She cannot endure much longer such distress and anxiety. He is sullen and will not speak to her or anybody." Jonathan's son Richard lived only three months longer than his father, killing himself in the belief that his breath was turning the members of John's family, with whom he lived, black—a clear indication of deeply repressed but active hostility in his attitude toward them. Richard was also a painter, trained by his uncle.

74. It is probably not a coincidence that John Martin stopped painting almost entirely between 1829 and 1838. On the other hand, he was deeply preoccupied with elaborate plans for the rebuilding of London, and he continued to work as an illustrator completing his illustrations of the Bible during those years. What had disappeared almost entirely was his involvement with urban destruction. This reappeared in its most violent form only in 1852 with the most impressive picture of his career, *The Great Day of His Wrath*, a depiction of the end of the world. This picture is discussed in L. R. Matteson, "John Martin's *The Deluge*: A Study in Romantic Catastrophe," *Pantheon* 39 (July 1981): 220–28.

FIVE. INSANITY IN THE CONTEXT OF ROMANTICISM

1. H. W. Janson, *History of Art* (New York, 1962), p. 453.

2. Marcel Brion, *Art of the Romantic Era* (London, 1966), pp. 7–9.

3. Robert Rosenblum, *Transformations in Late Eighteenth Century Art* (Princeton, 1967), p. vii.

4. Fuseli quoted in Peter Tomory, *The Life and Art of Henry Fuseli* (London, 1972), p. 85.

5. Johann Caspar Lavater, *Physiognomische Fragment zur Beförderung der Menschenkenntnis und Menschenliebe*, 4 vols. (1775–1778); English edition, *Essays in Physiognomy: Designed to Promote the Knowledge and Love of Mankind* (London, 1789–1810), 5 vols.

6. Lavater, *Physiognomy*, 2: 288. The plate is included in a very extensive discussion of Fuseli's work and character covering some fifteen pages and including engravings of several of his drawings and paintings. The drawing is indexed under the heading "Madmen." The complete engraving was not used in the original German edition, which included only the right half. Interestingly, William Blake also collaborated with Lavater on this publication as designer and engraver. For further discussion of Blake's involvement with the depiction of madness, see Sander L. Gilman, *Seeing the Insane* (New York, 1982), pp. 120–23. Lavater's relationship with Blake has been investigated by Anne K. Mellor, "Physiognomy, Phrenology, and Blake's Visionary Heads," in *Blake in His Time*, ed. Robert N. Essick and Donald Pearce (Bloomington, Ind., 1978), pp. 53–74.

7. Edmund Burke, *A Philosophical Enquiry into the Origin of Our Ideas of the Sublime and the Beautiful* (London, 1958), pp. 38–39.

8. *Blake: Complete Writings*, ed. Geoffrey Keynes (London, 1972), pp. 548–49. For a brief discussion of Blake in relation to insanity, see Roy Porter, *A Social History of Madness: The World through the Eyes of the Insane* (New York, 1987), pp. 64–65.

9. Letter to Farington, April 2, 1804. Tomory, *Fuseli*, p. 110. Tomory suggests that Fuseli's medical knowledge may have been supplied by his two close medical friends, Drs. Armstrong and Carrick-Moore.

10. John Milton, *Paradise Lost* (New York, 1962), p. 278. Frederick Antal suggests that Fuseli was influenced in the creation of this drawing by Hogarth's print. He warns us, "It would be unwise to exaggerate the degree of Fuseli's realism in depicting mad people. Looking at these figures in the *Madhouse*, and even more at his picture of *Mad Kate*, an illustration to Cowper's *Task*, it is at once apparent that Fuseli's conception was on the whole literary and somewhat schematic." See Frederick Antal, *Fuseli Studies* (London, 1956), p. 122.

11. Cowper, one of the most widely read English poets of his day, suffered throughout his life with recurring attacks of mental illness and had to be hospitalized repeatedly. *The Task* was written in 1785 while he was recovering from a period of insanity. For other illustrations of Cowper's poem in English art, see Gilman, *Seeing the Insane*, pp. 126–27. The more tragic story of poet John Clare (1793–1864) is told in Porter, *Social History of Madness*, pp. 76–81 (Porter also explores the case of Cowper on pp. 93–102).

12. Music too reveals a preoccupation with madness and its diagnostic categories, and in seventeenth-century England the "mad song" became very popular. "The English have more songs on the subject of madness than any of their neighbours," according to Bishop Percy. There were two types. In one the subject is represented as genuinely distracted by grief or disappointed love—for example, the famous song "Mad Bess of Bedlam" by Henry Purcell (1659–1695). In the other type, for dramatic or

comic purposes the subject performs "all the different degrees of madness"—Purcell's song "From Rosey Bow'rs," in which the whole range of madness is included: "sullen mad, mirthfully mad, melancholy madness, fantastically mad, and stark mad." In the nineteenth century these songs developed into the full-scale impersonations of madness found in opera; for example, Donnizetti's "Lucia di Lammermoor," written in 1835, the same year as Kaulbach's painting.

13. Werner Hofmann, *The Earthly Paradise: Art in the Nineteenth Century* (New York, 1961), p. 263.

14. Don Bernardo de Iriarte was Vice Protector of the Royal Academy of San Fernando in Madrid. There were three letters to him dated January 4, 7, and 9, 1794. The original letters are now in the British Museum, Department of Manuscripts.

15. Letter of January 4, 1794 to Don Bernardo. The letter is reproduced and translated in full in Pierre Gassier and Juliet Wilson, *Vie et oeuvre de Francisco Goya* (Fribourg, 1970), p. 382. It is occasionally suggested that Goya may have been influenced in his choice of subject by knowledge of Hogarth's engraving of the same subject. In the inventory of Goya's collection made in 1812, there is a reference to English prints. However, there is no visual evidence in the painting suggestive of such influence.

16. Ibid., p. 382, letter of January 7, 1794. The description of the painting in this letter makes it very clear that the picture could not be the one usually known as *The Madhouse*, which is presently in the Academy of San Fernando, yet for generations it has been customary to reproduce this painting and associate it with the letter of January 4, ignoring the letter of January 7. It was always known that the style of *The Madhouse* was that of Goya between 1808 and 1819. Xavier de Salas has recently collected documents indicating that the painting referred to is the *Corral de locos* in the Meadows Museum, Dallas. It forms part of a group of small paintings on tin plate. The *Corral de locos* exactly corresponds to Goya's description. See Gassier and Wilson, *Goya*, pp. 109–12.

17. For a detailed discussion of Goya's illness, see James L. Foy, "The Deafness and Madness of Goya," *Psychiatry and Art* 3 (Basel, 1971): 2–15; and Terence Cawthorne, "Goya's Illness," *Proceedings of the Royal Society of Medicine* 55 (1962): 213–17.

18. Although it is not likely that Goya was suffering from syphilis, it is very probable that both he and his physicians thought that he was. There is a letter in which it is implied that he blamed his own foolishness for his illness. If Goya believed he had contacted syphilis, he would have anticipated dying insane. Letter from Martin Zapater to Francisco Bayeu, March 30, 1793: "Pour Goya, comme je te l'ai dit, c'est son peu de réflexion qui l'a amené là."

19. "Interest in asylums may also have been fostered by the fact that during the Romantic period numerous mental institutions were opened and began to be headed by specialized physicians who lived constantly with their patients. . . . Some of these asylum physicians were strongly influenced by the Romantic tide." Henri F. Ellenberger, *The Discovery of the Unconscious* (New York, 1970), pp. 210–11. Examination of the asylum paintings of the period indicates that they do not reflect such new hospitals, but portray types of hospitals that had existed well before the onset of Romanticism. The most primitive of all are, of course, the Goya paintings that reflect conditions that have existed for centuries. For pictures portraying the innovative hospitals introduced during the Romantic era, one would refer to psychiatric reports and texts of the period. For a useful discussion of the differences between Hogarth's conception of the madhouse,

often pointed to as the source for Goya's painting, see Fred Licht, *Goya: The Origins of the Modern Temper in Art* (New York, 1979), pp. 199–202; and Lorenz Eitner, "Cages, Prisons, and Captives in Eighteenth Century Art," in *Images of Romanticism*, ed. Karl Kroeber and William Walling (New Haven, 1978), pp. 13–38.

20. Heinrich Heine, writing on an exhibition of pictures in 1833. Quoted in Hofmann, *Nineteenth Century*, p. 96.

21. An interesting attempt has been made by the Spanish critic Gregorio Marañon to demonstrate El Greco's involvement with the insane, and his use of the mentally ill as models for religious figures. He has found records proving that El Greco visited the asylum in Toledo on numerous occasions.

22. A brilliant discussion of the self-imposed stigma of madness on the part of the Romantic artist is to be found in George Becker, *The Mad Genius Controversy: A Study in the Sociology of Deviance* (Beverly Hills, Calif., 1978). As Becker points out (p. 64), "It seems clear that the association that has held the rank of scientific fact during the 19th and much of the 20th century is, in no small measure, the result of pronouncements made in support of this association by numerous men of genius."

23. The attribution of this statement to Goya is tenuous. It appears on the Prado manuscript and in a slightly different version in the López de Ayala manuscript. Eduardo Carderera, to whom the Prado Manuscript once belonged, wrote at the top of the manuscript, "Explanation of Goya's Caprichos written in his hand." However, although the handwriting reflects an early nineteenth-century style, the handwriting of the captions is not Goya's. Canton suggests they may be inventions of the playwright Leandro Fernández de Moratin. For our purposes the quotation is significant whether or not it was written by Goya, provided it dates to the early nineteenth century, in that it reflects contemporary attitudes to the respective roles of imagination and fantasy in the creation of art and madness. For further information, see Eleanor A. Sayre, *The Changing Image: Prints by Francisco Goya* (Boston, 1974), pp. 54–61 and 98–105.

24. Hofmann, *Nineteenth Century*, p. 262.

25. Quoted in Rudolf Wittkower and Margot Wittkower, *Born under Saturn* (London, 1963), p. 99.

26. Ibid., p. 100. "The notion of the 'mad artist' is a historical reality and by brushing it aside as mistaken, one denies the existence of a generic and deeply significant symbol." Wittkower here allies himself with Carl G. Jung in his insistence on psychological realities that, whether objectively true or not, exist and must be taken into account in that as symbols they possess enormous power to mold the world. For centuries artists have had to exist within the climate of opinion created by this illusion; they have been motivated by it, and it has affected their art and lives very deeply. To simply reject history in light of more modern psychological theory is not acceptable for the historian or for the psychologist. As we have seen, the idea of the insanity of genius is still very much alive for many people. For a detailed history and analysis of the genius–insanity theory, see Becker, *The Mad Genius Controversy*. Becker, a sociologist, has maintained an astonishing degree of objectivity in his analysis of the mechanisms at work within the evolution of this odd, but potent, idea.

27. Plato, *Ion*, 533, 534, and 535, respectively, in *The Dialogues*, trans. Benjamin Jowett (New York, 1920). All further references to *The Dialogues* are to this edition.

28. Plato, *The Laws*, 4.719, trans. R. G. Bury (London, 1955). All further references to *The Laws* are to this edition.

29. Plato, *Ion*, 534.

30. Plato, *Phaedrus*, 245.

31. Aristotle, *The Problemata*, 954, trans. E. S. Forster (Oxford, 1927).

32. Wittkower, *Born under Saturn*, p. 99.

33. William Shakespeare, *A Midsummer's Night Dream*, act 5, scene 1.

34. John Dryden, *Absalom and Achitophel*, pt. 1, lines 163–64.

35. Charles Lamb, "Sanity of True Genius," in *The Essays of Elia*, vol. 1 (London, 1929). The essay first appeared in the *New Monthly Magazine*, May 1826, as one of the "Popular Fallacies" under the title "That great Wit is allied to Madness."

36. Ibid., 1: 219.

37. Lionel Trilling, "Art and Neurosis," in *Art and Psychoanalysis*, ed. William Phillips (New York, 1963), p. 503.

38. Denis Diderot, *Pensées philosophiques, oeuvres complètes de Diderot* (Paris, 1875), p. 127.

39. Frank P. Chambers, *The History of Taste* (New York, 1932), p. 256.

40. Herbert Dieckmann, "Diderot's Conception of Genius," *Journal of the History of Ideas* 2 (New York, 1941): 152.

41. Ibid., p. 165.

42. Denis Diderot, *Salon of 1767*, in *Oeuvres complètes de Diderot* (Paris, 1876), 2: 125–26. Joseph L. Waldauer, referring to this passage in the *Salon of 1767*, points out how Diderot's conception of the creative process varies somewhat depending on his subject. "Unlike his descriptions of the poet who is apparently crazed in the midst of the creative act, Diderot's delineations are now of figures who enter madness at the end of the creative process." See "Society and the Freedom of the Creative Man in Diderot's Thought," *Diderot Studies* 5 (1964): 106–7.

43. Dieckmann, "Genius," p. 168.

44. Quoted in Nathaniel D. Mttron Hirsch, *Genius and Creative Intelligence* (Cambridge, Mass., 1931), p. 279.

45. Ibid.

46. Guy Pocock, *The Letters of Charles Lamb* (London, 1945), 1: 1.

47. Ibid., p. 2.

48. Ibid., p. 14.

49. Samuel Taylor Coleridge, *Biographia Literaria* (Oxford, 1907), pp. 30–31.

50. Ibid., pp. 60–61. That Coleridge had given some thought to the various categories of mental illness as understood in his own day is seen in a passage in his "Lecture on Don Quixote," where he attempts a classification of "madness and its different sorts (considered without pretension to medical science), which includes four subdivisions of madness, 1. Hypochondriasis, or, the man is out of his senses. 2. Derangement of the understanding, or, the man is out of his wits; 3. Loss of Reason; and 4. Frenzy, or, derangement of the sensations." See *Notes and Lectures upon Shakespeare and Some of the Old Poets and Dramatists*, ed. H. N. Coleridge (London, 1849), 2: 56.

51. Hirsch, *Genius*, p. 279. Becker, in *The Mad Genius Controversy*, p. 28, clarifies the evolution of the mad genius theory from early Romantic writers to the later clinical elaborations of physician-psychiatrists. "While genius was increasingly suspected as being somehow related to madness, this association was not firmly established during the Romantic period and lacked the 'scientific' support of professional psychologists. . . . It was not until the middle of the nineteenth century that psychological and pseudoclinical evidence was forthcoming and, thus, served to elevate the study of genius and madness to the rank of science."

52. Pierre-Jean David d'Angers, *Les carnets de David d'Angers* (Paris, 1958), 2: 3–4.

53. Ibid., p. 4. It would be of interest to know whether the hospital visited by David d'Angers at St. Rémy in Provence was the same hospital in which, fifty years later, Vincent van Gogh was a patient. See my discussion at the end of this chapter.

54. Ibid., p. 4.

55. Pierre Laubriet, *Un catéchisme esthétique* (Paris, 1961).

56. The story exists in several versions as Balzac was in the habit of reworking his novels over periods of years. The first version appeared in *L'artiste* 1 (1831): 319–23. A good deal was added to the story in 1837. I have used an edition of 1870, in *Etudes philosophiques*, vol. 1 (Paris: Alexandre Houssiaux, 1870). All references are to this French edition, and the translation is based on this edition.

57. Ibid., p. 295.

58. Ibid.

59. Ibid., p. 291.

60. See the study by M. Gilman, "Balzac and Diderot: Le Chef-d'oeuvre inconnu," *Periodical of the Modern Language Association* 65 (1950): 644–48.

61. Denis Diderot, *Essai sur la peinture*, in *Oeuvres complètes* (Paris, 1970), 6: 261.

62. Balzac, *Chef-d'oeuvre*, p. 301.

63. Ibid., p. 305.

64. Ibid., p. 304.

65. Ibid., p. 307.

66. Ibid., pp. 304–5.

67. Letter written by Balzac to Mme Hanska, May 24, 1837, in *Lettres à Madame Hanska* (Paris, 1967), 1: 506.

68. Anthony R. Pugh, "Interpretation of the 'Contes philosophiques,'" in *Balzac and the Nineteenth Century* (Leicester, 1972), pp. 47–56, and E. J. Oliver, *Honoré de Balzac* (London, 1965), p. 96.

69. Honoré de Balzac, *Le chef-d'oeuvre inconnu* (Paris, 1931). Picasso was concerned with Balzac as early as 1927 when he engraved the plate *Le peintre observé par le modèle nu*. In 1931 he was commissioned by Ambroise Vollard to do a set of illustrations for *Le chef-d'oeuvre inconnu*, an edition that Alfred Barr has called one of the most remarkable books of our time; see his *Picasso: Fifty Years of His Art* (New York, 1980), p. 145.

70. Letter to Georges Izambard, May 13, 1871, in Wallace Fowlie, *Rimbaud: Complete Works, Selected Letters* (Chicago, 1973), p. 302. English translation by Louise Varèse in *Rimbaud: "Illuminations" and Other Prose Poems* (New York, 1946), p. xxvii.

71. Letter to Paul Demeny, May 15, 1971, in Fowlie, *Rimbaud*, p. 306. English translation, Varèse, *Rimbaud*, pp. xxx–xxxi.

72. Fowlie, *Rimbaud*, p. 309; Varèse, *Rimbaud*, p. xxxiii.

73. William Shakespeare, *Hamlet*, act 2, scene 2, line 206.

74. Maxime du Camp, *Souvenirs littéraires* (Paris, 1883), 2: 160–61.

75. Gérard de Nerval, *Aurélia: Le rêve de la vie*, ed. Jean Richer (Paris, 1965). The history of the writing and publication of *Aurélia* is complex. A first version appears to have been written during Nerval's first hospitalization in 1841–1842. The final version belongs to his last stay in the asylum of Dr. Emile Blanche, and the last pages of the work are said by some scholars to have been found on his body. However, publication had begun before his death. On January 1, 1855, the first part of *Aurélia* appeared in *La revue de Paris*, and the second part, after his death, in the same journal on February 15, 1855. For an English edition of *Au-*

rélia, see *Gerard de Nerval: Selected Writings*, ed. Geoffrey Wagner (St. Albans, Herts, 1968), pp. 115–81. For a thoughtful discussion of the content of *Aurélia* in the context of Nerval's life, see Norma Rinsler, *Gérard de Nerval* (London, 1973).

76. Théophile Gautier, statement of November 2, 1867, quoted in Nerval, *Aurélia*, p. 234.

77. du Camp, *Souvenirs*, 2: 177.

78. Nerval, *Aurélia*, p. 12.

79. Alexandre Dumas, "Causerie avec mes lecteurs," in *Le mousquetaire* 10 (December 1853), quoted in Jean Richer, *Nerval par les témoins de sa vie* (Paris, 1970), pp. 261–63.

80. In that Dr. Emile Blanche is a figure of some importance in the study of psychiatry and art in the nineteenth century, it is essential to realize that Nerval had dealings with two physician members of this family. During his first illness in 1841 he was in a hospital run by Dr. Esprit Blanche in Montmartre. Later he was hospitalized repeatedly in an asylum operated by his son, Dr. Emile Blanche, at Passy. It was Dr. Emile who took such extraordinary interest in Nerval and played such an important part in his life. Nerval appears to have painted on the walls of both hospitals. (Dr. Emile Blanche is also known as the physician who cared for Theo van Gogh when at the end of his life Theo became mentally unstable and had to be hospitalized.)

81. Nerval, *Aurélia*, p. 36.

82. Ibid., pp. 108–10.

83. Ibid., p. 112.

84. Alphonse Esquiros, "Les maisons de fous de Paris," *La revue de Paris* (November 1843 and January 1844). Cited in Jean Richer, *Nerval: Expérience et création* (Paris, 1963), p. 438.

85. Cited in Richer, *Nerval: Expérience*, p. 439. The author and location of this article entitled "Le Docteur Blanche" was unknown to Richer.

86. du Camp, *Souvenirs*, p. 162.

87. Maxime du Camp and Cesaré Lombroso, "L'arte nei pazzi," *Archivio di psichiatria scientifico, penali, antropologia, e criminal* 1 (1880): 424–37. This collaboration is discussed further in Chapter 6.

88. Nerval, *Aurélia*, p. 36.

89. The drawing forms part of a manuscript page and is accompanied by a sketch for a poem entitled *Rêves fatals—Lilith*. The drawing can be seen to illustrate the text, the relevant lines referring to "Je vous fixe comme des papillons, La Reine du Mal." Jean Richer, on the basis of internal evidence, has been able to date the drawing to 1841, the period of Nerval's first illness.

90. *L'age du Romantisme: Série d'études sur les artistes, les littérateurs et les diverses célébrités de cette période*, 5 vols., ed. Ph. Burty and Maurice Tourneux (Paris, 1887–1888). The reproduction of the Nerval drawing is in vol. 3.

91. I would like to thank Professor Aaron Sheon for drawing my attention to the parallels in the lives of Nerval and Meryon. Although Nerval was thirteen years older than Meryon, the period of their artistic activity in Paris overlaps, with both men producing their finest work between 1850 and 1855. I have not been able to determine whether they knew one another, but it is certain that they would have known one another's work.

92. James D. Burke, *Charles Meryon: Prints and Drawings* (New Haven, 1974), p. 1.

93. I refer here in particular to the printed texts with illustrations, *La loi solaire* of 1855 and *La loi lunaire* of 1856.

94. Campbell Dodgson, *The Etchings of Charles Meryon* (London, 1921), p. 19. The most elaborate discussion of this difficult period as seen by the friends who were trying to help him is found in Gustave Geffroy, *Charles Meryon* (Paris, 1926). A. E. Foley, Meryon's shipmate, a close friend, and a medical student, wrote to the artist's father, informing him of the nature of his son's illness, and requesting his help. This letter is preserved in the British Museum, Add.Ms.37,015. For an extremely interesting discussion of the possible psychosomatic origins of Meryon's color blindness, see Michel Thévoz, "La recherche du sens perdu," in *Charles Meryon*, Musée d'art et d'histoire (Geneva, 1981), pp. 105–12.

95. Philippe Burty, *Maîtres et petits maîtres*, quoted in Aaron Sheon, "Charles Meryon in Paris," *Burlington Magazine* 110 (1968): 721–22.

96. Löys Delteil, *Meryon*, trans. G. J. Renier (London, 1928), p. 41, quoting Ph. Burty and Marcus B. Huish, *Charles Meryon, Sailer, Engraver, and Etcher* (London, 1878).

97. Meryon was hospitalized at Charenton on two occasions. From May 12, 1858, to August 26, 1859, and from October 12, 1866, to February 14, 1868. He died in the hospital. Various physicians were involved with Meryon at Charenton, and elsewhere. A. E. Foley, a close friend of the artist, wrote a study on his mental state that includes an interview with the artist while psychotic (reproduced in Geffroy, *Meryon*, pp. 114–16). Foley mentions that Meryon had an inflammation of the sexual organs that "contributed to ruining the sanity of my unfortunate friend." Arrangements for Meryon's confinement at Charenton were made by Dr. Sémerie, an extraordinary physician of extremely advanced and honest views, who wrote case notes on Meryon dated May 24, 1858 (see Geffroy, *Meryon*, pp. 111–20). The initial diagnosis of delirious melancholia was made by Dr. Calmel who saw Meryon at the time of his admission. The physician overseeing his care at the hospital was M. Rousselin, Médecin adjoint. The diagnosis attached to Meryon's later hospitalization of 1866 was chronic lypothymia accompanied by hallucinations of the senses.

Modern psychiatric studies of the psychological aspects of Meryon's life include F. Panse, "Persönlichkeit, Werk und Psychose Charles Meryons," *Archiv für Psychiatrie und Zeitschrift Neurologie* 187 (1951): 205–30; and Lars-Ingemar Lundström, "Charles Meryon: Peintre-Graveur-Schizophrène," *Acta Psychiatrica Scandinavica* 40, suppl. 180 (1964): 159–65.

98. Letter to Aglaus Bouvenne, December 1, 1881, reproduced in Geffroy, *Meryon*, pp. 49–50. The four drawings by Dr. Gachet are included.

99. Best known as the asylum that housed the Marquis de Sade, in the later years of his life, Charenton was now a private hospital. Meryon's friends went to great trouble to arrange funding for his stay in this hospital, rather than allowing him to be confined at the Bicêtre Hospital. Meryon's treatment at Charenton was as good as was available.

100. C. Meryon, "Mes observations sur l'article de la *Gazette des beaux-arts*," written June 1, 1863, an unpublished manuscript in the artist's hand, now in the Toledo Museum of Art. Viollet-le-Duc's original drawing is also preserved in this collection.

101. Born in the same year, Baudelaire was one of the earliest and most influential supporters of Meryon. It was his wish to write a text to accompany the *Eaux-fortes sur Paris*. The project failed to materialize because of Meryon's inability to cooperate with him. For a discussion of their relationship, see William Aspenwall Bradley, "Meryon and Baudelaire," *Print Collector's Quarterly* 1 (December 1911): 587–609.

102. Malcolm C. Salaman, *Masters of Etching: Charles Meryon* (London, 1927), avoids all stages of prints that introduce bizarre elements.

103. Dodgson, *The Etchings of Charles Meryon*, p. 22: "The only etchings of any importance that Meryon produced after his release from confinement are some of the last views of Paris, done at the time when he was retouching his old plates of Paris and making the not very judicious alterations, which distinguish their latest states."

104. An interesting modern example of the attempt to rationalize every single pathological element in Meryon's work out of existence is to be found in James Leo Yarnall, "Meryon's Mystical Transformations," *Art Bulletin* 61 (1979): 289–300.

105. Martin Hardie, *Charles Meryon and his Eaux-fortes sur Paris* (London, 1931), p. 9.

106. Philip Gilbert Hamerton, *Old Paris: Twenty Etchings by Charles Meryon* (Liverpool, 1914), p. 13.

107. The plate that underwent the most extensive and continual revision is the famous *Le Pont-au-Change*, which exists in twelve states. Meryon, in his more disturbed mental states, seems to have paid particular attention to the sky and to cloud formations. In a particularly striking reworking of this plate, preserved in the Metropolitan Museum of Art, New York, he erased part of the sky, adding in pencil reclining figures of women, a menacing snake, and a chariot. At this point in his illness we know he was experiencing visual hallucinations. See Burke, *Charles Meryon*, cat. nos. 53 and 57, and pp. 64–67, for a description of this unique plate. Burke suggests that the first reworkings of this plate may date to 1855, which would link them with the first signs of his illness in that year.

108. Dodgson, *The Etchings of Charles Meryon*, p. 23.

109. C. Meryon, Mes observations. . . . quoted in a translation by Burke, *Charles Meryon*, p. 79. Meryon's motive for the depiction of this building was the fact that Jean-Paul Marat was assassinated in it.

110. Quoted in Crépat, *Charles Baudelaire: Oeuvres posthumes* (Paris, 1887), p. 193. Translation by Burke, *Charles Meryon*. A letter to his publisher Poulet-Malassis, dated January 8, 1860.

111. Burke, *Charles Meryon*, pp. 63–64.

112. Ibid., p. 64. Baudelaire was one of the best-informed literary figures of his day with regard to psychiatric and psychological theory. He was in regular communication with Dr. Moreau de Tours, was reading Brierre de Boismont, and involved with the investigation of dreams, hallucinogenic drugs, insanity, and the unconscious. For detailed discussion of his psychiatric interests, see Aaron Sheon, "Courbet, French Realism, and the Discovery of the Unconscious," *Arts Magazine* 40 (1981): 114–28, and "Caricature and the Physiognomy of the Insane," *Gazette des beaux-arts* 88 (1976): 145–50. I am indebted to Dr. Sheon for information concerning Baudelaire's scientific interests and his influence in this regard on contemporary art.

113. Letter to A. Bouvenne, quoted in J. Bailly Herzberg, *L'eau-forte de peintre* (Paris, 1972), 1: 150.

114. See Yarnall, "Meryon's Mystical Transformations," pp. 291–92, where the additions are explained on the basis of Meryon's "feelings aroused by the failure of the Government to aid New Zealand" and his knowledge of homeopathic magic.

115. Charles Meryon, "Mes observations . . . ," translated by Yarnall, ibid.

116. From letters written by his physician at Charenton, Dr. Sémerie, discussing Meryon's ideas during his first period in hospital. Quoted in Geffroy, *Meryon*, p. 120.

117. Lundström, "Charles Meryon," states that this drawing in particular is indicative of extreme pathology and confirms his retrospective diagnosis of schizophrenia with periods of remission. It should be noted that a study drawing for this plate is said by Delteil to be in the collection of M.B.B. Macgeorge, a fact that is in no way in conflict with this diagnosis.

118. A notable exception to this is Yarnall's elaborate, but misleading, attempt to place the drawing within the context of alchemical theory, and to explain its formal characteristics on a basis of Meryon's acquaintance with primitive art; see Yarnall, "Meryon's Mystical Transformations."

119. The Romantic conception of mental illness is undergoing a revival in our own day. Largely as a result of the writings of Dr. R. D. Laing, a movement has developed that questions the application of the medical model to the understanding of insanity, conceptualizing it instead as a positive attempt at self-healing, a reintegrative process engendered by and in opposition to the social order, which is seen as pathological. As a result of misunderstanding this viewpoint, many young people, with no experience of mental illness, feel a very strong conviction that madness is a very positive state, that it should not be treated, and that wondrous things are to be discovered in its depths.

120. The precise diagnosis of the illness from which van Gogh suffered is not easily arrived at and has been a subject of much controversy. Study of various accounts of his behavior written by people in contact with him at the time make it very clear that during his attacks he was acutely psychotic, delusional, experiencing auditory and visual hallucinations, and occasionally paranoid and dangerous to himself and others. Whatever the basis of the illness, whether neurological or psychological (or even chemical), the fact remains that van Gogh experienced brief but extreme periods of madness, and that he himself felt he was at least periodically "a lunatic."

Recent studies of van Gogh's illness are reexamining the possibility that van Gogh suffered from a form of epilepsy. Research centers on a specific type of frontal lobe epilepsy, which is productive of nonconvulsive seizural events. See the publications of Dr. Russell R. Monroe of the University of Maryland Medical School, as well as the work of Howard Gardner at Harvard. I am grateful to Professor Aaron Sheon, who is currently studying van Gogh's response to his illness, for drawing my attention to these recent medical studies.

The effect of this serious illness on his work was, in my opinion, so slight that I decided not to include any discussion of the work in this study, and to confine our examination to van Gogh's own account of what it felt like to be an artist and insane. His art is not psychotic art.

121. Letter to Wilhelmina J. van Gogh, Vincent's youngest sister, dated April 10, 1889, Arles. In *The Complete Letters of Vincent van Gogh* (Greenwich, Conn., 1959), 3: 450. All further references to the letters of van Gogh are to this edition.

122. Letter to Theo van Gogh, in *Letters*, 3: 225. The letter is undated but belongs to the period of Vincent's hospitalization at St. Rémy, May 1889 to May 1890.

123. Letter to Wilhelmina J. van Gogh, October 1889, St. Rémy, in *Letters*, 3: 461. In this letter to his sister van Gogh refers to the painting as a depiction of the "fever ward at Arles." This title conflicts with his description in the letter to Theo, which identifies the subject as "the mad ward at Arles Hospital." The fact that no patients are seen in bed, and that the majority are seated about a stove, would suggest the latter description is the more accurate one. The Arles Hospital was a general hospital

serving the city of Arles just as it does today. While it was not a psychiatric hospital, it is highly probable that it had a special ward reserved for patients displaying acute psychiatric problems. Although it is not possible today to identify the room in the hospital painted by Vincent, I think his designation in the letter to Theo of the room being the "mad ward" should be respected. He may have changed the title to "fever ward" in writing to his sister to protect her from the unpleasant truth. It has been suggested by K. Bromig-Kolleritz, *Die Selbstbildnisse Vincent van Goghs* (Munich, 1955), that the third figure from the left could be the artist. As there is to my knowledge no evidence to support this view, it seems unwise to attempt an identification. One would expect van Gogh to have referred to such a self-portrait in the letters if he had any such intention. He was, of course, deeply involved in the painting of self-portraits in the hospital, but examination of these pictures would lead us away from our topic.

124. Letter to Theo, March 19, 1889, in *Letters*, 3: 139.

125. Letter to Theo, undated but belonging to the beginning of Vincent's hospitalization at St. Rémy in May 1889, in *Letters*, 3: 169.

126. Letter to Theo, May 25, 1889, in *Letters*, 3: 174. The room referred to in the letter is not that in the painting but one in the Hospital of St. Paul at St. Rémy.

127. *Letters*, 3: 173–74.

128. Letter to the artist's mother, undated but belonging to the period at St. Rémy, in *Letters*, 3: 266.

129. *Letters*, 3: 174.

130. Letter to Theo, September 10, 1889, in *Letters*, 3: 208.

131. Letter to Theo, May 3, 1889, Arles, in *Letters*, 3: 166.

132. Letter to the artist's mother, undated but belonging to the period at St. Rémy, in *Letters*, 3: 240.

133. *Letters*, 3: 123.

134. *Letters*, 3: 178.

135. Letter to Theo, in *Letters*, 3: 129.

SIX. CESARE LOMBROSO: THE THEORY OF GENIUS AND INSANITY

1. A superb study of the origins and evolution of this idea is George Becker, *The Mad Genius Controversy: A Study in the Sociology of Deviance* (Beverly Hills, Calif., 1978). It is an interesting fact, emphasized by George Becker in his discussion of Lombroso, that "a majority of participants in the genius controversy were members of the medical profession" (p. 48). In addition, Becker notes (p. 105 n. 4) that "Lombroso, ironically himself a lifelong 'defamer' of genius, held a variety of academic appointments."

2. As Becker also points out, the theory of the degeneracy of genius was first formulated by B. A. Morel around 1850 and then developed and popularized by Lombroso. Contributors to this epidemic, other than Cesare Lombroso, were Max S. Nordau, *Entartung* (Berlin, 1892)—English edition: *Degeneration* (New York, 1896)—and *Psychophysiologie du génie et du talent* (Paris, 1897); Forbes Winslow, "Mad Artists," *Journal of Psychological Medicine and Mental Pathology* n.s. 6 (1880): 33–75, and "On the Insanity of Men of Genius," ibid. 2 (1849): 262–91; J. F. Nisbet, *The Insanity of Genius* (London, 1891); and Wilhelm Lange Eichbaum, *Genie, Irrsinn und Ruhm* (Munich, 1928), and *Das Genieproblem* (Munich, 1931). The theory of mental degeneracy was then used by the Nazis in their assault on modern art and literature. See chapters 11 and 14.

3. L. Frigerio, "L'arte e gli artisti nel Manicomio di S. Bene-

detto," *Diario del Manicomio di Pesaro* 9, no. 6 (1880): 22–24. The translation is my own. Page references are cited in text hereafter.

4. I have not been able to obtain information about these classes, and the article does not indicate whether they continued to function up to the time it was written. The works described in the article seem to have been spontaneous productions done outside of any class. A drawing class in 1880 would not have encouraged such subjects and would probably have stressed copying and the development of technical skill.

5. It appears that a number of the cases described and illustrated in Lombroso's article were taken from Frigerio's collection. There may be instances of overlap where both physicians describe the same case.

6. The date of Lombroso's birth is given as 1835 or 1836 in various histories of psychiatry. For an interesting survey of Lombroso's contribution, see Elenade Bernart and Marcello Tricarico, "Per una rilettura dell'opera di C. Lombroso," *Physis* 18, no. 2 (1976): 179–84. The most extensive biographical study is that of Luigi Bulferetti, *Cesare Lombroso* (Turin, 1975).

7. *L'homme de génie* (Paris, 1889); *The Man of Genius* (London, 1891); *Entartung und Genie* (Leipzig, 1894).

8. Cesare Lombroso and Maxime du Camp, "L'arte nei pazzi," *Archivio di psichiatria, antropologia criminale, e scienzi penali* 1 (1880): 424–37. Lombroso was directing this new publication. The accurate dating of Lombroso's publication of his studies of the art of the mentally ill is a matter of considerable importance. He is often credited with the first serious contribution to the field, an innovation I have reassigned to Dr. Paul-Max Simon. The confusion arises from the fact that scholars have assumed that the first edition of *Genio e follia* of 1864 contained the discussion of the art of the patient in the chapter entitled "L'arte nei pazzi." However, this chapter was not included prior to 1880. It appears for the first time in the fourth edition of 1882, in the chapter "Con nuovi studi sull' arte nei pazzi." In 1888, the book was much revised and appeared for the first time with the new title, *L'uomo di genio*. At this point it appears to have attracted a great deal of attention, and the translations began to appear. Lombroso's contribution to the study of the art of the mentally ill is therefore preceded by that of Simon, in 1876, and by the less important discussion by Tardieu, in 1872. For a further reference to du Camp's involvement with the art of the mentally ill, see chapter 5.

9. Museo di Antropologia criminale, at the Istituto di Antropologia criminale, Corso Galileo Galilei 22, Turin. I am obliged to Professor Sergio Tovo, the former curator of the collection, for his kindness in allowing me to examine all of the material assembled by Lombroso in connection with his studies in art and psychiatry. It was obvious that I was the first person to open these folders in many years.

10. The museum, embracing as it does all of Lombroso's enormously varied interests, is devoted largely to objects relating to crime and criminals, the art of the insane forming only a minor segment of the collection. The drawings and other objects associated with psychiatric patients are unfortunately in perilous condition, and urgently require conservation.

11. The patient is identified as Eduardo G., Manicomio cantonale di Mendrisio, and diagnosed as suffering from "paranoia with criminal manifestations."

12. I have not been able to acquire photographs of these and other drawings in the Lombroso collection. I wish nevertheless to discuss some of the unpublished material to draw the attention of interested students to a largely untouched historical reposi-

tory. There is no reference to the case of James Wanamacker of Philadelphia in the American psychiatric literature that I know of. Students wishing to investigate this problem further may be helped by the fact that the inscription "James Wanamacker was James Lewis" appears on almost all of his drawings. I would be most interested in obtaining further information about this case.

13. For the work of Gaston Duf, see "Gaston le zoologue," *L'art brut*, 5 (1965): 75–101.

14. I have spent several hours talking with a Polish psychologist who is director of a large-scale research project to explore the entire range of schizophrenic processes. As part of the study several thousand drawings have been collected, representing the total graphic output of a large number of hospitalized patients over several years. Faced with this large body of material, which represents a permanent visual documentary record of the course of the illness of each of these patients, this physician was deeply puzzled. What could be done with these drawings and paintings? If a key could be found to use in exploring them, a mine of information would be made available. But where to begin? The same puzzle confronted Lombroso, though he was far less aware of the possibilities inherent in the study of drawings.

15. Cesare Lombroso, *The Man of Genius*, 2nd ed. (London, 1895), pp. 179–208. Hereafter all page references in text are to this edition unless otherwise noted. In later editions of *Man of Genius*, Lombroso enlarged his discussion to include the work of professional painters who had become insane.

16. This case was one of several that Lombroso borrowed from Frigerio; in fact, Lombroso's chapter on the art of the insane owes a great deal to observations and pictures supplied by other physicians. An example of the difference between Lombroso's and Frigerio's approach is seen in their differing responses to the work of this one patient. Lombroso simply lists his upside-down drawing as an example of absurdity. Frigerio, who knew the patient, asks, "Was this dependent on the anomalous structure of the eye, or on a recurrent sensorial illusion?" The patient, "T.," was an epileptic who revealed this problem in the art class at S. Benedetto.

17. The pictures whose content is overtly sexual (pls. 95, 96, and 97) were not included in the English edition of Lombroso's book, and discussion of them was also omitted.

18. This important case is discussed in detail in chapter 9, and is therefore omitted in the description of the work of Lombroso. Reference to it first appeared in the fifth edition of *L'uomo di genio* of 1888.

19. The case of "A.T." was made known to Lombroso in a communication from Dr. Morselli. "A.T." was not a patient known personally to Lombroso. This marvelous carving is sadly no longer to be found in the Lombroso Collection.

20. The main disease entities employed in Lombroso's discussion are melancholy, megalomania, dementia, acute or intermittent mania, general paralysis, moral insanity, and epilepsy.

21. Lombroso, *The Man of Genius* (London, 1891), p. 333.

22. Ibid., p. 209.

SEVEN. PAUL-MAX SIMON AND THE STUDY
OF PSYCHIATRY AND ART

An earlier version of this chapter appeared in *Art Therapy* 1, no. 1 (October 1983): 8–20.

1. "L'imagination dans la folie: Etude sur les dessins, plans, descriptions, et costumes des aliénés," was published in the periodical *Annales médico-psychologiques* 16 (Paris, 1876): 358–90.

No reproductions of the works discussed accompanied the text. "Les écrits et les dessins des aliénés" was published twelve years later in *Archivio di antropologia criminelle, psichiatria e medicina legale* 3 (1888): 318–55. This article included a lengthy discussion of the writings of the mentally ill, both in terms of graphological analysis and in terms of their content. The discussion of drawings was essentially identical to that of 1876, except that several new cases had been added, a new section on "délire érotique" was included, as well as a discussion of a number of prominent artists who had become insane. The text was now illustrated. Hereafter, page references to both articles will appear in text, identified by year.

2. Besides the bibliographies on the art of the insane by Norman Kiell and Anne Anastasi and John P. Foley, there are a number of short discussions of the history of the study of the art of the insane: Hans Prinzhorn, *Artistry of the Mentally Ill* (New York, 1972), pp. 1–7; Margaret Naumberg, "Introduction—A Study of the Significance of Psychotic and Neurotic Art: 1876–1950," in *Schizophrenic Art: Its Meaning in Psychotherapy* (New York, 1950), pp. 3–34; and Wolfgang Born, "Art and Mental Disease, *Ciba Symposium* 7 (1946): 202–37.

3. Cesare Lombroso and Maxime du Camp, L'arte nei pazzi," *Archivio di psichiatria antropologia criminale, e scienze penali* 1 (1880): 424–37.

4. Ambroise-Auguste Tardieu, *Etudes médico-légales sur la folie* (Paris, 1872). Translations are by the author.

5. Tardieu's graduate thesis dealt with the role of anatomical factors in the diagnosis and treatment of the neuroses. For further information on his life and career, see René Semelaigne, *Les pionniers de la psychiatrie française: Avant et après Pinel* (Paris, 1930–1932), pp. 49–55.

6. Tardieu, *Etudes*, p. 94.

7. Ibid.

8. Ibid., p. 103.

9. A contemporary instance of this creative process is represented by the mediumistic drawing of Madge Gill. See Roger Cardinal's *Outsider Art* (London, 1972), pp. 135–45, and "Madge Gill," *L'art brut* 9: (1973) 5–33.

10. Tardieu, *Etudes*, pp. 101–3. The psychotic content of the text makes it very difficult to determine which of a number of possible meanings the patient may have intended for many of the words. I am grateful to Mr. Richard Howard for advising me on difficult points in this translation.

11. Valuable sources on Simon's life and work are: Paul Max Simon, *Temps passé, journal sans date* (Dijon, 1895), and *Compte rendu du service médical de la section des hommes de l'asile d'aliénés de Bron* (Lyons, 1880). A complete Simon bibliography is to be found in *Catalogue général des livres imprimés de la bibliotheque nationale* (Paris, 1948), 173: 275–79.

12. Simon's use of an English term here results from his admiration for the English physician Sir Henry Holland, Physician in Ordinary to Queen Victoria, whom Simon described as the model of the "médecin-gentleman."

13. Simon, *Temps passé*, p. 202. This account of the ideal physician derives from Simon's description of his friend Dr. Fonssagrives, Professor of Medicine at Montpellier.

14. Paul-Max Simon, *Swift: Etude psychologique et littéraire* (Paris, 1893). The most important of Simon's creative writings are to be found in a collected edition entitled *Les marionnettes de la vie* (Dijon, 1873); it was followed by a second enlarged edition (Lyons, 1894).

15. Simon, *Swift*, p. 104.

16. Simon, *Temps passé*, p. 11.

17. Ibid., p. 14.

18. Ibid., p. 29.

19. Ibid., p. 36.

20. Ibid., p. 190.

21. Well before Freud had made such studies acceptable, Simon published a book entitled *Le monde des rêves* (Paris, 1882). Having decided, as a result of his studies in art and psychiatry, that hallucinations were a significant factor motivating the artistic productions of his patients, he proceeded to investigate both auditory and visual hallucinations: *Les invisibles et les voix* (Paris, 1880), and *Sur l'hallucination visuelle* (Paris, 1880).

22. Of particular importance in this connection is the article by Louis-Victor Marcé (1828–1864), "De la valeur des écrits des aliénés: Au point du vue de la sémiologie et de la médecine légale," *Journal de médecine mentale* 4 (1864): 85–95, 189–203. Marcé was at that time on the staff of the Bicêtre Hospital. His study on the writing of the insane was delivered as a paper at a medical congress in Rouen on October 3, 1863. He made no reference to drawings in his article, except to state that they occasionally occur in the body of a letter. Marcé's interest in writing developed out of the still earlier investigations of the pathology of speech. The format of Simon's study follows Marcé very closely. His analysis of formal factors in writing sets a high standard for a similar investigation of these factors in the examination of drawings. One feels the same reserve, the same exactness and avoidance of exaggeration in Marcé as in Simon. Simon is careful to indicate his debt to Marcé in the opening of his article of 1876: "Marcé, whose loss is to be regretted, devoted a work full of instructive observations to the study of the writing of the insane, in a work carried out, as was everything done by this gentle spirit, in truly elegant style."

23. Henri F. Ellenberger, *The Discovery of the Unconscious: The History and Evolution of Dynamic Psychiatry* (New York, 1970).

24. The study of the costume of the insane inevitably leads to a slightly greater skepticism regarding the clothing of so-called normal individuals. Simon's objectivity extended even to the members of his own profesion. In a passage in his memoirs he refers to "the undertaker's garb affected by certain physicians."

25. Simon added nothing new in the way of diagnostic categories, following the standard system of classification of his day. He discussed the drawings under the following headings: lypémania, distinguishing four subvarieties—lypémania généraux, aigus, stupides, anxieux, manie chronique; mégalomanie; paralysie générale; démense; les imbéciles; and, in 1888, délire erotique.

26. Lombroso's debt to Simon was enormous. He made reference to Simon's article as well as to that of Tardieu. Simon was in personal contact with Lombroso and was exchanging drawings and information with him.

27. Simon, *Temps passé*, p. 116.

28. An extensive discussion of these prints and of their influence on the art of the period is found in Meyer Schapiro, "Courbet and Popular Imagery," *Journal of the Warburg and Courtauld Institutes* 4 (1940-1941): 164–91.

29. Simon, *Temps passé*, p. 161.

30. Despite several inquiries addressed to the asylum at Bron, I have not succeeded in obtaining any information as to the present location of this historically important collection, or any further information on their one-time chief physician, Paul-Max Simon.

31. Ellenberger, *Discovery of the Unconscious*, p. 257.

32. Anne Coffin Hanson, *Edouard Manet*, exhibition catalog, Philadelphia Museum of Art (Philadelphia, 1966), p. 71. *Carmen* was produced at the Opéra Comique on March 3, 1875, and it too was received as something of a "délire érotique."

33. Simon, "Les ecrits" (1888), p. 352. In the first article of 1876, Simon discusses this case in rather different terms (p. 363), where the subject of the portrait is identified as "un prétendu écuyer du cirque nommé Bonaventure."

34. Wolff in *Le Figaro*, quoted in John Rewald, *The History of Impressionism* (New York, 1973), pp. 368–69.

35. Simon, "L'imagination" (1876), pp. 380–81. Unrelated but apposite is the remark made by Sam Ervin during the Watergate hearings: "A reporter asked Sam Ervin why the committee had failed to state in its report any conclusions about the responsibility for the Watergate scandal. Ervin replied that it was possible to draw a picture of a horse in two ways. You could draw the picture of a horse, with a very good likeness. Or you could draw the picture and write under it, 'This is a horse.' Well, said Sam Ervin, 'we just drew the picture.' " *Time*, July 22, 1974.

EIGHT. VICTORIAN BEDLAM: THE CASE OF RICHARD DADD

1. A list of nineteenth-century English artists diagnosed as insane by critics or psychologists would include almost every illustrious name in English art. Blake and Fuseli were high on every list, but Barry, Haydon, Landseer, Morland, and even Turner were included for one reason or another.

2. This examination of the history of nineteenth-century response to the life and work of Richard Dadd is possible only because of the detailed research and documentation published in recent years by Miss Patricia Allderidge, archivist to the Bethlem Royal Hospital and the Maudsley Hospital, London. Although my specific interest in Dadd necessitated a reexamination of all of the source material, this could be done because it had been previously located by Miss Allderidge. I have had the pleasure of discussing the Dadd material with her in great detail. Her generosity in making new and unpublished material available to me went well beyond the requirements of scholarly cooperation.

3. The Bethlem Asylum to which Dadd was committed was, of course, not the hospital of Hogarth's day, but the new building that had been constructed in St. George's Fields, Southwark, between 1812 and 1815 (the building that housed Jonathan Martin). Additions to the hospital had been made in 1838, the year of Martin's death, and again in 1845. It still stands, in part, though the wing for criminal lunatics in which Dadd resided has been demolished. The building no longer functions as a hospital, the patients having been moved to a new set of buildings in 1930.

4. The case books for the criminal lunatic department at Bethlem Hospital covering the period of Dadd's hospitalization still exist in the hospital archives, where I was able to study them in detail. The case book at Broadmoor Hospital, a large leather-bound volume containing Dadd's case record, has only recently been released for study, and I have not yet seen what it contains.

5. Able to attract the attention and interest of physicians and alienists of his own period, Dadd also has admirers among their modern successors. Dr. D. L. Davies of the Maudsley Hospital has studied his work from a psychiatric viewpoint, while Dr. I. Rosen is currently engaged on the psychoanalytic investigation of his life and work.

6. John Rickett, "Richard Dadd: Bethlem and Broadmoor," *The Ivory Hammer* 2 (1964): 22.

7. *Art Union* (October 1843): 267.

8. Ibid., p. 267. It is interesting to observe in these articles yet another myth taking shape around Dadd, the mythology employed in attempting to explain the origin and causes of mental illness.

9. The *Kentish Independent*, September 2, 1843, p. 4.

10. The *Pictorial Times*, September 9, 1843, pp. 45–46.

11. The *Kentish Independent*, September 2, 1843, p. 4.

12. The *Pictorial Times*, September 9, 1843, p. 46.

13. That this was the generally held opinion is reported by William Powell Frith in his book *My Autobiography and Reminiscences* (London, 1888), 3: 180.

14. The *Pictorial Times*, September 9, 1843, p. 46.

15. Frith, *Autobiography*, p. 181.

16. Frederick Goodall, *The Reminiscences of Frederick Goodall R.A.* (London, 1902), pp. 229–30. Goodall's *Reminiscences* are legendary for their abundant inaccuracies and inventions.

17. Twentieth-century critics also tend to understand fairy painting as much more than illustrations of folk tales. Jeremy Mass in *Victorian Painting* refers to it as "close to the Victorian subconscious," and discusses it in terms of "the world of dreams . . . tinged with eroticism." The initiator of fairy painting in England is usually identified as Henry Fuseli, whose illustrations to *A Midsummer Night's Dream* provide valuable comparative material for the study of Dadd's fairy paintings. The foremost influences contributing to the development of Dadd's earlier fairy painting style were his teacher Henry Howard (1769–1847), and Daniel Maclise (1806–1870). Dadd's later fairy paintings represent an entirely new conception of the problem and are unique documents in nineteenth-century painting.

18. *Art Union* (April 1841): 68. Any critic attempting a psychological study of the life and work of Dadd would have to grapple with the question of emerging psychological conflict in terms of the unconscious fantasy formations undoubtedly influencing the early fairy paintings of 1841–1843, as well as the poetry Dadd was writing at this time. It is worth considering whether, even in the context of a tradition of English fairy painting, Dadd's works in this vein contain personal elements indicative of mental pathology. The remark of the *Art Union* critic might seem to imply that his pictures may even then have appeared somewhat atypical.

19. *Art Union* (May 1844): 122. Information derived from a letter sent to Dadd's family by officials of the French asylum.

20. *Art Union* (May 1845): 137.

21. Ibid.

22. *Art Union* (February 1848): 66.

23. Patricia Allderidge has indicated: "Some of the work produced during his confinement at Bethlem Hospital and Broadmoor was known outside the hospitals during his lifetime, but the idea that this would one day be considered the most important period of his working life, would have seemed as bizarre as many of his pictures then appeared to those who saw them. In more recent times the picture has been reversed, and Dadd is now known chiefly as a 'mad-painter.'" See *The Late Richard Dadd* (London, 1974), p. 9.

24. A superb article by Allen Staley, "Richard Dadd of Bedlam," *Art in America* 62 (December 1974): 80–82, attempts to assess the psychopathological aspects of *The Flight out of Egypt*, and to arrive at a critical and stylistic evaluation of the effect of insanity and enforced isolation on Dadd's development as an artist.

25. Miss Allderidge refers to "a tendency [on the part of nineteenth-century critics] to pass over much of his work without really looking at it, because it was known to be from the hand of a madman. Many of the qualities which, from another painter would have been praised as evidence of a fine imagination, were liable to be identified as symptoms of insanity." *The Late Richard Dadd*, p. 36.

26. The six pictures included in the exhibition were: *Titania Sleeping* (1841), *Puck* (1841), *Caravan Halted by the Sea Shore* (1843), *Artist's Halt in the Desert* (lost), *Vale of Rocks* (lost), and *Dead Camels* (lost). That the last three paintings, all watercolors, were done prior to Dadd's hospitalization, is not absolutely certain.

27. *A Handbook to the Exhibition of British Paintings in the Art Treasures Exhibition* (Manchester, 1857), p. 126.

28. Ibid., pp. 126–27.

29. *A Handbook to the Watercolours, Drawings, and Engravings in the Art Treasures Exhibition* (Manchester, 1857), p. 12.

30. *Handbook to the Exhibition of British Paintings*, p. 127.

31. Ibid., pp. 126–27.

32. *Official Catalogue of the Fine Art and Industrial Exhibition* (Huddersfield, 1883), p. 280. The picture was titled *Eastern Inn Yard* in the exhibition catalog.

33. Goodall, *Reminiscences*, p. 230.

34. Frith, *Autobiography*, 3: 182.

35. W. M. Rossetti, *Some Reminiscences of William Rossetti* (London, 1906), pp. 269–70. Rossetti's awareness of Dadd's work should have been more extensive in that he shared a studio with Samuel B. Haydon, the brother of the Bethlem steward G. H. Haydon, a friend and collector of Dadd's work.

36. "Her Majesty's Pleasure, The Parricide's Story," *The World* (London), December 26, 1877, pp. 13–14.

37. Ibid., p. 13.

38. Ibid., p. 14. While the interviewer may have discussed the murder with Dadd, the details described here can also be seen to reflect an account of the murder and of Dadd's attitudes to it in William Wood, *Remarks on the Plea of Insanity* (London, 1851), pp. 41–43, which included a description of the murder and its motives written by Dadd himself.

39. "The Parricide's Story," p. 14.

40. G. A. Sala, "A Visit to the Royal Hospital of Bethlem," *Illustrated London News* (London), March 24, 1860, pp. 291–92; March 31, 1960, pp. 304–5.

41. "The Parricide's Story," p. 14.

42. The great-grandfather James Monro (1680–1752) was appointed physician to Bedlam in 1728. He would have worked at the hospital in Moorfield's, and have been in charge at the time Hogarth's engraving appeared.

43. For a detailed discussion of the scandal, and a report on conditions in the hospital prior to 1852, see "The Commissioners in Lunacy Report on Bethlem Hospital," *The Journal of Psychological Medicine and Mental Pathology* 6 (1853): 129–45, and "Bethlem Hospital in 1852," ibid., p. 62. For an extended historical study of these reports and their findings, see Andrew T. Scull, *Museums of Madness* (Harmondsworth, 1982).

44. Dr. Thomas Monro's involvement with the artists of his time is discussed in Jack Lindsay, *Turner* (New York, 1966). In 1976, an exhibition of the work of Dr. Monro and the artists of his circle was held at the Victoria and Albert Museum. A catalog

was published, entitled *Dr. Thomas Monro and the Monro Academy* (London, 1976), by F.J.G. Jeffriss.

45. Allderidge, *The Late Richard Dadd*, p. 28.

46. "Lunatic Asylums," *The Quarterly Review* 101 (1857): 361–62.

47. Ibid., p. 362.

48. The report of the Commissioners in Lunacy makes very clear that Dr. Monro visited the hospital very little, and had almost no contact with patients once they had been admitted.

49. Sala, "A Visit to the Royal Hospital of Bethlehem," pp. 304–5.

50. Ibid., p. 304.

51. John M. Galt, "On the Reading, Recreation, and Amusements of the Insane," *The Journal of Psychological Medicine and Mental Pathology* 6 (1853): 581–89.

52. *Casebook for the Year 1854 for Criminal Lunatics*, Archives of the Bethlem Royal Hospital.

53. Ibid.

54. Sale Catalogue, Christies, March 28, 1870, items 266–332a. I am indebted to Miss Patricia Allderidge for making a copy of this catalog entry available to me.

55. Joseph Octave Delapierre, *Histoire littéraire des fous* (London, 1860), p. 4.

56. Hood would have learned of the work of Jonathan Martin as well as the literary productions of his brother William from this book, if from nowhere else.

57. Miss Alldridge (*The Late Richard Dadd*, p. 30) suggests, "They seem almost to be used as a vehicle to channel his aggression," an example of modern psychotherapeutic practice applied retrospectively.

58. Several collections of Haydon's sketches and humorous caricatures assembled in bound scrapbooks are in the possession of Haydon's descendants. I was able to examine these in detail.

59. The essential source for Haydon's biography is a short obituary notice in *Under the Dome: The Quarterly Magazine of the Bethlem Royal Hospital* 1 (1892): 16–18.

60. It was probably through this contact with George Henry Haydon that W. M. Rossetti was able to arrange his visit to Bethlem.

61. *Under the Dome* 1: (1892) 17.

62. An earlier manuscript of the poem was known. See Allderidge, *The Late Richard Dadd*, p. 127. The newly discovered version, which I was able to examine through the kindness of Miss Allderidge, does not differ in content from the first. The fact that Dadd made two copies of the poem may relate to the two versions of the picture that he executed. The new manuscript has remained in the Haydon family presumably since Dadd gave it to George Henry Haydon.

63. Original manuscript in the collection of the Bethlem Royal Hospital.

64. The quotation from Shakespeare's *Henry VIII* is very nearly exact, though curiously it omits the name of the queen, Katherine. The omission of the Queen's name is difficult to explain in that Haydon would certainly have had a copy of Shakespeare to consult. The choice of such a peculiar passage also needs explanation. The possibility exists that Haydon, for whatever reason, may possibly have copied an original Dadd. If so, it would be interesting to speculate which of the passions Dadd might have selected this scene to illustrate. The other possibility is that Haydon, with his wild sense of humor, may have painted this sketch as a spoof. But why he would have been copying or

parodying Dadd's drawings in 1874, ten years after Dadd had left Bethlem, is not known.

65. I am very grateful to Miss Allderidge for bringing this enormously important annotated edition to my attention. The volume came up for sale at Sotheby's London, and was sold October 29, 1975. I was able to consult it there prior to the sale. Haydon acquired the book in 1859, and rewrote Dadd's penciled comments in ink in 1877. There is no family connection between B. R. Haydon and George Henry Haydon. It is a striking coincidence that B. R. Haydon's son became insane and was hospitalized in Bethlem where he too got to know George Henry and added a note to the book explaining the reasons for his father's suicide.

66. The concept of splitting of the mind has a long history in psychiatry. Its use in the context of schizophrenia, and in the term schizophrenia itself, was introduced in 1911 by Eugen Bleuler.

67. Annotated edition.

68. Ibid.

69. Ibid.

70. One further work belongs very clearly in this group, the picture known as *Bacchanalian Scene*. A number of other paintings display what may well be elements of Dadd's private inner world and of some of his delusional ideas: the *Mother and Child* (1860), *The Child's Problem* (1857), and the *Patriotism* scene from the *Sketches to Illustrate the Passions* (1857).

71. Richard Dadd, *Elimination of a Picture and its Subject—Called the Feller's Master Stroke*.

72. Ibid. Dadd left the *Fairy Feller's Master Stroke* unfinished when he moved to Broadmoor Asylum in July 1864. He began a second version of the painting after his arrival there, a fact that indicates how important work on this picture had become to him. The second version, now in the Fitzwilliam Museum, Cambridge, was considerably smaller in size, and very closely reproduces the original, although it makes more use of the swirling calligraphic lines on the surface. The picture appears to have been given to yet another hospital staff member, the superintendent of Broadmoor, Dr. John Meyer (1814–1870).

73. A significant predecessor of this type of picture is Goya's *Self-Portrait with his Physician Dr. Arrieta* (1820), a remarkably convincing portrayal of the physician-patient relationship. In that Goya's illness was probably not primarily psychiatric, and the physician depicted was not specifically linked with the care of the mentally ill, it cannot be said to have the unique significance of the Dadd portrait.

74. The problem of identifying the sitter is complicated by the fact that the painting has been relined some years ago, covering the back of the canvas on which Dadd almost invariably identified the subjects of his major pictures. As a result, various identifications have been put forward. In 1937 Lawrence Binyon identified the sitter as a Mr. Dolman, warden at Bethlem. This identification, repeated by J.B.L. Allen in his article, "Mad Robin: Richard Dadd," *Art Quarterly* 30, no. 1 (September 1967): 18–30, would probably have been made prior to the relining of the picture, but fails to accord with the lists of persons employed at Bethlem in these years. Patricia Allderidge (*The Late Richard Dadd*, 87) very tentatively linked the sitter with the most prominent physician then at Bethlem, Dr. Charles Hood, on the basis of a resemblance to a portrait of Dr. Hood executed in Paris in 1851 by Charles Fréchou, an identification that she has now come to doubt. The identification of the sitter as an attendant at

the hospital is based on a chalk drawing of the head attendant at Bethlem in which the sitter wears clothing similar to that worn by Dadd's subject, clothing that would not be characteristic of patients in the criminal lunatic department.

75. The picture remained in the Morison family until 1927, when it was presented to the Royal College of Physicians of Edinburgh by Morison's grandson, Alexander Blackhall Morison. Only recently was it recognized as a work of Richard Dadd. It is now in the Scottish National Portrait Gallery, Edinburgh (PG 2623).

76. I am profoundly grateful in this discussion of the newly discovered portrait of Sir Alexander Morison for the scholarly generosity of the Scottish National Portrait Gallery and in particular for the kindness of Miss Helen Smailes, who provided me with an extraordinary amount of background material on Dr. Morison and his involvement with Dadd. Particularly useful was Miss Smailes's superb essay on the portrait, *Method in Madness* (Edinburgh, 1980), a catalog designed to accompany the first public exhibition of the picture after its restoration. Also essential were the extracts from Morison's journals referring to his contacts with Dadd.

77. This encounter between Charles Gow and Dadd is elaborated on later in this chapter. Dadd arrived at Bethlem on August 22, 1844, and so had only been there three months when Morison's first reference to him appears in his journal.

78. In the manuscript journal, Morison has penciled in a correction or addition in the margin to the effect that the Egyptian female is Jewish. Given the content of Dadd's religious delusions, centering on Egyptian deities, any reference to things Egyptian is significant. No such drawing is known to exist at present.

79. On December 13, 1861, Morison refers to a move to his new estate at Balerno, stating, "Dadd's drawings removed today." That he would bother to refer to this seemingly insignificant aspect of moving house may imply that the collection had grown to a considerable size. The seeming disappearance of Morison's Dadd pictures may help to account for the relative rarity of Dadd paintings from the early years of his stay at Bethlem.

80. The ladies have in fact "escaped" from an earlier Dadd painting, *The Fishmarket by the Sea*, also painted at Bethlem (ca. 1849). The subject is the fishwives of the village of Newhaven, made famous through the calotype studies of them by D. O. Hill and Robert Adamson, published in 1845. Although no exact prototype exists among these photographs, it is likely that Dadd was shown a collection of photographs of this kind during his first years at Bethlem.

81. The most bizarre example of such spatial irrationality is the painting *Landscape with Bull Calf* painted five years later in 1857, but many of Dadd's Bethlem pictures seem strangely constructed with figures oddly positioned in relation to one another. In *Method in Madness*, Miss Smailes drew attention to the unique spatial qualities of the painting, in terms of Dadd's psychological state. She also raised the question of the prominent handkerchief as "another disguised obsession," pointing to its appearance in other Dadd pictures, particularly the *Portrait of a Young Man*, which is so closely related to the Morison picture.

82. The use of an enormous sunflower plant directly behind the sitter is of particular significance. The sunflower appears in the painting *Pope's House*, which Dadd altered by adding a portrait of his father and a group of enormous sunflowers. It will be recalled that after the murder Dadd became obsessed with staring at the sun, which he called his father. Psychoanalytic investigations of the sun symbol have revealed the stability of the sun as a symbol of the father. The use of the sunflower in this context provides insight into the nature of Dadd's internal relationship to his physicians and other senior hospital staff as father substitutes. Freud's paper on the Schreber case helps to clarify the processes at work. See "Psychoanalytic Notes upon an Autobiographical Account of a Case of Paranoia (Dementia Paranoides)" (1911), in *The Standard Edition of the Complete Psychological Works of Sigmund Freud*, ed. James Strachey (London, 1956–1974), 12: 9–82.

83. This important painting is now known with certainty to have been destroyed in 1935 during the installation of the Imperial War Museum in the Bethlem Hospital building, St. George's Fields.

84. "Lunatic Asylums," *The Quarterly Review* 101 (1857): 353–93.

85. The decorative scheme for the theater has been destroyed with the exception of the small panels that formed the front of the stage. A number of important works by Dadd still survive at Broadmoor, including the six panels that he painted for the stage, and eleven glass panels that were probably designed for his own ward. There are also three watercolors and the oil portrait of Dr. Orange. A museum is being built at Broadmoor to house these works, as well as objects made by other patients.

86. *The World*, December 26, 1877, p. 14. The painted stage curtain that depicted "The Temple of Fame" was "thrown away when it became tattered."

87. Letter, Sir Hugh Orange, to Ian Phillips, February 12, 1946. Quoted in Allderidge, *The Late Richard Dadd*, p. 137. An article in *The Observer*, Sunday, December 16, 1984, says simply that the painting of Flora was "painted over." It does not say whether any effort has been made to recover this important picture.

88. John Rickett, "Richard Dadd: Bethlem and Broadmoor," *The Ivory Hammer* 2 (1964): 23. The history of the ownership of the Passion series is not as simple as Rickett implies. What is certain is that Hood owned sixteen of them, considering them his personal property. Six others appear always to have remained at Bethlem. The others were acquired by the hospital in the twentieth century from various sources.

89. Frith, *Autobiography*, p. 93.

90. Sir Alexander Morison, *The Physiognomy of Mental Diseases* (London, 1838).

91. Letter, J. E. Johnson to Sir Alexander Morison, May 5, 1856, in *Bridewell and Bethlem Letter Book*, 1856–1859. Archives of Bridewell Royal Hospital. As late as January 1859, Morison was still visiting Bethlem's Criminal Lunatic Department. An entry in his journal dated January 25 refers to "Dadd at work on a watercolour drawing."

92. Frith, *Reminiscenses*, p. 96. A number of Charles Gow's original drawings of patients at Bethlem survive. They are signed and dated to the day and reveal the fact that Gow was involved in making drawings of patients at Bethlem over many years, with drawings dated between 1842 and 1848. These drawings, along with others by Alexander Johnston and François Théodore Rochard, were given by Morison himself to the Library of the Royal College of Physicians, Edinburgh, where they remain.

93. Ibid., p. 94. The rather exaggerated tone of the account can be understood in terms of Frith's natural desire to make the event into a good anecdote. The story remains nevertheless a valuable account of a meeting between an insane artist at work and his sane brother.

94. Sala, "A Visit to the Royal Hospital of Bethlem," p. 304. The identification of the collection of photographs once owned by Dr. Hood with those now in the Bethlem Archives has recently been questioned and the Bethlem photographs are now thought to be the work of Henry Hering.

95. Hugh H. Diamond, "On Photography Applied to the Phenomenon of Insanity," *The Journal of the Photographic Society* 3 (1857): 88–89. Diamond exhibited his photographs several times in the 1850s in London, and they stimulated a good deal of critical reaction. See Ernst Lacan, "Review of Exhibition of Diamond Photographs," *La Lumière* 4 (1853). Diamond's photographs deserve to be better known as important examples of the early history of photography. Sander L. Gilman has published a short monograph on the Diamond photographs of patients entitled *The Face of Madness: Hugh W. Diamond and the Origin of Psychiatric Photography* (Secaucus, N.J., 1977). In this book, he reproduces the complete text of Diamond's "On the Application of Photography to the Physiognomic and Mental Phenomena of Insanity" in a version read before the Royal Society, May 22, 1856. Dr. Gilman also points out that Hood himself became involved in photographing patients at Bethlem at a slightly later date.

96. *The Asylum Journal* 1 (1853).

97. Dr. Diamond's photographs were extensively used by Dr. John Connolly (1794–1866) in a series of articles titled "The Physiognomy of the Insane," published during 1858–1959 in the *Medical Times and Gazette*, which utilized engravings made from the photographs.

98. Diamond, "On Photography," p. 89.

99. Ibid.

100. Forbes Winslow, "Mad Artists," *Journal of Psychological Medicine and Mental Pathology* n.s. 6 (1880): 33. The Collection has unfortunately disappeared, and it is not known which hospital Dr. Winslow had in mind when he referred to "an asylum which received patients almost exclusively from the educated classes." This hospital would most probably have been a private institution of which there were many. See William L. Parry-Jones, *The Trade in Lunacy: A Study of Private Madhouses in England in the Eighteenth and Nineteenth Centuries.* (London, 1972).

However, in an unpublished manuscript, "Adam the Shetlander: Artist Extraordinary and Psychiatric Patient for Fifty Years," Kenneth M. G. Keddie has identified the author of the unsigned article "Mad Artists" not as Dr. Forbes Winslow, but as a Scottish psychiatrist with a very early interest in the art of the insane, Dr. W.A.F. Browne. "Browne was appointed the first medical superintendent at the Royal Mental Hospital, Montrose, in 1834. Four years later he moved to take up the superintendency of the newly built Crighten Royal Infirmary, Dumfries. Browne collected paintings and drawings done by psychotic patients. He had this collection carefully bound, and the book can still be viewed at the Crighten Royal Infirmary. Browne wrote a paper giving his views on the relationship between mental illness and its effect on established artists entitled, 'Mad Artists.' Journal of Psychological Medicine and Mental Pathology. Vol. VI Part i (1880)." If this article is indeed by Browne, rather than Forbes Winslow, then the bound collection of psychotic art preserved at the Crighton Royal Infirmary may be the lost collection referred to. The fact that Forbes Winslow died in 1876 would tend to support Dr. Keddie's view that the article "Mad Artists" is not by him.

101. "Mad Artists," p. 33.

102. Ibid., p. 35.

103. Ibid., p. 34.

104. While the passions chosen for depiction are for the most part rather commonplace, the choice of the subject used to represent the passion was at times rather bizarre. The illustration of Patriotism with its accompanying text is the most extreme example.

105. Whether Hood possessed the degree of psychological sophistication or curiosity suggested here is not known. He published nothing to indicate any involvement with such problems, and his existing writings convey an impression of a physician concerned with providing adequate care for his patients but possessed of no remarkable degree of insight or curiosity as to the nature of their mental states.

106. Hood, *Statistics of Insanity, 1846–1860* (London, 1862), quoted in J.B.L. Allen, "Mad Robin: Richard Dadd," *Art Quarterly* 30, no. 1 (Spring 1967): 20.

107. Hood, Case Report for March 21, 1854, Bethlem Hospital Archives.

108. Sala, "A Visit to the Royal Hospital of Bethlem," p. 291. The "late Mr. Graves" was in fact very much alive. It is possible that his generosity to the hospital extended to its director, thus accounting for the large number of Victorian engravings in Dr. Hood's collection when it was sold in 1870. Many of the engravings, including works of Frith and Landseer, are still in the Bethlem collection.

109. "Lunatic Asylums," *Quarterly Review* 101 (1857): 361.

110. Sala, "A Visit to the Royal Hospital of Bethlem," p. 291.

111. John M. Galt, "On the Reading, Recreation, and Amusements of the Insane," *The Journal of Psychological Medicine and Mental Pathology* 6 (1853): 584.

112. The identification and discussion of these pictorial sources appears in Allderidge, *The Late Richard Dadd*, pp. 51 and 124, where the comparative material is illustrated. Imprisoned within the walls of Bethlem, Dadd would have been particularly dependent on memory or on borrowed material in painting his sometimes elaborate landscapes. The background of his portrait of Morison was based, he tells us, on a landscape painting done by one of Morison's daughters.

113. *The World*, December 26, 1877, pp. 13–14.

114. Sacheverell Sitwell, *Narrative Pictures* (London, 1937), pp. 69–74.

115. Ibid., p. 13.

116. Laurence Binyon: "A Note on Richard Dadd," *Magazine of Art* 30 (1937): 106–7, 125–28.

NINE. WILLIAM NOYES AND THE CASE OF "G"

1. William Noyes, "Paranoia: A Study of the Evolution of Systematized Delusions of Grandeur," *The American Journal of Psychology* 1 (May 1888): 460–78 and 2 (May 1889): 349–75. Hereafter, page references to both articles will appear in text, identified by year. William Noyes was an American psychiatrist and research worker of considerable distinction. He graduated from Harvard University in 1881, and from the Harvard Medical School in 1885. After graduation he accepted a fellowship in psychology at Johns Hopkins University. His stay at the Bloomingdale Hospital, where he served as Second Assistant Physician, ended in the same year that the patient "G" was transferred (1885–1889). Noyes then went to study in Vienna and Berlin, returning to organize a psychological laboratory at the McLean Hospital in Boston. For many years he was clinical instructor in

mental diseases at Harvard Medical School. For further information, see Henry M. Hurd, ed., *The Institutional Care of the Insane in the United States and Canada* (Baltimore, 1917), 4: 465–66.

2. The Bloomingdale Asylum evolved in 1821 from the New York Hospital. It was one of the first distinct mental hospitals in America to respond to the appeal for "moral treatment." The hospital was famous for its avoidance of mechanical restraint. Built between 1818 and 1821, the building was situated on 112th Street between 10th and 11th Avenues in New York and was designed to accommodate seventy-five patients. It was intended, like the old Bethlem Hospital, to look like a palace and was considered one of the finest buildings of its kind in America.

The early history of the hospital was described in 1845 in an article by Dr. Pliny Earle entitled, "Descriptive Account of the Bloomingdale Asylum for the Insane," *American Journal of Insanity* 2 (1845). Dr. Earle, then director of the hospital, was also interested in the creative activity of patients and published an early paper on the literature of the insane entitled, "The Poetry of Insanity," *American Journal of Insanity* 2 (1845): 193–224. In 1892, the hospital was relocated in White Plains, New York and is presently a branch of the New York Hospitals. For further information, see J. K. Hall, ed., *One Hundred Years of American Psychiatry* (New York, 1944); and J. F. Richmond, *New York and Its Institutions* (New York, 1871).

3. Efforts to identify this American student of Gérôme have thus far proved unsuccessful. I would like to thank Dr. Gerald M. Ackerman, and Miss Elizabeth Roth, keeper of prints for the New York Public Library, for their help in trying to unearth the identity of "G." The solution to the problem will probably be found in the case books of the New York Hospitals, but despite the effort of the archivist, Ms. Adele Lerner, on my behalf, the nineteenth-century records of the Bloomingdale Asylum remain unavailable for historical research.

4. Sigmund Freud, "Psychoanalytic Notes on an Autobiographical Account of a Case of Paranoia (Dementia Paranoides)" (1911), in *The Standard Edition of the Complete Psychological Works of Sigmund Freud*, ed. James Strachey (London, 1956–1974), 12: 9–82. Concerning the patient's interest in the sun, Noyes informs us, "On the headboard of his bedstead he has placed a circle carved out of soft wood and with the rays gilded to represent the sun. This emblematic sun comes directly above his head when lying down." The significance of this symbol was made clearer to me on a recent visit to a small Swiss museum. I encountered a seventeenth-century child's covered bed, on the inner ceiling of which was painted a sun disk, in the center of which was drawn the eye of God, placed there to watch over the sleeping child. In one of "G"'s poems reference is made to the relationship between the sun and the feeling of being watched. "For His God in the sky, / Has him close to his eye." In "G"'s delusional system the underlying equation between God, father, sun, and eye is easily recognized.

5. Noyes was very active during these years publishing abstracts from the new French and German psychological literature. These abstracts, covering a very wide range of topics, appeared in *The American Journal of Psychology* and in *The Psychological Review*. Interestingly, Simon's second article of 1888, "Les ecrits et les dessins des aliénés," appeared in the same year as Noyes's first discussion of the case. However, a footnote in Noyes's article informs us that the essay was received for publication the year before, in March 1887. Similarities in their treatment of the material, as well as Noyes's familiarity with the French psychiatric literature, make it almost certain that he had studied Simon's earlier publication of 1876.

6. Noyes's style is not unrelated to that of the French illustrator Félicien Rops (1833–1898). "G"'s work has considerable erotic content for an American illustrator of the 1880s. Rops was at the height of his career when "G" arrived in Paris in 1874. Similarities are also to be seen between the work of "G" and that of Adolfe Willette.

7. The artist who is not identified is described only as a New York artist who had known "G" in Paris.

8. Carl G. Jung, "Concerning Mandala Symbolism," in *Collected Works*, vol. 9, no. 1 (Princeton, 1969), pp. 355–84. Noyes's patient tends to confirm this interpretation in that he related an article he had read on the seven coverings of the wheat berry to the seven "seals of the soul" that are depicted concentrically in the mandala diagrams that he drew. "The wheat berry has seven coverings the same as man has the seven seals of God upon his spiritual grain or soul." It is also of significance in terms of our earlier discussion of sun symbolism in paranoia to discover that "G" considered these diagrams as depictions of the sun, referring to a part of the mandala as follows: "the large light triangles, or rather, rays of the sun."

TEN. THE CHICAGO CONFERENCE

1. J. G. Kiernan, "Art in the Insane," *Alienist and Neurologist* 13 (1892): 244–75. The discussion appeared in the same volume under the title "Discussion of the Paper on 'Art in the Insane,'" *Alienist and Neurologist* 13 (1892): 684–97. Page references to both will appear in the text hereafter.

2. James G. Kiernan, "Is Genius a Neurosis," *Alienist and Neurologist* 13 (1892): 119–50. Kiernan published a number of articles on this topic, including "Genius not a Neurosis," *Neurological Review* 1 (1886): 212–17.

3. The discussants were Dr. G. Frank Lydston; Dr. C. G. Chaddock of Traverse City, Mich.; Dr. Harriet C. B. Alexander; Dr. Archibald Church; Dr. Casey A. Wood; Dr. C. C. Hersman of Pittsburgh; Dr. Daniel Clark of Toronto, Canada; Dr. C. B. Burr of Pontiac, Mich.; Dr. J. A. Benson of Chicago; Dr. Lagorio of Chicago; and Dr. R. Dewey of Kankakee, Ill.

4. Dr. Burr's interest in the art of the insane continued, and he subsequently published an extensive article on the subject: "Art in the Insane," *American Journal of Insanity* 73 (1916): 165–94.

5. I am grateful to a student of mine, Mr. Peter Chapman, who undertook a detailed investigation of all of Dr. Clark's published writings, as well as unearthing information about his life and work in Toronto. Serious efforts have been made to locate whatever remains of Dr. Clark's collection of patient art, so far without success.

6. Dr. Daniel Clark, *Pen Photographs of Celebrated Men and Noted Places* (Toronto, 1873); editor, *Scottish Canadian Poets* (Toronto, 1900), which contains some of his poems; and *Josiah Garth*, a novel, which I have been unable to locate.

7. Ales Hrdlička, "Art and Literature in the Mentally Abnormal," *American Journal of Insanity* 55 (1899): 385–404. Hereafter, page references are cited in text.

8. His address is given as the Pathological Institute of the New York State Hospitals, 1 Madison Avenue, New York City. I wrote to this address to see if the Pathological Institute survived in any form, but the letter simply disappeared, lost, no doubt, in time.

9. Dr. Hrdlička's involvement with Middletown Hospital lasted only from 1894 to 1896. He left five years before Blakelock's arrival.

10. The true story of Blakelock's illness and hospitalization along with correct information about his artistic activity while at Middletown Hospital has only recently begun to emerge. The most valuable study thus far was published by the late grandson of the painter, David D. Blakelock, "The Confinement Period," in *Ralph Albert Blakelock*, a catalog published by M. Knoedler and Co., Inc. (New York, 1973), pp. 20–26. Abraham A. Davidson, "The Wretched Life and Death of an 'American Van Gogh,'" *Smithsonian* 18 (December 1987): 80–90, describes the bizarre story of Blakelock's final years, and the attempt to manipulate his artistic production while he was confined in a private asylum, Lynwood Lodge in West Englewood, N.J.

11. Vernon Young, "The Emergence of American Painting," *Art International* 18 (1974): 16–17.

The innocent source of some of the early forgeries was Blakelock's daughter Marian who followed her father into the asylum. For a detailed study of their works see Maurice J. Cotter, and E. V. Sayre, "Neutron Activation Analysis of Oil Paintings by Ralph A. Blakelock," *American Scientist* (January–February 1981): 17–28.

12. Davidson, "The Wretched Life and Death of an 'American Van Gogh,'" p. 86.

13. Blakelock, "The Confinement Period," p. 20.

14. In recent years Blakelock's descendants have taken on the task of correcting the erroneous picture of the artist. Mrs. Susielies Blakelock and the late Mr. David D. Blakelock were preparing a detailed biography of the artist based on a large body of material still in the possession of the family. "A great deal of information was gathered relating to Blakelock's actual mental and physical condition while in the hospital. Families of the doctors, attendants and nurses who tended to his daily cares gave us personal accounts which differed greatly from some of the headlines appearing in the newspapers they saved. These usually said—'Mad Artist etc.,' 'Violently Insane Painter' and so on." Blakelock, "The Confinement Period," p. 22.

15. James Thomas Flexner, *Nineteenth Century American Painting* (New York, 1970), p. 206.

16. Ibid.

17. Lloyd Goodrich, "c. 1865 to the Armory Show," *Encyclopedia of World Art* 1: 294.

18. The late David Blakelock had studied well over a hundred paintings from the artist's final period (1899–1919) and concluded "many have an expressionistic effect not apparent earlier" ("The Confinement Period," p. 26). He attempts to account for these changes on the basis of the artist's lack of paints, excitement over having paints, freedom from commissions, falling off of creative ability due to advanced age, and so forth.

19. *Art International* 17 (May 1973): 31–32.

20. *Arts Magazine* 47 (May 1973): 67.

21. *Art News* 72 (April 1973): 84.

ELEVEN. MARCEL RÉJA: CRITIC OF THE ART OF THE INSANE

1. One of Hyslop's larger works, a conventional landscape, is presently preserved in the Archives of Bethlem Royal Hospital. We are told that "two of his paintings, which were exhibited at the Royal Academy in 1900 and 1901 respectively, hang in the entrance hall of the Administrative Unit at Bethlem." Langford

Guest, "A Bethlem Physician," *Bethlem-Maudsley Hospital Gazette* (March 1956): 133–34.

2. T. B. Hyslop, "Post-Illusionism and Art in the Insane," *The Nineteenth Century and After* 408 (1911): 270.

3. Ibid., pp. 271–72.

4. Hyslop developed the term as equivalent to *degenerate* in a book entitled *The Borderland: Some of the Problems of Insanity* (London, 1924). Interestingly, the term was used in a different sense by Prinzhorn in 1922 to designate the area between psychiatry and art (see chapter 12).

5. This passage is of value in illustrating the old psychiatric attitude to neurotic patients, as opposed to the position adopted by Sigmund Freud and his circle in developing methods of treatment for them.

6. Hyslop, "Post-Illusionism," pp. 279–80.

7. Ibid., p. 274.

8. Arthur Thomson, foreword in *Mental Handicaps in Art* by T. B. Hyslop (London, 1927), p. xii.

9. The portfolio, bearing Hyslop's name and address, was found in a desk in the administrative offices at Bethlem Royal Hospital. I am grateful to the archivist, Miss Patricia Allderidge, for bringing it to my attention.

10. The identification of the work of this patient came about as the result of a lucky discovery. A drawing with a letter on the verso signed George Greenshields turned up in a private collection in London, and it was then possible to identify the works in the Bethlem archives on the basis of similarity of styles. The letter is dated August 2, 1901.

11. *Evening News* (London), November 23, 1905.

12. Interestingly, the question of psychoanalysis was hotly debated in the psychiatric meetings, with Pierre Janet launching a vicious attack against Freud and his circle. The analytic cause was ably defended by Ernest Jones. The impact of analytic thinking was not yet apparent in English psychiatry, or in any of the psychiatric writing on art produced in England.

13. The exhibition did not include case histories, and works "manifesting the slightest indelicacy or displaying what are called sexual tendencies were excluded." See "Art and Insanity in the Light of an Exhibition of Pictures by Lunatics," *Current Opinion* 55 (1913): 340.

14. Ibid. Lacking an illustration of one of the pictures in the Bethlem Exhibition, *Current Opinion* provided an American example, a picture from the article on "G" by William Noyes.

15. *The Daily Mirror*, August 9, 1913, p. 5.

16. *The Times*, August 8, 1913.

17. *The Daily Mirror*, August 9, 1913, p. 5. The lines quoted are attributed to "a great expert in mental diseases." The content of the interview is sufficiently characteristic to make an identification of the "expert" possible. It was, almost certainly, Hyslop.

18. Ibid.

19. Quoted in *Current Opinion* 55 (1913): 340.

20. Ibid.

21. *The Daily Mirror*, August 9, 1913, p. 5.

22. *Illustrated London News*, August 23, 1913, p. 281.

23. "Art and Insanity: The Bethlem Hospital Exhibition," *The Times*, August 14, 1913.

24. In response to my inquiry, Archivist Gordon Phillips of *The Times* put forward the suggestion that the article might have been written by Arthur Clutton-Brock, the regular art critic of *The Times* at that period, but he was unable to supply a firmly documented identification.

25. *Evening News* (London), November 23, 1905.

26. See "Collection du Docteur A. Marie," *L'art brut* 9 (1973): 79–80, for an account of the origins of the collection and of the recent transfer of a large part of it to the Musée de l'Art Brut in Lausanne. See also A. Marie, "Les musées d'asile," *Bulletin de la Société clinique de médecine mentale* 38 (1910); and A. Marie, "Le musée de la folie," *Je sais tout* 9 (October 15, 1905): 353–60.

27. *The Sketch*, November 22, 1905, p. 174. The picture, which also appeared in Professor Marie's article, "Le Musée de la Folie," (October 15, 1905), involves a number of serious problems. One naturally assumes it represents Dr. Marie standing in his museum at Villejuif. However, all of the carved pieces of furniture in the background, and the carved "portrait," are now in the Lombroso Collection in Turin, and, the furniture has been there since at least 1894, when Lombroso reproduced them in the sixth, revised and enlarged edition of *L'Uomo di Genio*. (Fig. 6.2) Since it is unlikely that these large pieces of furniture, given to Lombroso by an Italian physician, migrated to Paris in 1905 and then returned to Turin sometime later, it seems more plausible that Dr. Marie was photographed in Turin while visiting the Lombroso Collection at some time prior to 1905. If the statue is indeed a portrait of Dr. Marie, then we might assume he brought it with him and presented it to the Lombroso Collection, where it is still to be seen today. (In that collection, however, it is identified as the portrait of a prison governor.)

In 1910, the picture of Dr. Marie was reproduced once again, in an article entitled, "Les Musées d'Asile" in which we are told that Dr. A. Marie (de Villejuif) gave a report on a museum devoted to the art of the insane at Maüer-Öhling. This article, which appeared in the Bulletin of the Société Clinique de Médecine Mentale, 38 (1910), pp. 38–42, includes three photographs of the museum at Maüer-Öhling (1908), along with three small photographs identified as depictions of the Lombroso Collection. In each of the pictures pieces of the furniture referred to above are to be seen. One of these three photographs of the Lombroso Collection is the picture of Dr. Marie, and the wooden portrait. (Fig. 11.4) For this reason, I am inclined to assume that it is a photograph of Dr. Marie standing in the Lombroso Collection in Turin, and not in his museum at Villejuif, as has been stated or implied repeatedly. The article also includes a photograph of the museum at Villejuif.

28. Dr. A. Marie, "L'art et la folie," *Revue scientifique* 67 (1929): 393.

29. The students influenced by Dr. Marie included: Professors Claude, Laignel-Lavastine, and Bagenoff; Drs. Sérieux (an important collector), Marchand, Vinchon (a major contributor to the study of psychotic art), and Borel of Paris; Pailhas d'Albi, MacAuliffe, Bardet, and R. de Fursac of Villejuif; Livet and M. de Montyel of Ville Evrard. As we shall see, Dr. Paul Meunier also was part of this circle, and certainly was strongly influenced by the collection of Dr. Marie.

30. The collection was most extensively reproduced and discussed in a book by Dr. Marie's student Jean Vinchon, *L'art et la folie* (Paris, 1924), and this would be the crucial source for a reconstruction of this extremely important early collection.

31. From an article by Dr. Marie, "L'art chez les aliénés" (1930), quoted in *L'art brut* 9 (1973): 80.

32. Ibid.

33. Ibid., p. 81. This is the first time that this drawing, now in the Collection de l'Art Brut in Lausanne, has been reproduced in color. This case attracted the attention of several physicians in the circle around Dr. Marie. It was discussed by Marcel Réja

(1907) and Jean Vinchon (1924) and extensively by Dr. Paul Regnard in his book *Les maladies épidémiques de l'esprit: Sorcellerie, magnétisme, morphinisme, délire des grandeurs* (Paris, 1887). Regnard diagnosed Maurice N. (Fulman Cotton) as suffering from chronic delusions of grandeur (monomanie vaniteux), of some twenty-five years' duration. He described the evolution of his case in some detail, reproducing an engraving of him (based on a photograph), in which he appears dressed in his "papal regalia" (Fig. 11.7). Two further drawings from the collection of Dr. Magnan are reproduced, as well as a written text by the patient and some of his poems. Because it was discussed by numerous psychiatrists in France over many years, this case deserves particular attention.

34. Marie, "L'art et la folie," p. 395. Two hundred pieces from the collection were shown in June 1929 in the Salon of M. Bine, 48 ave. d'Iéna. A number of pieces from this exhibition were reproduced by Dr. Marie in "L'art chez les aliénés," *La revue de médecin* (1930): 11–14. These exhibitions are discussed in more detail in chapter 16.

35. J. Rogues de Fursac, *Les écrits et les dessins dans les maladies nerveuses et mentales: Essai clinique* (Paris, 1905), pp. 275–303.

36. Marcel Réja, "L'art malade: dessins de fous," *Revue universelle* 1 (1901): 913–15 and 940–44. (Hereafter, page references to this article are cited in text, identified by year.) This important article included twenty-two reproductions. It seems likely that it included works from Dr. Marie's collection, which had only begun to take shape the year before. Whether Réja played an active part in the formation of the "mad museum" at the Villejuif Asylum remains to be determined. One indication of a connection between Dr. Marie and Réja is an article they appear to have coauthored: "Note sur les dessins stéréotypés d'un dément précoce," *Journal de psychologie normale et pathologique* 4 (1903): 342–46.

37. In the same year, *Le révue universelle*, which appeared weekly, published serious articles on children's art, and on the art of primitive people, as well as on Rodin, Moreau, and Lautrec. It included reproductions of the work of all of these artists as well as pictures by van Gogh and Emile Bernard.

38. I wish to acknowledge my sincere gratitude to my friend and colleague Michel Thévoz, Director of the Musée de l'Art Brut, Lausanne, for providing me with the solution to this puzzle. He is presently involved with research into the life and work of Meunier-Réja, but generously interrupted his work to provide me with information on this intriguing physician and man of letters. See Michel Thévoz, "Marcel Réja, découvreur de l'art des fous," *Gazette des beaux-arts* 107 (May–June 1986): 200–208. The now firmly established dates for Réja's birth and death are derived from the Registre d'état civil for the town of Puiseaux, entry thirty for August 1873. The fact that Paul Meunier made use of the pseudonym is provided in Henry Coston, *Dictionnaire des pseudonymes* (Paris, 1969) 2: 148.

39. His thesis was published in 1900 in Paris under the title *Mesures de quelques modifications physiologiques provoquées chez les aliénés par l'alitement thérapeutiques*.

40. "Analogies du rêve et de la folie, d'après Moreau de Tours," *Archives générales de médecine* (published in collaboration with N. Vaschide) (1903).

41. Dr. Paul Meunier and Rene Masselon, *Les rêves et leur interprétation: Essai de psychologie morbide* (Paris, 1910). Meunier's 211-page book thoroughly describes the phenomenology of dreams of various patients. The reference to "interpretation" in the title is, however, without foundation. Although his references

to the earlier literature on dreams in French, German, and English is extensive, including lengthy quotations and examples from Paul-Max Simon's *Le monde des rêves*, as well as the writings of Janet and Charcot, he does not refer anywhere to Freud's *Interpretation of Dreams*, published ten years earlier. Nothing in his book indicates any familiarity with psychoanalysis. For his part, Freud made no reference to Meunier anywhere in the collected works, nor did Jung. Despite the obvious relevance of the title, the book was seldom referred to in the psychoanalytic literature at the time, or later.

42. The answers to these questions must await the investigation of Meunier's life and work to be published by Michel Thévoz. It is no doubt significant that his father, Théodore Étienne Meunier, was also a physician, practicing in Puiseaux. For a complete list of Meunier's literary publications under the pseudonym of Réja, see the Bibliography.

43. As a man of letters, poet and playwright, Réja was quite naturally more "at home" in the realm of verbal and written expression. This is quite apparent in *L'art chez les fous* (Paris, 1907), where more attention is paid to the poetry and prose of the insane. (Hereafter, page references to this book are cited in text, identified by year.) He was convinced that the insane writer was capable of producing true works of art. "The insane, the truly insane, have a literature which is excessively rich."

44. Significantly, the serious study of the art of the prehistoric caves of France and Spain was getting underway at this same period.

45. Réja refers in passing to Lombroso's book, but his study is confined to discussion of spontaneous artistic activity among the truly insane, and has nothing to do with pathography.

46. However, because some of the patients discussed by Réja must have been present at the Hospital of Villejuif, he may have avoided direct quotations from patients or descriptions of their behavior or symptomatology to conceal his psychiatric identity.

47. Hyslop, "Post-Illusionism," p. 270.

48. Réja was also interested in the art of prisoners, and drew parallels with the art of the insane in terms of the tendency of both to use images as a means of countering a frustrating reality through the use of concrete images. A superb illustration of the principle is to be encountered in Jean Genet's *Our Lady of the Flowers*.

49. The famous banquet in the Bateau-Lavoir, which confirmed the fame of the naive painter Henri Rousseau, was held in the following year, 1908.

50. Still later developments in the history of twentieth-century art, particularly the development of abstract art and of "action painting," have led to renewed interest in these most primitive of all psychotic styles. See for example the work of a patient known only as Max, discussed in Leo Navratil, *Die Künstler aus Gugging* (Vienna, 1983), pp. 260–70, which until recently would have been dismissed as unworthy of discussion even in books devoted entirely to psychotic art.

51. Very similar categories have been developed by art historians trying to deal with the extremely varied visual phenomena of Surrealism (see chapter 16).

52. Réja mentions studying the collections housed in the Trocadéro Museum, and he was familiar with Eskimo, African, Polynesian, and American Indian art objects and drawings. His influence in drawing the attention of the French avant-garde to these objects has never been commented upon.

53. Although Ensor's work had been shown in Paris as early as 1898, he was still far from well known outside of artistic circles.

In the article of 1901, in the context of a discussion of art produced under the influence of narcotics, he made comparisons with the work of Goya, Ensor, and Redon.

54. Recent critics have tended to accept the fact that Séraphine was insane, though able to function in her small village. Edith Hoffmann, for example, states: "Undoubtedly Séraphine had reached the borderline of insanity when she painted [her pictures]." See "Naive Painters in Rotterdam and Paris," *Burlington Magazine* 106 (1964): 473–74.

55. William Uhde, "Painters of the Inner Light: Séraphine," *Formes* 17 (1931): 115.

56. William Uhde, *Picasso et la tradition française: Notes sur la peinture actuelle* (Paris, 1928).

57. Ibid., pp. 115–16. The phrase "fine frenzy" is, of course, borrowed from Shakespeare, *A Midsummer's Night Dream*: "The poet's eye, in a fine frenzy rolling."

58. Pierre Schneider, reviewing an exhibition of Séraphine's work, referred to her as "an hallucinated Breugel de Velours." "Séraphine establishes between the privacy of madness and the publicness of art, the same link that Rousseau established between art and the naive." *Art News* 61, no. 5 (1962): 54.

59. Uhde, "Painters of the Inner Light," p. 116.

60. William Uhde, *Fünf primitive Meister* (Zurich, 1947), p. 135.

61. Ibid., p. 134.

TWELVE. HANS PRINZHORN AND THE GERMAN CONTRIBUTION

1. The Villa, one of the masterpieces of Italian Baroque architecture, was begun in 1705 and still stands. Commissioned by the grandfather of Ferdinando Gravina, it was the work of the architects Maria Tommaso Napoli and Agatino Daidone. The sculpture and furnishings of the building with which we are concerned were a later addition dating to the later years of the eighteenth century, and the ensemble was still incomplete when visited by Goethe in 1787. See Anthony Blunt, *Sicilian Baroque* (London, 1968).

2. It was understood as such by the first German writers on the art of the insane.

3. Although extremely eccentric, Gravina was at liberty at the time of Goethe's visit, and not confined in a madhouse. Goethe's interest in the prince's strange inventions extended to a desire to see the man himself, a wish that was gratified on the following day.

4. Goethe, *Italian Journey* (1786–1788), trans. W. H. Auden and Elizabeth Mayer (London, 1962), pp. 231–33. All further references are to this edition.

5. Goethe, *Italian Journey*, pp. 234–35.

6. Ibid., pp. 233–34.

7. Ibid., pp. 233.

8. The therapeutic use of art, music, and drama, as opposed to its occupational or recreational function, was now introduced, having emerged with the birth of individual psychotherapy. The first treatise on the art of psychotherapy was that of Johann Christian Reil (1759–1813), inventor of the term psychiatry. It was Reil who recognized the profound influence that art, music, and drama might exert on the mind of the patient.

9. Carl Gustav Carus, *Psyche: Zur Entwicklungsgeschichte der Seele* (Pforzheim, 1846), p. 1. Translated in H. F. Ellenberger, *The Discovery of the Unconscious* (New York, 1970), p. 207.

10. See Marianne Prause, *Carl Gustav Carus: Leben und Werk* (Berlin, 1968); and E. Jansen, ed., *Carl Gustav Carus, Lebenser-*

innerungen und Denkwürdigkeit (Weimar, 1966); and Carl Hä-berlin, "Der Arzt C. G. Carus und Goethe: Mit Ausblicken auf die Psychologie des Unbewussten," *Jahrbuch der Goethegesellschaft* 13 (1927): 184–204.

11. Franz G. Alexander and Sheldon T. Selesnick, *The History of Psychiatry* (New York, 1966), p. 145.

12. Fritz Novotny, *Painting and Sculpture in Europe, 1780–1880* (Harmondsworth, 1960), p. 57, quoted from Carus's memoirs, 1865–1866.

13. Kraepelin's followers subdivided the psychotic illnesses, and in particular schizophrenia; however, because these numerous subcategories cannot be convincingly linked to specific types of drawings, I have avoided utilizing them in discussion of diagnoses or case material.

14. "Zeichnungen von Geisteskranken," *Zeitschrift für Angewandte Psychologie und Charakterkunde* 2 (1908–1909): 291–300.

15. So numerous are the publications that deal with psychiatry and art, and so repetitive and poor in quality, that from 1900 on it is no longer possible or desirable to be comprehensive in discussing publications in this field. Accordingly the discussion of early twentieth-century material is restricted to those studies that represent major early contributions to the psychiatric and art historical investigation of psychotic art.

16. H. Rorschach, "Analytische Bemerkungen über das Gemälde eines Schizophrenen," *Zeitschrift für Psychoanalyse und Psychotherapie* 3 (1913): 270–72.

17. Robert Sommer, *Kriminalpsychologie* (Leipzig, 1904), pp. 170–80. See also his *Diagnostik der Geisteskrankheiten* (Vienna, 1894), pp. 282–85. Wilhelm Weygandt, *Atlas und Grundriss der Psychiatrie* (Munich, 1902), and "Kunst und Wahnsinn," *Die Woche* 22 (1921): 483–85. Some years later Näcke published a brief article on the subject entitled "Einige Bemerkungen bezüglich der Zeichnungen und anderer künstlerischer Ausserungen von Geisteskranken," *Zentralblatt für die gesamte Neurologie und Psychiatrie* 17 (1913): 453–73, which gives a clear idea of his approach.

18. In the group working with Eugen Bleuler at the Bergholzli Hospital, which included the young Carl Jung, studies of word association phenomena in terms of the psychoanalytic theory of repression and psychological conflict were leading to an understanding of the effect of unconscious complexes on the pattern of word and thought associations.

19. The term *complex* was developed by Jung and his group in Zurich and adopted briefly by Freud and the psychoanalytic circle in Vienna.

20. Mohr, "Über Zeichnungen," p. 106.

21. Ibid., pp. 116–17.

22. Mohr, "Zeichnungen," pp. 295–96.

23. Mohr, "Über Zeichnungen," pp. 125–27.

24. Ibid., p. 126.

25. Ibid., p. 127.

26. Hans Prinzhorn, *Bildnerei der Geisteskranken: Ein Beitrag zur Psychologie und Psychopathologie der Gestaltung* (Berlin, 1923).

27. I would like to thank Dr. Inge Jádi, the curator of the Prinzhorn Collection for her kindness in making the whole of the collection available to me and in helping to make my stay in Heidelberg a rich and memorable experience. The collection is housed in an attic of the Psychiatrischen Klinik der Universität Heidelberg, and is available for study and research purposes on application to the curator. A series of exhibitions is planned, and it is eventually hoped to continue with further publication of the material, much of which remains unknown. It is not planned to add further material to the collection.

The collection now contains approximately six thousand objects, by some 516 patients, seventy percent of whom were diagnosed as schizophrenic. The majority of the works were created between 1890 and 1920, with a few works dated earlier, and a larger number later, having been added to the collection after Prinzhorn's departure, but not after 1933.

Prinzhorn wrote letters to many major psychiatric hospitals in Germany, Austria, and Switzerland, requesting works of psychiatric art, and explaining with great care the nature of the material in which he was interested, with a view to assuring that the aesthetic notions of the hospital directors would not eliminate some of the most important works. This naive aesthetic selectivity interferes with the preservation and collection of psychotic art to this day. Prinzhorn requested, "drawings, paintings, and sculptures by the mentally ill that do not merely reproduce prototypes or remembrances from times when they were healthy, but rather are the expression of personal experience during illness . . . productions that are clearly the result of mental disturbances, so called 'catatonic drawings' . . . any type of doodling, including the most primitive, that does not have value by itself, but only gains significance with extensive comparable material." Letter of 1920, signed by Drs. Prinzhorn and Wilmann, quoted in Inge Jádi, "The Prinzhorn Collection and Its History," *The Prinzhorn Collection*, Krannert Art Museum Catalog (Urbana-Champaign, Ill., 1985), p. 2. See also her article, "Die Prinzhorn-Sammlung," in *Die Prinzhorn-Sammlung* (Königstein, 1980), pp. 15–27. For a major study of psychotic texts in the collection, see Inge Jádi, ed., *Leb wohl sagt mein Genie Ordugele muss sein* (Heidelberg, 1985), with an introductory essay by Ferenc Jádi (pp. 11–39).

28. For a brilliant introduction to the cultural milieu in Vienna when Prinzhorn was growing up see, Carl E. Schorske, *Fin de Siècle Vienna: Politics and Culture* (New York, 1980). A valuable discussion of the historical background influencing Prinzhorn is provided by Sander L. Gilman, "Madness and Representation: Hans Prinzhorn's Study of Madness and Art in Its Historical Context," in *The Prinzhorn Collection*, pp. 7–14, which describes the intellectual milieu of the Heidelberg Clinic. See also Wolfram Schmitt, "Die Psychiatrie und der Geisteskranke im Wandel der Zeit," in *Die Prinzhorn-Sammlung*, pp. 44–54.

29. A full-length biography of Prinzhorn has yet to be written. Biographical information appears in a number of useful articles upon which my brief account of his life is based. See Maria Rave-Schwank, "Hans Prinzhorn und die Bildnerei der Geisteskranken," in *Bildnerei der Geisteskranken aus der Prinzhorn-Sammlung* (Heidelberg), 1967, pp. 7–9; James L. Foy, introduction to *Artistry of the Mentally Ill* (New York, 1972), pp. ix–xvi; and the preface by Dr. W. von Baeyer in the same edition. I am grateful to Dr. von Baeyer for taking the time to discuss Prinzhorn's life and work with me. The finest description of Prinzhorn by someone who knew him was published as a tribute after his death by an American disciple, David Lindsay Watson, "In the Teeth of All Formalism," *The Psychoanalytic Review* 23 (1936): 353–62. The astonishing fact is that Prinzhorn stayed at the Heidelberg Clinic for only a year and a half, and that the bulk of the collection was assembled during this short stay. See Jádi, "The Prinzhorn Collection and Its History," pp. 2–4.

30. The finest pieces in the collection, including a number not included in Prinzhorn's book, were exhibited in October 1967 at

the Galerie Rothe in Heidelberg and published in an elegant exhibition catalog.

In recent years the collection has begun to travel and to gain the worldwide fame it deserves. The first major exhibition toured Germany and Switzerland in 1980. It was accompanied by a vast and elegantly written catalog entitled, *Die Prinzhorn-Sammlung: Bilder, Skulpturen, Texte aus Psychiatrischen Anstalten (ca. 1890–1920)* (Königstein, 1980). Its chief importance lies in the fact that it made available for the first time whole sections of the Prinzhorn Collection. In 1985 a further selection of works toured America. This exhibition, organized by the Krannert Art Museum of the University of Illinois, was also accompanied by an excellent catalog with new and stimulating articles on Prinzhorn and the collection in English (*The Prinzhorn Collection*). It includes a detailed presentation of the work of seventeen artists in the collection as well as many additional pieces not discussed by Prinzhorn, including the work of several outstanding women artists. Analysis of critical response to these two recent exhibitions will provide valuable evidence concerning the changing response to this art in the latter part of the twentieth century. A first effort in this direction is provided by Constance Perin's article, "The Reception of New, Unusual and Difficult Art," in *The Prinzhorn Collection*, pp. 21–28, which discusses European critical response to the touring exhibition.

It is now known that Prinzhorn and Dr. Karl Wilmanns planned to develop a permanent museum to house the collection. In a letter dated May 1919, Prinzhorn wrote "There is, therefore, a plan to keep the collection in its entirety and to open it to the interested public in the form of a museum for pathological art." See Bettina Brand, "Aspects of the Prinzhorn Collection," in *The Prinzhorn Collection*, p. 5. It is to be hoped that this dream will be realized in the near future.

31. Hans Prinzhorn, "Das bildnerische Schaffen der Geisteskranken," *Zeitschrift für die gesamte Neurologie und Psychiatrie* 52 (1919): 307–26.

32. Hans Prinzhorn, *Artistry of the Mentally Ill*, trans. Eric von Brockdorff (New York, 1972), p. 3, n. 5. Hereafter, page references to this edition are cited in text.

33. Hans Prinzhorn, *Bildnerei der Gefangenen* (Berlin, 1926).

34. Rave-Schwank, "Hans Prinzhorn," p. 7.

35. W. von Baeyer and H. Hafner, "Prinzhorn's Basic Work on the Psychopathology of the Gestaltung," in *Psychopathology and Pictorial Expression*, ser. 6, vol. 1 (New York and Basel, n.d.).

36. Watson, describing Prinzhorn's impact at Yale and Antioch College in 1929, says, "He was much more (or less) than a scientist. The Anti-formalist slant of his mind made a great gulf between himself and the background of psychologists who might have been supposed to be his immediate audience." See "In the Teeth of All Formalism," p. 360.

37. Ibid., pp. 358–59.

38. Ibid., p. 354.

39. Prinzhorn's psychiatric approach to psychotic art can be seen on one level as a detailed reaction against the ideas of Cesare Lombroso, whom he never missed an opportunity of refuting.

40. German art theorists had by 1900 rejected the outmoded term *Kunstgeschichte* (art history), preferring the less constricting term *Kunstwissenschaft* (science of art), which allowed for the full range of academic disciplines necessary to the study of art. Psychology at the turn of the century so pervaded the "science of art" that doctoral dissertations were not uncommonly devoted to such problems. To speak of the most famous examples, Wölfflin's dissertation was entitled, "Prolegomena to a Psychology of Architecture," while Worringer's "Abstraction and Empathy" of 1907 had the title, "A Contribution to the Psychology of Style." The dazzling culmination of this trend is to be seen in our own day in the work of Professor Ernst Gombrich.

41. The enormous importance of the work of the psychologist-philosopher, Ludwig Klages, to the student of the psychology of expression and of style cannot be overestimated. See particularly his *Grundlegung der Wissenschaft vom Ausdruck* (Leipzig, 1936), and *Handschrift und Charakter* (Leipzig, 1936).

42. Analysts who have taken a particular interest in play and its relation to artistic creativity include W.R.D. Fairbairn, D. Winnicott, P. Greenacre, and Marion Milner.

43. August Natterer, (b. 1868), patient in the Heidelberg clinic, previously known by the pseudonym August Neter; Emile Nolde (1867–1956), German Expressionist painter. In recent years the Prinzhorn Collection has abandoned the use of pseudonyms, restoring to the artists their own names, thereby according to them the fame that is rightfully theirs.

44. The complete set of "skirt transformation" drawings was reproduced in *The Prinzhorn Collection*, p. 41.

45. The title is not Natterer's but was supplied by Dr. W. von Baeyer.

46. Minutes of the Vienna Psychoanalytical Society, October 12, 1921.

47. The exact nature of Prinzhorn's involvement with psychoanalysis is difficult to establish. Miss Anna Freud remembered Prinzhorn and his reputation, but was uncertain as to whether he was ever seen as an analyst by the analytic community. Watson refers to him as practicing as an analyst. Prinzhorn usually referred to himself as a psychotherapist, but all his later books and articles contain extensive discussion of psychoanalysis. A certain ambivalence in his relation to it would suggest that he was not so much an adherent as an interested outsider.

I am particularly proud of the fact that fifty-five years after Prinzhorn's appearance at Freud's Wednesday meeting, I was invited to address the Wednesday meeting of the Hampstead Clinic on the topic of psychotic art, with Freud's daughter Anna in the chair. The title of this lecture, delivered on June 9, 1976, was "Jonathan Martin of Bedlam: An Introduction to the History of the Art of the Insane at Bethlem Hospital, London."

48. Oskar Pfister, *Imago* 9 (1923): 503–6.

49. Ibid., p. 504.

50. Ibid., p. 503.

51. It is striking that Prinzhorn makes use of the Freudian terms for this material—"phylogenetic remains, regression, and archaic thinking"—rather than Jung's concept of the archetype, despite his familiarity with Jung's writings. The possibility has been raised by Watson that Prinzhorn's writings on psychotherapy may have influenced Jung. Watson refers to Prinzhorn as "the first great critic and synthesizer of the psychotherapeutic movement." It is also apparent that both Jung and Prinzhorn were influenced by the thought of Ludwig Klages, in particular by his celebration of the unconscious as a source of wisdom.

52. Although psychiatrists have attempted repeatedly to characterize the essential features of psychotic art, art historians, with their sophisticated methods of stylistic and formal analysis, have not yet undertaken in any extensive way to define the unique features of this form of visual material. In terms of purely stylistic and formal criteria, can a distinct psychotic mode of pictorial and plastic expression be said to exist? For further comment on this problem, see chapter 14.

53. An insightful psychological exploration of the relationship

between certain formal characteristics of schizophrenic artistic productions and the underlying detached mental state is to be found in Rudolf Arnheim, "The Artistry of Psychotics," *American Scientist* 74 (January–February 1986): 48–54. A more formal attempt of Prinzhorn to address the problem of the essential characteristics of psychotic art is found in his article, "Gibt es schizophrene Gestaltungsmerkmale in der Bildnerei der Geisteskranken?" *Zeitschrift für die gesamte Neurologie und Psychiatrie* 78 (1922): 512–31.

54. The artists referred to are two of the leading German Expressionist painters, Max Pechstein (1881–1955) and Erich Heckel (1883–1970).

THIRTEEN. THE WORLD OF ADOLF WÖLFLI

1. Carl G. Jung, *Memories, Dreams, Reflections* (New York, 1961), esp. chap. 6; and H. F. Ellenberger, *The Discovery of the Unconscious* (New York, 1970), chap. 9.

2. In these museums the work of these painters is exhibited without distinguishing labels, and in juxtaposition with the work of their "normal" contemporaries. The number of works in the permanent collections varies from dozens in the case of Aloïse, to thousands in the case of Wölfli.

3. A valuable discussion of the process of discovery of Wölfli's work is to be found in Alfred Bader, "The Reception of Wölfli's Art in the Course of Time," in *Adolf Wölfli*, ed. Elka Spoerri and Jürgen Glaesemer (Berne, 1976), pp. 113–14. Bader points out that following the publication of Morgenthaler's book in 1921, there was a forty-year time lag in response to Wölfli in Switzerland, with the exception of an exhibition held in 1930 at the Industrial Museum in Winterthur where Wölfli's work was seen only as a "supplement to a display of 'Children and Youth drawings.'"

4. The contribution of Dr. Ladame was brought to my attention by a visit to the Collection de l'Art Brut in Lausanne. Ladame's collection, or what was left of it, was given to the Compagnie de l'Art Brut in 1948, and is now housed in the museum in Lausanne. See "Le Cabinet du Professeur Ladame," *L'art brut* 3 (1965): 59–95. My discussion of Ladame's contribution is based on this article and on research in the files and picture collection at the Collection de l'Art Brut.

5. Charles Ladame, "A propos des manifestations artistiques chez les aliénés," *Schweizer Archiv für Neurologie und Psychiatrie* 6 (1920): 166–68. His artistic interests extended to literature as well, and he published a psychiatric study of Guy de Maupassant.

6. *L'art brut* 3 (1965): 67.

7. Ibid., p. 68.

8. Ibid., p. 71.

9. Morgenthaler, *Ein Geisteskranker als Künstler* (Bern, 1921). All further page references are to this edition and will be cited in text. The translations are my own. A new edition of the rare 1921 book was published in 1985 by Medusa Verlag (Vienna, Berlin).

10. Rorschach's book, *Psychodiagnostik* (Bern, 1921), appeared in the same series of publications in which Morgenthaler's did, under the general title *Arbeiten zur angewandte Psychiatrie* (Studies in Applied Psychiatry), the first volume of which was the Wölfli study. The enormous importance of the Rorschach test and its protocols for studies in visual response to art and in aesthetics is as yet little appreciated. Despite the shortness of his life, Rorschach also contributed to the study of psychotic art. "Analytische Bemerkungen über das Gemälde eines Schizophrenen," *Zeitschrift für Psychoanalyse und Psychotherapie* 3 (1913): 270–72, and "Analyse einer Schizophrenen Zeichnung," ibid., 4 (1914): 53–55.

11. The main sources for the biography of Dr. Morgenthaler are a brief autobiographical statement, *Aus meinem Leben* (Bern, 1960), and a necrology written by Dr. Hans Walther-Büel. These were published together as part of a memorial booklet. I am also grateful to Dr. Walther-Büel for taking time from his busy schedule as director of the Psychiatrische Universitätsklinik, Bern (The Waldau), to talk with me about the collection and his memories of Morgenthaler. Professor Alfred Bader describes a conversation with Dr. Morgenthaler, in the 1950s, in which Morgenthaler stated "that his monograph had been completely misunderstood by his colleagues, even smiled at, causing him more trouble than appreciation." See Bader, "The Reception of Wölfli's Art in the Course of Time," p. 113.

12. The Morgenthaler Museum at the Psychiatrische Universitätsklinik, Bern, had been the only surviving example of a museum devoted to psychiatric art from the early years of this century. This building also contained the room in which Wölfli lived, the ceiling of which was painted with a superb mural by him. However, both the museum and Wölfli's room have recently been destroyed. Plans exist to recreate the museum in one of the old buildings on the hospital grounds, but interest in Wölfli at the hospital has all but ceased to exist. For a brief account of the founding of this early museum in 1914, see Jacob Wyrsch, "Adolf Wölfli and the Waldau," in *Adolf Wölfli*, pp. 107–9, and his book, *One Hundred Years Waldau* (Berne, 1955).

13. Morgenthaler's interest in psychotic art was not confined to the Wölfli study. As early as 1918 he had published "Übergänge zwischen Zeichnen und Schreiben bei Geisteskranken," *Schweizer Archiv für Neurologie und Psychiatrie* 3 (1918): 255–305, and in the following year, "Über Zeichnungen von Gesichtshalluzinationem," *Zeitschrift für die gesamte Neurologie und Psychiatrie* 45 (1919): 19–29. He continued to write articles on psychiatry and art as late as 1942, when he published a paper on the psychology of drawing.

14. The exhibition was held in a bookstore in Bern in 1921, in connection with the publication of Morgenthaler's book by the Ernst Bircher Press.

15. *Leonardo da Vinci and a Memory of His Childhood*, in *The Standard Edition of the Complete Psychological Works of Sigmund Freud*, ed. and trans. James Strachey (London, 1956–1974), 11: 59–138.

16. Morgenthaler, *Aus meinem Leben*, p. 17.

17. Hermann Ebbinghaus (1850–1909) has been described as the German William James, and like James he was a pyschologist gifted with the ability to write clear and lucid prose.

18. A number of further studies of Wölfli's art followed on that of Dr. Morgenthaler. See particularly Julius v. Reis, *Über das Dämonisch-Sinnliche und den Ursprung der ornamentalen Kunst des Geisteskranker Adolf Wölfli* (Bern, 1946). The recently published catalog of the huge Wölfli exhibition, Bern 1976, edited by Spoerri and Glaesemer, is a collaborative effort including contributions by eleven individuals: art historians, scholars specializing in music and literature, psychiatrists, and psychoanalysts. I am now at work on a monograph on Wölfli's work.

19. The first part of this major undertaking was completed with the publication of Wölfli's *Von der Wiege bis zum Graab: Schriften (1908–1912)*, 2 vols., ed. Elka Spoerri and Dieter Schwarz (Frankfurt, 1988).

20. Wölfli had himself written a very precise and fully accurate

account of his life prior to hospitalization, at the time of his admission to the Waldau. It is reprinted in *Adolf Wölfli*. By 1912 he had completed his fantastic autobiography entitled, "From the Cradle to the Graave [*sic*]," and had begun to elaborate his Cosmic Voyages in the person of The Holy Saint Adolf II.

21. Some years earlier, Morgenthaler wrote a study of the history of the treatment of the insane in Bern prior to 1749. Dr. Walther-Büel described it as "a small cultural history of an epoch."

22. Contact with Wölfli, and later with Wölfli's vast oeuvre, has changed and deepened many psychiatrists. This is made particularly evident in a magnificent tribute to Wölfli written by Dr. Hemmo Müller-Suur entitled "Wölfli's Art as a Problem for Psychiatry," in *Adolf Wölfli*, pp. 99–106. As he points out, "Wölfli's art puts to us not the question of the cause, but the question of the meaning of psychosis."

23. Morgenthaler was also faced with the task of analyzing Wölfli's literary output, both prose and poetry, using sophisticated techniques of literary criticism. This undertaking is continued in a remarkable essay by Elsbeth Pulver, a specialist in German literature, entitled "Signed: Adolf Wölfli, a Victim of Misfortune: Language Structure in Adolf Wölfli's Written Work," in *Adolf Wölfli*, pp. 67–80. Transcription of all of Wölfli's written material continues under the auspices of the A. Wölfli Foundation, Kunstmuseum, Berne, under the direction of Elka Spoerri.

24. Tragically, the origins of Wölfli's creative activity cannot be described since the drawings from the period 1899–1903 were destroyed, dismissed by the physicians and others who supervised him as nonsense. The earliest known drawings by Wölfli are the forty-nine black-and-white drawings of 1904–1906, two of which include the use of blue pencil. The complete black-and-white drawings have been reproduced in *Adolf Wölfli: Zeichnungen 1904–1906*, ed. Elka Spoerri (Stuttgart, 1987). The first colored drawing is *Felsenau, Berne* of 1907. For a detailed chronology of Wölfli's pictorial development and its connection with the forty-four volumes of written work, see Elka Spoerri, "Inventory of Basic Forms and Picture Types in the Pictorial Work of Adolf Wölfli" in *Adolf Wölfli*, pp. 9–33.

25. I am indebted to Mrs. Elka Spoerri for pointing out to me the important pictorial function of Wölfli's music, and for her enthusiastic introduction to the Wölfli archives in Bern. The music has been studied by Mr. Peter Streiff and is, in part, playable. At my suggestion, a concert of Wölfli's music was given at the opening of the Wölfli Exhibition in Bern, on June 8, 1976.

26. Elka Spoerri's introduction to the catalog of the Wölfli exhibition of 1976, "Inventory of Basic Forms and Picture Types in the Pictorial Work of Adolf Wölfli," pp. 9–33, is the single most important contribution to Wölfli studies since Morgenthaler's pioneering study. Her detailed description of the evolution of abstract and figurative elements in the pictures, accompanied by a useful pictorial inventory, "Wölfli's Vocabulary of Forms," pp. 50–53, is the essential document for anyone attempting to obtain insight into Wölfli as an artist-creator.

27. This passage was written by Morgenthaler for the French edition of his book, and does not appear in the original text of 1921. See Walter Morgenthaler, *Adolf Wölfli*, trans. Henri-Pol Bouché (Paris, 1964), p. 146.

28. It should be stressed that I refer here to psychoanalysis as a body of psychological theory and as a method of investigation, but not as a method of treatment. Wölfli's case was quite unsuited to the application of psychoanalytic therapy, and neither Morgenthaler nor Freud would have undertaken such a task.

29. *Rainer-Maria Rilke, L. Andreas-Salomé: Briefwechsel* (Zurich, 1952), pp. 449–55 and notes on pp. 626–28. Rilke reacted to Morgenthaler's book and to Wölfli's work with enormous enthusiasm, seeing it as a means of gaining new insight into the creative process. "Wölfli will help us to acquire new information about the origins of creativity." The Bircher press sent Rilke an original drawing by Wölfli. Rilke sent a copy of the book to Lou Andreas-Salomé who immediately drew Freud's attention to it. However, no reference to Wölfli's case is to be found in Freud's published work, and I was unable to locate Morgenthaler's book in Freud's library in London. Andreas-Salomé, who was also familiar with Prinzhorn's work in Heidelberg, saw the psychotic artist as a crucial source for the understanding of the psychology of artistic creativity. "Although himself incurable, he communicates to us something immensely important about ourselves, insofar as we take the trouble (as has happened in the last decade) to understand his dialect."

30. Morgenthaler would have had in mind the application of psychoanalysis to the word association studies then underway in Zurich.

31. Jung's *Psychology of the Unconscious* had been published in 1917, and Morgenthaler refers to it in a footnote on p. 68. Two important early drawings by Wölfli were recently discovered in the collection of the C. G. Jung Foundation, Zurich. Although Jung knew of Wölfli's work, he does not appear to have made any direct reference to it in his published writings.

32. The first publication referred to is probably the important paper, "Further Remarks on the Neuro-Psychoses of Defence" (1896), in *Standard Edition*, 3: 157–86. The Schreber analysis was published under the title "Psychoanalytical Notes on an Autobiographical Account of a Case of Paranoia (Dementia Paranoides)" (1911); see *Standard Edition*, 12: 1–84.

33. Sigmund Freud, *Leonardo da Vinci and a Memory of his Childhood*, pp. 63–137. On the other hand, Morgenthaler disputed, with reason, Freud's opinion, put forward in his discussion of the Schreber case, that in paranoia one encountered a strongly repressed homosexual component as the basis of the psychological conflict. Morgenthaler could detect no signs of repressed homosexuality in the sexual constitution of his patient, or in his art.

34. At the end of his life, ill with an inoperable cancer, Wölfli seemed to understand that he was dying, and indeed expressed a wish to die. The final two years of his life were entirely occupied by the composition of his *Funeral March*, a gigantic work involving poetry, drawing, and collage. Although he continued to work on it almost to the last day, it was unfinished at his death, November 6, 1930.

FOURTEEN. EXPRESSIONISM AND THE ART OF THE INSANE

1. The exhibition was staged by a group of Düsseldorf artists known collectively as the Sonderbund. The 1912 exhibition, however, was not limited to group members but was an overview of contemporary art in Europe.

2. The term *Expressionism* was introduced in 1911 and originally included more than we would now identify as Expressionist art. El Greco, Picasso, the Fauves, and even Orphism and Cubism, were seen as aspects of Expressionism.

3. Karl Jaspers, *Strindberg und Van Gogh: Versuch einer pathographischen Analyse* (Munich, 1949), p. 182. Jaspers's study was first published in 1922 as part of a series devoted to studies in applied psychiatry. Jaspers was for many years on the

staff of the Heidelberg Psychiatric clinic and would have been well acquainted with Hans Prinzhorn and the collection of psychiatric art that he was assembling there.

4. For a detailed collection of Expressionist writings on insanity, see Thomas Anz, ed., *Phantasien über den Wahnsinn: Expressionistische Texte* (Munich, 1980). Also, Wolfgang Rothe, "Der Geisteskranke im Expressionismus," *Confinia Psychiatrica* 15 (1972): 195–211.

5. For an elaborate, extremely detailed discussion of the influence of primitive, or tribal art, on the Expressionist artists, see William Rubin, ed., *Primitivism in Twentieth Century Art: Affinity of the Tribal and the Modern* (New York, 1984). Donald E. Gordon's contribution, "German Expressionism," pp. 369–403.

6. Jean Cassou, Emile Langui, and Nikolaus Pevsner, *The Sources of Modern Art* (London, 1962), p. 149.

7. Peter Selz, *German Expressionist Painting* (Berkeley, 1957), p. 106.

8. Wassily Kandinsky, *Concerning the Spiritual in Art* (1917; New York, 1947), p. 69.

9. Selz, *German Expressionist Painting*, p. viii.

10. Kandinsky, *Concerning the Spiritual in Art*, p. 75.

11. Robert Goldwater, *Primitivism in Modern Art* (1938; New York, 1967), p. 105.

12. Cassou et al., *The Sources of Modern Art*, p. 150.

13. Emil Nolde, quoted in Peter Selz, *Emile Nolde* (New York, 1963), p. 16.

14. Nolde, letter to Hans Fehr, Friedenau, March 5, 1909, quoted in Selz, *Emile Nolde*, p. 15.

15. Emile Nolde, *Jahr der Kämpfe* (Cologne, 1967), p. 163.

16. The work of van Gogh and of Gauguin was shown in an exhibition at the Gallery Arnold in Dresden in 1905.

17. Will Grohmann, *E. L. Kirchner* (Stuttgart, 1961), p. 32.

18. Kirchner, quoted in Grohmann, *E. L. Kirchner*, p. 32.

19. Werner Haftmann, *Painting in the Twentieth Century* (New York, 1965), p. 25.

20. Felix Klee, ed., *The Diaries of Paul Klee 1898–1918* (Berkeley, 1964), p. 220, entry made during 1908. Klee had been introduced to van Gogh's work and letters by his friend Sonderegger in 1907.

21. Ibid., p. 224.

22. Ibid.

23. *Münchener Neueste Nachrichten*, September 10, 1910, quoted in Selz, *German Expressionist Painting*, p. 196. The critic was reacting to an exhibition of the New Artists Association in Munich, which included the work of Kandinsky, Jawlensky, and Kubin, as well as paintings by the School of Paris.

24. Richard H. Samuel and R. Hinton Thomas, *Expressionism in German Life, Literature and the Theatre* (Cambridge, 1939), pp. 31–32. My discussion of Expressionist literature is derived completely from Samuel and Thomas's study and from a reading of several of the plays.

25. Ibid., p. 84.

26. Ibid., p. 11.

27. See Hal Foster, "The Madman: On Erich Heckel's Madman of Essen' (1914)," *Arts Magazine* 55 (February 1981): 152–53.

28. Joseph Paul Hodin, *Oskar Kokoschka* (New York, 1966), p. 214.

29. For a discussion of Kirchner's mental state and its effect on his work, see Alfons Reiter, "Ernst L. Kirchner; Psychoanalytische Perspektiven der Psychoökonomie seines künstlerischen Schaffens," *Confinia Psychiatrica* 23 (1980): 118–28. Both Kirchner and Max Pechstein are said to have been enthusiastic about

the Prinzhorn collection. See Stephen Prokopoff "The Prinzhorn Collection and Modern Art," in *The Prinzhorn Collection*, Krannert Art Museum Catalog (Urbana-Champaign, Ill., 1984), p. 16.

30. The chief source of information on this period of Kirchner's life is Donald E. Gordon's *Ernst Ludwig Kirchner* (Cambridge, Mass., 1968). Gordon analyzes the Königstein hospital paintings, studying their form in relation to Kirchner's paralysis quite convincingly. The paintings (pls. 70–72 in Gordon) were destroyed in 1938.

31. An equally impressive case whose evolution was perhaps less well known to the European art world was that of Carl Fredrik Hill (1849–1911), a professional painter whose work underwent massive change as a result of the onset of schizophrenia in 1877. See the catalog *Carl Fredrik Hill* (Malmo, Sweden, 1976). Professor Nils Lindhagen is preparing a major study on the four thousand drawings belonging to Hill's period of illness. See also Marina Schneede and Uwe M. Schneede, *Vor der Zeit: Carl Fredrik Hill, Ernst Josephson; zwei Künstler des späten 19. Jahrhunderts* (Hamburg, 1984).

32. "Le salon de 1881," *Gazette des beaux-arts* 24 (1881): 35–36.

33. It is of some interest that Vincent van Gogh knew of the work of Josephson. While in Paris, Josephson had come to know Theo van Gogh and had given him an oil sketch, one of the preparatory studies for his bizarre prepsychotic masterpiece *The Water Sprite* (1888). When Theo wrote to Vincent describing his new acquisition, Vincent replied, much puzzled by Theo's description of the picture's subject, and expressing the hope that he would see the painting soon. Whether he ever saw the picture, or met Josephson himself, is not recorded. See *The Letters of Vincent van Gogh* (Greenwich, Conn., 1959), 2: 343.

34. The psychiatric aspects of the case are extensively described in Ernst Kris, *Psychoanalytic Explorations in Art* (New York, 1962), pp. 96–98, 107–10.

35. Josephson's letters provide detailed information concerning the content of his delusional state. See K. Wählin, *Ernst Josephson* (Stockholm, 1910–1911).

36. See for example *The Studio* 56 (July 1912): 156–59.

37. Erik Blomberg, "Ernst Josephson: Painter, Poet, Precursor," in *Paintings and Drawings by Ernst Josephson*, Portland Art Museum Catalog (Portland, 1964), p. 18.

38. Ellen Johnson, "Ernst Josephson," *Magazine of Art* 42 (1949): 22.

39. Translated by V. Gale, in *Paintings and Drawings by Ernst Josephson*.

40. Quoted in Simon L. Millner, *Ernst Josephson* (New York, 1948), p. 55.

41. W. Mayr, *Le délire graphique et verbal* (Paris, 1928), pp. 27–28. Mayr was a pupil and follower of Dr. A. Marie. The book was intended to form part of a series dealing with "La folie dans les lettres et les arts," edited by Dr. Marie. An earlier psychiatric study by B. Gadelius had appeared in 1922, but I have not been able to obtain a copy of it.

42. Quoted in Blomberg, "Ernst Josephson: Painter, Poet, Precursor," p. 19.

43. G. Pauli, *Ernst Josephson: En Studie* (Stockholm, 1902); K. Wählin, "Ernst Josephson," *Kunst und Künstler* 7 (1909): 479–90; H. Struck, "Ernst Josephson," *Zeitschrift für bildenden Kunst* n.s. 20 (1909): 243–47.

44. Nolde, *Jahre der Kämpfe*, p. 189. Nolde and Prinzhorn had known each other since at least 1912. The two families exchanged visits frequently, Prinzhorn and his wife Erna visiting the Noldes in Berlin and Seebüll, and Nolde returning visits to

the Prinzhorns in Heidelberg and Frankfurt. The Prinzhorns owned several Nolde pictures, including two oils. Nolde was well acquainted with Prinzhorn's collection of psychotic art in Heidelberg and was interested in his ongoing research. Indeed, Prinzhorn thanked Nolde for valuable contributions to his book *The Art of Prisoners* (1926). This long-term friendship undoubtedly played a major role in enlarging Prinzhorn's knowledge of contemporary art, and acquainted him with the aims and aesthetic outlook of the Expressionist movement. Dr. Urban, Director of the Stiftung Seebüll Ada und Emil Nolde, generously shared this information with me.

45. This would be the collection published in 1918 under the title *Ernst Josephsons Teckningar: 1888–1906*, with an introduction by G. Paulsson (Stockholm, 1918).

46. Original drawings by Josephson were circulating in Paris in the 1920s, brought there by Swedish art students. Tristan Tzara published a book of poetry, *Les feuilles libres*, illustrated with Josephson drawings. See J. P. Hodin, "Ernst Josephson," *Norseman* 7 (1949): 43–50. Also G. F. Hartlaub, "Der Zeichner Josephson," *Genius* 2 (1920): 21–32. See also Otto Benesch, "Rembrandts Bild bei Picasso" in *Pour Daniel-Henry Kahnweiler*, ed. Werner Spies (Stuttgart, 1965), pp. 44–54.

47. F. Klee, ed., *The Diaries of Paul Klee*, entry 905 for 1912, pp. 265–66. Klee indicates that this statement was published in "my Munich art-letter, which I wrote for Switzerland."

48. W. Kandinsky and Franz Marc, eds., *The Blaue Reiter Almanac*, trans. Henning Falkenstein (New York, 1974), p. 176. An extremely interesting study, approaching the problem of spiritual necessity from the psychiatric angle, is Paul Schilder's book, *Wahn und Erkenntnis* (Berlin, 1918), in which the work of a psychotic patient, G. R., is studied in the context of contemporary art and, in particular, the theories put forward by Kandinsky. Schilder, a highly cultured psychiatrist, used clinical insights not to attack modern art, but to come to its defense.

49. W. Kandinsky, "Der blaue Reiter (Rückblick)," *Das Kunstblatt* 14 (1930): 57. The pictures by children chosen to illustrate the almanac are very disappointing. They are the work of older children; no totally nonrepresentational works appear, and the work chosen is not free of influences from adult art teachers. There is little relationship between Kandinsky's published statements in regard to this art, and the paintings used as comparative material in the almanac.

50. Felix Klee, ed., *Paul Klee: His Life and Work in Documents* (New York, 1962), p. 182. See also O. K. Werckmeister, "The Issue of Childhood in the Art of Paul Klee," *Arts Magazine* 52 (September 1977): 138–51; and James Smith Pierce, *Paul Klee and Primitive Art* (New York, 1976).

51. Kandinsky and Marc, *Blaue Reiter Almanac*, p. 174. Of particular importance in this connection are the discoveries of Professor Jonathan Fineberg of the University of Illinois, Urbana-Champaign. Having rediscovered the location of Kandinsky's personal collection of children's art, he is able to demonstrate convincingly the direct influence of specific children's paintings owned by Kandinsky on paintings done by the artist prior to World War I.

52. In 1912 Klee had just joined the Blaue Reiter group and he played no part in the writing of the almanac.

53. It would be very important to be able to prove that Klee was familiar, in the period prior to 1912, with the work of Adolf Wölfli or Heinrich Anton Müller (1865–1930), both of whom were in the neighborhood of Bern. Dr. Morgenthaler knew Klee through his brother who was also a well-known Swiss painter. I raised the question of Klee's awareness of Wölfli with the late Jürgen Glaesemer, a leading expert on Klee. Glaesemer stated that he was certain Klee knew Wölfli's work as early as 1912, and that it was the basis for his revolutionary opinions concerning the relevance of psychotic art to the future of twentieth-century painting. At a later date, the collection of Klee's friend, Sacha Morgenthaler, would have provided ample opportunity for Klee to see Wölfli's work.

54. Goldwater, *Primitivism in Modern Art*, pp. 194–95.

55. Ibid., p. 195.

56. See Tut Schlemmer, ed., *The Letters and Diaries of Oskar Schlemmer* (Middletown, Conn., 1972), p. 83. Letter to Tut, July 1920, where Prinzhorn is said to mention drawings of the insane and Klee's enthusiasm for them, before July 1920.

57. Ibid., 83–84.

58. James Smith Pierce, "Paul Klee and Baron Welz," *Arts Magazine* 52 (September 1977): 128–31; and "Paul Klee and Karl Brendel," *Art International* 22, no. 4 (1978): 8–20.

59. From Lothar Schreyer, *Erinnerungen an Sturm und Bauhaus*, quoted in translation in F. Klee, ed., *Paul Klee: His Life and Work in Documents*, pp. 182–83.

60. Ibid., pp. 183–84.

61. Alfred Kubin, "Die Kunst der Irren," *Das Kunstblatt* (1922): 185–88; reprinted in Kubin, *Aus meiner Werkstatt* (Munich, 1973), pp. 13–17. In this article, Kubin makes no reference to Prinzhorn, or Prinzhorn's book, and it seems possible that his visit to the collection preceded the book's appearance, occurring, however, after Prinzhorn had left the clinic. Whatever knowledge Kubin had about the collection and its artists, he seems to have acquired from Dr. Willmanns, not from the Prinzhorn book. Ms. Johanna Sea, of the San Francisco Public Library, kindly assisted me in translating Kubin's complex, often poetic, German.

62. Alfred Kubin, *Die andere Seite: Ein phantastischer Roman* (Munich, 1909).

63. Alfred Kubin, *Dämonen und Nachtgesichte: Eine Autobiographie* (Munich, 1959), p. 58.

64. Alfred Kubin, *Traumland I, II* (Berlin, 1922), each with twelve lithographs.

65. Kubin, *Aus meiner Werkstatt*, p. 14.

66. Ibid., p. 17.

67. Ibid., p. 14.

68. Ibid., p. 15. Kubin did not identify each artist whose work he was examining. I have tentatively identified eight of the thirteen. Karl Junger (perhaps), followed by: 1, Peter Moog; 3, August Klotz; 8, Adolf Schudel; 9, Heinrich Anton Müller; 10, Carl Lange; 11, Franz Pohl; and 12, Karl Brendel. A visit to the Prinzhorn Collection would doubtless enable one to identify the rest. Kubin was a close friend of Klee, having known him from at least 1904.

69. Ibid.

70. Ibid., p. 16.

71. Ibid., p. 17. This sentence, with which Kubin concluded his essay, in its stark poetic beauty, deserves to be quoted in German: "Dann könnte von dieser Stätte, wo gesammelt wurde, was Geisteskranke schufen, Geistesfrische ausströmen."

72. Professor Karl Wilmanns, the director of the Heidelberg Psychiatric Clinic, was replaced in 1933 by a Nazi sympathizer, Carl Schneider, whose only interest in the collection consisted in using it as part of the systematic attack on modern art. Invited to speak at the opening of the exhibition of degenerate art by Goebbels, he produced an essay entitled "Entartete Kunst und Irrenkunst," which was later published in *Archiv für Psychiatrie*

und Nervenkrankenheiten 110 (1939): 164. (He had been unable to deliver the speech on the occasion for which it was written.) See Inge Jarchov, "Die Prinzhorn-Sammlung," in *Die Prinzhorn-sammlung* (Königstein, 1980), pp. 23–24.

73. Albert Speer, chief architect to the Third Reich, tells in his autobiography of the fate of a group of watercolors by Emil Nolde that he had himself selected to decorate Goebbels's house. "Goebbels and his wife were delighted with the paintings—until Hitler came to inspect and expressed his severe disapproval. Then the minister summoned me immediately. 'The pictures have to go at once—they are simply impossible.'" Speer, *Inside the Third Reich*, trans. Richard Winston and Clara Winston (New York, 1970), p. 27.

74. Read, "Hitler on Art," *Listener*, September 22, 1937, pp. 605–7.

75. Hitler, Speech at the Nürnberg Rally on September 11, 1935, reproduced in Norman H. Baynes, ed., *The Speeches of Adolf Hitler* (London, 1942). See Donald Kuspit, "Diagnostic Malpractice: The Nazis on Modern Art," *Art Forum* 25 (November 1986): 90–98.

76. Max Simon Nordau, *Degeneration* (New York, 1895), pp. vii and viii, from the dedication to Professor Cesare Lombroso.

77. Hans F. K. Guenther, *Rasse und Stil* (Munich, 1926); Paul Schultze-Naumberg, *Kunst und Rasse* (Munich, 1928). Paradoxically Max Nordau was a Jew and one of the most significant members of the Zionist movement.

78. Lionel Lindsay, *Addled Art* (London, 1946), p. 18. The virulence of the Nazi attack on art and artists also inspired a counterreaction on the part of liberal thinkers in Europe and America. In England Sir Herbert Read crossed swords with Hitler, and an exhibition of modern German painting was mounted at the New Burlington Galleries in 1938 as a reply to the exhibition of degenerate art staged by the Nazis.

79. Ibid., p. ix.

80. Carl G. Jung, "Picasso," in *Collected Works* (New York, 1966), 15: 135–39. It is not without significance that this discussion of Picasso's work was written during the period of Jung's brief flirtation with National Socialism and his attempt to formulate an "Aryan psychology" better suited to the German people than the Jewish psychology of Freud.

81. The exhibition traveled to other German cities as well and was a resounding success wherever it appeared.

82. *The Speeches of Adolf Hitler*, 1: 588.

83. The works exhibited in the show were reassembled in 1962 and put on display in the Haus der Kunst in Munich. The catalog reproduces and identifies all of the work that was shown with the exception of the truly psychotic pictures that had been introduced in 1937 purely as comparative material. *Entartete Kunst: Bildersturm vor 25 Jahren* (Munich, 1962).

84. *Entartete "Kunst": Führer durch die Ausstellung* (Berlin, 1937).

85. The finest discussion of the exhibition of degenerate art is to be found in Ian Dunlop, *The Shock of the New* (London, 1972), chap. 7, pp. 224–59.

86. Adolf Ziegler, "Ausgeburten des Wahnsinns." Remarks at the opening of the Exhibition of Degenerate Art, July 19, 1937.

87. Paul Ortwin Rave, *Kunstdiktatur im Dritten Reich* (Hamburg, 1949), quoted in Hellmut Lehmann-Haupt, *Art under a Dictatorship* (Oxford, 1954), p. 65.

88. Hitler, Speech at the Opening of the House of German Art, July 18, 1937.

89. Karl Jaspers, *Strindberg und Van Gogh* (Munich, 1949). This discussion focuses particularly on the concluding chapter of Jaspers's book, "Schizophrenia and the Culture of Our Time" (page references are cited in text).

90. Both Prinzhorn's and Jaspers's books were published in 1922, attempting investigations in applied psychiatry from similar, and yet significantly different directions.

FIFTEEN. PSYCHOANALYSIS AND THE STUDY OF PSYCHOTIC ART

1. Hans Sedlmayr, *Verlust der Mitte—Die bildende Kunst des 19. und 20. Jahrhunderts als Symptom und Symbol der Zeit* (Salzburg, 1948). Translated as *Art in Crisis: The Lost Centre* by Brian Battershaw (London, 1957), pp. 117–18.

2. Sedlmayr's book reflects the influence of psychiatric and psychoanalytic conceptions throughout. The linking of the terms *symptom* and *symbol* in the title suggest the direction of his investigation, which was intended as a "diagnosis" of contemporary art, a last flicker of the National Socialist aesthetic stance by a scholar of enormous culture.

3. Sedlmayr, *Verlust*, p. 121.

4. Anna Freud, "Regression in Mental Development," in *The Writings of Anna Freud* (London, 1970), 5: 407–8.

5. The failure of both analysts and art historians to recognize this simple fact has resulted in a considerable amount of amateurish and naive "psychologizing."

6. The members of Freud's original circle all undertook investigations of human artistic expression. Otto Rank, Hanns Sachs, and Oskar Pfister published books on art and artistic creativity. Carl Jung, Karl Abraham, and Ernest Jones published shorter papers on art historical subjects. For a more extended bibliography of psychoanalytic publications on art, see Alexander Grinstein, *The Index of Psychoanalytic Writings*, vol. 9, *Subject Index: 1953–60* (New York, 1966), and vol. 14, *Subject Index: 1960–69* (New York, 1971), s.v. "Psychoanalysis and Art."

7. Jung worked for many years at the Burghölzli Hospital in Zurich. "Dominating my interests and research was the burning question, 'What actually takes place inside the mentally ill?'" *Memories, Dreams, Reflections*, trans. Richard Winston and Clara Winston (New York, 1963), p. 114. Jung's most extensive attempt to solve this problem is found in his book *Psychology of the Unconscious*, first published in 1912, and republished in vol. 5 of the *Collected Works* as *Symbols of Transformation* (New York, 1956).

8. Sigmund Freud, "Psychoanalytic Notes upon an Autobiographical Account of a Case of Paranoia (Dementia Paranoides)" (1911), in *The Standard Edition of the Complete Psychological Works of Sigmund Freud*, ed. James Strachey (London, 1956–1974), 12: 9–82. See also William G. Niederland, *The Schreber Case* (New York, 1974).

9. Sigmund Freud, "A Seventeenth-Century Demonological Neurosis" (1923), in *The Standard Edition*, 19: 72–105. See also Ida Macalpine and R. A. Hunter, *Schizophrenia 1677* (London, 1956), which provides color reproductions of all of the paintings, as well as an alternate psychiatric assessment of the case. More critical still of Freud's procedure is Roy Porter, *A Social History of Madness: The World through the Eyes of the Insane* (New York, 1987), pp. 83–89.

10. The paintings, which presently form part of the manuscript known as the *Trophaeum Mariano-Cellense* Ms 14,086 in the Austrian National Library, are copies of paintings executed by

Christoph Haizmann after his successful cure, and are therefore poor material on which to base a discussion of psychotic art.

11. Margaret Naumburg, *Schizophrenic Art: Its Meaning in Psychotherapy* (New York, 1950), p. 15.

12. Sigmund Freud, Letter to Dr. Oskar Pfister, June 21, 1920. While Freud was not particularly interested in contemporary art and artists, he was a profoundly serious student and collector of ancient art and archaeological material. An extremely thorough and thoughtful analysis of Freud's involvement with art, aesthetics, and the psychology of creativity is to be found in Jack J. Spector, *The Aesthetics of Freud: A Study in Psychoanalysis and Art* (New York, 1972). See also Suzanne Cassirer Bernfeld, "Freud and Archaeology," *American Image* 8 (1951): 107–8.

13. Paul Federn, "The analysis of Psychotics: On Technique," in *Ego Psychology and the Psychoses* (New York, 1952). Another analytically oriented therapist working with psychotic patients is Dr. Marguerite Sèchehaye, who has also published a report on her work with a female schizophrenic patient whom she took into her home: *Symbolic Realization: A New Method of Psychotherapy Applied to a Case of Schizophrenia* (New York, 1951). Although this case does not involve drawings, it is of particular importance in providing psychoanalytic understanding of the role of symbols and of image-making activity as an aspect of therapeutic work with this type of patient. Dr. Sèchehaye's theory of "symbolic realization" deserves careful study by anyone interested in psychotic image-making activity as a means to psychological growth.

14. Oskar Pfister, *Expressionism in Art: Its Psychological and Biological Basis* (London, 1922).

15. In his book, *The Psychoanalytic Method* (London, 1917), Pfister included a section entitled "Analysis of Artistic Production," which uses the case of an eighteen-year-old art student, Franz J., to demonstrate his method of incorporating pictorial material in analysis.

16. Pfister, a kind and guileless Protestant pastor trained in the use of psychoanalysis, seemed to think himself particularly fated to make use of psychoanalysis in the study of art and religion. His efforts in this cause did little to enhance the prestige of psychoanalysis in artistic circles. Pfister was in contact with Morgenthaler, who supplied him with a picture by Wölfli which he reproduced in his book. Pfister had no experience with psychotics and little interest in their work, which he dismissed as "diseased art . . . a symptom, a wrecked attempt at deliverance . . . a phantasmagoria which is not based on reality" (*Expressionism*, pp. 262–64).

17. D. W. Winnicott, Foreword to *The Hands of the Living God* by Marion Milner (London, 1969), p. ix.

18. For an account of this period in Jung's life, see C. G. Jung, *Memories, Dreams, Reflections*, esp. chap. 6, "Confrontation with the Unconscious," pp. 170–99.

19. Ibid., p. 188.

20. Dr. Jolande Jacobi (1890–1973) an analyst working in Jung's immediate circle, was deeply involved in the study of patient art, including that of psychotic patients. Her book *Vom Bilderreich der Seele* (Olten, 1969), provides the most extensive review of Jungian thinking about patient art and its interpretation currently available. Dr. Jacobi was kind enough to let me read the English translation of this book, which, despite its enormous importance, has not yet appeared in print.

21. This archive is available for use by qualified students. It houses Dr. Jung's personal collection of patient art, as well as

that of Dr. Jacobi. A detailed investigation of Jung's attitude to art and artists is Morris H. Philipson, *Outline of a Jungian Aesthetics* (Evanston, Ill., 1963).

22. H. G. Baynes, *Mythology of the Soul* (London, 1969).

23. Ibid., pp. 2–5.

24. Jung, *Memories, Dreams, Reflections*, p. 185. Long afterward Jung's attitude toward this inner perception changed. "This time I caught her [the inner voice] and said, 'No, it is not art. On the contrary, it is nature' " (p. 186).

25. Sigmund Freud, Introductory Lecture 10 of the *Introductory Lectures* (1916–1917), in *The Standard Edition*, 15: 165–66.

26. Ibid., p. 166.

27. Freud, in 1913, used the term atavistic vestige in speaking of certain aspects of neurotic behavior, which suggested to him the functioning of "an inherited archaic constitution." See *Totem and Taboo*, in *The Standard Edition*, 13: 66.

28. Sigmund Freud, "Analysis Terminable and Interminable" (1937), in *The Standard Edition*, 23: 240.

29. Freud, *Introductory Lectures*, p. 199. Freud's involvement with the question of inherited mental contents extends throughout his published writings. It awoke intense resistance in his immediate followers, particularly Ernest Jones, and has remained something of an embarrassment in analytic circles ever since. For further discussion of Freud's views on this matter, see my paper, "Psychological Aspects of the Work of Immanuel Velikovsky" in *Recollections of a Fallen Sky*, ed. E. R. Milton (Lethbridge, Alberta, 1977), pp. 45–66.

30. Freud himself used the term "collective mind" in 1913. "No one can have failed to observe in the first place, that I have taken as the basis of my whole position the existence of a collective mind, in which mental processes occur just as they do in the mind of the individual." *Totem and Taboo*, in *The Standard Edition*, 13: 157. It is highly probable that Jung influenced Freud to examine the problem of an archaic inheritance. Freud continued to support the idea well after the break with Jung and was, in fact, still reading Jung after personal contact between the two men had been suspended.

31. Naumburg, *Schizophrenic Art*. Naumburg includes a thorough discussion of the different attitudes of Freud and Jung in regard to the problem of inherited mental contents in the chapter entitled "A Survey of the Significance of Psychotic and Neurotic Art: 1876–1950," pp. 31–34.

32. Freud, Introductory Lecture 10, p. 199.

33. Sigmund Freud, "From the History of an Infantile Neurosis" (1918), in *The Standard Edition*, 17: 97.

34. Ernst Kris, "Approaches to Art," in *Psychoanalytic Explorations in Art* (New York, 1952), pp. 13–63. This book includes most of Kris's publications in psychoanalysis and art written over a period of some twenty years. See also "Psychoanalysis and the Study of Creative Imagination" (1953), in *Selected Papers of Ernst Kris* (New Haven, 1975), pp. 473–93.

35. See Samuel Ritvo and Lucille B. Ritvo, "Ernst Kris: Twentieth Century Uomo Universale," in *Psychoanalytic Pioneers*, ed. Franz Alexander (New York, 1966), pp. 484–500.

36. Ernst Kris, *Meister und Meisterwerke der Steinschneidekunst in der italienischen Renaissance*, 2 vols. (Vienna, 1929). For a relatively complete bibliography of Kris publications in the field of art history, see "Writings of Ernst Kris" in *The Psychoanalytic Study of the Child* 13 (1958): 562–73.

37. Ernst Kris, *Catalogue of Postclassical Cameos in the Milton Weil Collection* (Vienna, 1932).

38. Ernst H. Gombrich (1964), quoted in Ritvo, "Ernst Kris," p. 491. See also Ernst H. Gombrich, "A Mind of Distinction," Kris's obituary notice in *The Times* (London), March 23, 1957, p. 11.

39. From my notes of an interview with Dr. Marianne Kris, February 22, 1977, and July 31, 1977.

40. I am grateful to Dr. Anna Freud for providing me with the opportunity of spending an afternoon browsing among the books and art objects in Freud's London study and consulting room.

41. Kris insisted on sharing the editorship of *Imago* with another analyst, Dr. Robert Waelder, who later contributed a significant publication to the psychoanalytic study of art: Robert Waelder, *Psychoanalytic Avenues to Art* (New York, 1965).

42. Kris's failure to utilize psychoanalysis in the study of art earlier may be explained by the lack of problems in Renaissance decorative arts that could be explored through psychological means. His involvement with psychoanalysis resulted in a shift in the nature of his art historical interests.

43. At the center of this scholarly metamorphosis one is led to suspect the influence of Sigmund Freud. As Kris pointed out at the time, Freud "had no sooner set foot in this new territory [psychoanalysis] . . . than he recognized the necessity of applying the newly obtained insights to the subject matter of cultural scholarship." The conversion of a highly respected art historian to the cause of psychoanalysis would have been an event of considerable importance to Freud. Kris's increasing involvement with psychoanalysis coincided with the slow departure of Otto Rank (1884–1939). In some sense, the loss of Rank, the member of the original psychoanalytic circle most keenly involved in the application of psychoanalysis to the study of art and artists, was compensated for by the arrival of the far more highly qualified Kris. This is confirmed by the fact that Kris assumed Rank's responsibilities as editor of *Imago*.

44. Ernst Kris, "Die Charakterköpfe des Franz Xaver Messerschmidt: Versuch einer historischen und psychologischen Deutung," *Jahrbuch der Kunsthistorischen Sammlungen in Wien* 6 (1932): 169–228. This article appeared as a separate monograph under the same title, published by Anton Schroll and Co. (Vienna, 1932). For a recent and very interesting reevaluation of the life and work of Messerschmidt, and of Kris's views on the problem, see Maria Potzl-Malikova, *Franz Xaver Messerschmidt* (Vienna, 1982), which includes a catalogue raisonné. Also see *Franz Xaver Messerschmidt: Character-Heads 1770–1783*, ed. James Lingwood and Andrea Schlieker (London, 1988).

45. Ernst Kris, "Ein geisteskranker Bildhauer: Die Charakterköpfe des Franz Xaver Messerschmidt," *Imago* 19: 384–411. This second article was translated as chap. 4 of Kris, *Explorations*, entitled "A Psychotic Sculptor of the Eighteenth Century," pp. 128–50. All three publications differ extensively, and deserve independent investigation by anyone interested in Kris's contribution to the Messerschmidt problem.

46. Kris, *Imago* 19 (1933): 386.

47. Page numbers cited in text in this section refer to Kris's *Jahrbuch* article. I am grateful to Mr. Walter Heinrichs for his assistance in translating the extremely complex German used in this article.

48. For an example of such an approach, see Rudolf Wittkower and Margot Wittkower, *Born under Saturn* (London, 1963) and Lorenz Eitner, "The Artist Estranged: Messerschmidt and Romako," *Art News Annual* 32 (1966): 85–90. Although the exact nature of the illness from which Messerschmidt suffered could be debated, the fact that he was psychotic continues to be absolutely clear to any informed psychiatric observer.

49. Paul Julius August Möbius was a major figure among German pathographers, notable for his pathographic studies of Goethe, Neitzsche, and Schopenhauer. His contribution to the psychology of art is to be found in his book *Über Kunst und Künstler* (Leipzig, 1901).

50. Kris might have been wise to dissociate himself from the pathographic approach by introducing a new term free of stigma. His rejection of the basic tenets of the older pseudoscience should have been accompanied by a rejection of the term *pathography*. Later psychoanalytic workers, particularly Erik H. Erikson, have made use of the terms *psychobiography* and *psychohistory* in an attempt to distinguish their entirely new approach to the application of psychoanalysis to historical and biographical investigation from pathography. See Erik H. Erikson, *Life History and the Historical Moment* (New York, 1975), and Robert J. Lifton, ed., *Explorations in Psychohistory: The Wellfleet Papers* (New York, 1974).

51. Kris, "Comments on Spontaneous Artistic Creations by Psychotics," in *Explorations*, p. 110.

52. Kris, "A Psychotic Sculptor of the Eighteenth Century," in *Explorations*, p. 132. Page numbers cited in text in this section refer to this essay.

53. In his study of the psychotic drawings of the medieval cleric Opicinus de Canistris (1296–1350), Kris makes reference to A. Heimann, an art historian who had worked on the drawings with a similar aim, "attempting to ascertain precisely what elements of the drawing could be accounted for in terms of fourteenth-century technical procedure, and which were unique and explainable only in terms of the psychotic illness of its creator." (This is a unique example of an art historian attempting to work with a historical psychotic document, and clarifies the necessity for an art historical specialist to differentiate the contribution of period style to any psychotic document.)

54. See especially the letter of Count Kaunitz, the prime minister, to Empress Maria Theresa: "Although the confusion in his head has meanwhile subsided, it occasionally is still evident in a not perfectly healthy imagination." A contained psychosis is no less confusing to a psychiatrically inexperienced person in our own day than it was in the eighteenth century. Naive people expect the insane to be raving lunatics; when they prove capable of intelligent conversation, controlled behavior, and artistic excellence, the tendency is to deny that they are insane. After the acute phase of his illness, it is doubtful that Messerschmidt was ever "raving mad." See also Friedrich Nicolai, "Recollection of a Meeting with Messerschmidt in Pressburg in 1781," in *Messerschmidt: Character-Heads*, pp. 14–16.

55. While some part of these beliefs can be understood in the light of religious beliefs of the period, the complete list is in no way typical of any known religious dogma, and is absolutely clear evidence of a psychotic process. It would have been recognized as such by any late eighteenth-century psychiatrist.

56. See, for example, Gaza Roheim, *Magic and Schizophrenia* (Bloomington, Ind., 1970).

57. Kris conceived of the image-making process in schizophrenia as an aspect of what Freud termed the process of "restitution." An unfortunate term, it refers to the patient's efforts to counteract the slow but inexorable process leading to his eventual, near complete, loss of relationship to the world and to "reality." "In Freud's view [of schizophrenia], this relationship is loosened or impoverished, cathexis of the world around is diminished, and in extreme conditions disregard of and indifference to reality become supreme. During the phases preceding

this final stage, the loosening of the relation to the world around is counteracted and covered by vehement attempts to re-cathect objects outside. We are inclined to view the increase of productivity as an attempt of this kind." Kris, "A Psychotic Sculptor of the Eighteenth Century," in *Explorations*, p. 93.

58. Kris, "Spontaneous Artistic Creation by Psychotics," in *Explorations*, p. 115.

59. Kris may also have been influenced in the choice of Messerschmidt for this first psychoanalytic study of a psychotic artist by the fact that Freud's taste was very traditional and directed more toward sculptural works than paintings.

60. Interview with Dr. Marianne Kris. Mrs. Kris described her memories of response to the article by art historians as "probably more positive than negative. If it had been negative I would certainly have heard about it."

61. No doubt his involvement as editor of *Imago* inclined him to publish such studies in his own journal. Nevertheless, it would seem that his attempt to enrich art history with psychoanalytic insight and methodology was abandoned. In later years Kris appears to have disliked reference being made to his art historical background. Ernst Gombrich stated, "On the whole he disliked being reminded of his art historical past. . . . Somehow he preferred their not knowing—he enjoyed having become a different person." Gombrich (1964), quoted in Ritvo, "Ernst Kris," p. 490.

62. Kris, "The Function of Drawings and the Meaning of the 'Creative Spell' in a Schizophrenic Artist," (page numbers in text in this section refer to this essay). Originally given as a paper at a meeting of the New York Psychoanalytic Society in March 1945, and subsequently published in the *Psychoanalytic Quarterly* 15, no. 1 (1946): 6–31. Kris collaborated with Dr. Else Pappenheim, a psychoanalyst currently practicing in New York, in the writing of this study.

63. "His production started in June 1937. At that time he scribbled on the margin of newspapers: the first drawing on a clean sheet is dated July 1, 1937. He did about ten larger drawings before October of that year. From then on until his outburst of rage and his subsequent commitment in January, he produced from three to six large sheets daily. There are indications of a 'creative spell' " (p. 158).

64. Ramon Geremia, "Tinsel, Mystery Are Sole Legacy of Lonely Man's Strange Vision," *Washington Post*, December 15, 1964, p. C2. James Foy, a psychiatrist at Georgetown University Hospital, has published an extensive study on the Hampton Altar; see James L. Foy and James P. McMurrer, "James Hampton, Artist and Visionary," *Psychiatry and Art* 4 (1975): 64–75. I am grateful to Dr. Foy for bringing the altar to my attention. See also Lynda Hartigan, *The Throne of the Third Heaven of the Nations Millennium General Assembly* (Montgomery, Ala., 1977), and Stephen Jay Gould, "James Hampton's Throne and the Dual Nature of Time," *Smithsonian Studies in American Art* 1, no. 1 (Spring 1987): 47–57.

65. Curiously, this drawing, so conventional and "normal," was reproduced as an example of psychotic art, probably through carelessness. See A. A. Roback and Thomas Kiernan, *Pictorial History of Psychology and Psychiatry* (New York, 1969), p. 47.

66. Kris, "Spontaneous Artistic Productions by Psychotics," in *Explorations*, p. 88. Kris had visited the Prinzhorn Collection in Heidelberg in 1931. He realized, as I did, that Prinzhorn had been extremely selective in his choice of material for the book. "It was meant to support an aesthetic thesis."

67. Kris, "The Creative Spell in a Schizophrenic Artist," in *Explorations*, p. 169.

68. Kris shared Freud's conservative views concerning the nature of art. Like Freud, he equated the art of the insane with dreams, as autistic products of no interest to anyone but the dreamer. Mrs. Kris was able to confirm my feeling that Ernst Kris was but little interested in contemporary art. "His interest was mainly not in modern. He certainly was looking at modern art too, but it wasn't really his interest too much." Interview with Mrs. Kris.

Insight into Kris's objectivity in regard to artistic creativity is to be seen in Ernst Kris and Otto Kurz, *Legend, Myth and Magic in the Image of the Artist* (New Haven, 1979), with a preface by Ernst Gombrich. Kris explained his thinking about the artistic value of psychotic art in "Psychoanalysis and the Study of Creative Imagination," in *Selected Papers*, pp. 473–93. As a result of the enormous influence of Kris in American psychoanalytic circles, more timid analysts have simply adopted his conservative stance and respond to any mention of psychotic art with the same negative opinion.

69. Kris, "Spontaneous Artistic Creation by Psychotics," in *Explorations*, p. 107.

70. Ibid., p. 108.

71. Ibid.

72. Although he never published a case of this kind, some of his writings on psychotic art seem to imply personal experience of such patients. Mrs. Kris was able to confirm that Dr. Kris had worked with one patient "who did drawings and prints and this played a part in the analysis." The patient in question was not psychotic.

73. Kris, "Spontaneous Artistic Creation by Schizophrenics," *Explorations*, pp. 95–96, n. 25. Kris was particularly conscious of the psychoanalytically oriented form of art therapy developed by Margaret Naumburg, and refers to it as providing detailed case material of this kind. "I believe that future students of this question will be strongly impelled to draw on the material so carefully presented by Naumburg. In no other similiar publication of which I know is there, for instance, an equal opportunity to compare graphic and verbal productions of one patient." Kris, Review of *Schizophrenic Art*, by Margaret Naumburg *Psychoanalytic Quarterly* 22 (1953): 98–101. Unusual for an orthodox Freudian, Kris also makes reference to Baynes's *Mythology of the Soul*, as providing an example of the Jungian approach to the same problem.

74. Kris "Spontaneous Artistic Creation by Schizophrenics," in *Explorations*, p. 111.

75. These comments are not intended as a criticism of art therapy. Good therapy does not necessarily produce aesthetically viable images, but then, that is in no sense its goal.

76. The method is described in D. W. Winnicott, *Therapeutic Consultations in Child Psychiatry* (London, 1971).

77. Mrs. Winnicott told me a charming story of how, while she was doing her hair for the night, her husband would hop into bed and begin doing squiggle drawings. Only a fine psychiatrist is capable of such relaxed "craziness." Kris too is said to have occasionally produced doodle drawings during the analytic session.

78. "In the work of art, as in the dream, unconscious contents are alive; here too, evidences of the primary process are conspicuous, but the ego maintains its control over them, elaborates them in its own right, and sees to it that the distortion does not go too far. . . . It can be considered a sign of the ego's strength if occasionally and for a specific purpose, it is capable of tolerating the mechanisms of the 'ID.' " Kris, "Spontaneous Artistic Creation by Schizophrenics," in *Explorations*, pp. 103 and 116.

79. The American analyst Roy Schafer has put forward some interesting hypotheses concerning the relationship between training in art and the characteristics of the gifted psychoanalyst, in a review of *The Selected Papers of Ernst Kris* entitled "The Psychoanalysis of Surfaces," *Times Literary Supplement*, July 23, 1976, p. 923. See also Robert Coles, *Erik H. Erikson: The Growth of his Work* (Boston, 1970).

80. Marion Milner, *The Hands of the Living God: An Account of a Psycho-analytic Treatment* (London, 1969). Page references cited in text hereafter.

81. Marion Milner, *On Not Being Able to Paint* (New York, 1967). Publication of this book was delayed until 1967, so that Susan's decision to make drawings play a part in her analysis was not directly influenced by Dr. Milner's involvement with drawing. See also Dr. Rollo May, *My Quest for Beauty* (New York, 1985).

82. Anna Freud, Foreword to Milner's *On Not Being Able to Paint*, p. xiii.

83. Milner, *The Hands of the Living God*, p. 82. The term "doodle drawing" is often thought to imply that the drawings are insignificant and worthless graphic products. The attitude to these automatic drawings, despite all the efforts of the Surrealists on their behalf (see chapter 16), parallels the attitude once adopted toward the art of the insane. The term "doodle drawing" implies only that the drawing is the product of a psychological state that allows the unconscious to involve itself in the production of a drawing through techniques of automatism, and in no way suggests that the product of such a process could not be a "work of art."

SIXTEEN. PSYCHOSIS AND SURREALISM

1. Reproduced in Fleur Cowles, *The Case of Salvador Dali* (Boston, 1959), p. 270. Cowles provides translations of all of the correspondence between Zweig and Freud relating to the Dali visit.

2. *Letters of Sigmund Freud: 1873–1939*, ed. Ernst L. Freud (London, 1961), p. 444.

3. The painting *Metamorphosis of Narcissus* (1937) was then owned by Edward James and is now in the Tate Gallery, London. The first version of the drawing of Freud on blue blotting paper remains in Dali's possession. The analogy of Freud's skull and the shell of the snail was not arrived at during the interview, as had been thought, but was, in fact, a spontaneous association of Dali's to a photograph of Freud that the artist had seen during a dinner party some time before at which snails had been served. See Salvador Dali, *The Unspeakable Confessions of Salvador Dali*, ed. André Parinaud, trans. Harold J. Salemson (New York, 1976), p. 23.

4. Salvador Dali, *The Secret Life of Salvador Dali* (London, 1968), p. 25.

5. *Unspeakable Confessions*, p. 121.

6. *The Secret Life of Salvador Dali*, p. 397.

7. The relative contribution of Freud, and other psychiatric authorities, to the development of Breton's ideas has been discussed in detail by French literary historians. See Jean Starobinski, "Freud, Breton, Myers," *L'arc* 34 (1968); Jean-Louis Houdebine, "Méconnaissance de la psychoanalyse dans le discours surréaliste," *Tel Quel* 46 (1971). The best discussion of Breton's early involvement with psychiatry and psychoanalysis is to be found in Marguerite Bonnet, *André Breton: Naissance de l'aventure surréaliste* (Paris, 1975). An extremely important predecessor of

Breton and the Surrealists in regard to both the literature and art of the insane is Guillaume Apollinaire (1880–1918). The extent of his involvement with the art of the insane, both prior to and after World War I, is described in Katia Samaltanos, *Apollinaire: Catalyst for Primitivism, Picabia and Duchamp* (Ann Arbor, Mich., 1984) pp. 84–101, who traces Apollinaire's involvement with psychotic art to Marcel Réja's *L'art chez les fous* of 1907, and to the publication by Rogues de Fursac, *Les écrits et les dessins dans les maladies nerveuses et mentales* (Paris, 1905), as well as to his close friendship with psychiatrist Jean Vinchon, an early French authority on psychotic art.

8. André Breton, *Manifesto of Surrealism* (Paris, 1924), in *Manifestoes of Surrealism*, trans. Richard Seaver and Helen R. Lane (Ann Arbor, Mich., 1972), p. 5. All further references to the Surrealist manifestos are to this edition.

9. In fact there was in Breton throughout his life a tendency to alternate between the artist and the analyst. Anna Balakian in her study of Breton describes this unresolved split. "It was this paradox in Breton that exasperated his friends: on the one hand the free, poetic spirit, passionate and spontaneous, and on the other, the erudite, exhaustively well read, deeply analytical man, as dispassionate in his vivisection of himself and his friends as if in a clinical laboratory." See *André Breton: Magus of Surrealism* (New York, 1971), p. 117.

10. Breton, *Manifesto* (1924), pp. 22–23.

11. Ibid., pp. 10–11.

12. Ibid., pp. 10–14.

13. From a lecture given on March 29, 1935, in Prague entitled "Surrealist Situation of the Object," in *Manifestoes of Surrealism*, p. 274.

14. Breton, *Manifesto* (1924), p. 21n.

15. Breton, *Manifesto* (1930), p. 175. For a discussion of Breton's involvement with the language of the insane, see Roger Cardinal, "André Breton: Wahnsinn und Poesie," in *Sonderdruck aus psychoanalytische und psychopathologische Literaturinterpretation* (Darmstadt, 1981), pp. 300–20.

16. Breton's interest at that time consisted of identifying predecessors of the Surrealists among recognized artists, such as Uccello, Gustave Moreau, De Chirico, and Klee. The use of automatic drawing techniques had been used previously in Dada circles, and had a great vogue in the nineteenth century as part of the spiritualist phenomenon.

A brilliant presentation of the psychiatric literature on psychotic art available to Breton before 1925, emphasizing French sources, is to be found in Françoise Will-Levaillant, "L'analyse des dessins d'aliénés et de médiums en France avant le Surréalisme," *Revue de l'art* 50 (1980): 24–39.

Given the seeming irrationality of the European movement known as Dada, one might expect that there would have been links between the Zurich originators of Dada (ca. 1914) and psychotic art. Dada's "madness" was, however, programmatic, a calculated insanity intended primarily to shock the Zurich bourgeoisie. As Hugo Ball put it, "Our voluntary madness, our enthusiasm for illusion, will put them to shame"; quoted in Gordon Frederick Browning, *Tristan Tzara: The Genesis of the Dada Poem* (Stuttgart, 1979), p. 11. In a milieu dedicated to the simulation of madness for political, moral, and artistic ends, true interest in psychotic individuals and their creative activity is not likely to develop. The imaginary conception of insanity surfaces, once again, and the sane artist is content to give voice to his own vision of the liberated madman, free of all constraints, prompted only by fantasy, illusion, and dreams.

I insist on the sanity of the Dada group in Zurich in spite of a contradictory opinion mentioned by one of the founders of Dada, Marcel Janco (1895–1984): "I remember one evening a group of youngsters from Vienna came to the Cabaret Voltaire, students of Dr. Jung, the well known psychiatrist. They came to see if we were normal or insane. We had a long discussion with them, but they concluded that we were not sane"; quoted from Francis M. Naumann, "Janco/Dada: An Interview with Marcel Janco," *Arts Magazine* 57 (November 1982): 81. In this interview, Janco, speaking of the preoccupations of the Zurich artists said, "We not only thought of primitive art as the real art, but we also regarded the art of childhood as a real art. We even came to the idea of exhibiting the art of the insane" (p. 83). What examples of this art were available in Zurich, for either study or exhibition, he did not explain.

Dada, in its original form, was almost over by 1922 when Prinzhorn's book appeared. Early in that year, Sophie Tauber wrote to her future husband, Jean Arp, to the effect that Prinzhorn's book "had finally appeared, and that he must, without fail obtain it." He did, in fact, acquire the book and it remained permanently in his library. These facts are contained in the unpublished correspondence of Sophie Tauber-Arp in the estate of the artist. Quoted in Stefanie Poley, "Prinzhorns Buch 'Die Bildnerei der Geisteskranken' und seine Wirkung in der modernen Kunst," in *Die Prinzhornsammlung* (Königstein, 1980), p. 58. However, by 1922, Arp's work had moved away from a position that might have been open to influence from Prinzhorn's schizophrenic masters. That influence might be said to have moved, along with Dada itself, to Paris.

17. Paul Eluard, "Le génie sans miroir," *Les feuilles libres* 35 (1924): 301–8. The article, without the pictures, is reprinted in Paul Eluard, *La poète et son ombre* (Paris, 1963), pp. 125–31.

18. Eluard, *Le poète*, p. 125.

19. Eluard thanks a Dr. Rozé for obtaining the original documents for him from the insane asylum at P. . . . in Poland. Eluard, *Le poète*, p. 130.

20. It was discussed briefly in *Almanach des lettres françaises et étrangères*, April 29, 1924, p. 113. "Monsieur Paul Eluard in *Les feuilles libres* has devoted a long article to the insane and their drawings, which establishes a parallel between insanity and genius which is not without interest."

21. André Breton, *Nadja*, trans. Richard Howard (New York, 1960), p. 31.

22. Ibid., p. 79.

23. Ibid., p. 136. For a more elaborate discussion of Breton's behavior toward Nadja, the reader should consult Roger Cardinal, "Nadja and Breton," *University of Toronto Quarterly* 12, no. 3 (1972): 185–99. I would also like to thank Dr. Cardinal for drawing the Nadja pictures to my attention. There are striking similarities between Nadja's drawings and those of Dr. Milner's patient Susan, whose work is discussed in chapter 15.

24. Breton, *Nadja*, p. 144.

25. Ibid., p. 116.

26. Ibid., p. 121.

27. Ibid., p. 112.

28. Max Ernst, "An Informal Life of M.E. (as told by himself to a young friend)," in *Max Ernst*, ed. William S. Lieberman (New York, 1961), p. 9. (This quotation was originally written by Ernst in the third person, and in the present tense.) Roland Penrose, a close friend of the artist from 1925 until his death, emphasized Ernst's continuing interest in psychiatry and the art of the insane throughout his life (lecture on Ernst given at the Tate Gallery, London, December 10, 1975). Lucy Lippard stresses Ernst's position as the first of the Surrealists to exhibit an interest in the pictorial art of the insane. See Lucy R. Lippard, *Changing: Essays in Art Criticism* (New York, 1971). See also Werner Spies, "L'art brut avant 1967," *Revue de l'art* 1–2 (1968): 123–26, reprinted in English in Werner Spies, *Focus on Art* (New York, 1982), pp. 230–36.

29. The most recent attempt to locate the collection is that of Eduard Trier, "Was Max Ernst studiert hat," in *Max Ernst: Retrospective* (Munich, 1979), pp. 31–42, in which he states that no trace of any such collection is to be found at the university or at the associated hospital. One possibility, which does not seem to have been considered, is that it might have been given to the Prinzhorn Collection, ca. 1919–1920. But since no information appears to exist concerning its contents, it would be difficult to associate pieces now in the Prinzhorn Collection with those once housed in Bonn.

30. The exact nature of Max Ernst's studies while at the university in Bonn has been determined by Trier, "Was Max Ernst studiert hat," pp. 31–42. Several Ernst specialists have suggested that Ernst was for a time seriously considering a career in psychiatry, which is not contradicted by his declared intention upon entering the university in Bonn of pursuing studies in philology. See Lothar Fischer, *Max Ernst: In Selbstzeugnissen und Bilddokumenten* (Hamburg, 1969), pp. 18–19; and André Pieyre de Mandiargues, "The Paintings: 'It is Beautiful Enough the Way It Is,' " in *Max Ernst: Sculpture and Recent Paintings*, ed. Sam Hunter (New York, 1966), p. 19; as well as Ernst himself in "Max Ernst: An Informal Life of M.E.," p. 9.

31. Werner Spies, *Max Ernst (1950–1970): The Return of La Belle Jardinière* (New York, 1972), p. 38. Spies has put forward the interesting suggestion that Ernst's Dada phase was influenced by Freud's book on wit, whereas the later Surrealist period reveals the influence of *The Interpretation of Dreams*. See Werner Spies, "Hallucination and Technique: Max Ernst at Eighty," in *Focus on Art*, p. 94. In later years, Ernst became a personal friend of Carl G. Jung, with whom he spent a holiday in Switzerland in 1934.

32. It should also be noted that another major contributor to the Dada circle in Germany, Richard Huelsenbeck (1892–1974), also studied psychiatry, though slightly later, in the period after World War I. In 1922 he was in Danzig as assistant to Professor Wallenberg, a leading authority in neuropsychiatry. In 1936 he emigrated to New York, obtained psychoanalytic training, and, abandoning almost completely his artistic pursuits, settled down to the practice of psychiatry. He occasionally continued to write on art and literature. See Charles R. Hulbeck, "Psychoanalytic Notes on Modern Art," *The American Journal of Psychoanalysis* 20 (1960): 173.

33. See Fischer, *Max Ernst*, in which reference is made to traces of this project surviving in Ernst's notebooks. Publication of these notebooks may eventually provide information concerning the content of the collection of psychotic art in Bonn, as well as evidence of what other collections Ernst may have seen.

34. Werner Spies, "Getting Rid of Oedipus: Max Ernst's Collages: contradiction as a way of knowing," in *Focus on Art*, p. 96.

35. Evan Maurer, "Dada and Surrealism," in *Primitivism in Twentieth Century Art* (New York, 1984), pp. 535–93. The magnificent study of Ernst's involvement with the primitive demonstrates with great clarity the psychological motivations underlying Ernst's choice of images, and the nature and purpose of his artistic quotations. It is to be hoped that Dr. Maurer will, in time,

undertake a similarly comprehensive investigation of Ernst's involvement with psychotic art.

36. Spies, "L'art brut avant 1967," p. 125.

37. Spies, "Hallucination and Technique," p. 91.

38. Although it is perhaps somewhat unconventional for an author to postulate events for which no documentary proof exists, such a stance must inevitably challenge scholars involved in Ernst studies to provide evidence either confirming or refuting the hypothetical event, and this is my intention.

39. Ernst is listed on the back cover of *Bulletin D* (the catalog of the first main Cologne Dada exhibition, November 1919) as responsible for the contents of the exhibition. I wish to thank Roger Cardinal for drawing my attention to this fact.

40. Werner Spies, *Max Ernst: Collagen; Inventar und Widerspruch* (Cologne, 1974), reprinted as "Getting Rid of Oedipus," in *Focus on Art*, pp. 96–103. My discussion of the Ernst collage, *Oedipe*, is indebted to Werner Spies's observations.

41. The collage was reproduced in *Le surréalisme au service de la révolution* (Paris, 1933), 5: 58, with the new title, *Oedipe*.

42. The book dedicated to the pictorial work of Max Ernst appeared as a special number of *Cahiers d'art* in 1937.

43. Spies, "Getting Rid of Oedipus," p. 101.

44. As convincing as these two images now are as sources for the *Oedipe*, it is highly unlikely that they would ever have been discovered by the typical procedures of the art historian. Indeed, the decision to juxtapose them with the Ernst image would represent such a subjective act that one would be forced to point to it as a dazzling example of paranoid critical thinking in the Dalian sense. However, the subjective element would be considerably lessened if, as I believe, Max Ernst himself, a close friend of Werner Spies, assisted with the identification of the pictorial sources behind the *Oedipe*, thereby permitting an invaluable glimpse into his working methods. I have excluded any reference to the important role of the *Boy Extracting a Thorn* since it does not relate to our subject.

45. Spies, "Getting Rid of Oedipus," p. 99.

46. A reproduction of Ingres's 1806 painting *Oedipus and the Sphinx* hung in Freud's London consulting room immediately beside his chair, as described in my unpublished paper, "A Visit to Freud's Library" (1976). Spies points to this painting, as well as a reversed variant of it in the Walters Gallery in Baltimore, as yet another important source behind Ernst's image.

In terms of his profound interest in psychoanalysis and Freud, Ernst, more than any other artist of the surrealist group, provided masses of autobiographical information concerning his earliest childhood memories, dreams, and fantasies, his relationship to his parents and siblings, as well as ideas concerning the origins of his creative drives, exposing himself with a degree of honesty and forthrightness characteristic of Freud.

47. I am indebted to Stefanie Poley for her article, "Prinzhorns Buch 'Die Bildnerei der Geisteskranken' und seine Wirkung in der modernen Kunst," p. 66, in drawing this derivation to my attention.

48. The connection between the sculptural oeuvre of Ernst and Brendel is so marked that Stephen Prokopoff has been led to speculate, without evidence, that the bread sculptures that so impressed Ernst in the Bonn collection may have been the work of Brendel, whose initial work was executed in chewed bread. See "The Prinzhorn Collection and Modern Art," in *The Prinzhorn Collection*, Krannert Art Museum Catalog (Urbana-Champaign, Ill., 1984), p. 18, where speaking of Brendel's work, he states, "That Ernst should recall this work when he began to create his own sculpture does not appear surprising. And while Ernst's sculpture encompasses many primitive sources, reflections of Brendel seem to appear at almost every turn in such works as *Habukkuk* (c. 1934) and *Moonmad* (1944)."

49. Quoted in Roger Cardinal, *Outsider Art* (London, 1972), p. 20.

50. A. Marie, "L'art et la folie," *Revue scientifique* 67 (1929): 393–98.

51. All of the students of Dr. A. Marie seem to have built up private collections of psychotic art over the years, and the exhibition included loans from all of these private sources. Will-Levaillant points out the possible contents of "a museum, more imaginary than real," that would have included famous personal collections of the following physicians in France; Sentoux (celebrated for the insane of Charenton, who edited an illustrated paper called *La Glaneur, Journal de Madopolis*); Simon (at the Bron Asylum); Luys (at the Salpêtrière); Chambard, Thivet, and Magnan (at Sainte-Anne, a collection that included the work of Fulmen-Cotton); Pailhas (at Albi); Leroy (at Évreux); Marie (at Villejuif), and Jean Vinchon. See "L'analyse des dessins d'aliénés et de médiums en France avant le Surréalisme," p. 35.

52. A number of works from the Prinzhorn Collection were acquired by the Parisian dealer in primitive art, Ladislas Szecsi (d. 1988) in trade with Hans Prinzhorn who wished to obtain examples of primitive art. These works are now in New York in the collection of Sam Farber.

53. Jean Vinchon, *L'art et la folie* (Paris, 1924). For French artists interested in the art of the insane, but unable to read Prinzhorn's book in German, Jean Vinchon's publication, which appeared two years later, provided an extensive, though far more conventional and uninspiring, discussion of the art of hospitalized psychotics, accompanied by twenty-six reproductions. This pioneering publication may have been inspired, in part, by Vinchon's close friendship with Guillaume Apollinaire. He describes how he and Apollinaire searched together for drawings made by the insane. As Katia Samaltanos points out, the richest collection available in Paris was still that of Dr. Auguste Marie at Villejuif, which Vinchon was using as the basis for his study of psychotic art. See Samaltanos, *Apollinaire*, pp. 88–89.

54. His actual membership in the group lasted only from 1924 to 1926 when he withdrew because of disagreement with Breton and others over the Surrealists' growing involvement with the communist cause.

55. Susan Sontag, "Artaud," introduction to *Antonin Artaud: Selected Writings*, trans. Helen Weaver (New York, 1976), p. xxvi.

56. For a detailed discussion of his mental state, see Bettina L. Knapp, *Antonin Artaud: Man of Vision* (New York, 1969). Also see Roy Porter, *A Social History of Madness: The World through the Eyes of the Insane* (New York, 1987), pp. 141–45.

57. Quoted in Knapp, ibid., p. 162.

58. The opposed points of view are best clarified in Isidore Isou, *Antonin Artaud torturé par les psychiatres* (Paris, 1970); and Gaston Ferdière, "J'ai soigné Antonin Artaud," *La tour de feu*, 63–64 (December 1959): 28–37. Ferdière appeared at the conference on Surrealism at Cerisy-la-Salle and gave a brief talk on madness. I would like to thank Dr. Ferdière for his assistance.

59. *Antonin Artaud*, trans. Weaver, p. 435. One is inevitably inclined to ponder the tone of servility in this letter and to question Artaud's aim in writing it.

60. *Antonin Artaud: Portraits et dessins* (Paris, 1947). See also the section on Artaud in *Aftermath: France 1945–54*, ed. Germain Viatte and Sarah Wilson (Paris, 1982), pp. 120–25.

61. In *Antonin Artaud*, trans. Weaver. See also Antonin Ar-

taud, *Oeuvres complètes*, 13: 299–322, for valuable notes regarding the origin of this essay.

62. Joachim Beer, "Van Gogh: Sa folie," *Arts* (Paris), January 31, 1947.

63. *Antonin Artaud*, trans. Weaver, p. 484.

64. Ibid., p. 485.

65. Ibid., p. 487.

66. Ibid., p. 495.

67. Ibid., pp. 489–90.

68. Ibid., p. 492.

69. Ibid., pp. 496–97.

70. Ibid., p. 497.

71. Dali, *The Secret Life*, p. 314.

72. Dali, *The Unspeakable Confessions*, p. 126.

73. Dali, *The Secret Life*, p. 313.

74. Ibid., pp. 222–23.

75. James Thrall Soby, *Dali* (New York, 1946). This curious statement seems to presuppose that the insane, and their physicians, share a common language that they alone can understand and enjoy.

76. Dali, *Declaration of Independence of the Imagination and Man's Right to His own Madness* (New York, 1939). Quoted in Soby, *Dali*.

77. Dali, *The Secret Life*, p. 349.

78. Dali, *Dali*, ed. Max Gérard, trans. Eleanor R. Morse (New York, 1968), p. 234.

79. Dali, *The Conquest of the Irrational* (New York, 1935), p. 15.

80. See particularly his book *De la psychose paranoïaque dans ses rapports avec la personalité* (Paris, 1932).

81. Salvador Dali, *Oui: Méthode paranoïaque-critique et autres textes* (Paris, 1971), p. 96n.

82. Dali, *Conquest of the Irrational*, p. 12.

83. André Breton. From a lecture given in Brussels in June 1934, quoted in Dali, *Conquest of the Irrational*, p. 1.

84. Of particular importance is a study of Millet's painting, *The Angelus*, published in the first issue of *Minotaure*, and his discussions of the *Lacemaker* of Vermeer. See Dali, "Aspects phenomenologiques de la méthode paranoïaque-critique," pp. 39–52.

85. Dali, *Conquest of the Irrational*, p. 18.

86. *Life*, 19, no. 13 (September 24, 1945): 63–66.

87. For a detailed discussion of the influence of psychotic art and artists in France of this period, see Henry-Claude Cousseau, "The Search for New Origins," in *Aftermath: France 1945–1954*, pp. 14–23, 74–150.

88. The complex meaning of this term is discussed in the following chapter, which is devoted to the work and influence of Jean Dubuffet.

89. Notes from a discussion with Dubuffet in the possession of the author, p. 15.

90. Alain Jouffroy, "La collection André Breton," *L'oeil* 10 (October 1955): 32–39.

91. Through the kindness of Sam Farber of New York, it was possible to obtain information about Szecsi's involvement with psychotic art both in Paris and New York. Some of the psychotic works from the Szecsi Collection, including five pieces obtained from Hans Prinzhorn, are now in the Farber Collection.

92. L. Szecsi, "On Works of Art of the Insane," Catalog of the Exhibition of the Szecsi Collection (New York, 1935). Two years after the Surrealist exhibition, a show entitled "Art and Psychopathology" was organized in New York by the Federal Art Project of the Works Progress Administration and Belleview Hospital. This exhibition was, however, an example of a very different kind of activity, that promoted by "art therapists." There is no doubt that the tendency of art therapists to exhibit the work of their patients derives from the historical process we are studying, but the works produced in such a context are easily distinguished from the spontaneous art of the insane. See "U.S. Government and Bellevue Exhibit Art of Insane Patients," *Life* 5, pt. 2 (October 24, 1938): 26–27.

93. Man Ray, *Autoportrait* (Paris, 1963), p. 254.

94. Breton, "L'art des fous," in *La clé des champs* (Paris, 1953), all quotes from pp. 270–71.

95. Articles on and reproductions of psychotic art in Surrealist books and periodicals become far more common in the 1950s and 1960s. Among the later exponents of Surrealism, Richard Lindner (1901–1978) demonstrated a most serious involvement with the art of the insane, and specifically with the Prinzhorn Collection, which he visited in 1925. In an interview conducted in the last year of his life, he stated that his visit to the collection had been "the most important artistic experience of my life"; quoted in Prokopoff, "The Prinzhorn Collection and Modern Art," p. 18. In Lindner's case, the influence of specific psychotic masters can be convincingly identified, particularly that of the painter Aloïse. See Stefanie Poley, "Prinzhorns Buch 'Die Bildnerei der Geisteskranken und seine Wirkung in der modernen Kunst," p. 67; see pls. 14 and 15 for a comparison of Aloïse's *Sphinx* with Lindner's *Study for Miss American Indian* (1969). Less direct, but no less profound influences on Lindner's stylistic evolution can be seen as originating in the work of the Prinzhorn master, Gustav Sievers, and in the better-known work of the "Outsider," Friedrich Schröder-Sonnenstern (1892–1982). Pursuit of these later parallels would lead to the tremendous renewal of interest in, and influence from, the Prinzhorn Collection evident in recent trends in German Neoexpressionist painting, and to topics beyond the scope of this study.

96. Breton, "L'art des fous," p. 274.

97. Pierre Naville, "Beaux-Arts," *La révolution surréaliste* 3 (April 15, 1925): 27.

98. Breton, *Manifesto* (1924), p. 9.

99. Ibid. Breton identifies this passage as deriving from Proust.

100. Ibid., p. 18.

101. Clifford Browder, *Andre Breton: Arbiter of Surrealism* (Geneva, 1967), p. 16.

102. Breton's acquisition of 1929, the assemblage by a patient reproduced as pl. 224, which appears on pp. 42–43 of issue no. 12, December 15, 1929. Drawings reproduced on p. 30 of the same issue are almost certainly the work of a psychotic artist. Significantly, none of these works is identified as the spontaneous production of an untrained psychotic individual.

103. Notes from the author's discussion with Dubuffet, pp. 30–31.

104. Tristan Tzara, "Ernst Josephson," *Les feuilles libres* 42 (1926): 381–82, with eight illustrations of Josephson's work.

SEVENTEEN. DUBUFFET AND THE AESTHETIC OF ART BRUT

1. To avoid confusion, the reader should be aware that Dubuffet did not accept labels such as psychotic, nor did he restrict his interests in regard to such images to works created inside of mental hospitals. Nevertheless, his influence on the perception of the art of individuals diagnosed as insane has been more extensive than that of any other artist in this century. This chapter, the result of extensive discussion with Dubuffet, contains the first extended account of the history of his evolving relationship with

the art that he has termed "Art Brut," a concept the implications of which extend well beyond the creations of the hospitalized insane.

2. Such an investigation will be rendered difficult by the fact that Dubuffet destroyed all but twenty or thirty of his pictures created before 1942.

3. Dubuffet was given the book shortly after its publication by his friend, the Swiss writer Paul Budry.

4. Conversation with Jean Dubuffet, August 1976, pp. 1–3. The quotations from the conversations with Dubuffet are based on notes made at the time by the author in English. Dubuffet was speaking in French and in some cases, the process of instantaneous translation may have led to slight distortions. All further references to these notes are simply labeled "Conversation," followed by a page number that refers to a page in the unpublished notebook in the author's possession.

5. I was fortunate in being permitted access to these books in the archives of the Musée de l'Art Brut, Lausanne. All quotations from these notes are labeled "Daybooks," followed by a date where possible. There are no page numbers.

6. Up to now, the history of this aspect of his work had been recorded largely by Dubuffet himself, who, despite his anti-intellectual stance, had a keen sense of the historically significant detail.

7. Dubuffet went to Switzerland because his friend Paul Budry was sufficiently well connected in Swiss medical circles to arrange for his reception there. He was accompanied on the trip by the French writer and man of letters Jean Paulhan; see his account, "Guide d'un petit voyage en Suisse au mois Juillet 1945," *Les cahiers de la pliade* 1 (1946): 197–216.

8. Although Dubuffet had signed a contract, the project was abandoned by Gallimard.

9. Conversation, p. 7.

10. Conversation, pp. 7–8.

11. "I felt that for the sake of Art Brut it would be better if it wasn't seen as associated strictly with me, especially from the point of view of collecting. Liberated from my personality it would survive. . . . I hoped it would grow." Conversation, p. 14.

12. Charles Ratton was one of the earliest dealers in primitive art in France and an expert in the subject. Roche was also a dealer, and a friend of Duchamp.

13. The lists of membership for the early years of the Compagnie de l'Art Brut are included in the Daybooks, vol. 1, which covers 1948–1949.

14. An important exchange of letters between Dubuffet and Breton occurred in 1951. The letters concern the decision to move the collection to America and reveal some of the tensions inherent in the organization in the early stages. They are reproduced in Jean Dubuffet, *Prospectus et tous les écrits suivants* (Paris, 1967), 1: 491–98. Breton too approached Art Brut with his own dogmas well established, and it is not surprising to discover that he saw Art Brut, and Dubuffet himself, as an extension of Surrealism, an act of annexation that Dubuffet determinedly resisted.

15. This catalog was seen as one of the manifestos of modern art; one thousand copies were printed. An English translation is available in *Art Brut: Madness and Marginalia*, in *Art and Text* 27 (December 1988): 31–33.

16. This was given as a paper at the Faculté des lettres at Lille, January 10, 1951, in connection with the opening of an exhibition of Art Brut. It was published in its entirety only in 1967 in *Prospectus*, 1: 203–204, edited by Hubert Damisch.

The lecture to the Chicago Art Club in 1951 can be seen as a major factor initiating interest in psychotic art and artists in America. Chicago had always been in the forefront of this development with a group of Chicago artists playing the lead role. I am preparing an account of the history of this development and of more recent events in New York and elsewhere, which lies outside of the time span of this book. For a brief sketch of events in Chicago, both before and after Dubuffet's lecture, see Michael Bonesteel, "Chicago Originals," *Art in America* 73 (February 1985): 128–34.

17. Conversation, pp. 28–30.

18. The new managing board included Jean Dubuffet, Michel Petitjean, Slavko Kopac, Daniel Cordier, and Emmanuel Peillet. The council met for the first time on September 27, 1962. All of the costs involved in the purchase of the new building, and of moving and arranging the collection, were assumed by Dubuffet.

19. These two artists were discovered and first published in 1961 by Dr. Alfred Bader of Lausanne, in his book *Insania pingens* (Basel, 1961).

20. "Pour qu'y soient consignés à partir de cette date les menus faits dont il est bon de garder mémoire."

21. In 1968 Dubuffet stated his revolutionary position in regard to established culture and professionalism in art in *Asphyxiante culture* (Paris, 1968), which has only recently appeared in translation; see *Asphyxiating Culture: And Other Writings*, trans. Carol Volk (New York, 1988).

22. A catalog accompanied the exhibition. It contained an introductory essay by Dubuffet entitled "Place à l'incivisme," now translated as "Make Way for Incivism," in *Art Brut: Madness and Marginalia*, pp. 34–36. The extent of Dubuffet's personal collection can be seen in his *Catalogue de la collection de l'art brut* (Paris, 1971).

23. A document, accounting for the decision to give the collection to the city of Lausanne, was circulated among the members of the Compagnie de l'Art Brut and the matter was voted on. An effort was made to obtain the collection for the new museum of modern art in Paris, the Centre Beaubourg, but Dubuffet was not interested in submerging Art Brut in a museum of "official art." For an indication of activities in Switzerland on behalf of the collection, see Alfred Bader, *L'histoire d'une petition concernant La Collection de l'Art Brut* (Lausanne, 1971).

24. Dubuffet's interest in graffiti developed independently. He was introduced to Brassai in 1944 because of their common interest in wall art. Graffiti can be seen correctly as an aspect of Art Brut, but, on the whole, a feeble version in that it is so persistently involved with copying.

25. "Place à l'incivisme," in *Prospectus*, 1: 453.

26. Letter to the author, September 9, 1976.

27. Conversation, p. 28.

28. Dubuffet feels that his significant work began to appear in the early 1940s. He destroyed most of the earlier work, saving twenty to thirty pieces. "It wasn't good, too much influenced by culture."

29. Peter Selz, *The Work of Jean Dubuffet* (New York, 1962), p. 20.

30. *Art News* 48, no. 10 (February 1950): 48.

31. Conversation, p. 33.

Not only was Dubuffet influenced, but he, in turn, influenced other artists. For example, Karel Appel came in contact with Dubuffet's ideas during the period of his most intense involvement with children's art. As a result, both Appel, and the Cobra Group in general, exhibited an immediate and intense involve-

ment with children's art. However, as Stephen Prokopoff has pointed out, "Both Asger Jorn and Jean-Michel Atlan were close students of mental illness, and both studied and worked in asylums; Atlan had himself admitted in order to paint among patients." See Stephen Prokopoff, "The Prinzhorn Collection and Modern Art," in *The Prinzhorn Collection*, Krannert Art Museum Catalog (Urbana-Champaign, Ill., 1984), p. 20. A detailed account of these contacts between the members of Cobra and psychotic art and artists has yet to be written. Jean-Michel Atlan's involvement with psychotic art and the Hôpital de Ste. Anne is described in *Aftermath: France 1945–1954*, ed. Germain Viatte and Sarah Wilson (Paris, 1982), pp. 83–85.

32. *La gazette des lettres*, October 18, 1947. The Pompiers were a group of academic painters of the late nineteenth century in France, notable for their speed in supplying any type of painting that represented the current fashion.

33. I asked Dubuffet about the similarities between these two works. In response he did a drawing illustrating the difference between his style and that of Müller. He characterized Müller's drawing as a more elaborate linear style—almost ornate. "He had a way of drawing which was very sophisticated." The small drawing provided an interesting example of Dubuffet's precise visual memory and his ability to imitate Müller if he wanted to do so.

34. Georges Limbour, *Tableau bon levain à vous de cuire la pate: L'art brut de Jean Dubuffet* (Paris, 1953), p. 59.

35. At the same time, suggestions that Dubuffet has indulged in conscious imitation of psychotic art or of Art Brut are unfair distortions of the creative integrity of a dedicated artist.

36. Jean Dubuffet, "Memoire on the Development of My Work from 1952," in Selz, *The Work of Jean Dubuffet*, p. 102.

37. Ibid., p. 81.

38. Jean Dubuffet, "Honneur aux valeurs sauvages," in *Prospectus* 1: 206 and 213.

39. Jean Dubuffet, *Landscaped Tables, Landscapes of the Mind, Stones of Philosophy* (New York, 1952), p. 71. Reprinted in Selz, *The Work of Jean Dubuffet*, p. 64.

40. I asked Dubuffet if he would be in favor of the burning of the museums. He agreed this would be beneficial. "If all the museums were closed, you'd have a recrudescence of creativity. It is impossible to see the art of the past with fresh eyes. Works of art can only be seen with fresh eyes in their own time, when they are created." Conversation, p. 6.

41. Dubuffet, *Prospectus*, 1: 198.

42. *Prospectus*, 1: 201.

43. "Positions anticulturelles," in *Prospectus*, 1: 94.

44. Ibid., p. 97.

45. *Landscaped Tables, Landscapes of the Mind, Stones of Philosophy*.

46. "Positions anticulturelles," in *Prospectus*, 1: 98–99.

47. In response to a question as to whether his work might fall within the definition of Art Brut, Dubuffet replied, "No, I don't believe so. I don't merit it, I'm not worthy. My cultural background is too extensive. The creators of Art Brut are mostly people who have had no instruction, that's not my case. I have attempted to attain a spiritual position that is close to Art Brut, by an act of will. I gave the name to the collection, not to my own art. . . . I have never managed to rid myself completely of the influence of cultural art." Conversation, p. 27.

48. "Honneur aux valeurs sauvages," in *Prospectus*, 1: 215.

49. "Place à l'incivisme," in *Prospectus*, 1: 453.

50. This may account for Dubuffet's attitude to Freud. "I don't like him at all! I don't like his theory, and I don't like all psychoanalysts." Conversation, p. 36.

51. "I invented it while I was on the trip of 1945, or very shortly after. I needed a title for the series of publications I was planning to produce." Conversation, p. 13.

52. "Place à l'incivisme," in *Prospectus*, 1: 454.

53. "Honneur aux valeurs sauvages," in *Prospectus*, 1: 216–17.

54. Dubuffet is not familiar with R. D. Laing and other members of the "antipsychiatry movement." His interest in psychiatry had been stimulated by a small group of French psychiatrists, among whom he mentioned Dr. Jean Oury and Roger Gentis.

55. Conversation, pp. 10–11.

56. "Honneur aux valeurs sauvages," in *Prospectus*, 1: 218.

57. The term *aliénés* used in French to refer to the insane is not directly translatable into English. It implies that the insane are alienated or split off from the rest of humanity by their mental condition.

58. "Honneurs aux valeurs sauvages," in *Prospectus*, 1: 220.

59. "Place à l'incivisme," in *Prospectus*, 1: 455.

60. "Honneurs aux valeurs sauvages," in *Prospectus*, 1: 219–20.

61. "Place à l'incivisme," in *Prospectus*, 1: 457.

62. Ibid., 1: 453–54.

63. Conversation, p. 24.

64. Conversation, p. 25.

65. "Place à l'incivisme," in *Prospectus*, 1: 454.

66. Ibid., 1: 456.

67. "L'art brut préféré aux arts culturels," in *Prospectus*, 1: 202.

68. "Heinrich Anton M," *L'art brut* 1 (1964): 131–42, reprinted in *Prospectus*, 1: 269–75.

69. The passage of almost fifty years since the death of Heinrich Anton Müller permits the publication of his name. Prinzhorn concealed it completely, referring to him as "M." The Documente 5 exhibition in Kassel, where his work was shown, provided an opportunity for his work and his name to be associated for the first time.

70. "Heinrich Anton M," in *Prospectus*, 1: 269.

71. Ibid., 1: 269–70.

72. "Honneur aux valeurs sauvages," in *Prospectus*, 1: 222. Dubuffet is well aware that works produced in the context of hospital departments of art therapy bear little or no relationship to Art Brut, and cannot be seen as spontaneously produced. In fact, the mental hospital, once an outpost of freedom, is becoming increasingly drug oriented, manipulative, and controlling, so that Art Brut is less and less likely to be discovered today within the walls of psychiatric hospitals. "Physicians in the early part of this century left their patients alone. They didn't try to 'cure' them and were simply glad if they kept themselves busy with art. Perhaps they had more sense. Now they want to prevent it, and to kill originality." Conversation, p. 22. An example of the material exhibited by psychiatrists that Dubuffet had in mind was the vast exhibition organized as part of the World Congress of Psychiatry in Paris in 1950; see Robert Volmat, *L'art psychopathologique* (Paris, 1956).

73. "Heinrich Anton M," in *Prospectus*, 1: 272. Report on Müller written by Dr. Max Müller.

74. The text is Müller's and is left in the original language because any attempt at translation would involve too great distortion.

75. "Heinrich Anton M," in *Prospectus*, 1: 275.

76. Conversation, p. 20.

77. "The term is generally accepted internationally. It is, of course, misunderstood. Each understands it in his own way. In

Paris it is often interpreted as meaning art objects formed by nature without human activity: shells, stones, and driftwood." Conversation, p. 13.

78. "Honneur aux valeurs sauvages," in *Prospectus*, 1: 213–16.

79. The director, M. Michel Thévoz, is admirably qualified to fulfill this goal. The opportunity of studying in the collection has convinced me that they have succeeded to a remarkable degree in creating the environment they wished to establish, both architecturally and socially.

80. Conversation, p. 9.

CONCLUSION

1. A similar process is observed in regard to "primitives"—in the attitude of anthropologists, for example, toward Native Americans and their art. Depictions of native people by European artists and descriptions of their way of life by nonnative anthropologists long preceded serious willingness to allow them to tell their own story, either in words or images. The present attitude toward the art of children, or of convicts, betrays a similarly undeveloped attitude.

2. This does not imply the demise of Art Brut. Outside of the hospital, many people who, were they inside, might well be diagnosed as clinically insane continue to exist and, in rare cases, to create. These artists are best characterized, using Roger Cardinal's term, as "Outsider Artists," or Outsiders, since we have no business identifying people living outside of psychiatric hospitals as psychotic or insane. Nevertheless, their unique experiences of reality, their somewhat eccentric adaption to society, and the very special nature of their image-making activity, all serve to identify them as participants in the diverse creative activities we group together as Art Brut.

3. For a discussion of the historically derived dangers still inherent in the present psychiatric milieu, see the final chapter of Andrew T. Scull, *Museums of Madness* (London, 1982), pp. 254–66.

4. Marion Milner, *The Hands of the Living God* (London, 1969), p. xix.

5. Mary Barnes and Joseph Berke, *Mary Barnes: Two Accounts of a Journey through Madness* (Harmondsworth, 1973). For a critical examination of the Barnes case, see Roy Porter, *A Social History of Madness: The World through the Eyes of the Insane* (New York, 1987), pp. 120–24.

6. Mary Barnes's work was first publicly exhibited at the Camden Art Centre in Hampstead, London, in April 1969. It received extensive coverage in the English press. Since leaving the residence at Kingley Hall, Miss Barnes has established herself as a professional painter.

7. While the provision of materials for drawing, painting, or sculpture within a hospital setting cannot be objected to, the interference of individuals with minimal training in psychiatry or psychotherapy cannot be seen as an advantage. The teaching of art has no place in psychiatric institutions, and the use of paint-by-number sets, and artistic "techniques" such as hard-edge painting, though they may serve to pass the time, are inevitably understood as childish and demeaning by the patients. The freedom to create is easily transformed into yet another means of psychic manipulation.

8. See Frieda Fromm-Reichmann, *Principles of Intensive Psychotherapy* (Chicago, 1950).

9. Margaret Naumburg's work with schizophrenic patients provides perhaps the finest example of a psychoanalytically trained art therapist's accomplishments in this direction. Jungian analytical psychology has made the most extensive efforts to modify analytic technique in terms of using pictorial images as an aspect of analysis.

10. Peter Shaffer's play *Equus* (London, 1973) portrays the struggle of an infuriatingly naive psychiatrist to come to grips with this fact. The play is of value in depicting a situation in which the patient's subjective reality possesses vastly greater validity and beauty than that of his physician.

11. As an art historian I have been deeply impressed by the willingness of psychoanalysts and psychoanalytic training institutes to be of help in whatever way they could, and to assist me in obtaining further training in areas where I felt it would help my research. This was particularly true of the Hampstead Clinic in London, England, where Sigmund Freud's celebrated daughter Anna firmly maintained the tradition of interdisciplinary cooperation established by her father. It should be stressed that the minimum requirement for any research worker engaging in interdisciplinary studies that involve psychoanalysis is a thorough personal analysis as a basis for undertaking studies of psychoanalytic theory, or research.

12. Ernst Kris, *Psychoanalytic Explorations in Art* (New York, 1952), p. 87.

13. The growth of the Bethlem Archives, and the recent addition of the important Guttmann-Maclay Collection of Psychiatric Art that now forms part of it, has necessitated plans for building a new museum complex as a part of the archive at Bethlem Royal Hospital, Kent. This new building will once again demonstrate the profound historical awareness that is unique to the administration of this venerable institution.

14. A number of brief historical outlines preceded this publication, in most cases mere bibliographical lists of publications, or brief surveys included in books whose function was essentially nonhistorical. The one important exception would be R. Volmat, *L'art psychopathologique* (Paris, 1956). Since the first version of this book appeared (University Microfilms, Ann Arbor, Mich., 1978), an additional dissertation on the subject has been written and published: Maria Meurer-Keldenich, *Medizinische Literatur zur Bildnerei von Geisteskranken* (Cologne, 1979). Also uniquely valuable is Françoise Will-Levaillant, "L'analyse des dessins d'aliénés et de médiums en France avant le Surréalisme," *Revue de l'art* 50 (1980): 24–39.

15. The author would be deeply interested in learning of any collection of psychiatric art still in private hands.

16. As this final chapter was being written news reached me from Scotland of another very early student of the art of the insane. In 1834, Dr. W.A.F. Browne was appointed the first medical superintendent to the Royal Mental Hospital, Montrose, Scotland. Four years later he became superintendent at the Crighton Royal Hospital in Dumfries. While working in these institutions, he became involved in the study of psychotic art. He assembled a collection of the work of the patients, which he had bound. This very early collection is still to be seen at the Crighton Royal Infirmary, Scotland. I am grateful to Dr. K.M.G. Keddie of the Sunnyside Royal Hospital for drawing this early collection to my attention. My sincere thanks to the present director of the Crighton Royal Infirmary, Dr. Stirling, and to the hospital archivist, Mrs. Morag Williams, for providing me with new and extensive documentation derived from their thorough and ongoing research into the history of this very important early collection. It is to be hoped that an illustrated catalog of the collection will appear shortly.

17. The artists working with Dr. Navratil are known collectively as the artists at Gugging (named after the suburb of Vienna in which the hospital, and the new Gugging Art Centre, *Das Haus der Künstler, in Gugging* is located). Over a dozen of these artists have attained considerable fame. Their work is known from numerous exhibitions all over Europe and from publications devoted to them, including Leo Navratil and Michel Thévoz, *Gugging*, fascicule 12 of *L'art brut* (Lausanne, 1983); and the enormous publication by Dr. Navratil, *Die Künstler aus Gugging: Zustandgebundene Kunst* (Vienna, 1983). Navratil has brought together the only significant group of schizophrenic masters since Prinzhorn, and has gone beyond his great predecessor in creating an environment in which they can continue to create with undiminished intensity.

18. The international society devoted to the study of psychotic art is burdened with the inadequate and demeaning title, Society of Psychopathology of Expression.

19. Dr. Navratil's major books on the subject of psychotic art are: *Schizophrenie und Kunst: Ein Beitrag zur Psychologie des Gestaltens* (Munich, 1965) and with Dr. Alfred Bader, *Zwischen Wahn und Wirklichkeit* (Luzern and Frankfurt, 1976). See also Leo Navratil, *August Walla: Sein Leben und seine Künst* (Nördlingen, 1988).

20. Hauser's work has been much reproduced and he is acquiring an international reputation that extends well outside of psychiatric circles. He has had numerous exhibitions and Navratil's monograph on his life and work has appeared, the result of the collaboration of Hauser and Navratil, compiled by Navratil, *Johann Hauser: Kunst aus Manie und Depression* (Munich, 1978). A portfolio of colored reproductions of his work was published in *Psychopathologie und Bildnerischer Ausdruck* (Linz, 1969), with the unfortunate title "Mutteridole eines Imbezillen." His work is also included in all the Gugging publications.

21. For discussion of Arnulf Rainer's involvement with the art of the insane and reproductions of his early work, which very clearly reveals the influence of this artistic source, see Otto Breicha, *Arnulf Rainer: Uberdeckungen* (Vienna, 1972); and Otto Breicha et al., *Arnulf Rainer: Zeichnungen 1947–51* (Vienna, 1969). My discussion of Rainer's involvement with the art of the insane is based on an interview with the artist conducted on April 11, 1976. See also James Lingwood and Andrea Schlieker, *Franz Xaver Messerschmidt: Characterheads 1770–1783* (London, 1988), for a discussion of Arnulf Rainer's "Overdrawings," which involve graphic additions to photographs of the Messerschmidt heads.

22. The Rainer collection has been exhibited in various European cities, including an exhibition at the Galerie Nächst in Vienna, entitled "L'Art Brut—Collection Rainer," which establishes his acceptance of the term established by Dubuffet.

23. Duchamp was well aware that the artist's intention in making or identifying a work of art is not sufficient to ensure its survival. In a discussion concerning "the creative act," he commented, "In the last analysis, the artist may shout from all the rooftops that he is a genius; he will have to wait for the verdict of the spectator in order that his declarations take a social value and that, finally, posterity includes him in the primers of Art History." Session on The Creative Act, Convention of the American Federation of Arts, Houston, Texas, April 1957. Quoted in R. Lebel, *Marcel Duchamp*, trans. George Heard Hamilton (New York, 1959), p. 77. For information concerning Duchamp's awareness of psychotic art, see Katia Samaltanos, *Apollonaire: Catalyst for Primitivism, Picabia, and Duchamp* (Ann Arbor, Mich., 1984), p. 89.

24. This belief in the artistic value of psychotic art is not universally held. As an example of a totally opposed point of view, I refer to a comment by Dr. William Rubin of the Museum of Modern Art, New York: "However strange and wonderful paintings by insane artists have appeared to me at first glance, the more I looked at them, the more I found the obsessional and/or repetitive character of their implementation gave them very little staying power. Indeed, what seems to me to separate really good Surrealist painting from the work of the insane is precisely the former's melding of the fantasy elements with a great deal of what one might call 'painting culture'—precisely the component of esthetic density that the insane works seem to me to lack. This being said, I quite obviously do not question the immense intellectual value of the study of the art of the insane." From a letter to the author, August 5, 1985. Dr. Rubin was well acquainted with the early Dubuffet collection, having made several visits to it when it was housed in Easthampton.

25. Roger Fry, "Art History as an Academic Study," in *Last Lectures* (Cambridge, 1939). See Introduction, n. 20.

26. The term is Marcel Duchamp's. It does not imply an intellectual as opposed to an emotional art, but rather an art that appeals to the mind rather than the eyes.

27. The ideal solution, at present, would still seem to be the creation of specialized museums devoted to Outsider Art, the Collection de l'Art Brut in Lausanne providing the model. An important endeavor in this direction was the founding, in 1981, of *Art House*, the London home of Outsider Art, by Victor Musgrave. Initially motived by his exhibition "Outsiders" held in 1979 under the auspices of the Arts Council of Great Britain, this museum and study center will, in time, provide a second major home for European, as well as the little-known British, examples of Outsider Art (Director, Monika Kinley, 213 South Lambeth Road, London, SW8 1XR).

It is unfortunate that no serious museum dedicated to Outsider Art exists, as yet, in North America. This is, in part, a result of the continuing tendency there of confusing folk art with naive art, and naive art with Outsider Art. When these distinct entities are lumped together, Outsider Art, by far the rarest form among these various types of image, tends to be lost sight of, and to be neither properly studied nor understood. Outsider Art in America is rapidly falling into the hands of art dealers, with important assemblages being bought, sold, and disbursed, the associated context and documentation being neglected and lost. It is to be hoped that a major archive and museum will eventually be created to provide a safe home for the vast, still largely undiscovered, treasure of Outsider Art that undoubtedly exists in North America.

28. Michel Thévoz, *Art brut* (Geneva, 1976), pp. 158–61.

Selected Bibliography

The selected bibliography, which is not exhaustive, includes and supplements the articles and books used as direct references and is intended to aid the reader who may wish to pursue further the subject matter of each chapter.

INTRODUCTION

Anastasi, Anne, and John P. Foley, Jr. "A Survey of the Literature on Artistic Behavior in the Abnormal: 1. Historical and Theoretical Background." *The Journal of General Psychology* 25 (1941): 111–42.

Anonymous. *Arts primitifs dans les ateliers d'artistes.* Paris: Musée de l'homme, 1967.

Bihalji-Merin, Oto. *The Art of the Naive Painters of Yugoslavia.* Belgrade, 1958.

———. *Modern Primitives.* London, 1971.

Born, Wolfgang. "Art and Mental Disease." *Ciba Symposia* 7 (1946): 202–36.

Cahill, Holger, et al. *Masters of Popular Painting.* New York: Museum of Modern Art, 1938.

Champfleury [Fleury, Jules]. *Histoire de la caricature antique.* Paris, 1879.

Dorival, Bernard. *Twentieth Century Painters.* Translated by Arnold Rosin. Paris, 1958.

Foucault, Michel. *Madness and Civilization.* New York, 1965.

Foy, James L. Introduction to *Artistry of the Mentally Ill,* by Hans Prinzhorn. Translated by Eric von Brockdorff. New York, 1972.

Fry, Roger. "Art History as an Academic Study." In *Last Lectures* (1933), pp. 1–21. Cambridge, 1939.

Golding, John. *Cubism: A History and Analysis.* London, 1968.

Goldwater, Robert J. *Primitivism in Modern Art.* New York, 1967.

Gombrich, E. H. "Psychoanalysis and the History of Art." *International Journal of Psychoanalysis* 35 (1954): 401–11.

Jung, Carl G. *Collected Works.* New York, 1957.

Kahler, Erich. *The Disintegration of Form in the Arts.* New York, 1968.

———. *The Tower and the Abyss.* London, 1958.

Kiell, Norman. *Psychiatry and Psychology in the Visual Arts and Aesthetics: A Bibliography.* Madison, Wis., 1965.

Miller, Margaret. "Géricault's Paintings of the Insane." *Journal of the Warburg and Courtauld Institutes* 4 (1940–1941): 151–63.

Naumburg, Margaret. *Schizophrenic Art: Its Meaning In Psychotherapy.* New York, 1950.

Panofsky, Erwin. *Renaissance and Renascences in Western Art.* Stockholm, 1960.

Prinzhorn, Hans. *Bildnerei der Gefangenen.* Berlin, 1926.

———. *Bildnerei der Geisteskranken.* Berlin, 1922.

Ricci, C. *L'arte dei bambini.* Bologna, 1887.

Rubin, William, ed. *Primitivism in Twentieth Century Art.* New York, 1984.

Sedlmayr, Hans. *Art in Crisis.* London, 1957.

Sweeney, J. J. "Picasso and Iberian Sculpture." *Art Bulletin* 23 (1941): 190–99.

Trilling, Lionel. "Art and Neurosis." In *The Liberal Imagination: Essays on Literature and Society*, pp. 160–80. New York, 1950.

Uhde, Wilhelm. *Henri Rousseau.* Düsseldorf, 1914.

Vallier, Dora. *Henri Rousseau.* New York, 1962.

Venturi, Lionello. *Il gusto dei primitivi.* Turin, 1972.

ONE. THE CONFRONTATION: THE ARTIST AND THE MADMAN

Allderidge, Patricia. *Catalogue of the Bethlem Historical Museum.* London, 1976.

———. "Cibber's Figures from the Gates of Bedlam." *Victoria and Albert Masterpieces,* sheet 14. London, 1977.

Anonymous. *Sketches in Bedlam.* London, 1823.

Bucknill, John Charles. "The Diagnosis of Insanity." *The Asylum Journal* (July 1856): 444.

Burdett, Henry C. *Hospitals and Asylums of the World.* London, 1891.

Charcot, J. M., and Paul Richer. *Les Démoniaques dans l'art.* Paris, 1887. Reprinted. Amsterdam, 1972.

Clark, L. P. "Mental and Nervous Diseases in Classic Pictorial Art." *Medical Pickwick* 2 (1916): 1–14.

Cohen, Michael M. "Hogarth's 'A Rake's Progress' and the Technique of Verse Satire." In *Studies in Iconography* 5, pp. 159–62. Murray, Ky., 1979.

Dürek-Kaulbach, Josefa. *Erinnerungen an Wilhelm von Kaulbach und sein Haus.* Munich, 1918.

Faber, H. *Caius Gabriel Cibber.* Oxford, 1926.

Foucault, Michel. *Madness and Civilization.* Toronto, 1967.

Gilman, Sander L. *Seeing the Insane.* New York, 1982.

Görres, Guido. *Das Narrenhaus von Wilhelm von Kaulbach: Erläutet von Guido Görres.* Koblenz, 1836.

Heitz, J. "Les démoniaques et les malades dans l'art byzantin." In *Nouvelle iconographie de la Salpêtrière.* Paris, 1901.

Hofmann, Werner. "D'un aliénation a l'autre: L'artiste allemand et son public au XIXᵉ siècle." *Gazette des beaux-arts* ser 6, 90 (October 1977): 124–36.

Ireland, John. *Hogarth Illustrated.* London, 1791.

Karp, Diane. "Madness, Mania, Melancholy: The Artist as Observer." *Bulletin of the Philadelphia Museum of Art* 80, no. 342 (Spring 1984): 1–22.

Kellner, A. W. "Portrayals of Mentally Diseased Persons up to 1100 A.D." *Medizinische Welt* 2 (1937): 1227–30.

Klibansky, Raymond, Erwin Panofsky, and Fritz Saxl. *Saturn and Melancholy.* London, 1964.

Lemke, Rudolf. *Psychiatrische Themen in Malerei und Graphik.* Jena, 1958.

Lichtenberg, G. Ch. *Lichtenberg's Commentaries on Hogarth's Engravings.* London, 1966.

Menninger, Karl, and Paul Pruyser. *The Vital Balance.* New York, 1967.

Morrison, Sir Alexander. *The Physiognomy of Mental Diseases.* London, 1840.

O'Donoghue, Edward Geoffrey. *The Story of Bethlem Hospital.* London, 1914.

Ostini, Fritz von. *Wilhelm von Kaulbach.* Bielefeld, 1906.

Paulson, Ronald. *Hogarth: His Life, Art and Times.* New Haven, 1971.

——, comp. *Hogarth's Graphic Works.* New Haven, 1965.

Portigliotti, Giuseppe. *I Pazzi nell arte.* Turin, 1907.

Summerson, John. *Architecture in Britain: 1530–1830.* Harmondsworth, 1963.

Swift, Jonathan. "The Legion Club" (1736). In "A Character, Panegyric and Description of the Legion Club." In *The Poems of Jonathan Swift.* Edited by William Ernst Browning, 2: 264–71. London, 1910.

Thieme, Ulrich, and Felix Becker. *Allgemeines Lexikon der bildenden Künstler.* Vol. 20. Leipzig, 1927.

Tuke, Daniel Hack. *Chapters in the History of the Insane in the British Isles.* London, 1882.

Wäldfogel, Melvin. "Narrative Painting." In *The Mind and Art of Victorian England.* Edited by Joseph L. Altholz, pp. 159–74. Minneapolis, 1976.

Walpole, Horace. *Anecdotes of Painting in England.* Oxford, 1937.

Whinney, Margaret. *Sculpture in Britain: 1530–1830.* Harmondsworth, 1964.

Zigrosser, Carl. *Medicine and the Artist.* New York, 1970.

TWO. THE PHYSICIAN AND THE ART OF THE PATIENT

Alkan, Alphonse. *Berbiguier: Un halluciné et son livre "Les Farfadets," ou tous les démons ne sont pas de l'autre monde.* Paris, 1889.

Alexander, Franz G., and Sheldon T. Selesnick. *The History of Psychiatry.* New York, 1966.

Berbiguier de Terre-Neuve du Thym, Alexis-Vincent-Charles. *Les farfadets: Ou tous les démons ne sont pas de l'autre monde,* 3 vols. Paris, 1821.

Binger, Carl. *Revolutionary Doctor: Benjamin Rush, 1746–1813.* New York, 1966.

Butterfield, L. H. *Letters of Benjamin Rush.* Princeton, 1951.

Bynum, W. F. "Rationales for Therapy in British Psychiatry: 1780–1835." *Medical History* 18 (1974): 317–34.

Dingwall, Eric John. *Some Human Oddities.* London, 1947.

Ellenberger, Henri F. *The Discovery of the Unconscious.* New York, 1970.

Freud, Sigmund. "A Seventeenth-Century Demonological Neurosis." In *The Standard Edition of the Complete Psychological Works of Sigmund Freud,* 19: 72–105. Edited and translated by James Strachey. London, 1956-1974.

Garrucci, R., and L. Correra. *Graffiti di Pompei.* Paris, 1856.

——. *Graffiti di Roma.* Rome, 1895.

Gmelin, Eberhardt. *Materialen für die Anthropologie.* Tübingen, 1791.

Goodman, Nathan G. *Benjamin Rush: Physician and Citizen.* Philadelphia, 1934.

Haslam, John. *Illustrations of Madness: Exhibiting a Singular Case of Insanity and a No Less Remarkable Difference in Medical Opinion.* London, 1810.

Jefferiss, F.J.G. *Dr. Thomas Monro and the Monro Academy.* London, 1976.

Kris, Ernst. "A Psychotic Artist of the Middle Ages." In *Psychoanalytic Explorations in Art,* pp. 118–27. New York, 1952.

——. "A Psychotic Sculptor of the Eighteenth Century." In *Psychoanalytic Explorations in Art,* pp. 128–50. New York, 1952.

Lewis, Sir A. *Philippe Pinel and the English.* London, 1967.

Masters, Anthony. *Bedlam.* London, 1977.

Matthews, James Tilly. *Useful Architecture.* London, 1812.

Mauron, Marie. *Berbiguier de Carpentras.* Paris, 1959.

Meige, Henry. "Les fous dans l'art." In *Nouvelle iconographie photographique de la Salpêtrière,* pp. 97–107. Paris, 1909.

Meyer, J. E., and Ruth Meyer. "Selbstzeugnisse eines Schizophrenen um 1800." *Confinia Psychiatrica* 12 (1969): 130–43.

Navratil, Leo. "Matthews—Sein Wahn." *Protokolle: 76* (Munich and Vienna, 1976), 1: 293–314.

Pinel, Philippe. *Traité médico-philosophique sur l'aliénation mentale, ou la manie.* Paris, 1801. English edition. *A Treatise on Insanity.* Translated by D. D. Davis. London 1806. Reprinted. New York, 1962.

Porter, Roy. *A Social History of Madness: The World through the Eyes of the Insane.* New York, 1987.

Pritchard, V. *English Medieval Graffiti.* Cambridge, 1967.

Rees, Abraham, ed. *Cyclopedia.* London, 1778.

Rush, Benjamin. *Medical Inquiries and Observations upon the Diseases of the Mind.* Philadelphia, 1812. Reprinted. New York, 1962.

Salomon, Richard. "Aftermath to Opicinus de Canistris." *Journal of the Warburg and Courtauld Institutes* 25 (1962): 137–46.

——. "A Newly Discovered Manuscript of Opicinus de Canistris." *Journal of the Warburg and Courtauld Institutes* 16 (1953): 45–57.

——. *Opicinus de Canistris.* London, 1936.

Semelaigne, René. *Les grands aliénistes français.* Paris, 1894.

——. *Philippe Pinel et son oeuvre au point de vue de la médicine mentale.* Paris, 1888.

——. *Les pionniers de la psychiatrie française avant et après Pinel.* Paris, 1930.

Tausk, Victor. "On the Origin of the Influencing Machine in Schizophrenia." *Psychoanalytic Quarterly* 2 (1933): 519–56.

Tuke, Samuel. *Description of the Retreat, an Institution Near York.* Philadelphia, 1813.

Vinchon, Jean, and M. Laignel-Lavastine. *Les malades de l'esprit.* Paris, 1930.

Woods, Evelyn A., and Eric T. Carlson. "The Psychiatry of Philippe Pinel." *Bulletin of the History of Medicine* 35 (1961): 14–25.

Zilboorg, Gregory, and G. W. Henry. *A History of Medical Psychology.* New York, 1941.

THREE. GEORGET AND GÉRICAULT: THE PORTRAITS OF THE INSANE

Adhemar, Jean. "Un dessinateur passionné pour le visage humain: Georges-François-Marie Gabriel." In *Omagiu lui George Oprescu,* pp. 1–4. Bucharest, 1961.

Aimé-Azam, Denise. *Mazeppa: Géricault et son temps.* Paris, 1956.

Alexander, Franz G., and Sheldon T. Selesnick. *The History of Psychiatry.* New York, 1966.

Antal, Frederick. "Reflections on Classicism and Romanticism."

The Burlington Magazine 77 (1940): 72–80, 188–92; and 78 (1941): 14–22.

Berger, Klaus. *Géricault and His Work.* Lawrence, Kansas, 1955.

———. *Géricault's Drawings and Watercolors.* New York, 1946.

Cailler, Pierre. *Géricault raconté par lui-même et par ses amis.* Geneva, 1947.

Clément, Charles. *Géricault.* Paris, 1879.

Combe, Colonel de la. *Charlet, sa vie et ses lettres.* Paris, 1856.

Dubaut, Pierre, and Hans E. Buhler. *Géricault.* Winterthur, 1956.

Duchenne de Boulogne, Guillaume Benjamin Amant. *Mécanisme de la physionomie humaine ou analyse électro-physiologique de l'expression des passions.* Paris, 1862.

Eitner, Lorenz. *Géricault's Raft of the Medusa.* London, 1972.

———. "The Sale of Géricault's Studio in 1824." *Gazette des beaux-arts* 53 (1959): 115–26.

Esquirol, Jean Etienne Dominique. *Des maladies mentales.* Paris, 1838.

Fechter, Paul. "Théodore Géricault." *Kunst und Künstler* 11 (1913): 267.

Friedlander, Walter. *From David to Delacroix.* Cambridge, 1963.

Genty, Maurice. "A propos de Géricault." *Le progrès médical* 20 (1924).

Georget, Etienne. "Ataxie." In *Dictionnaire de la médecine*, vol. 6. Paris, 1821.

———. "Catalepsie." In *Dictionnaire de la médecine*, vol. 4. Paris, 1821.

———. "Délire." In *Dictionnaire de la médecine*, vol. 3. Paris, 1821.

———. *De la folie.* Paris, 1820.

Gigoux, Jean. *Causeries sur les artistes de mon temps.* Paris, 1885.

Gilman, Sander L. *Seeing the Insane.* New York, 1982.

Jammes, André, and Robert Sobieszek. *French Primitive Photography.* New York, 1970.

Klingender, F. D. "Géricault as Seen in 1848." *The Burlington Magazine* 81 (1942): 254–56.

Knowlton, John. "The Stylistic Origins of Géricault's 'Raft of the Medusa.' " *Marsyas* 2 (1942): 125–44.

Menninger, Karl A. *A Manual for Psychiatric Case Study.* New York, 1962.

Menninger, Karl, and Paul Pruyser. *The Vital Balance.* New York, 1967.

Miller, Margaret. "Géricault's Paintings of the Insane." *Journal of the Warburg and Courtauld Institutes* 4 (1940–1941): 151–63.

Nicolson, Benedict. "The 'Raft' from the Point of View of Subject Matter." *The Burlington Magazine* 96 (1954): 241–49.

Régamey, Raymond. *Géricault.* Paris, 1926.

Rosenthal, Léon. "L'art et l'influence de Géricault." *La revue de l'art* 45 (1924): 225–35.

———. *Géricault.* Paris, n.d.

———. "Géricault et la médecine." *Le progrès médical: Supplément illustré.* 4 (1924).

Scull, Andrew T. *Museums of Madness: The Social Organization of Insanity in Nineteenth-Century England.* London, 1979.

Semelaigne, René. *Les pionniers de la psychiatrie française avant et après Pinel*, 2 vols. Paris, 1930–1932.

Sheon, Aaron. "Caricature and the Physiognomy of the Insane." *Gazette des beaux-arts* 6, 88 (October 1976): 145–50.

Szasz, Thomas S. *The Age of Madness.* Garden City, N.Y., 1973.

Winslow, Forbes. "Mad Artists." *Journal of Psychological Medicine and Mental Pathology* n.s. 6 (1880): 33–75.

FOUR. JONATHAN MARTIN OF BEDLAM

Anonymous. "Bits of Biography: Blake, the Vision Seer, and Martin, the York Minster Incendiary." *The Monthly Magazine* n.s. 15 (1933): 244–49 and 399.

———. "Jonathan Martin and York Minster." *The Monthly Chronicle of North Country Lore and Legend* 1 (1887): 418–21.

———. *Sketches in Bedlam.* London, 1823.

———. "William Martin the Anti-Newtonian Philosopher." *The Monthly Chronicle of North Country Lore and Legend*, vol. 1. Newcastle upon Tyne, 1887.

Balston, Thomas. *John Martin: His Life and Works.* London, 1947.

———. *John Martin, 1789–1854, Illustrator and Pamphleteer.* London, 1934.

———. *The Life of Jonathan Martin, Incendiary of York Minster.* London, 1945.

Bellerby, H. *A Full and Authentic Report of the Trial of Jonathan Martin, with an Account of the Life of the Lunatic.* York, 1829.

Bindman, David. "Hogarth's 'Satan, Sin and Death' and Its Influence." *The Burlington Magazine* 112 (1970): 153–59.

Camidge, William. *Jonathan Martin the Incendiary.* York, n.d.

d'Offay, Anthony. *Dream and Fantasy in English Painting.* London, n.d.

Emerson, Ralph Waldo. *Letters of Ralph Waldo Emerson.* New York, 1939.

Feaver, William. *The Art of John Martin.* Oxford, 1975.

Fox, John. *The Book of Martyrs.* London, 1822.

Frazer. *Report of the Trial of Jonathan Martin.* London, 1829.

Gould, S. Baring. *Yorkshire Oddities: Incidents and Strange Events.* London, 1874.

Keynes, Geoffrey, ed. *The Poetry and Prose of William Blake.* London, 1939.

Lee, William. *Historical Notes of Haydon Bridge and District.* Hexham, 1876.

MacGregor, John M. "Psychological Aspects of the Work of Immanuel Velikovsky." In *Recollections of a Fallen Sky.* Edited by E. R. Milton, pp. 45–66, Lethbridge, Alberta, 1977.

Martin, John. *A Descriptive Catalogue of the Engraving of the Deluge by John Martin.* London, 1828.

Martin, Jonathan. *The Life of Jonathan Martin of Darlington, Tanner.* Darlington, 1825.

———. *The Life of Jonathan Martin of Darlington, Tanner.* 2nd edition. Barnard Castle, 1826.

———. *The Life of Jonathan Martin of Darlington, Tanner.* 3rd edition. Lincoln, 1828.

Martin, Leopold Charles. "The Reminiscences of John Martin, K.L." *Newcastle Weekly Chronicle*, 1889.

Martin, William. *Prophetic Knowledge.* Newcastle, 1839.

———. *A Short Outline of the Philosopher's Life.* Newcastle, 1833.

———. *William Martin's Challenge to the Whole Terrestrial Globe.* Newcastle upon Tyne, 1829.

Milton, John. *Paradise Lost.* London, 1827.

Pendered, Mary L. *John Martin: His Life and Times.* London, 1923.

Rede, Leman Thomas. *York Castle in the Nineteenth Century.* Leeds, 1829.

Tibble, T. W., and Anne Tibble. *John Clare: A Life.* London, 1932.

Todd, Ruthven. *Tracks in the Snow: Studies in English Science and Art.* London, 1946.

Welford, Richard. *Men of Mark 'twixt Tyne and Tweed.* London, 1874.

Wilenski, R. H. *English Painting*. London, 1933.

Wölfflin, Heinrich. *Principles of Art History*. Translated by M. D. Hottinger. London, 1932.

FIVE. INSANITY IN THE CONTEXT OF ROMANTICISM

Alexander, Franz G., and Sheldon T. Selesnick. *The History of Psychiatry*. New York, 1966.

Antal, Frederick. *Fuseli Studies*. London, 1956.

Anthony, Katherine. *The Lambs: A Study of Pre-Victorian England*. New York, 1945.

Aristotle. *Works*. Translated and edited by W. D. Ross. Oxford, 1908–1952.

Balzac, Honoré de. *Le chef-d'oeuvre inconnu*. Paris, 1931.

——. *Le chef-d'oeuvre inconnu*. Illustrations by Pablo Picasso. Paris, 1966.

——. *Etudes philosophiques*. Edited by Alexandre Houssiaux. Paris, 1870.

——. *Lettres à Madame Hanska*. Edited by Roger Pierrol. Paris, 1967.

Baskin, Leonard. *Five Addled Etchers*. Dartmouth, 1969.

Becker, George. *The Mad Genius Controversy*. Beverly Hills, Calif., 1978.

Beguin, Albert. *L'ame romantique et le rêve*. Marseilles, 1937.

Blum, Carol. *Diderot: The Virtue of a Philosopher*. New York, 1974.

Bouvenne, Aglaüs. *Notes et Souvenirs sur Charles Meryon*. Paris, 1883.

Bradley, William Aspenwell. "Meryon and Baudelaire." *Print Collector's Quarterly* 1 (1911): 587–609.

Brion, Marcel. *Art of the Romantic Era*. London, 1966.

Bromig-Kolleritz, K. *Die Selbstbildnisse Vincent van Gogh*. Munich, 1955.

Burke, Edmund. *A Philosophical Enquiry into the Origin of Our Ideas of the Sublime and the Beautiful*. London, 1958.

Burke, James D. *Charles Meryon: Prints and Drawings*. New Haven, 1974.

Burty, P. H., and Maurice Tourneux, eds. *L'age du Romantisme: Série d'études sur les artistes, les littérateurs et les diverses célébrités de cette période*. Paris, 1887–1888.

Canton, Felix J. S. *Goya*. New York, 1964.

Cawthorne, Terence. "Goya's Illness." *Proceedings of the Royal Society of Medicine* 55 (1962): 213–17.

Chambers, Frank P. *The History of Taste*. New York, 1932.

Clark, Sir Kenneth M. *The Romantic Rebellion: Romantic Versus Classic Art*. London, 1973.

Coleridge, Samuel Taylor. *Biographia Literaria*. Oxford, 1907.

——. *Notes and Lectures upon Shakespeare and Some of the Old Poets and Dramatists*. Ed. H. N. Coleridge. London, 1849.

Crocker, Lester G. *Diderot's Chaotic Order*. Princeton, 1974.

——. *The Embattled Philosopher*. Ann Arbor, Mich., 1954.

Cru, Robert L. *Diderot as a Disciple of English Thought*. New York, 1913.

David d'Angers, Pierre-Jean. *Les carnets de David d'Angers*. Paris, 1958.

Delteil, Löys. *Meryon*. Translated by G. J. Renier. London, 1928.

——. *Le Peintre-Graveur Illusté*, vol. 2: *Charles Meryon*. New York, 1969.

Diderot, Denis. *Oeuvres complètes*. Paris, 1970.

——. *Pensées philosophiques. Oeuvres complètes de Diderot*. Paris, 1875.

——. *Salon of 1767*. In *Oeuvres complètes de Diderot*, 2: 125–26. Paris, 1876.

Dieckmann, Herbert. "Diderot's Conception of Genius." *Journal of the History of Ideas* 2 (New York, 1941): 151–82.

Dodgson, Campbell. *The Etchings of Charles Meryon*. London, 1921.

Doiteau, Victor, and Edgard Leroy. *La folie de Vincent van Gogh*. Paris, 1928.

Du Camp, Maxime. *Souvenirs littéraires*. Paris, 1883.

Du Camp, Maxime, and Cesare Lombroso. "L'arte nei pazzi." *Archivio di psichiatria scientifico, penali, antropologia, e criminal* 1 (1880): 424–37.

Dumas, Alexandre. "Causerie avec mes lecteurs." *Le mousquetaire* 1 (1853): 261–63.

Ellenberger, Henri F. *The Discovery of the Unconscious*. New York, 1970.

——. "La notion de maladie créatrice." *Dialogue, Canadian Philosophical Review* 3 (1964): 25–41.

Esquiros, Alphonse. "Les maisons de fous de Paris." *La revue de Paris*, November 1843 and January 1844.

——. *Paris: Les sciences, les institutions et les moeurs au XIX siècle*. Paris, 1847.

Fellows, Otis E. "The Theme of Genius in Diderot's 'Neveu de Rameau.'" *Diderot Studies* 2 (1952): 168–99.

Foucault, Michel. *Madness and Civilization*. Translated by Richard Howard. New York, 1965.

Fowlie, Wallace. *Rimbaud: Complete Works, Selected Letters*. Chicago, 1973.

Foy, J. L. "The Deafness and Madness of Goya." *Psychiatry and Art* 3 (Basel, 1971): 2–15.

Ganz, Paul. *The Drawings of Henry Fuseli*. London, 1949.

Gassier, Pierre. *Les dessins de Goya*. Fribourg, 1973.

——. *Goya*. Lausanne, 1955.

Gassier, Pierre, and Juliet Wilson. *Vie et oeuvre de Francisco Goya*. Fribourg, 1970.

Geffroy, Gustave. *Charles Meryon*. Paris, 1926.

Gilbert, Katharine Everett, and Helmut Kuhn. *A History of Esthetics*. Bloomington, Ind., 1953.

Gilman, Margaret. "Balzac and Diderot: Le Chef-d'oeuvre inconnu." *Periodical of the Modern Language Association* 65 (1950): 644–48.

——. "The Poet According to Diderot." *Romantic Review* 37 (1946): 37–54.

Gilman, Sander L. *Seeing the Insane*. New York, 1982.

Gudiol, José. *Goya*. New York, 1964.

Hamerton, Philip Gilbert. *Old Paris: Twenty Etchings by Charles Meryon*. Liverpool, 1914.

Hardie, Martin. *Charles Meryon and his Eaux-Fortes sur Paris*. London, 1971.

Harris, Enriqueta. *Goya*. New York, 1969.

Hirsch, Nathaniel D. Mttron. *Genius and Creative Intelligence*. Cambridge, Mass., 1931.

Hofmann, Werner. *The Earthly Paradise: Art in the Nineteenth Century*. New York, 1961.

Holcomb, Adele M. "Le Stryge de Notre-Dame: Some Aspects of Meryon's Symbolism." *Art Journal* 31 (1971): 150–57.

Janson, H. W. *History of Art*. New York, 1962.

Jourdain, Margaret. *Diderot's Early Philosophical Works*. Chicago, 1916.

Kneller, John W. "An Approach to 'Aurélia.'" In *Aurélia*. Edited by Jean Richer. Paris, 1965.

Lamb, Charles. *The Essays of Elia*. London, 1929.

Laubriet, Pierre. *Un catéchisme esthétique*. Paris, 1961.

Lautréamont, Comte de [Isidore Ducasse]. *Les chants de Maldoror*. Translated by Guy Wernham. New York, 1965.

Lavater, Johann Caspar. *Essays in Physiognomy: Designed to Promote the Knowledge and Love of Mankind*. London, 1789–1810.

Lefebure, Molly. *Samuel Taylor Coleridge: A Bondage of Opium*. London, 1974.

Lundström, Lars-Ingemar. "Charles Meryon: Peintre-Graveur-Schizophrène." *Acta Psychiatrica Scandinavica* 40, suppl. 180 (1964): 159–65.

Malraux, André. *Saturn: An Essay on Goya*. London, 1957.

Marie, Aristide. *Gérard de Nerval: Le poète et l'homme*. Paris, 1955.

Mason, Eudo C. *The Mind of Henry Fuseli*. London, 1951.

Milton, John. *Paradise Lost*. New York, 1962.

Monroe, Dougald McDougal, Jr. "Coleridge's Theories of Dreams, Hallucinations and Related Phenomena in Relation to his Critical Theories." Ph.D. dissertation, Northwestern University, 1953.

Nerval, Gérard de. *Aurélia: Ou le rêve de la vie*. Edited by Jean Richer. Paris, 1965.

——. *Selected Writings*. Translated by Geoffrey Wagner. St. Albans, 1973.

Novotny, Fritz. *Painting and Sculpture in Europe: 1780–1880*. Harmondsworth, 1960.

Oliver, E. J. *Honoré de Balzac*. London, 1965.

Panse, F. "Persönlichkeit, Werk und Psychose Charles Meryons." *Archiv für Psychiatrie und Zeitschrift Neurologie* 187 (1951): 203–30.

Plato. *The Dialogues of Plato*. Translated by Benjamin Jowett. New York, 1920.

——. *The Laws*. Translated by R. G. Bury. London, 1955.

——. *The Republic*. Translated by H.D.P. Lee. London, 1955.

Pocock, Guy. *The Letters of Charles Lamb*. London, 1945.

Porter, Roy. *A Social History of Madness: The World through the Eyes of the Insane*. New York, 1987.

Powell, Nicolas. *The Drawings of Henry Fuseli*. London, 1951.

Pugh, Anthony R. "Interpretation of the 'Contes philosophiques.' " In *Balzac and the Nineteenth Century*. Leicester, 1972.

Raymond, Jean. *Nerval par lui-même*. Paris, 1964.

Rhodes, S. A. *Gérard de Nerval: Poet, Traveler, Dreamer*. New York, 1951.

Richards, I. A. *Coleridge on Imagination*. London, 1934.

Richer, Jean. "Nerval devant la psychanalyse." *Cahiers de l'association internationale des études françaises* 7 (1955): 51–64.

——. *Nerval: Expérience et création*. Paris, 1963.

——. *Nerval par les témoins de sa vie*. Paris, 1970.

Rimbaud, Arthur. *Rimbaud: "Illuminations" and Other Prose Poems*. Translated by Louise Varèse. New York, 1946.

Rosenblum, Robert. *Transformations in Late Eighteenth Century Art*. Princeton, 1967.

Salaman, Malcolm C. *Masters of Etching: Charles Meryon*. London, 1927.

Sayre, Eleanor A. *The Changing Image: Prints by Francisco Goya*. Boston, 1974.

Schapiro, Meyer. "Diderot on the Artist and Society." *Diderot Studies* 5 (1964): 5–11.

Schiff, Gert. *Johann Heinrich Füssli*. Zurich, 1973.

Seznec, Jean. *Diderot sur l'art et les artistes*. Paris, 1967.

Sheon, Aaron. "Caricature and the Physiognomy of the Insane." *Gazette des beaux arts* 88 (1976): 145–50.

——. "Courbet, French Realism, and the Discovery of the Unconscious." *Arts Magazine* 55 (1981): 114–28.

——. "Charles Meryon in Paris." *Burlington Magazine* 110 (1968): 721–22.

Sowerby, Benn. *The Disinherited: The Life and Word of Gérard de Nerval*. London, 1973.

Thévoz, Michel. "La recherche du sens perdu." In *Charles Meryon*. Catalog, Musée d'art et d'histoire. Geneva, 1981.

Tollemache, Beatrix L. *Diderot's Thoughts on Art and Style*. New York, 1971.

Tomory, Peter. *The Life and Art of Henry Fuseli*. London, 1972.

Trilling, Lionel. "Art and Neurosis." In *Art and Psychoanalysis*. Edited by William Phillips, pp. 502–20. New York, 1963.

Van Gogh, Vincent. *The Complete Letters of Vincent van Gogh*. New York, 1959.

Wagner, Geoffrey. Introduction to the *Selected Writings of Gérard de Nerval*. New York, 1957.

Waldauer, Joseph L. "Society and the Freedom of the Creative Man in Diderot's Thought." *Diderot Studies* 5 (1964): 106–7.

Walker, Eleanor. "Towards an Understanding of Diderot's Aesthetic Theory." *Romantic Review* 35 (1944): 277–87.

Wittkower, Rudolf, and Margot Wittkower. *Born under Saturn*. London, 1963.

Yarnall, James Leo. "Meryon's Mystical Transformations." *Art Bulletin* 61 (1979): 289–300.

SIX. CESARE LOMBROSO: THE THEORY OF GENIUS AND INSANITY

Alexander, Franz G., and Sheldon T. Selesnick. *The History of Psychiatry*. New York, 1966.

Bulferetti, Luigi. *Cesare Lombroso*. Turin, 1975.

Chizh, V. F. "Intellectual Feelings in the Mentally Diseased." *Nevrol. Vestnik* (Kazan, 1896), 4, no. 1: 27–52; 4, no. 2: 69–88; 4, no. 3: 1–18.

Daudet, Alphonse. *Jack*. Paris, 1892.

du Camp, Maxime. *Souvenirs littéraires*. Paris, 1887.

Ellenberger, Henri F. *The Discovery of the Unconscious*. New York, 1970.

Frigerio, L. "L'arte e gli artisti nel Manicomio di S. Benedetto." *Diario del Manicomio di Pesaro* 9 (1880): 22–24.

Hirsch, Nathaniel D. Mttron. *Genius and Creative Intelligence*. Cambridge, Mass., 1931.

Kurella, Hans. *Cesare Lombroso: A Modern Man of Science*. London, 1911.

Lange-Eichbaum, Wilhelm. *Genie, Irrsinn und Ruhm*. Munich, 1935.

——. *The Problem of Genius*. New York, 1928.

Lombroso, Cesare. *Genio e degenerazione*. Palermo, 1897.

——. *Genio e follia*. Milan, 1864.

——. *The Man of Genius*. London, 1891.

——. *Nuovi studi sul genio*. Palermo, 1901–1902.

——. *Les Palimpsestes des prison*. Paris, 1894.

——. *L'uomo di genio*. 6th edition. Turin, 1894.

Lombroso, Cesare, and Maxime du Camp. "L'arte nei pazzi." *Archivio di psichiatria, antropologia criminale, e scienze penali* 1 (1880): 424–37.

Maristany, Luis. *El gabinete del doctor Lombroso.* Barcelona, 1973.

Nisbet, J. F. *The Insanity of Genius.* London, 1891.

Nordau, Max S. *Entartung.* Berlin, 1892. English edition: *Degeneration.* New York, 1896.

———. *Psychophysiologie du génie et du talent.* Paris, 1897.

SEVEN. PAUL-MAX SIMON AND THE STUDY OF PSYCHIATRY
AND ART

Bell, Sir Charles K. H. *Expression: Its Anatomy and Philosophy.* New York, 1873.

Burdett, Henry C. *Hospitals and Asylums of the World.* London, 1891.

Cardinal, Roger. *Outsider Art.* London, 1972.

Ellenberger, Henri F. *The Discovery of the Unconscious: The History and Evolution of Dynamic Psychiatry.* New York, 1970.

Hanson, Anne Coffin. *Edouard Manet.* Philadelphia, 1966.

Marcé, Victor-Louis. "De la valeur des écrits des aliénés: Au point de vue de la sémiologie et de la médecine légale." *Journal de médecine mentale* 4 (1864): 85–95, 189–203.

Regnard, Paul. *Les maladies épidemiques de l'esprit: Sorcellerie, magnétisme, morphinisme, délire des grandeurs.* Paris, 1887.

Rewald, John. *The History of Impressionism.* New York, 1973.

Schapiro, Meyer. "Courbet and Popular Imagery." *Journal of the Warburg and Courtauld Institutes* 4 (1940–1941): 164–91.

Séglas, Jules. *Les troubles du langage chez les aliénés.* Paris, 1892.

Semelaigne, René. *Les pionniers de la psychiatrie française: Avant et après, Pinel,* 2 vols. Paris, 1930–1932.

Simon, Paul-Max. *La comédie de soi-même.* Paris, 1892.

———. *Compte rendu du service médical de la section des hommes de l'asile d'aliénés de Bron.* Lyon, 1880.

———. "Les écrits et les dessins des aliénés." *Archivio di antropologia criminelle, psichiatria e medicina legale* 3 (1888): 318–55.

———. "L'imagination dans la folie: Etude sur les dessins, plans, descriptions, et costumes des aliénés." *Annales médico-psychologiques* 16 (1876): 358–90.

———. *Les invisibles et les voix.* Paris, 1880.

———. *Les marionnettes de la vie.* Dijon, 1873.

———. *Le monde des rêves.* Paris, 1882.

———. *Sur l'hallucination visuelle.* Paris, 1880.

———. *Swift: Etude psychologique et littéraire.* Paris, 1893.

———. *Temps passé, journal sans date.* Dijon, 1895.

Sollier, Paul. *Psychologie de l'idiot et de l'imbécile.* Paris, 1891.

Tardieu, Ambroise-Auguste. *Etudes médico-légales sur la folie.* Paris, 1872.

EIGHT. VICTORIAN BEDLAM: THE CASE OF RICHARD DADD

Allderidge, Patricia H. "Criminal Insanity: Bethlem to Broadmoor." *Proceedings of the Royal Society of Medicine* 67 (1974): 897–904.

———. *The Late Richard Dadd.* London, 1974.

———. "Midsummer Nightmare." *Sunday Times Magazine,* September 24, 1972, pp. 48–61.

———. *Richard Dadd.* London, 1974.

———. "Richard Dadd 1817–1886: Painter and Patient." *Medical History* 14 (1970): 308–13.

Allen, J.B.L. "Mad Robin: Richard Dadd." *Art Quarterly* 30, no. 1 (Spring 1967): 18–30.

Anonymous. "Bethlem Hospital in 1852." *The Journal of Psychological Medicine and Mental Pathology* 6 (1853): 62.

———. *A Handbook to the Exhibition of British Paintings in the Art Treasures Exhibition.* Manchester, 1857.

———. *A Handbook to the Watercolours, Drawings, and Engravings in the Art Treasures Exhibition.* Manchester, 1857.

———. "Haydon: A Psychological Study." *Journal of Psychological Medicine and Mental Pathology* 6 (1853): 501–27.

———. "The Late Richard Dadd." *The Art Union,* October 1, 1843, pp. 267–71.

———. "Lunatic Asylums." *The Quarterly Review* 101 (1857): 353–93.

———. *Official Catalogue of the Fine Art and Industrial Exhibition.* Huddersfield, 1883.

———. "The Parricides Story." *The World* (London), December 26, 1877, pp. 13–14.

Bethlem Royal Hospital. *Under the Dome: The Quarterly Magazine of the Bethlem Royal Hospital* 1 (1892).

Bethlem Royal Hospital Archives, London. Records of the Criminal Lunatic Department and Casebooks.

Binyon, Laurence. "A Note on Richard Dadd." *Magazine of Art* 30 (1937): 106–7, 125–28.

"The Commissioners in Lunacy Report on Bethlem Hospital." *The Journal of Psychological Medicine and Mental Pathology* 6 (1853): 129–45.

Conolly, John. "The Physiognomy of the Insane." *Asylum Journal of Mental Science* 6 (1860): 207–33.

———. "The Physiognomy of the Insane." *Medical Times and Gazette* (1858–1859).

Dadd, Richard. *Elimination of a Picture and Its Subject—Called the Feller's Master Stroke.* Unpublished manuscript in the possession of the descendants of George Henry Haydon.

Delapierre, Joseph-Octave. *Histoire littéraire des fous.* London, 1860.

Diamond, Hugh. W. "On Photography Applied to the Phenomena of Insanity." *The Journal of the Photographic Society* 3 (1857): 88–89.

Frith, W. P. *My Autobiography and Reminiscences.* London, 1888.

Galt, John M. "On the Reading, Recreation, and Amusements of the Insane." *Journal of Psychological Medicine and Mental Pathology* 6 (1853): 581–89.

Goodall, Frederick. *The Reminiscences of Frederick Goodall R.A.* London, 1902.

Graysmith, David. *Richard Dadd: The Rock and Castle of Seclusion.* London, 1973.

Haydon, Benjamin Robert. *Benjamin Robert Haydon: an Autobiography.* Edited by Thomas Taylor. London, 1853.

———. *Lectures on Painting and Design.* London, 1844–1846.

Hood, Charles. *Criminal Lunatics: A Letter to the Commissioners in Lunacy.* London, 1860.

———. *Suggestions for the Future Provision of Criminal Lunatics.* London, 1854.

Hughes, Robert. "From the Dark Garden of the Mind." *Time,* July 8, 1974, pp. 52–53.

Hunter, Richard A., and Ida Macalpine. *Three Hundred Years of Psychiatry.* London, 1963.

Jeffriss, F.J.G. *Dr. Thomas Monro and the Monro Academy.* London, 1976.

Lacan, Ernst. "Review of Exhibition of Diamond Photographs." *La lumière* 4 (1853).

Maas, Jeremy. *Victorian Painters.* London, 1969.

Morison, Sir Alexander. *The Physiognomy of Mental Diseases.* London, 1838.

Philomneste Junior [Brunet, Pierre Gustave]. *Les fous littéraires: Essai bibliographique.* Brussels, 1880.

Rickett, John. "Richard Dadd: Bethlem and Broadmoor." *The Ivory Hammer* 2 (1964): 22–25.

Rossetti, W. M. *Some Reminiscences of William Rossetti.* London, 1906.

Royal College of Physicians, London. *Lives of the Fellows of the Royal College of Physicians of London: 1826–1925.* London, 1955.

Sala, G. A. "A Visit to the Royal Hospital of Bethlem." *Illustrated London News,* March 24, 1860, pp. 291–92, and March 31, 1860, pp. 304–5.

Sitwell, Sacheverell. *Narrative Pictures.* London, 1937.

Smailes, Helen. *Method in Madness.* Catalog of 1980–1981 exhibition. Scottish National Portrait Gallery. Edinburgh, 1980.

Winslow, Forbes. "Mad Artists." *Journal of Psychological Medicine and Mental Pathology* n.s. 6 (1880): 33–75.

Wood, Christopher. *Dictionary of Victorian Painters.* London, 1971.

Wood, William. *Remarks on the Plea of Insanity.* London, 1851.

NINE. WILLIAM NOYES AND THE CASE OF "G"

Andrews, Judson B. "Asylum Periodicals." *American Journal of Insanity* 33 (1876): 42–49.

Bolton, Theodore. *American Book Illustrators.* New York, 1938.

Brigham, A. "Illustrations of Insanity Furnished by the Letters and Writings of the Insane." *American Journal of Insanity* 4 (1848): 290–303.

Deutsch, Albert. *The Mentally Ill in America.* Garden City, N.Y., 1937.

Exsteens, Maurice. *L'oeuvre gravé et lithographié de Felicien Rops.* Paris, 1928.

Hall, J. K., ed. *One Hundred Years of American Psychiatry.* New York, 1944.

Hamilton, Sinclair. *Early American Book Illustrators and Wood Engravers, 1670–1870.* Princeton, 1958.

Hurd, Henry M., ed. *The Institutional Care of the Insane in the United States and Canada.* Baltimore, 1917. Reprinted. New York, 1973.

Jung, Carl G. "Concerning Mandala Symbolism." In *Collected Works,* vol. 9, no. 1, pp. 355–84. Princeton, 1969.

Noyes, William. "Paranoia: A Study of Systematized Delusions of Grandeur." *The American Journal of Psychology* 1 (1888): 458–79, and 2 (1889): 348–75.

Richmond, J. F. *New York and Its Institutions.* New York, 1871.

Smith, F. Hopkinson. *American Illustrators.* New York, 1892.

Tuke, Daniel Hack. *The Insane in the United States and Canada.* London, 1885. Reprinted. New York, 1973.

Weitenkampf, Frank. *American Graphic Art.* New York, 1970.

Willette, Adolfe. *Oeuvres choisies.* Paris, 1901.

TEN. THE CHICAGO CONFERENCE

Adelson, Warren J., et al. *Ralph Albert Blakelock.* New York, 1973.

Blakelock, David D. "The Confinement Period." In *Ralph Albert Blakelock,* pp. 20–26. New York, 1973.

Burr, C. B. "Art of the Insane." *American Journal of Insanity* 73 (1916): 165–94.

Clark, Daniel. *Pen Photographs of Celebrated Men and Noted Places.* Toronto, 1873.

Clark, Daniel, ed. *Scottish Canadian Poets.* Toronto, 1900.

Davidson, Abraham A. *The Eccentrics and Other American Visionary Painters.* New York, 1978.

———. "The Wretched Life of an 'American Van Gogh.' " *Smithsonian* 18 (December 1987): 80–90.

Dangerfield, E. *Ralph Albert Blakelock.* New York, 1914.

Dewdney, Selwyn. "The Role of Art Activities in Canadian Mental Hospitals." *Bulletin of Art Therapy* 9 (January 1969): 58–66.

Flexner, James Thomas. *Nineteenth Century American Painting.* New York, 1970.

Gebhard, D., and P. Stuurman. *The Enigma of Ralph A. Blakelock.* Berkeley, 1969.

Geske, N. A. *R. A. Blakelock: 1847–1919.* Lincoln, Neb., 1975.

Goodrich, Lloyd. "c. 1865 to the Armory Show." In *Encyclopedia of World Art* 1: 294.

Hall, J. K., ed. *One Hundred Years of American Psychiatry.* New York, 1944.

Hrdlička, Ales. "Art and Literature in the Mentally Abnormal." *American Journal of Insanity* 55 (1899): 385–404.

Hurd, Henry M., ed. *The Institutional Care of the Insane in the United States and Canada.* Baltimore, 1917.

Kiernan, J. G. "Art in the Insane." *Alienist and Neurologist* 13 (1892): 244–75.

———. "Discussion of the Paper on 'Art in the Insane,' " *Alienist and Neurologist* 13 (1892): 684–97.

———. "Genius not a Neurosis." *Neurological Review* 1 (1886): 212–17.

———. "Is Genius a Neurosis?" *Alienist and Neurologist* 13 (1892): 119–50.

Tuke, Daniel Hack. *The Insane in the United States and Canada.* London, 1885.

Young, Vernon. "The Emergence of American Painting." *Art International* 18 (1974): 14–17.

ELEVEN. MARCEL RÉJA: CRITIC OF THE ART OF THE INSANE

Anonymous. "Art and Insanity in the Light of an Exhibition of Pictures by Lunatics." *Current Opinion* 55 (1913): 340.

———. "Art and Insanity: The Bethlem Hospital Exhibition." *The Times,* August 14, 1913.

———. "Art in Asylums." *Evening News* (London), November 23, 1905.

———. "Aspects of Schizophrenic Art, Exhibition at the Institute of Contemporary Art, London." *Art News* 54 (1955): 58.

———. *Bauchant, Bombois, Séraphine, Vivin.* Basel, 1956.

———. "Collection du Docteur A. Marie." *L'art brut* 9 (1973): 79–80.

———. "The Insane Asylum as the Source of the Coming Craze in Art." *Current Literature* 50 (1911): 505–10.

———. "A Mad Museum: The Insane as Artists." *The Sketch,* November 22, 1905, p. 174 and supplement, pp. 6–7.

———. *Le monde des naives.* Paris, 1964.

———. "Psychiatry and Art: Netherne Hospital Exhibition." *British Medical Journal* 2 (1949): 228.

———. "The Sanity of the Insane: Work by Mad Artists at 'Bedlam.' " *Illustrated London News,* August 23, 1913, p. 281.

Audry, J. "La folie dans l'art." *Lyon médical* 134 (1924): 631–34.

Bacon, G. Mackenzie. *On the Writings of the Insane.* London, 1870.

Barbé, A. "Les dessins stéréotypés d'un catatonique." *Encephale* 15 (1920): 49–50.

Bihalji-Merin, Oto. *Modern Primitives: Masters of Naive Painting.* New York, 1961.

———. *Das naive bild der Welt.* Cologne, 1959.

———. *Die Naiven der Welt.* The Hague, 1972.

B. K. "Self-Taught Quintet: Review of W. Uhde, Five Primitive Masters." *Art News* 48 (September 1949): 56.

Boullier, R. "Les expositions à Paris." *Aujourdhui* 6 (1962): 51.

Capgras, J. "Une Persécutée démoniaque présentation d'écrits et de dessins." *Bulletin de la Société clinique de médecine mentale* (Paris) 4 (1911): 360–72.

Dasnoy, Albert. *Exégèse de la peinture naïve.* Brussels, 1970.

De Fursac, Rogues. *Les écrits et les dessins dans les maladies nerveuses et mentales.* Paris, 1905.

Ducoste, M. "Deux aliénés inventeurs présentation d'épures et de dessins." *Bulletin de la Société clinique de médecine mentale* 4 (1911): 372–82.

Fay, H. M. "Réflexions sur l'art et les aliénés." *Aesculape* 2 (1912): 200–4.

Guest, Langford. "A Bethlem Physician." *Bethlem-Maudsley Hospital Gazette* (March 1956): 133–34.

Hamilton, A. M. "Insane Art." *Scribner's Magazine* 63 (1918): 484–92.

Hoffmann, Edith. "Naive Painters in Rotterdam and Paris." *Burlington Magazine* 106 (1964): 473–74.

Hyslop, T. B. *The Borderland: Some of the Problems of Insanity.* London, 1924.

———. *The Great Abnormals.* New York, 1925.

———. *Mental Handicaps in Art.* London, 1927.

———. "Post-Illusionism and Art in the Insane." *Nineteenth Century and After* 408 (1911): 270–81.

Karpov, Pavel Ivanovich. *The Creative Activity of the Insane and Its Influence on the Development of Science, Art, and Technique.* Moscow, 1928.

Lehel, François. *Notre art dément.* Paris, 1926.

Leroy, M. "Dessins d'un dément précose avec état maniaque." *Bulletin de la Société clinique de médecine mentale* 4 (1911): 303–8.

Marie, A. "L'art et la folie." *Revue scientifique* 67 (1929): 393–98.

———. "Des dessins stéréotypés des aliénés." *Bulletin de la Société clinique de médecine mentale* 5 (1912): 261–64.

———. "L'expression artistique chez les aliénés." *Archives internationales de neurologie* 50 (1931): 211–12.

Marie, A., and B. Pailhas. "Dessins curieux de déments précoses." *Archives internationales de neurologie* 35 (1913): 51.

———. "Sur quelques dessins de déments précoses." *Bulletin de la Société clinique de médecine mentale* 5 (1912): 311–19.

Mayr, W. *Le délire graphique et verbal.* Paris, 1928.

Meunier, Paul Gaston. *Mesures de quelques modifications physiologiques provoquées chez les aliénés par l'alitement thérapeutique* (Paris, 1900).

Meunier, Paul Gaston (in collaboration with N. Vaschide). "Projection du rêve sur l'état de veille." *Revue de Psychiatrie* (n.d.).

Meunier, Paul Gaston (in collaboration with N. Vaschide). "Analogies du rêve et de la folie d'après Moreau de Tours." *Archives générales de médecine* (1903).

Meunier, Paul Gaston (in collaboration with René Masselon). *Les rêves et leur interprétation: Essai de psychologie morbide.* Paris, 1910.

Réja Marcel. *L'art chez les fous: Le dessin, la prose, la poésie.* Paris, 1907.

———. "L'art malade: dessins de fous." *Revue universelle* 1 (1901): 913–15, 940–44.

———. *Au pays des miracles.* Paris, 1930.

———. *Ballets et variations.* Paris, 1898.

———. *Chagrins d'amour* (one-act play). Paris, 1908.

———. Introduction to *Inferno* by Auguste Strindberg. 2nd edition. Paris, 1898.

———. *La vie héroïque.* Paris, 1897.

Réja, Marcel, with Henry Vernot. *Le pain quotidien* (one-act play). Paris, 1910.

Schneider, Pierre. "Art News from Paris: Exhibition at Galerie Pierre Birtschansky." *Art News* 61, no. 5 (September 1962): 48–49, 54.

Sicard, J. A. "A propos de dessins executes sous la suggestion hypnotique." *Aesculape* 1 (1911): 129.

Thévoz, Michel. "Marcel Réja: Découvreur de l'art des fous," *Gazette des Beaux-Arts* 107 (May–June 1986): 200–208.

Trépsat, L. "Dessins d'un dément précose." *Encephale* 8 (1913): 541–44.

Uhde, William. *Fünf primitive Meister.* Zurich, 1947.

———. *Henri Rousseau.* Dusseldorf, 1914.

———. "Painters of the Inner Light: Séraphine." *Formes* 17 (1931): 115–17.

———. *Picasso et la tradition française: Notes sur la peinture actuelle.* Paris, 1928.

Vallier, Dora. *Henri Rousseau.* New York, 1962.

Venturi, Lionello. *Il gusto dei primitivi.* Turin, 1972.

Vinchon, Jean, and M. Laignel-Lavastine. *Les malades de l'esprit et leurs médecines du XVIe au XIXe siècle.* Paris, 1930.

Winslow, Llyttleton S. Forbes. "Mad Artists." *The Journal of Psychological Medicine and Mental Pathology* n.s. 6 (1880): 33–75.

TWELVE. HANS PRINZHORN AND THE GERMAN CONTRIBUTION

Alexander, Franz G., and Sheldon T. Selesnick. *The History of Psychiatry.* New York, 1966.

Anonymous. "Modern Art as a Form of Dementia Praecox." *Current Opinion* 71 (1921): 81–82.

———. "Proving Painters Insane." *Literary Digest* 69 (1921): 26–27.

———. "Report of a Meeting of the Vienna Psychoanalytical Society October 12, 1921." *International Journal of Psychoanalysis* 3 (1922): 133–34.

Baeyer, W. v., and H. Häfner. "Prinzhorn's Basic Work on the Psychopathology of the Gestaltung." In *Psychopathologie und Bildnerischer Ausdruck*, vol. 1. New York and Basel, n.d.

Bertschinger, H. "Illustrierte Halluzinationen." *Jahrbuch für Psychoanalytische und Psychopathologische Forschungen* 3 (1911): 69-100.

Betensky, Mala. Review of *Bildnerei der Geisteskranken* by Hans Prinzhorn. *American Journal of Art Therapy* 9 (1970): 193–96.

Birnbaum, K. *Psychopathologische Dokumente: Selbsterkenntnisse und Fremdzeugnisse aus dem seeligschen Grenzlande.* Berlin, 1920.

Blunt, Anthony. *Sicilian Baroque.* London, 1968.

Boring, Edwin G. *A History of Experimental Psychology.* New York, 1950.

Cardinal, Roger. "Review of *Bildnerei der Geisteskranken* by

Hans Prinzhorn. *The Studio* 186 (1973): 54–55.

Carus, Carl Gustav. *Psyche: Zur Entwicklungsgeschichte der Seele*. Pforzheim, 1846.

——. *Symbolik der menschlichen Gestalt: Ein Handbuch zur Menschenkenntnis*. Leipzig, 1853.

——. *Über Grund und Bedeutung der verschiedenen Formen der Hand in verschiedenen Personen*. Stuttgart, 1846.

Christoffel H., and E. Grossman. "Über die expressionistischen Komponente in Bildnereien geistig minder wertiger." *Zentralblatt für die gesamte Neurologie und Psychiatrie* 87 (1923): 372–76.

Ellenberger, Henri F. *The Discovery of the Unconscious*. New York, 1970.

Ernst, W. "Plastische Arbeiten verbrecherischer Geisteskranker." *Archiv für Psychiatrie und Nervenkrankheiten* 74 (1925): 838–42.

Foy, James L. Introduction to *Artistry of the Mentally Ill* by Hans Prinzhorn. New York, 1972.

Gaupp, R. "Das Pathologische in Kunst und Literatur." *Deutsche Revue*, Berlin (1911).

Goethe, J. W. *Italian Journey*. Translated by W. H. Auden and Elizabeth Mayer. London, 1962.

Häberlin, Carl. "Der Arzt C. G. Carus und Goethe: Mit Ausblicken auf die Psychologie des Unbewussten." *Jahrbuch der Goethegesellschaft* 13 (1927): 184–204.

Hassmann, O., and H. Zingerle. "Untersuchung bildlicher Darstellung und sprächlicher Äusserungen bei Dementia praecox." *Journal für Psychologie und Neurologie* 20 (1913): 24–61.

Hellpach, W. *Das Pathologische in der modernen Kunst und Literatur*. Heidelberg, 1911.

Hildebrandt, K. *Norm und Entartung des Menschen*. Dresden, 1920.

Howells, John G., ed. *World History of Psychiatry*. London, 1975.

Jádi, Inge, ed. *Leb wohl sagt mein Genìe Ordugele muss sein*. Heidelberg, 1985.

Jansen, E., ed. *Carl Gustav Carus Lebenserinnerungen und Denkwürdigkeit*. Weimar, 1966.

Kraepelin, Emil. *Lectures on Clinical Psychiatry*. London, 1904. Reprinted, New York, 1968.

——. *One Hundred Years of Psychiatry*. Translated by Wade Baskin. London, 1962.

——. *Psychiatrie: Ein Lehrbuch*. Leipzig, 1896.

Kurbitz. "Die Zeichnungen geisteskranker Personen in ihrer psychologische Bedeutung und differential diagnostischen Verwertbarkeit. *Zentralblatt für die gesamte Neurologie und Psychiatrie* 13 (1912): 153–82.

Lersch, Philip. *Der Traum in der deutschen Romantik*. Munich, 1923.

Lohmeyer, K. *Palagonisches Barock*. Frankfurt, 1943.

Malraux, Clara. *Memoirs*. Translated by Patrick O'Brian. London, 1967.

Mohr, Fritz. "Über Zeichnungen von Geisteskranken und ihre diagnostische Verwertbarkeit." *Journal für Psychologie und Neurologie* 8 (1906): 99–140.

——. "Zeichnungen von Geisteskranken." *Zeitschrift für angewandte Psychologie und Charakterkunde* 2 (1908–1909): 291–300.

Mohr, P. "Das künstlerisches Schaffen Geisteskranker und seine Beziehungen zum Verlauf der Krankheit." *Schweiz Archiv für Neurologie und Psychiatrie* 45 (1940): 427–46.

Monakow, P. "Analyse du livre de H. Prinzhorn: Bildnerei der Geisteskranken." *Schweiz Archiv für Neurologie und Psychiatrie* 2 (1922): 314–17.

Näcke, P. "Einige Bemerkungen bezüglich der Zeichnungen und anderer künstlerischer Ausserungen von Geisteskranken." *Zentralblatt für die gesamte Neurologie und Psychiatrie* 17 (1913): 453–73.

Novotny, Fritz. *Painting and Sculpture in Europe, 1780–1880*. Harmondsworth, 1960.

Pfeifer, R. A. *Der Geisteskranke und sein Werk: Eine Studie über schizophrene Kunst*. Leipzig, 1923.

——. "Über aussergewöhnliche Kunstleistungen von Geisteskranken." *Zentralblatt für die gesamte Neurologie und Psychiatrie* 31 (1923): 61.

Pfister, Oskar. Review of *Bildnerei der Geisteskranken* by Hans Prinzhorn. *Imago* 9 (1923): 503–6.

Poritzky, J. E. "Der pathologische Künstler." *Der Freihafen* 4, no. 1 (1921).

Prause Marianne. *Carl Gustav Carus: Leben und Werk*. Berlin, 1968.

Prinzhorn, Hans. *Artistry of the Mentally Ill*. Translated by Eric von Brockdorff. New York, 1972.

——. *Bildnerei der Geisteskranken: Ein Beitrag zur Psychologie und Psychopathologie der Gestaltung*. Berlin, 1923.

——. "Das bildnerische Schaffen der Geisteskranken." *Zeitschrift für die gesamte Neurologie und Psychiatrie* 52 (1919): 307–26.

——. "Gibt es schizophrene Gestaltungsmerkmale in der Bildnerei der Geisteskranken?" *Zeitschrift für die gesamte Neurologie und Psychiatrie* 78 (1922): 512–31.

——. "Der Künstlerische Gestaltungsvorgang in psychiatrischer Beleuchtung." *Zeitschrift für Aesthetik und allgemeine Kunstwissenschaft* 19 (1925): 154–80.

——. *Psychotherapy: Its Nature, Its Assumptions, Its Limitations, A Search for Essentials*. Translated by Arnold Eiloart. London, 1932.

——. "Über Zeichnungen Geisteskranker und Primitiver." *Wiener psychoanalytischer Verlag*, October 12, 1921.

Rave-Schwank, Maria. "Hans Prinzhorn und die Bildnerei der Geisteskranken." In *Bildnerei der Geisteskranken aus der Prinzhorn-Sammlung*, pp. 7–9. Heidelberg, 1967.

——. *Zur Prinzhorn-Sammlung Heidelberg*. Heidelberg, 1972.

Rochowanski, L. W. *Psychopathologische Künstler*. Leipzig, 1923.

Rothe, Wolfgang. "Zur Vorgeschichte Prinzhorns." In *Bildnerei der Geisteskranken aus der Prinzhorn-Sammlung*, pp. 17–42. Heidelberg, 1967.

Sapas, E. "Zeichnerische Reproduktionen einfacher Figuren durch Geisteskranke." *Schweiz Archiv für Neurologie und Psychiatrie* 4 (1918): 140–52.

Schilder, Paul. *Wahn und Erkenntnis*. Berlin, 1918.

——. "Zur Kenntnis symbolähnlicher Bildungen im Rahmen der Schizophrenie." *Zentralblatt für die gesamte Neurologie und Psychiatrie* 26 (1914): 201–44.

Simon, Paul-Max. "Die Einbildungskraft im Irresein, eine Studie über Zeichnungen, Pläne, Beschreibungen, und Anzüge der Irren." *Allgemeine Zeitschrift für Psychiatrie* 36 (1880): 210ff.

Sommer, Robert. *Diagnostik der Geisteskrankheiten*. Vienna, 1894.

Stadelmann, H. *Die Stellung der Psychopathologie zur Kunst*. Munich, 1908.

Von Hartmann, Eduard. *Philosophy of the Unconscious*. New York, 1931.

Warstat, W., and H. Stadelmann. "Die Stellung der Psychopath-

ologie zur Kunst." *Archiv für die gesamte Psychologie* 24 (1912): 163–67.

Watson, David L. "In the Teeth of All Formalism." *The Psychoanalytic Review* 23 (1936): 353–62.

Weygandt, Wilhelm. "Kunst und Wahnsinn." *Die Woche* 22 (1921): 483–85.

——. *Atlas und Grundriss der Psychiatrie.* Munich, 1902.

THIRTEEN. THE WORLD OF ADOLF WÖLFLI

Anonymous. "Le Cabinet du Professeur Ladame." *L'art brut* 3 (1965): 59–95.

Bader, Alfred, ed. *Geisteskrankheit, bildnerischer Ausdruck und Kunst.* Bern, 1975.

Bader, Alfred, and Leo Navratil. *Zwischen Wahn und Wirklichkeit.* Lucerne, 1976.

Bouché, H. P. "Adolf Wölfli." *L'art brut* 2 (1964).

Cardinal, Roger. "Adolf Wölfli." In *Outsider Art*, pp. 55–64. London, 1972.

Ferndriger, Marti. "Zu den Bildern eines Insassen der Irrenanstalt Waldau in Bern." *Kunst und Volk* 4 (1944).

Forel, Jacqueline. *Aloyse ou la peinture magique d'une schizophrène.* Lausanne, 1953.

Freud, Sigmund. *Leonardo da Vinci and a Memory of His Childhood.* In *The Standard Edition of the Complete Psychological Works of Sigmund Freud* II: 59–138. Edited and translated by James Strachey. London, 1956–1974.

Jung, Carl G. *Memories, Dreams, Reflections.* New York, 1961.

Koepplin, Dieter. "Adolf Wölfli." In *Katalogue Adolf Wölfli 1864–1930.* Werk aus einer Privatsammlung, Kupferstichkabinett, Kunstmuseum. Basel, 1971.

Ladame, Dr. Ch. "A propos des manifestations artistiques chez les aliénés." *Schweiz Archiv für Neurologie und Psychiatrie* 2 (1922): 166–67.

Meier-Müller, Hans. Review of *Ein Geisteskranker als Künstler* by Walter Morgenthaler. *Schweiz Archiv für Neurologie und Psychiatrie* 11 (1922): 309–14.

Meyer, Franz, and Dieter Koepplin. *Adolf Wölfli: Werke aus einer Privatsammlung.* Basel, 1971.

Morgenthaler, W. *Ein Geisteskranker als Künstler.* Bern, 1921.

——. "Gibt es eine psychopathische Höherwertigkeit?" *Neurologisches Zentralblatt* 3 (1919).

——. "Die Grenzen der geistigen Gesundheit." *Schweizer Rundschau für Medizin* (1918).

——. *Aus meinem Leben.* Bern, 1960.

——. "Übergänge zwischen Zeichnen und Schreiben bei Geisteskranken." *Schweizer Archiv für Neurologie und Psychiatrie* 3 (1918): 255–305.

——. "Über Zeichnungen von Gesichtshalluzinationen." *Zeitschrift für die gesamte Neurologie und Psychiatrie* 45 (1919): 19–29.

Ries, J. v. *Über das Dämonisch-Sinnliche und den Ursprung der ornamentalen Kunst des geisteskranken Adolf Wölfli.* Bern, 1946.

Rilke, Rainer Maria, and Lou Andreas-Salomé. *Briefwechsel.* Zurich, 1952.

Rorschach, Herman. "Analyse einer Schizophrenen Zeichnung." *Zeitschrift für Psychoanalyse und Psychotherapie* 4 (1914): 53–55.

——. "Analytische Bemerkungen über das Gemälde eines Schizophrenen." *Zeitschrift für Psychoanalyse und Psychotherapie* 3 (1913): 270–72.

——. *Psychodiagnostik.* Bern, 1921.

Schär, Hans, and Hans Walther-Büel. *Dr. Walter Morgenthaler: 1883–1965.* Bern, 1965.

Spoerri, Elka. "Adolf Wölfli." *Künstler Lexikon der Schweiz XX Jahrhundert*, vol. 2. Frauenfeld, 1963–1967.

——. "Adolf Wölflis Erzählwerk." In *Die Sprache des Anderen.* Edited by Peter Kisker and Gunter Hofer. Basel and New York, 1976.

——. *Adolf Wölfli: Zeichnungen 1904–1906.* Stuttgart, 1987.

——. "Walter Morgenthaler und Adolf Wölfli: Die Pionierleistung eines unkonventionellen Psychiaters." In *Morgenthaler: Ein Geisteskranker als Künstler*, pp. 152–54. Vienna, 1985.

Spoerri, Elka, ed. *Adolf Wölfli.* Bern, 1976.

——. *Der Engel des Herrn im Küchenschurz: Über Adolf Wölfli.* Frankfort, 1987.

Spoerri, Elka, and Stefan Frey. *Adolf Wolfli (1864–1930): Werke aus einer Privatsammlung.* Bern, 1984.

Spoerri, Theodor. "L'armoire d'Adolf Wölfli." *Le surréalisme, même* 4 (1958): 50.

——. "Die Bilderwelt Adolf Wölflis." In *Psychopathologie und bildnerischer Ausdruck*, vol. 5. Basel, 1964.

——. "Identität von Abbildung und Abgebildetem in der Bildnerei der Geisteskranken." In *Documente 5*, vol. 11, pp. 1–18. Cologne, 1972.

Walther-Büel, Hans. "Walter Morgenthaler (1883–1965)." *Schweizer Archiv für Neurologie, Neurochirurgie und Psychiatrie* 97 (1966): 149–51.

Wölfli, Adolf. *Von der Wiege bis zum Graab: Schriften (1908–1912)*, 2 vols. Edited by Elka Spoerri and Dieter Schwarz. Frankfurt, 1985.

FOURTEEN. EXPRESSIONISM AND THE ART OF THE INSANE

Allen, Edgar L. *The Self and Its Hazards: A Guide to the Thought of Karl Jaspers.* London, 1950.

Anonymous. *Arts primitifs dans les ateliers d'artistes.* Paris, 1967.

——. *Entartete Kunst: Bildersturm vor 25 Jahren.* Munich, 1962.

——. *Entartete "Kunst": Führer durch die Ausstellung.* Berlin, 1937.

——. Le salon de 1881." *Gazette des beaux-arts* 24 (1881): 35–36.

——. *The Studio* 56 (July 1912).

Anz, Thomas ed. *Literature der Existenz: Literarische Psychopathographie und ihr soziale Bedeutung im Frühexpressionismus.* Stuttgart, 1977.

——, ed. *Phantasien über den Wahnsinn: Expressionistische Texte.* Munich, 1980.

Bader, Alfred. "Art moderne et Schizophrénie." *Revue suisse psychologique* 17 (1958): 48–54.

Baynes, Norman H., ed. *The Speeches of Adolf Hitler.* London, 1942.

Blomberg, Erik. "Ernst Josephson: Painter, Poet, Precursor." In *Paintings and Drawings by Ernst Josephson* (Portland Art Museum Catalog). Portland, 1964.

——. *Ernst Josephsons Kunst.* Stockholm, 1956.

Brandell, Gunnar. *Strindberg in Inferno.* Cambridge, 1974.

Broekman, Jan M. "Das Gestalten Geisteskranken und die moderne Kunst." In *Bildnerei der Geisteskranken aus der Prinzhorn-Sammlung*, pp. 10–16. Heidelberg, 1967.

Busch, Günter. *Entartete Kunst: Geschichte und Moral.* Frankfurt, 1969.

Cassou, Jean, Emile Langui, and Nikolaus Pevsner. *The Sources of Modern Art.* London, 1962.

Dresler, Adolf. *Deutsche Kunst und Entartete "Kunst."* Munich, 1938.

Dunlop, Ian. *The Shock of the New.* London, 1972.

Foster, Hal. "The Madman: On Erich Heckel's 'Madman of Essen' (1914)." *Arts Magazine* 55 (February 1981): 152–53.

Golding, John. *Cubism: A History and an Analysis.* London, 1968.

Goldwater, Robert. *Primitivism in Modern Art* (1938). New York, 1967.

——. Review of *Ernst Josephson* by Simon L. Millner. *Magazine of Art* 42 (1949): 30.

Gordon, Donald E. *Ernst Ludwig Kirchner.* Cambridge, Mass. 1968.

——. *Ernst Ludwig Kirchner: A Retrospective Exhibition.* Seattle, 1969.

——. "Kirchner in Dresden." *The Art Bulletin* 48 (1966): 335–66.

Grochowiak, Thomas. *Ludwig Meidner.* Recklinghausen, 1966.

Grohmann, Will. *E. L. Kirchner.* Stuttgart, 1961.

Grunberger, Richard. *A Social History of the Third Reich.* London, 1971.

Guenther, Hans F. K. *Rasse und Stil.* Munich, 1926.

Haftmann, Werner. *Emil Nolde.* New York, 1959.

——. *Painting in the Twentieth Century.* New York, 1965.

Hartlaub, G. F. "Ernst Josephson." *Kunst und Künstler* 8 (1910): 192, 194.

——. "Ernst Josephson." *Zeitschrift für bildende Kunst* n.s. 21 (1910): 175–77.

——. "Der Zeichner Josephson." *Genius* 2 (1920): 21–32.

Hodin, Joseph Paul. "Deux maitres suédois: Une étude d'art pathologique." *Les Arts plastiques* 9–10 (1948): 379–91.

——. "Ernst Josephson." *The Norseman* 7 (1949): 43–50.

——. *Ludwig Meidner: Seine Kunst, seine Persönlichkeit, seine Zeit.* Darmstadt, 1973.

——. *Oskar Kokoschka.* New York, 1966.

Jaspers, Karl. *Kunst und Zeichnungen in Allgemeine Psychopathologie.* Berlin, 1923.

——. *Strindberg und van Gogh: Versuch einer pathographischen Analyse.* Munich, 1949.

Johnson, Ellen. "Ernst Josephson." *Magazine of Art* 42 (1949): 22–26.

——. "Ernst Josephson's Drawings." *Bulletin of the Allen Memorial Art Museum* 4 (1947): 89–95.

——. Review of *Ernst Josephson* by Simon L. Millner. *American-Scandinavian Review* 37 (1949): 73–74.

Jolowicz, Ernst. "Expressionismus und Psychiatrie." *Kunstblatt* 4 (1920): 273–76.

Jung, Carl G. "Picasso." In *Collected Works.* New York, 1966. 15: 135–39.

Kandinsky, Wassily. *Concerning the Spiritual in Art.* 1917. Reprinted. New York, 1947.

Kandinsky, Wassily, and Franz Marc, eds. *Der blaue Reiter.* 1912. Reprinted. Munich, 1965. English edition: *The Blaue Reiter Almanac.* Translated by Henning Falkenstein. New York, 1974.

Klee, Felix, ed. *The Diaries of Paul Klee: 1898–1918.* Berkeley, 1964.

——. *Paul Klee: His Life and Work in Documents.* New York, 1962.

Kris, Ernst. *Psychoanalytic Expolorations in Art.* New York, 1952.

Kubin, Alfred. *Die andere Seite: Ein phantastischer Roman.* Munich, 1909.

——. *Aus meiner Werkstatt.* Munich, 1973.

——. *Dämonen und Nachtgeschichte: Eine Autobiographie.* Munich, 1959.

——. *Traumland I, II.* Berlin, 1922.

Kuspit, Donald. "Diagnostic Malpractice: The Nazis on Modern Art." *Art Forum* 25 (November 1986): 90–98.

Lehel, F. *Notre art dément: Quatre études sur l'art pathologique.* Paris, 1926.

Lehmann-Haupt, Hellmut. *Art under a Dictatorship.* Oxford, 1954.

Lindsay, Lionel. *Addled Art.* London, 1946.

Mayr, W. *Le délire graphique et verbal.* Paris, 1928.

Michaelis, Karen. "Der Tolle Kokoschka." *Kunstblatt* 2 (1918): 361–66.

Millner, Simon L. *Ernst Josephson.* New York, 1948.

Mosse, George L. *Nazi Culture.* New York, 1966.

Nolde, Emil. *Jahre der Kämpfe.* Cologne, 1967.

Nordau, Max. *Degeneration.* New York, 1895.

Pauli, G. *Ernst Josephson: En Studie.* Stockholm, 1902.

Paulsson, Gregor. *Ernst Josephsons Teckningar: 1888–1906.* Stockholm, 1918.

Perkins, Geoffrey. *Contemporary Theory of Expressionism.* Bern, 1974.

Pierce, James Smith. "Paul Klee and Karl Brendel." *Art International* 22, no. 4 (1978): 8–20.

——. "Paul Klee and Baron Welz." *Arts Magazine* 52 (September 1977: 128–31.

——. *Paul Klee and Primitive Art.* New York, 1976.

Piron, Herman T. *Ensor: Een psychoanalytische studie.* Antwerp, 1968.

Poley, Stefanie. "Prinzhorns Buch 'Die Bildnerei der Geisteskranken' und seine Wirkung in der modernen Kunst." In *Die Prinzhornsammlung.* Königstein, 1980, pp. 55–69.

Prokopoff, Stephen. "The Prinzhorn Collection and Modern Art." In *The Prinzhorn Collection,* Krannert Art Museum Catalog (Urbana-Champaign, Ill., 1984), pp. 15-20.

Rave, Paul Ortwin. *Kunstdiktatur im Dritten Reich.* Hamburg, 1949.

Read, Herbert. "Hitler on Art." *Listener,* September 22, 1937: 605–7.

Reiter, Alfons. "Ernst L. Kirchner: Psychoanalytische Perspektiven der Psychoökonomie seines künstlerischen Schaffens." *Confinia Psychiatrica* 23 (1980): 118–28.

Roh, Franz. *Entartete Kunst: Kunstbarbarei im Dritten Reich.* Hanover, 1962.

Rothe, Wolfgang. "Der Geisteskranke im Expressionismus." *Confinia Psychiatrica* 15 (1972): 195–211.

Samuel, Richard H., and R. Hinton Thomas. *Expressionism in German Life, Literature and the Theatre.* Cambridge, 1939.

Schilpp, Paul A. *The Philosophy of Karl Jaspers.* New York, 1957.

Schlemmer, Tut, ed. *The Letters and Diaries of Oskar Schlemmer.* Middletown, Conn., 1972.

Schmied, Wieland. *Alfred Kubin.* New York, 1969.

Schneede, Marina, and Uwe M. Schneede. *Vor der Zeit: Carl Friedrich Hill, Ernst Josephson: Zwei Künstler des späten 19. Jahrhunderts.* Hamburg, 1984.

Schreyer, Lothar. *Erinnerungen an Sturm und Bauhaus.* Munich, 1956.

Schultze-Naumberg, Paul. *Kunst und Rasse.* Munich, 1928.

Selz, Peter. *Emil Nolde*, Museum of Modern Art Catalog. New York, 1963.

——. *German Expressionist Painting*. Berkeley, 1957.

Speer, Albert. *Inside the Third Reich*. Translated by Richard Winston and Clara Winston. New York, 1970.

Strindberg, Johan August. *Die gotischen Zimmer*. Munich, 1912.

Struck, H. "Ernst Josephson." *Zeitschrift für bildende Kunst* n.s. 20 (1909): 243–47.

van Gogh, Vincent. *The Letters of Vincent van Gogh*. Greenwich, Conn., 1959.

Wåhlin, K. *Ernst Josephson*. Stockholm, 1910–1911.

——. "Ernst Josephson." *Kunst und Künstler* 7 (1909): 479–90.

Werckmeister, O. K. "The Issue of Childhood in the Art of Paul Klee." *Arts Magazine* 52 (September 1977): 138–51.

Whitford, Frank. *Expressionism*. London, 1970.

Willet, John. *Expressionism*. New York, 1970.

Wulf, Joseph. *Kunst und Kultur im Dritten Reich*. Hamburg, 1966.

Zennstrom, Per-Olov. *Ernst Josephson*. Stockholm, 1946.

FIFTEEN. PSYCHOANALYSIS AND PSYCHOTIC ART

Alexander, Franz, Samuel Eisenstein, and Martin Grotjahn, eds. *Psychoanalytic Pioneers*. New York, 1966.

Anonymous. "Writings of Ernst Kris." *The Psychoanalytic Study of the Child* 13 (1958): 562–73.

Baynes, H. G. *Mythology of the Soul*. London, 1969.

Bernfeld, Suzanne Cassirer. "Freud and Archaeology." *American Imago*. 8 (1951): 107–28.

Bychowski, Gustav. "The Rebirth of a Woman." *Psychoanalytic Review* 34 (1947): 32–57.

Coles, Robert. *Erik H. Erikson: The Growth of His Work*. Boston, 1970.

Eitner, Lorenz. "The Artist Estranged: Messerschmidt and Romako." *Art News Annual* 32 (1966): 84–95.

Ellenberger, Henri F. "The Concept of Creative Illness." *The Psychoanalytic Review* 55 (1968): 442–56.

Erikson, Erik H. *Life History and the Historical Moment*. New York, 1975.

Fairbairn, W.R.D. "Prolegomena to a Psychology of Art." *British Journal of Psychology* 28 (1938): 288–303.

Federn, Paul. *Ego Psychology and the Psychoses*. New York, 1952.

Foy, James L., and James P. McMurrer. "James Hampton, Artist and Visionary." *Psychiatry and Art* 4 (1975): 64–75.

Fraiberg, Louis. "Freud's Writings on Art." *International Journal of Psychoanalysis* 37 (1956): 82–95.

Freud, Anna. "Regression in Mental Development." In *The Writings of Anna Freud*, 5: 407–18. London, 1970.

Freud, Sigmund. "Psychoanalytic Notes upon an Autobiographical Account of a Case of Paranoia (Dementia Paranoides)." 1911. In *The Standard Edition of the Complete Psychological Works of Sigmund Freud*, 12: 9–82. Edited by James Strachey. London, 1956–1974.

——. "A Seventeenth-Century Demonological Neurosis." 1923. In *The Standard Edition of the Complete Psychological Works of Sigmund Freud*, 19: 72–105. Edited by James Strachey. London, 1956–1974.

Geremia, Ramon. "Tinsel, Mystery, Are Sole Legacy of Lonely Man's Strange Vision." *Washington Post*, December 15, 1964, p. C2.

Gombrich, E. H. "A Mind of Distinction." *The Times* (London), March 23, 1957, p. 11.

——. "Psychoanalysis and the History of Art." In *Freud and the 20th Century*. Edited by Benjamin Nelson, pp. 186–206. Cleveland, 1963.

Grinstein, Alexander. *The Index of Psychoanalytic Writings*. New York, 1956–.

Hartmann, H. "Ernst Kris: 1900–1957." *The Psychoanalytic Study of the Child* 12 (1957): 9–15.

Hoffer, W. "Obituary: Ernest Kris." *International Journal of Psychoanalysis* 38 (1957): 359–62.

Jacobi, Jolande. *Vom Bilderreich der Seele*. Olten, 1969.

Jones, Ernest. *The Life and Work of Sigmund Freud*. New York, 1957.

Jung, Carl G. *Memories, Dreams, Reflections*. Translated by Richard Winston and Clara Winston. New York, 1963.

——. *Symbols of Transformation*. In *Collected Works*, vol. 5. New York, 1956.

Kris, Ernst. "Bemerkungen zur Bildnerei der Geisteskranken." *Imago* 22 (1936): 339–70.

——. *Catalogue of Postclassical Cameos in the Milton Weil Collection*. Vienna, 1932.

——. *Die Charakterköpfe des Franz Xaver Messerschmidt*. Vienna, 1932.

——. "Die Charakterköpfe des Franz Xaver Messerschmidt: versuch einer historischen und psychologischen Deutung." *Jahrbuch der kunsthistorischen Sammlungen in Wien* 6 (1932): 169–228.

——. "Ein geisteskranker Bildhauer: Die Charakterköpfe des Franz Xaver Messerschmidt." *Imago* 19 (1933): 384–411.

——. *Meister und Meisterwerke der Steinschneidekunst in der italienischen Renaissance*, 2 vols. Vienna, 1929.

——. "Psychoanalysis and the Study of Creative Imagination." *Bulletin of the New York Academy of Medicine* 29 (1953): 334–51.

——. *Psychoanalytic Explorations in Art*. New York, 1952.

——. Review of *Schizophrenic Art* by Margaret Naumburg. *Psychoanalytic Quarterly* 22 (1953): 98–101.

——. "Der Stil 'rustique.'" *Jahrbuch der kunsthistorischen Sammlungen in Wien* 1 (1936): 137–208.

Lacan, Jacques. *The Language of the Self*. Baltimore, 1968.

——. "Le probleme du style et la conception psychiatrique des formes paranoïaques de l'experience." *Minotaure* 1 (1933).

Lewis, Nolan D. C. "Graphic Art Productions in Schizophrenia." *Proceedings of the Association of Research on Nervous and Mental Disorders* 5 (1928): 344–68.

——. "The Practical Value of Graphic Art in Personality Studies." *Psychoanalytic Review* 12 (1925): 316–22.

Lifton, Robert J., ed. *Explorations in Psychohistory: The Wellfleet Papers*. New York, 1974.

Loewenstein, R. M. "In Memoriam Ernst Kris." *Journal of the American Psychoanalytic Association* 5 (1957): 741–43.

Macalpine, Ida, and R. A. Hunter. *Schizophrenia 1677*. London, 1956.

MacGregor, John M. "Psychological Aspects of the Work of Immanuel Velikovsky." In *Recollections of a Fallen Sky*. Edited by E. R. Milton, pp. 45–66. Lethbridge, Alberta, 1977.

May, Rollo. *My Quest for Beauty*. New York, 1985.

Meng, H., and E. L. Freud. *Sigmund Freud: Psychoanalysis and Faith; Dialogues with the Reverend Oskar Pfister*. New York, 1963.

Milner, Marion. *The Hands of the Living God: An Account of a Psychoanalytic Treatment.* London, 1969.

——. *On Not Being Able to Paint.* New York, 1967.

Möbius, Paul Julius August. *Über Kunst und Künstler.* Leipzig, 1901.

Naumburg, Margaret. *Schizophrenic Art: Its Meaning in Psychotherapy.* New York, 1950.

Niederland, William G. *The Schreber Case.* New York, 1974.

Pfister, Oskar. "Die Enstehung der Künstlerischen Inspiration." *Imago* 2 (1913): 481–512.

——. *Expressionism in Art: Its Psychological and Biological Basis.* Translated by Barbara Low and M. A. Mügge. London, 1922.

——. "Farbe und Bewegung in der Zeichnung Geisteskranker." *Schweizer Archiv für Neurologie und Psychiatrie* 34 (1934): 325–65.

——. *The Psychoanalytic Method.* Translated by Charles Rockwell Payne. London, 1917.

Philipson, Morris. *Outline of a Jungian Aesthetics.* Evanston, Ill., 1963.

Phillips, William, ed. *Art and Psychoanalysis.* New York, 1963.

Porter, Roy. *A Social History of Madness: The World through the Eyes of the Insane.* New York, 1987.

Potzl-Malikova, Maria. *Franz Xaver Messerschmidt.* Vienna, 1982.

Rank, Otto. *Art and Artist* (1932). New York, 1975.

Ritvo, Samuel, and Lucille B. Ritvo. "Ernst Kris: Twentieth Century Uomo Universale." In *Psychoanalytic Pioneers.* Edited by Franz Alexander, pp. 484–500. New York, 1966.

Roback, A. A., and Thomas Kiernan. *Pictorial History of Psychology and Psychiatry.* New York, 1969.

Roheim, Gaza. *Magic and Schizophrenia.* Bloomington, Ind., 1970.

Sachs, Hanns. *The Creative Unconscious.* Cambridge, 1942.

Schafer, Roy. "The Psychoanalysis of Surfaces." *Times Literary Supplement,* July 23, 1976, pp. 923–24.

Sèchehaye, Marguerite Albert. *Symbolic Realization: A New Method of Psychotherapy Applied to a Case of Schizophrenia.* New York, 1951.

Sedlmayr, Hans. *Verlust der Mitte—Die bildende Kunst des 19. und 20. Jahrhunderts als Symptom und Symbol der Zeit.* Salzburg, 1948. Translated as *Art in Crisis: The Lost Centre* by Brian Battershaw. London, 1957.

Spector, Jack J. *The Aesthetics of Freud: A Study in Psychoanalysis and Art.* New York, 1972.

Sterba, Richard. "The Problem of Art in Freud's Writings." *Psychoanalytic Quarterly* 9 (1940): 256–68.

Waelder, Robert. *Psychoanalytic Avenues to Art.* New York, 1965.

Winnicott, D. W. *Therapeutic Consultations in Child Psychiatry.* London, 1971.

Wittkower, Rudolf, and Margot Wittkower. *Born under Saturn.* London, 1963.

SIXTEEN. PSYCHOSIS AND SURREALISM

Anonymous. *Antonin Artaud: Portraits et dessins.* Paris, 1947.

——. *Art and Psychopathology: An Exhibition Jointly Sponsored by the Psychiatric Division of Bellevue Hospital and the Federal Art Project of the W.P.A.* Washington and New York, 1938.

——. "Dali and Miro Jar New York with Visions of the Subconscious." *Art Digest* 16 (1941): 5–6.

——. "Dali Proclaims Surrealism a Paranoic Art." *Art Digest* 9 (1935): 10.

——. *The International Surrealist Exhibition.* London, 1936.

——. "U.S. Government and Bellevue Hospital Exhibit Art of Insane Patients." *Life* 5, no. 17 (October 24, 1938): 26–27.

Artaud, Antonin. *Antonin Artaud: Selected Writings.* Translated by Helen Weaver. New York, 1976.

——. *Oeuvres complètes.* Paris, 1974.

——. "Van Gogh: The Man Suicided by Society." Translated by Bernard Frechtman. *The Tiger's Eye* 7 (1949): 93–115.

Balakian, Anna. *André Breton: Magus of Surrealism.* New York, 1971.

Barr, Alfred H., ed. *Fantastic Art, Dada, Surrealism.* New York, 1936.

Bonnet, Marguerite. *André Breton: Naissance de l'aventure surréaliste.* Paris, 1975.

Bosquet, Alain. *Conversations with Dali.* Translated by Joachim Neugroschel. New York, 1969.

Boswell, Payton Jr. "Is Dali Crazy?" *Art Digest* 15 (1941): 3.

Breton, André. "L'art des fous, la clé des champs." In *La Clé des champs,* pp. 270–74. Paris, 1953.

——. "Lettre aux médecins-chefs des asiles de fous." *La revue surréaliste* 3 (1925): 29.

——. "Manifesto of Surrealism" 1924). In *Manifestoes of Surrealism.* Translated by Richard Seaver and Helen R. Lane, pp. 3–47. Ann Arbor, Mich., 1974.

——. *Nadja.* Translated by Richard Howard. New York, 1960.

——. *Surrealism and Painting.* Translated by Simon Watson Taylor. London, 1972.

Breton, André, and Paul Eluard. *L'Immaculée Conception.* Paris, 1930.

Browder, Clifford. *André Breton: Arbiter of Surrealism.* Geneva, 1967.

Cardinal, Roger. "Nadja and Breton." *University of Toronto Quarterly* 12, no. 3 (1972): 185–99.

Cardinal, Roger, and Robert Stuart Short. *Surrealism: Permanent Revelation.* London and New York, 1970.

Cousseau, Henry-Claude. "The Search for New Origins." In *Aftermath: France 1945–1954.* Edited by Germain Viatte and Sarah Wilson. Paris, 1982.

Cowles, Fleur. *The Case of Salvador Dali.* Boston, 1959.

Dali, Salvador. *The Conquest of the Irrational.* New York, 1935.

——. *Dali.* Edited by Max Gérard. Translated by Eleanor R. Morse. New York, 1968.

——. *Declaration of Independence of Imagination and Man's Right to His own Madness.* New York, 1939.

——. *Diary of a Genius.* New York, 1965.

——. *La femme visible.* Paris, 1930.

——. *Oui: Méthode paranoïaque-critique et autres textes.* Paris, 1971.

——. *The Secret Life of Salvador Dali.* London, 1968.

Delanglade, Frédéric. "Antonin Artaud chez Gaston Ferdière." *La tour de feu* 63 (1959): 75–78.

Dunlop, Ian. *The Shock of the New.* London, 1972.

Durozoi, Gerard. *Artaud: L'aliénation et la folie.* Paris, 1972.

Eluard, Paul. "Le génie sans miroir." *Les feuilles libres* 35 (1924): 301–8.

——. *Le poète et son ombre.* Paris, 1963.

Ernst, Max. *Beyond Painting.* Translated by Dorothea Tanning. New York, 1948.

——. "An Informal Life of M.E. (as told by himself to a Young

Friend)." In *Max Ernst*. Edited by William S. Lieberman. New York, 1961.

Ey, Henry. *Le surréalisme devant la psychiatrie*. Paris, 1950.

Ferdière, Gaston. "L'aliénation créatice." *Folia Psychiatrica, Neurologica, et Neurochirurgica Neerlandica* 51 (1948): 15–30.

——. "Le dessinateur schizophrène." *Evolution psychiatrique* 2 (1951): 215–30.

——. "J'ai soigné Antonin Artaud." *La tour de feu* 13 (1959): 28–37.

——. "Le style des dessins schizophrénique." *Annales Médico-psychologiques* 106 (1948): 430–34.

Fischer, Lothar. *Max Ernst: In Selbstzeugnissen und Bilddokumenten*. Hamburg, 1969.

Freud, Ernst L., ed. *The Letters of Sigmund Freud: 1873–1939*. London, 1961.

Furst, Herbert. "Art Notes: Sanity or Insanity in Art." *Apollo* 24 (1936): 111–12.

Gauss, Charles E. "The Theoretical Background of Surrealism." *Journal of Aesthetics* 2 (1943): 37–44.

Greene, Naomi. *Antonin Artaud: Poet without Words*. New York, 1970.

Hirschman, Jack, ed. *Antonin Artaud Anthology*. San Francisco, 1965.

Hulbeck, Charles R. "Psychoanalytic Notes on Modern Art." *American Journal of Psychoanalysis* 20 (1960): 173.

Hunter, Sam. *Max Ernst: Sculpture and Recent Painting*. New York, 1966.

Isou, Isidore. *Antonin Artaud torturé par les psychiatres*. Paris, 1970.

Janis, Harriet. "Paintings as a Key to Psychoanalysis." *Arts and Architecture* 63 (1946): 38–40.

Jean, Marcel. *Histoire de la peinture surréaliste*. Paris, 1959.

——. *The History of Surrealist Painting*. Translated by Simon Watson Taylor. London, 1960.

Josephson, Matthew. *Life Among the Surrealists: A Memoir*. New York, 1962.

Jouffroy, Alain. "La collection André Breton." *L'oeil* 10 (October 1955): 32–39.

Knapp, Bettina L. *Antonin Artaud: Man of Vision*. New York, 1969.

Lacan, Jacques. *De la psychose paranoïaque dans ses rapports avec la personalité*. Paris, 1932.

Lippard, Lucy R. *Changing: Essays in Art Criticism*. New York, 1971.

Man Ray. *Self Portrait*. London, 1963.

Marie, A. "L'art et la folie." *Revue scientifique* 67 (1929): 393–98.

Marowitz, Charles. "Artaud at Rodez." *Evergreen Review* 12, no. 53 (1968): 64–67, 81–86.

Mauriac, Claude. *André Breton*. Paris, 1949.

Naville, Pierre. "Beaux Arts." *La révolution surréaliste* 3 (1925): 27.

Parinaud, André, ed. *The Unspeakable Confessions of Salvador Dali*. Translated by Harold J. Salemson. New York, 1976.

Poley, Stefanie. "Prinzhorns Buch 'Die Bildnerei der Geisteskranken' und seine Wirkung in der modernen Kunst." In *Die Prinzhornsammlung*, pp. 55–69. Königstein, 1980.

Porter, Roy. *A Social History of Madness: The World through the Eyes of the Insane*. New York, 1987.

Prinzhorn, Hans. "Auguste Neter." Translated by Meret Oppenheim. *Medium* 4 (1955): 27–30.

Prokopoff, Stephen. "The Prinzhorn Collection and Modern Art." In *The Prinzhorn Collection*, Krannert Art Museum Catalog, pp. 15–20. Urbana-Champaign, Ill., 1984.

Quinn, Edward. *Max Ernst*. London, 1977.

Rubin, William S. *Dada, Surrealism and Their Heritage*. New York, 1968.

Russell, John. *Max Ernst: Life and Work*. London, 1967.

Samaltanos, Katia. *Apollinaire: Catalyst for Primitivism, Picabia and Duchamp*. Ann Arbor, Mich., 1984.

Soby, James Thrall. *Salvador Dali*. New York, Museum of Modern Art, 1946.

Sontag, Susan. "Artaud." Introduction to *Antonin Artaud: Selected Writings*. Translated by Helen Weaver. New York, 1976.

Spies, Werner. "L'art brut avant 1967." *Revue de l'art* 1–2 (1968): 123–26. Translated as "Hippopotamus with Bootjack: The Art of Psychopaths and Modern Art." In *Focus on Art*, pp. 230–36. New York, 1982.

——. "Getting Rid of Oedipus: Max Ernst's Collages: Contradiction as a Way of Knowing." In *Focus on Art*, pp. 96–103. New York, 1982.

——. "Hallucination and Technique: Max Ernst at Eighty." In *Focus on Art*, pp. 91–96. New York, 1982.

——. *Max Ernst: Collagen; Inventar und Widerspruch*. Cologne, 1974.

——. *Max Ernst-Loplop: The Artist in the Third Person*. New York, 1983.

——. *Max Ernst (1950–1970): The Return of La Belle Jardinière*. New York, 1972.

Spoerri, Theodore. "L'armoire d'Adolf Wölfli." *Le surréalisme même* 4 (1958): 50–55.

Szecsi, Ladislas. *On Works of Art of the Insane*. New York, 1935.

Trier, Eduard. "Was Max Ernst studiert hat." In *Max Ernst: Retrospective*, pp. 31–42. Munich, 1979.

Tzara, Tristan. "Ernst Josephson." *Les feuilles libres* 42 (1926): 381–82.

Vinchon, Jean. *L'art et la folie*. Paris, 1924. Revised. Paris, 1950.

Waldberg, Patrick. *Max Ernst*. Paris, 1958.

Winthrop, Sargent. "Dali: An excitable Spanish Artist, now scorned by his fellow Surrealists, has succeeded in making deliberate lunacy a paying proposition." *Life* 19, no. 13 (September 24, 1945): 63–68.

SEVENTEEN. DUBUFFET AND THE AESTHETIC OF ART BRUT

Allen, Virginia. *Jean Dubuffet: Drawings*. New York, 1968.

Alloway, Lawrence, ed. *Jean Dubuffet: 1962–1966*. New York, 1966.

Bader, Alfred, et al. *Insania Pingens*. Basel, 1961.

Berne, Jacques. *Dubuffet*. Paris, 1973.

Cardinal, Roger. *Outsider Art*. London, 1972.

Cordier, Daniel. *The Drawings of Jean Dubuffet*. New York, 1960.

Dubuffet, Jean. *L'art brut préféré aux arts culturels*. Paris, 1949. Reprinted in *Prospectus et tous les écrits suivants*, 1: 198–202. Paris, 1967.

——. *Asphyxiante culture*. Paris, 1968.

——. *Communication aux membres de la Compagnie de l'Art Brut*. Paris, 1971.

——. "Culture et subversion." *L'arc*, 35 (1968).

——. Daybooks. Unpublished manuscripts in the Archives of the Musée de l'Art Brut, Lausanne.

——. "Heinrich Anton M." *L'art brut* 1 (1964): 130–43. Reprinted

in *Prospectus et tous les écrits suivants*, 1: 269–75. Paris, 1967.

——. "Histoire de la Compagnie de l'Art Brut." In *L'art brut*, Catalog of the Musée des arts décoratifs, pp. 123–25. Paris, 1967.

——. "Honneur aux valeurs sauvages." In *Prospectus et tous les écrits suivants*, 1: 205–24. Paris, 1967.

——. *Landscaped Tables, Landscapes of the Mind, Stones of Philosophy*. New York, 1952.

——. "Memoir on the Development of My Work from 1952." In *The Work of Jean Dubuffet*, by Peter Selz. New York, 1962.

——. *Nouvelle communication aux membres de l'ex-Compagnie de l'Art Brut*. Paris, 1975.

——. "Place à l'incivisme." In *Prospectus et tous les écrits suivants*, 1: 453–57. Paris, 1967.

——. "Positions anticulturelles." In *Prospectus et tous les écrits suivants*, 1: 94–100. Paris, 1967.

——. *Prospectus aux amateurs de tout genre*. Paris, 1946.

——. *Prospectus et tous les écrits suivants*, 2 vols. Paris, 1967.

Gagnon, François. *Jean Dubuffet: Aux sources de la figuration humaine*. Montreal, 1972.

Henrion, Françoise. *L'art brut et après*. . . . Brussels, 1988.

Limbour, Georges. *Tableau bon levain à vous de cuire la pate: l'art brut de Jean Dubuffet*. Paris, 1953.

Loreau, Max. *Jean Dubuffet: Stratégie de la création*. Paris, 1973.

——, ed. *Catalogue des travaux de Jean Dubuffet*. Paris, 1966.

——. *Dubuffet et le voyage au centre de la perception*. Paris, 1966.

——. *Jean Dubuffet: Délits, déportements, lieux de haut jeu*. Paris, 1971.

Presler, Gerd. *L'Art Brut: Kunst zwischen Genialität und Wahnsinn*. Cologne, 1981.

Ragon, Michel. *Dubuffet*. Paris, 1958.

Rowell, Margit. "Jean Dubuffet: An Art on the Margins of Culture." In *Jean Dubuffet: A Retrospective*. New York, 1973.

Selz, Peter. *The Work of Jean Dubuffet*. New York, 1962.

Thévoz, Michel. *Collection de l'Art Brut*. Lausanne, 1976.

CONCLUSION

Anonymous. *Bildnerei der Geisteskranken aus der Sammlung Arnulf Rainer*. Munich, 1970.

Bader, Alfred, et al. *Insania Pingens*. Basel, 1961.

Barnes, Mary, and Joseph Berke. *Mary Barnes: Two Accounts of a Journey through Madness*. Harmondsworth, 1973.

Breicha, Otto. *Arnulf Rainer: Überdeckungen*. Vienna, 1972.

——, et al. *Arnulf Rainer: Zeichnungen, 1947–51*. Vienna, 1969.

Fromm-Reichmann, Frieda. *Principles of Intensive Psychotherapy*. Chicago, 1950.

Fry, Roger. "Art History as an Academic Study" (1933). In *Last Lectures*, pp. 1–21. Cambridge, 1939.

Henrion, Françoise. *L'art brut et après*. . . . Brussels, 1988.

Jakob, Irène. *Dessins et peintures des aliénés*. Budapest, 1956.

Jakob, Irène, ed. *Psychiatry and Art*. Basel and New York, 1968.

Klein, Melanie. *Narrative of a Child Analysis*. New York, 1975.

Kris, Ernst. *Psychoanalytic Explorations in Art*. New York, 1952.

Lebel, R. *Marcel Duchamp*. Translated by George Heard Hamilton. New York, 1959.

Meurer-Keldenich, Maria. *Medizinische Literatur zur Bildnerei von Geisteskranken*. Cologne, 1979.

Milner, Marion. *The Hands of the Living God*. London, 1969.

——. *The Suppressed Madness of Sane Men*. London, 1987.

Naumberg, Margaret. *An Introduction to Art Therapy*. New York and London, 1973.

Navratil, Leo. *August Walla: Sein Leben und seine Künst*. Nördlingen, 1988.

——. *Der Himmel Elleno: Psychopathologie, Kunst und Sprache*. Vienna, 1975.

——. *Johann Hauser: Kunst aus Manie und Depression*. Munich, 1978.

——. *Die Künstler aus Gugging: Zustandgebundene Kunst*. Vienna, 1983.

——. "Mutteridole eines Imbezillen." In *Psychopathologie und Bildernischer Ausdruck*. Linz, 1969.

——. *Schizophrenie und Kunst: Ein Beitrag zur Psychologie des Gestaltens*. Munich, 1965.

——. *Über Schizophrenie und die Federzeichnungen des Patienten O.T*. Munich, 1974.

Navratil, Leo, and Alfred Bader. *Zwischen Wahn und Wirklichkeit*. Luzern and Frankfurt, 1976.

Navratil, Leo, and Peter Pongratz. *Der Mensch-Psychopathologische Zeichnungen*. N.p., n.d.

Navratil, Leo, and Michel Thévoz. *Gugging*. Fascicule 12 of *L'art brut*. Lausanne, 1983.

Pickford, R. W. *Studies in Psychiatric Art*. Springfield, Mass., 1967.

Plokker, J. H. *Artistic Self-Expression in Mental Disease*. London, 1964.

Porter, Roy. *A Social History of Madness: The World through the Eyes of the Insane*. New York, 1987.

Rennert, Helmut. *Die Merkmale schizophrener Bildnerei*. Jena, 1962.

Scull, Andrew T. *Museums of Madness*. London, 1982.

Shaffer, Peter. *Equus*. London, 1973.

Thévoz, Michel. *Art brut*. Geneva, 1976.

Volmat, R. *L'art psychopathologique*. Paris, 1956.

Will-Levaillant, Françoise. "L'analyse des dessins d'aliénés et de médiums en France avant Surréalisme." *Revue de l'art* 50 (1980): 24–39.

Index